CALL OF THE NORTH

An Explorer's Journey to the North Pole

Jean Malaurie

Translated from the French by Molly Stevens

HARRY N. ABRAMS, INC., PUBLISHERS

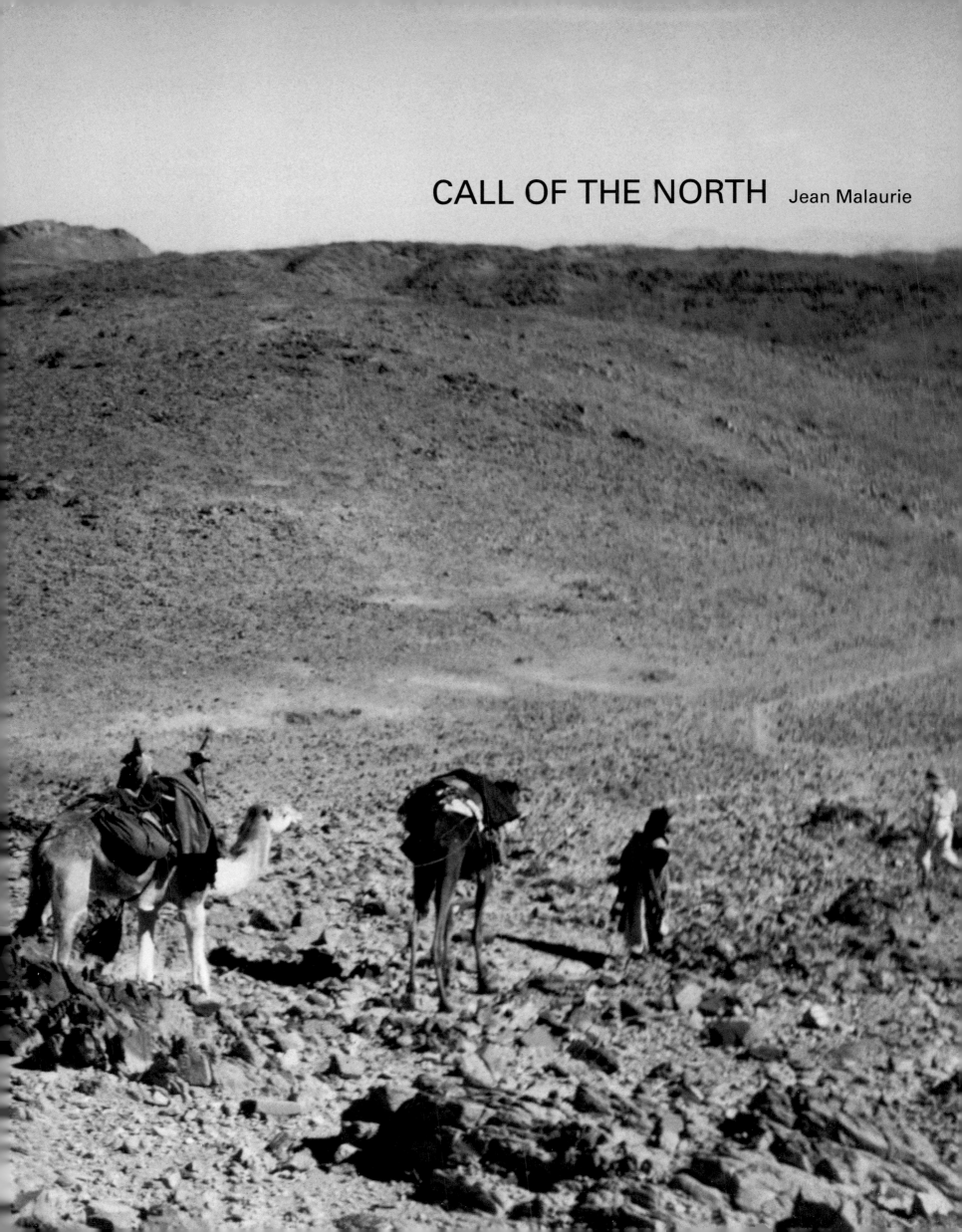

CALL OF THE NORTH Jean Malaurie

ARCTIC OCEAN

North Pole

R
U
S
S
I
A

Severnaya Zemiya
(RUSSIA)

Zemlya
Frantsa-Iosifa
(RUSSIA)

Peary
Land

Pole (1951)

Lincoln
Sea

Washington Land

Humboldt
Glacier

Kane
Basin

Inglefield

Cape Cheliuskin

Laptev
Sea

New Siberian
Islands
(RUSSIA)

Sverdrup Islands

Ellesmere Island

Queen Elizabeth Is.

North magnetic
pole (1985)

Melville

East Siberian Sea

MacClure Strait

Bank
Isla

Cherskiy

Chukelin
Sea

Beaufort
Sea

SIBERIA

Wrangel Island

Long Strait

Sea of
Okhotsk

CHUKOTKA NORD-ORIE

Pt. Barrow

Brooks
Range

Point Hope

Cape Dejnev

Velen

Kotzebue

Arctic Circle

Anadyr

Lavrentia

Shishmaref

Selawik

Allakaket

Fairbanks

Nov Caplino
Providenija

Wales

Teller

Seaward
Peninsula

Alaska
(USA)

R o c

Anadyr
Bay

Ittygran
Island

Savoonga

Saint
Lawrence
Island

Nome

Chevak

Akiachak

Bethel

Anchorage

Bering

Sea

Gulf
of Alaska

Eismitte **

French central station

Greenland
(DENMARK)

Skansen
Eqe
Tullissat
Qeqertarsuaq
(Godhavn)
Disko
Island
Disko
Bay
(Jakobshaven)

Nuuk
(Godthlab)

LABRADOR

SEA

Newfoundland

Sisimiut
(Holsteinborg)

Moriussaq
Thule
(Base USA)
Savissivik
Kap York
Melville
Bay

Davis Strait

Baffin Bay

Clyde River

Q U E B E C

Frobisher Baie
(Iqaluit)

Kuujjuaq
(Fort Chimo)

Ile Herbert
Baie de
l'Etoile Polaire

Pond Inlet

Bylot
Island

Baffin Island

Hudson Strait

Ungava
Peninsula

Lancaster Sound

Devon Island

Canadian Arctic

Igloolik

*Foxe
Basin*

Hudson

Bay

Cornwallis
Island

Barrow Sound

Prince of Wales
Island

Somerset
Island

Thom Bay

Spence Bay

Boothia
Peninsula

Melville
Peninsula

Repulse Bay

Gjoa Haven

Chantrey Inlet

Chesterfield
Inlet

King
William
Island

Back River

Baker Lake

Rankin
Inlet

Victoria Island

Eskimo
Point

Churchill

U
N
I
T
E
D

S
T
A
T
E
S

Mountains

Areas studied in
Jean Malaurie's 31 missions
(1948–1997)

CONTENTS

THE CALL OF THE NORTH

The call of the North is ancient and deep. It penetrates our unconscious and conjures images of solitude, harshness, and purity. The polar night is filled with uncertainties and visions of utopia, with fantastic tales, with the myths of the North—of cruel and virile Nordic gods, of Nerrivik, the scorned Inuit girl and goddess of the sea; of Apollo, young and handsome, god of the North, god of hunting and music, the great arbiter. This intricate mesh of myth and archetype came from seven years of reading—of the gods of antiquity, in Greek, as well as tales of the great explorers, the stories of Jules Verne, and the legends of the Scots and Vikings. And this fabulous pantheon spurred my unconscious rejection of dogma—particularly the one about the single God revealed to humans. These myths buried themselves and emerged as the gods of the moment in the vague animism of a teenager.

Uranus, god of the sky, and Gaia, goddess of the Earth. How could we forget you? I see you in the tundra as I decipher the Inuit stories my companions recount. Sometimes the legends seem to be inspired by the Greeks—but this may be the simplistic perspective of a beginner in Eskimo history. In Cronus, who devoured his own children except for Zeus and was saved by his mother, I find a parallel with Igimarasugguaq, an ogre who ate children lured by his companion. The Titans, the Cyclops, and the monsters that Uranus and Gaia bore: I listened again to their adventures in Thule, and later in the company of Netsilik Eskimos from the central Arctic and Saint Lawrence Island in the Bering Sea. They are the *Krévitoq*, the *Tunit*, the giant monsters and dwarfs that fill the Inuit's nightmares. Cronus cut off his father Uranus's testicles with a sickle, his blood and sperm fertilizing the Earth; I heard worse tales when I was with the Inuit.

A ONE-SIDED EDUCATION

I did not like my childhood. Though my high school had a distinguished reputation, new ideas were neither encouraged nor elicited. So I lived in my dreams—of Rhineland, of the great castle Burg Rheinstein, the schloss of the Great Electors of the Holy German Empire, and especially of Lorelei, a mythical woman who had thrown herself off a cliff in despair over a faithless lover. She became a kind of German siren, luring sailors to their death in the Rhine's rapids. And sometimes my mind was carried away on the back of a wild goose, as in Selma Lagerlöf's *Nils Holgersson*, to explore the vastness of the Scandinavian Great North. The years went by.

When I began to study philosophy and the liberal arts in Paris, I was shocked to find that the dominant model of thought was Western, drawn from the philosophies of Descartes, Pascal, Spinoza, Kant, and Hegel. It was as if the civilizations of Africa and Asia, Buddhism and Shintoism, and Hebrew, Christian, and Muslim theologies, which were not taught because they were secular, did not exist. Things didn't change much when I began to study at the Université de Paris. So when it was time to choose a subject for my doctoral thesis, I chose to escape the West and its dogmas, to escape my own world, and to escape school and its strictness, where duty replaced thought.

IN SEARCH OF FREEDOM

In the spring and summer of 1948 and 1949 I went to Disko Bay, on the west coast of Greenland, to work as a geographer for Paul-Emile Victor's glaciological expeditions. Why the North and not, say, the Sahara, where I had also traveled? If I had to answer, I would say: Because it was farther away, and because among its fog and ice floes Paleolithic men had crossed the Bering Strait to settle what was then the deserted Americas. But if I dig deep into my memory, I have to admit that it was mainly an emotion that kept me at Disko Bay. It was an emotion imbued with water—the constant presence of water everywhere.

Yes, water. It enveloped me and diffused its mysterious frozen harmonies. The black water of Disko Bay, leaden, heavy with its potential to become ice; the majestic drift of the icebergs; the moving, misty glow of the tundra. At night, the winter silence has a captive energy. And then the first moments of winter: the sea suddenly freezes. Farewell to the crash of waves and the incessant tides! Farewell to the joyful cries of the birds that went from sea to cliff to feed their little ones, beak to beak, before their long, perilous flight south. The buzz of life is hushed, as if it were muffled by the blanket of snow that came before daybreak. Movement itself freezes.

But then, emerging from this lunar landscape, come the Inuit, with their gentleness, their wild impulses, their trickery, their discreet anxiety. They are silent links to the past, men and women wearing animal hides—bear pants, seal boots, caribou jackets with hoods that end in fox tails. They bring the odor of seal and the stale smell of igloos; the guttural call of their dogs; and a memory of early man. They evoke the childhood of the human Earth, the harshness and violence, the stammering of the first millennia of humanity.

A LOST KINSHIP

I experienced a crucial moment in the long history of the Earth's most northerly people, the Eskimos of northern Greenland, before the construction of an American military base threw the area into disorder in 1951. I am searching my memory as I look at my photographs from that time. When I return to those decisive years, 1950 and 1951, the Arctic nights are what first stir again in me. I hear the screeching cries of the dogs and my inner being rustles uncomfortably. My innermost fibers respond to this call from the dawn of time. A dog (*qimmiq*) stands before me, his mouth turned toward the moon, his eyes possessed. *Miagguuqtuq*! He lets out his first lugubrious cry, which is lost in the distance. He calls out to his lost wolf relatives. Other dogs nearby do the same and soon the entire pack joins into a desperate choir. It's as if the dogs, fathers of the Inughuit, of all the Inuit, were appealing to the gods of chaos. They also address an agonizing cry to men: "Why did you break the ancient bond that brought us together? We were cousins then. Why? Why?" It is a sustained cry, a dismal three-minute modulation, repeated twice or three times. Then it suddenly stops. If a straggler cries out alone, he will stop immediately, the pack of hounds refusing to join in.

A MYSTICAL POLE

Our three major religions were born in the hot deserts of the Middle East: Sinai, Jerusalem, and Mecca. But in the Far North, in the deserts of ice, there is another transcendence: the mineral cold, the infinite void, the studded cosmos in this nave open to the universe. It draws you into the absolute and the unspeakable. Little by little, the divine wisdom of the Western world suffocates. Only its whimper can be heard. I went

from a civilization of books to one of men with an oral tradition, their main language and gesture being what is left unsaid.

I am Norman; my father is from Cauche and my mother has Scottish roots. But I am also from Rhineland—I was born in Mainz, Germany, on December 22, 1922. My lullabies were Schubert's *Lieder*, Bach's choirs, and Schumann's romanticism. The Black Forest sparked my childhood imagination. But when I read the Greek tragedies I learned of another world to the north, a frontier that was unknown but still had a name. It was said that the Far North was the home of a heavenly land and also an open sea. Despite facts gathered by travelers—cold, ice, the endless polar night—legends are so powerful that the Far North region remained, for the Greeks, a place of happiness. According to Homer, Boreas, the North Wind, was the wind of generation. It carried souls.

Apollo, is god of the North, is the youngest, the most handsome, the most mysterious figure in Greek mythology. God of hunting, god of the wolf, god of archery and music (he played the lyre at Zeus's table), Apollo was born on the floating island Delos, where seals and sea monsters bred among the isolated rocks. As a child he traveled among the Hyperboreans—inhabitants of the sunny land beyond the North Wind— carried by swans, the birds of the Far North who sing only when dying, according to the poet Callimachus. Every autumn Apollo returned to the North to refresh and prepare himself for using his great prophetic powers in the spring at Delphi.

Apollo was *Alexiklakos*, a patron saint, the god who kept evil at bay, a miracle worker, a healer, a soothsayer. Being a sun god, Apollo confronts dark and infernal forces. He is forever young—naked and beardless, his hair grown wild, his features delicate, his shape effeminate. Apollo is the god of the mind. He inspires and orders the material world, he is the master of the world's harmony, he appeases and unites. According to Plato, Apollo proclaimed the fundamental laws of the Republic; he is the very spirit of the laws that bound man to the gods. "This god from the North," Plato says, "settled at the center and navel of the earth to guide mankind." Every year the Hyperboreans sent him young virgins as messengers who presented him with an offering.

These myths filled my mind when I journeyed north to meet the most northerly people on the earth. During the spring and summer of 1948 and 1949, I lived among Greenlanders in Disko Bay, about halfway up the west coast. Their stories inspired me to go farther north, to search for those legendary peoples that my companions from ancient times had described: "They are our fathers!" I set out on July 23, 1950, prepared for fourteen months of travel among the Inughuit, the Polar Eskimos.

Off I went, up and down the coast of North Star Bay, the frozen waters crashing around me, icebergs drifting by with superb nonchalance. I was reminded of the inscription on the pediment of the Scott Polar Research Institute at Cambridge University: *Quaesivit arcana poli: videt Dei,* "He sought the secrets of the Pole; he now sees those of God." I murmured psalms from Isaiah and, at night, I read the Apocalypse according to John, in particular the verses concerning the Second Coming: "You [Lucifer] said in your heart, 'I will ascend to heaven; I will raise my throne above the stars of God, And I will sit on the mount of assembly in the recesses of the north. I will ascend above the heights of the clouds; I will make myself like the Most High.'"

I, AN ORPHAN, FIND MY CHOSEN FAMILY

In a conversation with myself as I collected plants, I considered the idea of wintering in northern Greenland without special gear or provisions. A week later, on August 3, I set out for Siorapaluk, on Robertson Fjord at 77°47'N, 70°42'W, 100 miles north of Thule, to pursue an even more solitary life among thirty-four Inuit. Within two weeks I had an igloo of my own.

One morning that September I stepped out of my igloo and became certain that I was truly aware of the majesty of Siorapaluk in all of its harshness. I had been touched by other exceptional environments, such as the central Sahara, but on that morning I stopped being a spectator. I felt part of this world, received as a guest.

When I first met the Thule Eskimos, I was lucky not only to be different from them—I was white and alone—but also to be conducting research that required their participation and, most important, their own skills, including hunting and navigating by the stars. The channels of communication were opened. I was the researcher, taking notes and, in a sense, becoming their historian; they were hunters and informants. Little by little, I was adopted by this group, not like an orphan or even a lone traveler but as a scientist who had chosen them. The more they noticed my differences and my own personality, the more my presence was considered an asset. I was to record the memory of this society that had taken me in, and became so much a part of it that I entered its oral tradition. The name they gave me was to become a kind of passport, giving me dual citizenship in their world and my own.

When I met the Thule Eskimos I was twenty, and had already lost my father and mother. There, for the first time, I felt at home. I had found a new family. Readers would later call me, though it is an exaggeration, the "white Eskimo." The Inuit called me simply *Maloringuâq* ("our Malaurie") or just Malaurie.

Everything around me seemed to be a miracle—and until that point I hadn't believed in miracles. The pure air, the light, so bright and fragile, its reflection on the clear water, the pink sandstone cliffs, the white sand beaches, the colorful flowers, the vitality of a day that lasted for weeks. I was experiencing an enchanted moment, as if I were discovering a new continent as well as a new way of being. For me, it was the first morning of the world.

The Arctic has certain powers and I was under their influence. Was such a strong first impression—which I had already experienced in Disko Bay—the reason for my close relationship with these northern places? Who could know? Who could tell me? In February 1951, at -40°F, with a smile and some pride, I endured the frostbite that appeared in concentric circles on my peeling cheeks.

In April 1969 the Inuit and I took great risks as we tried to save some friends caught in dangerous waters. "*Sordlo Atauseq*" ("All as one!") they shouted to encourage me on the difficult ice. I felt as if I had been lifted above the crumbling ice and the black water and propelled forward, as light as can be. After that experience I thought about wintering in northern Greenland again. Sakaeunnguaq was preparing to organize winter communal quarters in Etah for a small group of my Inuit friends. I had daydreamed about wintering here for several years, about radically changing my life to make it more like the Inuit's, about isolating myself from my books and colleagues. I stopped myself. Alaska and the islands of the Bering Strait beckoned me. Sometimes you have to make decisions. But I have always regretted missing this chance.

THE CHOSEN NORTH

When one becomes this dedicated to his convictions, he feels a kind of gratefulness. This explains my loyalty to the "idea of North," an expression coined by Glenn Gould. This phrase explains the will and energy that I expended throughout my life walking through the tundra, attempting to explain in writing, photographs, films, and drawings all that I had witnessed, all that I had lived, during thirty-one missions that stretched over 3,800 miles of the Far North, from Thule in northern Greenland, to Chukchi, the Siberian cradle of the Inuit. Distance only brought my thoughts and sensibility closer to their igloos and camps. My imagination often rendered them more violent and true from afar. The distance from the actual landscapes and men seemed beneficial. Sometimes one needs distance to confirm one's impressions.

My final mission was in Nome, on the Bering Strait, in 1997. Nome is a frontier post, where drunken Inuit teeter back and forth down the main street, in search of tourists who will buy their knick-knacks. Their broken English and broken Eskimo is a schizophrenic language, proof that their cultural breakdown is so deep that it has affected their ability to talk. Their journey ends right there, at the close of a soul's dark night, and I understand that by going to their islands—to Saint Lawrence, to Savoonga, to the Diomede Islands—I have to strive, bit by bit, to transcend their humiliated past. What a responsibility!

WHY WRITE? WHY TAKE PICTURES?

It is a complicated question, and one I always hesitate to address, but here is an answer: in order to live better. To hold yourself back from writing, or taking pictures (photography being a form of writing), would be the same as refusing to wake up in the morning. I cannot stop thinking about the events I witnessed or of which I was part. And writing is a way to communicate with that great judge, public opinion.

It was unlikely that I would become a writer of the Eskimos. I had committed myself to a strict doctoral program studying geomorphology. Doing the fieldwork and writing my dissertation took me twelve years. Of necessity my dissertation was dry and impersonal, relaying the facts and nothing but the facts. Although to me the work was enthralling, I was sometimes tempted to escape. The endless hours in the sedimentary geology lab or surveying permafrost wasn't always appealing. At the time, though, I never thought of writing for the public. Scientific writing rejects the "I," banning it as if it were a trivial indulgence.

When I finally wrote for a general audience in 1955, I did so because I had no other choice. I was the only outside witness to the dramatic events that occurred in Thule in 1951. In the middle of the land belonging to the 302 Inughuit who had taken me in as their guest the U.S. Air Force built a huge base, home to some 5,000 soldiers. I had to speak for these people who had undergone such misfortune, and I had to convey my own indignation. I would never have forgiven myself if I had kept quiet about those events. I had to testify, and to take action.

Writing for a general audience was not easy. Despite classes in rhetoric, I had not been a good essayist in high school. And for a scientist, writing down one's own thoughts was almost depraved. Signing a contract with a Paris publisher hardly seemed to conform to the code of ethics of the Geological Society of France, which had so generously opened the pages of its *Bulletin* to me. Yet I had to rally public opinion at all costs. I had to fight for the indigenous people of the North. So at my table, in front of a blank sheet of paper and little by little, a writer was born.

My descriptions of the Crystal Palace, of Inglefield Land in northwestern Greenland, of drifting icebergs, seemed flowery to me. But the battle to support these people whose rights had been outrageously disregarded propelled me. My conscience, wounded in this righteous struggle, gradually told me what I should write down. Writing became a part of me. My first book, *Derniers Rois de Thulé*, was published in France in 1955 and a year later in England as *The Last Kings of Thule: A Year Among the Polar Eskimos of Greenland.*

I followed a similar path with photography. While traveling by dog sled, walrus-skin canoe, or by foot I sometimes needed to stop for a few moments while my companions hunted a seal or a bear. Always discreet, I would withdraw during and after the hunt to furtively take a few notes and, if inspiration struck, to take a picture. Sometimes, in a burst of feeling, I attempted a pastel drawing or a sketch. And when I returned to Normandy I would occasionally make some drawings. I didn't render the wheat fields before my eyes, but rather an Arctic landscape that was so clear in my mind that I felt I was there.

INUIT GODS

I can almost say that sometimes, at the edge of my tent, with the polar night surrounding me, I prayed. But I would be lying. The absolute is unspeakable. And because I am impatient, such a private dialogue has always proved impossible for me. The gods of the Inuit, however, can call out to you, envelop you, penetrate you. Omnipresent and sometimes imperious, Inuit gods come in many forms, even in many sounds. In the solitude of a blizzard, the ice field cracks beneath your feet, the distressed dogs question you with their beautiful brown eyes; there, I'm inventing gods just like the Inuit do. There is a force in the terror of wild nature, in the call of an icy void, that seems to unveil eternity.

At night, in the dim yellow light of a quiet igloo, in the serenity created by the little flame of a seal oil lamp, reason orders one's thoughts. But what I felt out on the trails was too strong. It became a part of my whole outlook and *ingnik, ikuma,* the little flame in this icy enclosure, became a symbol of the energy within this grandiose and cruel world. At this early point I had only an intuition about this energy; it was confirmed forty years later at Whalebone Alley in Chukotka, Russia. There, at an ancient shamanistic site marked by circles of giant whalebones, I saw the expression of this energy, which the Chinese call *jing*, "the primordial breath that gives life to the world and gives shape to all things," in the words of Joseph Needham.

I was never uncomfortable when I witnessed shamanism in the Arctic. It was just part of life. The shaman is not a crazy social misfit, as has been suggested by missionaries and psychiatrists. For the Inuit, the lure of talking to the dead is not a symptom of mental illness. The Inuit are hungry for the sacred. They take premonitions very seriously. The intensity of the call to the mysticism of the Far North is palpable. It becomes part of breathing; it is as natural as Icarus's desire to fly.

Sun-Brother, Moon-Sister, Wind-Brother, Water-Sister, Fire-Brother: The *Cantique de Créatures*, one of the most beautiful texts of medieval French literature, calls out to us from these high latitudes. It is the call from the poles of the world. The Earth, the sea, the animals seem to live with all living beings as one. In a radically different vision of the cosmos, man finds his identity again in what is divine; he is a part of the divine. All things begin in a common force: the hidden order of nature.

With the Inuit, it would be better to simply say stone, wind, breath, water. In their lost language, the Inuit think like pantheists; this has been the case for 10,000 years. They have engaged in symbolic thinking and understood the meaning of harmony since the late Paleolithic era. Indeed, the peoples we call "primitive" have an extrasensory perception that is more developed than Western man's. "They have a concrete memory that truthfully reproduces sensations down to the smallest detail," Lucien Lévy-Bruhl tells us. For them, the invisible and the visible are one and the same. Their heightened emotions and their keen sense of the hunt force them to note nature's details and experience its forces and energies.

In the last few years, researchers have discovered how malleable our brains are. New neurons grow in the stimulated areas of our brain, while in nonstimulated portions they do not. Cells there eventually die. The Inuit offer a kind of proof of this adaptation. They have heightened senses, and their capacity for dreaming is much greater than ours. The hysteria that overcomes the Inuit each fall, both in Greenland and in the central Canadian Arctic, is an example of their heightened emotions. It has been observed, for example, how they have nosebleeds at the slightest emotional stimulation. And early peoples possess telepathic and clairvoyant abilities we no longer have—something the Russian philosopher Léon Chestov calls penetrating vision. They know from experience that by staring intently into a fire, they can induce the first stages of hypnosis. The flame flickering in the darkness of the igloo during a shaman's ritual can stimulate their eyes. The drama of the shaman's rituals, with its drumming and dancing, moves these men deeply. The rhythms of the drum affect the auditory nerves while the dance rhythms raise their temperature, increasing brain

activity. It's no coincidence that the shaman asks men and women to press their bodies against each other, around him, in an enclosed space, in partial darkness. He entrances the audience.

SOUND: CONDUIT OF THE SOUL

The Inuit keep silent about essential matters. When I lived with them in 1950 and 1951, I faced a peculiar silence about shamanism. Having been evangelized for thirty years, the Inuit had a difficult time grappling with their dual, or dueling, religions. Some later admitted that they worried about losing their own gods, which missionary priests had deemed impious. But little by little I developed an understanding of the sacred as it is expressed through shamanism. In Savoonga, on Saint Lawrence Island in the Bering Strait, the entire population would get together two or three nights a week. These gatherings were meant to unite the group and strengthen its individuals. Everyone was present—men, women, and children, the elders, the hunters, sometimes even dogs. Packed tight in a semicircle, they huddled together as if to unify their minds through their senses.

The meetings lasted late into the night. A small orchestra of five drummers perched on wooden crates. The rhythms of their sacred walrus-stomach drums, or *cauyaq*, followed simple patterns based on sacred numbers: three, five, seven, nine. Dancers restored and rekindled life forces through their movements; their voices were muffled but the timbre and phrasing of their songs contained a kind of violence.

To sing, to dance, is to pray in two ways. The Eskimos think as much with their moving torsos, legs, and arms as they do with their minds, if not more. Their rhythm is that of a heartbeat. The dancers lean forward, move to the side, left, and right, and look out toward the high seas, their hands shading their eyes, the women lowering theirs. They begin by facing each other, not moving, their chests straight, their feet planted on the ground, their knees bent, their raised arms begging, palms facing the sky. Then they turn their hands to the audience as an offering; they stack them, right hand over left, overlapping their hands slightly. Other masked actors join in. A human torso turns into a whale's tail. Behind, a fox-man with a bird's beak doubles over, his hands becoming the ears of a giant. Another actor appears wearing a nose shaped like a whale's tail. The dancers transform themselves with high-cheekboned, ochre-colored wood masks; half their face is distorted, a red tongue hangs over the chin. Melodic chants turn into joyful cries. The drums beat more slowly and become muffled. The rhythm has become solemn, almost ceremonial. We all catch our breath.

In this imaginary womb, the group gives birth to a new self. The world is no longer split into opposites, into living and dead, human and animal, earth and sea, dry and humid, cold and hot, light and night, north and south, east and west. And these trances allow the living to communicate with their dear relatives— whales, walruses, seals, bears, fox—who are invited to visit the men and sometimes let themselves be eaten. Respect is tinged with fear. The animals are saluted with cries of joy. Their strength, grace, and trickery are magnified. Their generosity is continually thanked. To honor the wandering spirits, the dancers adorn their heads with white feathers and paper garlands. Such guests will feel comfortable only in a celebratory atmosphere.

Activating this mystical relationship requires everyone's participation. As the ceremony progresses, everyone presses against each other. To touch each other, to feel each other, is to express oneness with the group and with what happens beyond it, through it, and in it; to be energized by others. The Inuit do not think individually; they curb their inner thoughts so that they are only expressed through the group, the omnipresent arbiter. Over the course of an evening, the anxieties that isolate the Eskimos are curbed. The perverse spirits that haunt their dreams have been forgotten. The music brings together men with a passion for the sacred, and makes our senses aware of the reality of other worlds, and of the invisible.

In the West, religion no longer fulfills believers' expectations. European churches are empty. They fulfill their duties only as a place to hear spiritual music. Once again, the early people are teaching us a lesson. For the Inuit, words must be avoided—they run the risk of sparking debate. Language is not only poor, but inadequate. Why? Goethe shares his thoughts on this in his riveting conversations with Eckermann. Shortly before his death in 1831, Goethe observed: "Languages are born from the most immediate human needs, from the most ordinary concerns, sensations, and opinions. However, if a superior man has a premonition and his own vision on the secret image and power of nature, traditional language will no longer suffice to express an object that is so far from human things. He will have to have the language of the spirits in his possession to properly convey his personal intuitions. And as this does not exist, he will have to constantly fall back on human expressions, if he wants to express his vision on the peculiar relationships of nature; therefore, he is almost always lacking, he lowers his subject, or even mutilates it . . . and destroys it."

THE CALL OF THE SPIRIT OF THE DEAD

After forty years of expeditions and study, what is there left for me to feel? The torrents of water; the intricate patterns created by thousands of guillemots in front of a Siorapaluk cliff, outlining complicated geometric shapes in tight patterns in space, in a wild dance; the splendor of the heather and colorful bearberries; the tenacity of the petrels and the barnacles; the cracking at the edge of the drifting ice; the colliding hummocks of ice; the polar nights and the icy emptiness of the air—until the day I die, these unforgettable moments will be at the center of my thoughts. I will not cease to feel, to my last breath, the warm laugh of my hosts when I would enter the igloo, their eyebrows and lashes whitened by icy fibers, the copper color of their faces, and the chants of the shamans and the beating of the drums. How can I forget such loyal and generous companionship?

There is a kind of respect for a man who seeks, who pushes himself to think further. This was the case when I took photographs. It was the same attitude the Eskimos had toward the shaman: they would kill him if he tried to harm them. They preferred it when he allowed them to grasp the meaning of what was obscure to them. Knud Rasmussen noted this when he journeyed to northern Greenland in 1907: Inughuit curiosity is always piqued. Their eyes brightened when Rasmussen offered his point of view. They wanted to understand and learn. What did we talk about during our breaks? Well, first about our dogs, then about hunting, women, and the absurdity of this or that, and lastly of what came to mind when looking at the curls of our dogs' breath or the marks on the ice or the configurations of the clouds, which sparked their alert imaginations. Talking, talking to break the solitude. "I" am an other and everyone sets out a task for himself, in a desire to be democratic, to decipher himself publicly.

What haunts the Eskimos, in their most intimate thoughts, are the strange noises, the muffled sounds, the echoes from the caves. A peculiar scratching on the tent canvas, a crackling in the ice. A shrill noise. It is the dead calling. They, no, we are amidst total mystery; we grope. They teach us to better understand the dark; not to head toward Truth, but to discover one's personal truth. This is the rule that their elders teach us. Nature is the sacred book. They know no other. Henceforth, neither do I.

We are *in* nature and not above or beyond it. This book of my most important photographs, those I am most attached to, will, I hope, help the reader feel the emotions I experienced in that wide open space. The Inuit is a population of artists. Is beauty not an expression of the sacred? Their dress, the drama of their rituals, their painted masks of wood or fossilized whale bone—anyone who loves beauty is invited to enter into the private world hidden in their painful expressions.

"I want to praise the living

Who aspire to death among flames . . .

And as long as you have not understood

That: die and become!

You are but an obscure guest

On the darkness of the earth"

Goethe, "Blessed Longing," 1831.

EARLY PEOPLE TROUBLE THE MAN OF REASON

I feel as if I am rereading Spinoza as I observe these anarchist philosophers in their merciless environment: "It is indeed certain that nature considered absolutely has a sovereign right over everything that is in its power, that is, that the right of nature extends as far as its power; for the power of nature is the very power of God who has a sovereign right over all things" (*Tractatus Theologico-Politicus*, 1670).

Perhaps the reader will feel unsettled when looking at these pictures, particularly those that show the group of Utkuhikhalimiut in the central Canadian Arctic, the Inuit Sparta. Those people had just experienced a famine; they hardly heated their snow igloos. The poor, men and women, who have such harsh lives, do they have a unique grasp on eternal life? "The mysterious vocation of poverty . . . established in this world to atone for misery," writes Georges Bernanos. "The ancient tradition of poverty that lives one day at a time . . . to eat from the hand of God."

The poor people of the Far North affront the West in its domestic comfort. If these men who are said to be primitive—and they are, technically—are lighthearted, it is because they are led by a higher vision. Their interpretation of signs of the invisible calls out to us. In these snow igloos we feel the despicableness of men of progress, that is, our own selves. Yes, each and every one of us—me, you, everyone—who soil and pollute the tundra and the ice cap all the way up to the pole after having dared, in the name of technology, to change the ethical balance of a society that had built its own order thousands of years ago.

A PHOTOGRAPHER OF EFFUSIVE CONTEMPLATIONS

As a photographer of the endless day and the white nights, I was attached to the faces of the Eskimos and to the dawns and dusks draped with dramatic colors. But of all my photographs, the ones that are particularly dear to me are those I took in darkness. I am like the Inughuit: I like the dark. At the beginning of beginnings, the night of chaos. The gigantic vault, opening onto the cosmos, allows me to breathe in the universe with all the feeble strength of a man; to reach toward that vast cathedral whose spire disappears into infinity. "Nature! O you who make these men in a sacred way!" wonders Rimbaud in *Le Mal*. "Chthonian night, oracular night, night that tames the gods and man" (Homer, *The Iliad*). Only darkness reveals this shadow to me, your double, silent observer looking out into the distance. Prehistoric harmony. The peace of the Earth's elemental forces can be felt, the tremor of the ice, the murmurs of the rocks.

During the endless day of summer it is hard to feel anything. I consciously try to make out vague sensations. I hear the muffled murmur of the men. The light of the summer puts me in touch with my inner geometer, a vestige of my Western education. It is while walking on the Precambrian plateaus during spring and summer that the translucent light of the white nights, followed by the blinding endless day, evokes the dialectician, inciting him to a linear understanding of space. I squint my eyes in order to feel the hidden and

obscure order of things, filled with signs and rich in possibilities. It is then that another man rises, more sensitive, fragile, meditative, and contradictory, as if he had already lived another life. "Night is the warp and the silk; Fate, the spinner and fabric she weaves" (André Suarès).

A DAY IN THE LIFE OF A WILD MAN

I built my life by starting humbly from the beginning. I grew attached to what we tread on. I am a scholar of rocks. For fourteen years I studied the ecosystems of clusters and labyrinths of fallen rocks. I invented this discipline and I was one of the few people who specialized in the Arctic. After my time in northern Greenland I traveled the length and breadth of the North American shield.

How did I move from stones to men? By focusing on the place. I analyzed the social structures, the social contract, and the interactions between the natural systems and the society that lives among and uses them. In April and May 1951, I set out to draw a map of the Inglefield coast, about 185 miles long and extending a mile inland. Before making the map I created a genealogical tree of the seventy Thule families there, and then an analysis of the local micro-economy, which reflected a delicate balance between humans and the animals that helped them live.

Over many days and many treks by dogsled an alliance was formed between my Inuit companions and me. They were fascinated by the maps I was drawing. This is how they began talking to me. Stones also opened the Inuits' hearts: did they not accompany their lives? The walls of their oval igloos are made of sandstone slabs, as are their fox traps and their meat pantries. The Inuit interpret corbels, rocky protrusions, as the living dead. It is this exchange with the shadows that allowed these Inuit, lost among the ice, to resist despair. They were not alone. Their ancestors had been watching over them since the beginning of time.

When you first hear about the Inuit's beliefs and taboos they seem contradictory. But they only appear to be so; we, men of reason, can see that they are the expression of a very long history, the result of centuries of social and climatic crises. Conservative by nature, the Inuit prefer the confusion of lived experiences to artificial logic—duration means nothing to the Inuit, a second or a year are measured only in terms of significance. Nature has its reasons and they are supreme. Better to respect them according to their order and sequence. Logic will emerge through action, the Inuit through the event.

How could I not observe these companions who were with me at all times, all night, eating foul-smelling raw walrus, spitting fish bones at my feet? I have to admit that I, too, blew my nose in my hands, ate frozen liver from the tip of my knife, and sucked the fat from bird skin. My lips were the color of blood. I slept half-naked under furs at the side of the Inuit. Our clothes made of animal skin were laid out on a seal-leather rack placed over our heads, to dry by our rising body heat. I liked their primitiveness.

Of course, I did not forget to record these events, that is, to write down their lives. But how could I dare to give an account of a people who are so different from us? I am a prudent, cautious man. The only option was to try to describe this life very precisely. That in and of itself is very ambitious. I will let others dare to attempt a theory. By talking with the Inuit, and also with my students upon my return, I became an "anthrogeographer," a "geohistorian." I analyzed their demographic planning, their anarchic communalism, their selfsufficient microeconomy, and their thoughts. Through experience and over time these thoughts, always informed by their sense of the environment, allowed them to build a social contract and a shamanistic vision. The men I examined with Rorschach tests proved to be deeply worried about the spirits of the dead and about not following exactly the rituals that dictated an understanding of the forces of the energy emanating from the labyrinths of stone, from the memory of water buried in its depths, from the

forces of the underworld surging from the faults, splitting these ancient Precambrian plateaus. These forces become wind or animals—from the smallest insect to the whale—through complex and prodigious transformations. While such transformations seem metaphorical to ordinary people, they are very real for the most inspired among them, the shamans.

WILD THOUGHTS

My thoughts became wild and grew more and more so, despite my attempts to order them. I am expressing them here without any order, like in a conversation under my breath. I am sorry. I have turned into one of those hunters who, upon entering an igloo, throws down his clothes and gloves and anything else that is no longer of immediate use and shoves them with his foot under the *iglerk*, the sleeping platform. A discussion begins. A visitor arrives. All eyes are on him and the conversation changes. The dialogue cuts off abruptly and splits in two. The old man in the back of the igloo rests but sits up quickly, upset by a nightmare. We all think to ourselves, we're together with our words, and therefore we accompany the words that escape us.

I have acquired rather bad habits. The reader, taken from one thought to the next, will agree. But I am staying on track. While my imagination crosses the dark tundra, it travels through centuries and millennia. I consider the terror of our ancestors "when they were chased out of Paradise, wandering the Earth. . . . They laid horrified eyes on the night covering the horizon. . . . In the agony of their despair, they embraced each other tenderly. Then, the night was everywhere, they fell to the ground in silence, certain that God had taken light away from them forever."

Preoccupied with the stones that were the subject of my research—granite, gneiss, Precambrian Algonquian sandstone, sandstone conglomerates from middle and lower Thule, the dolomites of upper Thule, even the ice crystals that expand inside the stones, allowing them to breathe by contracting and dilating—I fill the landscape with my soul's fears. I humanize the cosmos. Memories redeem me. Let me quote from my journal, *Hummocks*:

"May 13, 1961. Space is bare. Sticky air. The sky and horizon are blurred. I am on the ice floe of the Foxe Basin, north of Hudson Bay, a desert of frozen water. The humidity is womblike. A humble breeze coils through the snow. 'The Earth was without form, and void. . . . And the Spirit of God moved upon the face of the waters.' My memory hesitates and I am furious that the words from the sacred text escape me. Inhuman immensity in which every notion of scale is abolished; conscious of my fragility, but also of the fierce will that binds me as a man.

"I raise my head: a vanishing line; my eye meets an undefined horizon the color of dried lavender. The sled moves at a high speed. A growler, as black as ebony, disappears into the distance, and then a bedsore of yellow-green ice, finally a ragged animal hide; the dogs, their muzzles lashed, quicken their pace so as to tear this leather with their fangs. Then they set out again, sniffing the air. I listen carefully to a sustained note, the sound of energy underground, within the ice. I forget the familiar noise of the sled in the snow. A drawn out groan comes, closer. The frozen blade grates the bumps of the old ice.

"To our left, a pale sun rises; diffuse in a veil of slightly blue mist. The air is frozen. A profound peace emerges from it. Eleven o'clock. The Inuit never leave before feeling a semblance of warmth: it's -4°F. . . . Soon it will have been five hours we have been together, Awa and I, alone on this *qaamutik*, an archaic thirty-three-foot sled, four inches high, narrow, the open planks covered by caribou hide, its hairs flattened and yellowed. We're heading toward the most outlying camp, south of the group of five hundred Iglouligmiut that I have been studying, family by family, for two winters now. Cries to urge the pack on, clicks of the

tongue; suddenly a growl of pain: the black dog up front, on the right, has bitten off a piece of his neighbor's ear. My thoughts, which I utter under my breath so as to better organize them, evolve with the rhythm of the sled's jolts. The words contort and come together with a logic all their own. Like an animal, I explore the hide on which I am seated; I smooth down the hairs. Then my thoughts break free. I can't concentrate. I stare into the obscure distance. The sled is the center; out there, imaginary boundaries.

"Sitting on this prehistoric vessel, I am dressed like Awa, in roomy pants (*qaarlii*) and a poncho (*quulitq*), both made of caribou hide. The latter opens at the top only enough to allow the head to slide through; it's topped by a hood (*nasak*) trimmed in blue fox. To dodge the blizzard, I lay under the wind and bury my face in the fur, as far back as possible, allowing my cheek to be caressed by the soft hem (*nuilak*) and breathing in the strong smell of animal skin. My boots (*kamik*) are made of caribou hide, hair on the outside, their soles (*atungak*) made of brill seal—a big, 200-pound seal—whose skin has been fermented. I wear a wool shirt, a thick wool sweater, socks. Underneath, there is one sign of progress: long underwear. My Eskimo companion wears only one shirt under his caribou parka and his feet are bare under his double boots. On my hands, double fingerless mittens (*pualuk*) made of seal on the inside and furry caribou hide on the outside. Our only weapons and tools are an ice pick, a harpoon with a detachable head, a spear (*kakivak*) for ice-hole fishing, an ivory fish used as a lure, two modern guns, one with bullets the other buckshot, an ax, and two knives.

"L'extrême-nord humain" by Paul Valéry; that is where I am.

THE ORDER OF NATURE

"Plants, as much as animals and stones, filled my childhood with a mysterious charm," confessed the poet Francis Jammes. "At age four, I stood contemplating mountain stones, broken in a heap alongside the roads; knocked together they could make fire, rubbed against each other they smelled of burning. I picked up a piece of marble that seemed heavy with water; mica fascinated me. I felt there was something they didn't know how to tell me." I would not know how to better describe my own development. Close-up photography inspired me. A willow leaf, a root's cells, Precambrian granite mica enlarged 10,000 or 50,000 times makes you discover the logic and balance of nature. It is clear that nature contained beauty, at least as we know it, even before humans appeared. The philosophical implications of this are deep.

This order of things that predates man, translated by geomorphology and by evolution, is the history of life. I am not researching a composition, that is to say a collection of structures, but rather a plan. And this is where I turn to Goethe. He was uncomfortable with the expression "composition of the forms of nature" that came up in Geoffroy St. Hilaire and Georges Cuvier's famous debate in 1830 over animal anatomy. He suggested instead the term morphology, which he had coined. Life and its mysteries. Is this not the domain of geography? That is to say, a discipline that invites you to read the Earth? Geo-graphy: Earth-writing. To find the logic of living forms. When I look at the Earth's dynamic geological processes, I have an objective: to study their function. For "if forms develop subsequently, they do so by modifying themselves, all in consideration of a necessary whole," as Goethe writes. I followed Cuvier's thought processes and his methodological principles: "From the individual to the whole."

The hunters of the Far North certainly did not have a rational knowledge of geodynamic equilibrium, yet the dialectic of Man and Nature was something that they experienced, that they felt. These men of the polar regions have developed a comprehensive understanding of the natural order by osmosis. This is what I was pursuing, first through observation—of geomorphology, of the Inuits' rituals, of their hidden thoughts—and then through what was not said, through an intense, shared life. It was only after years of listening that I

understood that the Inuit were not primitive, they weren't simply surviving, despite their poor material state.

Everyone understands that men, animals, and plants interact. No one is surprised when a hunter talks to a plant. In Nome in 1970, a semi-shamanistic Eskimo told me to sing so that the medicinal plant next to his hut would grow faster. I sang the tune that I was taught, though I didn't stay long enough to see what happened. But I knew the time had come when man and animals—bears, seals, foxes, birds, and spiders—began talking to each other. This may seem a mystical vision, but it is not so for the men of the far North. You cannot pilot a dogsled without feeling a bond with the dogs, and especially with the lead dog, who can understand a dog/man language.

Taaq: it's dark, almost night. The shadows grow. A silent companion surveys me on my solitary walk; he moves from rock to rock, resting for a few moments. He never responds to my calls and yet he follows me. He's a crow (*tuulaq*) and he's cawing now. I attempt a conversation in the gloomy silence. It is in vain. In this glacial valley, in this extreme solitude, only two living things could inspire terror: he and I. The crow is the only bird that remains for the winter. He prowls along the cliffs, plundering foxes larders of meat and bird eggs. I question him: I whistle, speak in Inuit, in French, but alas, I do not know *tuulaq* language. So what is he thinking? Why does he look at me with a mocking expression, with his keen, shining black eyes? He is my only companion when I go into the mountains to make geographical observations. He stays with me for an hour, keeping his distance but always with his eyes on me. What does he want to tell me? Does he want to help me, or does he want to agitate this awkward visitor with sarcastic laughter? How can I decipher his language? And how does he survive in this desert of snow and ice if he's not extremely intelligent? We now know, thanks to the laboratory of physiology and genetics of behavior at Moscow State University, that the intellectual level of the crow is one of the highest of all animals, similar to the monkey's. "They are capable of having abstract thoughts," notes physiologist Zoïa Zorina. "They know how to count. Tests conducted over the years confirm it. More clever than the fox, they even scoff at man, whose behavior they shrewdly flout, even during the tests."

What is knowledge? And what is it in an impoverished and isolated Northern society? It's a huge question. How can we understand the acquisition of knowledge in prehistory and protohistory? The first answers to these questions were provided by Gaston Bachelard and Goethe. "The problem with improving our being," the great French philosopher tells us, "is deeper and deeper communion with nature."[1] "What does it mean to start with nature," asks Goethe in *The Metamorphosis of Plants*, "if we are only involved in the material parts, through analysis, if we don't perceive the breath of the spirit that gives meaning to each part and corrects or sanctions every lapse according to a law all its own?"

1. Gaston Bachelard, *Le Droit de Rêver*, Paris: PUF, 1970.

TO THINK, BUT ESPECIALLY TO FEEL

Of the thousands of hours I spent alone among the Inuit, what is left at the moment I write these few lines? Innocence. In an innocence lost, joy mixed with impulsive violence. These men have a cruel past. They are hard with each other, as the environment is with them. Man and snow, man and ice, man looking up toward the stars; the wind, the cold, night; the stuttering of the first millennia of humanity. The calm stare in the face of misfortune, an exceptional ability to clear away everything, to silence, preludes to inspirations. A knowledge of life. The Northern hunter never gives a quick answer to a question. He ponders carefully: words have power. At first he hesitates to give them a reality in sound. Then come the first words, pronounced one by one, every syllable, as if he were being forced, as if he were making a definitive declaration. One example stands out from this string of impressions. Their fatalism, their dignity in the face of misfortune: "*Unniit!*" (Never mind!)

"Nothing is worth anything
Nothing happens
And yet everything happens
But it makes no difference."

Friedrich Nietzsche

A GLANCE AT THE FIRST PEOPLE

Sons of stone, ice, and wind, the "primitives" of the North can be understood only through the perspective of thousands of years of interaction with their environment. I always had two ways of seeing the Inuit, scientific and instinctual, especially when my companions were distant or pensive—while hunting, while waiting for a shaman's ritual to begin, in moments of extreme tension, in the face of danger, or during a bout with alcohol. It was during these times that I experienced moments of fundamental truth.

The memories agitate me. I am frustrated, like a witness who has not gotten to the truth his convictions push him toward. A man who has lived for a long time in the other world of primitiveness understands that if he remains rational, that is, if he retains a Western viewpoint, he will see only part of the truth. I have seen a lot more than what I have written. What I could not say, what I did not really see, I nevertheless felt.

This book, which follows my missions from east to west—the opposite of the Inuit's west-to-east migration 5,000 years ago—represents this two-sided and changing outlook. I will come back to this point. In August 1990, I finished my slow migration from Greenland to Siberia, finally reaching the birthplace of the Inuit, "Whalebone Alley" on the northern shore of Yttygran Island in the Bering Sea. Secret brotherhoods of Inuit have practiced shamanistic rituals on Yttygran Island since the thirteenth century. There is proof: a circular altar made of stone, whale skulls and sixteen-foot-high jaws turned toward the sky. Fifteen groups of these skulls are scattered along the coast in a kind of numerical order, perhaps reminiscent of the Chinese *I Ching*. There are thirty-four columns, three of them in pairs, on another path; the same arrangement exists on the other side of the strait, on Arakamchechen Island. (This site continued to be visited by Eskimos during the Soviet era, despite the Communist Party's prohibitions.)

I had an epiphany there. Able to focus my thoughts, I understood that fire is at the core of the questions posed by these prophets of the Far North. The flame of this sanctuary is a desire for rebirth. The fire of salvation, perched on the edge of the divinatory mirror of the Seniavin Strait, it carries the spirit of the dead toward their celestial home, helping them find heaven in the perilous journey through the vast space of the invisible.

The dream that moves through universal myths lies amidst the ice floes. It was while I was making my way, following my dreams, that I discovered Goethe again. Did he not remember this questioning two centuries earlier, in *The Metamorphosis of Plants?* "I seek the divine in grasses and stones . . . What is never was, what existed will not come about again. Everything is new and it is, nevertheless, the same thing. Nature is forever building and forever destroying. But its workshop remains inaccessible. It contains all eternity, life, future, movement and yet it does not progress. It is constantly transforming, never stopping. Men are all in Nature, and Nature in all men."

THE SECRET ART OF PHOTOGRAPHY

I went from topographical drawings—land drawings, quick surveys, diagrams, maps—to sketches, and then to landscapes rendered in pastels. With grease pencils and a blank piece of Bristol board I sought to

capture the fog glowing from the stormy sagas of the Eskimos, the untamed force of energy in the eternal ice. That is one reality; photography is another.

I have been taking pictures for more than fifty years. I was never trained; I do it by instinct. I've made thousands of snapshots, from Greenland to Siberia. As I look at them I learn more of my journey. When a CD-ROM of my photographs and film stills was published I noted that ethnographic images were rare: a few harpoons, a detail of my sled, a seal-leather knot, a kayak, domestic utensils, a fatty femur. What caught my eye instead was atmosphere, sunrises and sunsets, activity and movement, and especially the Inuit's faces.

Ethnographic photography exists to convey information—customs, clothing, action, etc. Close attention to detail and several different points of view are essential; this kind of photography has become an indispensable complement to written descriptions. In my book, *Hummocks,* I questioned the nature of photography. "Certainly there is reportage, the unpredictable moment, a camera surreptitiously capturing an animal or an event," I wrote. Most of my images stem from something else, from something more personal; they belong jointly to me and to the men or the place I was photographing. In "ethnophotography," the two words strung together imply two different kinds of relationships. Because I am not by training an ethnologist or a photographer, but rather a naturalist, I feel free to express both my experiences in the field and my intuition.

In the Arctic, I became aware of the difference between ethnography and capturing a wonderful moment with my camera. Let's take an Eskimo's face as an example, like the one on the cover of *The Last Kings of Thule.* This portrait of Kutsikitsoq wasn't a lucky shot. It was the result of six months of waiting and hunting—for a man. It is not an entirely subjective portrait; to me, absolutely subjective photographs are those pictures taken by tourists who, having set out barely an hour prior, take photo after photo of a group of Eskimos, a few dogs, and an iceberg—or, if they're in Paris, the Eiffel Tower. The commonness, the worthlessness of these snapshots reflect the silent refusal of the object being photographed. Of course, miracles do happen and, as is sometimes the case with love, a passion can grace a fleeting encounter, whether with Greenlanders or the Eiffel Tower, and it can be fully rendered in a stranger's photograph. Such miracles are rare.

I know a little about hunting. For the Inuit, an animal must let itself be invited to be hunted. The hunter is neither a butcher nor a killer. Hiding behind a rise in the land, he patiently awaits the moment when the animal, who knows he is being watched, will offer himself. The relationship continues after the animal is killed. There is a scene in my last film, *Hainâk Inuit* (1990): a woman uses her hands to give water to a seal that has just been killed, to thank it for allowing itself to be captured. This after the hunters waited ten hours at the *aglou* or breathing hole in the ice. In whale rituals, women honor the animal with chants, a Baroque formality of welcome from a Baroque theatre. These rituals establish a bond between man and animal.

A photographer works in a similar way. Making a portrait is a serious act—the subject is being captured—and there is an almost religious gravity to the operation. There is a palpable difference between pictures obtained with consent and awareness and those without—there is a kind of communion between the photographer and the photographed. My dear Kutsikitsoq is one part of the portrait; I am the other. One could even say that this photograph is "ours," just like one would say "our child." I remember the moment. It was neither at the beginning of my travels (I met Kutsikitsoq on top of a glacier one polar night in the midst of flurries, in November 1950) nor at the end (June 1951). In November, the image—which was difficult to make, since it was dark—ran the risk of being touristy; in June, too familiar. It was taken on May 31, 1951: we were alone, masters of our own destiny, in the extreme solitude of Inglefield Land, in Aungnartoq (Rensselaer Bay). Over several months and through many difficulties I had proved myself as a dog sled driver, as part of the group, a "white Eskimo." Kutsikitsoq and I had just reached the geomagnetic North Pole. I was proud; the only person who had visited this stretch of endless inland ice before was the fearsome and headstrong Robert Edwin Peary, whose cynical and curt personality haunted and repulsed me.

We were getting ready to set out for Ellesmere Island, across fifty miles of water punctuated by jagged icebergs and ice floes. We gathered in silence to prepare for the challenge. I trembled slightly before pressing the shutter release, for I knew that this was a fleeting, unique moment. When we become friends with someone, there is a long period where we are still curious about him or her but certain bonds are nevertheless formed. We begin to know each other enough to like each other, but not so much yet that we don't see each other anymore.

As another example: When I worked as a volunteer teacher in Clyde River, on Baffin Island in 1987, it was only after three weeks that the schoolchildren came to see me at my home. One night, when the sun was setting, I photographed them one after the other. Their intense stares—one of them in particular— examined me. It was a call from so far back. Like a trembling hand of a man drowning, seeking, with little hope, to be rescued. These photographs are among the most disturbing that I took of the young teenagers. In the ambiguous moment that is the gift of a meeting, photography appropriates a part of your identity.

My approach to a pastel drawing and a photograph of the Arctic is the same. First, there are preliminary sketches. Blotches of color that attempt to capture the drama of clouds along the horizon: you feel—or don't—that the landscape is offering itself. In my hands the pastel pigments yield strength and truth. I fear that my right hand—guided by instinct, emotion, excitability, by something unknown—will miss the sensations that spring from the environment.

WAYS OF SEEING: A CHANGING PERSPECTIVE

These three hundred images, selected from the 16,000 photographs in my collection, are an essential record of a moment in these people's lives. I wanted to be like the British officer on Captain James Cook's expedition who could, with a quick sketch, capture the essence of a landscape or a face, an encounter or a story. These photographs are the tangible proof of my strongest feelings, my doubts, my impulses. They are also flashes of inspiration, as of a naturalist with a fossil he has studied for a long time. What emerges could be a harmonious landscape, a blood-streaked dawn, a pained face, the heartbreaking look of an animal calling for help from a trap, or a perilous crossing through hummocks of ice.

When I found the Inughuit, the Polar Eskimos, in 1950 and 1951, I knew nothing of them. My mission in their land was academic—I was studying its geomorphology. During my first winter, while translating *Avangarnisalerssártutit* by Knud Rasmussen (the first book in the Inuktitut language) with the help of John Petrussen, a catechist from southern Greenland, I was introduced to the customs of these people. Thus my first photographs of the Inughuit, from the fall of 1950, were taken by a naturalist little informed about his subject.

I lacked the equipment usually necessary to winter in the Far North, so I strove to live like an Eskimo. I couldn't beg for the twenty pounds of seal meat that I needed every day for the eleven dogs in my pack and myself. I could only receive what was due to me. I had to slip into the group and become a part of it. The images from this lonely winter reveal this progressive intimacy.

I had to be careful—I had only a small 35mm camera and enough film for about 500 pictures over fourteen months. So these photographs reflect choices among the many faces that I met over the long months. They express my inner eye, my joys and doubts, and my assimilation into the Inughuit. This integration was not easy; it waxed and waned, progressed and receded. Preoccupied with material needs and with my strategy of gradual assimilation into a complex web of friendships, my eye remained innocent. I will never be able to see with such fresh amazement again. During my later missions in Canada—in 1960, 1961, 1962, 1963, and 1997—my eye was armed, or spoiled, by my experience among the Polar Eskimos of northern Greenland after the creation of the Thule U.S. Air Base in June 1951.

My journey from stone to man was completed. I had finished my studies in geomorphology and cartography, and my inner being had improved, too. My austere geographer's perspective had become sharper, ethnologically speaking, but I had only started to learn. My perspective changed: it was more penetrating and serious, and made more dramatic by the military and economic occupation of the Inughuit's land. This is clear in the photographs I made after 1951. For instance, the images from my four missions in Canada, from 1960 to 1963, are less free, perhaps less emotional, yet sharper, darker, and more personal, sometimes painful.

My camera was always at my side during my travels. I never hesitated to stop during my expeditions—during hunts, while working on my maps or testing my rock piles, conducting my genealogical research, researching shamanism—to learn more. I never felt I was disturbing my companions or that they were disturbing me. Exploring these people whose destiny was so fragile was my vocation. I was convinced that my role was special, that the moment I was observing was ephemeral. What is shall no longer be.

Without photography, I would have lost many moments in my life. Writing cannot revive the full impact of their hues, colors, and expressions. I am convinced that my readers and, I hope, my Inuit companions will be happy with these photographs. This book is a last homage to the dead. Leafing through my photo albums allows me to relive a past forever gone. Gone? Could it be true? To be kindled, memories need ashes which, buried, contain the embers of life. They say there is no love, only proof of love. I think there is no adventure without proof.

Photography complements my scientific works, but it is not secondary. For me, photographs serve the struggle that I have waged in my life and thoughts, to better describe a lost civilization. A tool is beautiful because it is indispensable to the craftsman. I do not know if these photographs are beautiful, but I do know that they are essential to further reflection. Observations need these essential proofs. Like a police investigation, field research without evidence loses not only its value, but its justification.

COLOR PHOTOGRAPHS

The Inuit's imagination comes from their experiences; their ego belongs to their senses. At the *aglou*, the seal hole in the ice, the Eskimo perceives the movements of seals migrating beneath the surface. With his ear on the paddle, the hunter can feel the direction the whale took from miles away. During the polar nights, the Eskimo can see better by the light of the moon than the white man can. I witnessed this skill during hunts for white hare and blue fox. And the thick fingers of these hypersensitive men become, against the silky skin of their wives, the expression of loving sensuality. *Tipi*! It stinks! Eight people live in a cramped, 100-square-foot igloo. It is filled with the stench of urine in the group pot, the sweat of their life together, the stale smell of aging walrus and hareskin-lined boots drying near the roof. Yet the slightest untimely odor, like flatulence, will embarrass you forever. Only taste seemed to be less developed among the Inuit.

Not surprisingly, the Inuit are also highly sensitive to color. In a brown world—of furs, of the peat that walls in the *q'angmat*, of the meat frozen whole, there are three colors that stand out: white, black, and red. Each color is symbolic. White is male; black is the expression of age and the dialogue with the afterlife; red is female, linked to fecundity, and evocative of menstrual blood and the power women acquired through Nerrivik, goddess of the sea.

These are the colors of life in the Far North. During the summer, you have to squint your eyes. The sky is too blue, the snow glistens too much; the green grass next to their houses, made thick by fat and human waste, is intensely springlike. On the sea, silvery white crests clash with the bluish black water as a kayak's stem delicately splits the waves. Inside the igloo there is a halo of condensation, the result of human breath

in damp cold. The walls and the dome soak in the sweat and life of bodies and after a few weeks become black with a kind of human soot. Copper-brown reindeer or seal hides are placed on top of a thin carpet of black twigs. The snow on the ground is worn down to a dirty gray. The expanse of the ice floe is light, a bluish white. The mornings are pinkish white, the evenings greenish blue. Dusk is orange with streaks of blood red. The clouds of September grow darker and darker with the coming polar night. Jewelry—earrings in Chukotka, Siberia, and in Alaska, pearl necklaces among the Netsilik and the Aïvillik in the central Canadian Arctic—comes in warm colors, especially red and white. Blue, deep and intense, is a much more recent arrival, coming in simple glass bead necklaces imported from Bohemia. There is green jade in the labrets in Chukotka and Alaska. Women's dresses are printed with bright colors—red, purple, green, and pink, with yellow, orange, and white flowers.

These deserts of ice inspire travelers to capture their emotions with pen or pastels. As a photographer, I couldn't bring myself to record this environment in black and white. If I had surrendered to the professional trend for shooting in black and white, my mission to explore the whole story would have failed. Although I knew that the quality and range of color film was questionable, I was determined to explore its possibilities. I even attempted to do so during the polar night, by moonlight, by the light of the star-studded sky, and by the reflected glow of the snow; black is not black, white is not white.

I was very lucky during that winter of 1950–51. I had only a very modest camera, the sturdy Foca, without zoom or flash. The film I used, Kodachrome, was stronger than film is now. It has remained intact for fifty years, as if protected by the good spirits of the Far North. Sometimes you have to believe in the benevolence of the photographer's god.

BEING PRIMITIVE, BEING CREATIVE

These photographs are the witnesses of a heroic people who have been broken. But these pictures are of the Inuit before they encountered our civilization. We know the terrible consequences of this encounter: venereal diseases, alcohol, drugs, violence, suicide, and, finally, AIDS. I will keep the photographs of the aftermath for another book that will be about the drama of a civilization. But that book will also be hopeful—it will be about the painful birth of young nations that are fed up with the cynicism of the conquerors who went to the Far North to exploit its resources, polluting the snow and tundra in the process. As if to complete their task, they also ended up polluting these ancient people. It seems like just yesterday! I am afraid I was one of the last to have seen the Inuit living their old ways.

It is difficult for a man from the city to understand the miracle that is primitive creativity. Inuit art is a raw art. I saw with my own eyes the work of primitive artists who clearly had a clairvoyant or visionary eye, and who worked without the burden of culture in which our artists are entangled. They were able to find an essential core within themselves, a rawness in their creativity, which is indispensable to the creation of a masterpiece. The extraordinary "technicians" of the hunt had the hands, or rather the fingers, of skilled, subtle artisans. The primitive art of their carved ivory—harpoon heads, burial figurines—and their masks is a hunter's art, inspired by shamanism. (The spirit of shamanism is drawn from a vital Asian principle, from the primordial breath that animates the world. This is essential to understanding how the most inspired among them—the seers—were able to develop such elaborate art.)

We can say with justification that Canada has only one art of its own: Inuit art. To understand this art it is necessary to have photographs of it. Yet it is also essential for the photographer to have known the artists in the flesh—to have witnessed not only the manual dexterity involved in building igloos and setting traps, but also to have confirmed their sharp senses, their ability to forecast changes in climate years in advance, to

find their way during the polar night, and especially to have participated in their magical life during shamans' rituals. And also to have seen and understood their guardian spirits, the invisible forces guided by their minds, their hearts, their inspirations—in a word, their breath and soul. If you ignore any of these parts—or think primitive means "spontaneous" (innocence being synonymous with ignorance or idiocy)—it would be both impossible and absurd to try to understand Inuit art, to understand what makes it so exceptional.

ALL I KNOW IS THAT I DO NOT KNOW

Who is the author? What gives him the right to penetrate someone else's life, or a people's history? What is his philosophical background, that is, his model of thought, based on which he will relate the thoughts of a society thousands of years apart from his own? Who is his interpreter? Anyone who reads detective stories knows exactly how and when an inexperienced investigator can be thrown off by appearances, causing him to convict an innocent man. Literary critics are often much more passionate about Proust's notebooks, Flaubert's letters, or Zola's *Carnets d'Enquêtes* than by their actual works. Do we not write first for the reader, who himself has to judge the author's conclusions on the strength of the actual evidence? Perhaps he will be the one to make conclusions? If not, why write? It's common to think that the reader will learn and then formulate his own opinion, engaging in a kind of dialogue with the author. He is then likely to come to different conclusions than the author's, especially when there are images involved.

In my book, *Hummocks,* I admitted to have made very little progress: "All I know is that I do not know." Someone else studying the same subject but using another methodology might have another opinion. If he reveals everything about the conditions of his research there is a chance that some progress will be made. The spirit of science, as Bachelard has noted, is an accumulation of corrected errors. And the great writer Michel Leiris once commented on my "Terre Humaine" series of books: "I think that the subjective element has to be present, it is always present, so it's better for it to be out in the open rather than hidden. In other words, you have to put your cards on the table Absolute objectivity would be best, but it is not possible, there is always subjectivity. So, it's infinitely better that this subjectivity be acknowledged rather than concealed, so that we know what to expect."

Is there anything to be ashamed of in writing a private journal about conducting research? It should be a scientific obligation. The journals of my predecessors are only useful to me if they precisely describe scenes they lived through. And these accounts are all the more precious when they reveal the observer's frame of mind or point of view. This is what I find in the diaries of the explorers of the eighteenth and nineteenth centuries, including James Cook, Captain William Parry, and Lieutenant Back. Yet the introverted nature of the British and the conventions of military writing were not conducive to this activity. But alas! Then came the academics, hesitating to conclude, with their pompous language and distant eye. The academic author is reluctant to describe—the I is hateful—and quickly moves to what will enable him to theorize, to build the temple that will make his career. For me, conclusions are of no use without proof, without being able to verification of how the facts were gathered and the conclusions formulated.

SENTRIES OF THE PLANET

The Inuit are convinced that we are mad. We are ruining the planet. Of course they did not go to college; many of this book's contributors are illiterate. But they are very able to observe their world. They have seen

the Arctic become a chemical dumping ground, the same as every other ocean. They have surveyed the effects of global warming with horror as each year the ice thaws more and more.

The Earth is alive; it reacts and takes revenge. According to a recent study, the thickness of the Arctic ice has shrunk by four feet in the past twenty to thirty years. The ozone layer at high latitudes has decreased by ten percent in the last two decades. Any rise in global temperature, however slight, can have huge and often irreversible effects in the Arctic. More of the ice cap will melt, changing the salinity of the oceans. The Gulf Stream will move farther off the coasts. Winters will become colder, the summers warmer (or vice versa). Some experts estimate that by 2100, the global temperature will increase by 1.4° to 5.8°C. Animals are also affected by man's impact. Bears, harmed by chemicals that affect their reproduction, bear hermaphroditic cubs.

And we, at the very end of the ecological chain, are also threatened. All the signs are there, right under our noses. In our cities, with their polluted air; in our food, contaminated with Mad Cow disease, amongst other things; and in our oceans— the tide off the coast of Brittany is black from the sinking of the oil tanker *Erika*. Storms are becoming stronger and more terrifying. And our waste, especially nuclear waste, is becoming less and less recyclable. Our prospects are grim.

THE NEW SONG OF THULE (WITHOUT A KING)

When I returned to northern Greenland in June 1951, I found something new and sinister: in the middle of land long inhabited by Polar Eskimos, the United States Air Force had built a military base. Five thousand men were thrust into the fragile and ancient landscape. And though Denmark—which includes Greenland— forbids nuclear weapons on its soil, the Americans secretly kept just such bombs at Thule. Denmark discovered the deception on January 21, 1968, when a B-52 carrying four hydrogen bombs crashed near the airfield; three of the bombs split open on the ice field, and a fourth was lost in the water nearby.

I was opposed to this invasion then, and remain so today. It was unauthorized by the Inuit, who were robbed of their history and their land. I was alone to protest the base at the time, in *The Last Kings of Thule* and, later, in *Ultima Thulé*. Journalists! Are you not free enough to report such a tragedy, suffered by such a legendary people? The H-bomb accident became a scandal only when it became public in Denmark in December 1999; the Danes felt their dignity had been scorned. The great Brazilian poet, Carlos Drummond de Andrade wrote this lament:

Long ago, in a far off time
A king in love, the King of Thule
Cast into the sea a golden cup
From which he had drunk all love. . . .
But this was long ago, in the mist of time!
Golden cups are no longer cast
From balconies that face the seas
Nor from any other place.
And Thule is other. But what do I see?
What is that object lodged
At the bottom of Baffin Bay
It is not one, but three or four
Precious treasures of a brokenhearted king
Whose unutterable memories

Fade away, at death's door?
But is it truly gold? No, it is
Plutonium (239)
And uranium, its older brother
(uranium 235)
in a union as close as was
the loving tenderness
of the king and the woman he loved
And the seals cry in horror:
"Why are we asked to keep
this sinister and sullen load
with this black box
marked with cabalistic signs
when we have committed no crime
in our lonely prisons?"
The Eskimos echo in chorus
The anguish of the seals, and their fear:
"Shall no one live in peace
in the depths of our exile?[2]

2. Carlos Drummond de Andrade, *Poésie*, translated by Didier Lamaison, Paris: Gallimard, 1990.

Of course, this is far from man's only affront to the environment. We truly believe we are gods. The icy waters off the Kola Peninsula near Murmansk were polluted by Soviet nuclear tests and radioactive waste dumping; nearby is the Barents Sea, one of the richest fisheries in the Northern Hemisphere. On every continent the water supply is diminishing. The rainforest has shrunk by 80 percent. Countless plants and animals are threatened with extinction. "We are witnessing the greatest destruction of plant and animal life since the dinosaurs disappeared 65 million years ago," noted Lester Brown, chairman of the Worldwatch Institute. "Species are disappearing 100 to 1000 times faster than the natural rate."[3]

3. Lester Brown, *Beyond Malthus*, New York: W.W. Norton & Company, 1999.

It is time to become aware of our terrifying instinct to destroy and kill, and instead to act as citizens of the world. This book is a wolf's howl in the steppes, a call. An alarm should be ringing in all the capitals of the world.

Jean Malaurie
February 2001

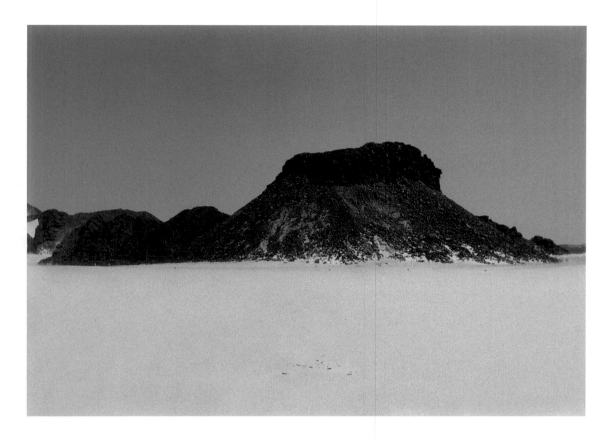

Opposite: March 1949. Tefedest mass of fallen rock. Hoggar Mountains, Central Sahara. Among the blue men, the Tuareg.

Below: February 1950. I am leaning on the *rahla* or saddle of my camel. Assekrem plateau. 8,944 feet. A geomorphic mission: geo-cryology and temperature measurements in the rocks, clay, and sand to specify the ecosystem *in situ.*

" *I was in the heart of the Hoggar Mountains in the Sahara of the polar night, where the echoes let you feel*

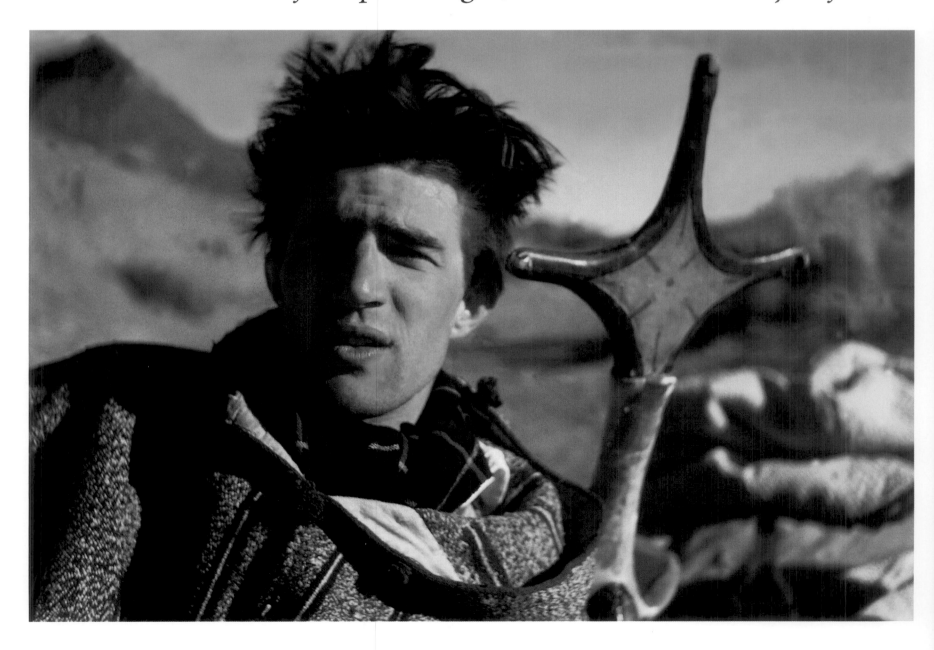

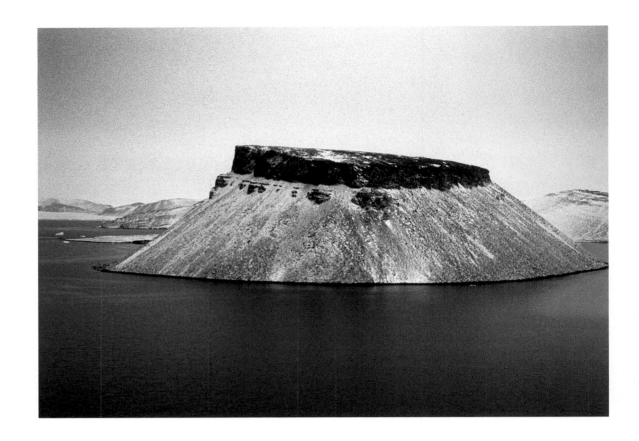

Opposite: July 1950. Uummannaq ("Heart of the Seal"). Legendary capital of the 302 Hyperboreans north of Greenland.

Below: May 31, 1951. Return from the geomagnetic North Pole in a dogsled, the night before a trek across the deserted Ellesmere Island in Canada.

when I felt the call of the icy empire, of the land of bears, what Goethe called the sound of the invisible. ❯❯

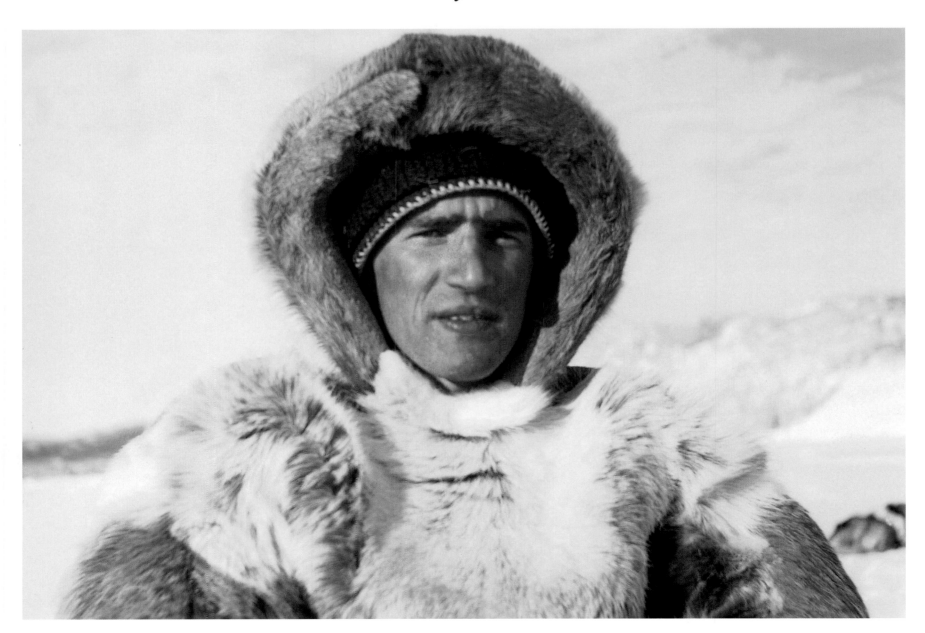

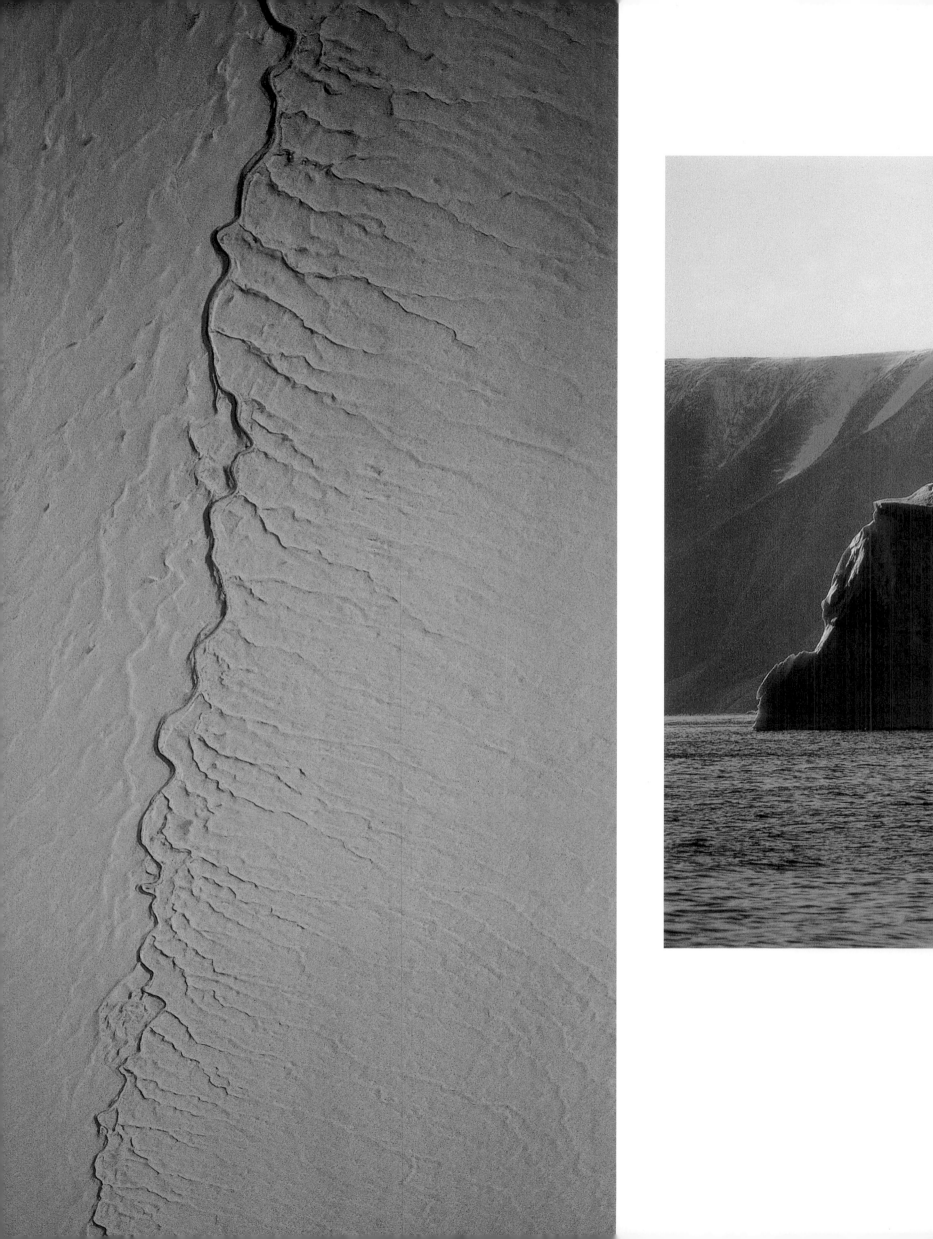

THE ROAD TO THE MYTHICAL POLE

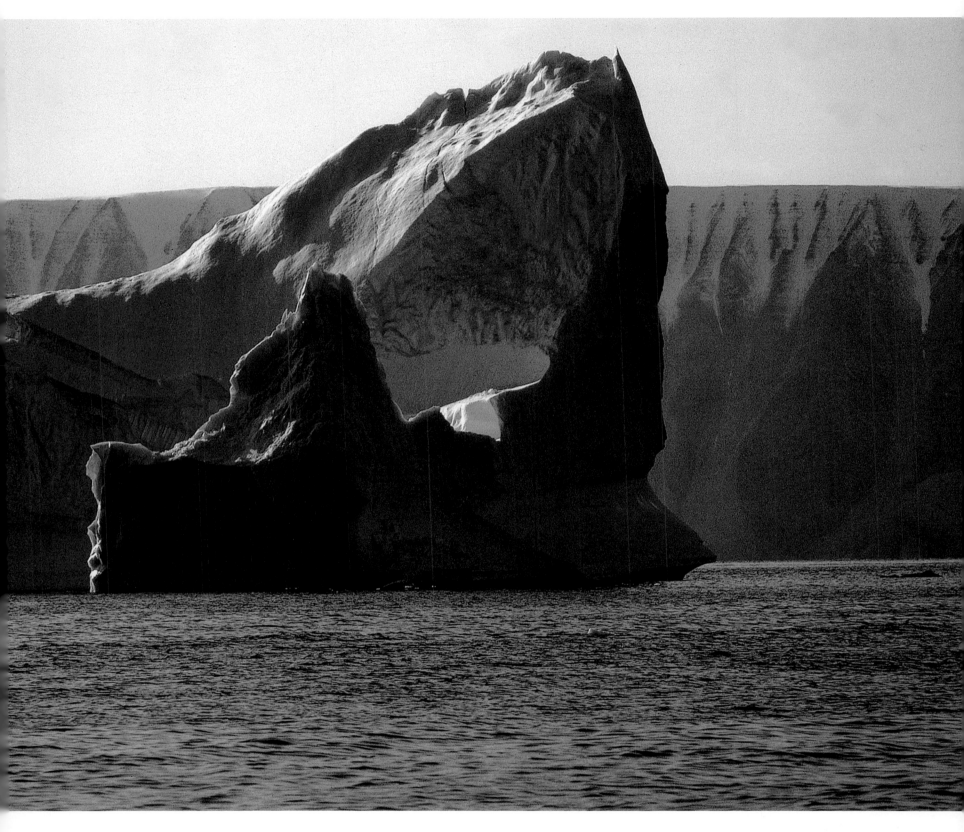

Following pages: Thule, North Star Bay. September 1967.

Beyond the far north, the ice, the today.
Beyond death, isolated
Our life, our happiness. Not by land or sea
Will you be able to find the hunter that will bring you
To us, Hyberboreans. It's also about us
That a prophet spoke wise words.

Friedrich Nietzsche, Poetry

AN UNKNOWN PEOPLE AT THE TOP OF THE WORLD

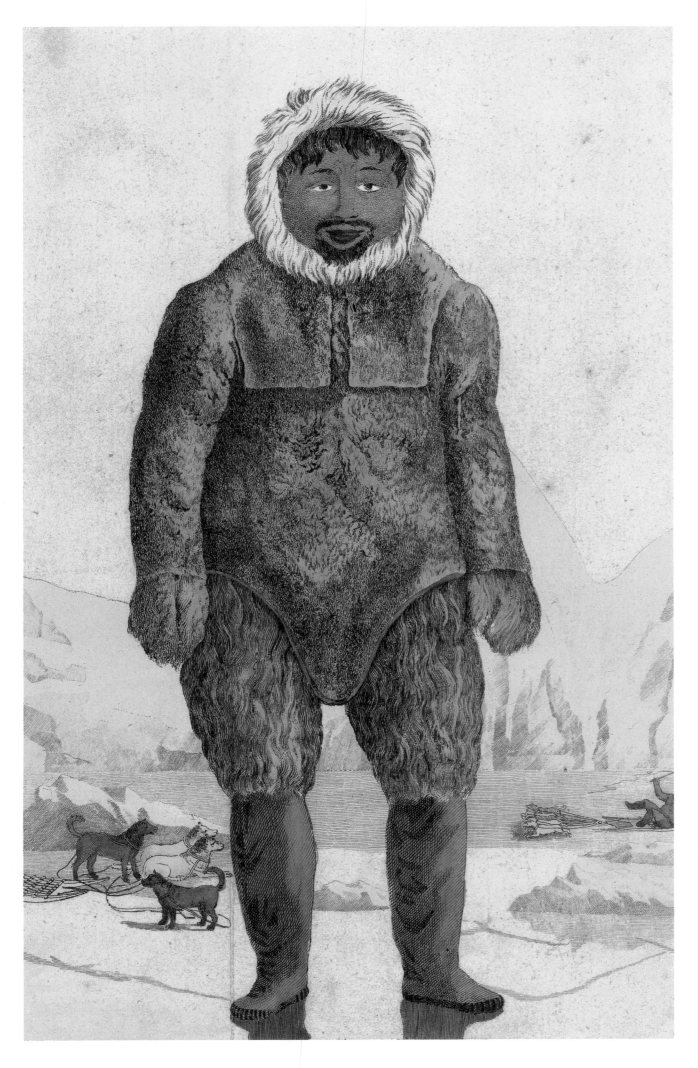

Left: Painting of John Sacheuse, a southern Greenlander who served as interpreter for John Ross's 1818 expedition. The expedition met a man named Ervick in August 1818—the first man of an unknown people. "When Ervick was told that there was an omnipotent, omnipresent, and invisible Being, who had created the sea and land, and all therein, he shewed much surprise, and eagerly asked where he lived. When told he was every where, he was much alarmed. . . . This man, who appeared to be about forty years of age, measured five feet one inch in height. . . . his beard and mustachios, which were suffered to grow, were scanty, and confined to the upper lip and chin. . . . On seeing their faces in the glasses [mirrors], their astonishment appeared extreme, and they looked round in silence, for a moment, at each other and at us. . . . A watch was held to the ear of one, who, supposing it alive, asked if it was good to eat." (John Ross, *A Voyage of Discovery*, 1819)

Right: Uummannaq (now Thule), July 1909. Ayorsalik, 40, son of a famous *angakoq*, or shaman.

Following pages: Robertson Fjord. For four million years Greenland has been covered by a 9,000-foot-thick glacier five times the size of France. The glacier dates back to the era of the Lascaux cave paintings, when Europe and Asia also suffered from an intensely cold climate. The ice beneath Greenland's tundra reaches a depth of 1,600 feet; the tundra's surface has been thawing for the last 8,000 years, as if the skin of the Earth were peeling off. Waves have carved the fjord's slopes, dragging rock, clay, and sand into the sea.

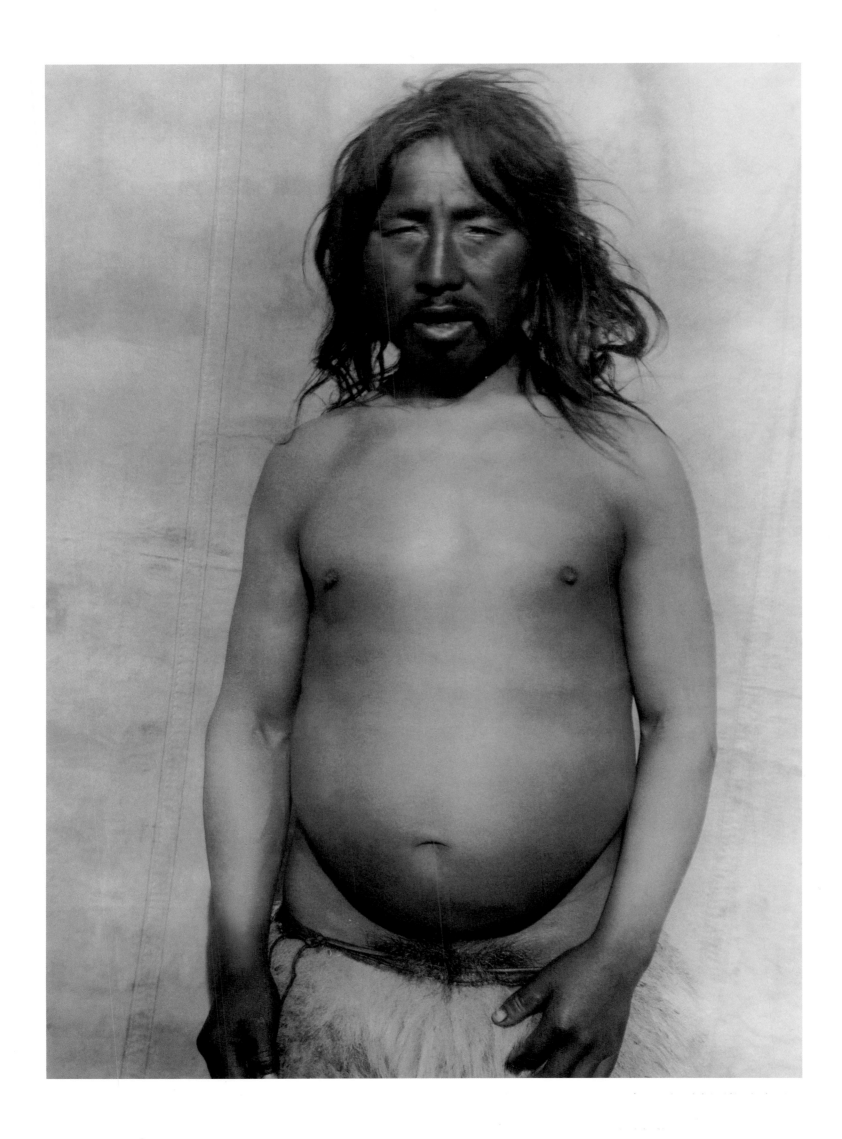

MY FIRST CONTACT WITH A POLAR ESKIMO.
I WILL NEVER FORGET IT.

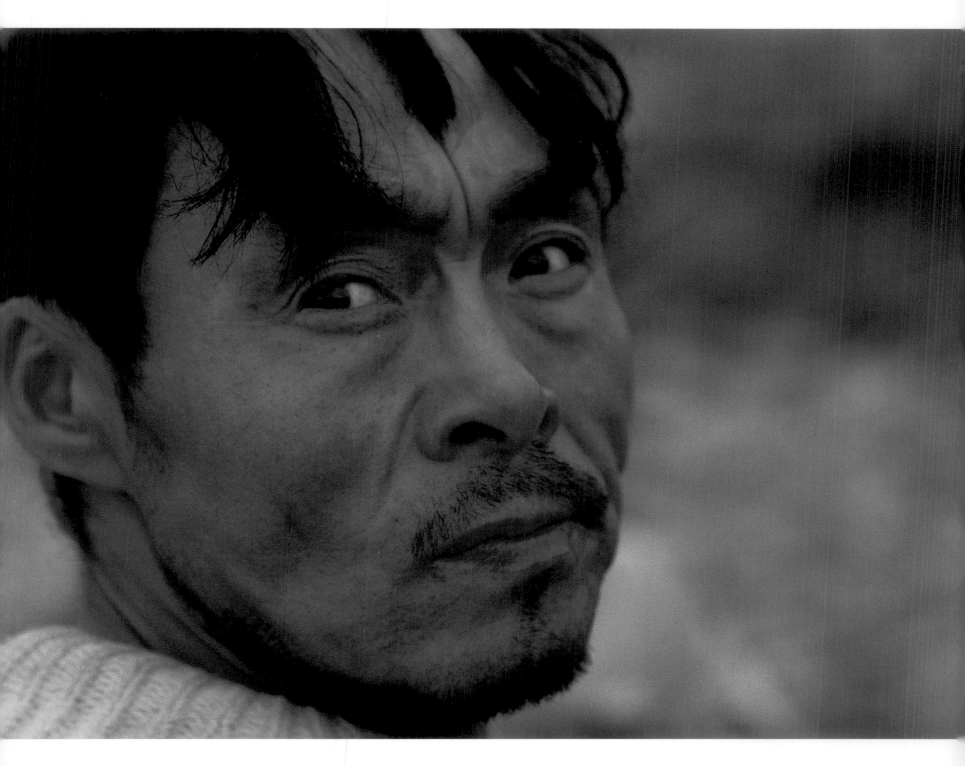

Above: July 23, 1950. I arrive in Thule. I am alone. I have neither equipment nor provisions for the winter. I had set out from Copenhagen on July 1 with permission for a four-week stay in the area, which was off-limits to whites. I stayed for a year, leading a solitary life among the Inuit.

Right: Alekaasinguaq. This faithful friend, the wife of the great shaman Inugteq, welcomed me to Kangerluarsuk in November 1950, after I had crossed the ice and mountains at night, alone on a dogsled.

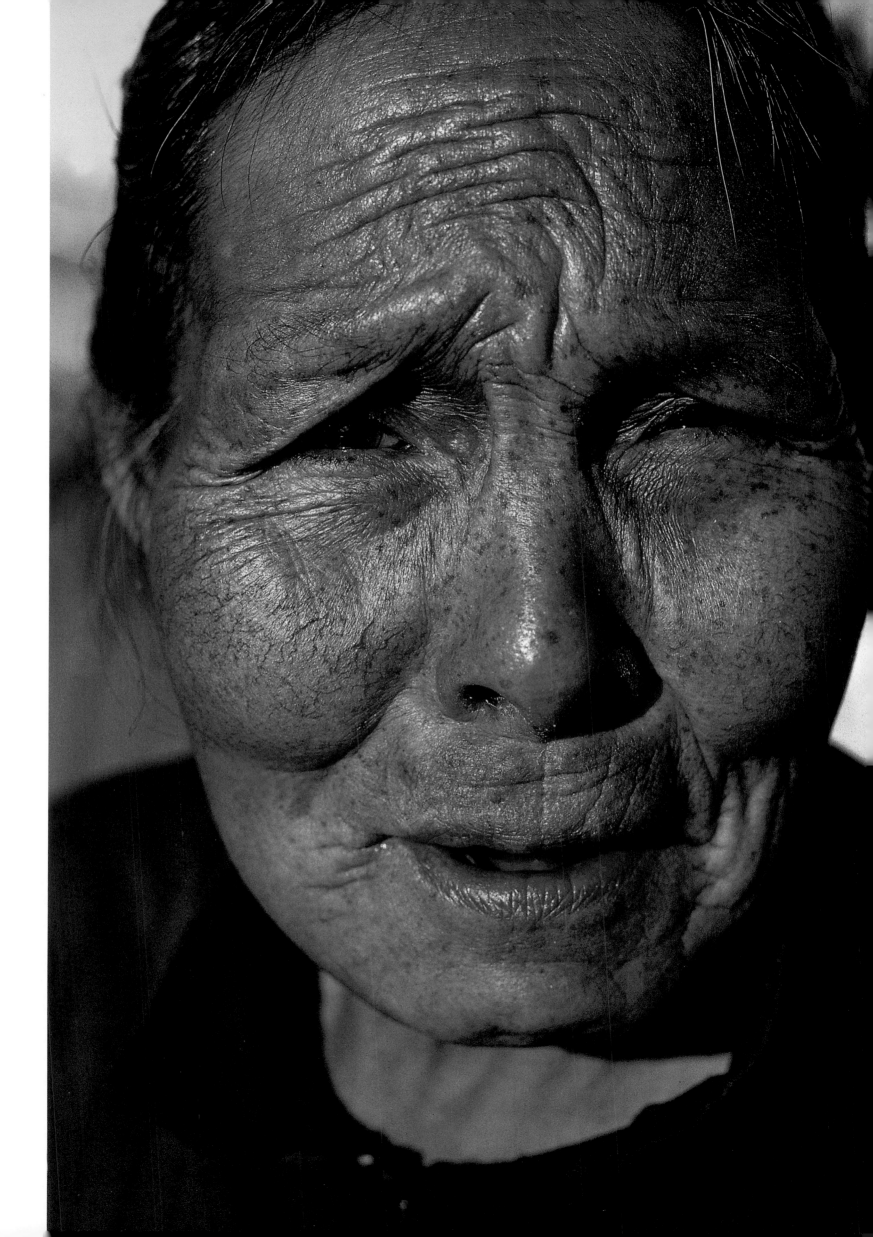

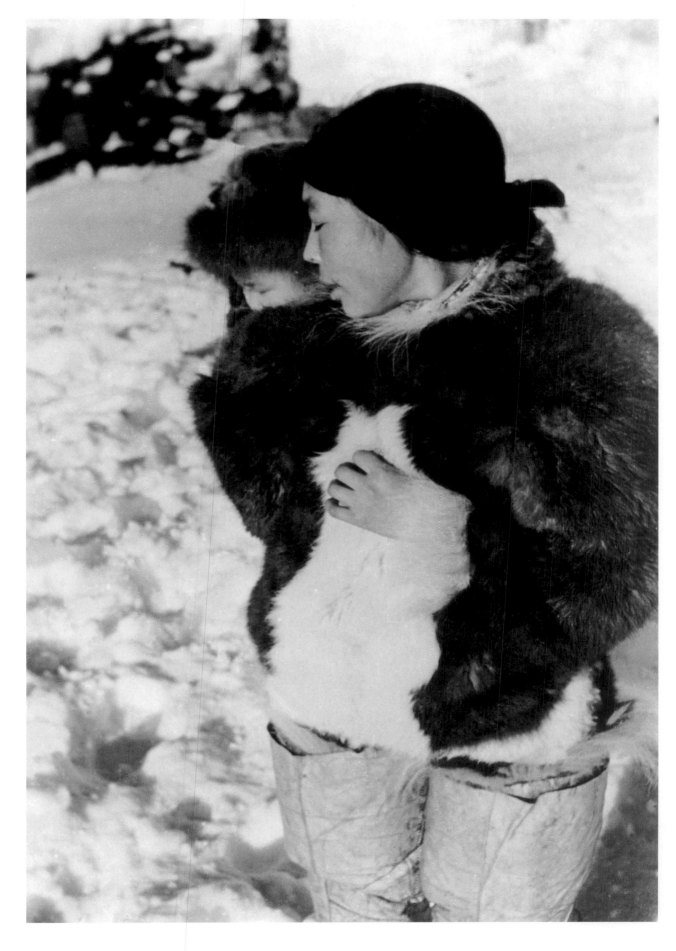

Above: Siorapaluk, September 1950. Tavfinguak, thirty-six years old.

Right: Thule, July 1950. Masaatsiaq, 39, began to teach me the dialect of north Greenland; I had learned the basics of the south Greenland language in Skansen during the previous two years.

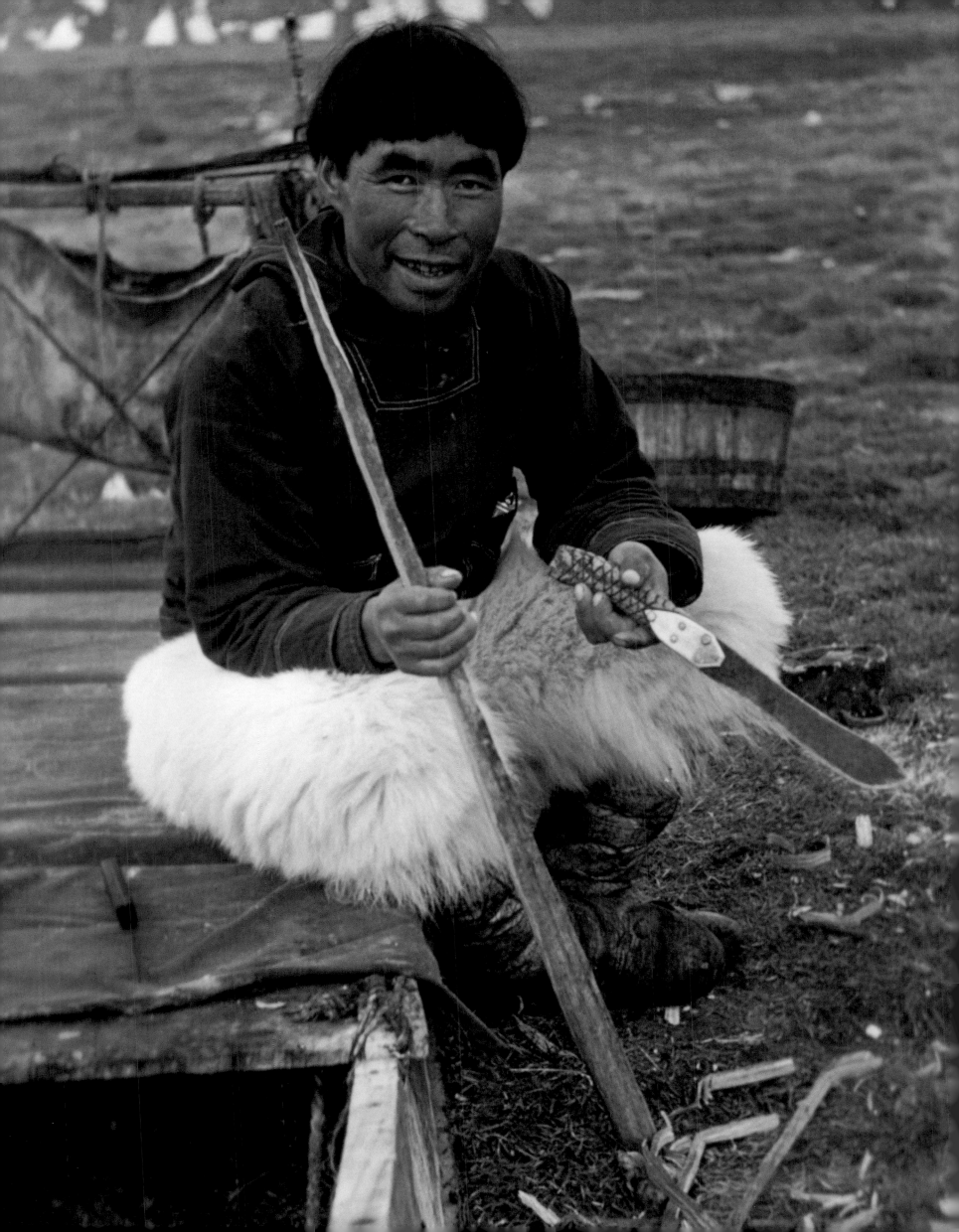

ETAH, THE HIGHEST PLACE OF POLAR EXPLORATION.

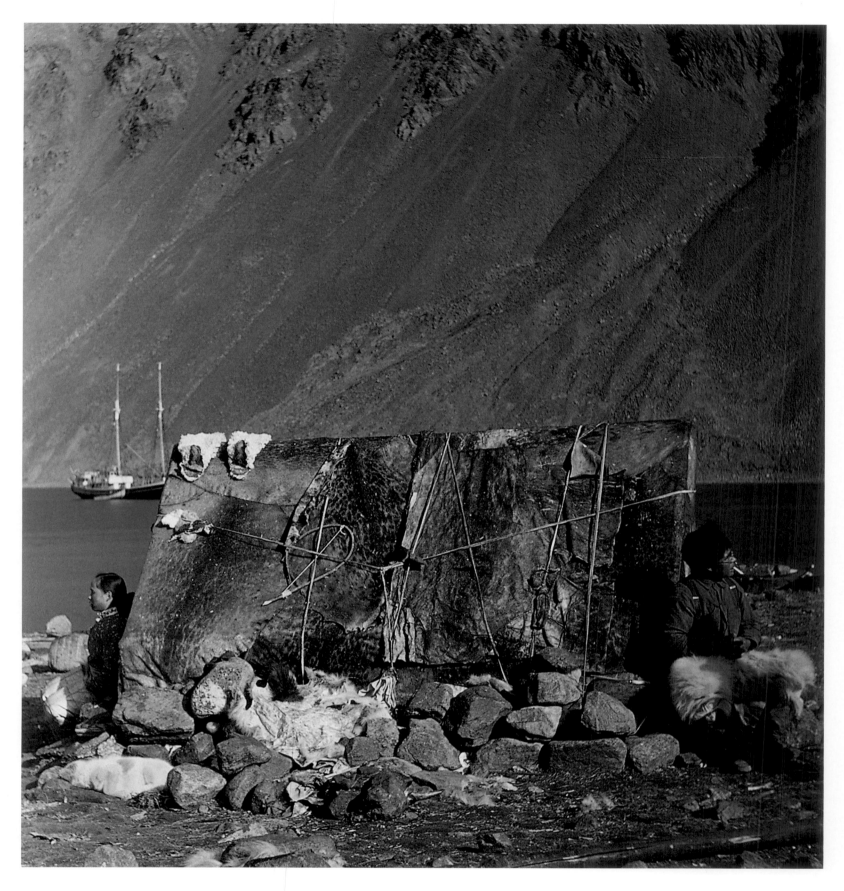

Above: Etah, August 1950. A seal-hide tent at Etah, the most northerly camp on Earth, at 78°20'N, 72°38'W. I explored campsites along the coast on board a sailboat before I chose a place to winter. This is what the Inuit shaman would say: "Adglané, Adglané. A long, long time ago in Etah, the *tunit*, the legendary giants who came before the Eskimos, tormented them. They approached one of their tents. The men were gone, and they raped all the women."

Right: Etah, August, 1950. Avortungiak, 55, always a loyal friend to me, had three names; this one was the name of her maternal aunt, who died the year she was born. Her three names gave her three personalities: her own, her aunt's, and that of a male ancestor.

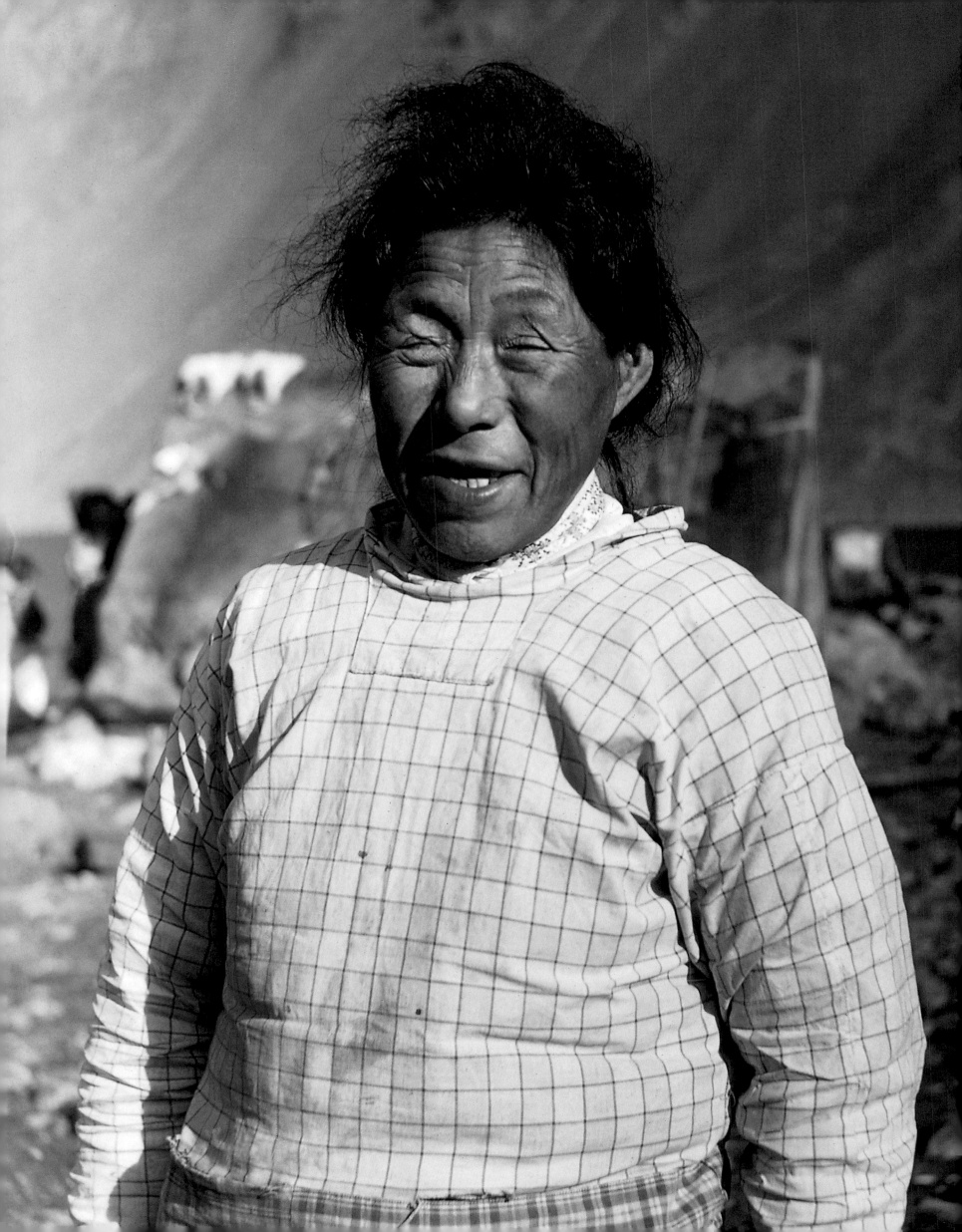

THE KAYAK, MASTERPIECE OF THE INUIT MIND

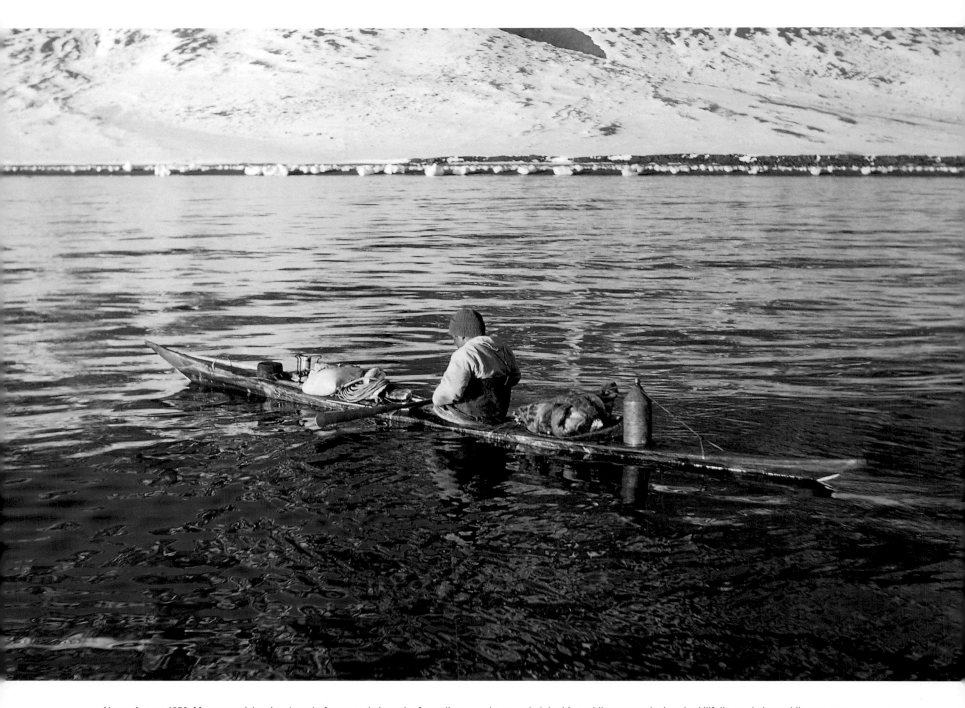

Above: August 1950. Magsanguak has just bought four months' worth of supplies at the little store in Siorapaluk. He lives in Neqe, a settlement of three igloos fifteen miles away.

The Eskimos' life has always been closely bound to the sea. For two centuries, from about 1600 to 1800, they contended with the "little ice age," a period of extreme cold. During those years, they used semipermanent ice floes as hunting rafts—they were wide enough that hunters could hunt seals and water fowl during the summer. The kayak was invented only after the climate warmed up a bit. They are usually nineteen feet long and eighteen inches wide, with the thickest part—the section above the knees—five to seven inches deep. Building a kayak requires five seal hides, which are treated and sewn by women—though only men use them.

Ivory-ended double-paddles power the kayak; skillfully used, the paddles can turn a kayak ninety degrees almost instantly. This maneuverability is important in emergencies, since Eskimos can't swim. (How could they learn in water so cold? It can kill a man in a few minutes.) For the Eskimos, the kayak is the expression of the human body. The stem, *usuujag*, resembles a penis, while the *paa*, the hole in which a man sits, looks like a mouth.

Left: Siorapaluk, "pretty little sand beach," on Robertson Fjord, 77°47′N, 70°42′W. When I returned from Etah on August 9, 1950, I set up my winter base in these austere surroundings—six igloos with peat walls, surrounded by snow, thirty-four Inuit, not a single other white man.

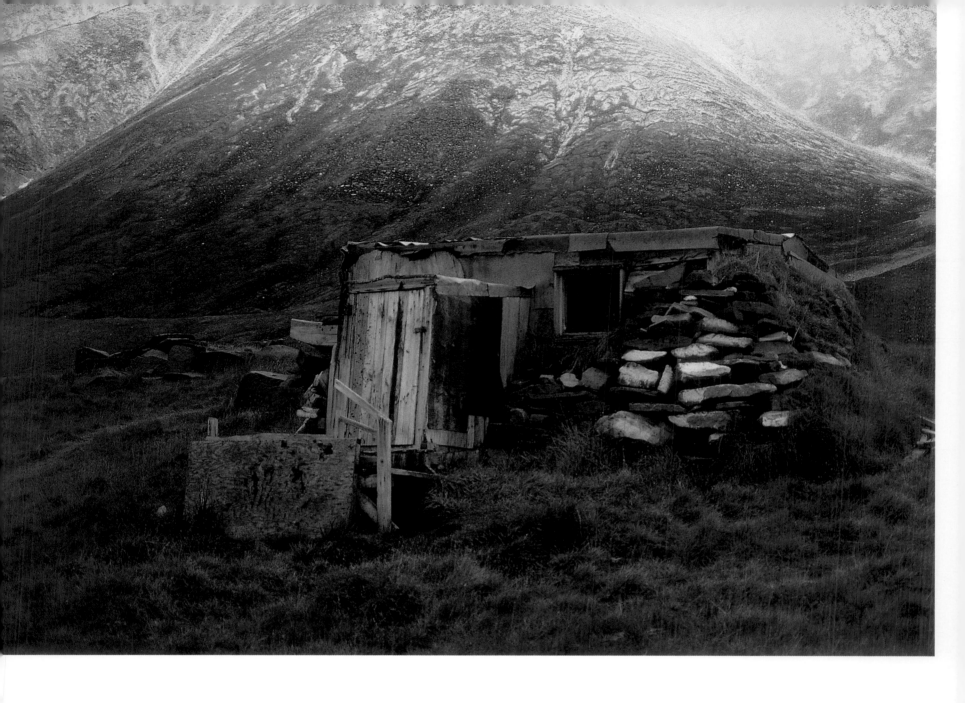

Above: This stone, peat, and wood igloo belongs to Aamma, an Inuit woman living in Qeqertarsuaq. She was one of my friends and an exceptional source of information.

Left: The entrance to the *turhuuk*, the nine-foot igloo hallway meant for ventilation. The entrance can't be too wide or too high, lest polar bears get in.

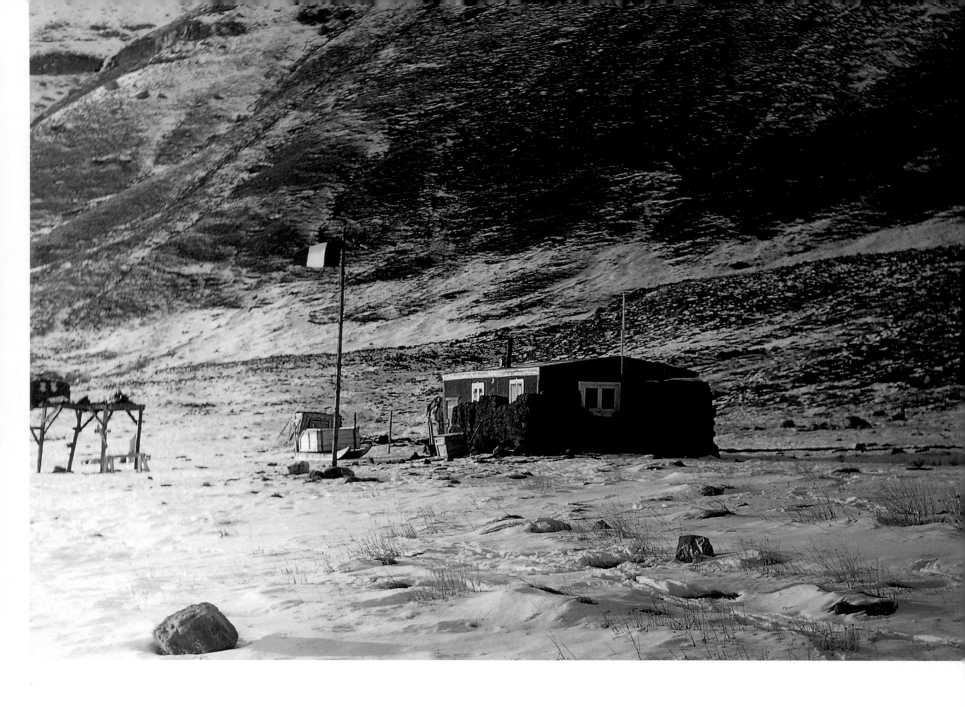

Above and right: Siorapaluk, September 1950. I lived alone in this hut. The inside was made of wood, the outside walls of peat; in winter, the peat was surrounded by a three-foot-thick snow wall. Inside there was a separate "cold entrance," where furs and guns were left and which prevented condensation in my living space; a central room for visitors; and an 86-square-foot office and sleeping area for me. I had two crates to sit on, a table made of a few boards, and an oil lamp whose soft light made us all look as if we were peasants in a Georges de La Tour painting.

I conducted one-on-one interviews with the community here every night during the winter of 1950–51. Here, too, I planned every detail and chose my companions for my spring expedition to the north, to the icy deserts of Inglefield Land, Washington Land, and Ellesmere Island. And later it was here that I envisioned further missions—deeper into the Canadian Arctic, to Alaska, and all the way to the Bering Strait.

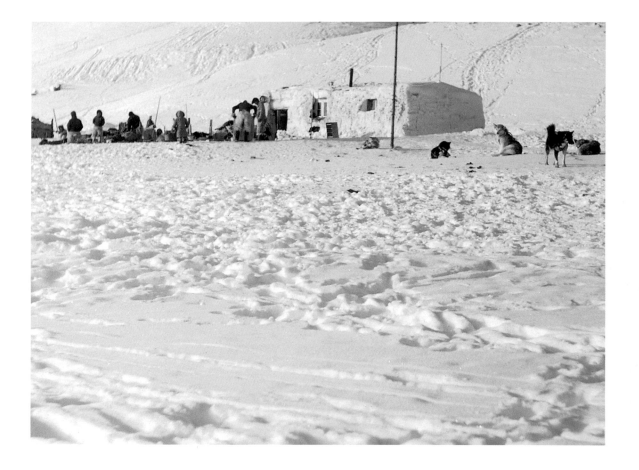

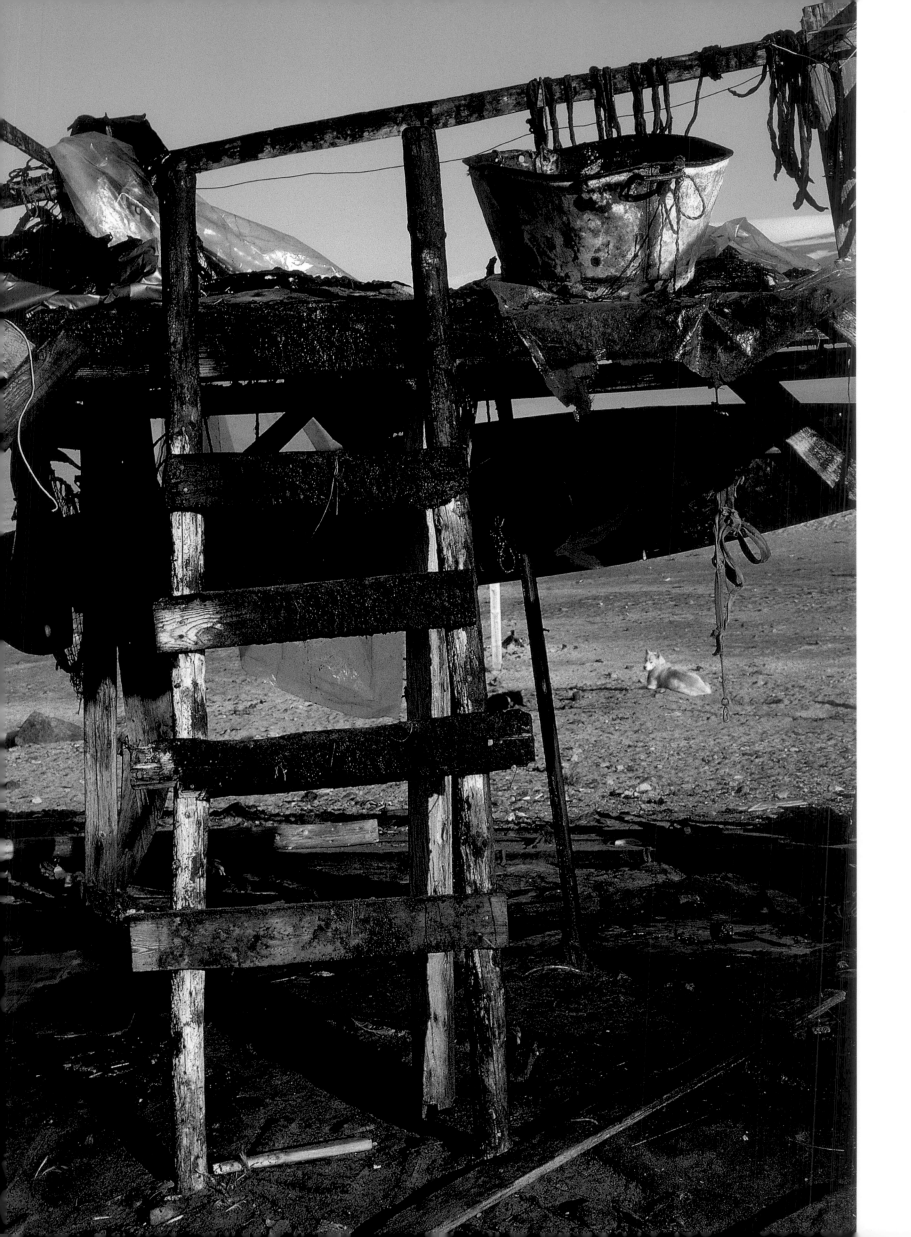

MEAT IS STORED AS CLOSE TO THE IGLOOS AS POSSIBLE SO IT CAN BE GUARDED AGAINST ROAMING PREDATORS: BIRDS IN THE SUMMER, BEARS AND FOXES IN WINTER.

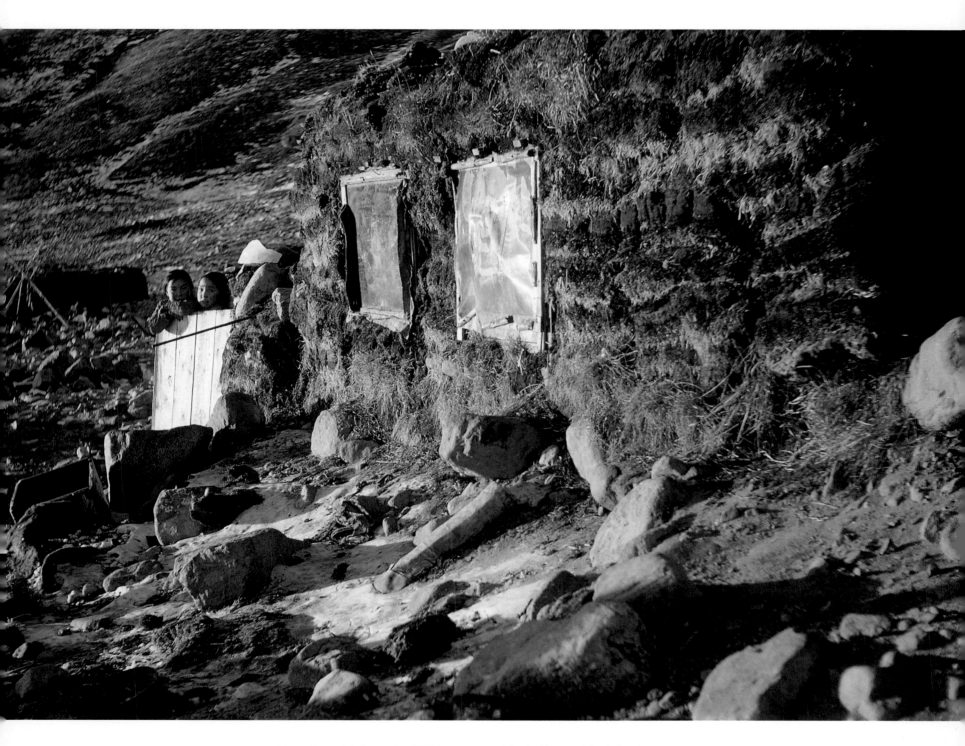

Above: Siorapaluk, September 1950. I spent many nights in this stone igloo belonging to my friend, the shaman Sakaeunnguaq, exchanging news and stories and peering at the future. He gradually made me Inuit.

Left: Siorapaluk, May 1969. This is my stock of meat and seal and walrus fat, to feed both me and my eleven dogs. A hunter has to consume 5,000 calories a day to resist the cold; the more meat dries in the sun and wind, the more nutritional value it has. I ate an Inuit diet—raw or cooked frozen meat and meat-and-blood broth. I never suffered from scurvy, and my strength increased with each passing month. In 1920 the meat pantry would have been a small stone tower, since Greenland has no native wood. Lumber has been imported for the past twenty years.

THE *NAALAGAQ,* THE HEAD DOG, MY CLOSEST COMPANION DURING MY TREKS. HE SENSED MY FEELINGS AND MY DOUBTS.

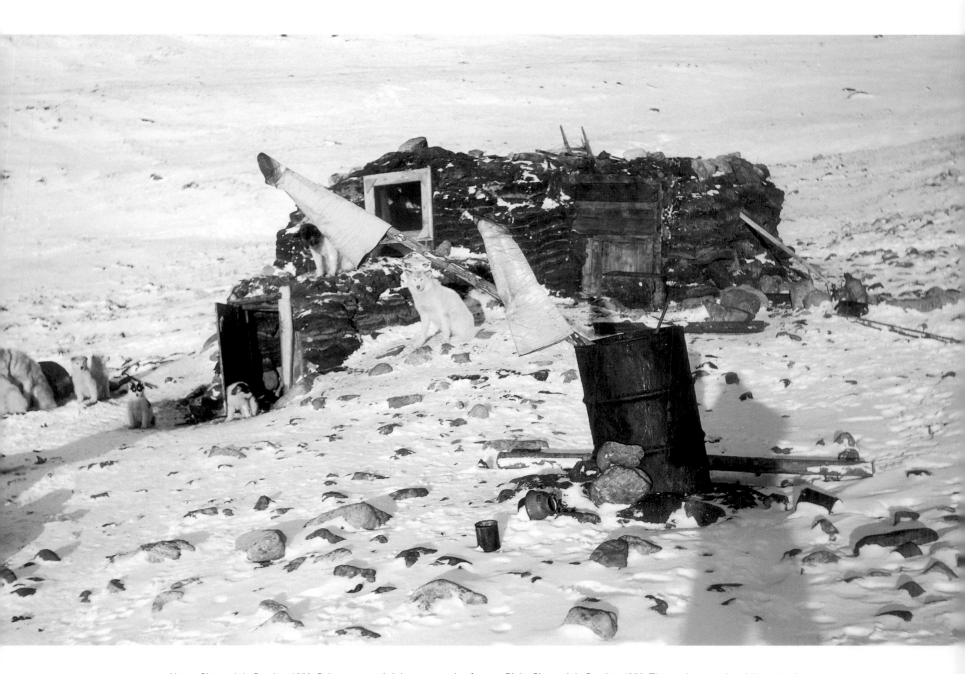

Above: Siorapaluk, October 1950. Sakaeunnguaq's igloo was made of stone and peat over a structure of bone and wood. (The snow igloo—*igluigaq*—is used only during treks.) Every family has an igloo, which is made up of a single room measuring about 190 square feet. The ceiling is about five feet two inches high, and there are one or two windows made from the intestinal wall of a large seal, known as *equut.* The windows aren't very transparent, though, and a hole is required to see outside. A six-to-twelve-foot-long hallway, known as a *turhuuq,* leads into the igloo. This *turhuuq* was three feet high and two-and-a-half feet wide at the entrance. It got smaller further in, to keep bears out. In the foreground are the big white shorn-seal-skin boots married women wear.

Right: Siorapaluk, October 1950. The *naalagaq,* or head dog, stands apart from the pack, waiting, his eyes calm and powerful. This is Paapaaq, who stayed with me during the long polar night and led my trek in the spring: 750 miles to the northern glaciers and then onto the ice cap. A pack of sled dogs is like someone you marry, and who marries you. Each dog has a name and it is rarely human. A glance between you and your lead dog renews the pact between you—a deal upheld by what is not said, small cries, secrets. When faced with danger, you must rely on the whip.

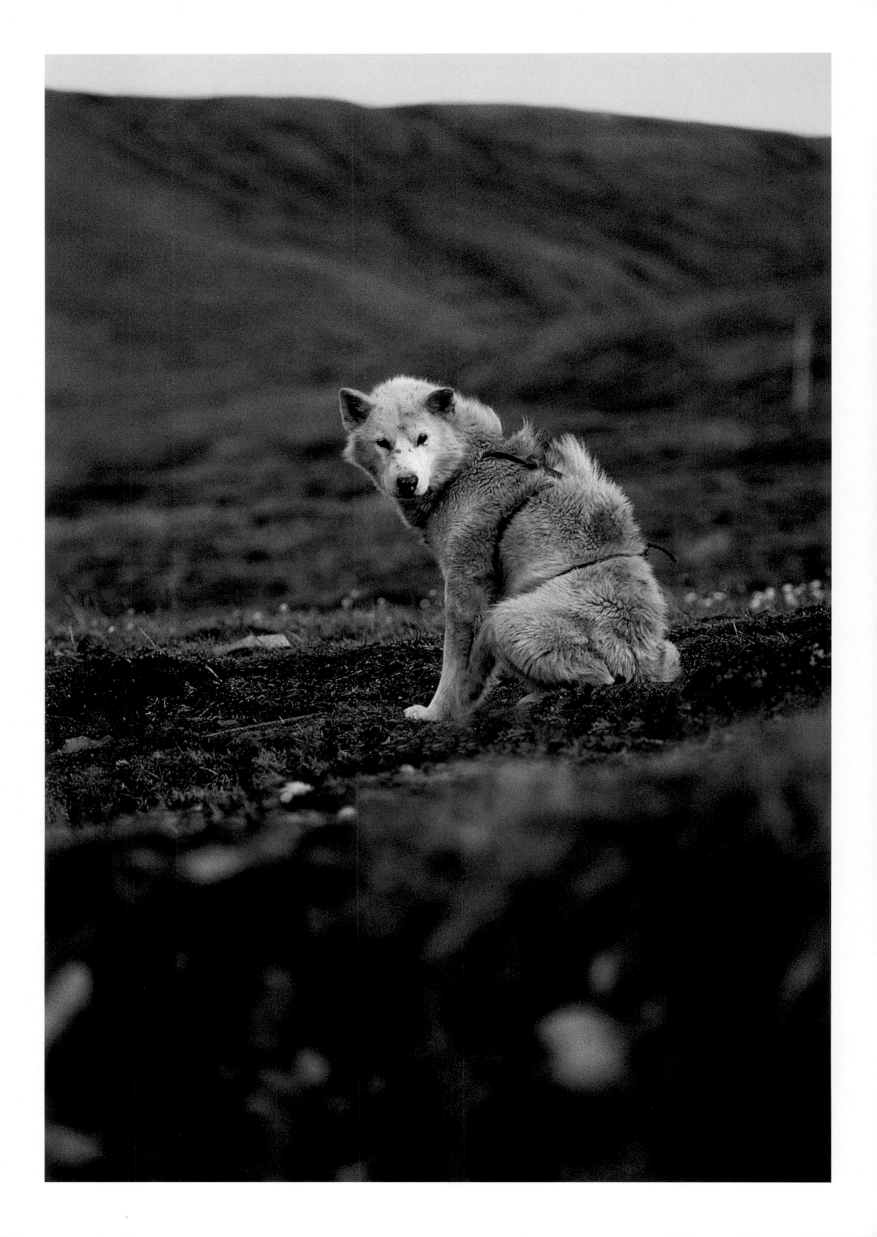

SACRED LAND, IT SIGHS WITH THE DEAD.

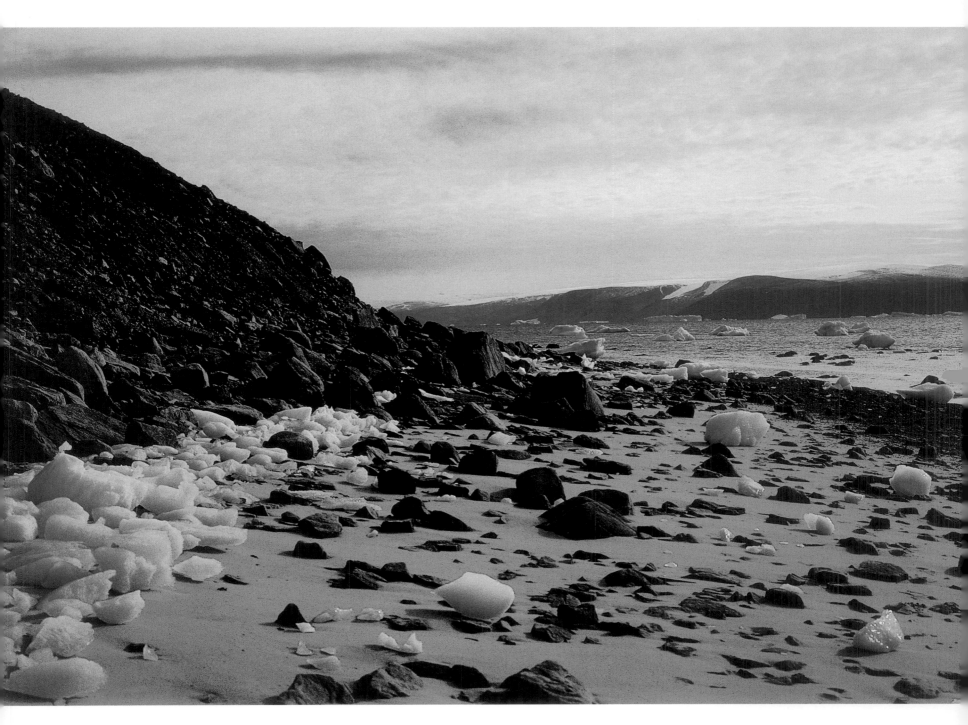

Above: Qaanaaq, Whale Strait, September 1972.

Right: Near Siorapaluk, August 1967. The shaman can talk to the elements. He converses with plants, breathes the air, interprets the whistle of blizzards, listens to the ice floes cracking. Watch the Inuit walk, with his light but confident step. If an Inuit finds a stone or some ice along his path, he won't kick it with his foot. Although the stone or ice lies in his way, he won't dare to interfere with the established order. The Inuit are philosophers.

The social and natural sciences pass in front of them. "The supreme law of nature is that everything strives to continue in its state." Anthropogeography takes into account the interaction between natural systems and the societies that depend on them. This was the method at the heart of my ethnohistorical studies, which focused on the Inuit imagination. I sought to place myself "behind the images that come to the fore, that stay hidden, to go to the very root of the force of the imagination." (Gaston Bachelard).

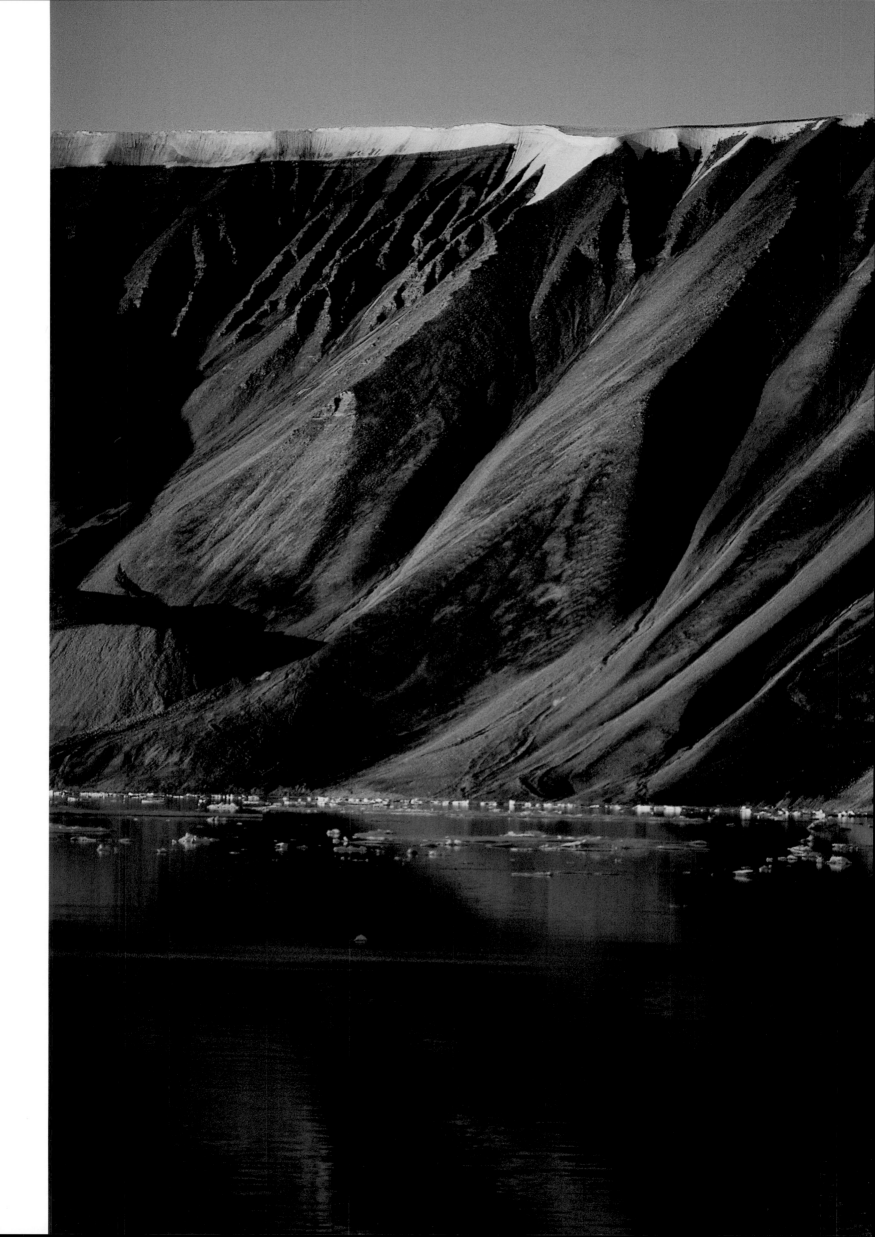

Siorapaluk, July 1969. The seal, *Phoca hispida*, called *puihi* or *natsiaq* by the Inuit. They grow to four-and-a-half feet long, four feet around, and 100 pounds. The bearded seal, *Erignathus barbatus*, or *ughuk*, can grow to nine feet and 400 to 600 pounds. Seals are born in small caves made by the mother, near breathing holes in the ice. When they are born their skin is white; the fur darkens later. The seal can hold its breath for seven minutes, diving 300 feet down; its whiskers allow it to find food on the sea bottom. They are nearsighted and use their senses of hearing and smell to protect themselves. Seals spend most

of their time under the ice; men wait for them to appear at breathing holes (*agluq*), which they maintain throughout the winter. When seals do surface, they stay there for only thirty seconds or so, lest a nearby bear or hunter attack. In the spring, hunters sneak up on the seals as they sleep in the sun. An Inuit family hunts between fifty and 100 seals each year. Ninety-five percent of their diet is meat—seal and walrus. The Inuit also hunt foxes, selling their hides along with those of seals to pay for guns, ammunition, sugar, coffee, tea, and cloth for summer clothes.

A HAPPY SUMMER DAY IN TASSERSUIT.
MEN AND WOMEN GO TO THE RAPIDS. COUPLES FORM.
THEY WILL BE MARRIED IN THE SPRING.

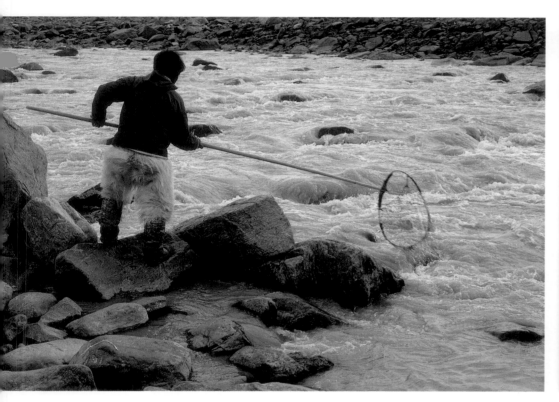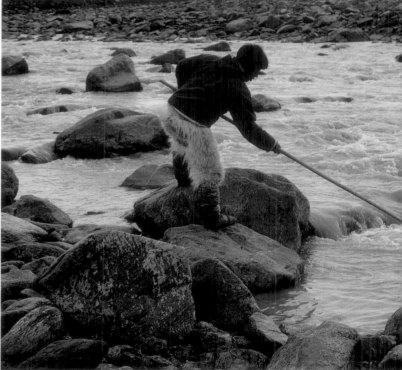

McCormick Fjord, August 1982. *Iqaluk*: the fish, the arctic char. They are born in a lake in Majortulerriffigssuaq, near Siorapaluk. On a July day four or five years later, the char will travel to the sea, where they eat plankton in the rich estuaries. After a final summer of freedom, the char swims up the rough current to spawn in the lake where it was born—or to be caught in the Inuit's fishnets (*kagdlun*). The nets are also used in June, when the Inuit skim the air to capture thousands of little auks (*akpaliarssuit*). Stored in fatty seal-hide pouches, the auks become the indispensable *kiviat*, the reserve of raw and cured birds, which will be eaten during the winter. A century ago the net handles were made of narwhal tooth, since there was no wood.

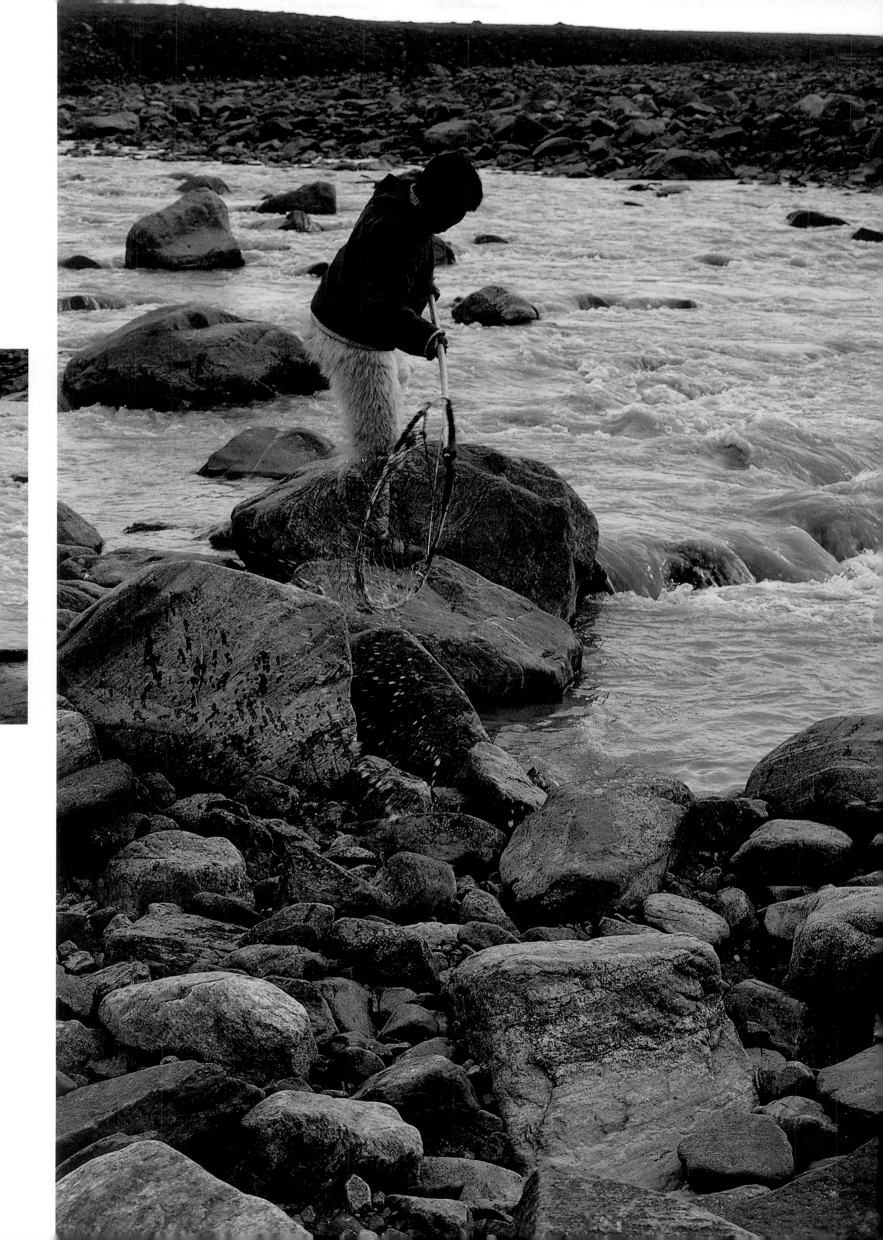

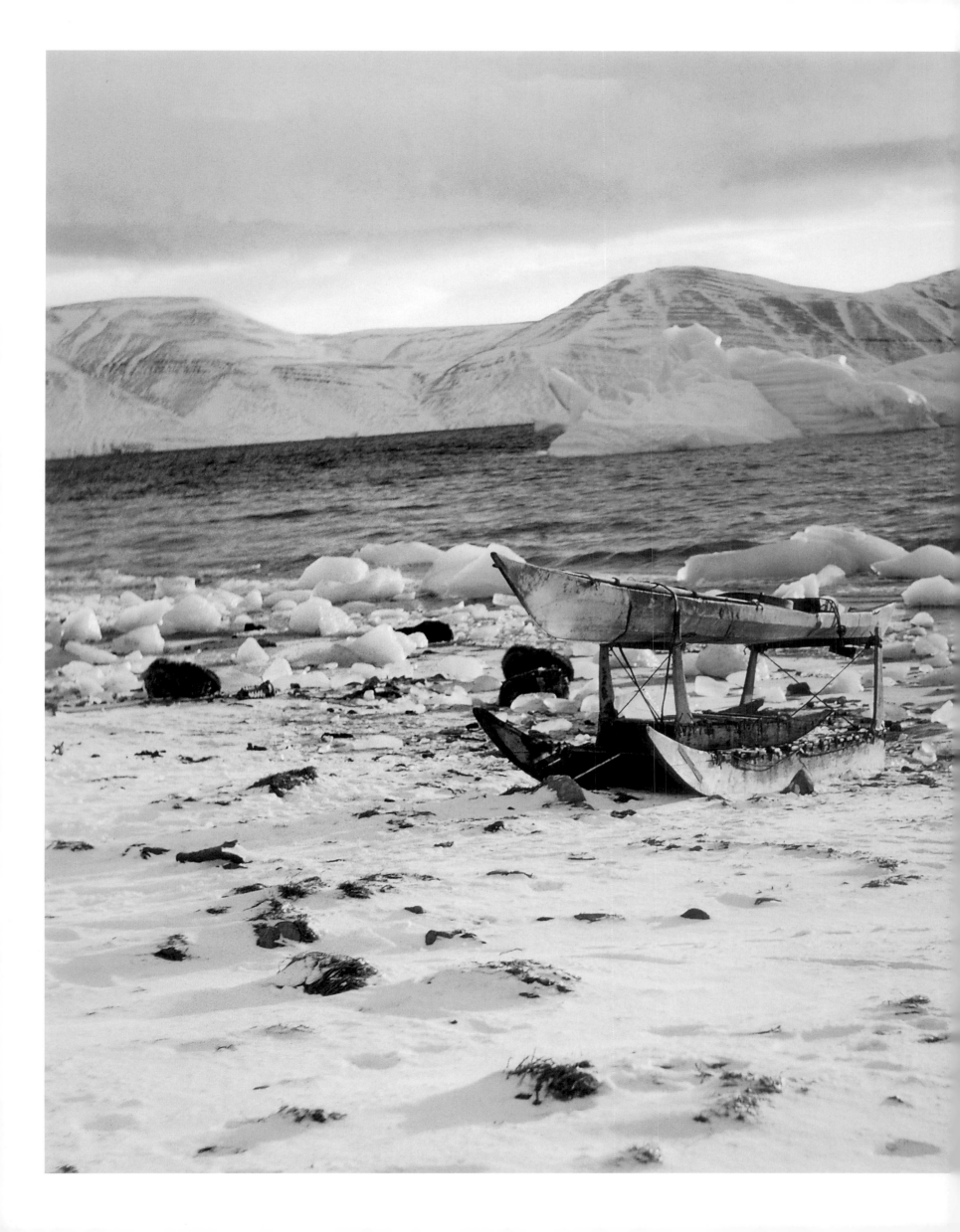

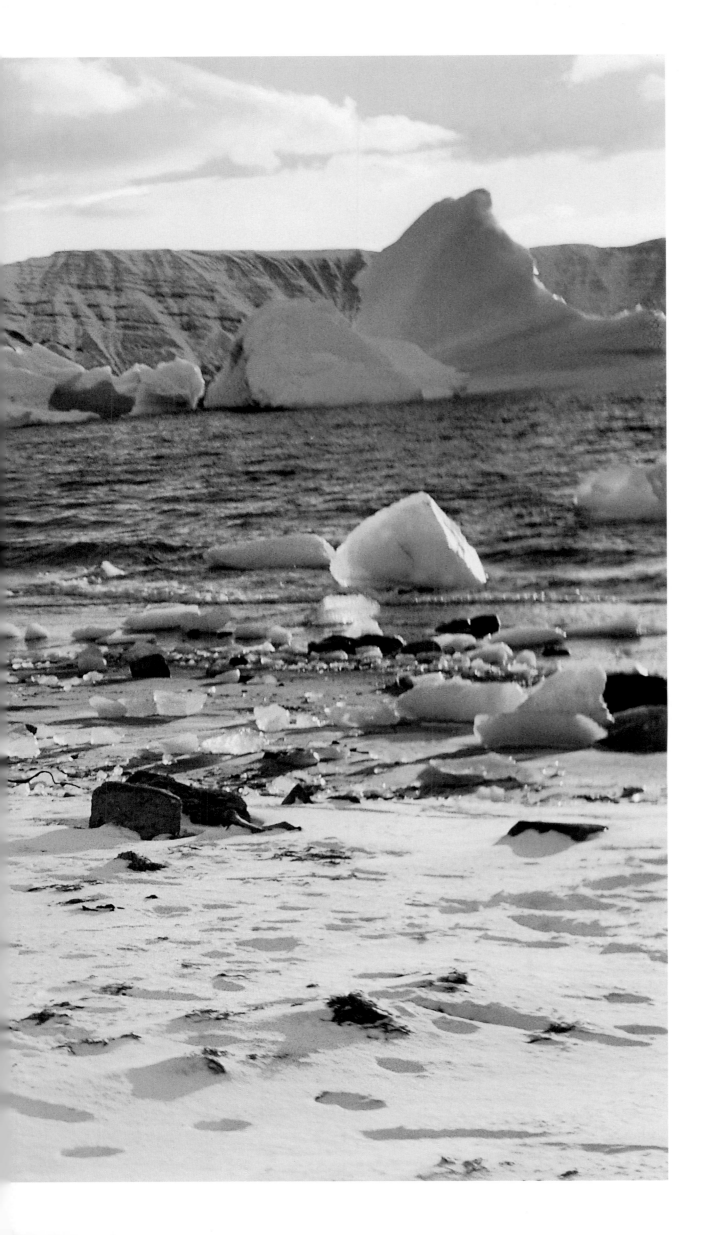

FIRST SNOWS OF OCTOBER. THE SIGNS OF A RAGING ANNOUNCEMENT.

Siorapaluk, September 1950. The first snowfall. Storms come one after the other. Broken pieces of icebergs are driven to shore by the winds and currents. The ice is gathered by women and children to supply water during the winter. When the snow comes, hunters stop using their kayaks: the sea is too rough and it would be difficult to spot a seal's head popping up in the sea spray. Here a kayak has been placed temporarily on two sleds aligned head to tail, to protect it from predators. It will later be stored on top of a meat pantry.

PIRAAQ, "LITTLE MAN." THE CHILD KING

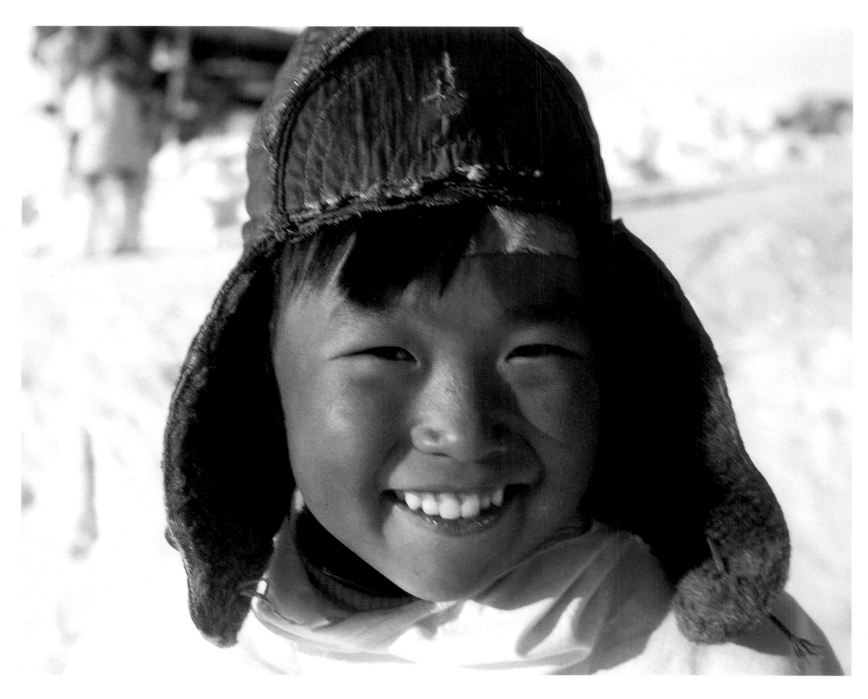

Having a child, or several, adopted or not, is essential for the Inuit. A child is given the name of someone who died the same year so that his or her breath lives on. As a result, the child has two personalities—his and his namesake's—in addition to the "good spirit," or *tuurngaq,* that protects him. One out of three newborns is adopted by a nonrelated family, an act that reminds everyone that the group is more important than the individual family. A child's education is quiet, filled with example and competition. Children lower their eyes when talking to their fathers. But striking or criticizing a child is considered scandalous; his personality is not yet formed; the spirit of the dead speaks through him.

Boys and girls are separated as early as age eight or ten. Incest is forbidden, as is homosexuality. Marriages are organized by parents. Little girls choose their husbands when they are three or four: *uiq nara,* "You are my husband." But it was the two families involved that made the decision, entering an agreement at the child's birth. A family lexicon: *Nukappiaraq*: boy. *Irniq*: son. *Niviarhiaraq*: little girl, or a small red flower. *Inuuhuktuq*: teenager. *Aataq*: grandfather. *Aanaq*: grandmother. *Ataata*: father. *Anaana*: mother.

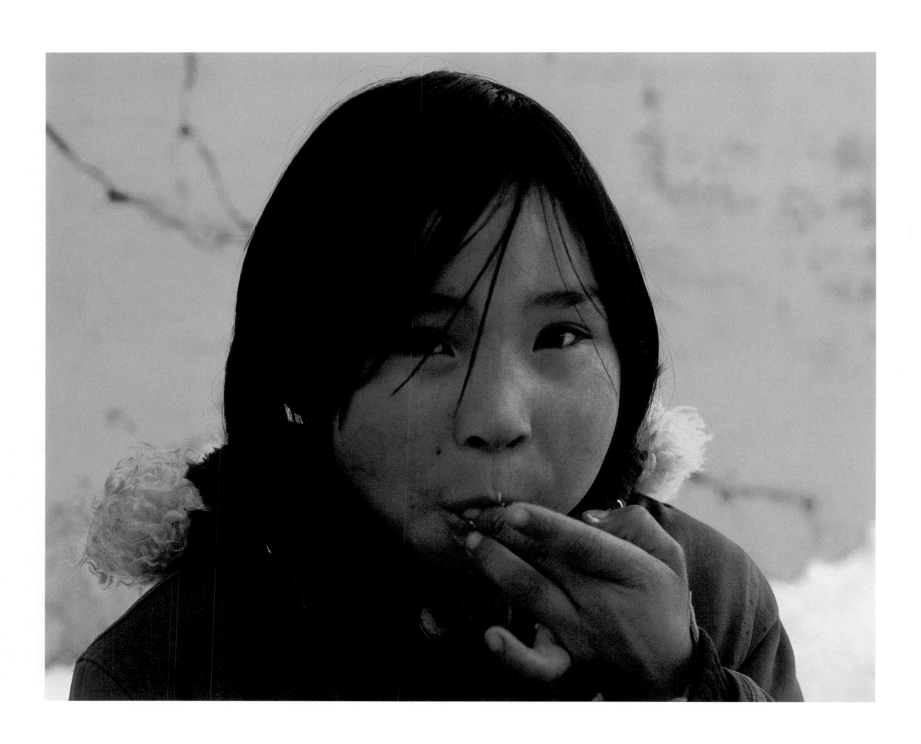

Following pages: Siorapaluk, October 1950. The vast bay, its surface still, iridescent during the white night, made more dramatic by the play of shadows and light, is the source of the Inuit imagination: the crash of splitting icebergs, the muffled sound of cracking ice, the congestive whistle of the blizzard, the dog giving an anguished cry to the moon.

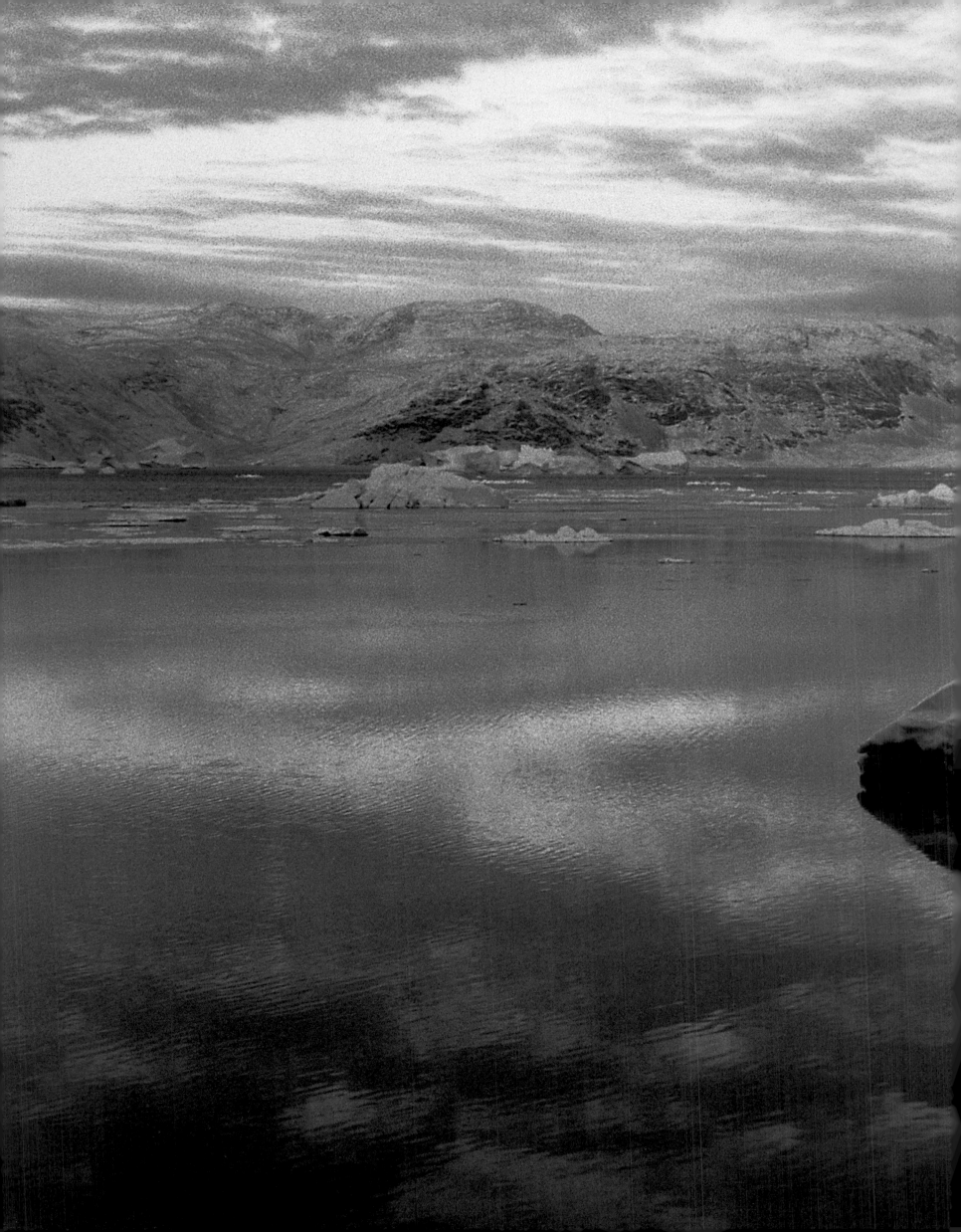

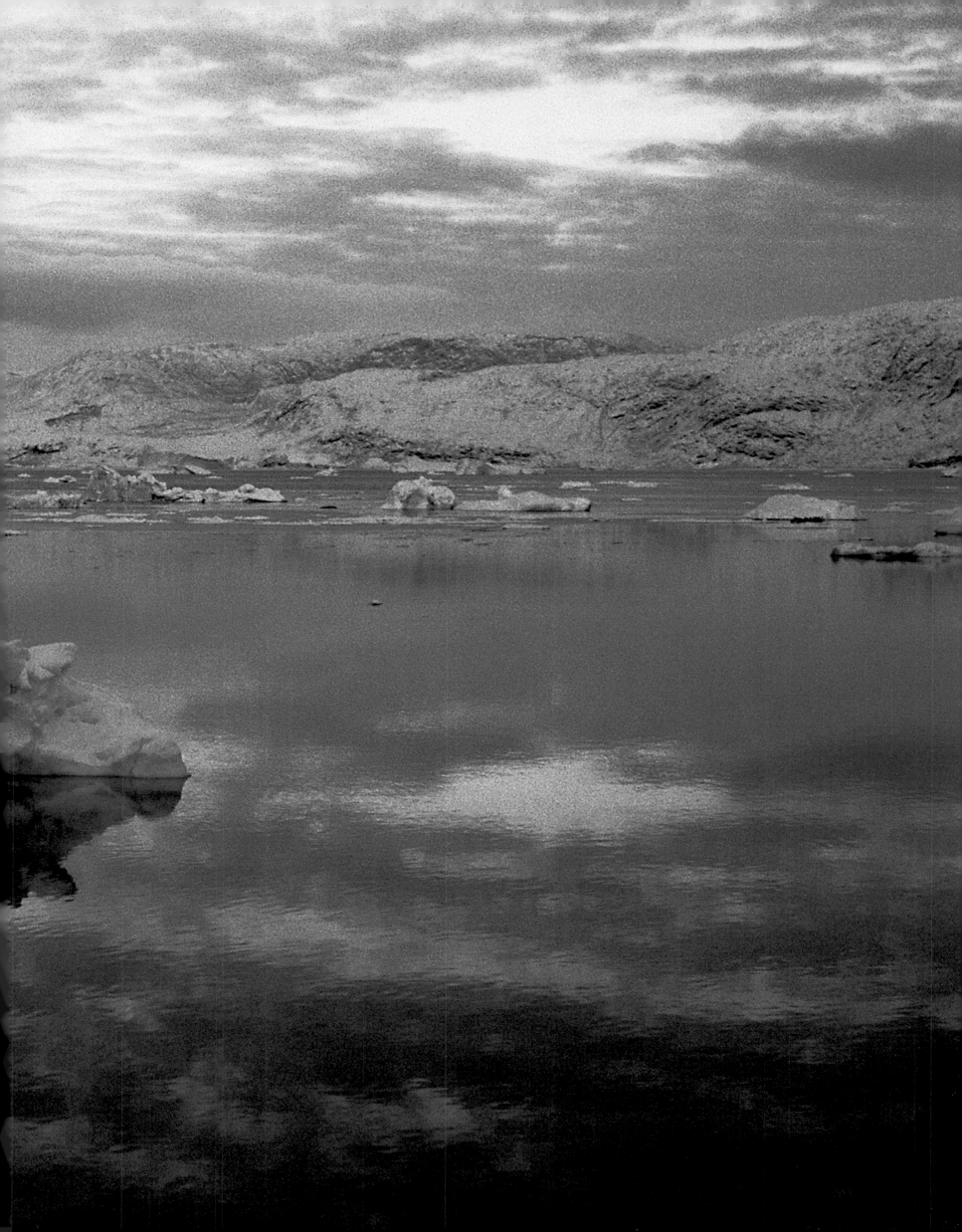

AT THE INUIT SCHOOL

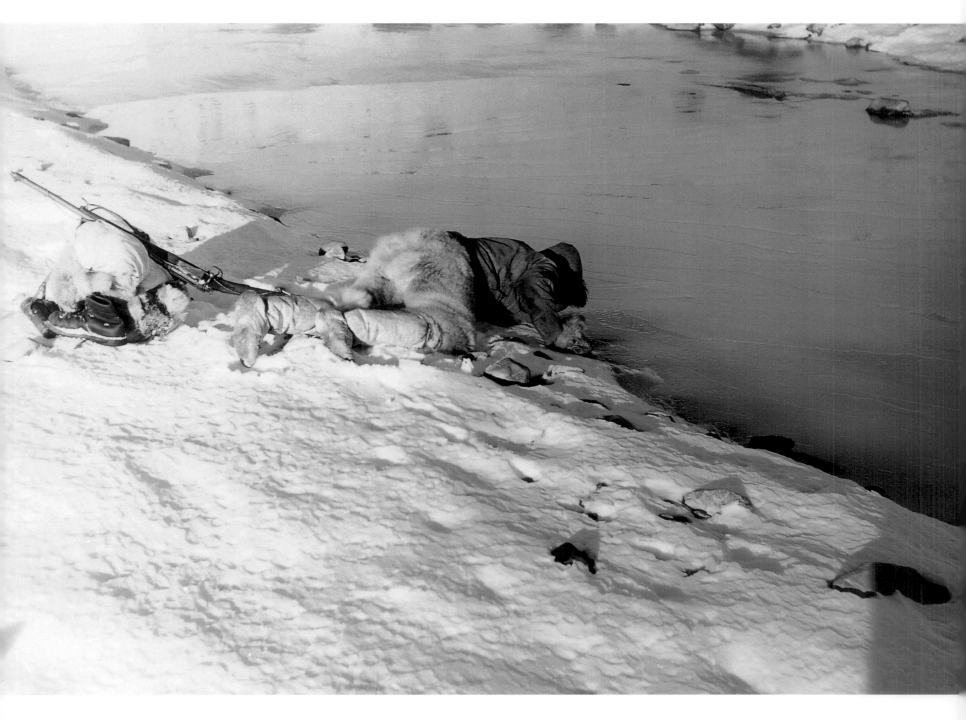

When I look at this picture of Iggianguaq quenching his thirst at the water's edge, I remember that day, August 20, 1950. It was my first walk alone with a young Inuit. I still could barely speak their language. There was a touchiness to his personality.

The Inuit continued to ask the same question. "Why does this white man want to winter alone among us? This is unheard of!" Those hours were a lesson in modesty and humility. My tent, meant for the Alps or Himalayas, was too sophisticated and too fragile for northern Greenland. My ice-walking shoes with steel crampons were also useless. (Look to the left of the gun.) Cow leather freezes at night and can't be softened by hand or through biting—as can the Eskimo's boots, made from seal leather. I started to wear them once I returned from this trek, and I gnawed on them every morning—when there wasn't a woman among us to do it.

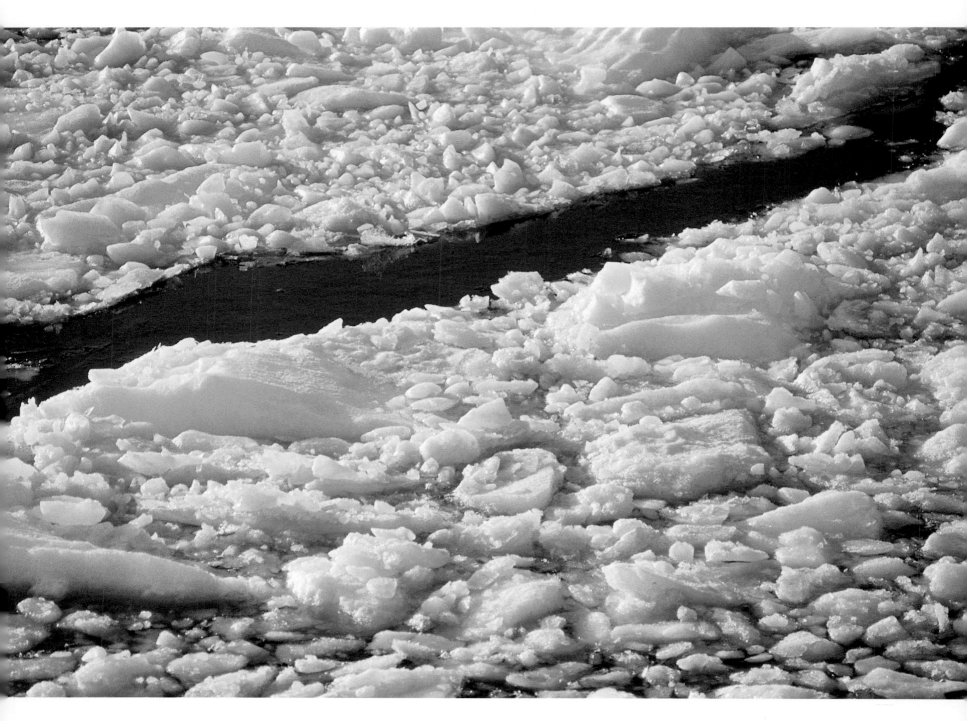

Hiku: the frozen sea.

Following pages: Whale Strait, September 1982.
These are the waters of the narwhal, which have
a single unicorn-like horn.

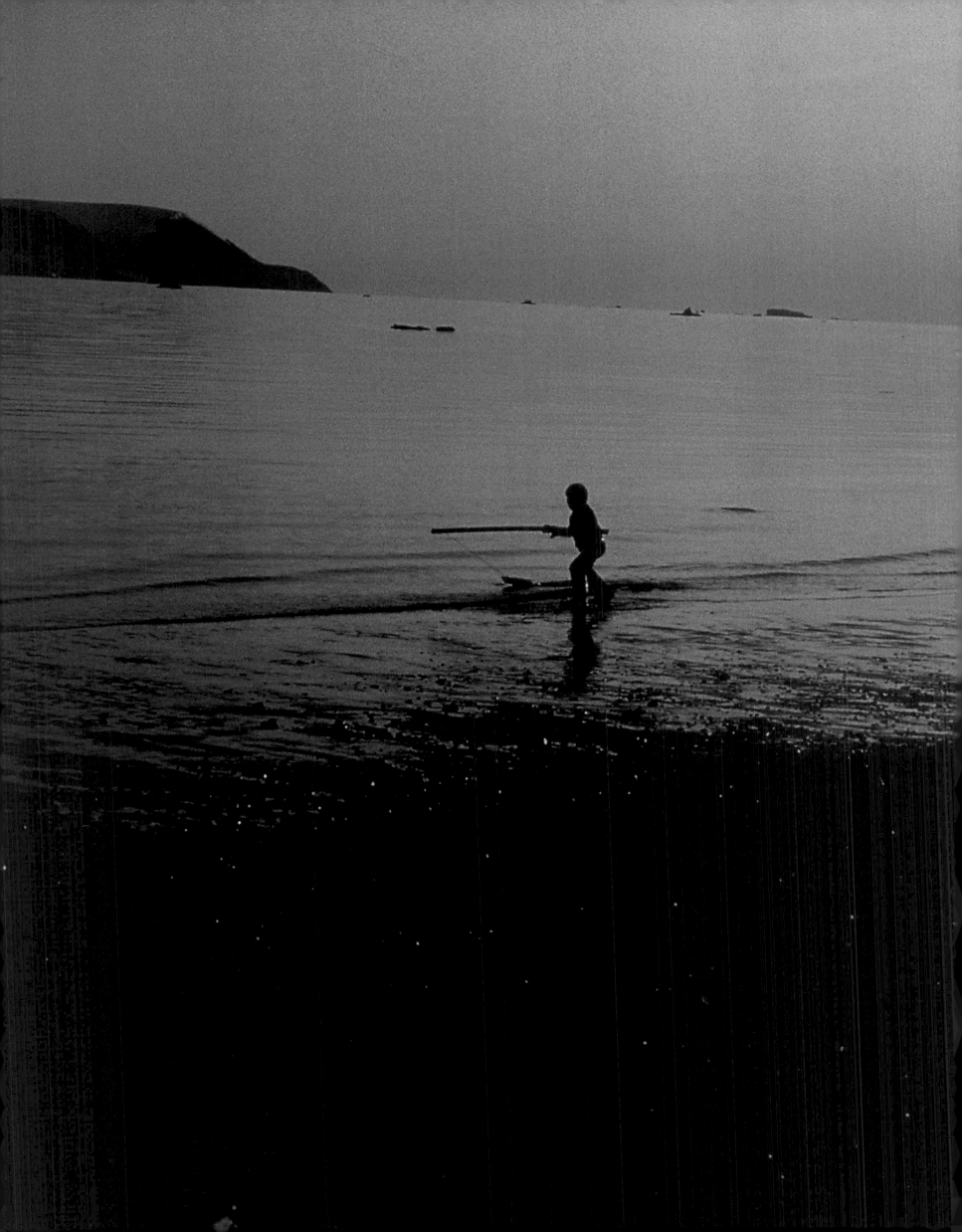

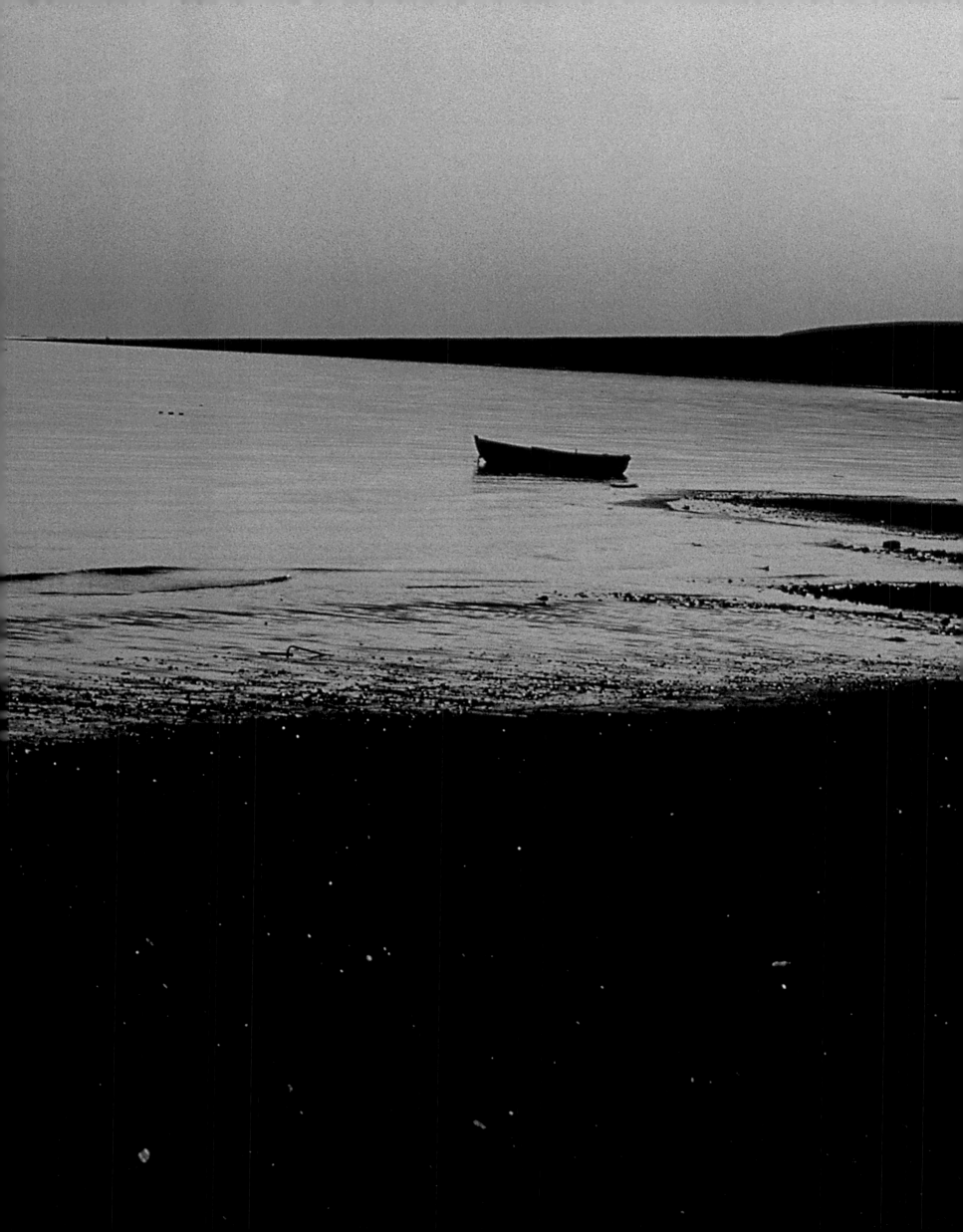

THE TREE OF LIFE.
"MY HORN SHALT THOU EXALT LIKE THE HORN OF AN UNICORN."
(PSALMS 92:10)

Left: In August, narwhals congregate in the depths of the great Inglefield Fjord, near Kekertak Island, to reproduce. Only the males, known as *Krelalouaq,* have the species' distinctive single horn. The narwhal is the source of the unicorn myth, a symbol of purity during the Middle Ages. For Saint Bonaventure, the unicorn represented the tree of life; according to John, it guards the entrance to heaven. A fourth-century medieval bestiary states: "It was in this way that Jesus Christ, our Savior, who is spiritually a unicorn tooth, descended into the stomach of the Virgin." The horn is actually an incisor, one of the whale's two teeth. In 1950, seventy Inuit hunted thirty male whales.

Right: Qeqertaq. Inglefield Fjord, October 1967.

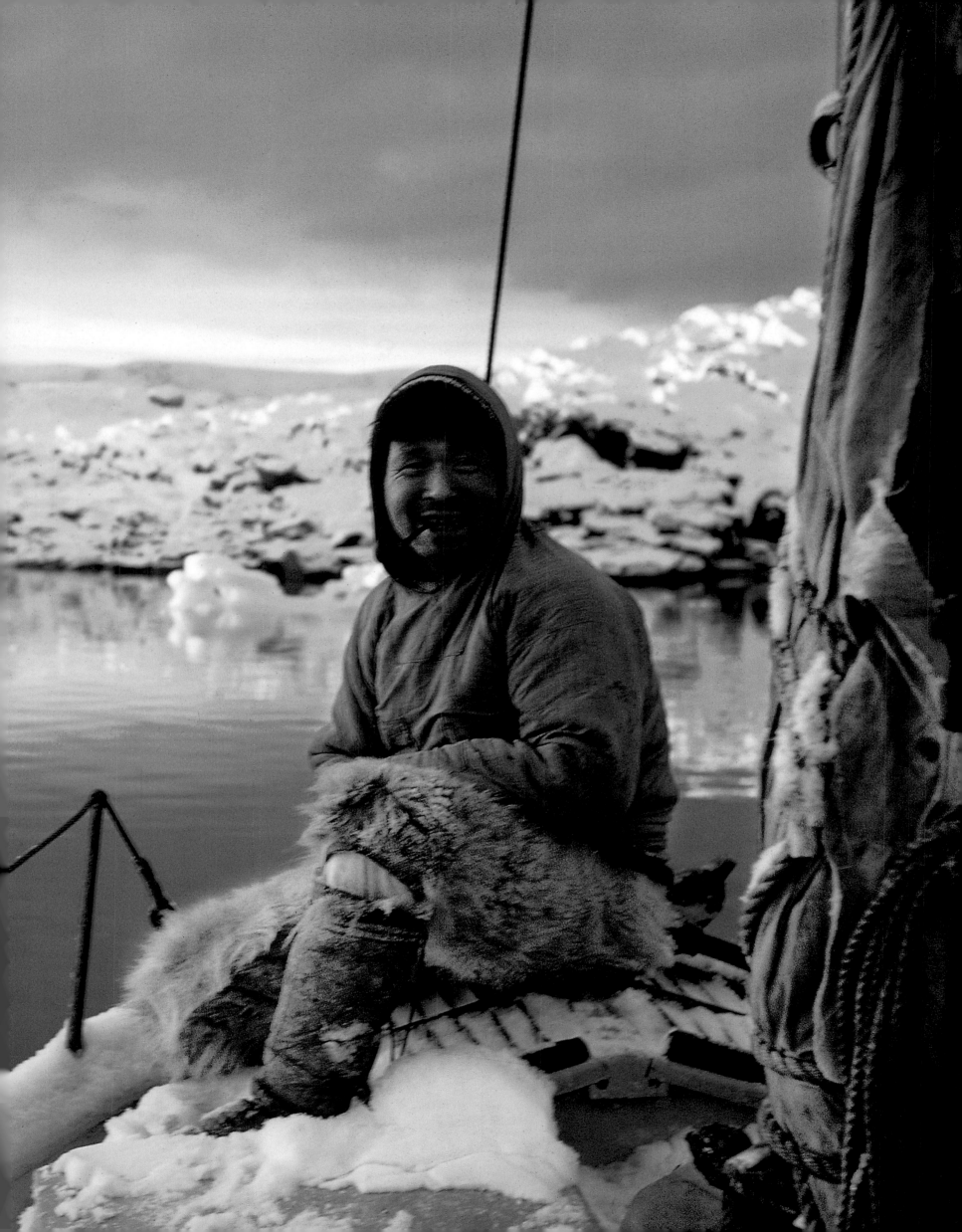

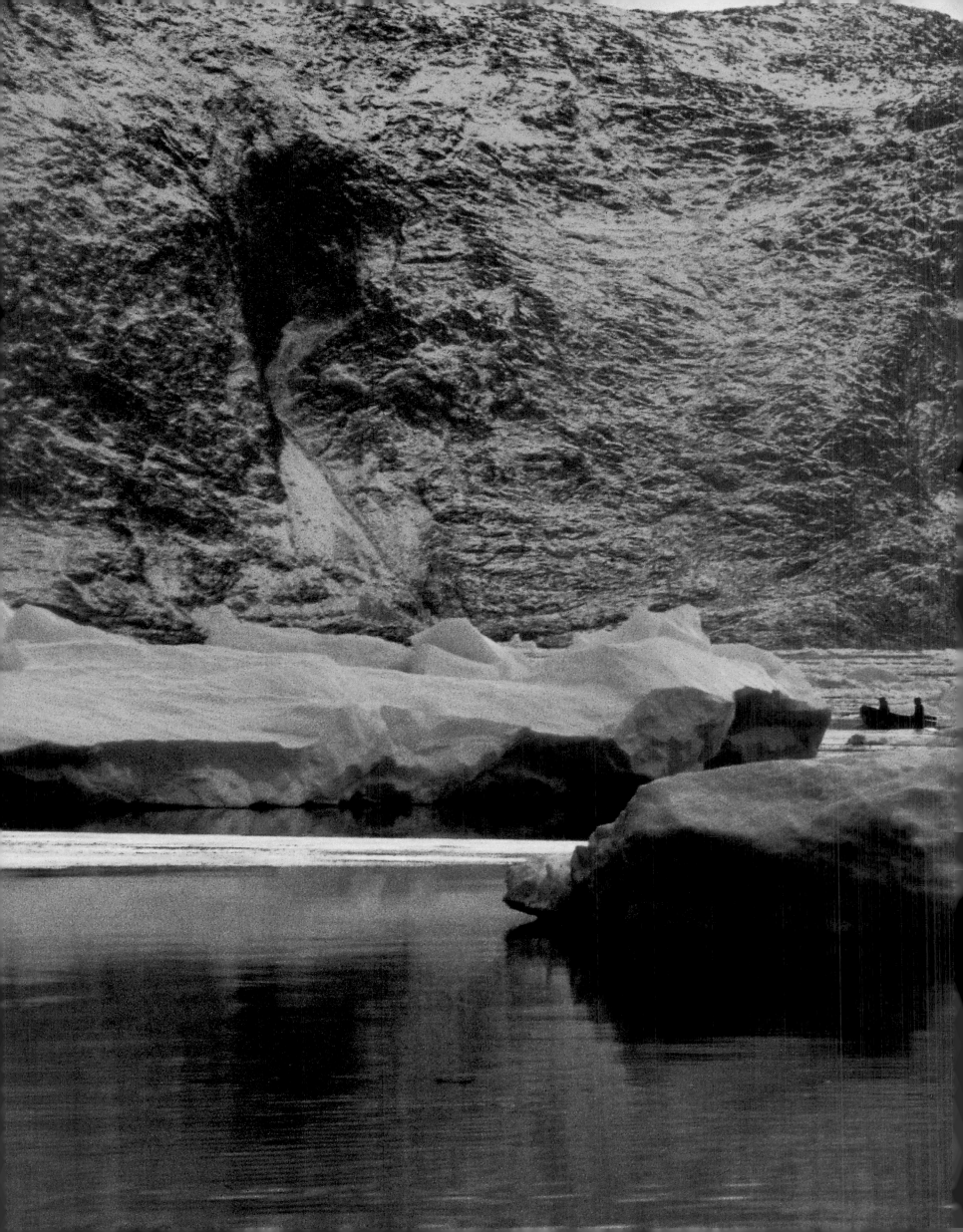

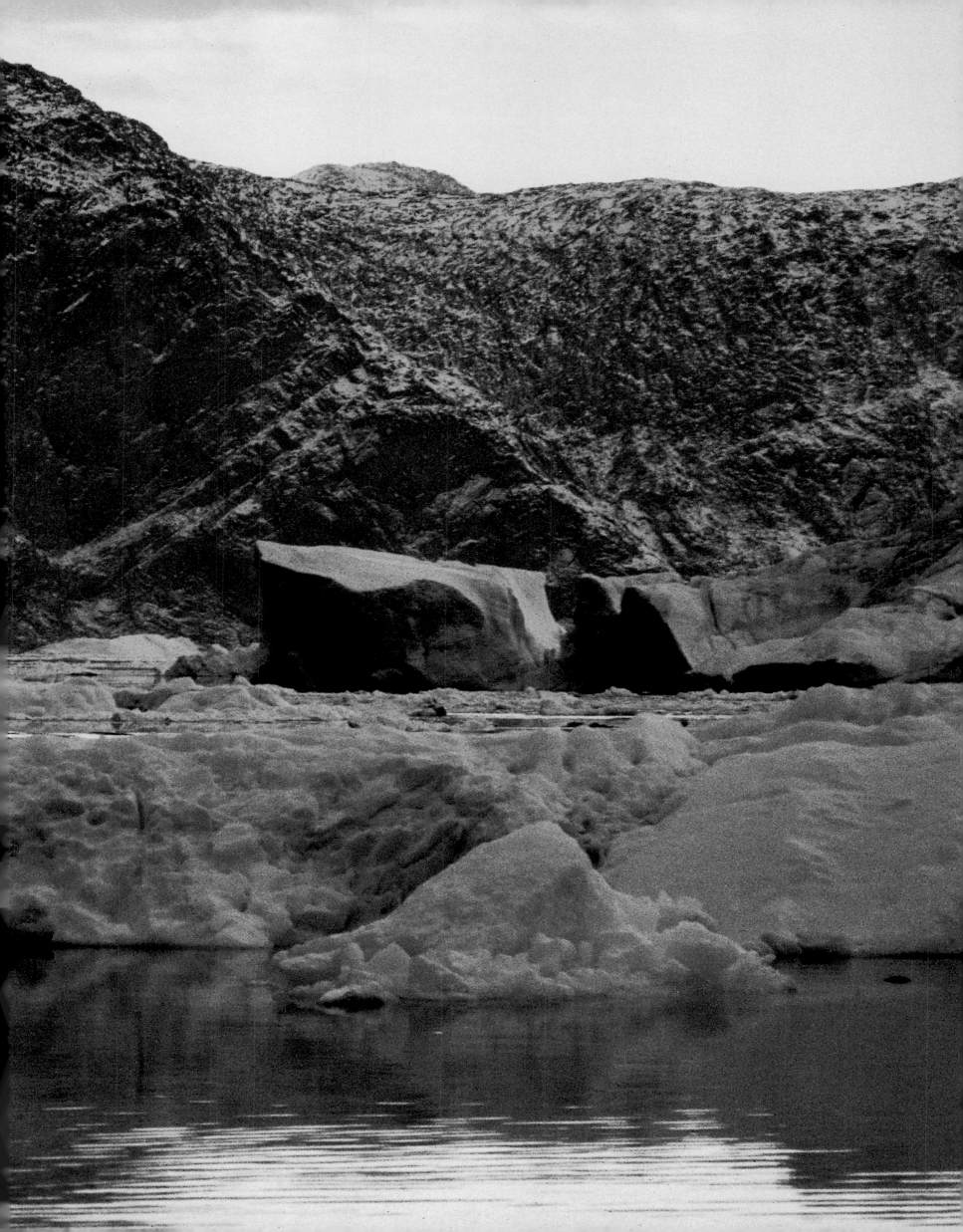

Siorapaluk, October 1967. Hunters set their traps near fallen rocks along the coasts, where foxes bury their guillemot and egg reserves for the winter. They also store walrus, seal, and beluga meat—from their collective hunts of August and September—under these rocks. This is their winter meat reserve.

Theft is unthinkable in this egalitarian, communal society. In November 1950, a couple was condemned to live alone in Inglefield Fjord. During a kayak hunt near Siorapaluk, the man had stabbed the husband of the woman he loved with a harpoon, then kidnapped her. They have been accused of stealing from the traps ever since.

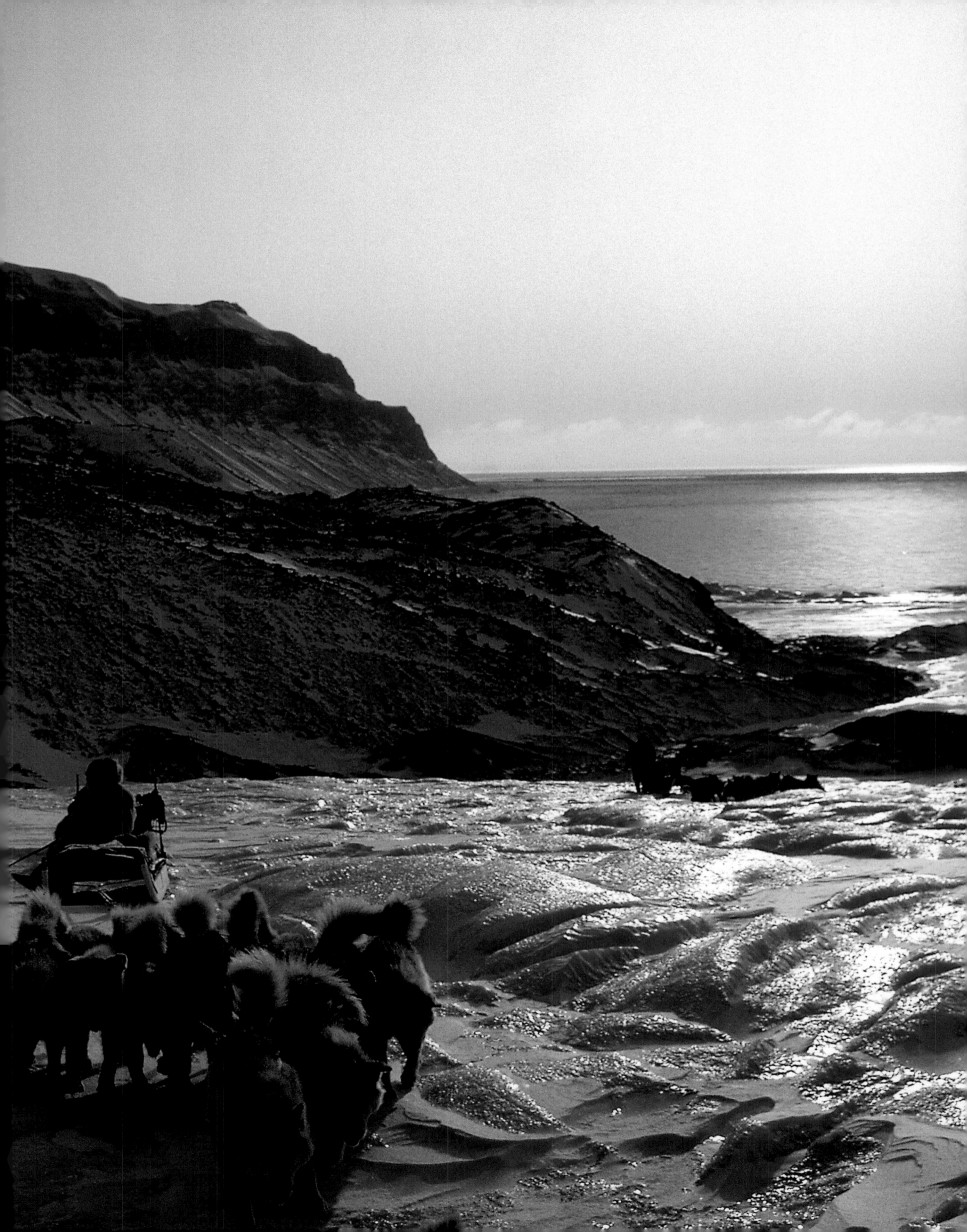

TALKING WITH
THE SHADOWS

Siorapaluk, October 1967. "A strange and eerie sight confronted me. Along the seashore, bending over the lapping black water, or standing here and there by inky, open leads in the severed ice, many Eskimo women were gathered. Some stood in groups of two or three. Bowed and disconsolate, her arms about them, with almost every hundred steps, I saw a weeping mother and her children. Standing rigid and stark, motionless graven images of despair, or frantically writhing to and fro, others stood far apart in desolate places, alone.

"The dull opaque air was tinged with a strange phosphorescent green, suggestive of a place of dead things; and now, like the flutterings of huge death-lamps, along the horizon, where the sun had sunk, gashes of crimson here and there fitfully glowed blood-red in the pall-like sky." (Frederick Albert Cook, *My Attainment of the Pole*, New York, 1913.)

POLAR HYSTERIA

In the fall, the Inuit, especially the women, experience "polar hysteria." Panting, mumbling traditional chants (ayayas) and invective, they try to rid themselves of the evil oppressing them. They are dark and disheveled, flushed and drooling. They undress and pick stones up off the ground and throw them at people around them. If they find dog feces, they sniff it, rub it on their faces, and sometimes eat it. They curse everyone around them; poorly shod, they walk over chunks of ice. Then their faces turn pale, their pupils yellow, their skin clear and cold, and they fall into a deep sleep. When they wake, six, ten, or twenty hours later, they are calm and remember nothing of what happened. This hysteria was common between 1910 and 1930, but it occurred only rarely during my stay in 1950 and 1951. I felt it myself at times, when I was alone with my darkest thoughts.

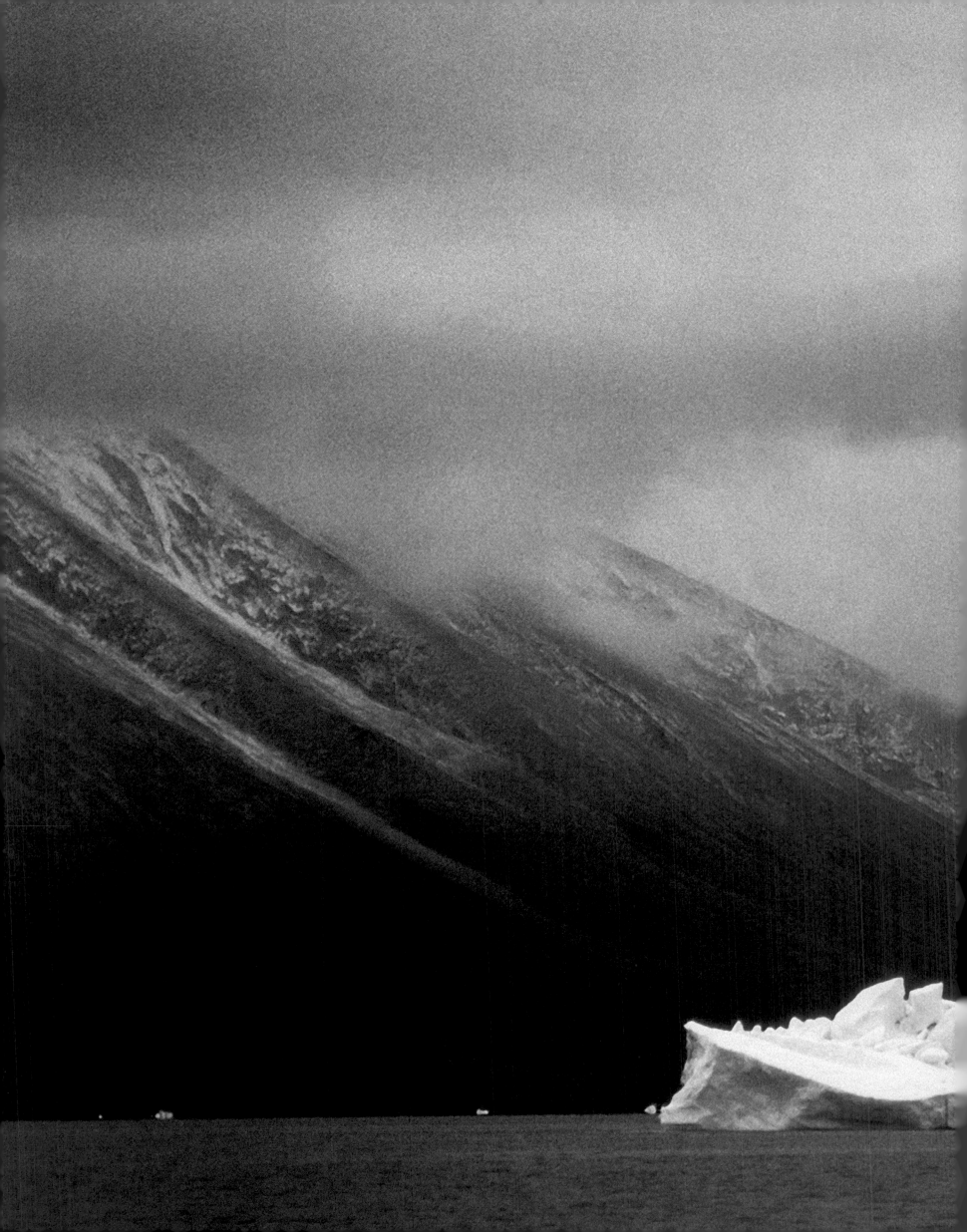

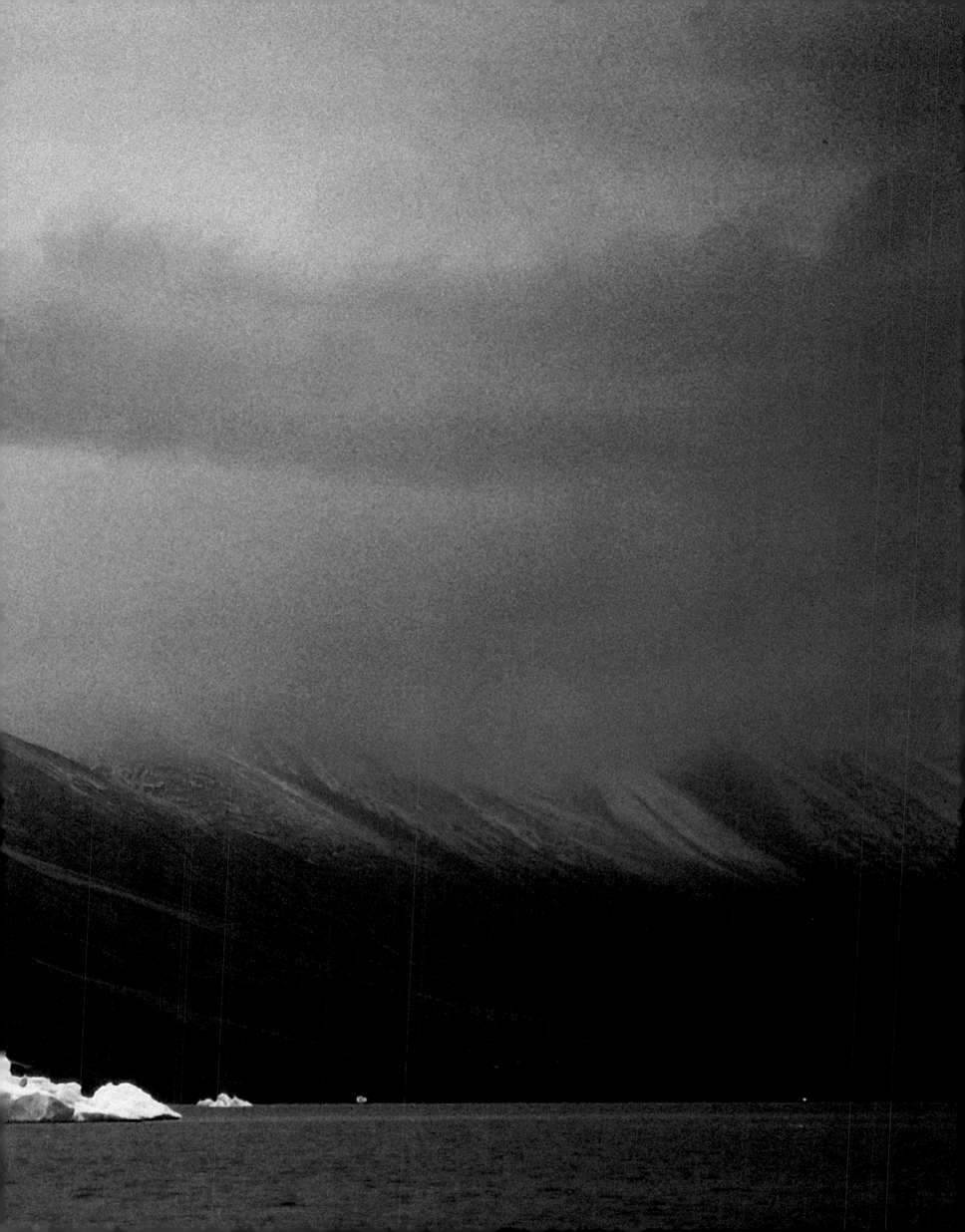

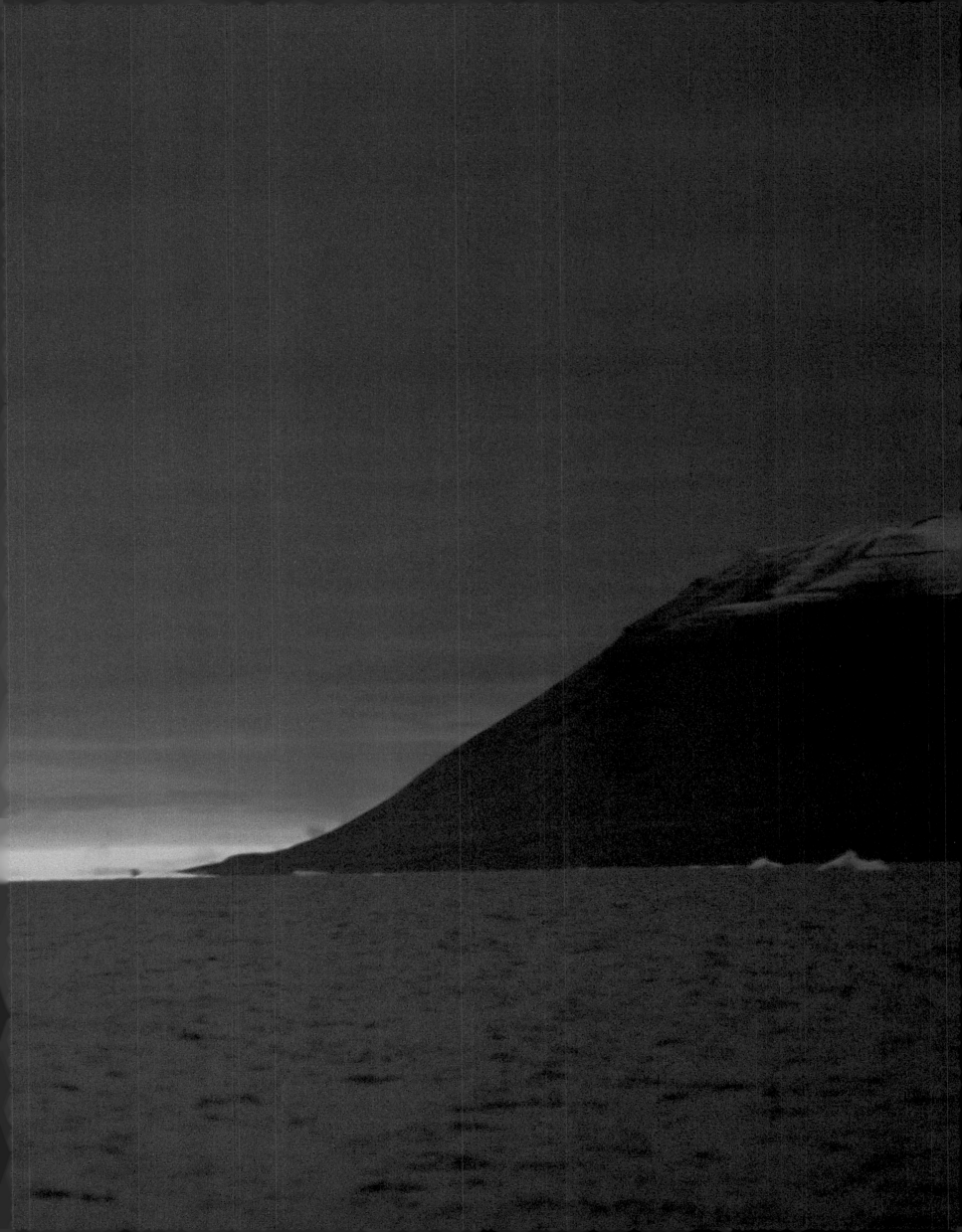

Previous pages:
The Inuit tell me the legend of the giants.
"The giants or *tunit* exchange wives with
humans. It is said that one human giant went
to stay among them. It is said that he had an
igloo all to himself. They say that the giant
came to live with the small humans. They say
that when he came to live with them, he began
sleeping with the little women. They say he
pushed them from the sleeping platform with
his big penis. He tried to mate with his big wife
but he got stuck in her large crotch. She could
only get him out by urinating."

Early November 1950. A solid ice cap about
one or one and a half feet begins to cover the
sea, reaching all the way to the horizon. By
December, it will be three feet thick, four feet
by March, and finally a bit more than four feet
in April.

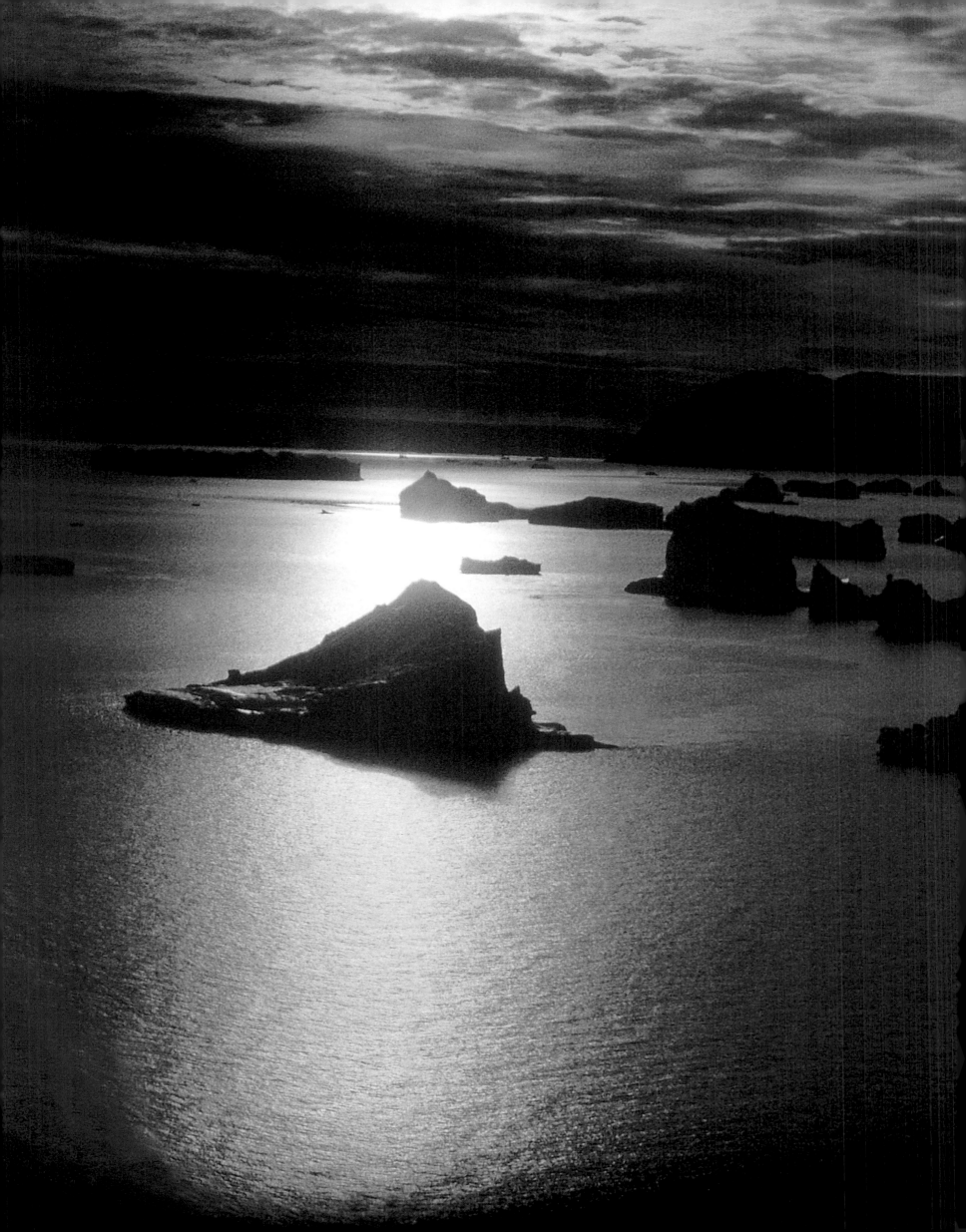

"NIGHT ALL AROUND
DEEP NIGHT . . . NIGH
THE WARP AND THE S
FATE, THE SPINNER A
THE FABRIC SHE WEA
ALL IDEAS ARE WOVE
ON THE CANVAS OF
NIGHT."

ANDRÉ SUARÈS,
HOMMES: PASCAL, I
DOSTOÏEVSKI (

Siorapaluk, October 1967. *Taaq*! It's dark.
Kapirlaktuq, the long polar night begins. Like th
Inuit, I have always experienced the long, po
night as warm, womblike. It brings the living
closer together. The circle closes in. *Pulaaqtu*
I have a visitor. Until winter comes, the eleve
villages—302 Inughuit in seventy families—
scattered over 300 miles were separated by
open water. Now they are joyfully reunited.
The coldest days (-75°F) are still to come.
 I like to be alone on the trail during the po
night, just me and my dogs. I travel respectfull
into the night, which is like the high, open
nave of a cathedral. The nebulae and galaxies
the star-studded sky seem so close. Mythical
pole, mystical pole. When I was in the Sahara,
the stars were considered foreign because the
seemed so far away. My dogs amble along so
not to disturb my meditation. I see a fluid light
the dark, as if it were diffused by the energy of t
big bang, the radiance of the cosmos growing.
And this is the center of the aurora borealis, ju
150 miles from the geomagnetic pole. The Inui
their hearing heightened in the frozen air, told
me to feel the energy of the emptiness on a cle
day. It is a sustained note, almost restrained. T
never-ending sharp chord of a cello or harp, an
anguished cry echoing off the horizon. It is a
sound from the origin of the world.

THE LITTLE FLAME OF THE SLEEPING IGLOO.

NIGHT, MOTHER NIGHT, WHO BROUGHT ME FORTH, A TORMENT
TO LIVING MEN AND DEAD,
HEAR ME, O HEAR!

—CHORUS OF THE ERINYES, IN AESCHYLUS'S *THE EUMENIDES*

IN THE BEGINNING OF THE BEGINNING WERE BORN THE GIANTS AND THE DWARVES,
THE TUPILAKS AND THE MONSTERS.

THE FLAME, THE ENERGY THAT HOLDS THE WORLD TOGETHER, "MATTER AND SUBSTRATUM,
NECESSITY OR LOGOS" ACCORDING TO HERACLITUS, IS INCORPORATED IN ALL INUIT INITIA-
TION RITES AND IN MOURNING.

IKKUMAHUQ! IN THE IGLOO NIGHT.

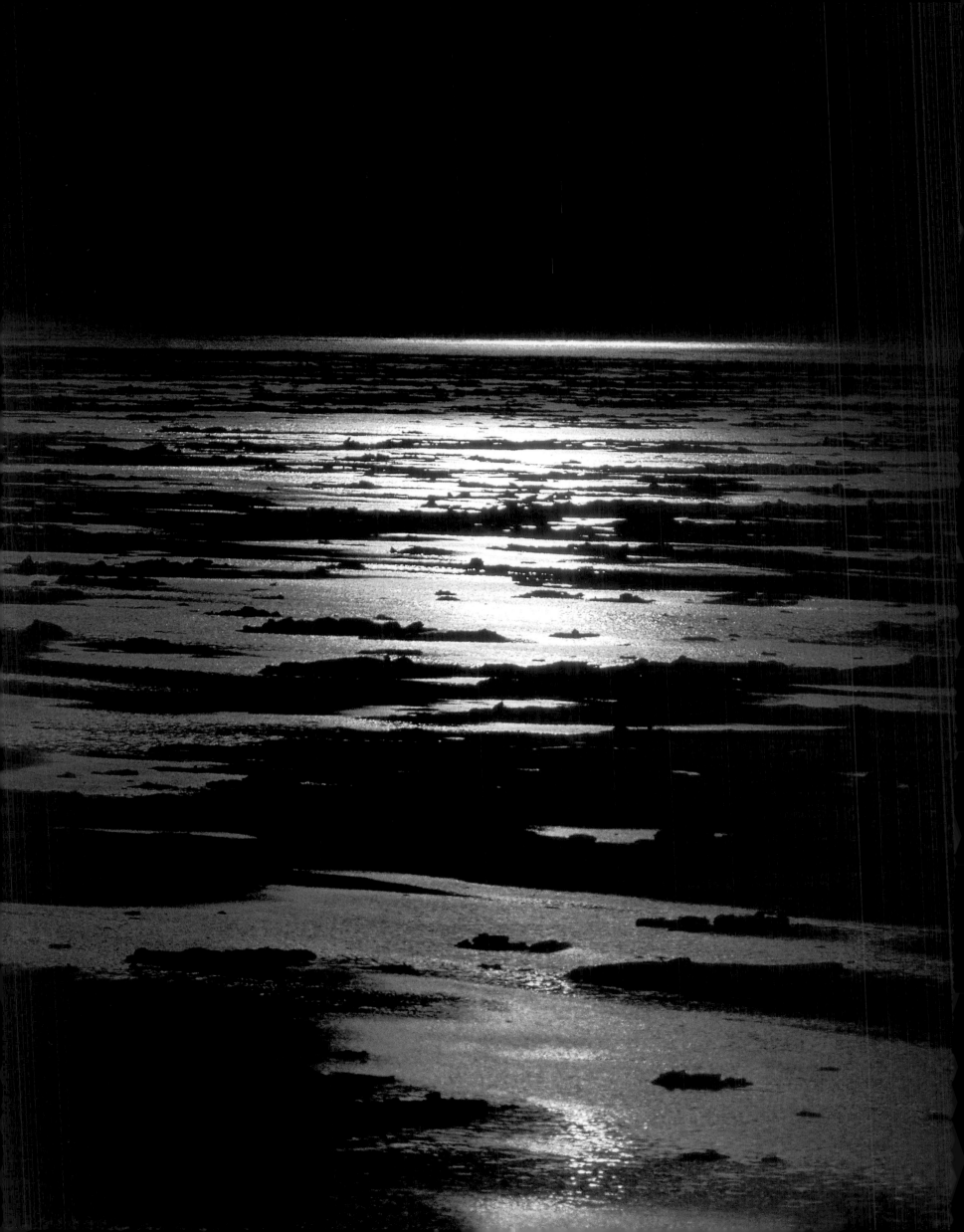

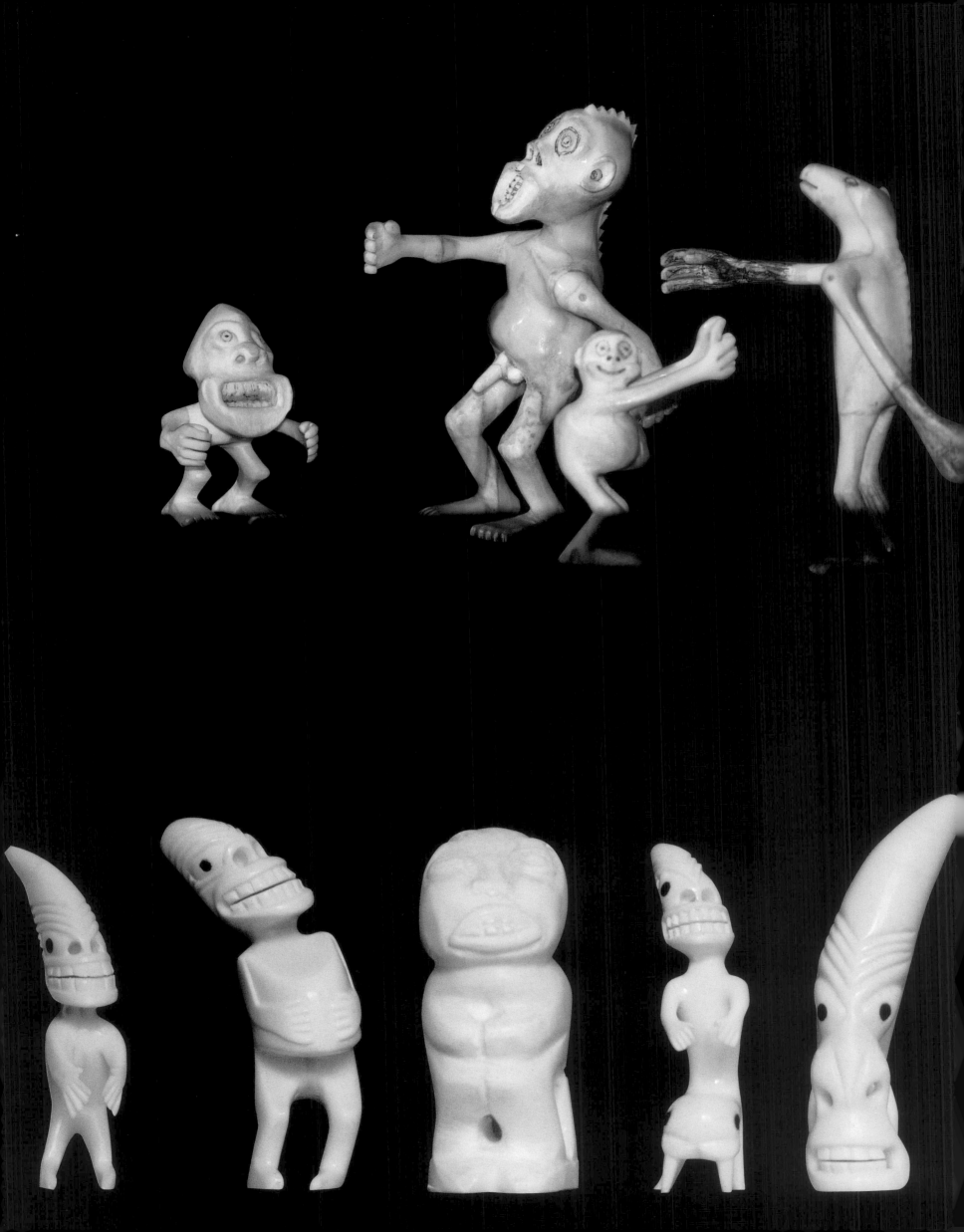

IN THE BEGINNING OF THE BEGINNING, DURING THE NIGHT OF CHAOS

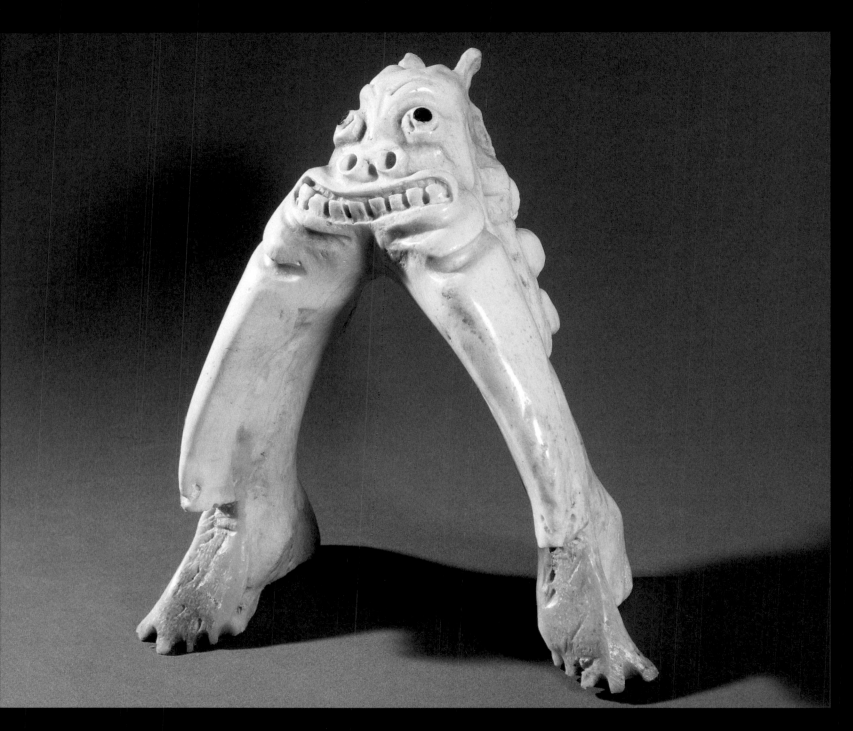

Tupilaks, evil spirits. Sakaeunnguaq tells me about the nocturnal visit of a *tupilak*, a gnome with short, bowed legs, a large head and receding brow, and round, protruding eyes. His flat nose consists simply of two nostrils, his teeth are square and project so far out that his lips rest on top of them. His ears are tiny. Sakaeunnguaq fought against this little monster the whole night long, fidgeting, shaking his arms and legs, letting out little cries, murmuring fragments of incomprehensible sentences.

"The people here do penance, because the dead are strong in their vital sap, and boundless in their might. 'If we did not take these precautions,' say the Eskimos, 'we believe that great masses of snow would slide down and destroy us, that snowstorms would lay us waste, that the sea would rise in violent waves while we are out in our kayaks.'" (Knud Rasmussen, 1907)

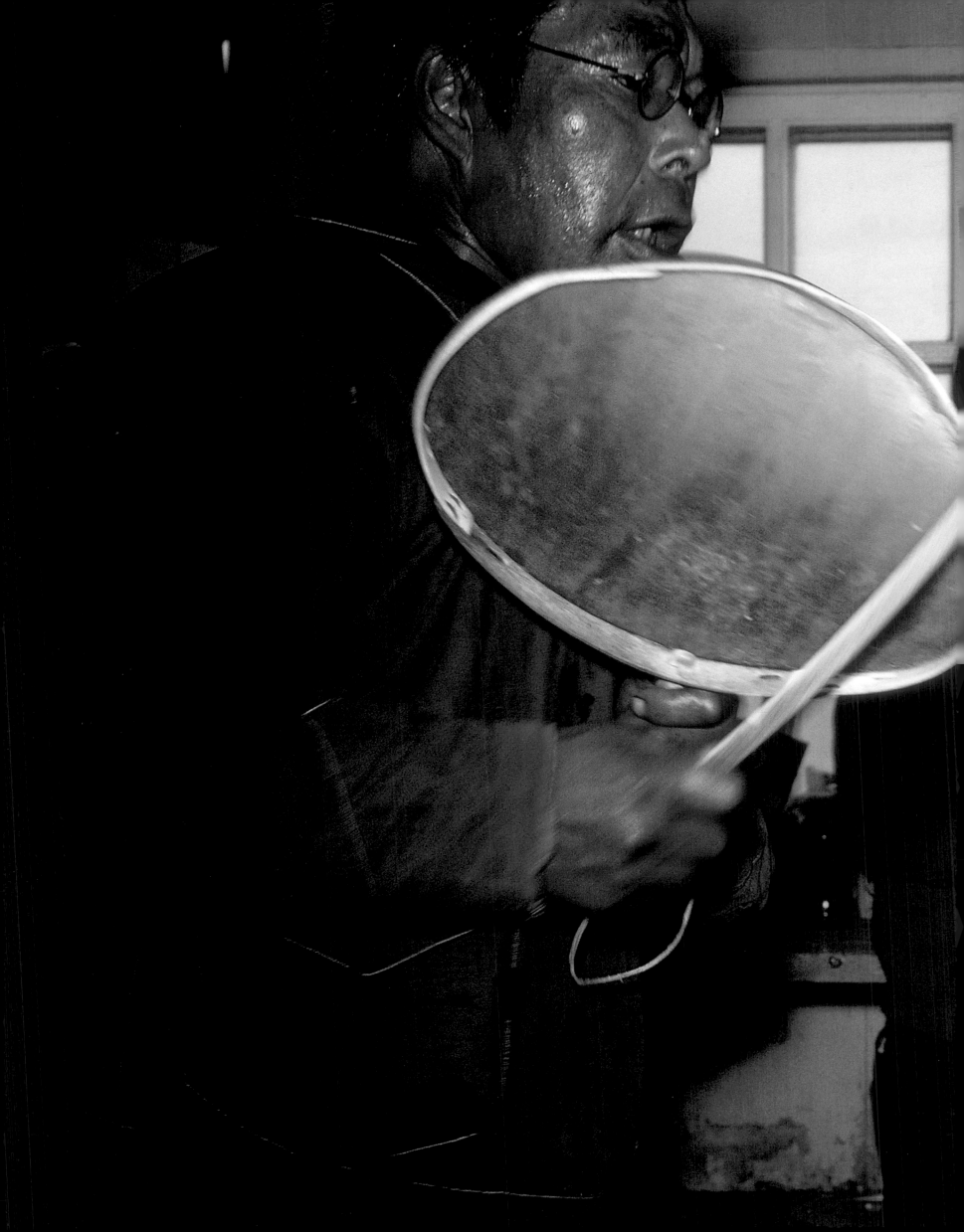

VIBRATIONS IN THE AIR, THE LANGUAGE OF THE DARKNESS

Siorapaluk, September 1967. The *angakoq*—
the shaman—sees further. He sees what is
infinitely small, what is hidden in plain sight.
He feels the forces inspired by the drums, the
gilaut, especially during the polar night.
"The *gilaut*, the only Eskimo instrument, is
made of skin from a narwhal's throat stretched
over bone. One strikes the frame, not the skin,
using a drumstick of bone or wood. The drum
acts only to beat time during a song. Before
the chant beings the igloo is made dark except
for a little flame, the *ikuma* of the seal oil
lamp. Two singers stand in the middle of the
room. The audience, sitting around the room,
swings from right to left, back and forth,
hypnotized by the voices and the muffled
sound of the drum. There are always three
drumbeats in a row, of varying strength
depending on the moment. One man at a time
sings; he dances, too. His partner stands in
front of him, stiff and serious, holding the
gilaut with both hands and waiting his turn.
When the first singer is almost finished, his
the partner takes the drumstick with two
hands and spins it, crying out: 'Ay! Ay! A . . .
Ay-Aa-A-A-A-Ay!'" (Peter Freuchen, 1920).
The singer in this photograph is Ussaqaq, the
forty-year-old son of a man who was part of
Frederick Cook's quest for the North Pole.

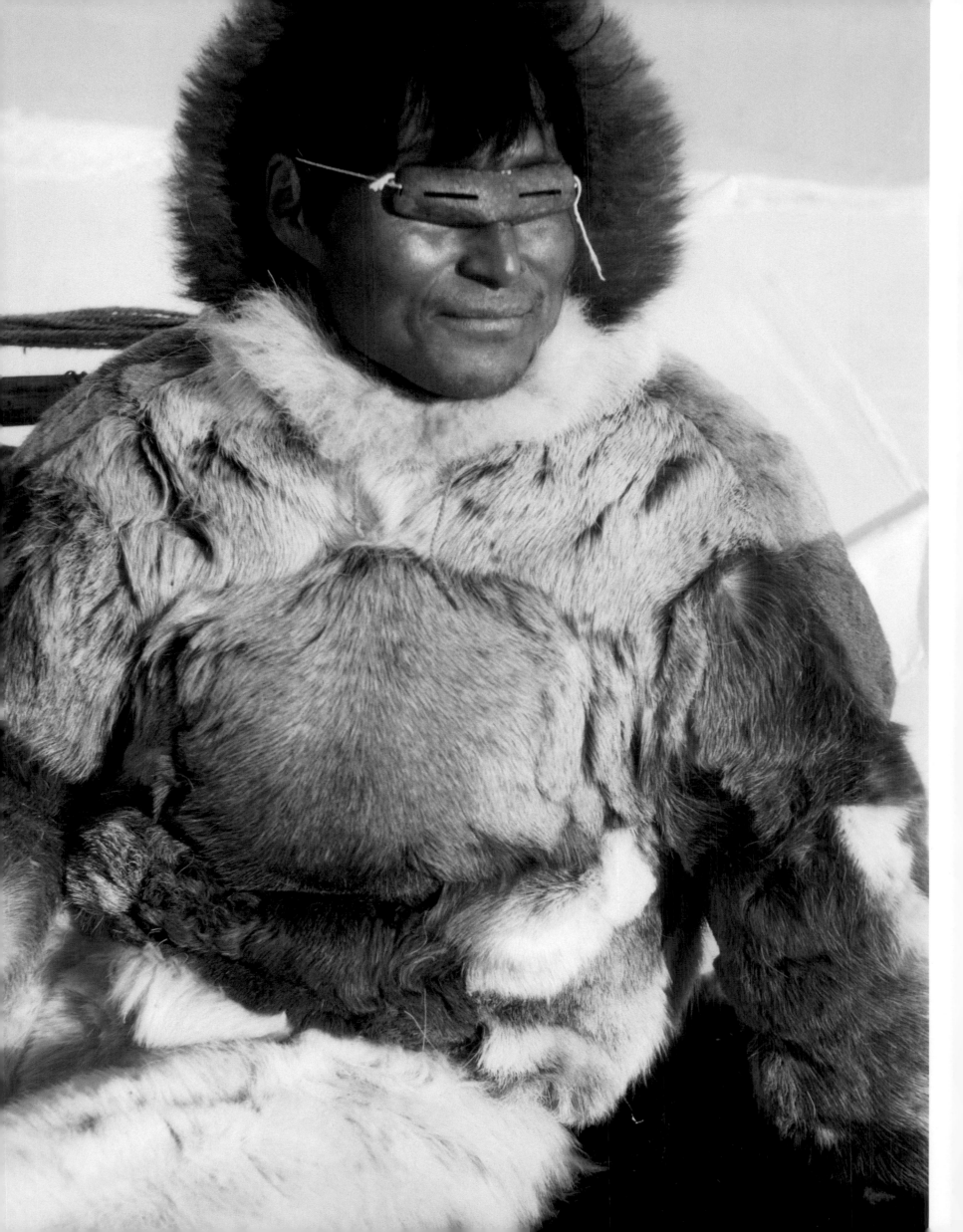

**KUTSIKITSOQ WANTED MY SON TO TAKE HIS NAME WHEN HE DIED.
AND SO IN MY SON, GUILLAUME, I FIND THE SPIRIT OF MY DEAREST COMPANION.**

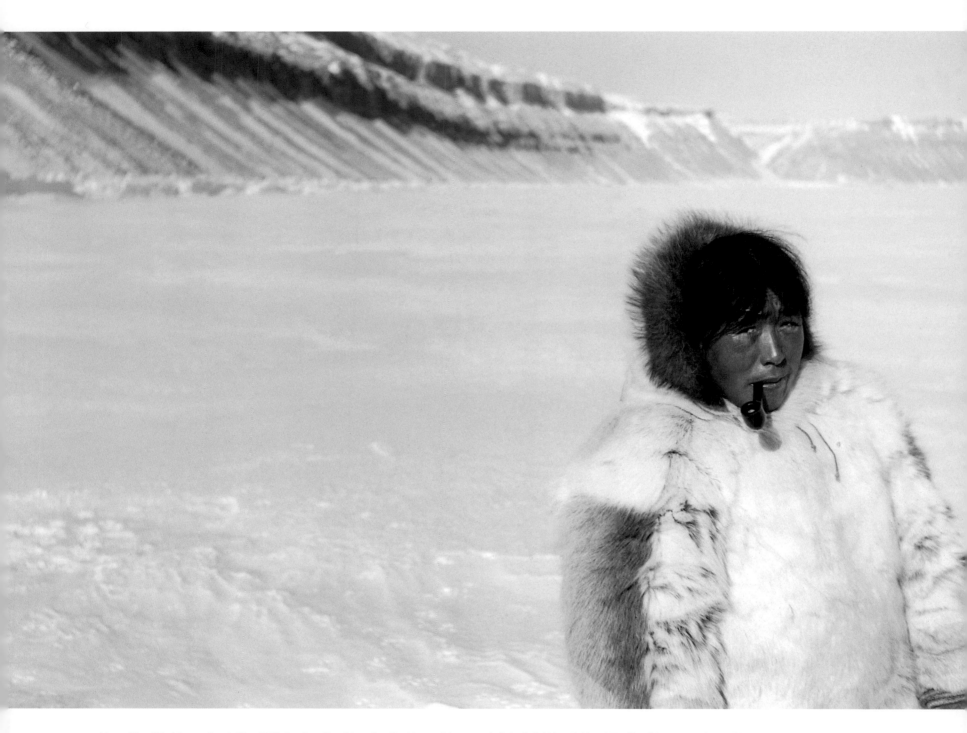

Above: Near Washington Land, May 1951. Patdloq, Kutsikitsoq's wife. Along with Qaaqutsiaq, these women were the heart of our group, which was on a mission in search of the Inuit's ancestors from Igloolik in Canada. This was one of the first scientific expeditions in which women participated. They proved to be very capable. The women were my silent allies, keeping out of the arguments I had with their husbands, two ruddy-faced hunters. The Inuit were in charge on the treacherous ice, but a mission is not a hunt, and conflict was inevitable. The women's level-headedness kept these disagreements from becoming serious. In modern political life, they are the ones with imagination.

Left: Inglefield Land, May 1951. Kutsikitsoq, my closest friend, was the son of the legendary Uutaaq, Robert Peary's companion to the Pole. He was forty-nine years old when I took this photograph. Kutsikitsoq's traditional snowglasses are made of fossilized walrus ivory that was darkened by hematite in the ground. He and I learned to cooperate as we crossed glaciers and seracs, sleeping side-by-side in our snow igloo or in seal-hide or canvas tents pitched atop our two sleds on a drifting ice floe. During my treks in March through June 1951, we sometimes faced great danger and were often on the brink of starvation. I drove my own sled not out of bravado, but to make the same efforts as my companions. This helped persuade them to accompany me on the risky mission.

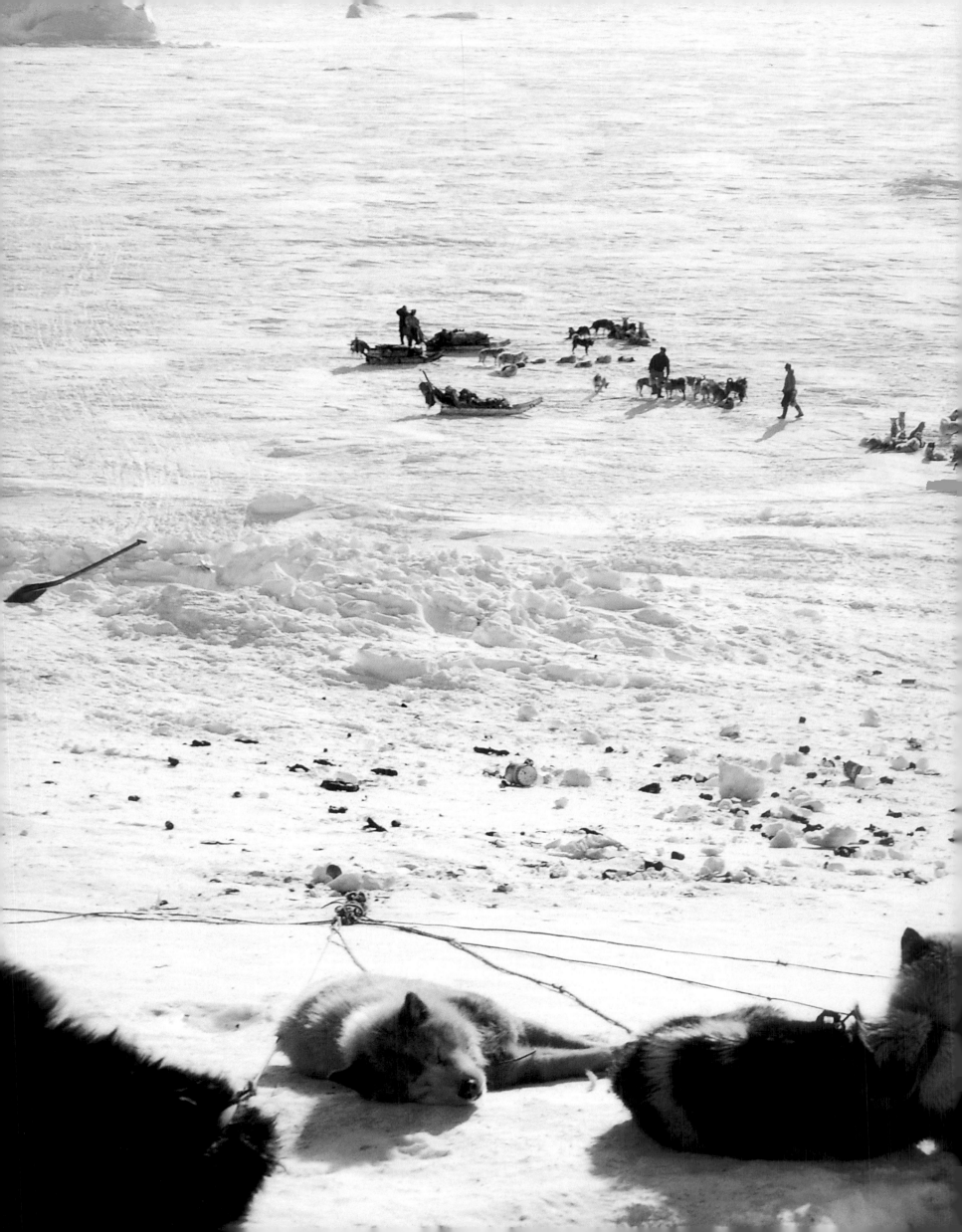

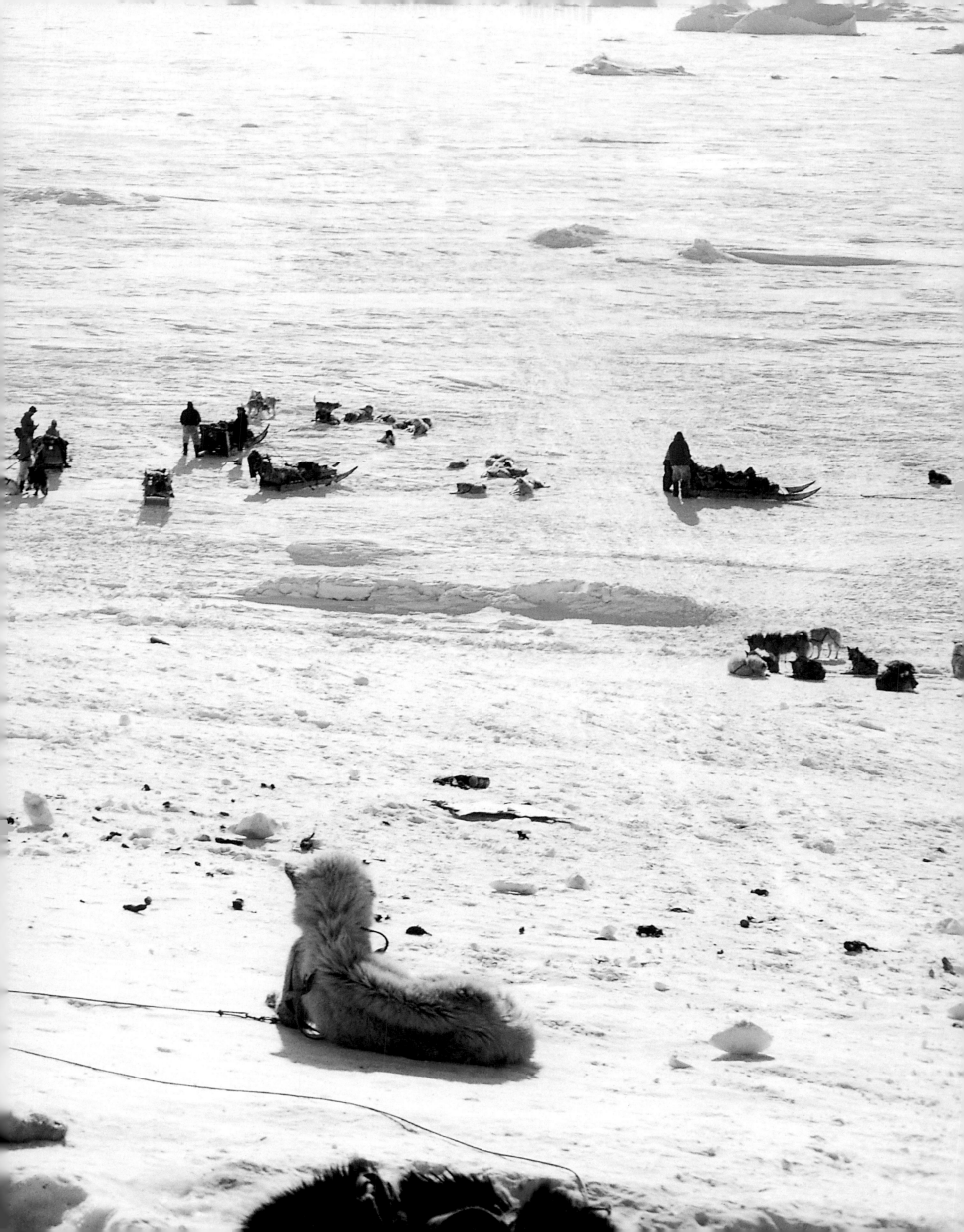

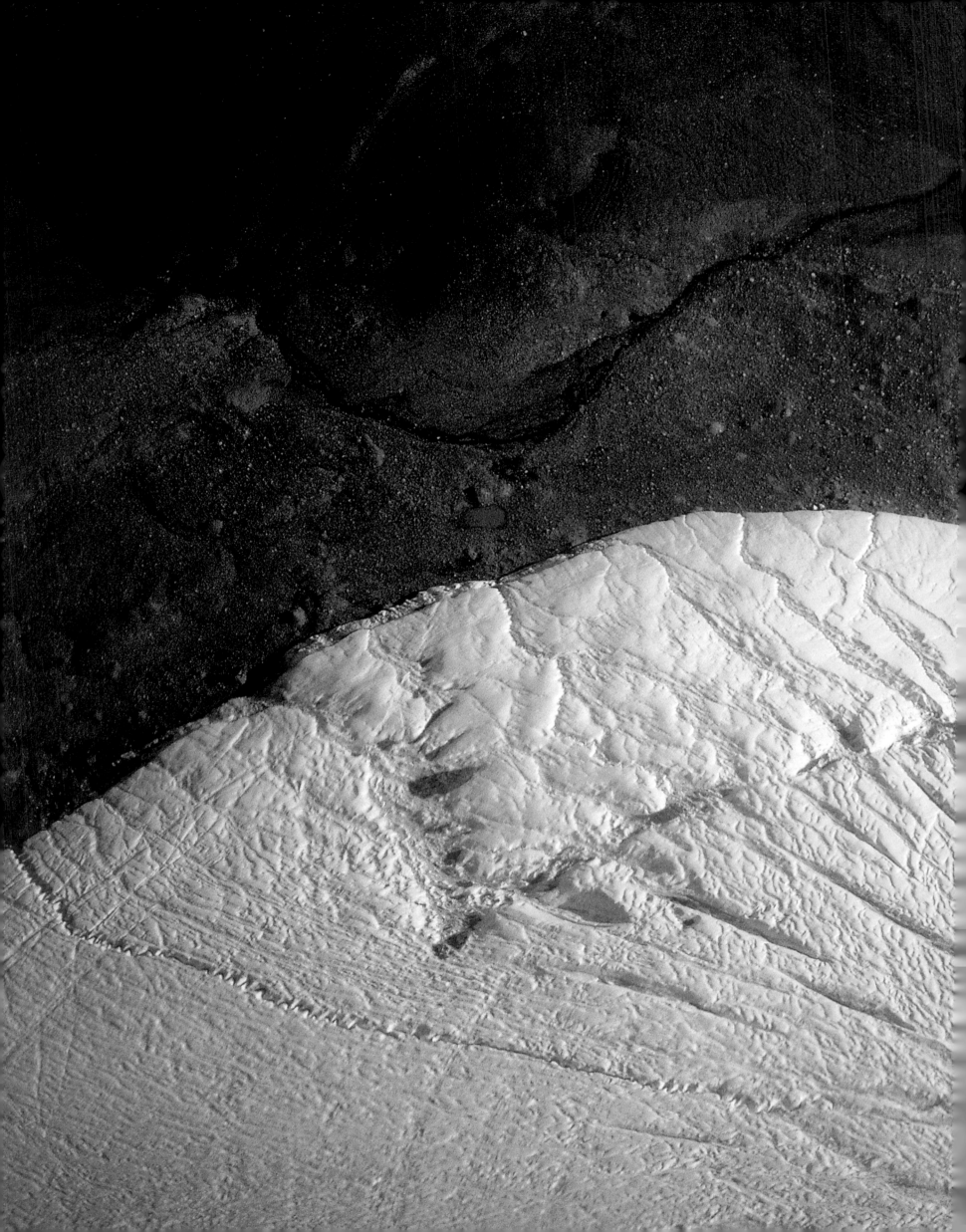

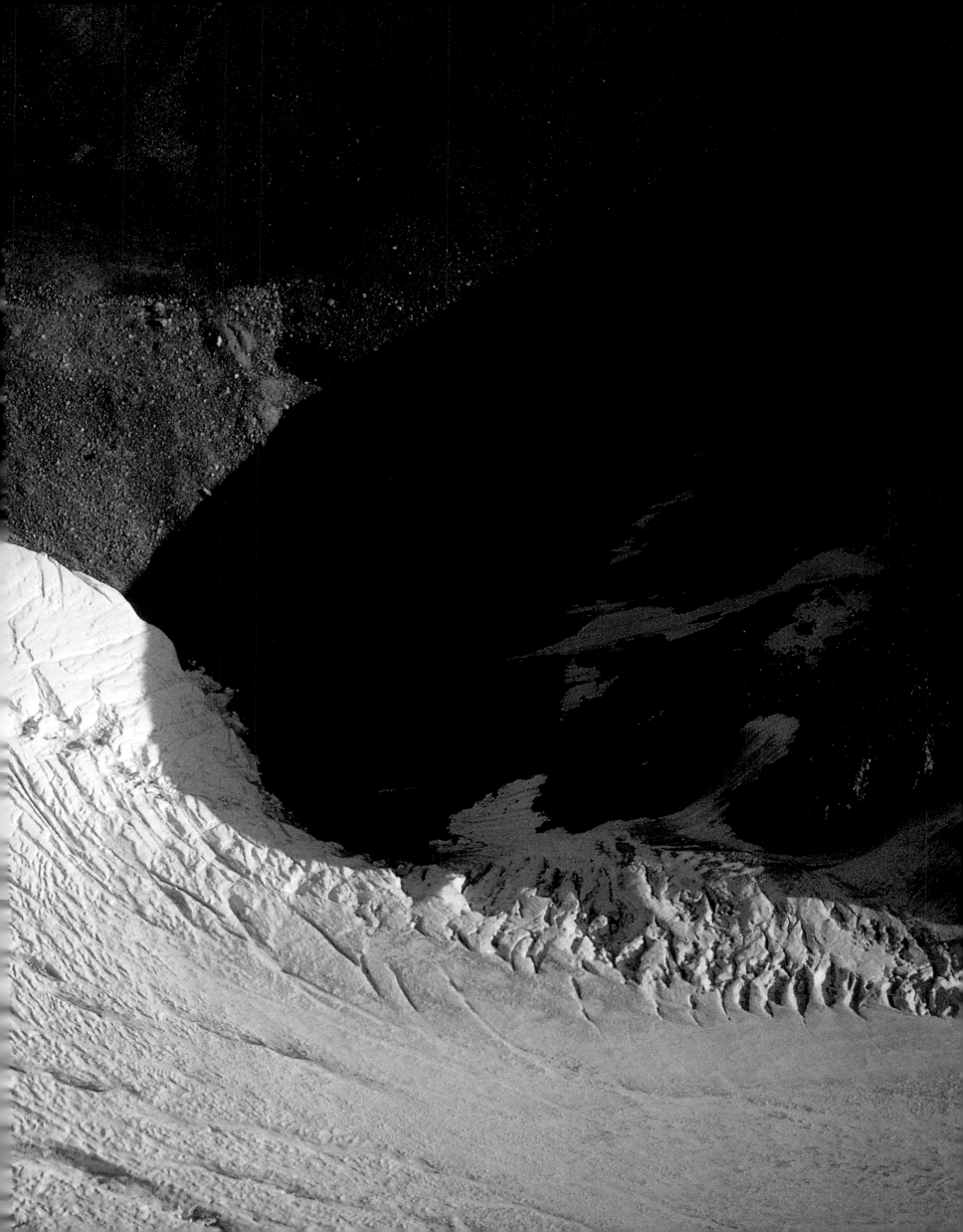

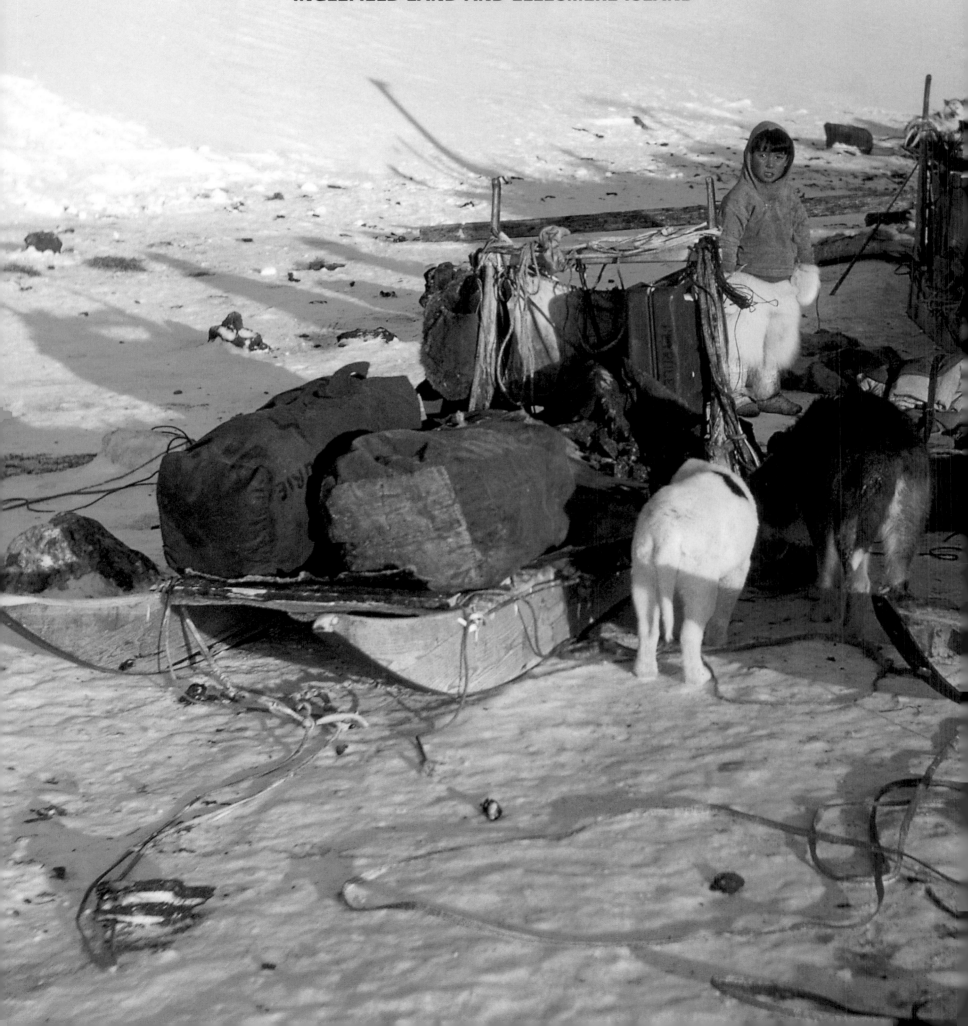

APRIL 2, 1951: SETTING OUT FOR THE DESERTED REGIONS OF
INGLEFIELD LAND AND ELLESMERE ISLAND

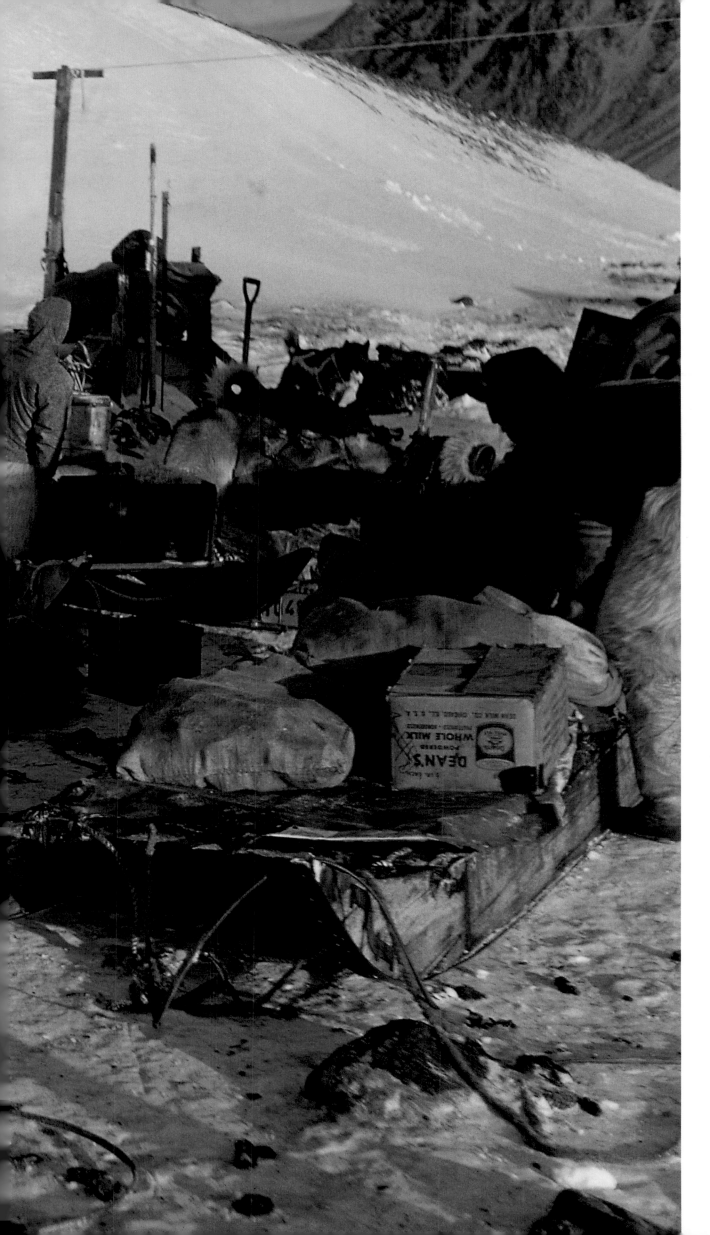

Previous pages: En route to Etah, August 1995. Climbing Storm Glacier, called Cape Ullersuaq by the Inuit, which lies immediately to the south of Cape Alexander. This was a difficult task. The glacier's spit is a shortcut around a peninsula where the coastal ice has been cracked by the Smith Straits' strong currents. The ice is practically bare, the snow having been blown away by winds coming from the center of the glacier. As we descended, we used the whip to keep the dogs behind the sled. The dogs braced themselves on the ice, with their claws serving as a brake.

Left: Etah, April 1951. Five igloos at the farthest tip of the inhabited world. It was a hard winter. Etah, on the brink of famine, was eating its dogs, and there was not enough seal meat for our packs. While my two companions and their wives hunted for walrus and seal to the west, I sequestered myself eight miles away in a snow igloo. I went there to start my scientific researches and to train a hesitant group for the challenges of the fierce, icy desert of Inglefield Land. Qaaqutsiaq had a brother who had been part of Knud Rasmussen's fatal mission; an exhausted Swedish botanist, Thorildt Wulff, was left North of Inglefield Land in September 1917. A little to the west, nineteen Americans had died of hunger in May and June 1884.

Our supplies were stored in hide or canvas bags and divided according to the strength of dog teams. On average, each sled carried 400 to 700 pounds—80 to 100 pounds per dog. Bear hunters from several camps to the south joined us, helping our group of three sleds transport supplies to Etah, north of Cape Alexander at 78°10′N, 73°09′W.

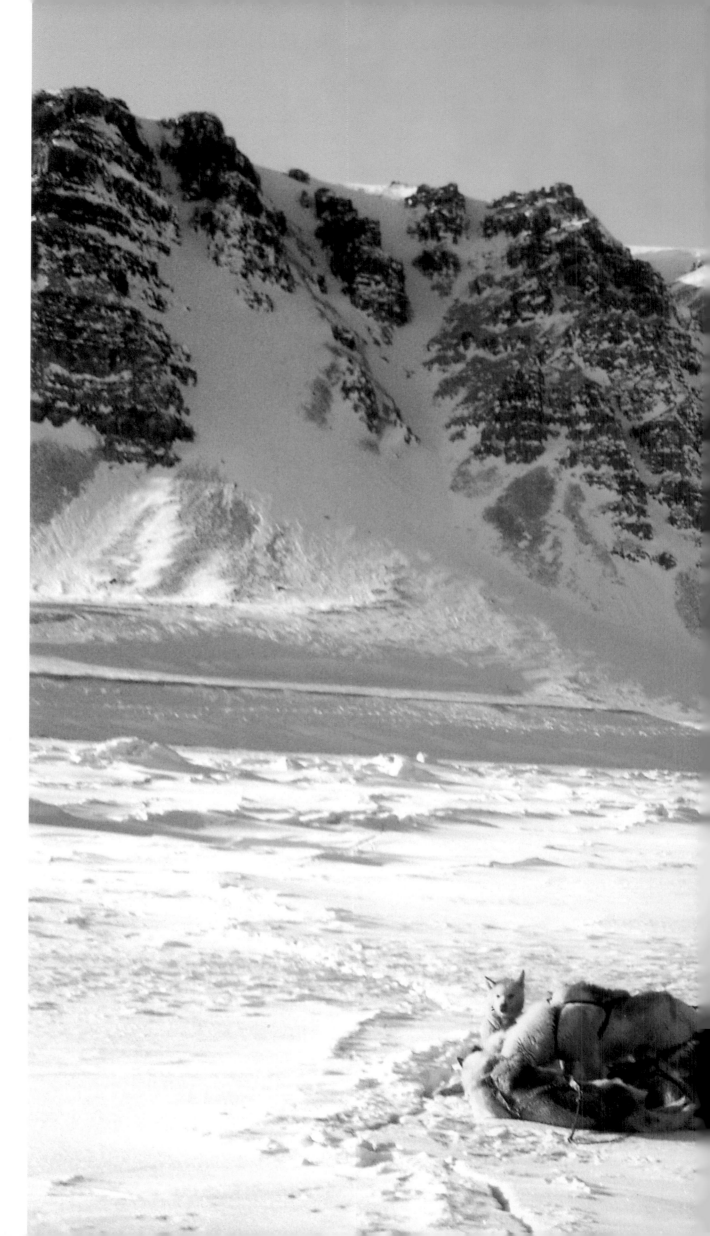

"ONE OF THE CENTURY'S MOST INSPIRED IDEAS IN NATURAL PHILOSOPHY IS THE QUESTION OF ORGANIC UNITY; PRESENTLY, IT HAS BEEN ACCEPTED IN OUR WORLD OF IDEAS, AND THE HONOR OF THIS MEMORABLE SUCCESS BELONGS TO GOETHE."
ETIENNE GEOFFROY SAINT-HILAIRE. ACADEMY OF SCIENCES, 1836

Parker Snow Bugt, south of Cape Dudley Digges, April 1969. Nature is not the expression of chaos but rather an order that preserves a whole, with each part dependent on this whole. In this mineral world, rock is everywhere, and rock is sacred. In the shaman's rituals, it is only after a young shaman repeatedly turns a stone in his hand—after a period of sexual abstinence and fasting—that he can transfer his spirit, and per- haps discover how to inhabit the body of a bear.

I recorded hundreds of geological measurements in my notebooks. Each stone exhibited a specific level of fragmentation, which varied depending on the type of rock and the microclimate. I also carbon-dated peat blocks and took samples of them to study pollen, which allowed me to see climatic changes over the last 3,000 years. Inuit hunters don't know about geodynamics, of course, but they are the ones who live the dialectic between Man and Nature. The environment— the genetic psychology of the environment—lies at the beginning of how a people constructs its thought, its philosophical system—from the physical ecosystem to the social ecosystem.

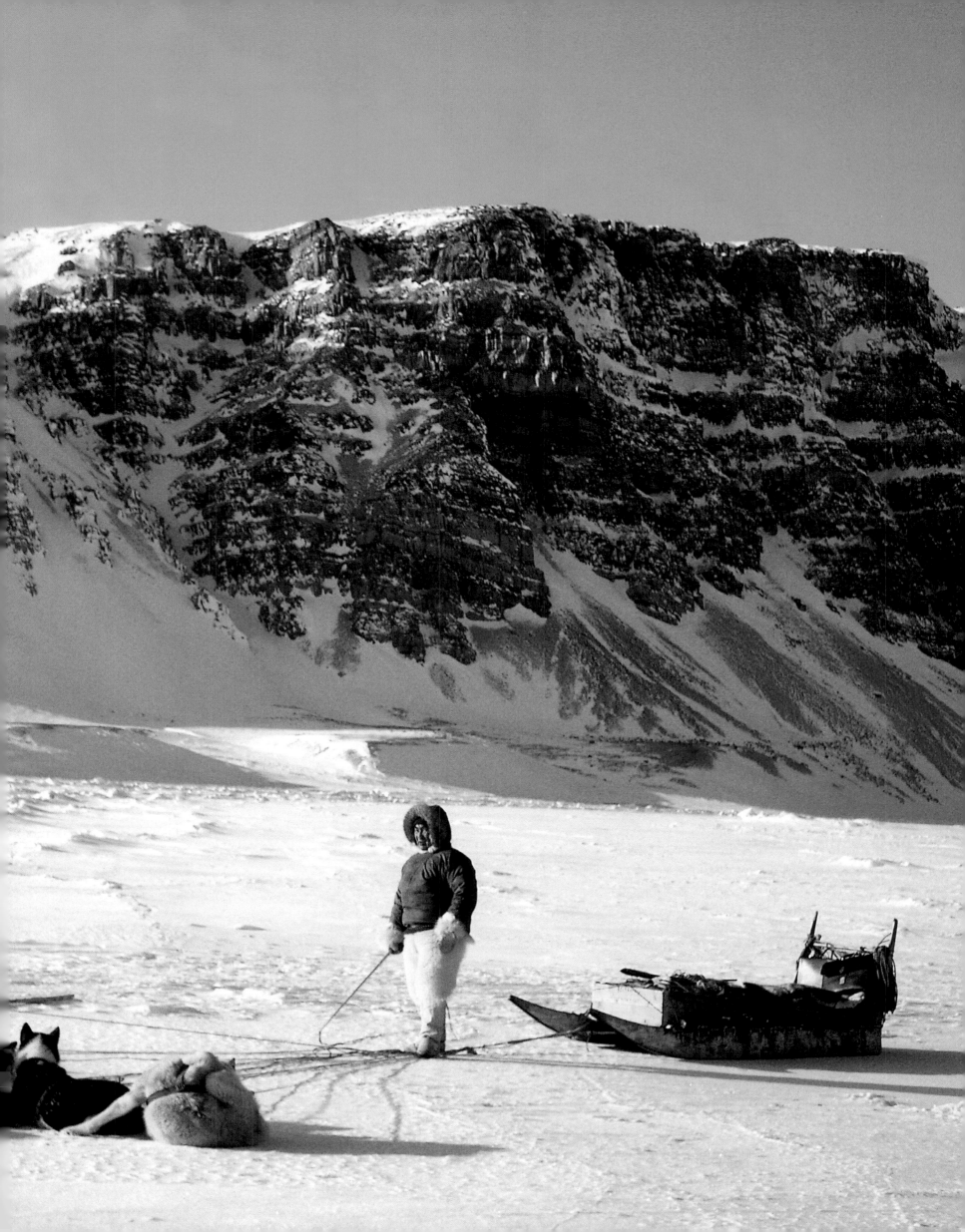

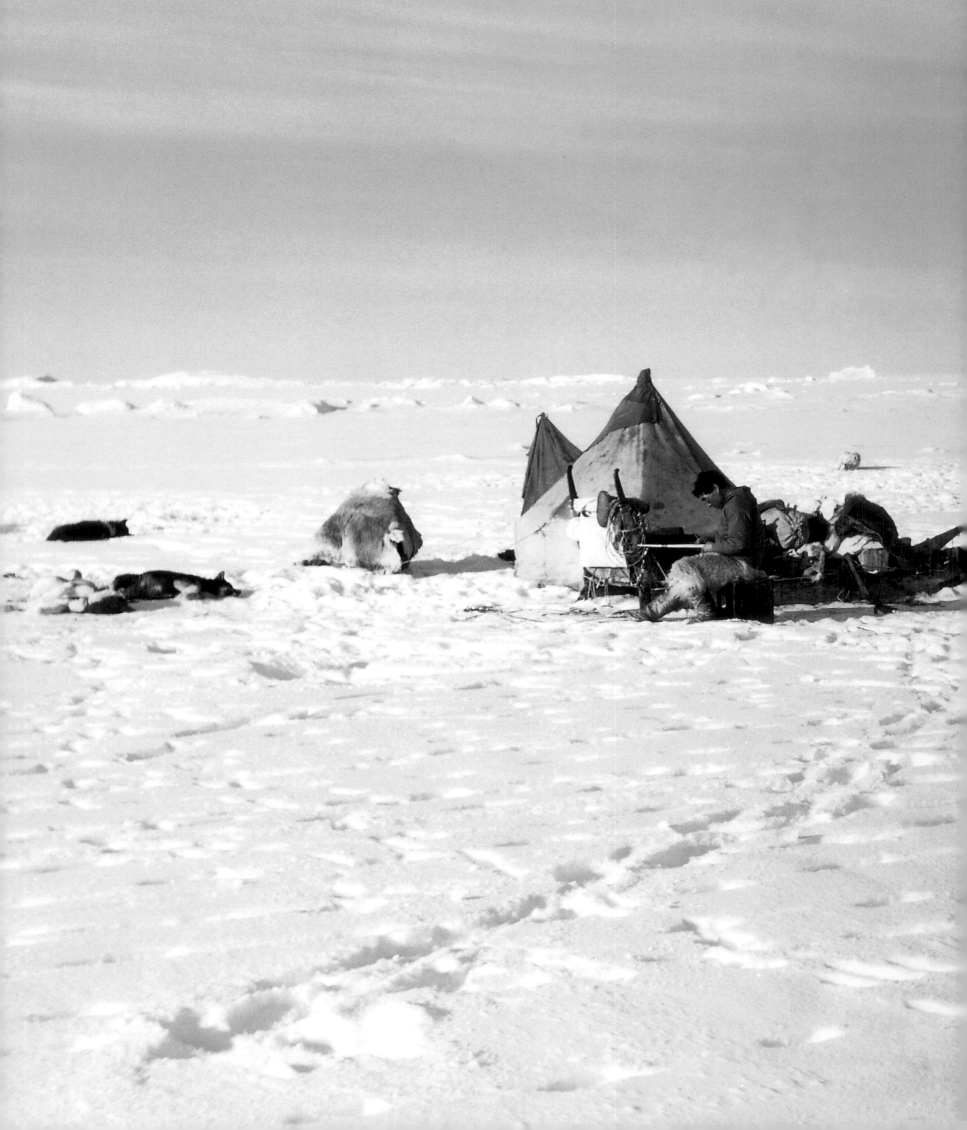

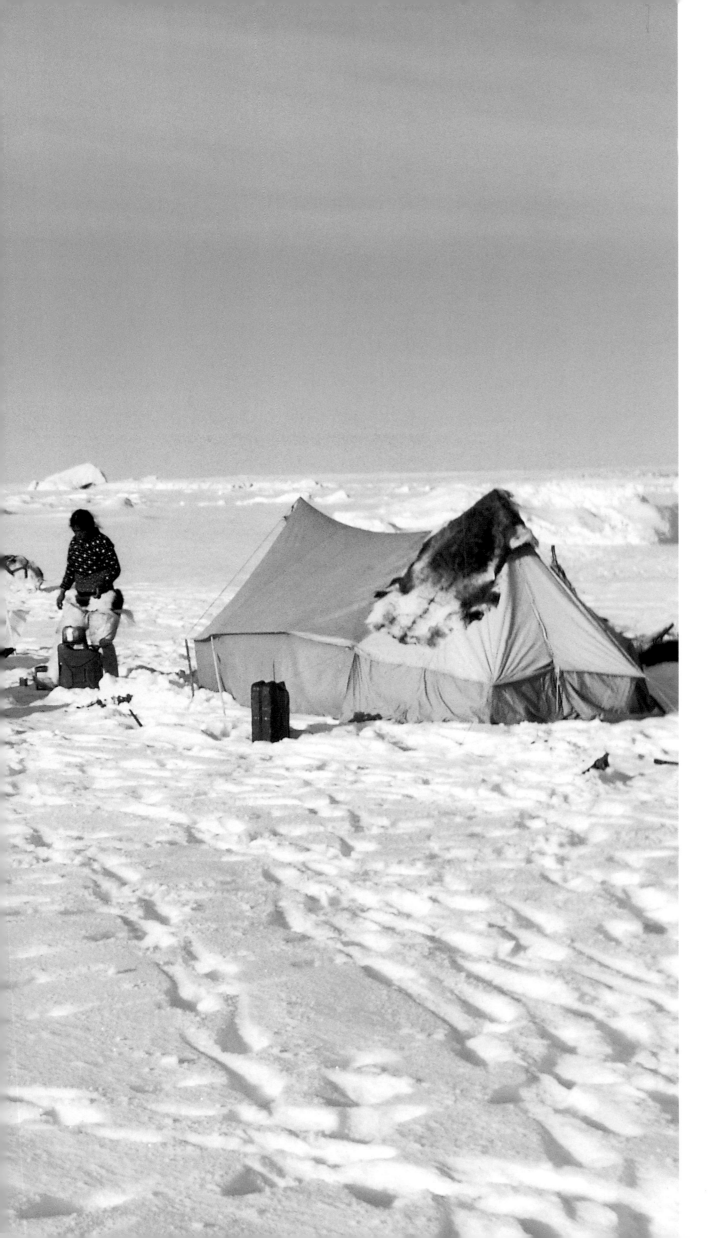

FREE TIME IN CAMP; EVERYONE TURNS INWARD.

On the sea-ice of Kane Basin, west of Humboldt Glacier, late April 1951. We rested here. Qaaqutsiaq, sitting on the sled at left, sharpens walrus ivory with his harpoon. To the right, Patdloq attends to household chores. The main tent, at right, is mine. A caribou hide is drying. Qaaqutsiaq's tent, at left, is the cone-shaped kind used on treks.

Early sleds, like those Ross used in 1818, were made of walrus bones tied together with leather. The five-foot-long blades were made of walrus ivory. The width at the back—the base—was 22 inches. The sleds I used in 1950 and 1951 were made out of wood and had steel blades. They were twelve feet long, three feet wide, and almost three feet high. Tied together with seal leather, they were flexible enough to travel over the ice hummocks.

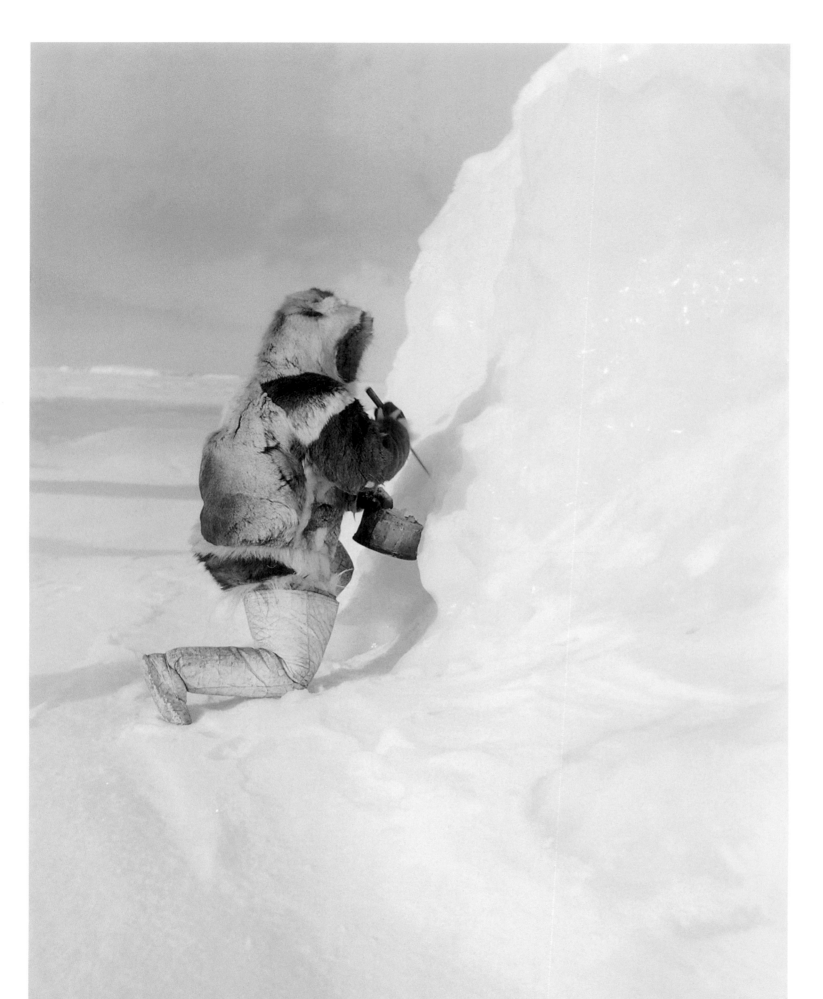

White night, April 1951. To help conserve our stove oil, which we use to melt ice into drinking water, Naduk chips pieces of the southern side of an iceberg—the sun's rays have made the ice more porous and thus easier to melt. The sea-ice along the coast is thin, so we have to be extremely careful. An accident would be fatal; we are in Washington Land, 300 miles north of any inhabited place, and we do not have a radio.

EVERYDAY LIFE:
THE ICE NOURISHES US.

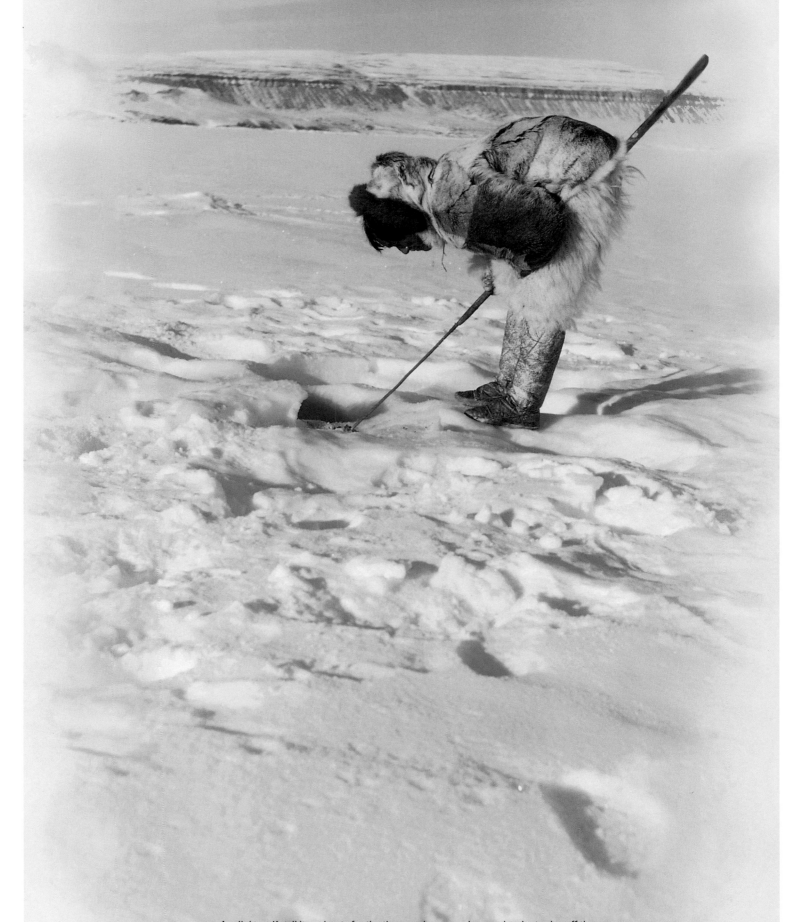

Aquiluktuq. Kutsikitsoq hunts for the three seals we need every day; he trades off the hunting with Qaaqutsiaq.

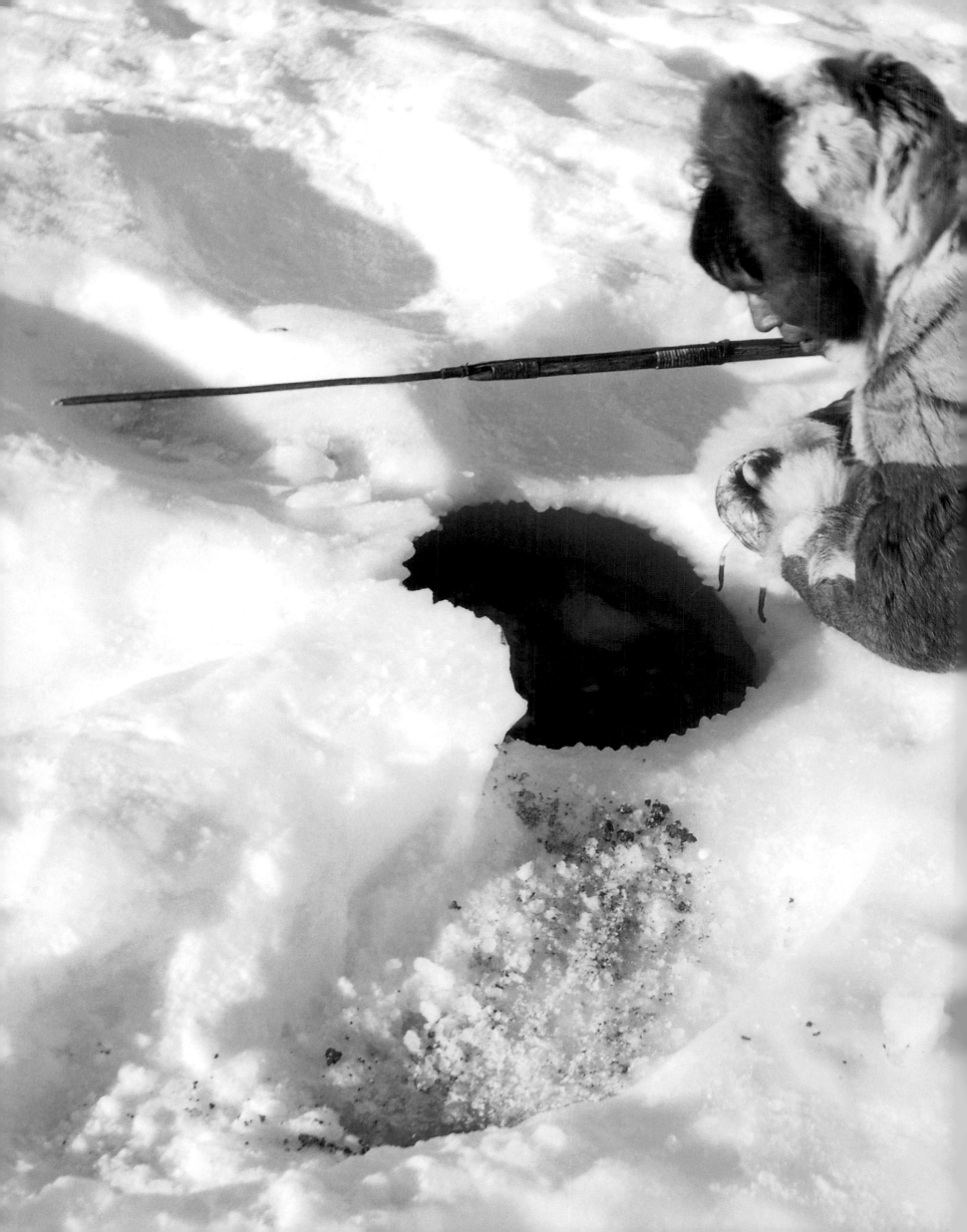

Nikparvik: Waiting for the seal at its breathing hole—fifteen minutes, an hour, two hours, as the seal pleases.

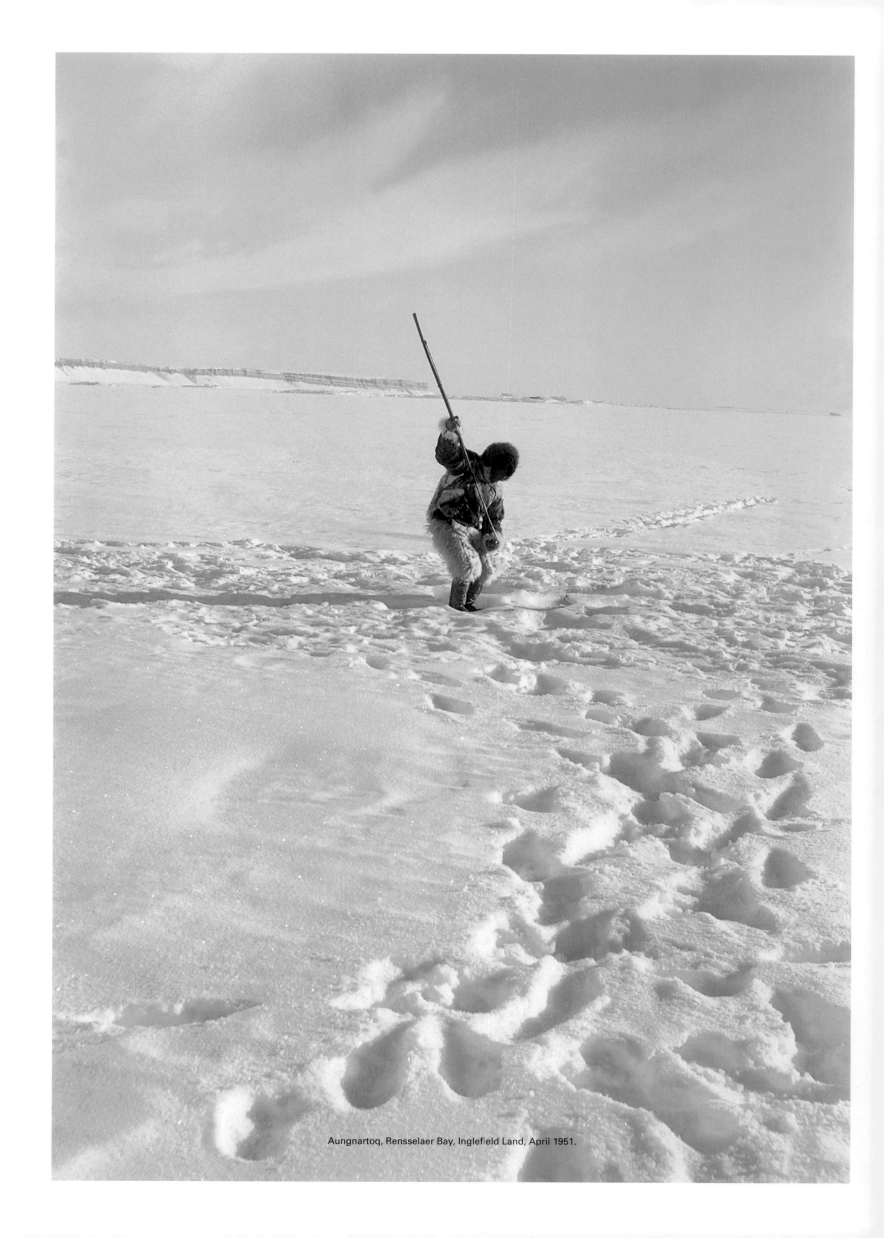

Aungnartoq, Rensselaer Bay, Inglefield Land, April 1951.

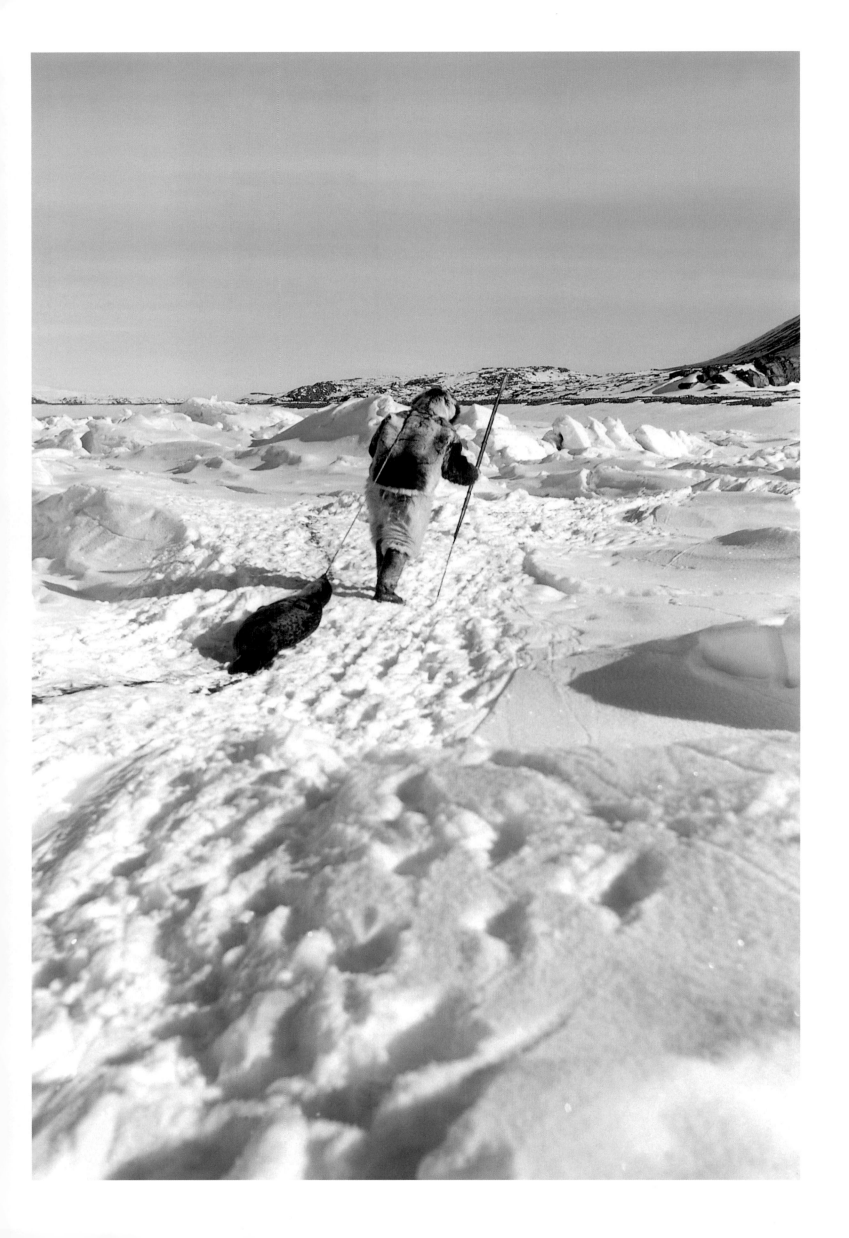

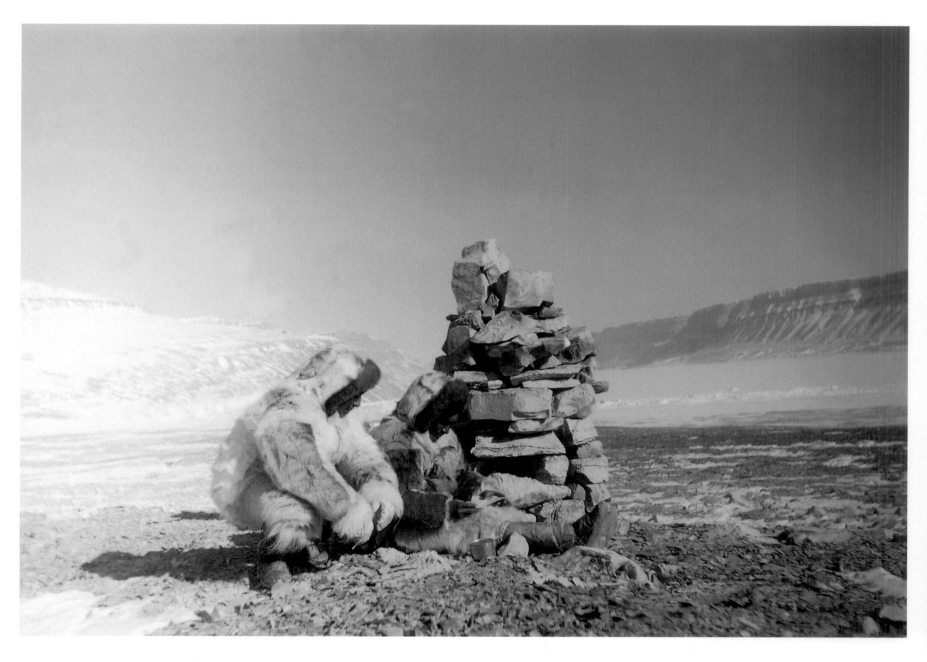

Above: Cass Fjord, Washington Land, May 1951. En route toward Kennedy Channel, which leads to the Arctic Ocean. Following tradition we are building cairns, small mounds of stones, in which we place a message contained in a metal box. I write it in English, and Kutsikitsoq adds a few words in the Eskimo language. We note the condition of the expedition's five men and women and our forty-three dogs, as well as the direction we're heading. We made five such cairns on our way from Etah to Ellesmere Island so a rescue mission could find us. We did not have a radio. The Inuit have visited this cairn regularly since 1951; they add messages to mine, for it has the reputation of bringing hunters good luck.

Right: Cass Fjord, Washington Land, May 15, 1951. Kutsikitsoq expresses his joy at this great adventure. Eskimos enjoy a challenge; that's why they came with me. Looking at my map, I realized we had discovered a previously uncharted fjord; I called it Torvegade Fjord; I had named another one, near the Humboldt Glacier, Paris Fjord.

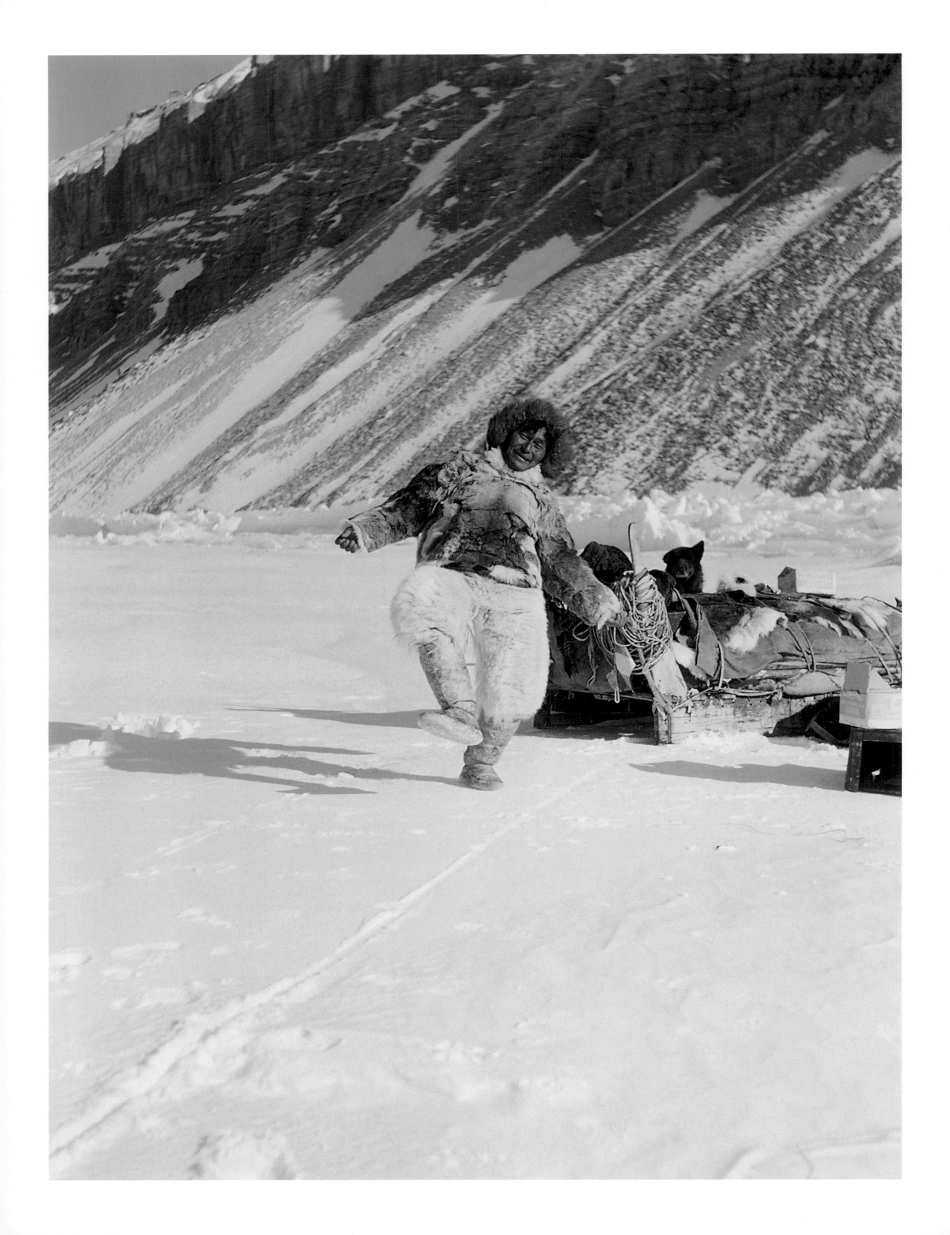

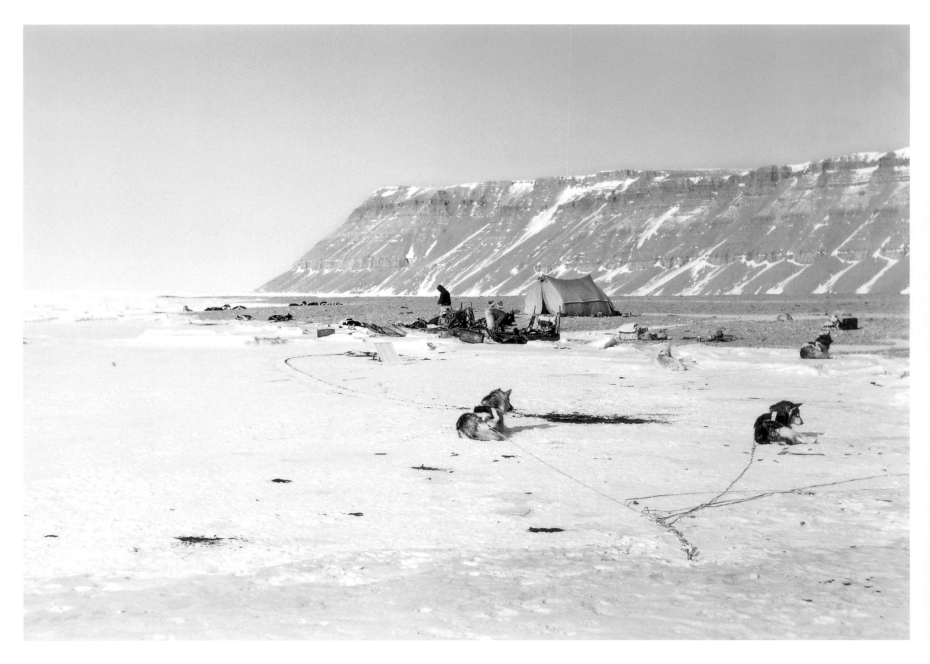

Cass Fjord, Washington Land, May 15, 1951. At right, Naduk, 40, mends clothing and boots for the two men and for me. In the foreground are my reindeer-hide shoes, which were useless. At the far right is the board on which I would draw my maps. If it was windy, an Eskimo would block the wind with his body while I drew. In front of the main tent are one of our two gas cars and my tin mess kit, which I used for my meals and for my washing. In the bag are seal hides for mending clothes, harnesses, and boots, and tufts of grass, which we used to separate our boots' inner and outer soles. During these breaks, when we could relax, the Inuit shared their most personal thoughts with me, and I with them.

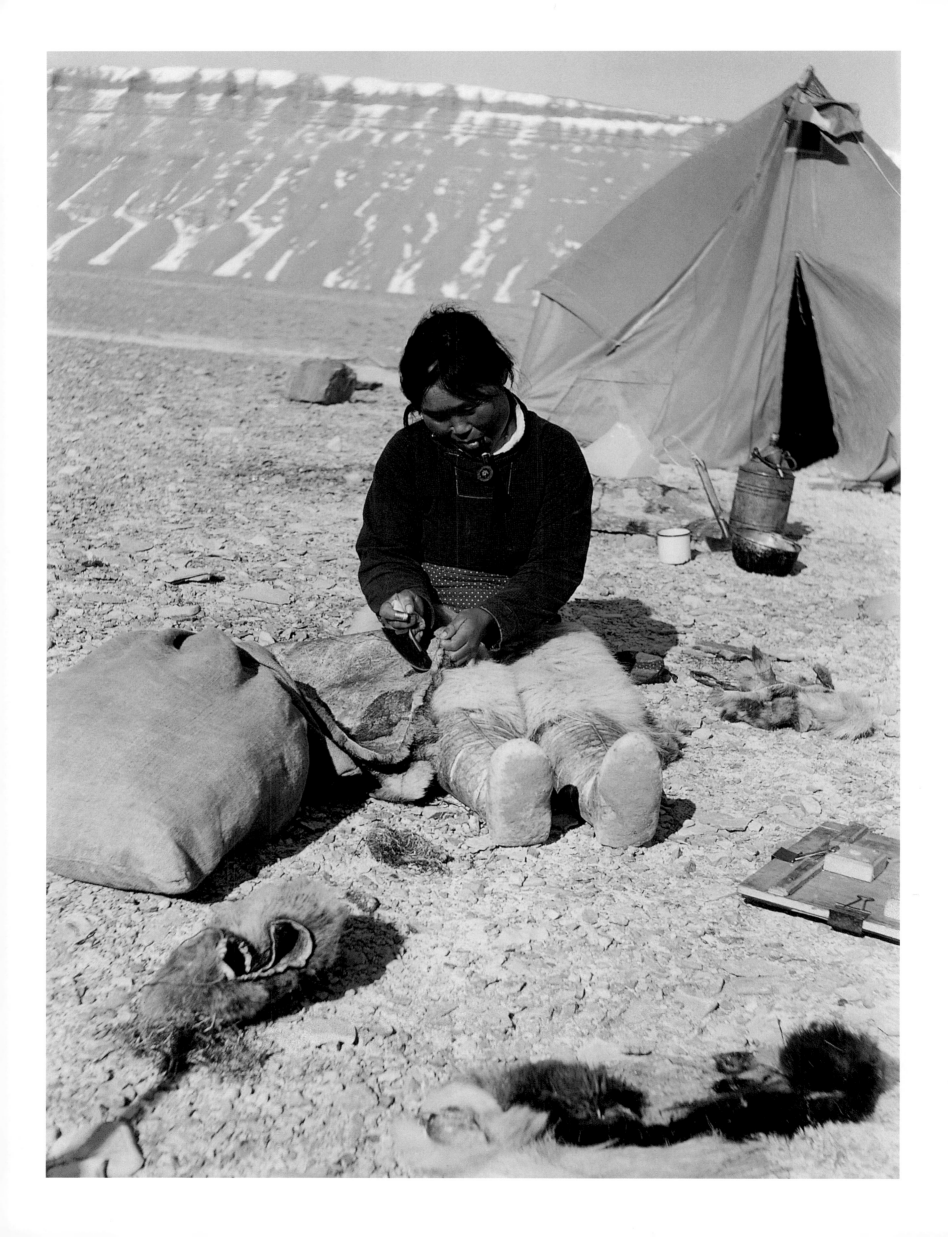

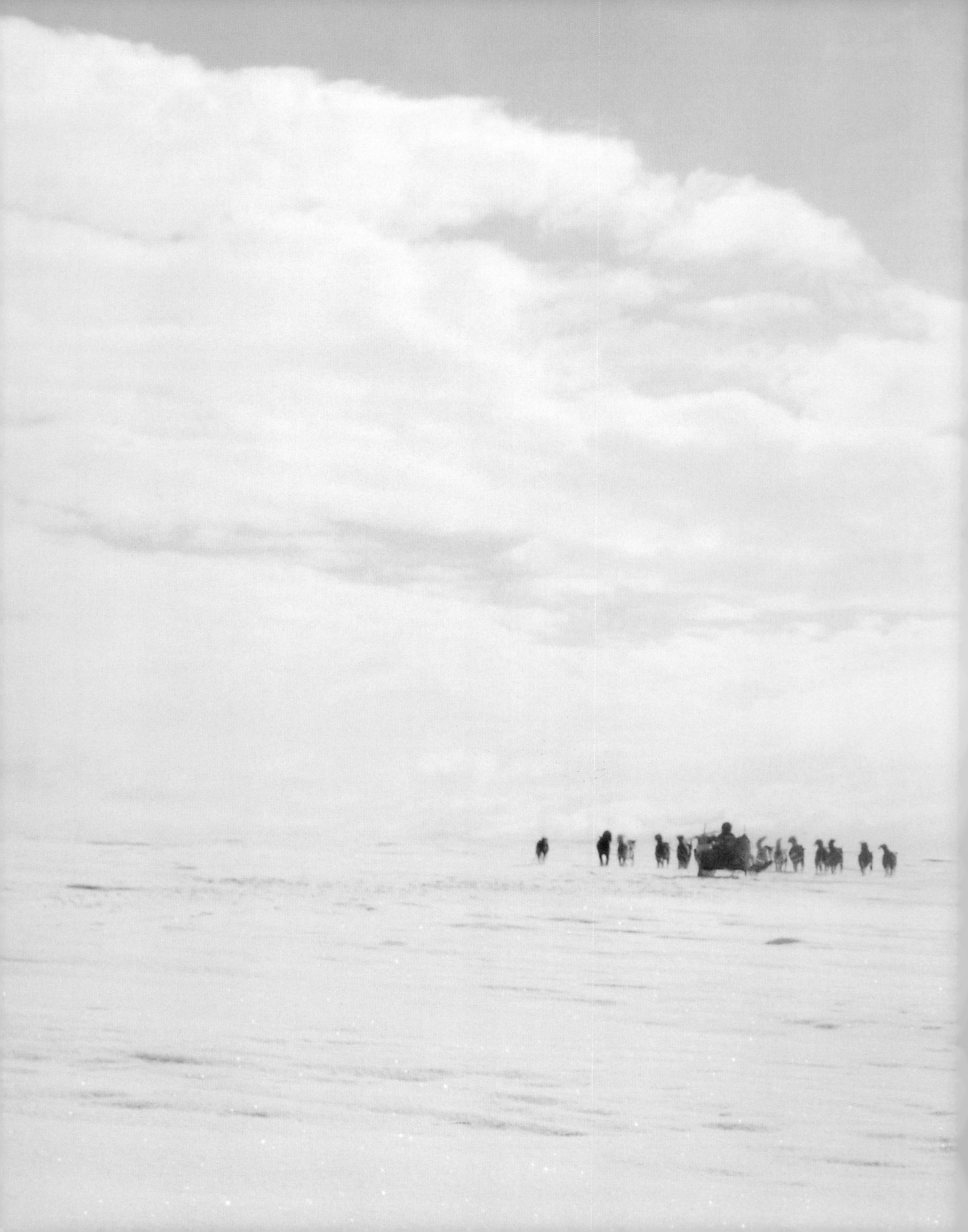

This photograph was taken from my sled near the geomagnetic North Pole, at 78°29'N, 68°54'W. Ahead, Kutsikitsoq is exploring the trail with his eighteen dogs. In the photo on the following pages, we are resting near the geomagnetic pole. I am the first Frenchman to have crossed this region; Robert Edwin Peary preceded me, accompanied by Evind Astrup, in April 1892.

Compasses cannot be used here; the needle shakes all about. I orient myself by the sun and by the direction of the sastrugis, the ridges on the surface of the hard snow. My Inuit companions recommended that we find a solitary, mysterious pass along the threatening cliff that would lead us off this glacier and back to the Inglefield plateau. We had allotted four days for this trek. Our food: two frozen seals that Kutsikitsoq and I shared with thirty dogs.

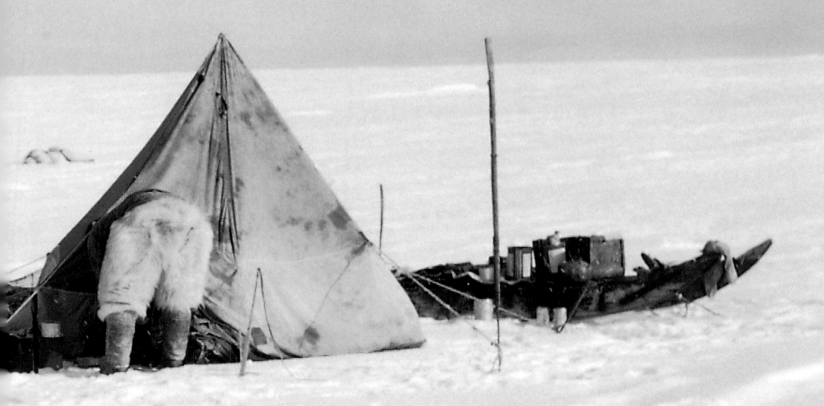

May 29, 1951, at the geomagnetic North Pole.

Ellesmere Island, June 1, 1951. We are traveling toward Canada; at that time, no Frenchman had ever made this crossing. The fifty miles of ice floes separating Canada and Greenland are pocked with ice hummocks up to twenty-one feet tall. Here, Qaaqutsiaq works to build a path for us, our dogs, and our sleds.

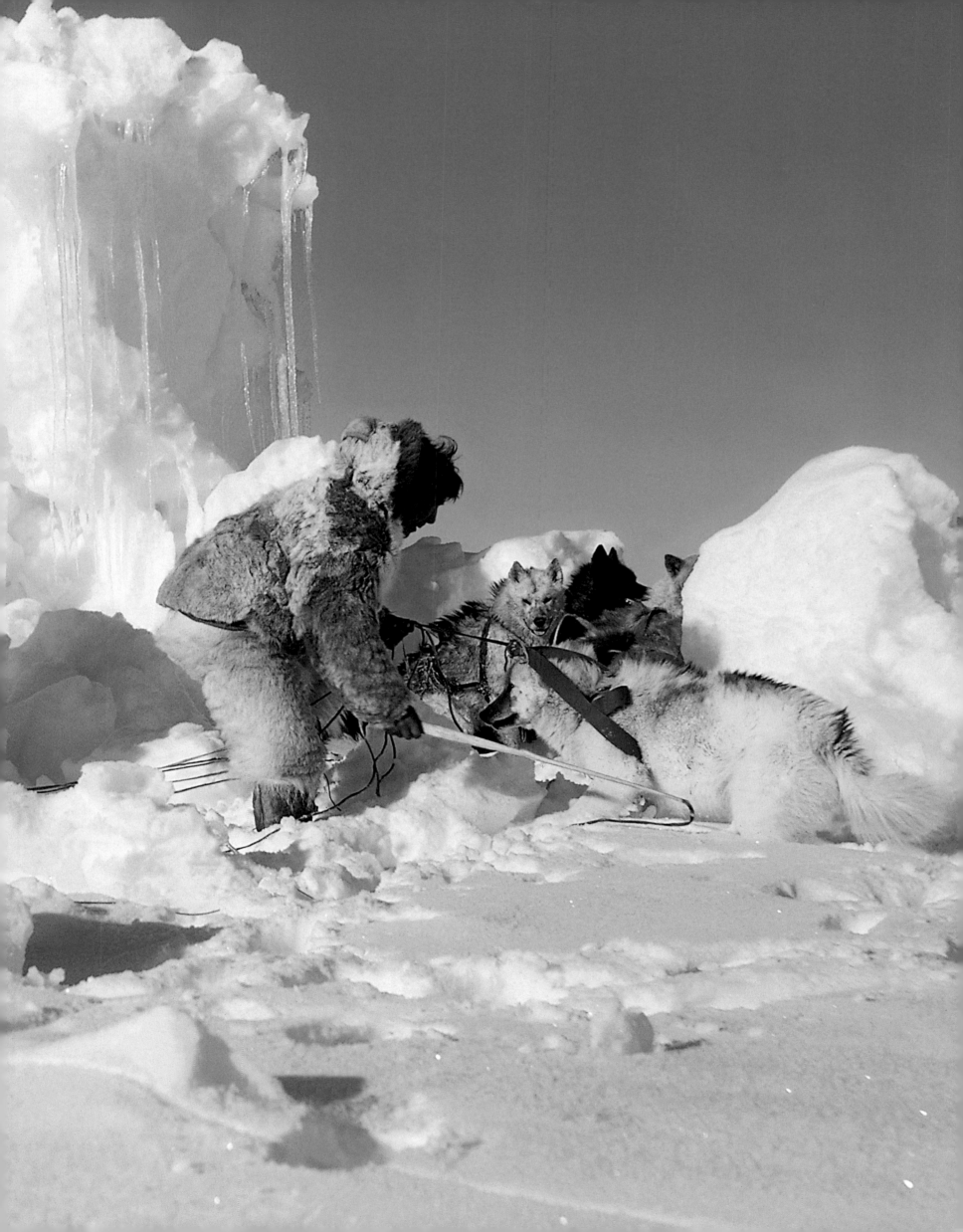

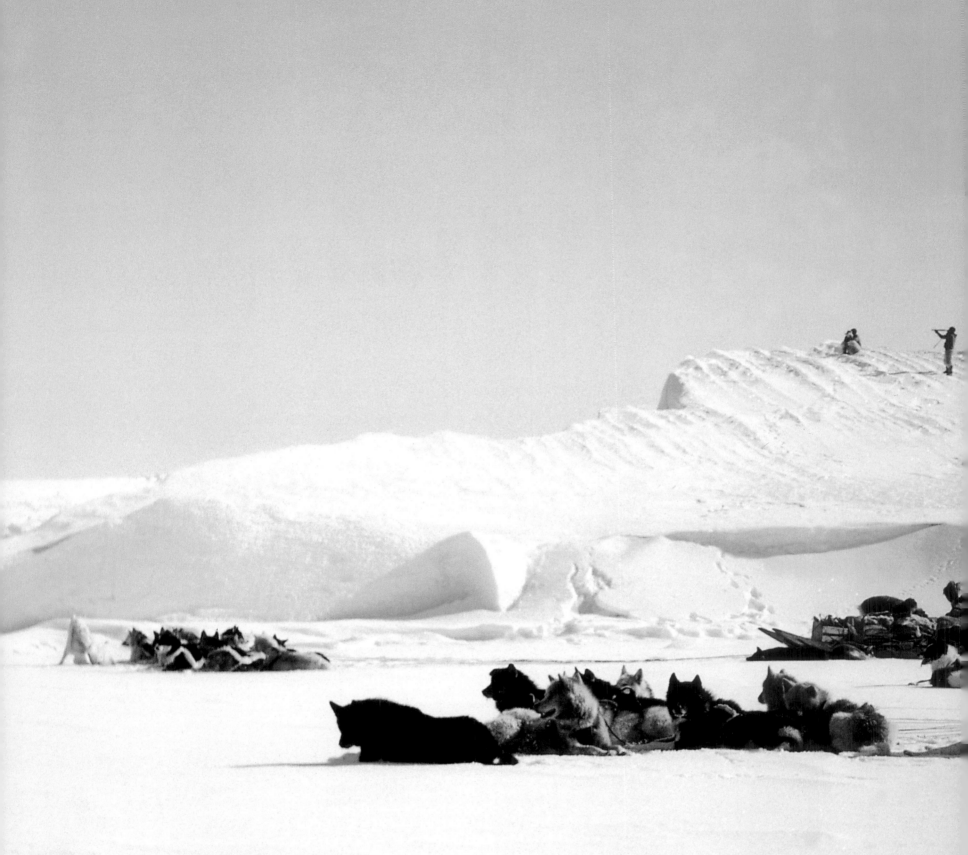

On the ice between Greenland and Canada, June 2, 1951. Climbing to the top of an iceberg, we trace a route through the maze of hummocks from where we are to the west, toward Ellesmere Island. We hope we can hunt for seal there; they are scarce among these drifting hummocks. The trek is a kind of commando raid, which is to say we have brought a minimum of equipment: coffee, sugar, tea, three rifles, ammunition (2,200 bullets, in case we are forced to winter), harpoons, lances, axes, and saws. We need to be fast, so we kept our load as light as possible. This is a dangerous time—the ice floe is breaking away—and we don't want to be cut off from our base on Greenland. In the foreground is my own sled and to the right is Pikouli, the female in my pack, who had just given birth to several puppies. We kept them all, and she took care of them. They're on my sled.

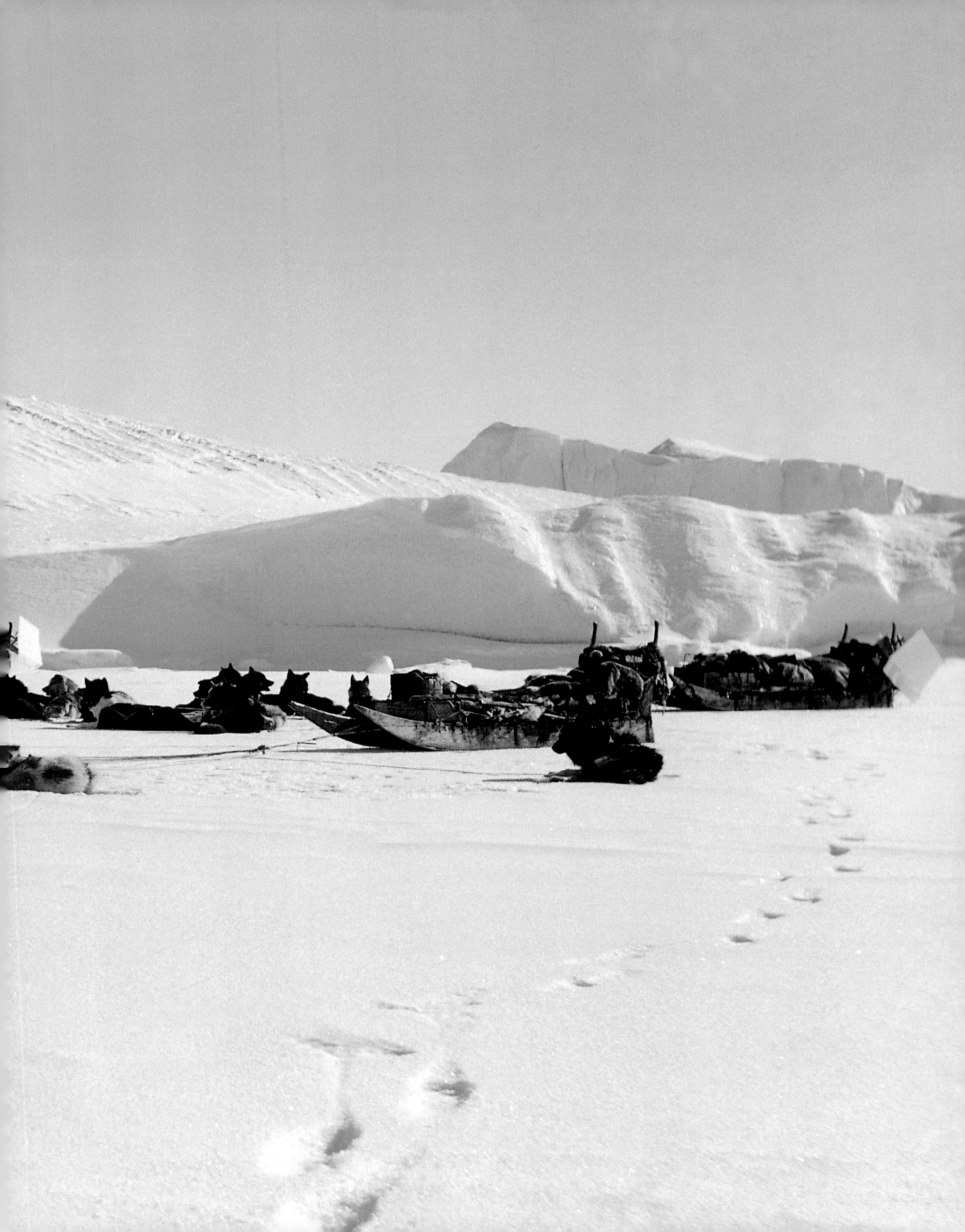

Ellesmere Island, Canada, June 1951. We are in Alexandra Fjord, a few miles from Cape Sabine, where, during the winter of 1884, nineteen young Americans lost their lives. Sixteen of them starved; some of the survivors lived only by cannibalism. When the six survivors—including the expedition's leader, the temperamental lieutenant Adolphus Washington Greely—were finally rescued during their third winter in the Far North, they had only forty more days of provisions. A 1933 expedition to Ellesmere, led by the German geologist H. K. Krueger, had preceded me; it was accompanied by Ajako, a hunter whose widow I knew. Krueger's expedition included three men using one dogsled; all three disappeared.

The four Inuits with me are admirable companions. They supported my scientific quest and the Inuit spirit that inspired us.

I had surveyed 150 miles of Greenland's coast—in Inglefield Land and the south of Washington Land—and I now wanted to measure the heights of Ellesmere Island's raised beaches. I could date the island's fossils and peat and determine the volume of ice on Ellesmere. With that done, I could compare the deglaciation rates of northwest Greenland and Ellesmere. At the mouth of Alexandra Fjord Kutsikitsoq and I built a last cairn containing a message that indicated the direction we were heading in. Our camp wasn't far from Skraeling Island and a small valley where there are ruins of prehistoric stone igloos. My Inuit companions think ahead: If we were forced to winter here—if the ice on Smith Strait has shifted to the south—we could use the ruins for refuge, adding peat blocks and surrounding them with snow. June is the month when the ice floe suddenly breaks apart.

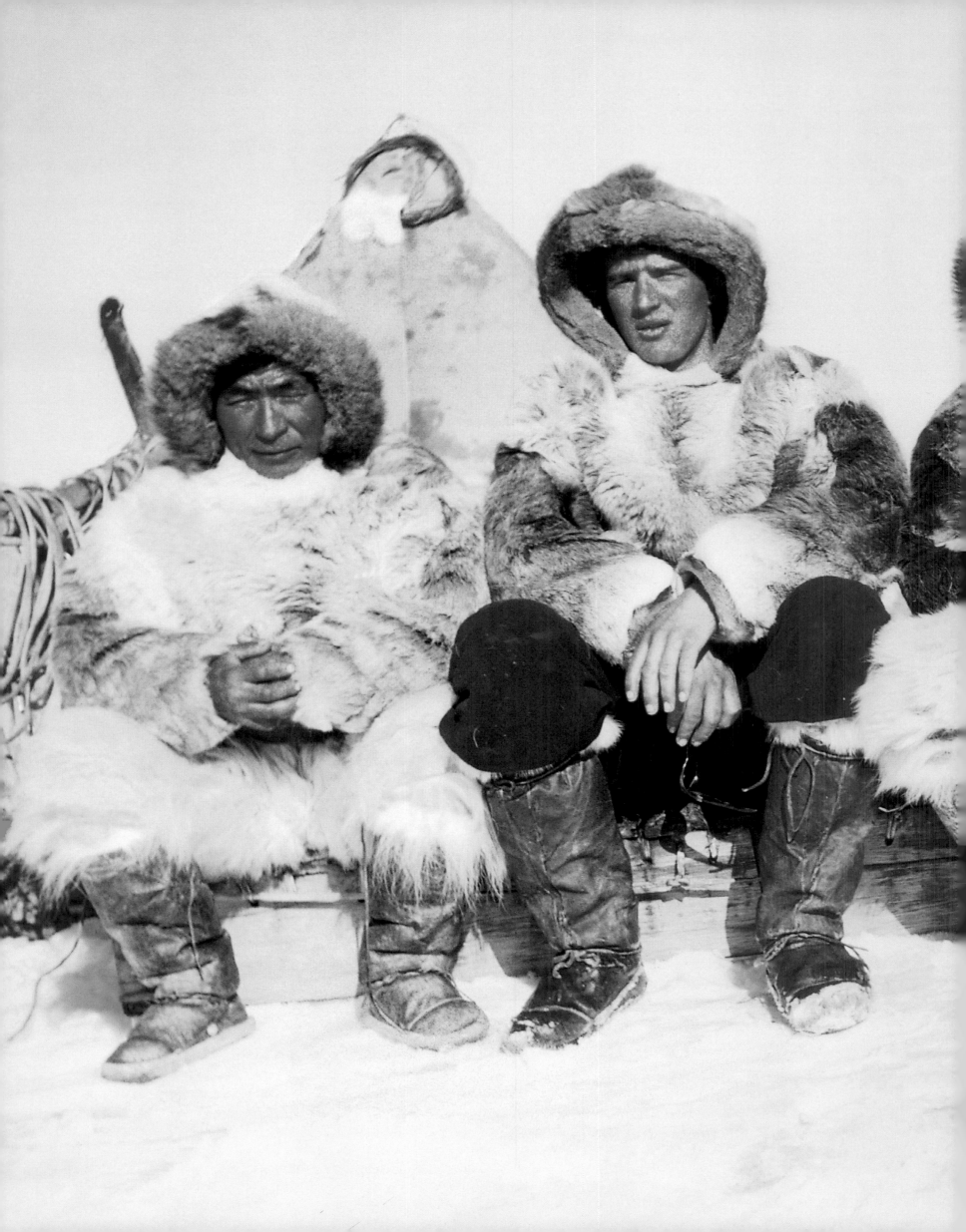

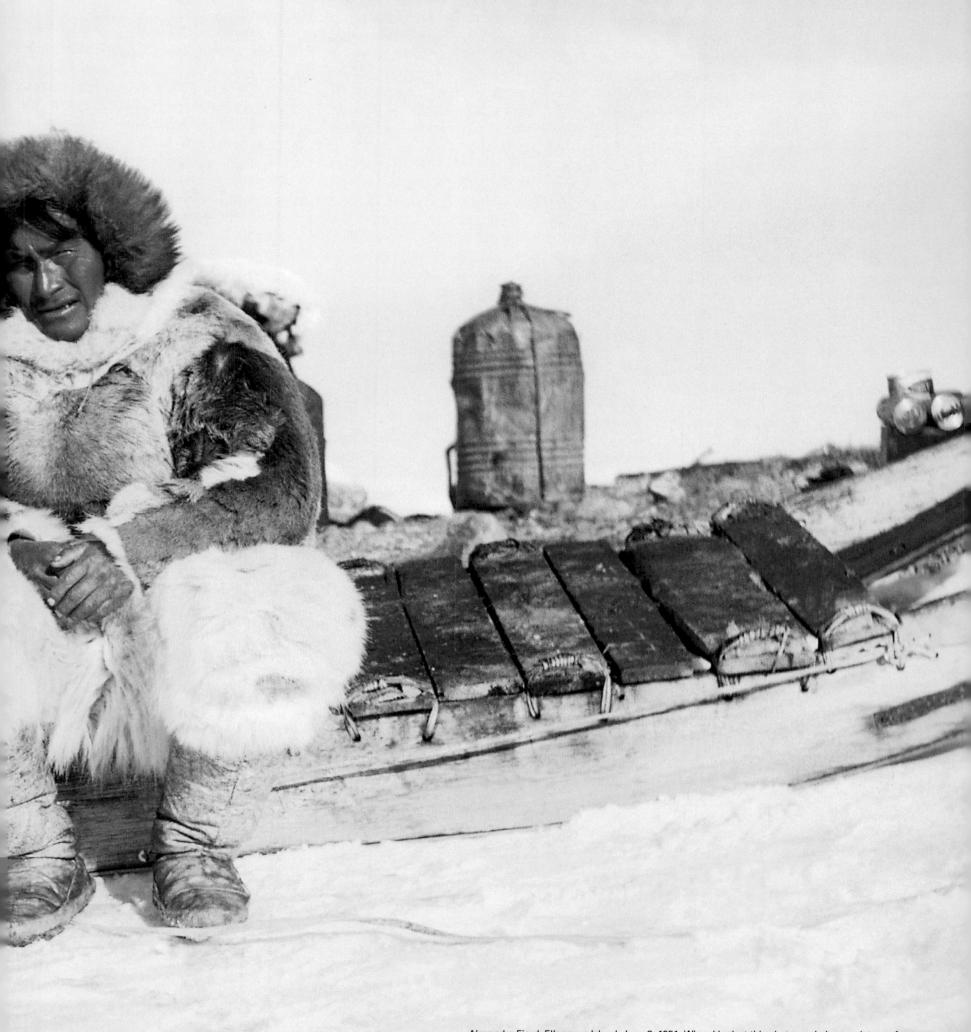

Alexandra Fjord, Ellesmere Island, June 3, 1951. When I look at this photograph, I appreciate my four companions more and more. Qaaqutsiaq is at the far left, Kutsikitsoq at the far right. Patdloq took the picture with Naduk's help. Though we were worried about being stranded on this barren island we didn't discuss it. They never hesitated to continue on the trek with me. Life has meaning when you run risks with others. Our relationship was subtle, strengthened by our difficulties and a mutual respect. The decisions I made reflected what we had been experiencing together for months and what they were teaching me: solidarity. As a geographer, I seek out an inner place. My thoughts were structured by a hidden order. It was here, on Ellesmere, that I neared the shores of my deepest self.

On June 5, 1951, I gave the signal to return east. Patdloq located the trail and, miraculously, we found the winding path through the drifting hummocks that we had cut with our axes. The next day, back at our little base on Greenland, I retrieved our reserves of seal meat and equipment. Patdloq was the more enterprising of the two women on the expedition.

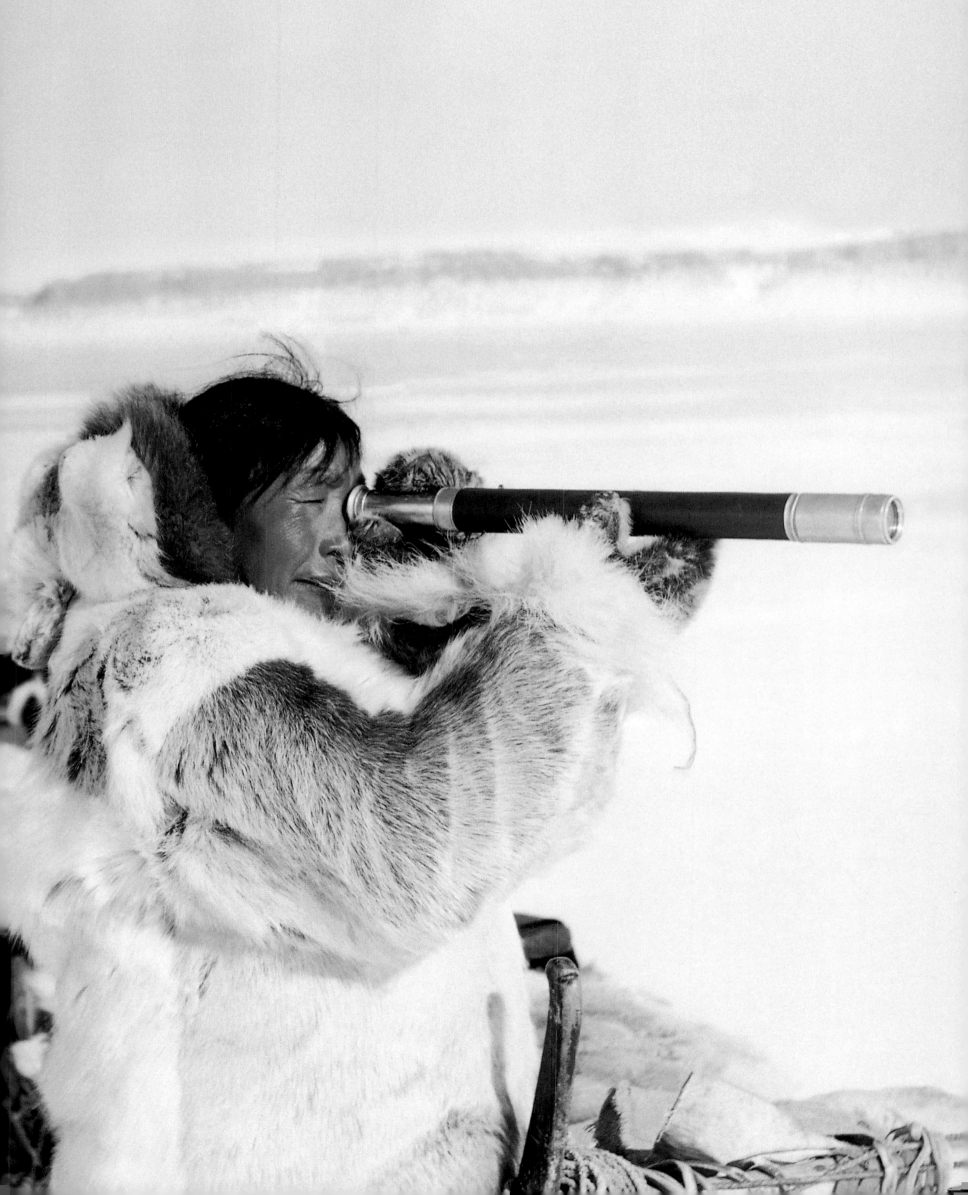

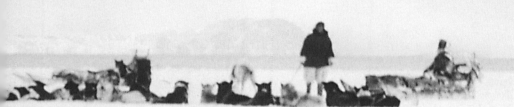

South of Siorapaluk, June 14, 1951. We cross the plateau of Inglefield Land and Greenland's huge continental glacier, a forced march of 150 miles south-southwest toward Thule. Qaaqutsiaq and Patdloq had left us at the glacier to return to Etah; I continued on with Kutsikitsoq and Naduk. In Siorapaluk I left my wintering base for good and a new group came with me: Sakaeunnguaq, my most loyal companion, and Qaalaasoq, Ululik's brother, known as "the navel." They wanted to stay with me until I said farewell to this northern place, where I had had the most monumental adventures of my life.

It's drizzling—it's raining and the ice floe is scarred with large cracks where the water has collected three feet deep. We advance over a lake separated from the sea by the ice floe.

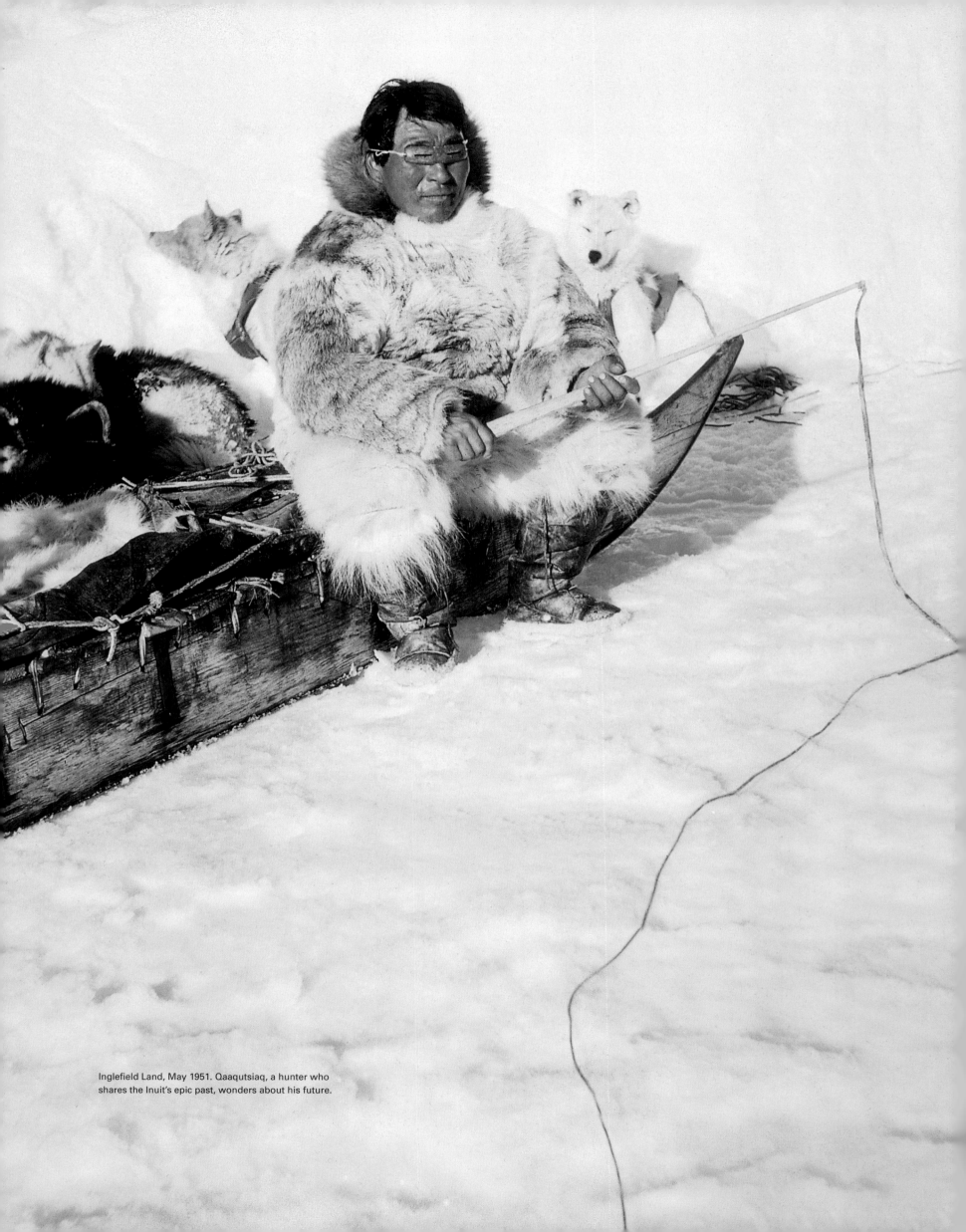

Inglefield Land, May 1951. Qaaqutsiaq, a hunter who
shares the Inuit's epic past, wonders about his future.

"AND YOU, LEADER OF THE BANDITS WHO OBEY YOU. QUICKLY PUSH YOUR VESSEL FROM OUR SHORE: WE ARE INNOCENT, WE ARE HAPPY, AND YOU WILL ONLY SPOIL OUR HAPPINESS."
DENIS DIDEROT, *SUPPLEMENT TO THE VOYAGE OF THE BOUGAINVILLE.*

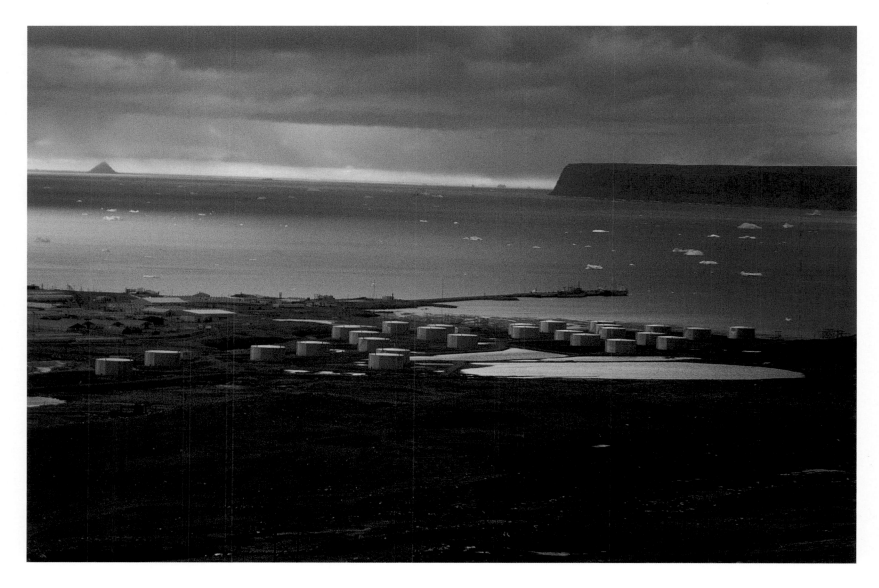

Thule, North Star Bay, September 1972. The nuclear clash in Thule. Three hundred and two Inughuit, sixty-two families, until then separate from the industrial world, discover its neglect and its destitution. Five thousand American servicemen were to become their new system of reference. The misfortune I predicted in *The Last Kings of Thule* unfortunately came true. On January 21, 1968, a B-52 carrying four hydrogen bombs crashed not far from Thule. Three bombs spread plutonium and lithium over the ice. The fourth was lost in the sea. Some Inughuit, including several of my friends, were hired by the army to clean up the contamination—50,000 tons of contaminated snow and ice. They were not given any special equipment. I filmed them and recorded their protestations. Ninety-eight Danes employed in the same operation died within a year of the accident; their mortality rate, according to Danish health authorities, was 40 percent higher than

normal. But the existence of the base was a secret, and the Danish were not told the whole truth. My films, which presented the complaints of the Inuit, were censored by Danish television despite the efforts of my editor. This silence is typical of scientific and moral authorities. Alerted by the press in 1999 and 2000, the Danish people, who are passionately attached to Greenland, felt that their dignity had been insulted.

If I ask an Inuit hunter today if there has been any progress since our first meeting, he'll shrug his shoulders: a drunken gesture, an aggressive "No." Meanwhile, the suicide rate for Inuit youth has become one of the highest in the world. Let us listen to Diderot again: "All of our opinions, all of our regulations, all of our practices, should have been adapted to [their] natural law. . . . What a mess! It didn't take much to make them miserable, to leave them without resources."

THE INUGHUIT: THE LAST KINGS OF THULE

NORTHERN GREENLAND

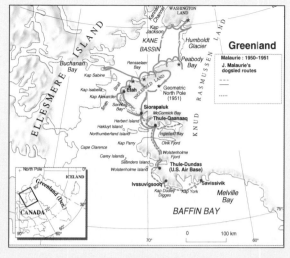

TRADITIONAL PANTHEISM

INUIT WISDOM

"Old Ulugatok from Cape York stopped him long enough to say: 'We are only poor, silly people. We have few ways of protecting ourselves for the sake of our children, so we only do as our forefathers have taught us to do. If you need not do the same thing, it is convenient for you, but you should not laugh at us merely because you are the stronger. We think that if we do this we shall not die at least until the sun returns next year. Even if it does no good, we enjoy life so much that we do anything to keep it.'"

—Peter Freuchen, *Arctic Adventure*, New York, 1935

INUIT WORDS

"'When we tell our myths, we do not speak for ourselves; it is the wisdom of the fathers which speaks through us.'"

—Knud Rasmussen, *Greenland by the Polar Sea*, London, 1921

ANARCHIST PHILOSOPHERS

"'I have often been asked,'" said Admiral Peary, who arrived at the North Pole on April 6, 1909, "'What purpose do the Eskimos serve on Earth? They live too far away to present any commercial interest and, besides, they don't have any ambition. They have neither literature, nor real art. They are not civilized beings, and yet they aren't savages. They have no government, but are not without legislation . . . one of my friends calls them the anarchist philosophers of the Far North.'"

—Robert Edwin Peary, *The North Pole: Its Discovery in 1909*, New York, 1910

CREATION ACCORDING TO THE INUIT

"That time, very long ago, when the earth was made, it dropped down from above—the soil, the hills and the stones—down from the heavens; and that is how the world came into existence. When the world was made, people came. They say that they came up out of the earth. Babies came out of the earth. They came out along the willow bushes, covered with willow leaves. And they lay there among the dwarf willows with closed eyes and sprawled. They could not even crawl about. They got their food from the earth."

—Knud Rasmussen, *The People of the Polar North: A Record*, London, 1908

THE POLAR NIGHT: TERROR FOR SOUTH GREENLANDERS

"Then it really grew winter and dreadfully cold, and the sky speedily darkened. Never had I seen the dark season like this, to be sure it was awful, I thought we should have no daylight any more. I was seized with fright and feel a weeping. I never in my life saw such darkness at noon time. As the darkness continued for three months, I really believed we should have no daylight more. However, finally it dawned, and brightness having set in, I used to go shooting hares."

—Hans Hendrik, *Memoirs of Hans Hendrik, The Arctic Traveller*, London, 1878
(Hendrik was the first South Greenlander to winter with the polar Eskimos, during Elisha Kane's expedition of 1852–54.)

PROFILES OF THE ESKIMO

NOMAD

"The Eskimos are a roaming people, always longing for a change and a surprise—a people which likes moving about in search of fresh hunting-grounds, fresh possibilities, and 'hidden things.'"

—Knud Rasmussen, *Greenland by the Polar Sea*, London, 1921

ARISTOCRAT

My friend Erik Holtved, a Danish philologist, wintered with this group in 1935–36 and 1946–47; in 1942 he wrote, "The Eskimos are aristocrats. During the hunt, I realized that no one had uttered the words 'tobacco' and 'cigarette,' except to offer me some from their supply. At home, in my house, they rarely repressed their desire, but in their territory, on the ice floe, I was their guest. They performed their role as host with tact and delicacy."

—Erik Holtved, *Polareskimoer*, Copenhagen, 1942

FATALIST

"What emerges in my memory is their courage—a courage connected to fatalism—in the face of misfortune. But also an immense curiosity about discovering what is unknown. How can one forget their humor? What fills these proud people and their thoughts is a vertical vision of the world. Theirs is a pantheist understanding of the order of nature."

—Jean Malaurie, Notebooks, 1951

THE INUIT CIVIL CODE

DO NOT HUMILIATE YOUR NEIGHBOR: ONCE IMMORTAL, HE WILL TAKE REVENGE

"Expedition of the *United States* to Etah, 1860–61. The *qivittoq* is a man who, having suffered sarcasm from his neighbors, distances himself from the sea, goes to the mountain or the glacier and lives there alone. Through suffering, he becomes immortal. He is dangerous to other men: he will try to steal their breath out of revenge, to torment them if they wander into his territory. He'll eat his own liver. "In the beginning of the winter one of these natives turned a Kivigtok [fled from human society, to live alone up the country]. We were unable to make out what might have induced him to do so. The only thing we remembered he had uttered was—'What does J— say when he whispers in passing by me?' . . . I found his foot prints going to the hills. I followed them and shouted to him, but got no answer.'"

—Hans Hendrik, *Memoirs of Hans Hendrik, The Arctic Traveller*, London, 1878

CHILDBIRTH AND PROCREATION

"They have no theories, but in practice they cling in a purely instinctive manner to all the old traditions. . . . At childbirth the following rules must be observed:— When a woman is about to give birth to a child, she must move out of the house that she inhabits with her husband. If it be summer-time, a little tent is erected for her; if winter, a snow-hut is built. As soon as the birth is over, she is at liberty to go back. The day the child is born she must only eat 'Serâlataq,' meat fried in fat on a flat stone. When she has slept a night after her confinement, she must begin to make herself new clothes; her old clothes must be thrown away. After a birth she must wash herself from head to foot. She must not push her hood back off her head outside, nor take off her mittens. Before she has had five children, she must not eat young rough seals, eggs, entrails, heart, lungs, or liver."

—Knud Rasmussen, *The People of the Polar North: A Record*, London, 1908

HOUSE OF PLEASURE: SEX EDUCATION FOR THE YOUNG

"At Cape York we ran across Minik . . . he was living in one of the houses reserved for the young people of the community. . . . In these houses boys and girls may live together without censure or obligation beyond the demands of the night. The Eskimos take a wholly natural and practical view of sex. They consider no marriage happy unless a sexual affinity exists between the two concerned, and therefore they believe it most important for the man and the woman to test and establish this affinity before they undertake a permanent union."

—Peter Freuchen, *Arctic Adventure*, New York, 1935

"Human sperm is an appealing smell for the bear and whale; sex brings humans closer to these relatives."

—Jean Malaurie, Notebooks, 1950–51

INUIT WOMEN

GIVING BIRTH (1950–51)

"Women give birth kneeling. Delivery is brought on by constricting the belly with a belt or by pressing on it strongly. Sometimes the husband stands behind his wife,

hugs her, and helps push from the small of her back. Mongolian spots [birthmarks just above the coccyx] are the very expression of Inuit ethnic identity. The Eskimos have no qualms about eliminating deformed or disabled children."

—Jean Malaurie, *The Last Kings of Thule*, Paris, 1955

AMENORRHEA

Dr. Frederick Albert Cook, doctor for the Peary expedition in 1891–92 made these observations: "Sexuality is seasonal. Throughout the long Arctic night, bodily fluids are reduced, passions are exhausted, which brings about great muscular weakness. Our own group suffered this way. This unique state is due to the prolonged absence of the sun, and I came to the conclusion that the presence of the sun is as essential for animal life as it is for plants. The passions of these people are periodic and their season of love generally comes after the return of the sun; in fact, during this period they practically shake, their urges are so intense, and for several weeks almost all of their time is spent satisfying them. Therefore, it is not surprising that children are born at the beginning of the Arctic night, about nine months later. During the Arctic night, menstruation usually stops; no more than one woman out of ten has her period. When the sun returns, menstruation resumes, every twenty-eight or thirty days."

—Dr. Frederick Albert Cook, *My Attainment of the Pole*, New York, 1911

SEASONAL BIRTHS

"According to my notes and my genealogical research, in 1950–51 births continued to be seasonal, most often happening in February, and the period of fertility and sexual activity was still linked to the return of the sun in June. The observations of Dr. Cook are one the first medical notes on winter amenorrhea. In 1950–51, in the rare cases in which I could gather such information, menstruation cycles were very weak during the winter, while the sexual cycle was intense during the spring."

—Jean Malaurie, Notebooks, 1951

THE FIRST PREGNANCY

"The females . . . never have children, even with every possible provocation, till at least three years [after puberty]."

—Robert E. Peary, *Northward Over the "Great Ice,"* Vol. 1, New York, 1898

THE GREAT FEAR: FEMALE STERILITY

"Women who don't have children are ostracized or are exchanged by their husband; they wander from one place to the other, from one man to the other, loveless and degraded. Some women prove to be permanently infertile."

—Observations of Dr. Frederick Albert Cook, 1891–92

EXCHANGING WOMEN

"It is generally on hunting expeditions that the men agree to exchange wives for a night, but to the woman herself

they say nothing at all about it on their return home; it is only when the woman sees a strange man lie down on her couch, and her own husband go to another house, that she understands the exchange. Women are never exchanged out of the house for a night. It is the men who exchange couches."

—Knud Rasmussen, *The People of the Polar North: A Record,* London, 1908

BATTERED WOMEN

"There was an animal lack of restraint about their intercourse and affection which at times vented itself in the most savage outbreaks. The Eskimos are much like animals. The men love their wives; but when the fancy takes them, when they are satiated with love, they maltreat them in a manner that we civilized men would consider brutal. But, say the Eskimos, if affection is to be kept alive, the woman must feel occasionally that the man is strong."

—Knud Rasmussen, *The People of the Polar North: A Record,* London, 1908

THE HIDDEN AUTHORITY OF WOMEN

"By virtue of the practice of exchanging women, which is still practiced [in 1950–51], and the 'game of extinguishing lamps,' which ended in 1920, each woman knows the sexual personality of each man. Therefore, in their first relations with a woman, many men isolate themselves from the group, for example, by going to a snow igloo on the ice floe during a solo hunt."

—Jean Malaurie, Notebooks, 1950

WHAT DO THEY EAT?

DAILY RATIONS

"Elisha Kane (1852–54) recorded that the Inuit ate up to eight to ten pounds of meat and fat per day per person during the winter, and a half-gallon of blood soup and broth. In 1950–51, I noted that these numbers were falling. During the winter, the Eskimos ate at most four to six pounds of meat per day (mainly seal and frozen and raw walrus), half of which was fat, and a half-gallon or more of tea, coffee, water, and meat broth. On treks, I ate the same food as my Inuit companions, though a third less than them."

—Jean Malaurie, *Hummocks,* Volume I, Paris 1999

THE *KIVIAK*

"We were consuming a special delicacy—auks pickled in oil. This is done by killing a seal and skinning it through its mouth without splitting the skin . . . [the sealskin is filled and] then latched and covered with stones. . . . During the summer the blubber turns to oil and soaks in into the birds, which decompose slowly without interference from the air. . . . He skins them, from the bill back, and, having turned the skin inside out, sucks the most delicious fat out of it."

—Peter Freuchen, *Arctic Adventure*, New York, 1935

KIVIAK OR LITTLE AUK: RESERVES FOR THE HARD WINTER MONTHS

"First you tear off the wing, then you suck the little piece of hanging flesh and remove the feathers sticking to your fingers . . . the fat is sucked and swallowed, you break the head with your teeth and suck out the brain . . . eating the bird is intoxicating and brings on sleep."

—Jocelyne Ollivier-Henry, *Sila Naalagaavoq: le temps est le maître*, Paris, 1998

DEATH RITUALS

"On the death of a man or woman, the body, fully dressed, is laid straight upon its back on a skin or two, and some extra articles of clothing placed upon it. It is then covered with another skin, and the whole covered in with a low stone structure, to protect the body from dogs, foxes, and ravens. . . . If the deceased is a man, his sledge and kayak, with his weapons and implements, are placed close by, and his favourite dogs, harnessed and attached to the sledge, are strangled to accompany him. If a woman, her cooking-utensils, and the frame on which she has dried the family boots and mittens, are placed beside the grave. If she has a dog, it is strangled to accompany her; and if she has a baby in the hood, it, too, must die with her. If the death occurred in a tent, the poles are removed, allowing it to settle down over the site, and it is never used again, but rots or is blown away. If the death occurred in an igloo, it is vacated and not used for a long time. The relatives of the deceased must observe certain formalities in regard to clothing and food for a certain time; the name of the dead person is never spoken, and any other members of the tribe who have the same name must assume another until the arrival of an infant, to which the name can be applied, removes the ban."

—Robert E. Peary, *Northward Over the "Great Ice"*, Vol. 1, New York, 1898

MINIK'S DECLARATION

"In 1897, Peary brought a young Eskimo named Minik to New York City; there he discovered that his father's skeleton was on display at the American Museum of Natural History. Before he left America, he declared, 'You're a race of scientific criminals. I know I'll never get my father's bones out of the Museum. I am glad enough to get away before they grab my brains and stuff them into a jar!'"

—Kenn Harper, *Give Me My Father's Body*, Ottawa, 1986

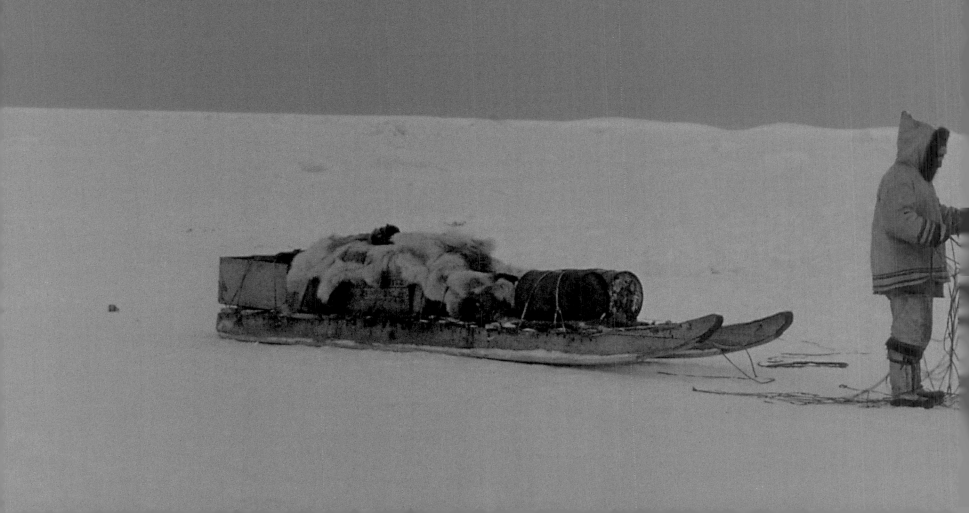

FOXE BASIN
SOUTH OF THE STRAITS OF FURY AND HECLA

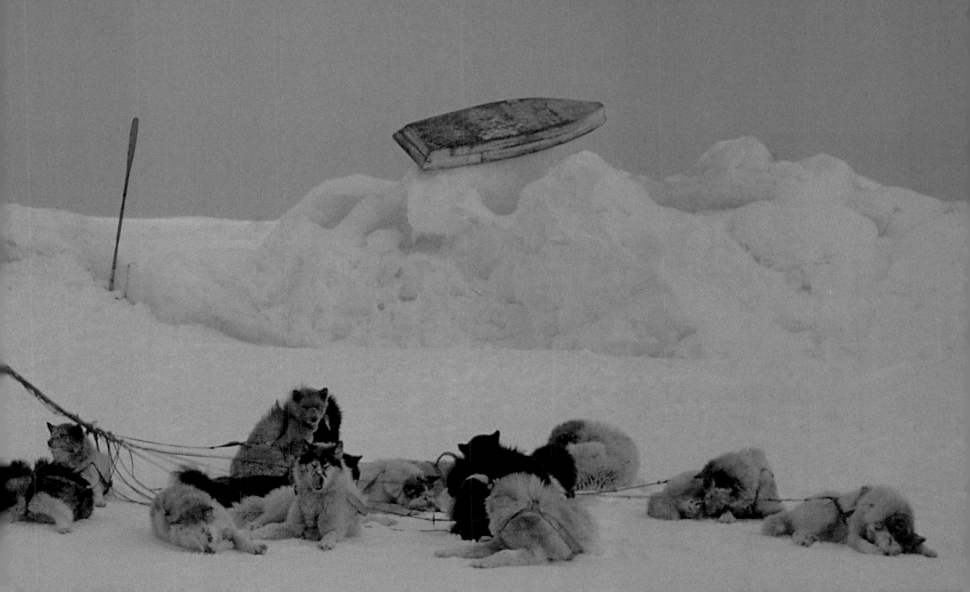

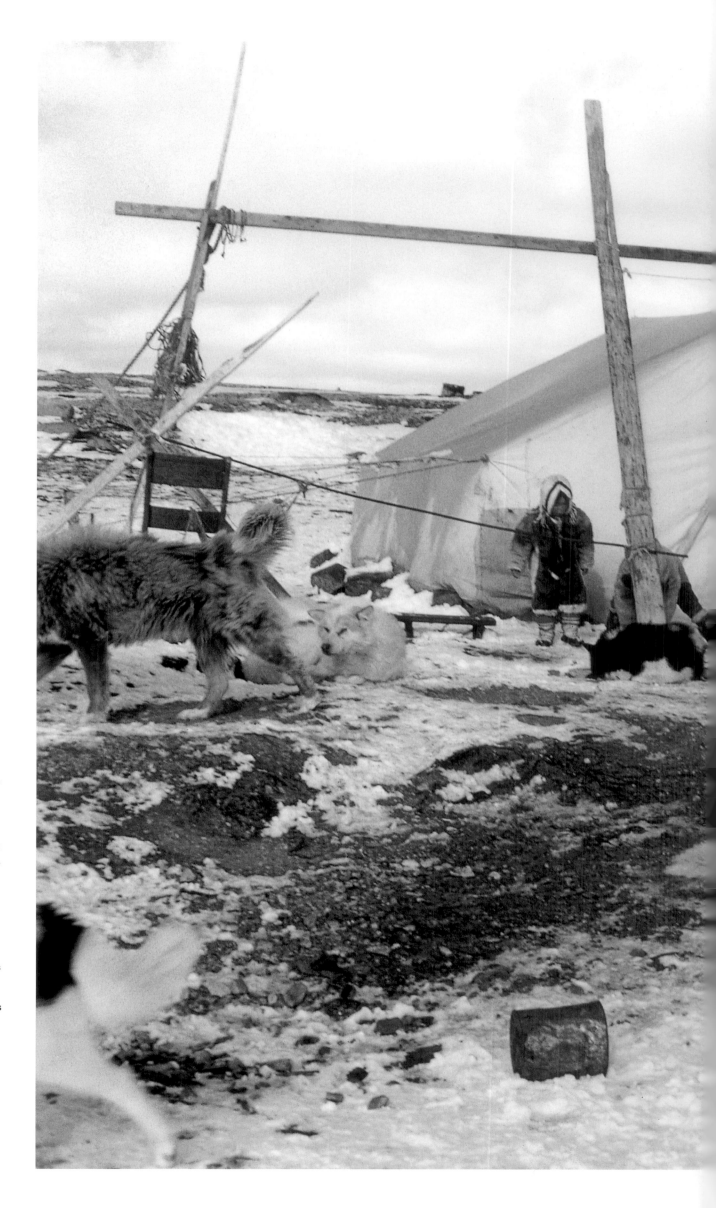

WITH THE HAUGHTY WALRUS HUNTERS OF IGLOOLIK AND Q'APUIVIK

Previous pages: Foxe Basin, north of Hudson Bay, May 1961. I am traveling with Awa, a father of seven, including three sons. Ten hours a day on the sled, seated side-by-side, moving at two miles an hour. The sled became a therapist's couch. We are going from Q'apuivik (Jens Munk Island) to Amitioke, on Parry Bay, seventy-five miles south of Igloolik. It's -4°F and the overcast sky tells us that snow is on its way. This is an empire of ice; the hummocks crack, a sound the Inuit interpret as a call of the dead. The icy emptiness breathes.

Right: Q'apuivik, Jens Munk Island, September 1960. This tent belongs to Issumatar, "he who thinks far," and Piugatu, "lover of peace," also known as Noah. My tent is at the far right. I was the only white man in this ancient walrus-hunting area. Most of the 494 Iglulimiut here are Anglican, the others Catholic. The Anglicans are strong walrus hunters; the Catholics are looked down upon as poor seal hunters.

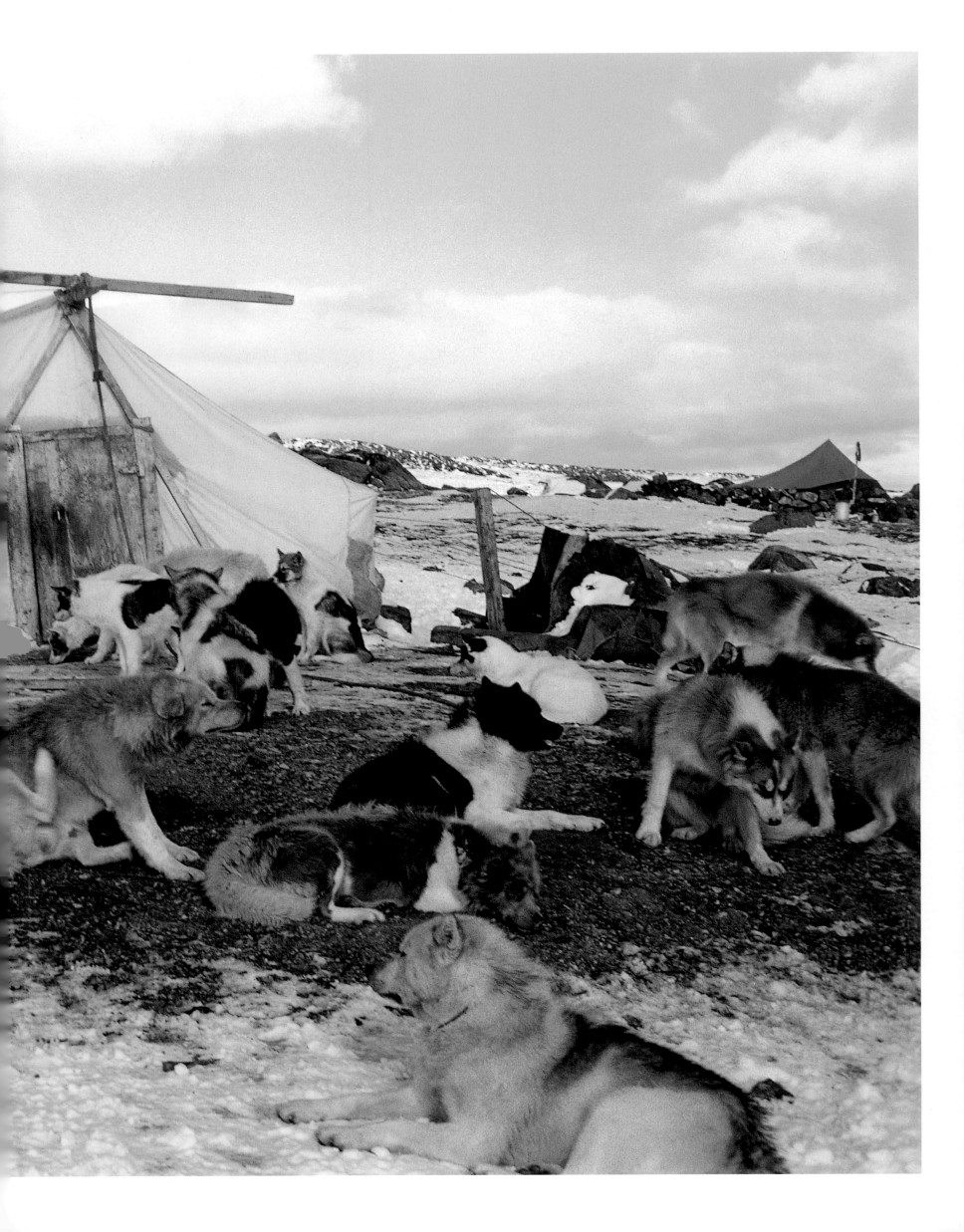

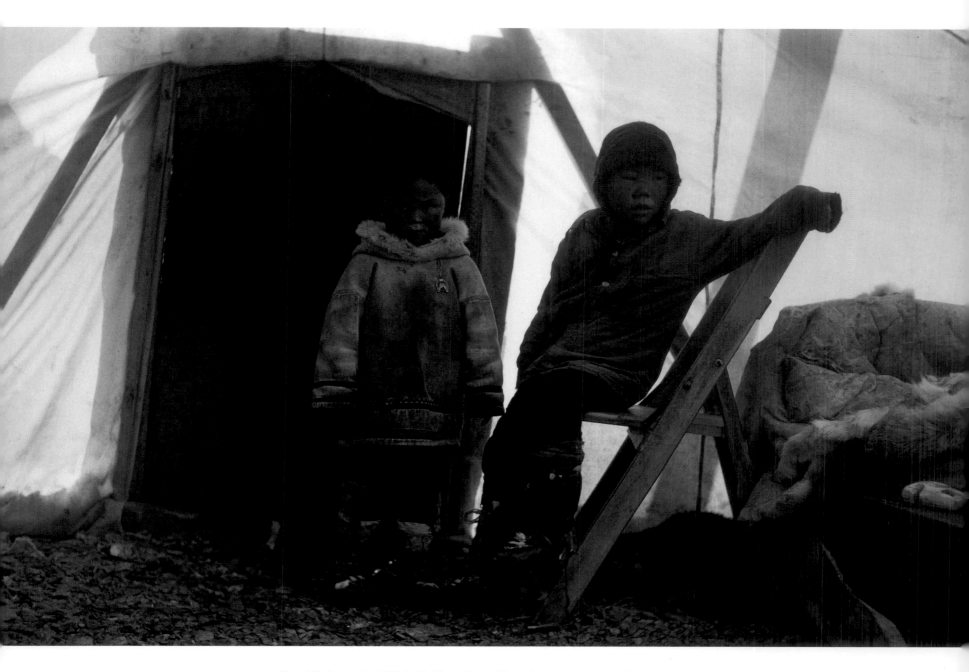

Q'apuivik, September 1960. Inside Piugatu's tent. The visitor's chair is to the left of the door as you walk in. To the right, raw salmon and quarters of raw walrus for the visitor lie over rocks. The sleeping platform is in the back. There is a subtle hierarchy at work.

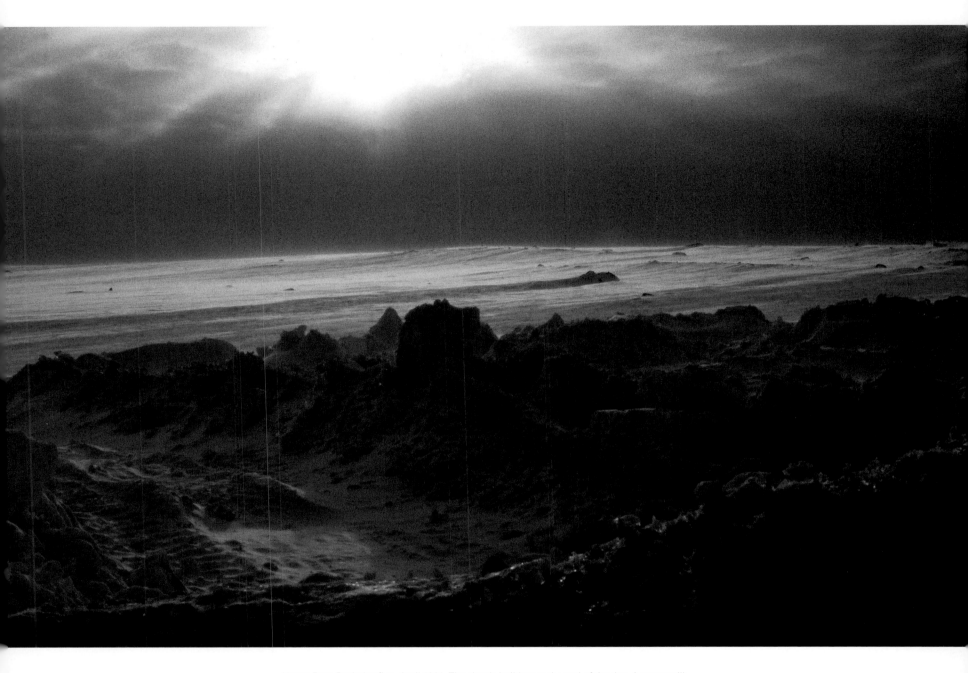

Above: Foxe Basin ice floe, April 1961. The clouds build up at the end of the day. A storm will clear the sky overnight.

Following pages: Q'apuivik, September 1960. A hundred dogs. In northern Greenland the Inuit give each dog a share according to its rank—the largest portion is reserved for the leader. Here, the abundant walrus meat and fat is distributed to all at once.

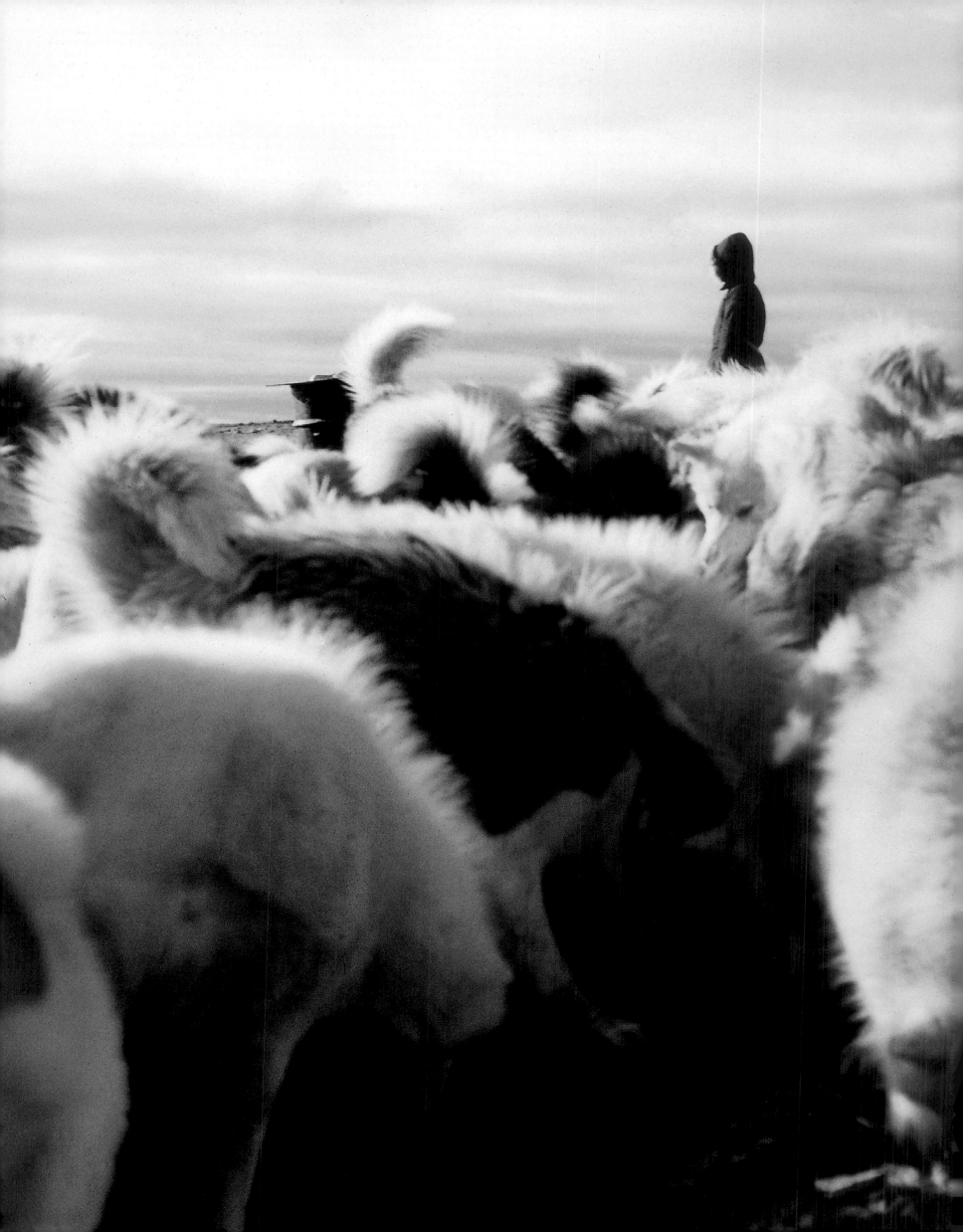

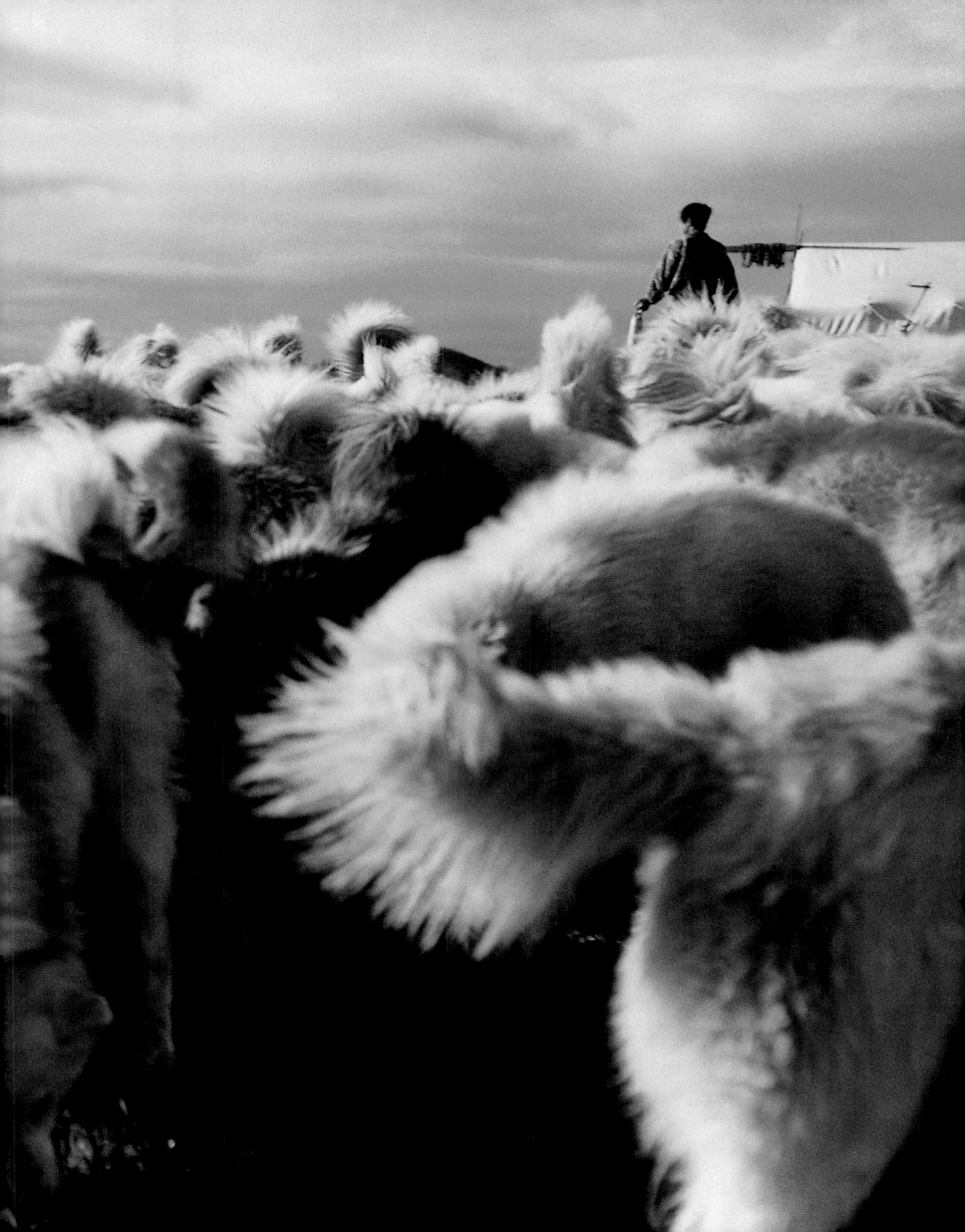

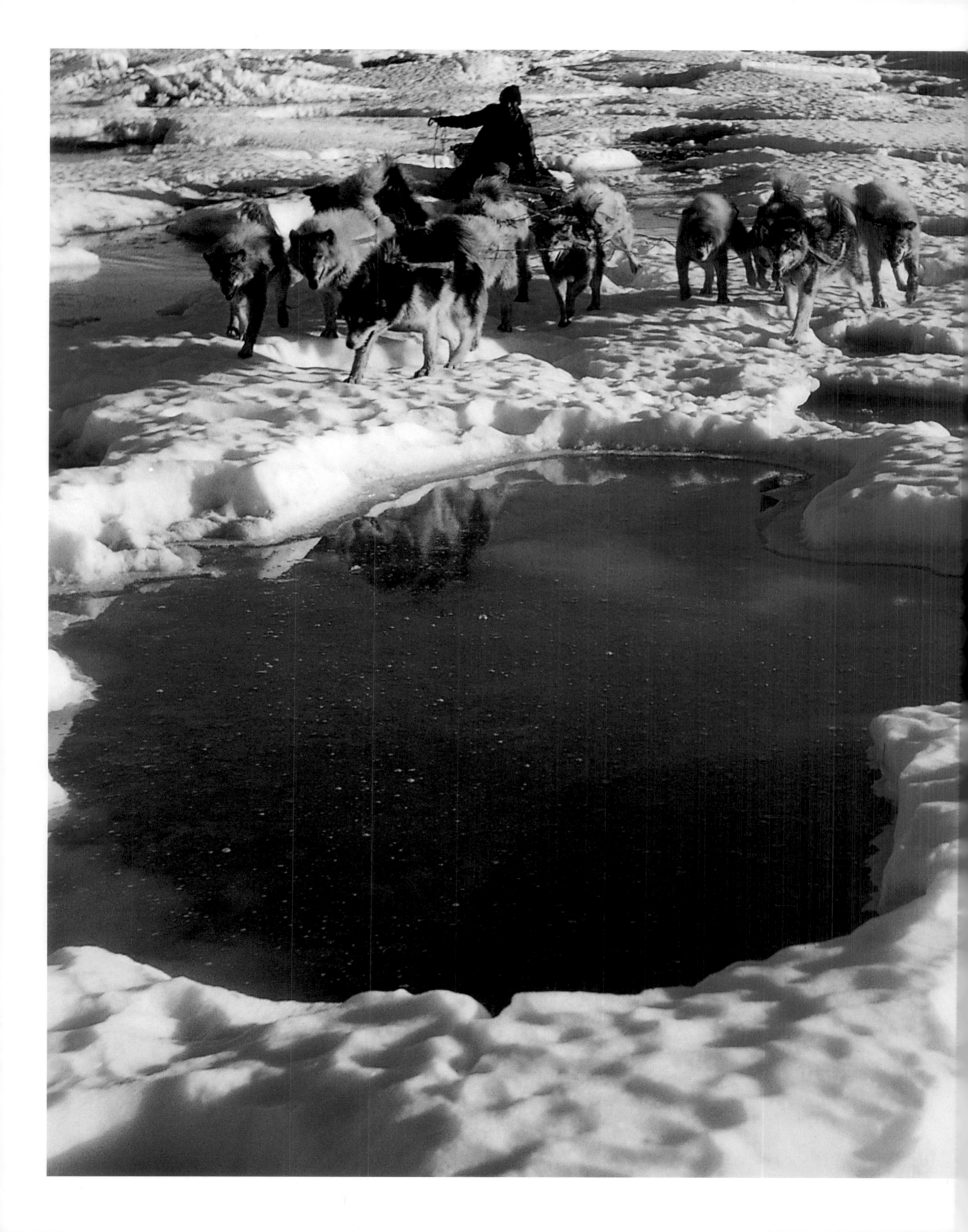

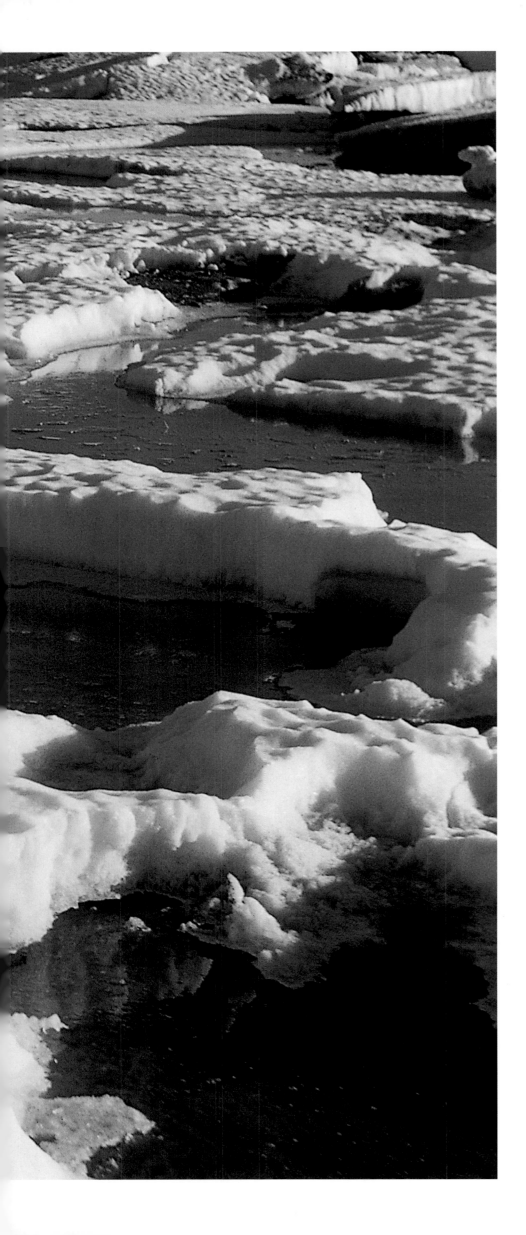

IN SEARCH OF SEALS

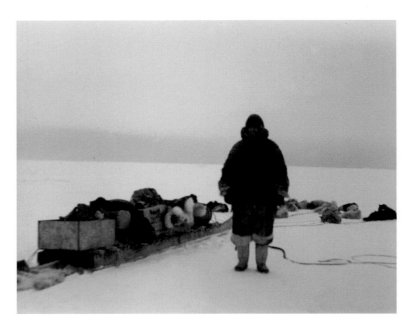

May 1961. The surface of the ice floe, still six feet thick, is melting quickly and is largely covered in water. In two or three weeks the ice will break up and become laced with wide channels.

To study the region's microeconomic system, I visit every village, every igloo. The Igluligmiut: 494 Inuit, 109 families in nine villages. I dress like them and I eat like them. I have immersed myself in this community, and can speak the language rather fluently and be well understood. Our party—thirty-nine men and women—will spend the night near Ingnertoq, south of Ooglit.

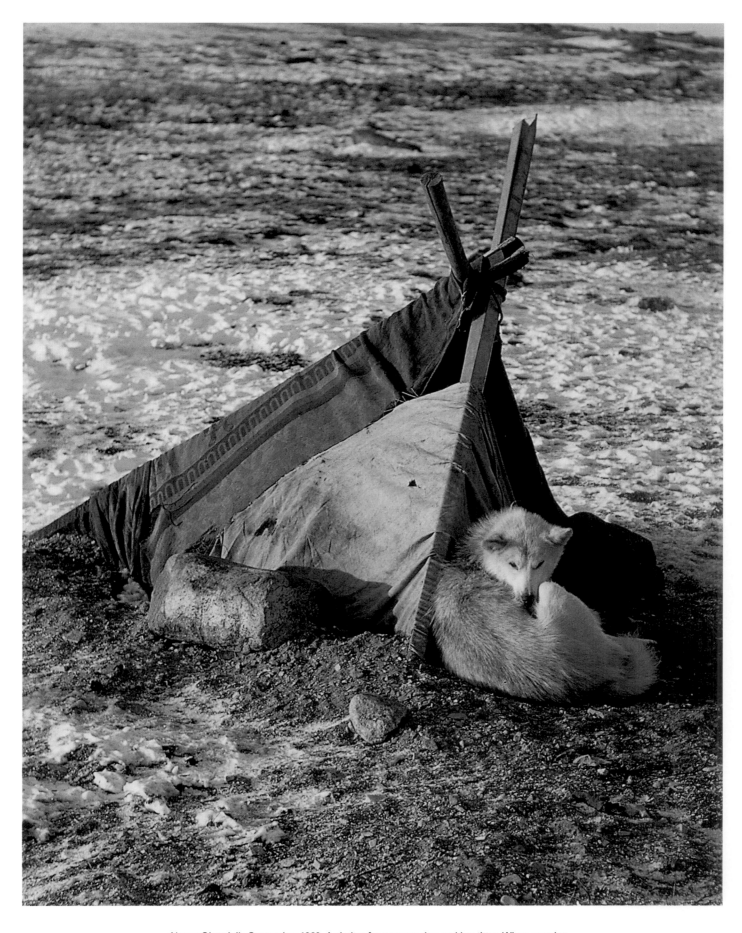

Above: Q'apuivik, September 1960. A shelter for a young dog and her litter. When puppies are born, one takes them by their front paws, their head facing you. Only strong dogs stand up; if a dog isn't strong it's killed. Over countless generations, crossbreeding has improved the race.

Right: End of September, 1960. The wind rises. Alareakuluk, seven years old, is cold and wants to get into Piugatu's tent. His pained face expresses the harshness of an Inuit upbringing. But this harshness has a purpose: it teaches children how to survive in a place where only the toughest endure.

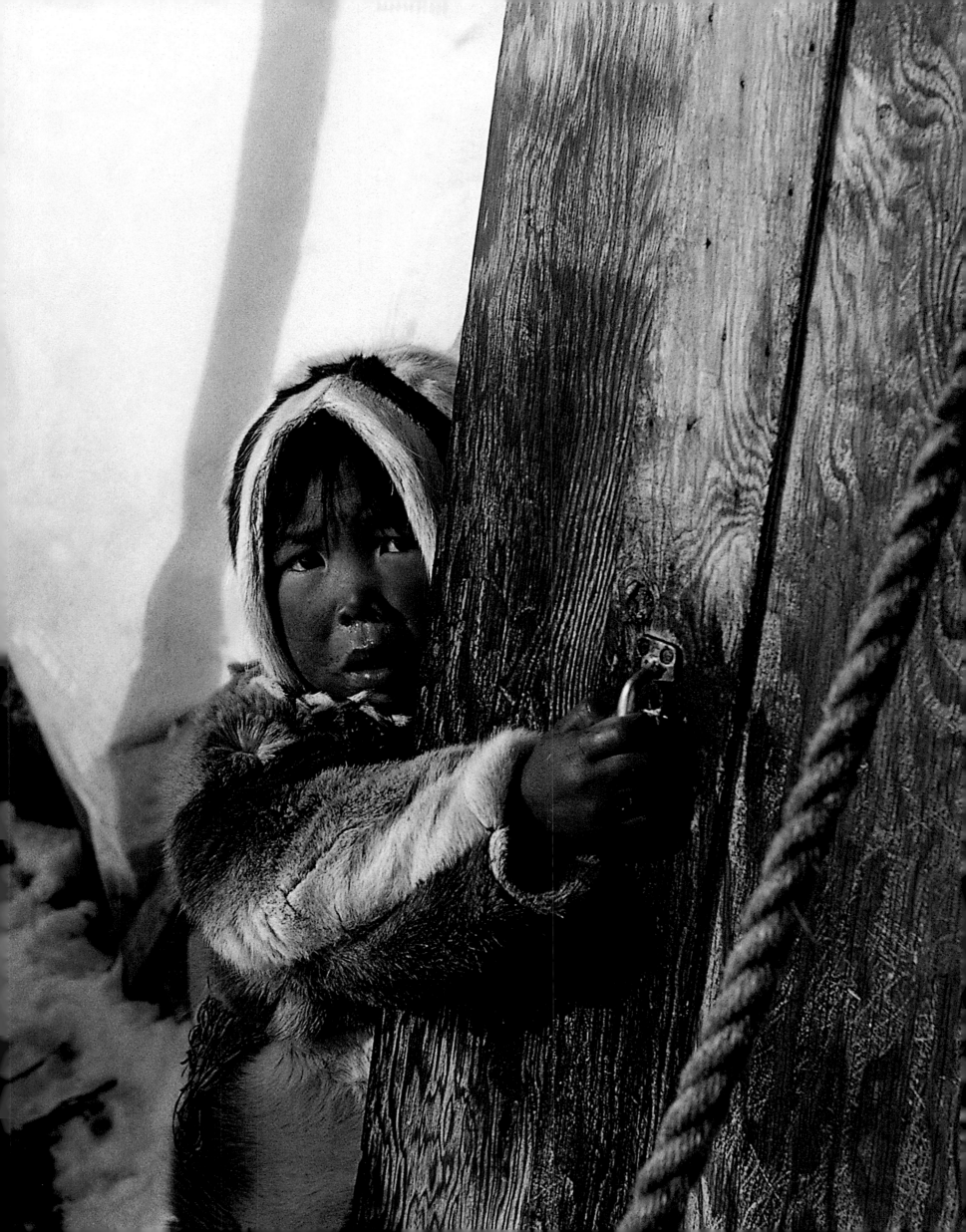

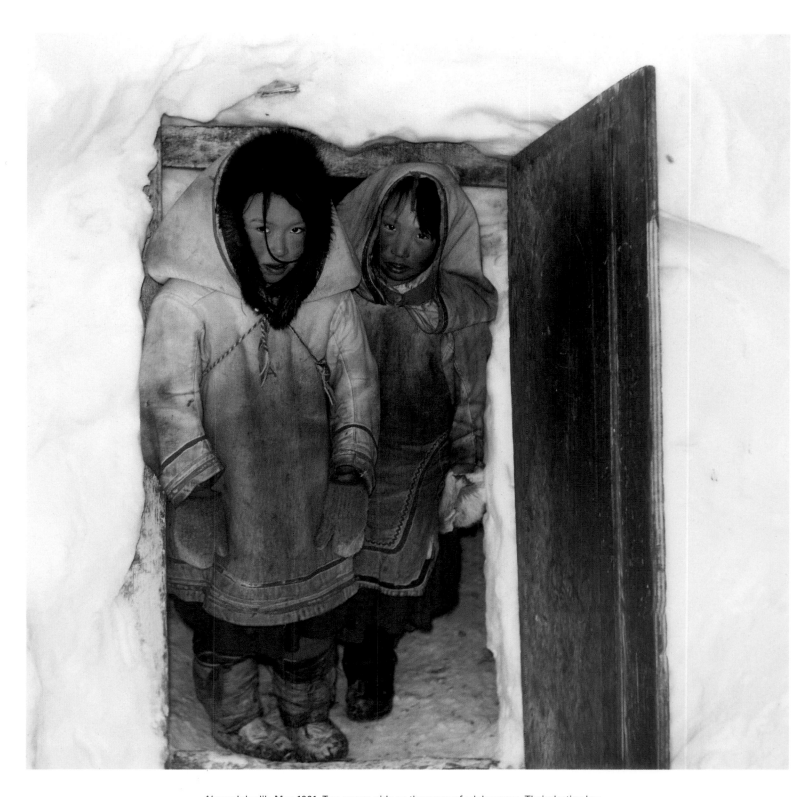

Above: Igloolik, May 1961. Two young girls on the verge of adolescence. Their destiny has already been decided: their marriages were arranged at birth.

Right: Naajaruluk, home to twenty-eight people, north of Fury Strait, August 1960. Nuliaq, twenty-three years old, is preparing her daily seal. She gives the seal a little offering of water after it is hunted, and talks to it to honor it. Then she skins it and cuts its hide to make clothes. Nuliaq's father arranged her marriage when she was born in order to increase cooperation between clans. Marriage has to be with kin, though a man cannot marry his sister, his half-sister, his adopted sister, his sister-in-law or his mother-in-law, or his first, second, or third cousin. This inbreeding diminishes the Inuit's fertility. Women are still traded, and still beaten. Yet Inuit society is secretly dominated by the women.

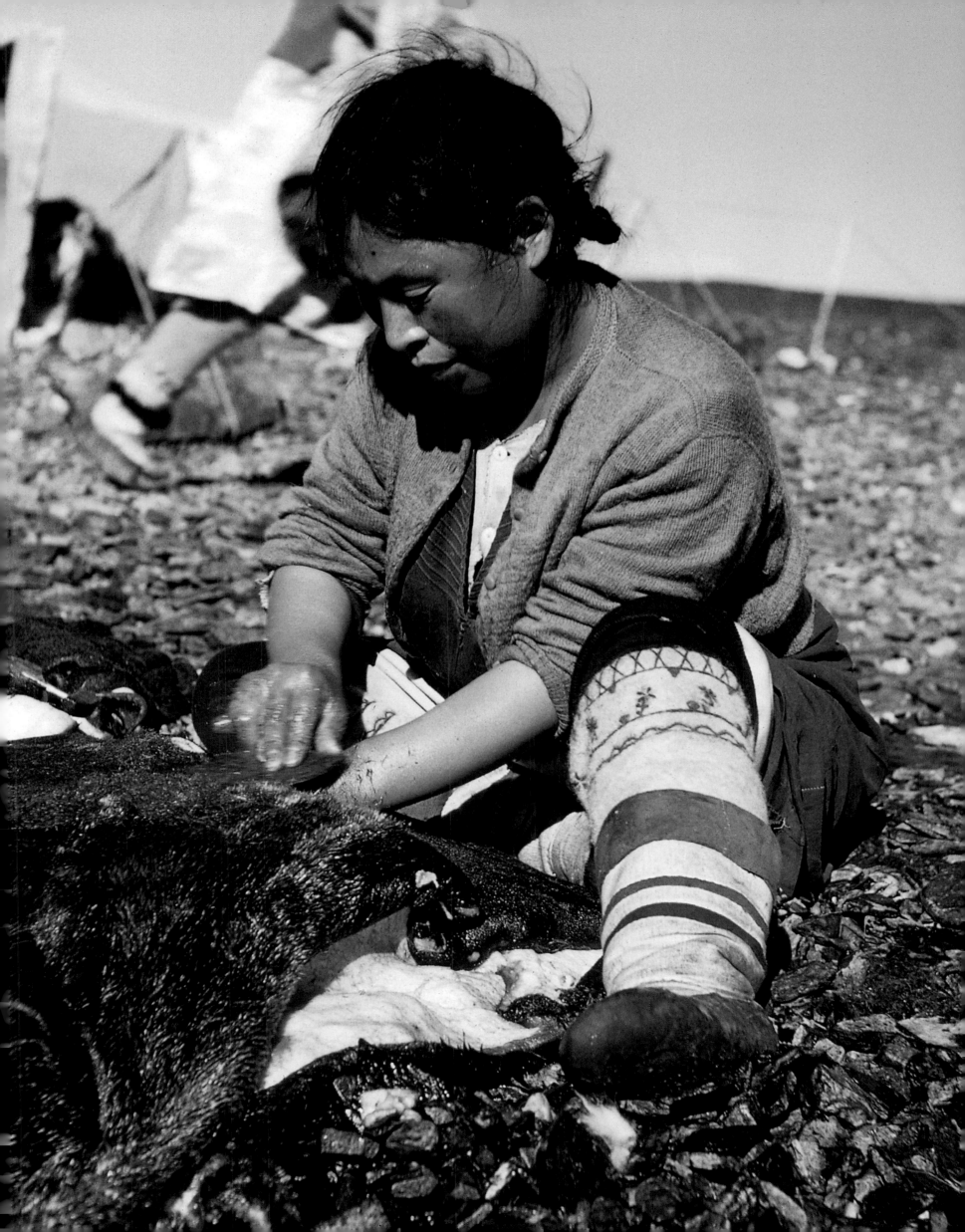

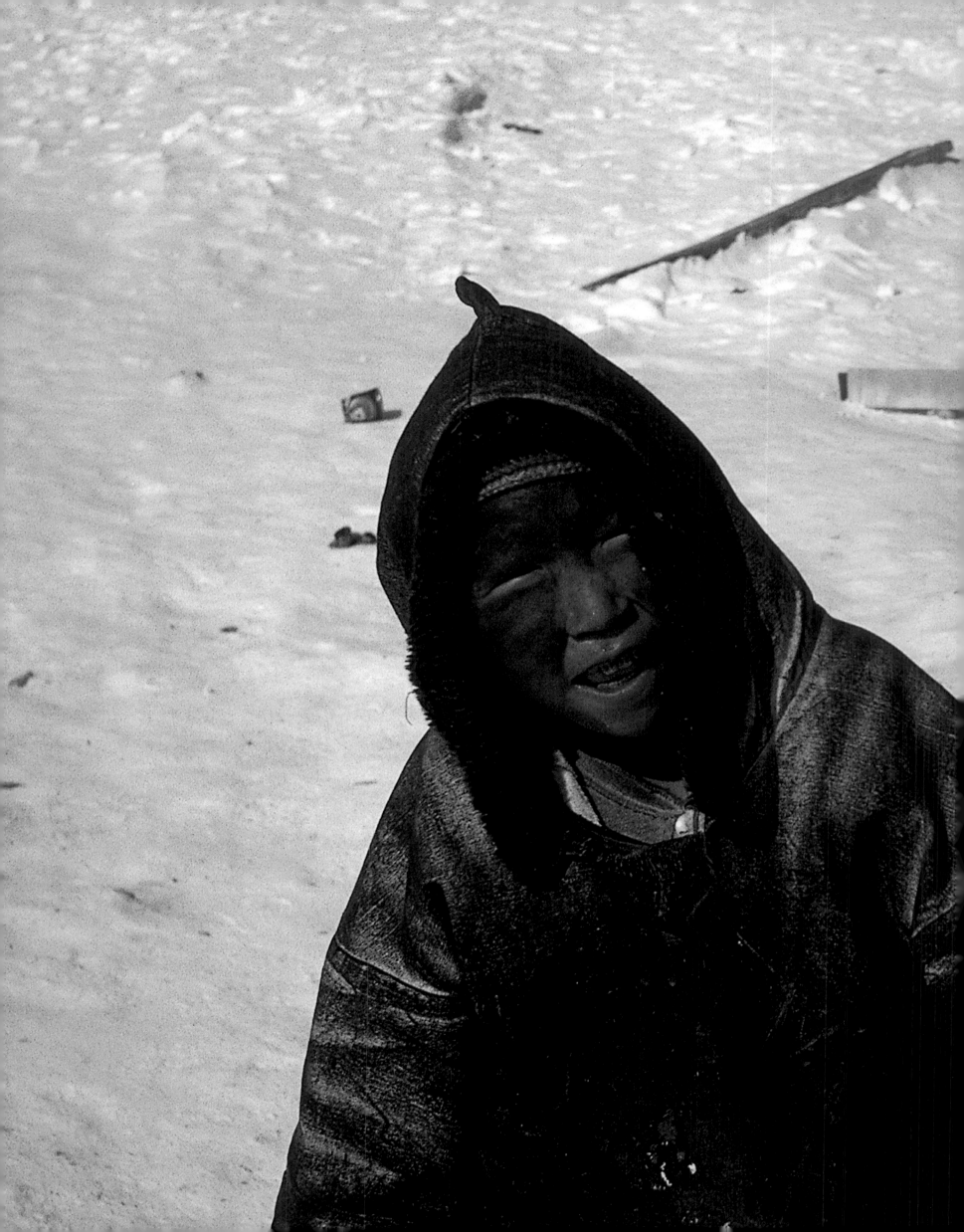

Previous pages: Q'apuivik, May 1961. An orphan, or *Illiyardjuk.* The life of an orphan is cruel. They have no family ties—a horrible taboo in this society. Inuit wisdom does not include compassion. Orphans are not allowed to sleep in a tent or even an igloo, only in the hallway. They eat leftover scraps and help each other survive. Yet one of the Inuit's great heroes, Kiviok, is an orphan. In stories of Kiviok, he never gives up and is never fooled by the evil spirits. He listens to his *tuurngaq,* the close spirit that guides him. He trusts his destiny.

I took a special interest in the outcasts. There was one, in Igloolik, who hated being Eskimo. He didn't have a kayak or a dog, a tent, rifle, or harpoon. He dreamed of becoming a taxi driver. This scrounger had one advantage: his wife was a nymphomaniac. He begged and was humiliated from group to group. Everyone distrusted him—and respected him. Perhaps he was filled with the spirit?

Right: Q'apuivik, September 1961. The first winter storm lies on the horizon. The Inuit are masters of raising children. An Inuit child is never beaten. He listens and observes and never asks questions. The unspoken, intonations, and humor punctuate his life. Children are separated by sex as early as age eight, both in games and in everyday life. Inuit children never rebel, neither against their parents or the group.

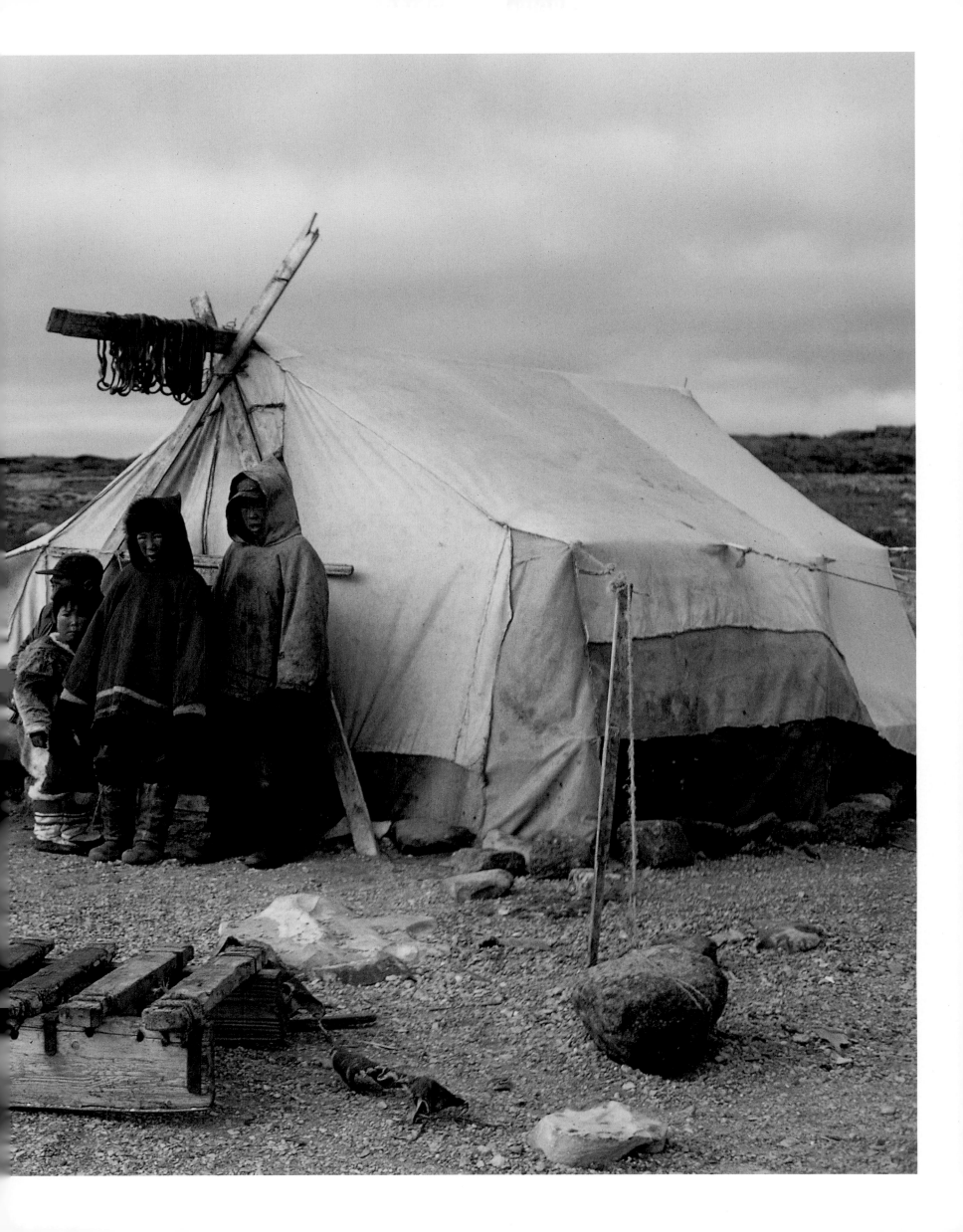

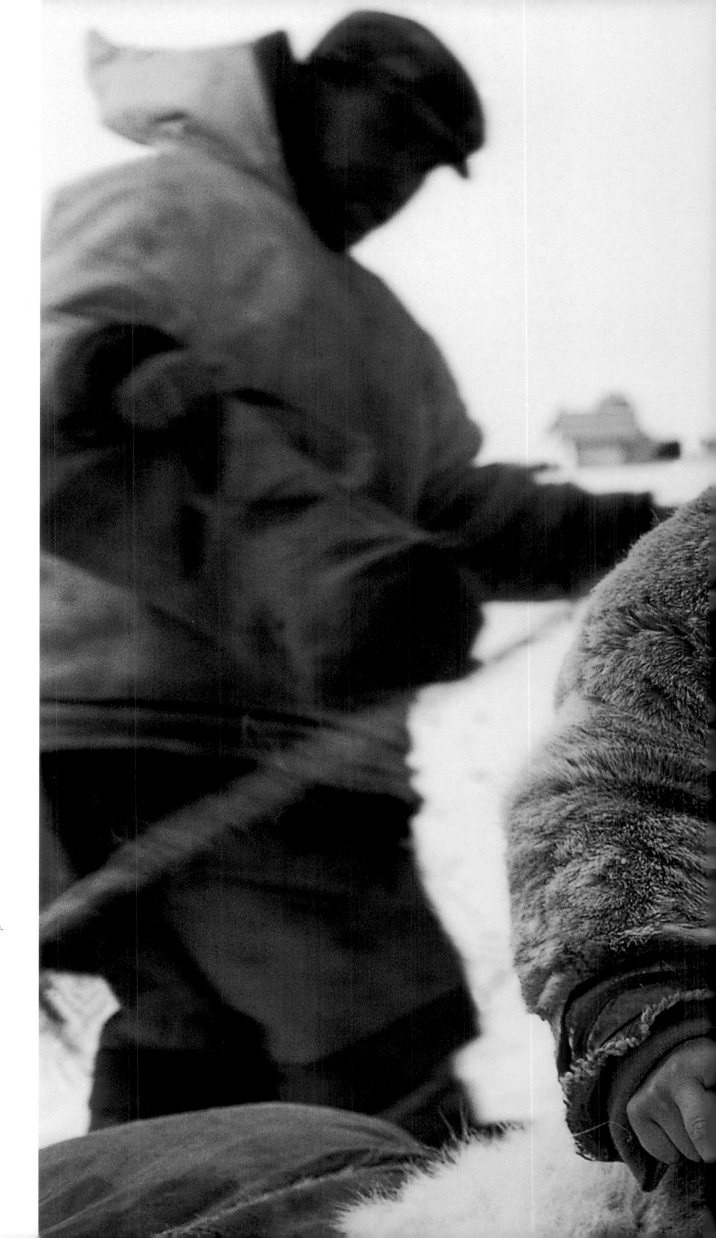

Igloolik, May 1961. The rigorous Inuit education. This boy is returning from a two-week caribou hunt with his father, made more cruel by -22°F temperatures and a blizzard.

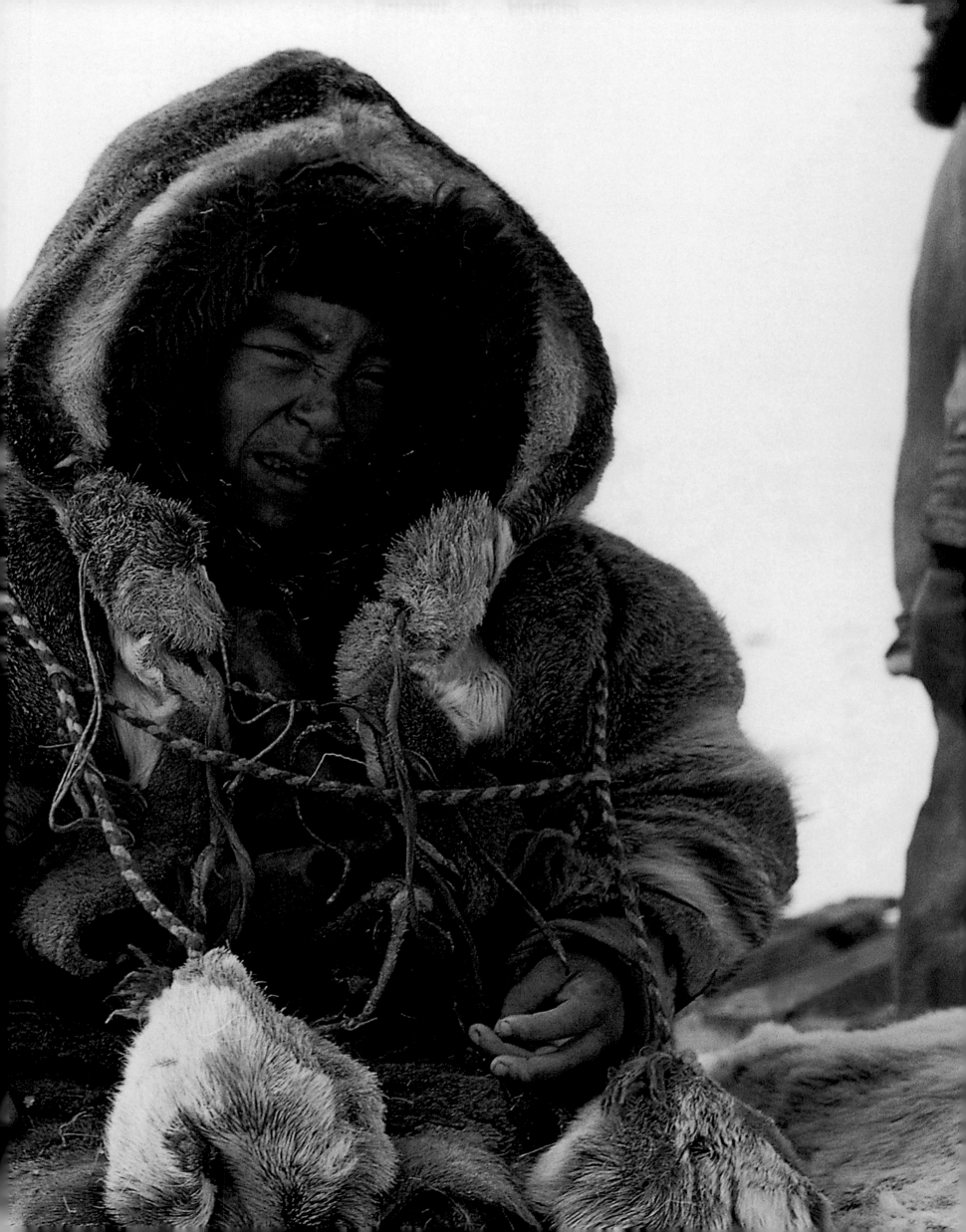

WHAT DO LITTLE GIRLS DREAM ABOUT?

Above: Igloolik, May 1961. The dreaming age. This little girl is playing with dolls. Rocks outline an imaginary igloo where she pretends to be a wife and a mother.

Right: Naajaruluk, August 1960. The wife of my companion Awa. During my missions from village to village, igloo to igloo, on the ice floes of Hudson Bay, Awa proved to be a diplomat, helped by his wife's encouragement and advice.

Following pages: Usuardjuk, "the little penis" or "the little cape," May 1961. Four igloos, seventy-five miles from Igloolik. Early morning. This picture was made inside a *q'angmat*, a rectangular room meant for a single family, measuring about 215 square feet. Eleven people sleep in their places, assigned by rank; I

sleep near the middle. The plywood came from a small U.S. radar station not far away. The five-foot-high walls are partially covered in newspaper; outside, they're surrounded by a foot of peat and a nine-inch snow wall. A tin can is used as a collective urinal. There are bottles of ketchup, powdered milk, boxes of tobacco. The Igluligmiut aren't poor, despite appearances. Their country has more wildlife than northern Greenland. In 1959 Awa hunted forty-nine foxes, sixty-two ringed seals (which fetch $3 to $5 a hide), twenty-seven large bearded seals, and ten caribou—and that's not counting birds. The last famine here was in 1932. Children had to chew on strips of seal skin.

By 1960 their ancient anarchic-communal society was faltering. The Inuit were confused. Would life be about getting rich?

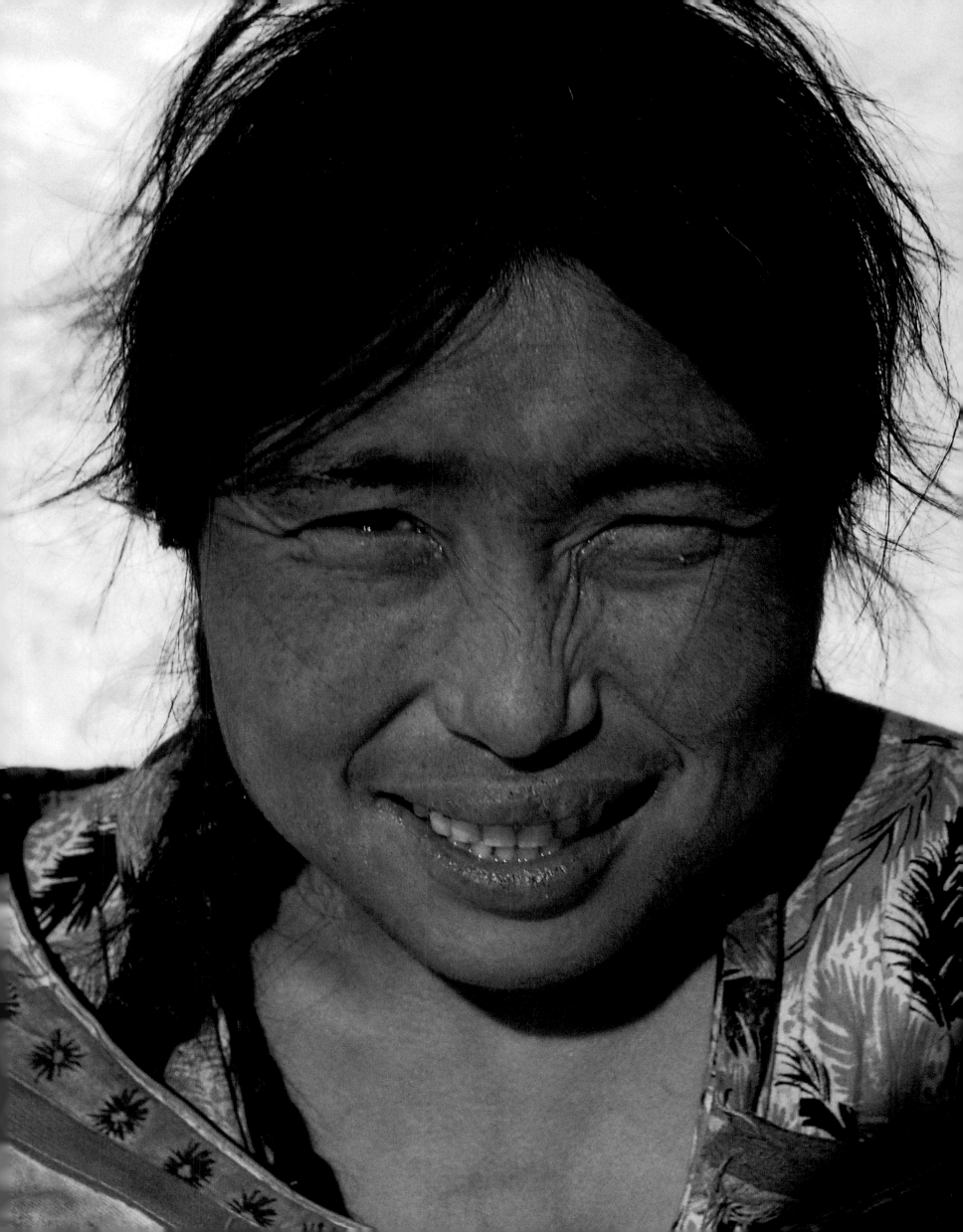

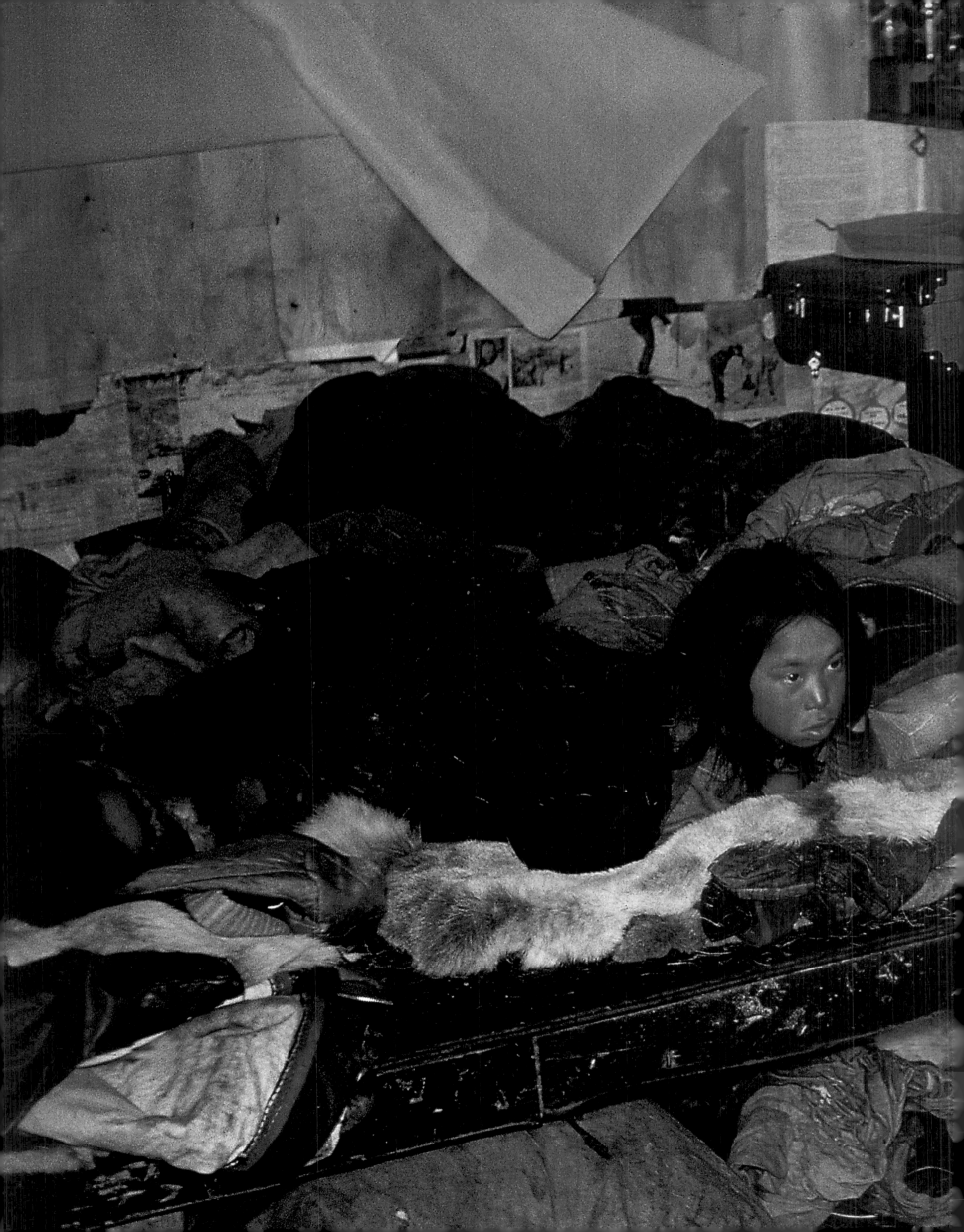

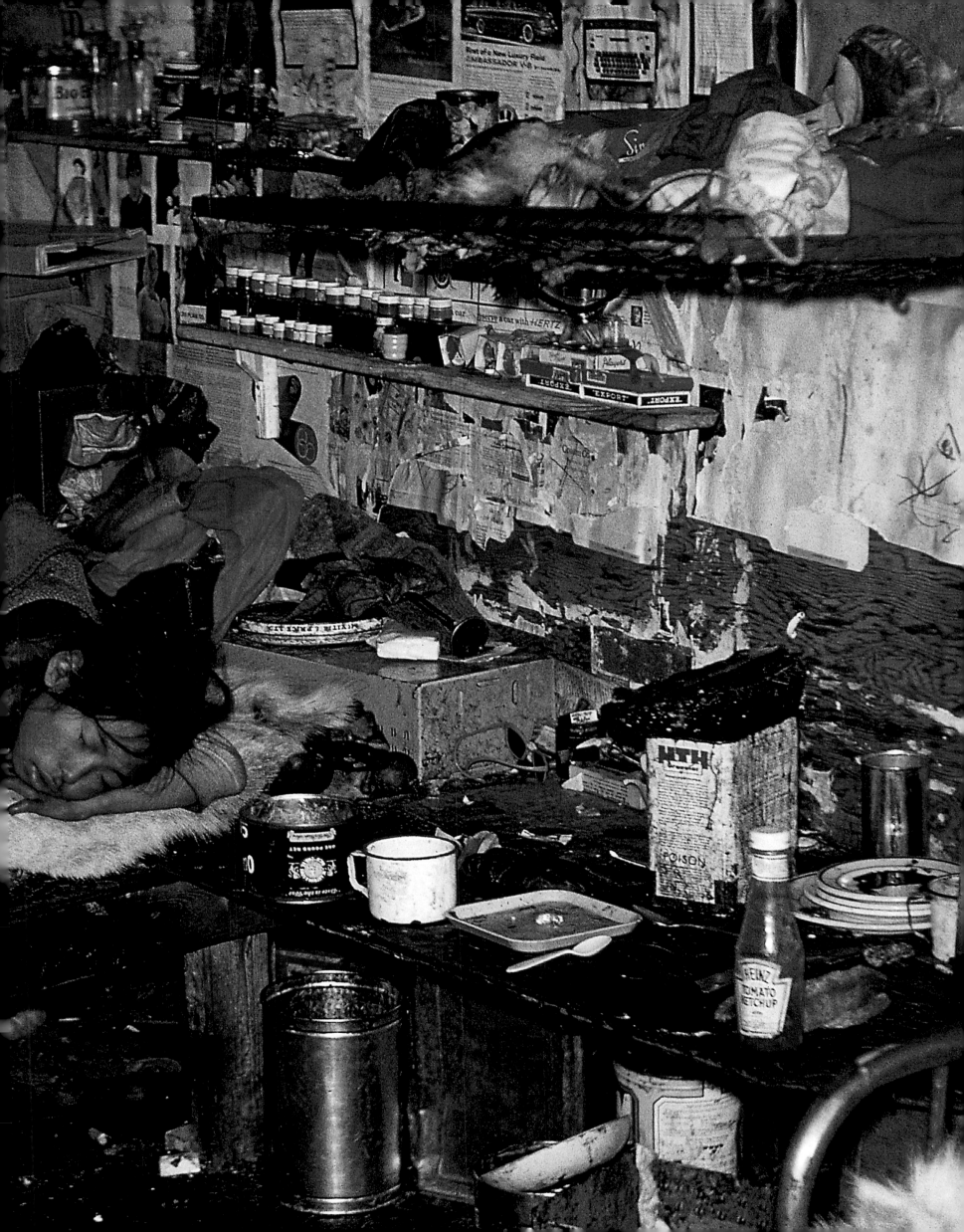

FOUR TO SIX POUNDS
A DAY

Our main source of food was raw seal, walrus, and reindeer. We ate it frozen or sometimes boiled, and we also ate the fat. We drank five to ten bowls of tea each day, plus another half-gallon of water. There was no alcohol. This diet, rich in protein and fat—"good" fat—protected the Inuit from cancer and cardiovascular disease. (Dr. Hugh Sinclair discovered these health benefits in the 1950s.)

Igloolik 1822–23: "It is considered extremely friendly for two men to exchange wives for a day or two, and the request is sometimes made by the women themselves. These extraordinary civilities, although known, are never talked of, and are contrived as secretly as possible. . . . Although no Eskimeaux can have the least certainty of being father of his wife's children, yet if she brings progeny, he is very indifferent as to their legitimacy, and considers them as undoubtedly his own." (Captain G. F. Lyon, *The Private Journal of Captain G. F. Lyon, of H. M. S. Hecla, During the Recent Voyage of Discovery Under Captain Parry*, 1824)

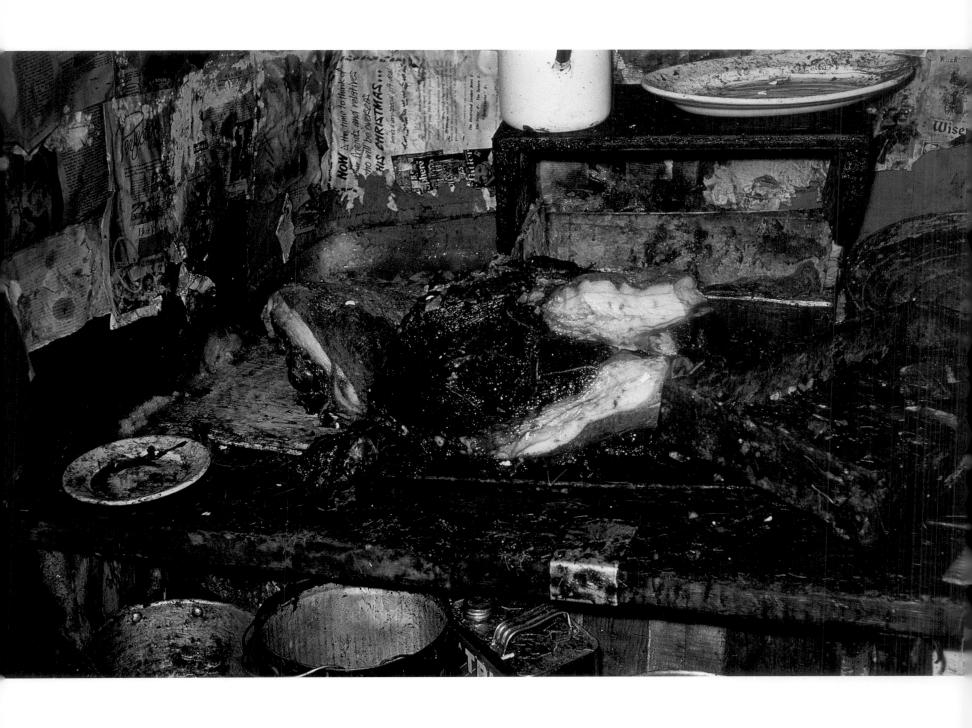

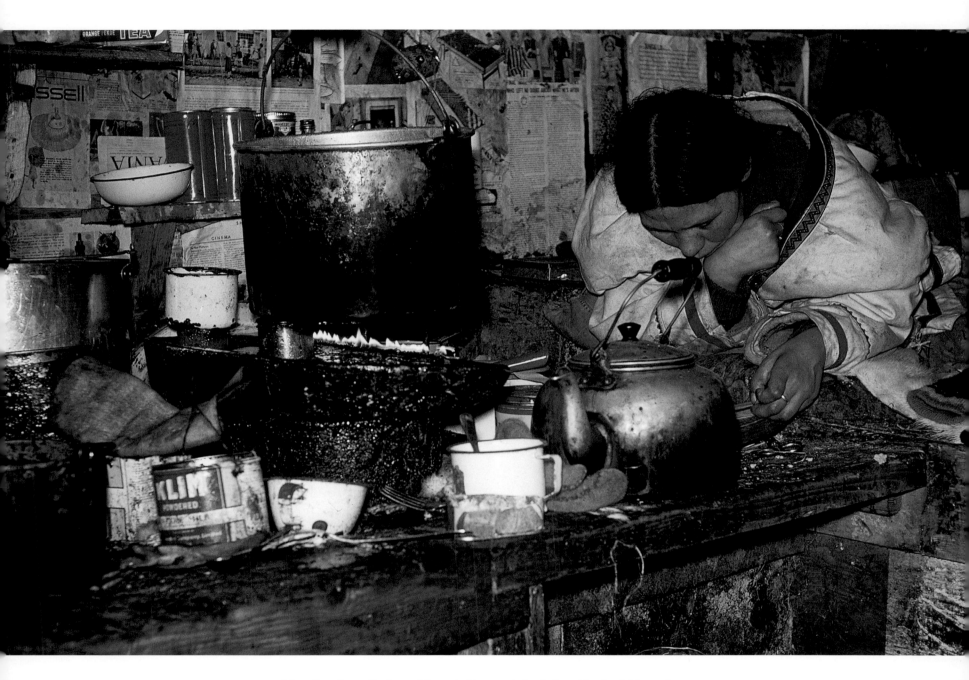

A long time. *Ikuma*, the flame of the seal oil lamp, sets the rhythm of the day. It takes an hour or two for the pot full of icy water, meat, and frozen walrus fat to boil.

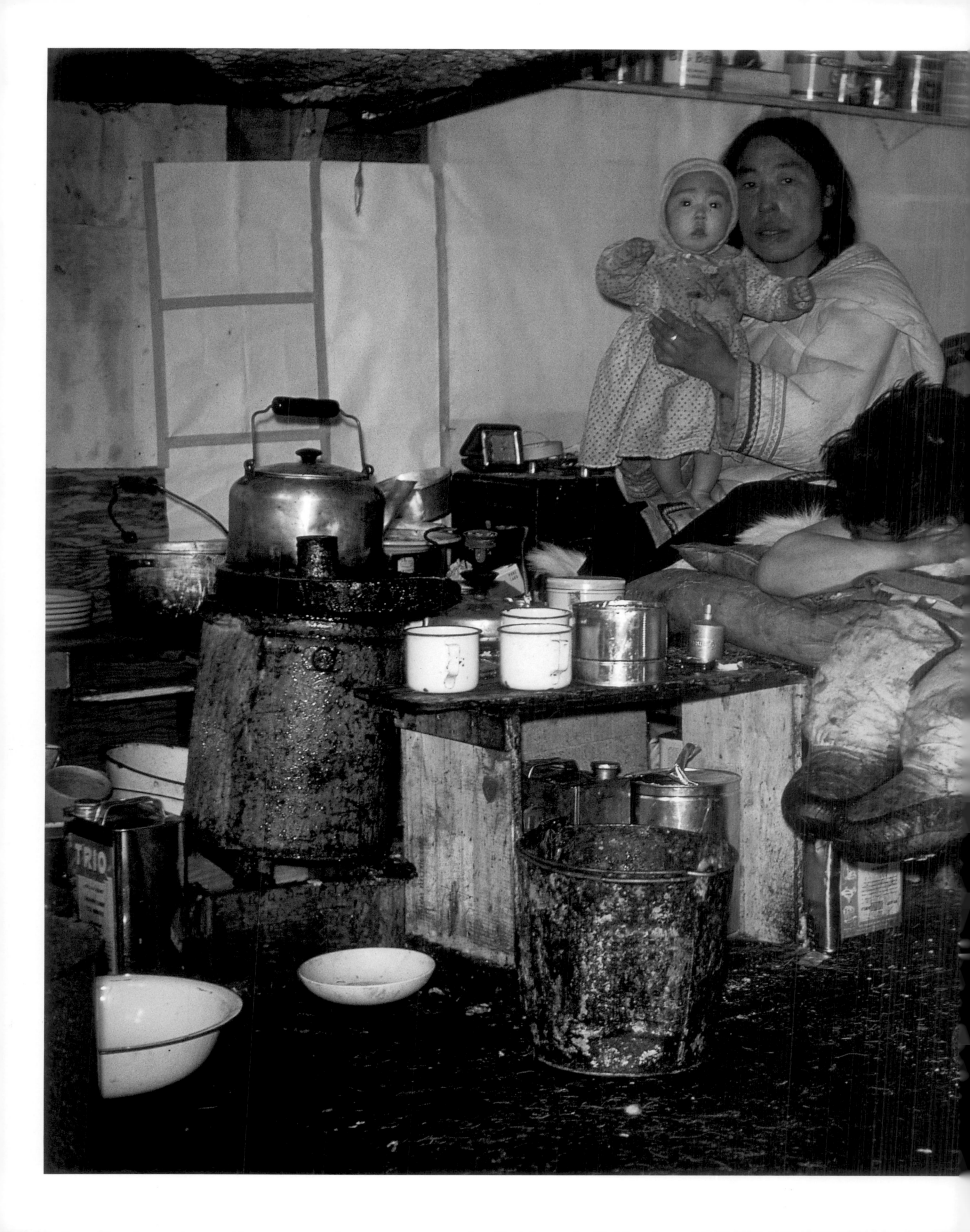

The igloo is lighted and heated by two half-moon-shaped seal oil lamps made of soapstone. One sleeps more in the winter here: twelve hours a day. We wake around noon to take advantage of the sun, which hovers just above the horizon. During the summer and during caribou hunts we'll sleep just two or three hours.

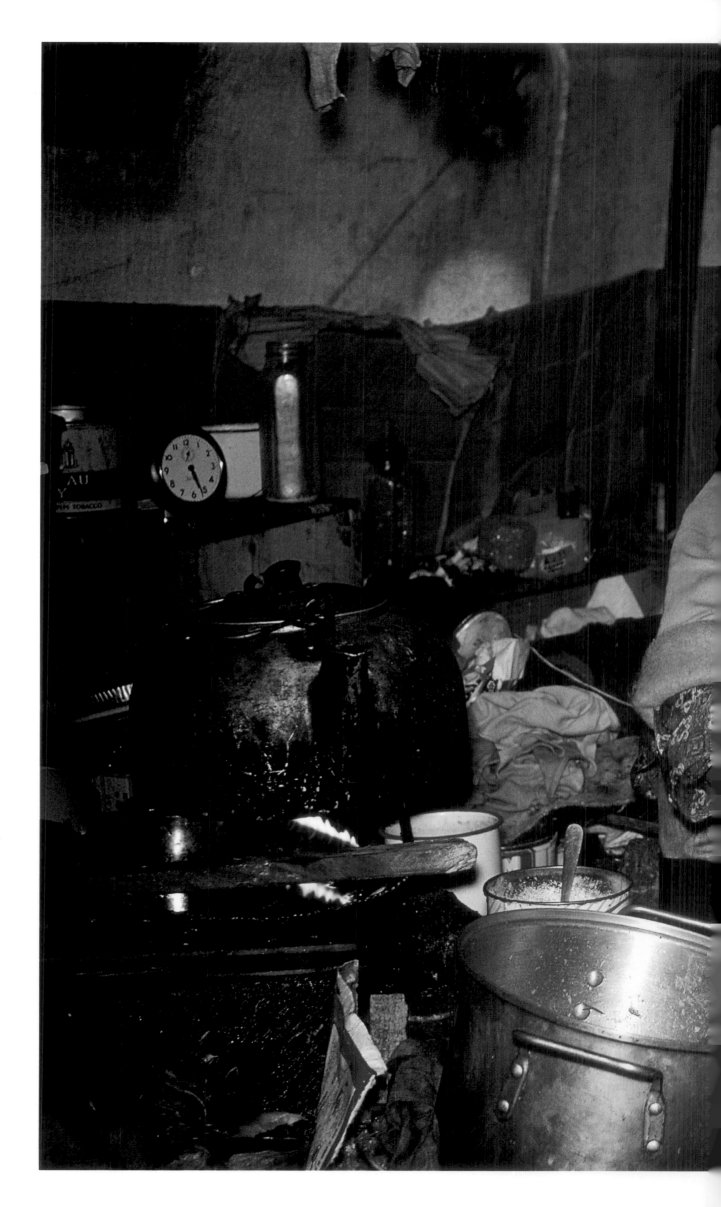

Usuardjuk, Igloolik, May 1961. In a famous speech at the Canadian House of Commons on December 8, 1953, Louis Saint-Laurent, the country's visionary prime minister, made this confession: "We have governed the vast lands of the Far North with an almost continuous state of absence of mind."

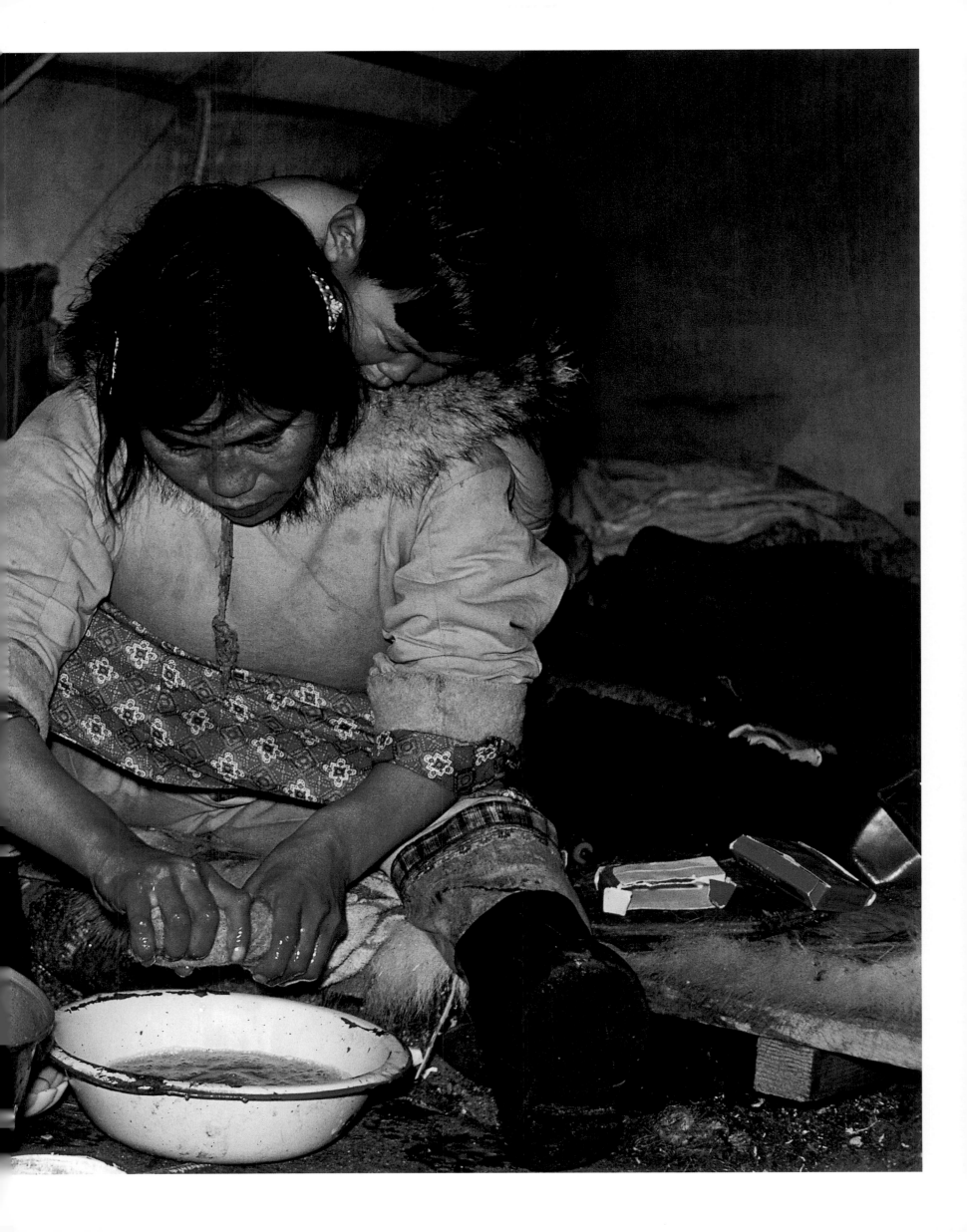

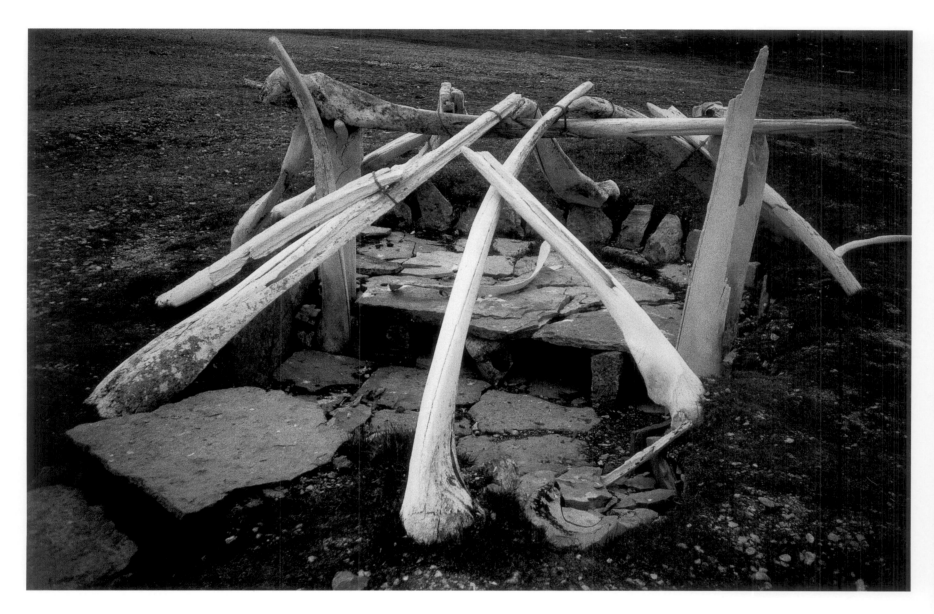

Above: Cornwallis Island, August 1995. The prehistoric igloo of a nomadic hunter of the Dorset culture, dating to about 600 A.D. He would have slept sitting up, huddled to fight against the cold.

Right: South of Igloolik, May 1961. This modernized igloo measures about 215 square feet. The walls are made of stone and peat surrounded with snow. Inside, the walls and floor are made of plywood; the single sleeping platform is also made of wood.

Right and following pages: South of Igloolik, May 1961. Two cultures clash. In a *q'angmat* made of peat, snow, and plywood, there is a modern luxury item: a manual sewing machine, bought with money a husband earned as a part-time, unskilled worker at the American military base.

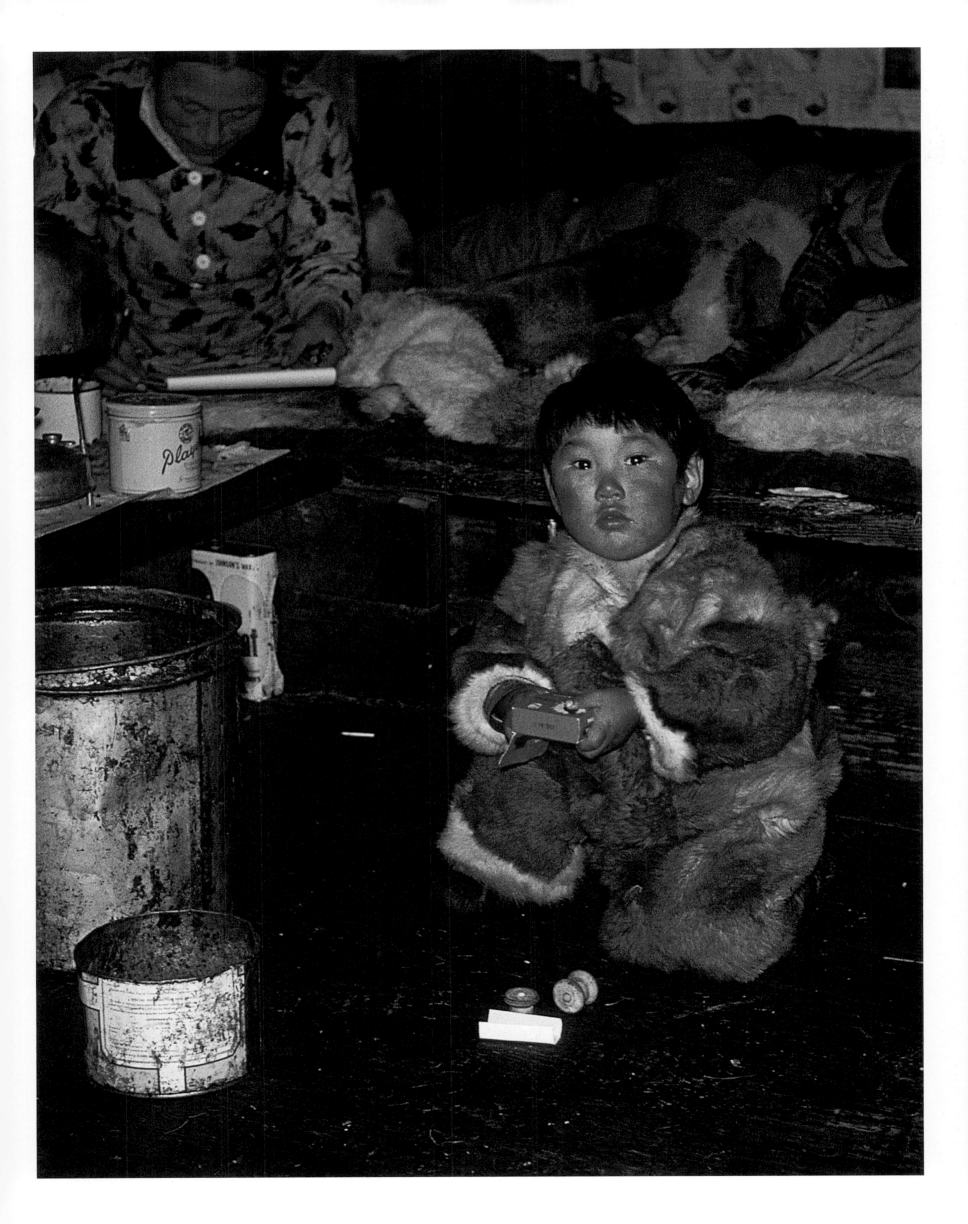

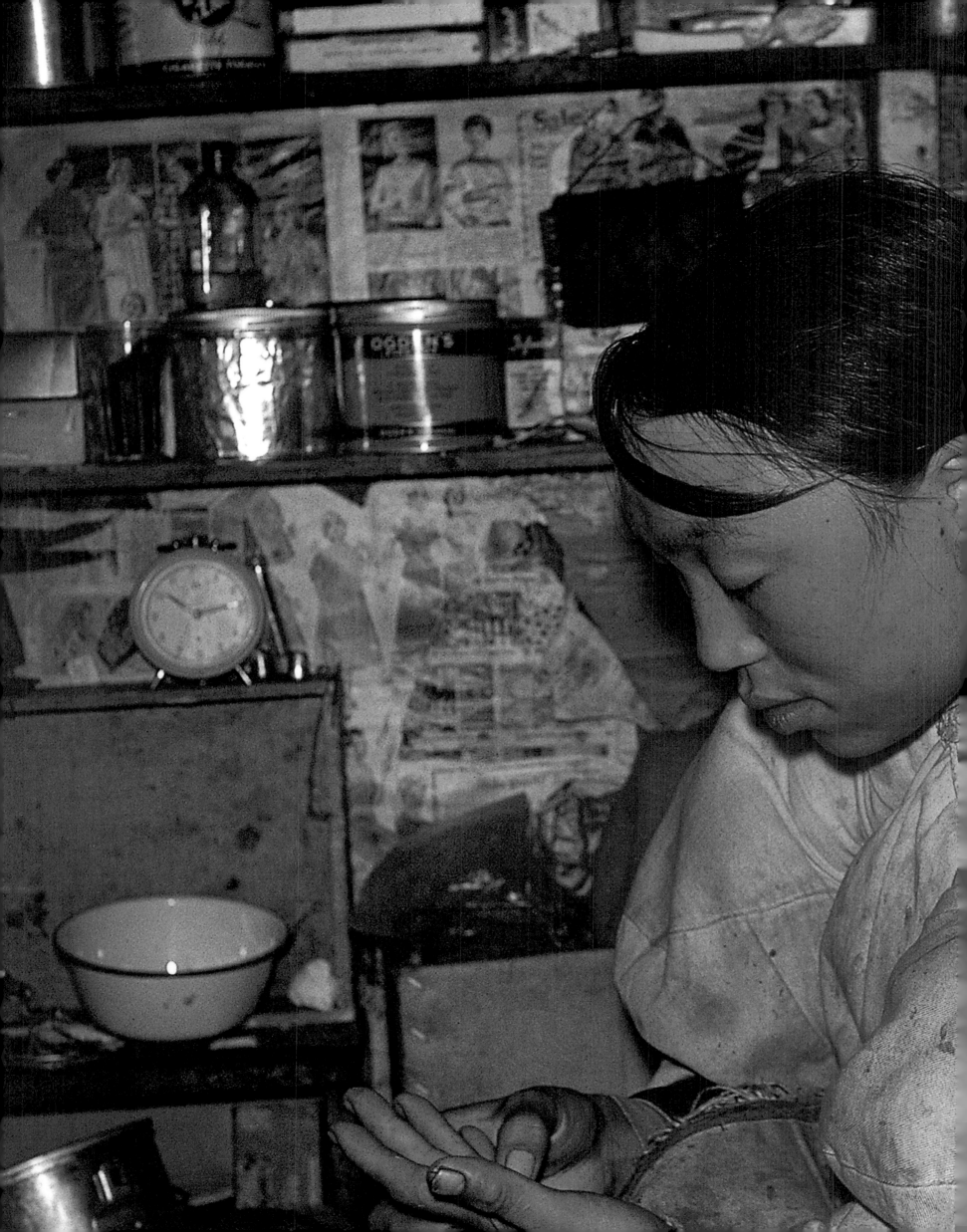

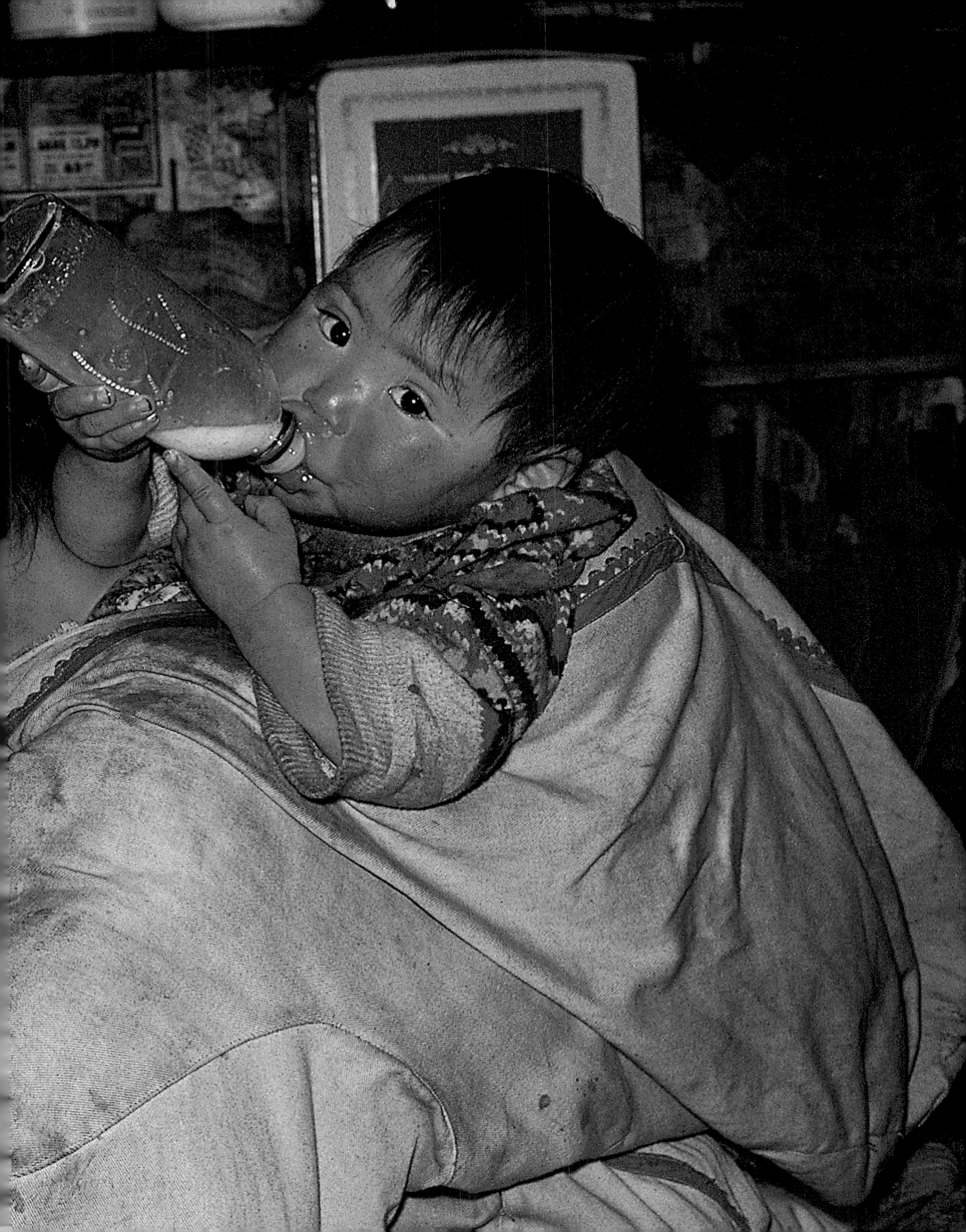

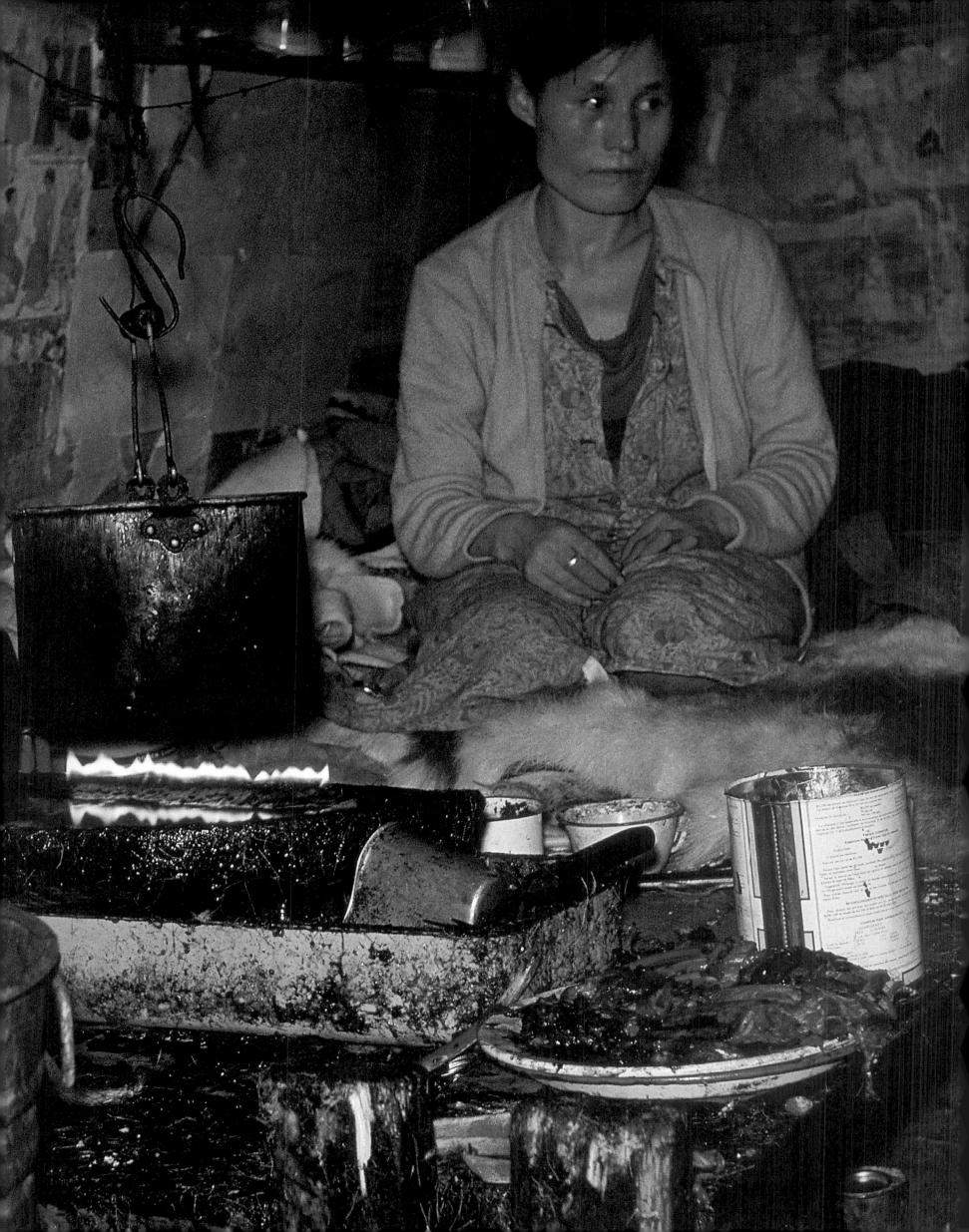

TOMORROW?

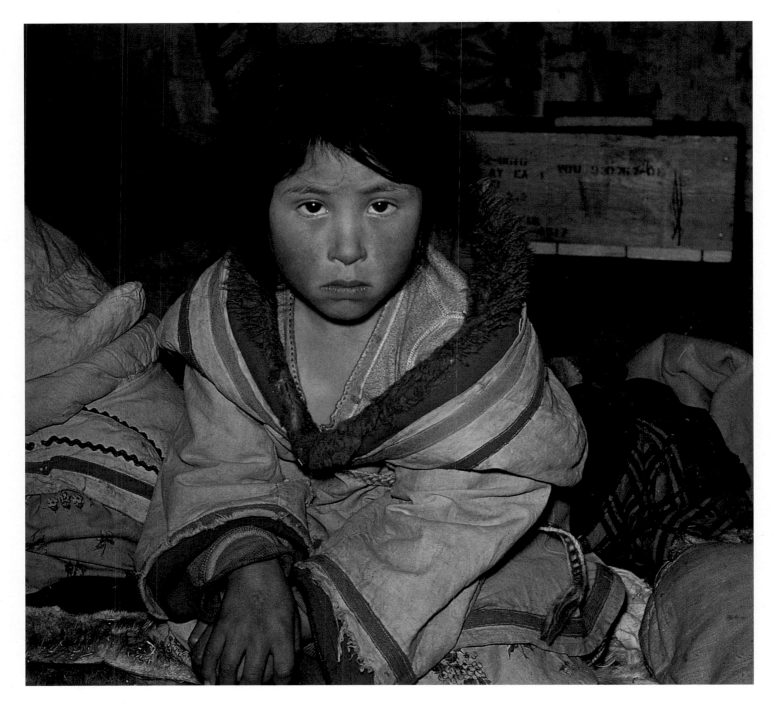

Above: What will happen to her tomorrow? Alcoholism? Violence?

Left: Usuardjuk, Igloolik, May 1961. Life is still hard, even more so for single women. Since 1950, women who live to 65 can receive a pension: $55 a month. But as the Inuit's traditional life disappears, so does their strength. A quarter of the population was struck with tuberculosis, and some by polio. Women had an especially high death rate: at 50, they are elderly.

"February 1823: On repassing the huts at Igloolik I went to see the parents and widow of Picooyak, who lived together in a hut of snow in a state of very great wretchedness. . . .and I could plainly perceive that her misery in great part proceeded from the robbery of most of her property, as described by [David] Crantz to be the usual fate of widows in Greenland." (William Edward Parry, *Journal of a Second Voyage for the Discovery of a North-West Passage from the Atlantic to the Pacific*, 1824)

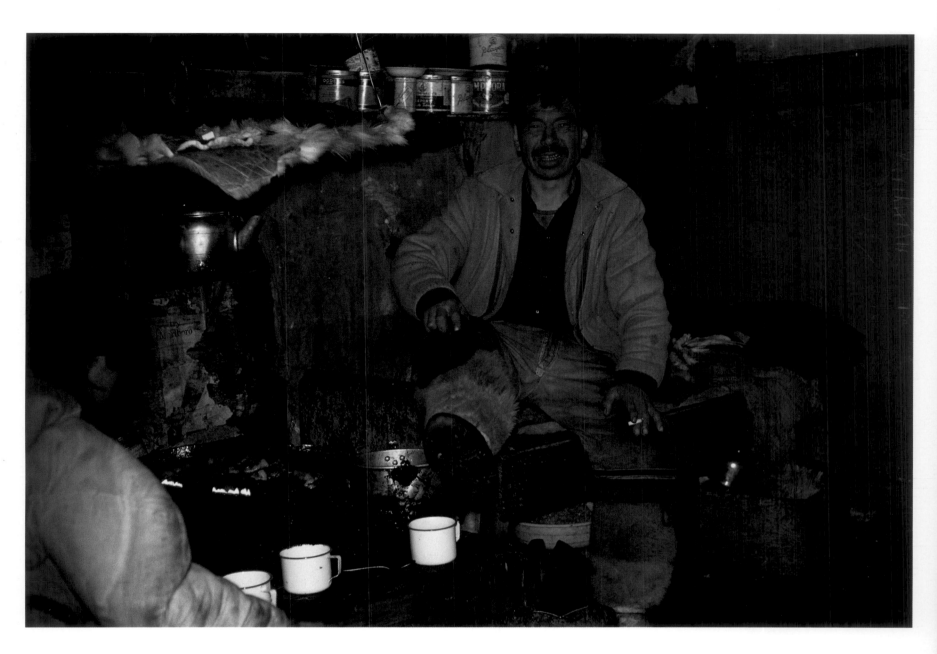

Above: Q'apuivik, September 1960. In private, Eskimos scorn the *kabloona*, the white people, who they think of as conquerors. In August 1960, a missionary delivered a long speech: "Therefore disperse . . . defend yourselves . . . game is abundant . . . you are rich . . ." To which Marc Idganguak responded, "*Amaï* . . . You speak very nice words and know how to make sentences . . . But this is not your concern. So stay in church and talk about the problems of God there. The future is ours and we will be the ones to decide . . . Nunavut is our land."

Right: Igloolik, 1961. How could I not understand the doubtful look he gives me? If they knew what was to come—pollution, drugs, violence, suicide, confusion in a deluge of dollars— it probably would have been a look of terror. By 1960 the market economy had entered the Far North and the defeated became subjugated. In school, children learned of the "primitiveness" of their fathers and mothers. Shamanism was a relic of the past. Parents painfully digested the devastating image their children presented to them. The Eskimos discovered self-hatred through their children's eyes. In 1990 to 1992, the suicide rate among the Inuit was 39.7 per 100,000 people, versus 13 per 100,000 for all of Canada. By 1999, the Inuit rate had jumped to 79 per 100,000. The same thing happened in Greenland: from 1962 to 1966, the suicide rate was 19.4 per 100,000 people; in 1982 to 1986, it was 114.1 per 100,000. The Canadian government has finally discovered this simple idea: culture and identity are the backbone of a society. In 1999, two new Canadian provinces were born, Nunavut and Nunavik. Here the Inuit seek to build a nation that is the master of its own destiny.

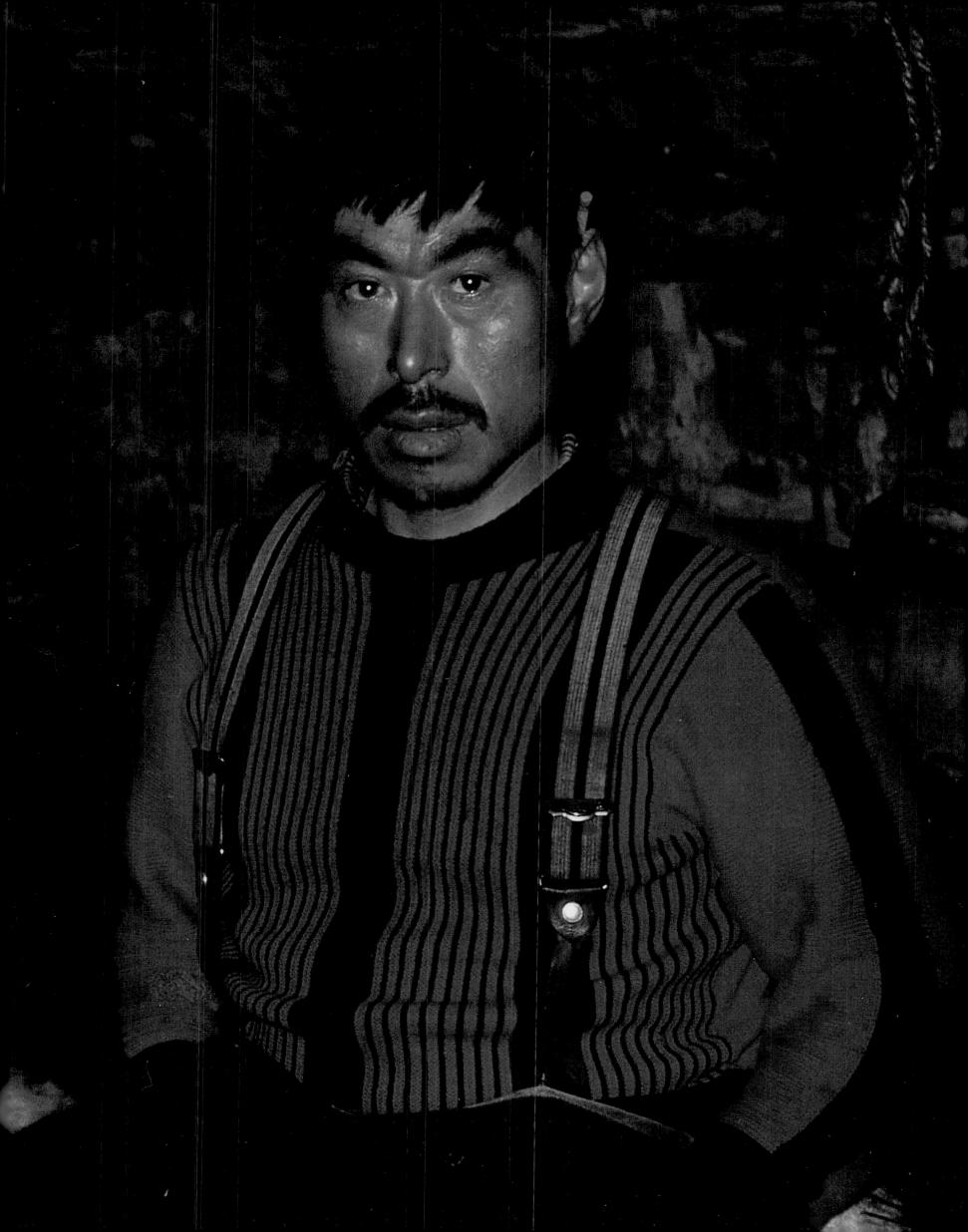

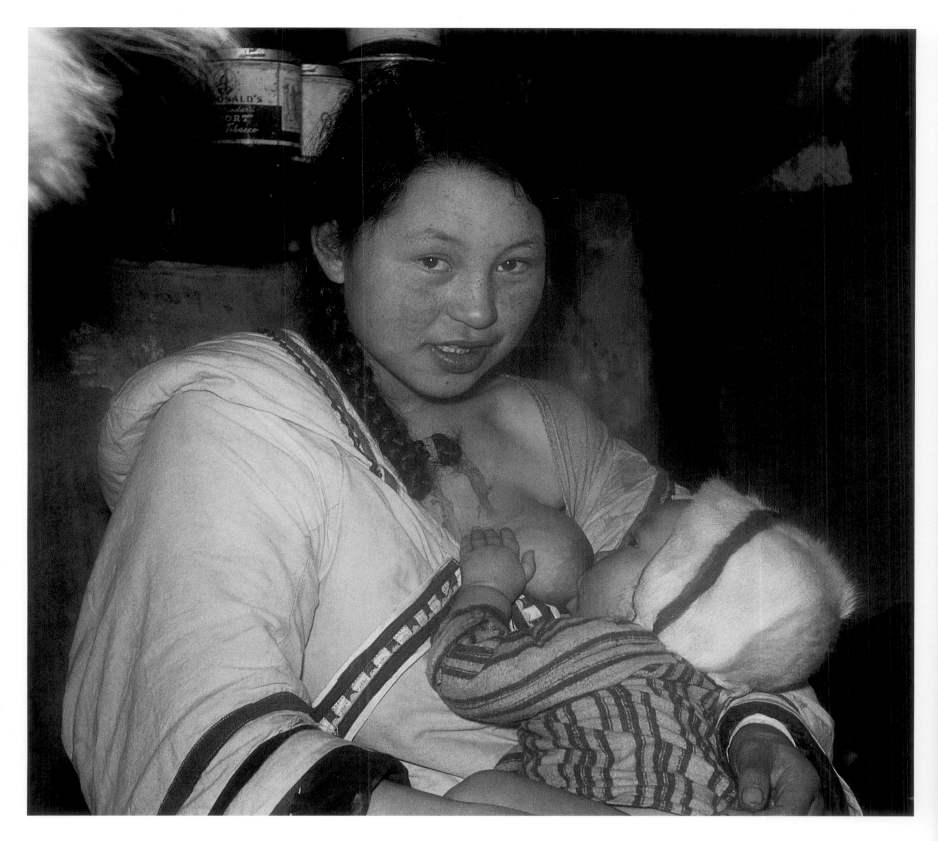

Above: Inuit women breast-feed their children until they are three years old. Since 1990, however, Inuit mother's milk has been contaminated with harmful chemicals, a result of eating contaminated whales and other animals. The government has recommended the Inuit use processed milk, though it's well proven that mother's milk strengthens a child's immune system.

Igloolik, September 1960 and May 1961. The young Inuit hear their elders talking about independence, about Nunavut, their own country, in their own language. They are appalled by the social injustices they've suffered at the hands of exploitative whites. These images can seem prehistoric—history has accelerated so much in the past forty years. A great nation is built in their suffering.

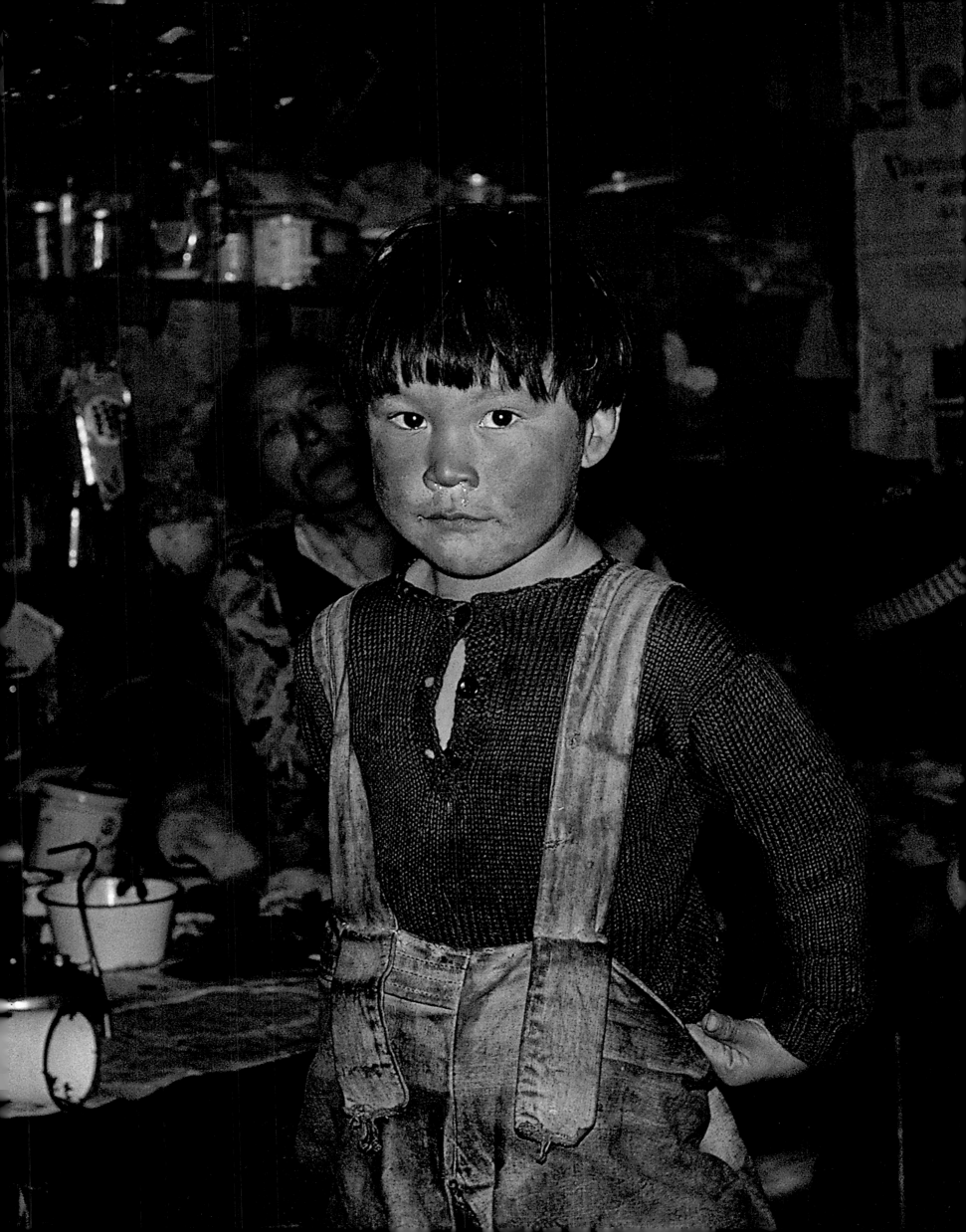

Gjoa Haven, King William Island, central Arctic,
April 1963. The Hudson's Bay Company
(H.B.C)—"Here Before Christ" they say with a
smile. The company was formed in 1670 to find
a Northwest passage to the Pacific; for the
next two centuries the company was devoted
mostly to the fur trade, trapping and trading
throughout what is now northern Canada.
The company continued trading furs until the
1980s, dictating the price of fur as well as the
prices it charged for supplies.

Following pages: Igloolik, September 1960.
The annual shipment of merchandise from the
H.B.C arrives—rifles, ammunition, tools, wood,
food, gas—and the annual exports—fox and
seal furs, ivory narwhal and walrus teeth—
leave. The Hudson's Bay Company had a
monopoly on the northern fur trade until the
Canadian government created competing firms
in 1970. Ten years later the Inuit, who had
become more organized politically, created a
network of Inuit cooperatives and, in Nunavik
(northern Quebec), an airline, Air Inuit.

Igloolik, October 1960. The Igloolik Inuit
cooperated in my study of the microeconomics
of eleven camps. During the summer of 1960
I traveled from village to village by canoe; and
the following May, by dogsled. Q'ipsiga is
indicating on a map where he set up fox traps,
and where seal, walrus, and caribou are found.
I made individual assessments of 494 Igloolik
Inuit, including 103 heads of families. I found
that they wisely reinvested two-thirds of their
revenue in equipment. This century has seen
continual technological progress: they stopped
using bows in 1920 and kayaks in 1941. The
first canvas canoe dates from 1950; the first
engines, from 1960.

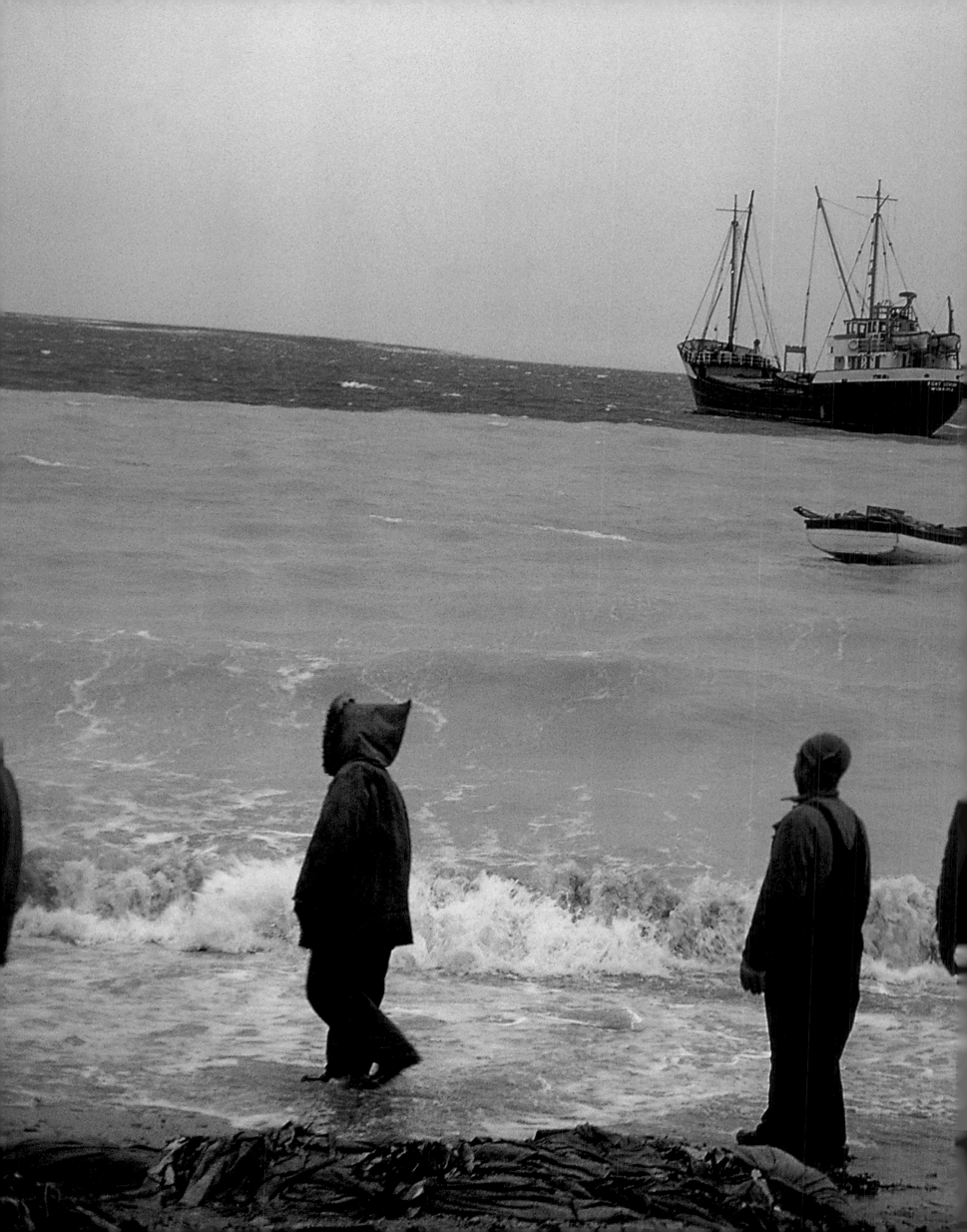

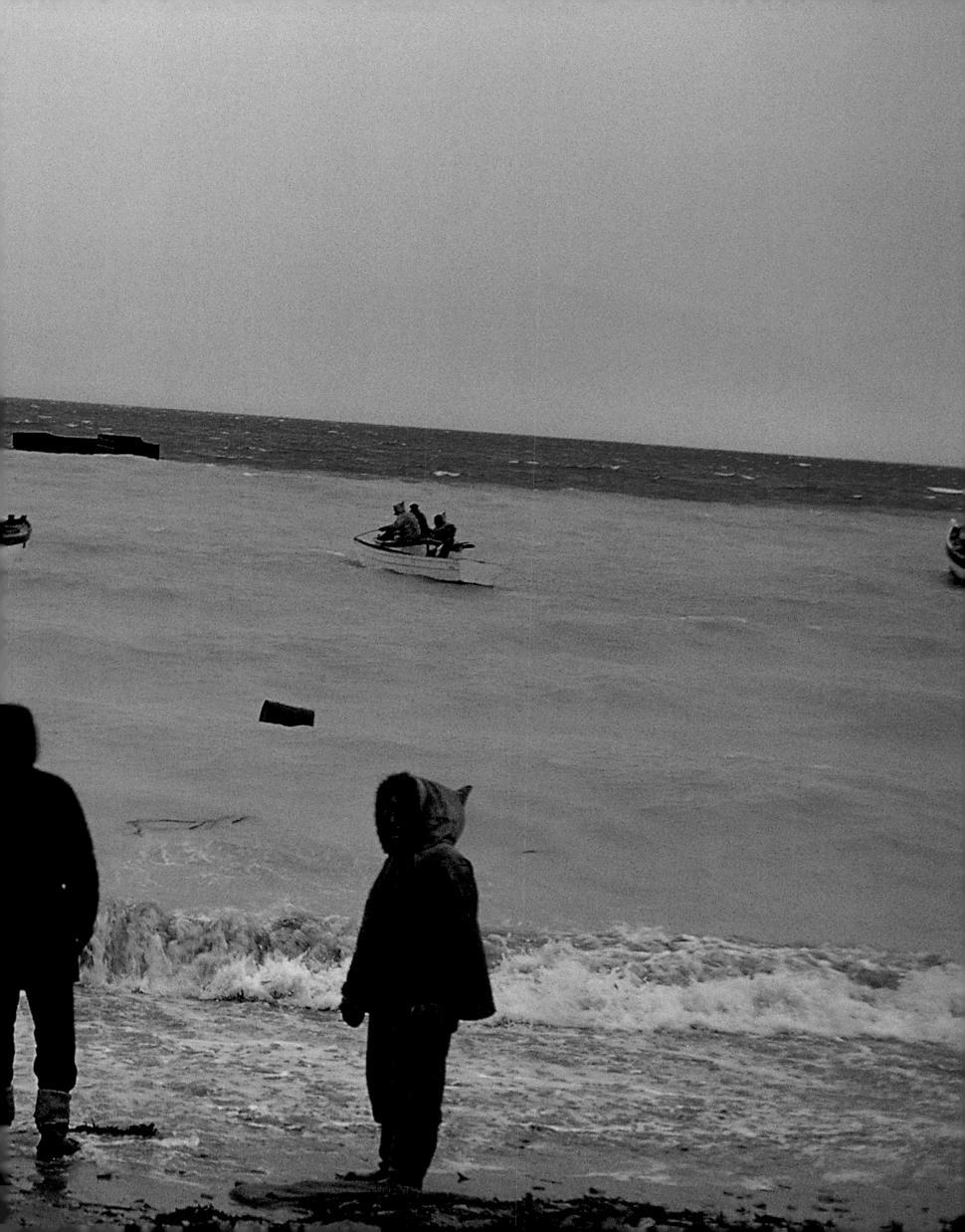

SUCH PRECIOUS COLLEAGUES

Iglulik, October 1960. Being excellent
cartographers, the Inuit were good colleagues.
They trusted my reporting. The Iglulik Inuit
actively cooperated in my research on the
microeconomics of eleven camps; these
missions were accomplished by canoe in the
summer of 1960 and by dogsled in May 1961.
Q'ipsiga is indicating on a map where he set up
fox traps and shows the seal, walrus and
caribou areas. Individual charted assessments
of a 103 heads of family of 494 Iglulik Inuit.
Two thirds of their revenue in dollars is wisely
reinvested in equipment. The bow was no
longer used after 1920; the last kayaks were
used in 1941; the first canvas canoe dates from
1950; the first engines, from 1960.

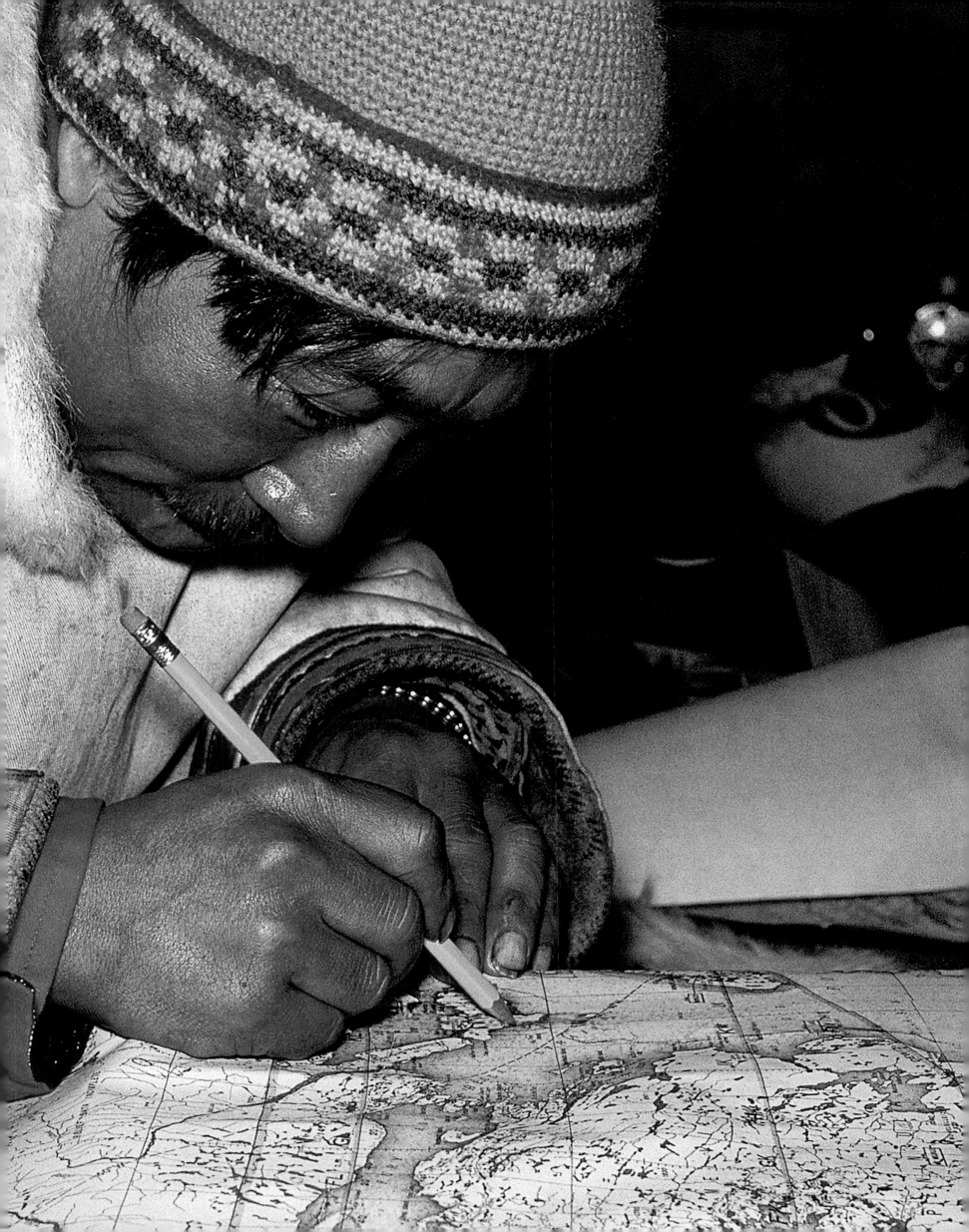

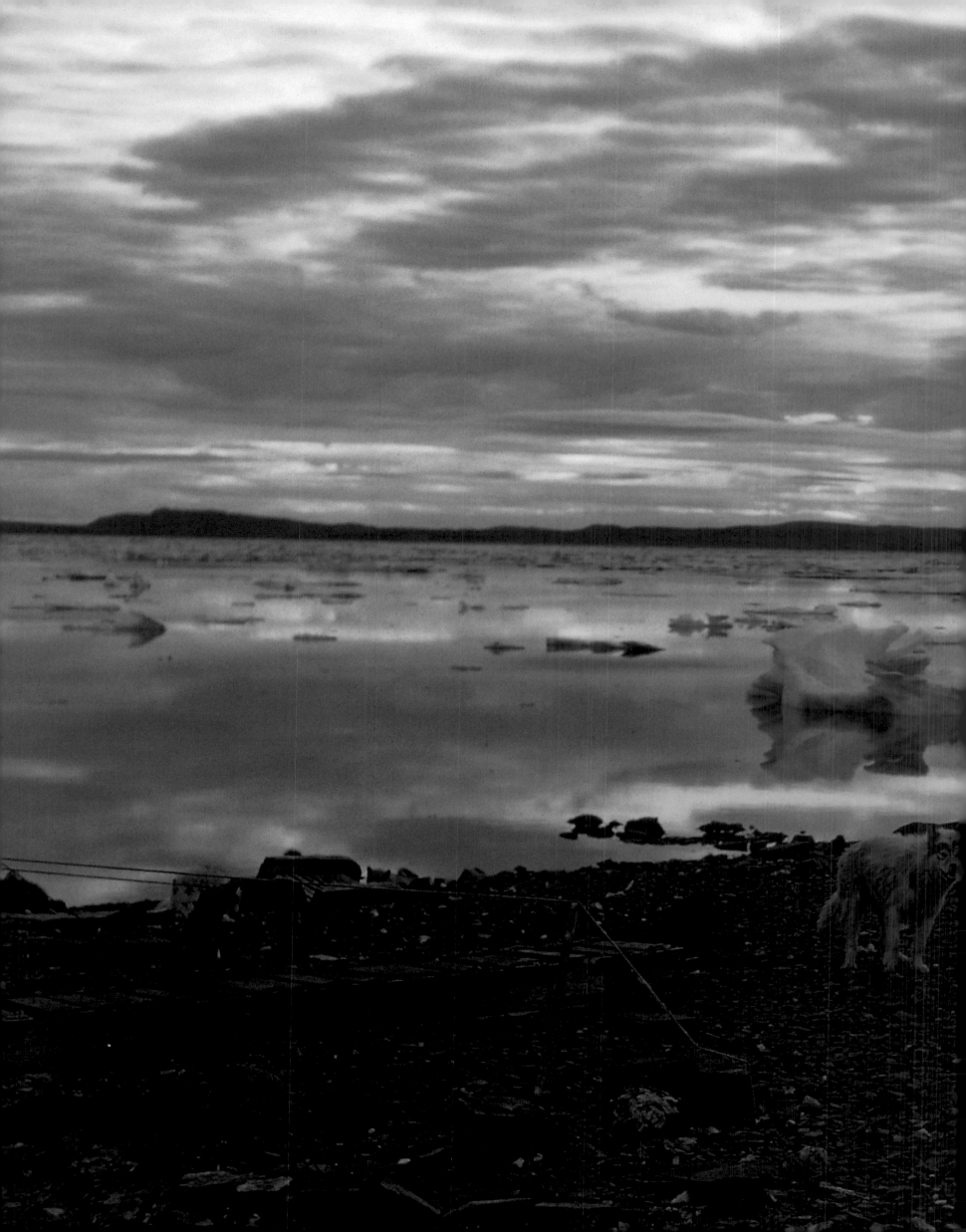

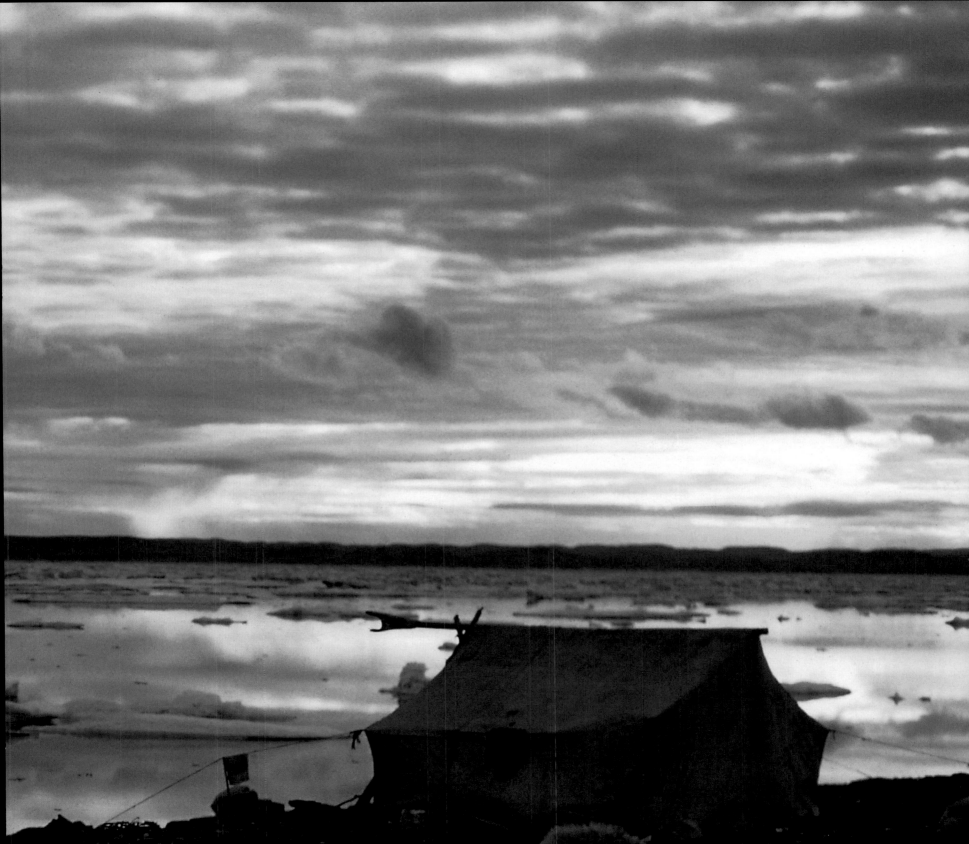

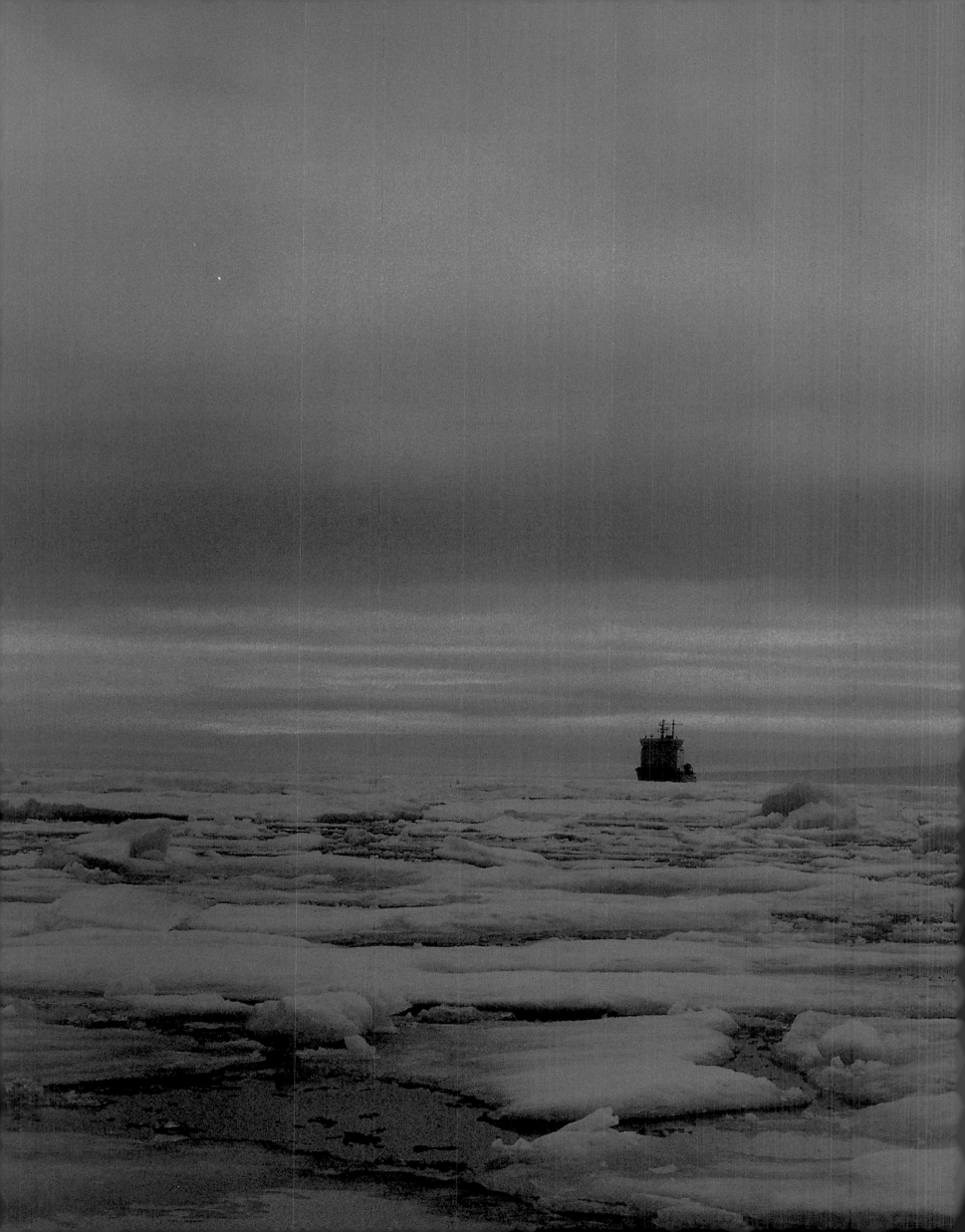

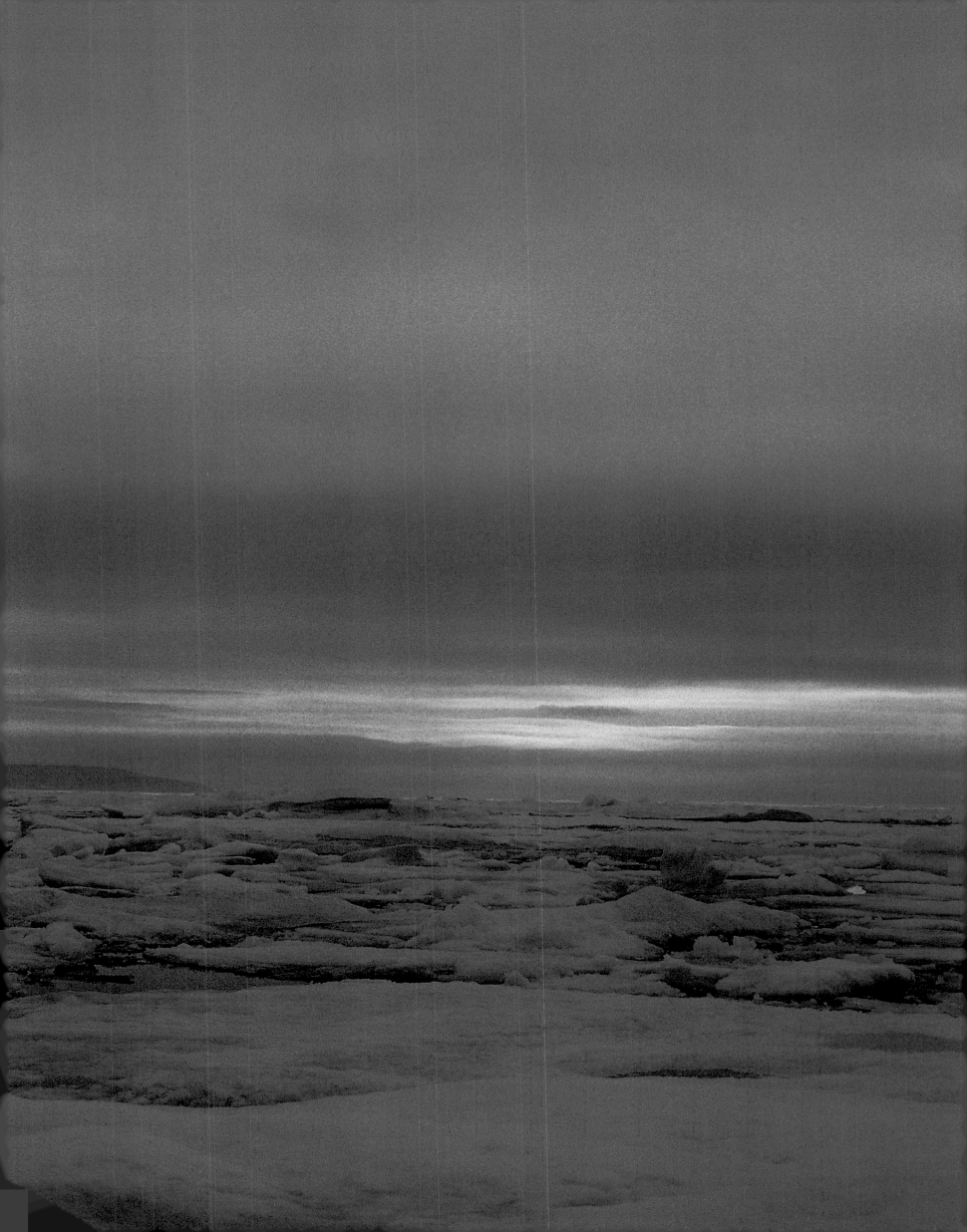

THE IGLULIGMIUT, WALRUS HUNTERS OF FURY AND HECLA STRAITS

EASTERN CANADIAN ARCTIC, NORTH OF FOXE BASIN

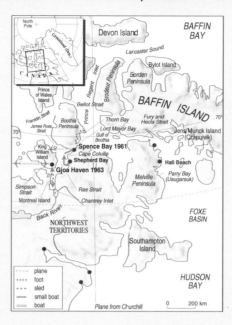

WHAT DO THEY EAT? AND HOW?

RAW MEAT

"They certainly in general prefer eating their meat cooked, and while they have fuel they usually boil it; but this is a luxury.... Their only drink is water; and of this when they can procure it they swallow an inconceivable quantity; so that one of the principal occupations of the women during the winter is the thawing of snow in the *ootkooseks* for this purpose.... I am certain that Toolooak one day drank nearly a gallon in less than two hours."

—William Parry, *Journal of a Second Voyage for the Discovery of a North-West Passage from the Atlantic to the Pacific*, London, 1824

FAMINE AND CHARITY

"The Esquimaux went out to endeavour to catch seals as usual, but returned unsuccessful after several hours' labor.... It became incumbent on us carefully to attend to their wants, and by a timely and judicious application of the slender resources we had set aside for their use, to prevent any absolute suffering among them. We therefore sent out a good meal of bread-dust for each individual, to be divided in due proportion among all the huts.... [We] found some of these poor creatures actually gnawing a piece of hard seal-skin with hair on it, while few of the huts had any lamp alight."

—William Parry, *Journal of a Second Voyage for the Discovery of a North-West Passage from the Atlantic to the Pacific*, London, 1824

GLUTTONY IN WINTER

"In January the temperature suffered an unseasonable rise, some successful captures of walrus also took place, and these circumstances, combined perhaps with some superstitious customs of which we were ignorant, seemed the signal for giving way to sensuality. The lamps were accumulated and the kettles more frequently replenished, and gluttony in its most disgusting form became for a while the order of the day. The Esquimaux were now seen wallowing in filth, while some surfeited lay stretched upon their skins enormously distended, and with their friends employed in rolling them about to assist the operations of oppressed nature.... What the consequences might have been had this state of affairs long continued it is not difficult to imagine.... A few went away very sick, some were unable to remove, and others taken ill upon the ice, and we heard of the death of several about this period."

—William Parry, *Journal of a Second Voyage for the Discovery of a North-West Passage from the Atlantic to the Pacific*, London, 1824

HEALTH AND HYGIENE

PREVENTION

"The sick must on no account see each other.... The using of a sick person's drinking-cup, knife, or other utensil by a second individual was sure to be vehemently exclaimed against."

—William Parry, *Journal of a Second Voyage for the Discovery of a North-West Passage from the Atlantic to the Pacific*, London, 1824

ABANDONING THE SICK AND THE WEAK

"I was under the necessity of quitting this scene of human wretchedness, which exceeded any thing my imagination could possibly have pictured.... On reproaching Nuyakka with the diabolical inhumanity of thus leaving her sister to perish, she made some excuse which I did not understand, but treated the whole matter with a degree of levity and indifference, of which it is painful to think any human creature capable on such an occasion."

—William Parry, *Journal of a Second Voyage for the Discovery of a North-West Passage from the Atlantic to the Pacific*, London, 1824

A SPIRIT OF SUPERIORITY AND SOLIDARITY

"Contradictory as it may seem, they certainly looked upon us in many respects with profound contempt; maintaining [their] idea of self-sufficiency.... I shall never forget the contemptuous sneer with which he muttered in soliloquy the word 'Kabloona!' in token of the inferiority of our materials to his own."

—William Parry, *Journal of a Second Voyage for the Discovery of a North-West Passage from the Atlantic to the Pacific*, London, 1824

INUIT INTELLIGENCE

"Igloolik. The few Inuit that returned from the south (Churchill, Ottawa), where they went for medical reasons, never expressed amazement about the technical superiority of whites. It's as if they were convinced that with the same means they would do infinitely better. 'You have books. *Our* intelligence is in our head. Wait, wait a while. *We* will be the leaders of our country. The time when we were your dogsled drivers will be over!'"

—Jean Malaurie, Notebooks, 1960–61

SHARING

"In an open boat, Krolaût and I explore all the camps to the east and south of Fury Strait; we returned to Igloolik with six seals we had hunted over three days. Within an hour, none were left for him. Everything had been shared. Inuit law: by helping a returning hunter, one becomes a partner in the hunt and has the right to one's part—including myself. When I hesitated to take it, they reminded me that I had the right."

—Jean Malaurie, Notebooks, 1960

DOWRIES

"The son-in-law has to give a gift to his future father-in-law. The boy's father brings this gift to the father-in-law. The gift has to be made one or two days after the marriage—never a month later. The nature of the gift remains confidential. The son-in-law has to spend at least a year with his father-in-law and in this way be at his service. Toutalik's dowry at his first marriage: a small boat. Koovolah: a harpoon and a dog. Kootaloo: a rifle."

—Jean Malaurie, Notebooks, 1960

DEATH RITUALS

TABOOS

"Takkeelikkeeta now prepared to dress the dead body, and in the first place stopped his nose with deer's hair and put on his gloves, seeming unwilling that his naked hand should come in contact with the corpse.... This ceremony finished, the deceased was sewed up in a hammock, and at the husband's urgent request her face was left uncovered.... The girl's hair was not to be put in pigtails, and every thing was neglected; Takkeelikkeeta was not to go sealing until the summer.... When the three days, and it is singular that such should be the time, were expired, the man was to visit the grave; and having talked with his wife, all duties were considered as over."

—William Parry, *Journal of a Second Voyage for the Discovery of a North-West Passage from the Atlantic to the Pacific*, London, 1824

DISPOSITION OF THE BODY

"When a body was thus buried, the stones ought to be arched over, so as not to rest upon it.... Close to the grave lay his spear, some buttons, a string or two of beads, and a small drinking-cup, all which the old man begged us to deposit."

—William Parry, *Journal of a Second Voyage for the Discovery of a North-West Passage from the Atlantic to the Pacific*, London, 1824

IMMORTALITY

"The ideas concerning the future state of the soul are confused and often contradictory. There appear to be three degrees of heaven, all situated above the earth.... It is probably that the idea of eternity is beyond the com-

prehension of the Eskimos. They believe that the soul of the departed will enter the body of a child named after it, and remain for a year, with later continued influence upon the child's character."

—A. P. Low, *The Cruise of the Neptune 1903–1904*, Ottawa, 1906

CRISIS OF THE SACRED

WHAT TO BELIEVE?

"The old people alone seemed to pay respect to the Angetkoks, while the young ones invariably treated their mysteries with contempt."

—William Parry, *Journal of a Second Voyage for the Discovery of a North-West Passage from the Atlantic to the Pacific*, London, 1824

CATHOLICS AND ANGLICANS

"The Anglican pastors and teachers and the Catholic priests dislike each other. In twenty years, the churches have succeeded in dividing the Eskimos, who had been united as a group for centuries."

—Jean Malaurie, Notebooks, 1961, and *Hummocks*, Volume I, Paris, 1999

POVERTY AND COMPASSION

July 16, 1960. "Tomorrow is the Sabbath; both Protestants and Catholics do not partake in any activity on Sunday, and sometimes prostrate themselves outside their services; this happens fifty-four days out of the year. I recall Georges Sorel's remark that connected the Christian spirit with that of begging.

"Sunday Mass at the Catholic Church, built stone by stone by Father Louis Fournier. It is very cold in this church. It can't be heated. . . . The Inuit—fathers, mothers, and children—cough and cough. It is heartbreaking. The service follows the Mass of the Angels, sung in Latin by these Inuit.

"Christianity is the fear of sin, Christianity is the contract that lets one avoid Hell and enter Paradise. The spirit of beatitude is to renounce worldly goods. This idea is difficult to convey to these Inuit, who have been so impoverished by colonialism. Is the destitute native a vehicle of compassion, allowing one to look inward? This is what Methodism has taught us. In John Wesley's famous words: 'I came [to America] to convert the Indians, but, oh, who will convert me?' Which brings to mind George Bernard Shaw's quip: 'Those who can, do. Those who can't, teach.' Christ will be in agony until the end of the world. . . .'"

—Jean Malaurie, Notebooks, 1960, and *Hummocks*, Volume I, Paris, 1999

INTOLERANT MISSIONARIES

Igloolik, May 1961. "Religion? It is good for children and the Inuit. And the colonizers? They are never in church

on Sunday. Why don't the priests focus their attention on these whites, on their appetite for money or their power over our resources, our thoughts, and our lives? 'The scientists are building their careers on us,' they tell me. Is the Church serving colonialism, reserving its message of poverty and submission for the Inuit?"

—Jean Malaurie, Notebooks, 1961

COOPERATION WITH THE RESEARCHER

My socioeconomic research, conducted family by family in 1960–61, by boat during the summer (with Piugatu) and by dogsled in the winter (with Awa), though previously unheard of was well received by the Inuit. It may eventually yield improvements, through a complete assessment of their resources. They would be grateful to receive them, but they don't aspire to it. Life is lived as if it were fated.

PIUGATU

"Piugatu is extremely courteous and respected by all. He talks to me with great interest; he expresses himself slowly so that I can understand him. I don't have an interpreter, but I can understand the crux of what he says in his Inuktitut language—it is similar to the language of northern Greenland—even on these technical subjects. When his meaning is not clear I make a tape recording, so it can be translated later. I return to Igloolik at the end of September. In the night, Piugatu comes to sleep with me for company in a *qangmat*—a house of wood surrounded with peat—that I adopted as my headquarters. These are the last hours we'll spend together this summer."

—Jean Malaurie, Notebooks, 1960

AWA

"Awa, forty years old, is regarded by the hunters as a diplomat. He comments on and informs me about everything that happens. Awa is part of an elite that would be the basis for an Inuit self-government, a self-government that is overdue and that I will recommend to the Ministry of the Far North. He demonstrates how quickly the Inuit can become specialists in their own history.

"Every time I entered one of these igloos after a long dogsled expedition—ten to twelve hours at -22°F—I was always welcomed with a laugh and with joy. To delight in

it, even artificially, to participate in the celebration of this meeting between men and women, is to experience the grace of being together. At some moment during the day and night—and if it were night they were half-naked, seated on their *igliq* or sleeping platform—everyone would eat some frozen raw walrus with their host to honor him."

—Jean Malaurie, Notebooks, 1961

A FEW ESKIMO NAMES

"(f = female, m = male) *Erkrelardjuk* (f): the pretty corner of the lips. *Tuluardjuk* (f): small crow. *Tonrrar* (f): spirit. *Alianakoluk* (m): little trouble. *Pikuyar* (f): hunchback. *Oreortok* (f): she who spits. *Mamatiar* (m): good to eat. *Erqroaluk* (f): large buttocks. *Iktuardjuark* (f): she who makes herself old. *Tapatsiar* (f): one who wants to monopolize. *Makki* (m): get up. *Umik* (f): beard. *Piugatu* (m): he who is made good. *Outeardjuk* (f): little big vulva. *Outokrutiuk* (m): pretty little vulva. *Paomik* (f): I'm itching to do it. *Anguvasak* (f): valorous man. *Issigaitsoq* (m): no feet. *Iktoriligak* (m): he turned handsome, the little old man. *Krangut* (m): innocent young thing. *Anguiliainun* (m): he who is caught unprepared and soils his pants."

—Jean Malaurie, *Hummocks*, Volume I, Paris, 1999

THE SEEDS OF A CRISIS

"Igloolik [in 1960], in its commerce and its dealings with the government, is thirty to fifty years behind Greenland, where Danish-Greenlander trading posts have created a closed world that is favorable to the Inuit economy. Here, there is no administrative training for the Inuit, either in schools or other institutions.

"After the U.S. Air Force base was established in Thule in 1951, the Americans created D.E.W. (Distant Early Warning) Line posts throughout the North American Arctic, located every thirty-five miles along the 68th parallel. These radar posts, guarding against a Soviet bomber or missile attack, were staffed with American specialists and equipped with a small airfield. Igloolik, in Hall Beach, has a major D.E.W. Line post that is open to Inuit visitors. A few hunters take unskilled jobs. Wood, tools, objects from home, cloth, and other things are obtained or plundered from the American base's surplus. The balance of Inuit life is upset by this intrusion. This 'pseudo-assistance' disturbs the micro-economy of the HBC trading post and Inuit family accounting, which also relies on barter between Inuit. Igloolik is thus thrust into a system of dependence, assistance, and irresponsibility. The settlement's five hundred hunters are having a more difficult time adjusting to this incursion of Western goods because the community is split into two more or less hostile factions: the Anglican Protestants, walrus hunters; and the Roman Catholics, seal hunters. My photographs attest to this crisis of adjustment and to the shifts that the young Inuit elite will, in the 1980s, intelligently master."

—Jean Malaurie, Notebooks, 1962, and *Hummocks*, Volume I, Paris 1999

WITH THE NETSILINGMUIT,
THE LAST NOMADS OF THE FAR NORTH

Above: Boothia Peninsula, Rae Strait, August 1961. The Ice Age left visible traces on the surface of the Earth. The landscape breaks down into geometric shapes and colors, creating a kind of Cubism.

Right: Boothia Peninsula, August 1961. The Netsilingmuit are one of the poorest groups of the central Arctic. They have been nomads for 4,000 years, following the caribou and musk ox. Each family needs to hunt 250 caribou a year for clothing, tools, and food, though 100 caribou will suffice if they're supplemented with fish.

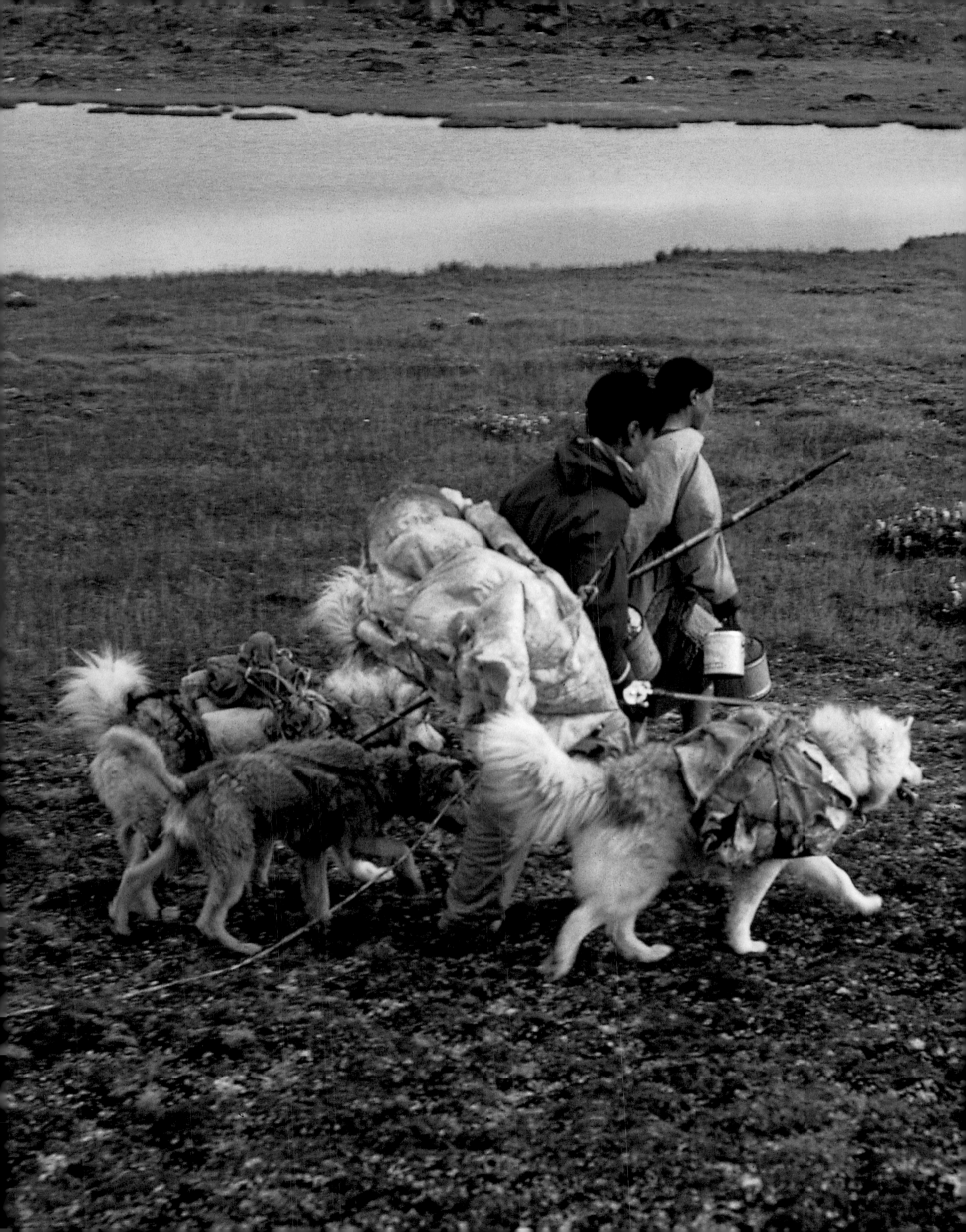

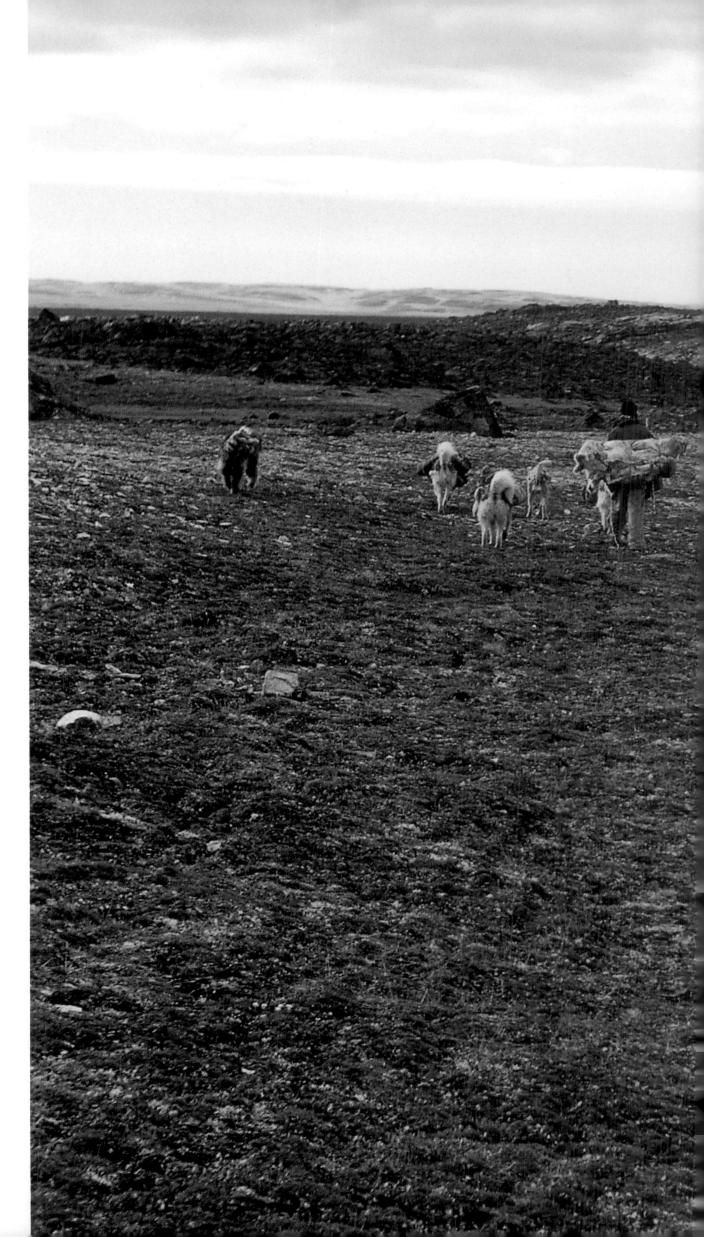

Boothia Peninsula, August 1961. Since 1930, the caribou population in the Canadian Arctic has dropped from 3 million to 200,000. This is due in part to a large number of wolves and the increased efficiency of rifles. But the Inuit are not to be held responsible. In 1960, the Canadian Inuit killed only 12,000 caribou.

Disperse, my Inuit friends! Escape these white outposts where the government, with its friendly excuses—schools, missions—settles you and, in the end, colonizes you. In 1950 there were fifteen camps on the Boothia Peninsula; in 1961, two. In 2000, there was only one village, Spence, with 600 inhabitants, many on welfare. The West is polluting the tundra and ruining the planet; the West is condemning nomadic peoples to a slow death. Escape to the Far North. Be free. Live on your own terms, until you feel that we finally consider you equals.

There was a wolf who was only skin and bones . . . This wolf met a mastiff who was as powerful as he was handsome. . . . The wolf approached him humbly, struck up a conversation, and complimented him on his stoutness, which he admired.

"Good sire, you can be as plump as I am," the dog replied. "Leave the woods. It will do you good. Your friends are miserable. They will starve to death in these conditions." The wolf said, "What will I have to do?" "Almost nothing," said the dog.

The wolf imagined such happiness that he shed tears of joy. Along the way, he saw the dog's mangy collar. "What's this?" he wondered. "Nothing!" "What! Nothing?' "Nothing much. Just the collar to which I am attached." "Attached?" asked the wolf. "So you don't run wherever you want?" "Not always, but it doesn't matter." "It matters so much that I don't want a single bite of your food."

Having said this, the wolf ran off, and still runs today.

Jean de La Fontaine, *Fables,*
"The Wolf and the Dog"

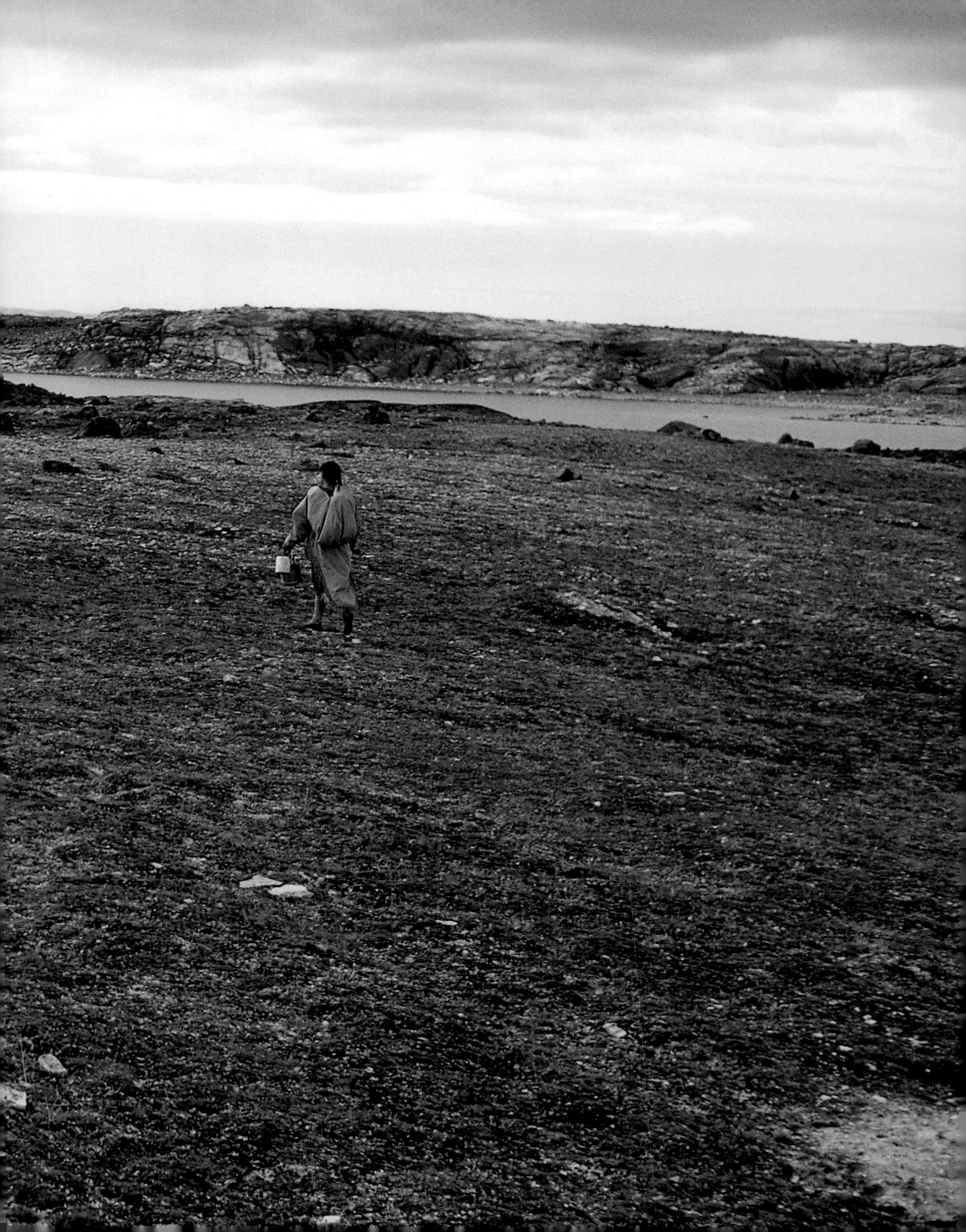

Boothia Peninsula, August 15, 1961. Krokiark, 35, father of a two-year-old son. He came from Spence, alone, by foot—fifty miles for a handful of tobacco. We return to Igpik (Thom Bay) together, a three-day walk. Krokiark carries a gallon of oil for the Inuit community. He stares innocently with his brown eyes; there's a touch of humor in them. He has never been alone with a white man. He is afraid of me. He was silent for a whole day.

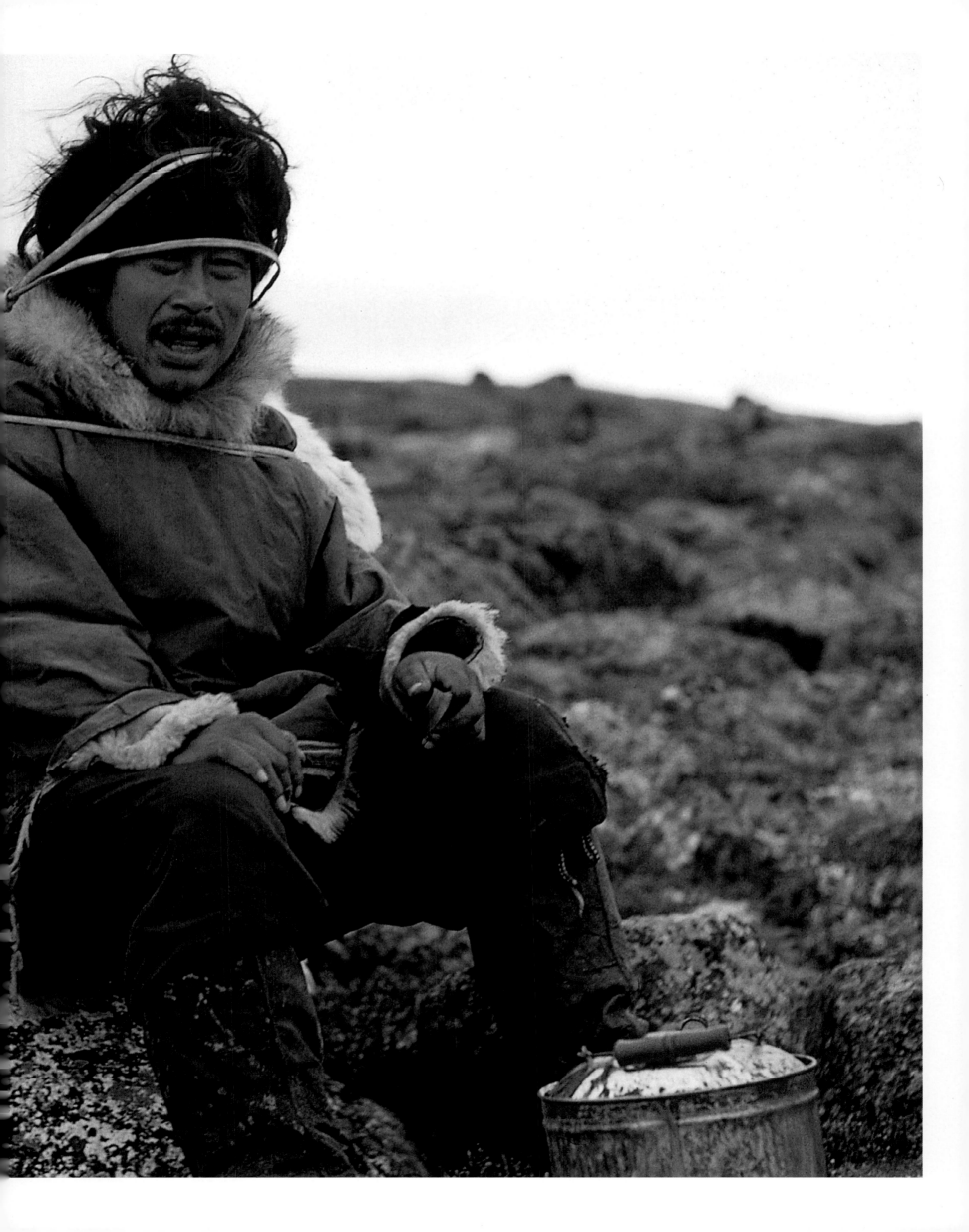

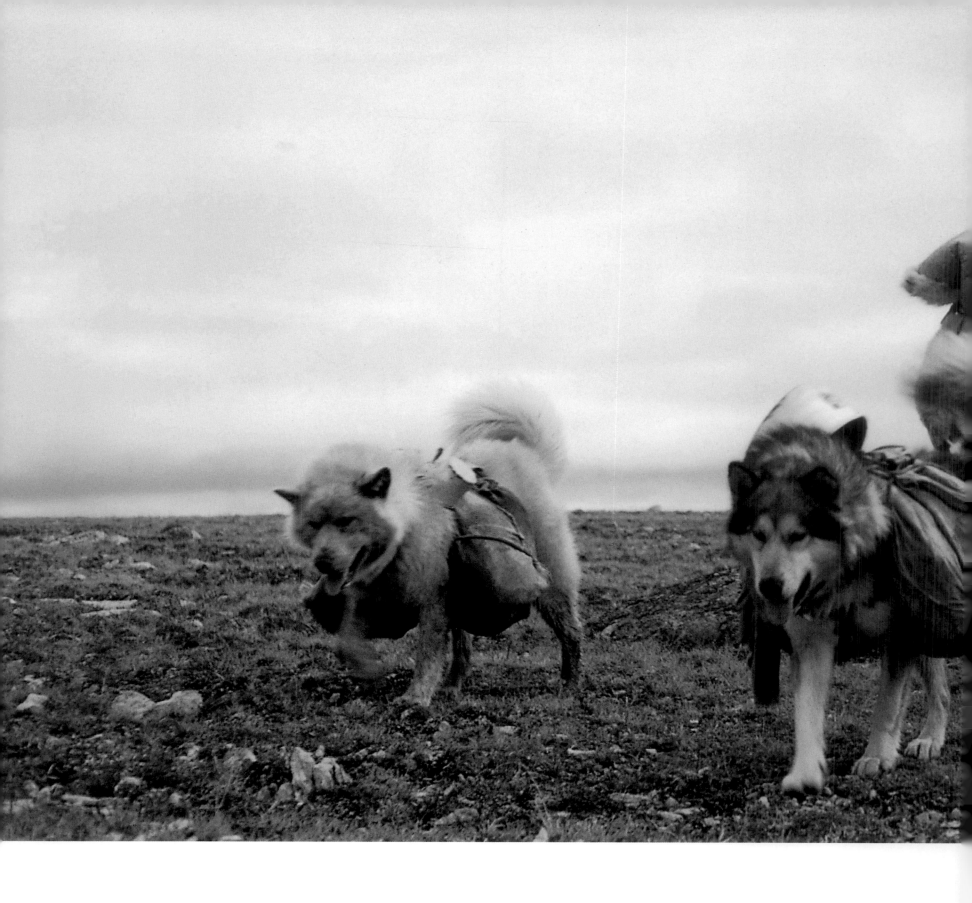

August 1961. Along the way, Krokiark began to confide in me. Old practices live on, he tells me—euthanasia of baby girls and the elderly; eugenics; trading wives. Cruel people in a cruel climate. To live and survive: there were 259 in 1929, and 259 in 1960. I walk across the peninsula to be connected with them. We carry thirty pounds each: tents, rifles, caribou hides. Three dogs carry my tape recorder and scientific materials on their backs.

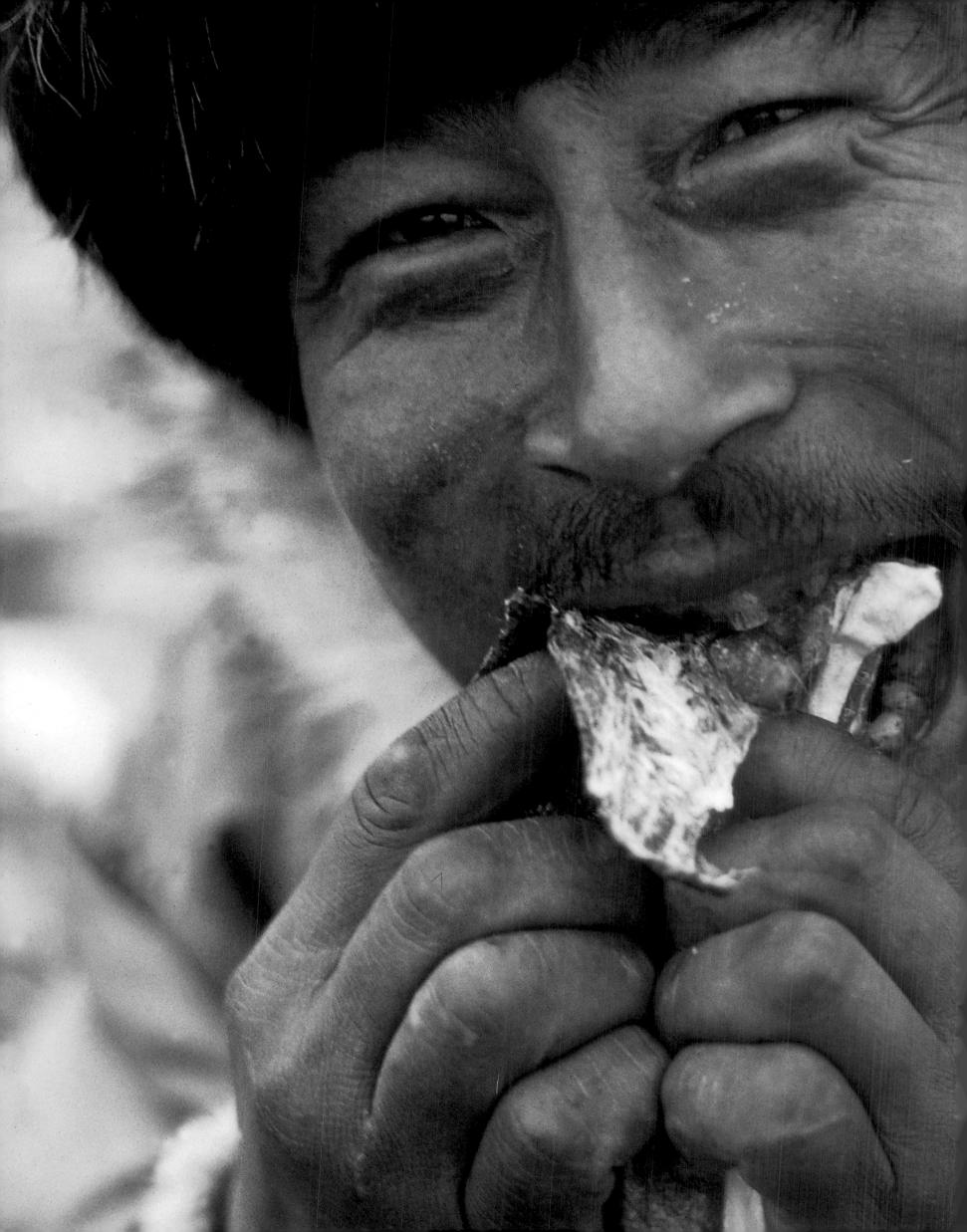

August 1961. There isn't any game on the trail—no caribou, no rabbits, no birds. We chew on dried salmon cut into little squares. Krokiark's teeth are yellow and decayed from too much sugar. He had them pulled by a shaman.

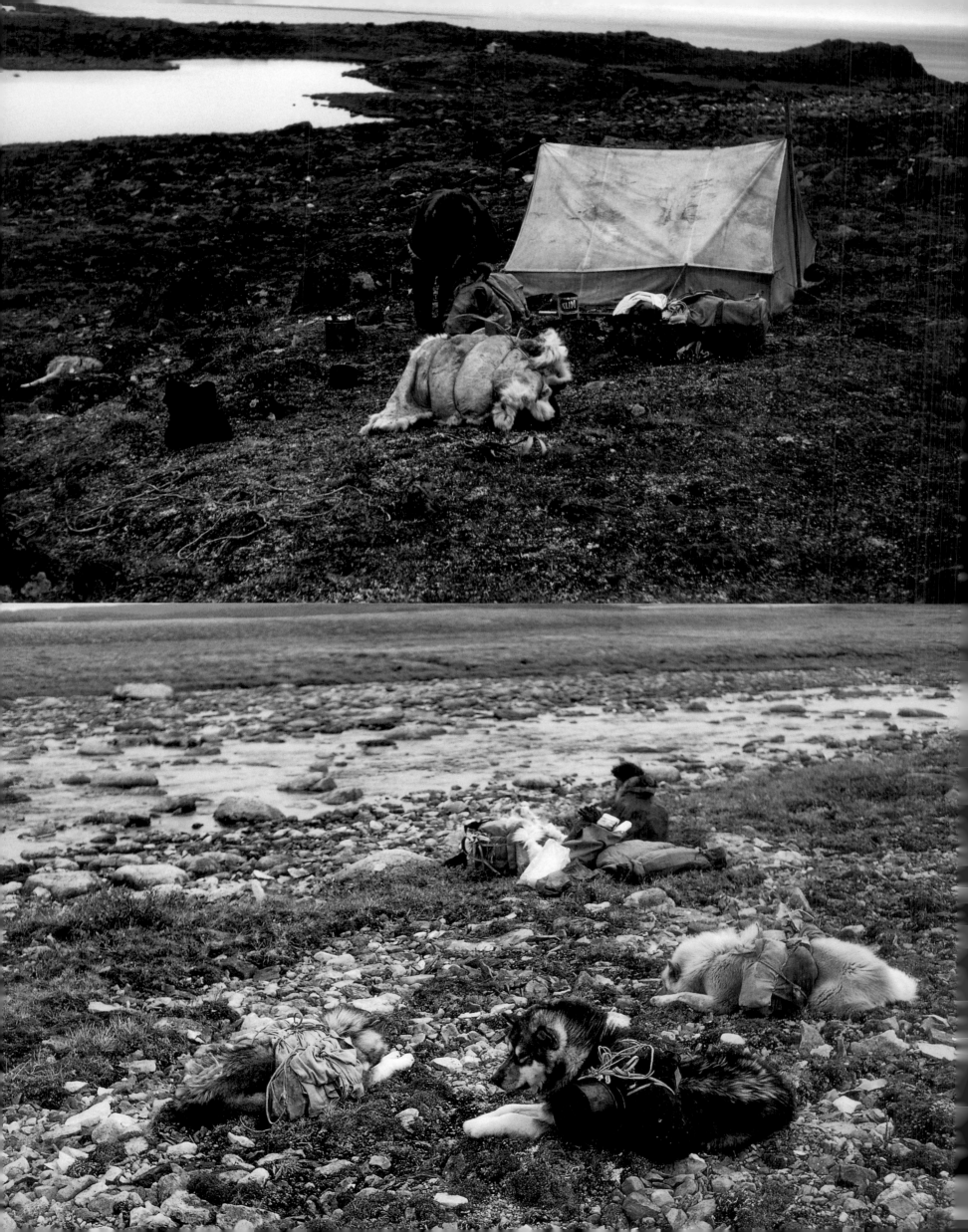

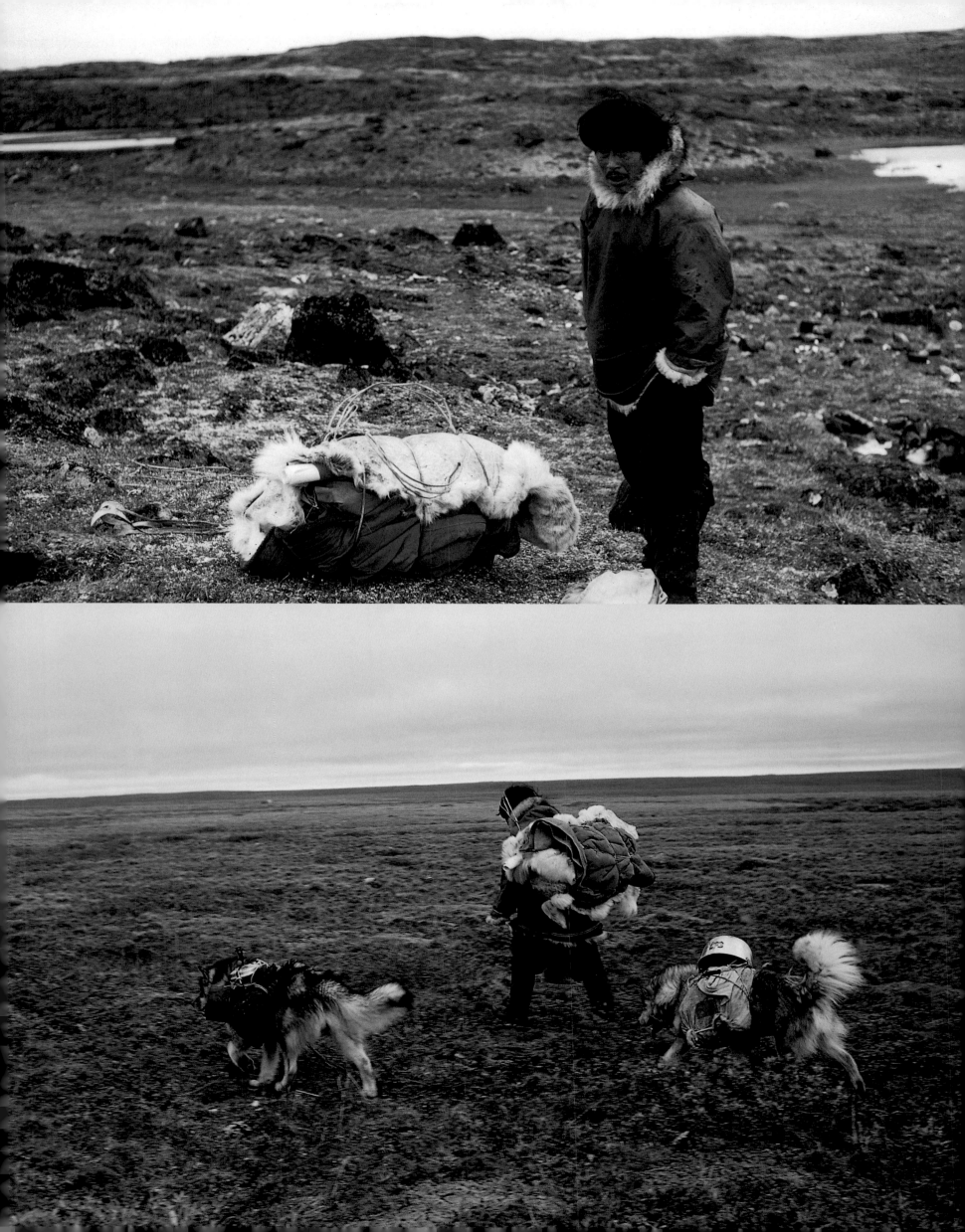

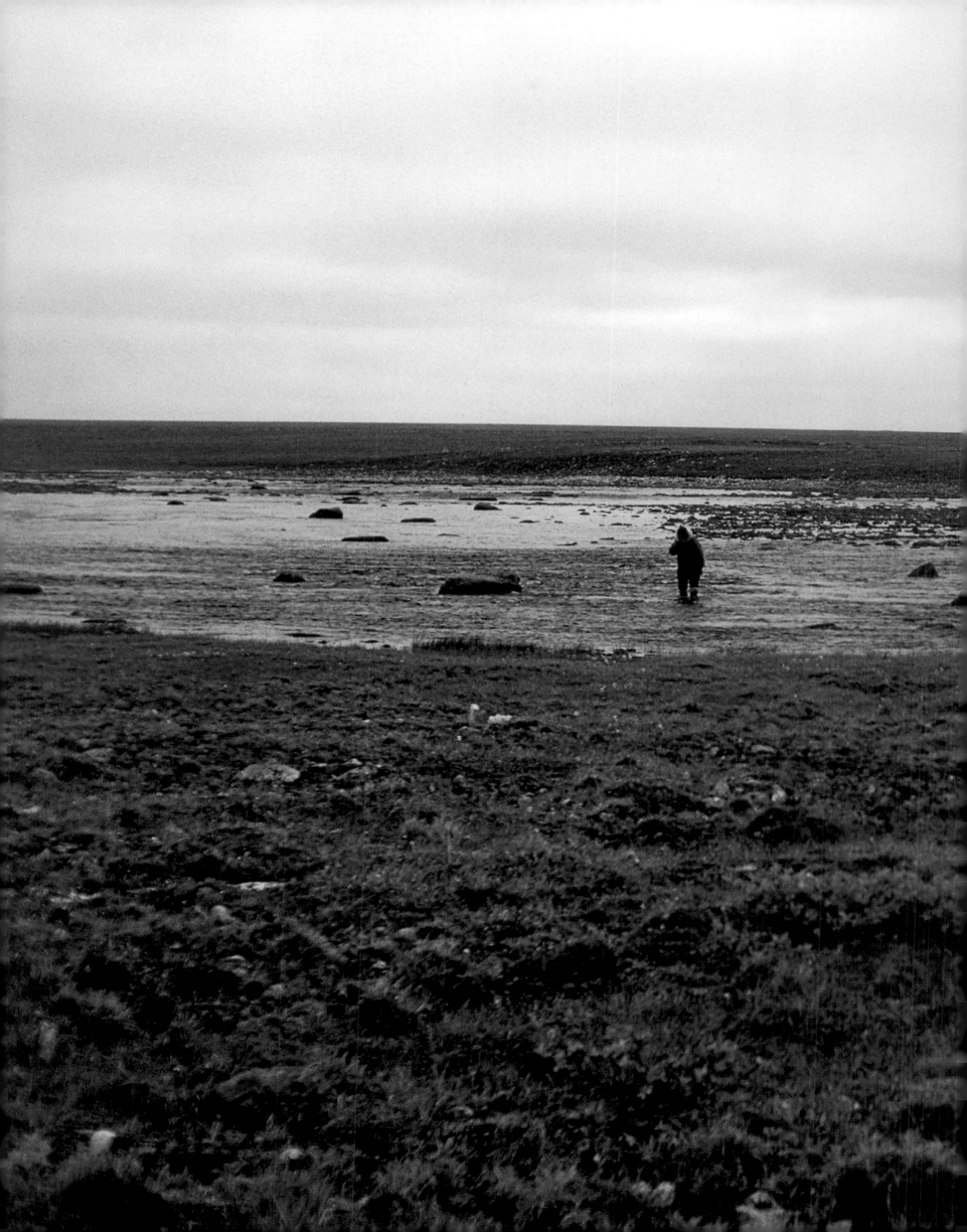

Previous pages: August 1961. This picture was taken after we had forded a harsh, twenty-two-foot-wide river, with our seal boots cinched above the knee to keep the water out. Our chests are bare, our dogs are leashed. Krokiark, usually reserved, opened his heart to me: "I don't like priests. They preach poverty, but live in good houses. *Kabloona!* Liars! *Nunavut!* Our land! They should go away! All of them!"

Right: August 1961. Rain, snow; it is freezing at night, 14°F. We huddle together in my tent. With great care, Krokiark mends my seal boot with his thimble and a triple thread of caribou nerve. "*Ayorama*," he tells me. "Life is hard. No seals in the fall, caribou are scarce, and we're not big fish eaters . . . Our elders let themselves die . . . Inuit law. Our women suffer when they are separated from their babies. We love our children. We aren't dogs. To the police, to the church, we are criminals. What do they know of our customs? Nothing!"

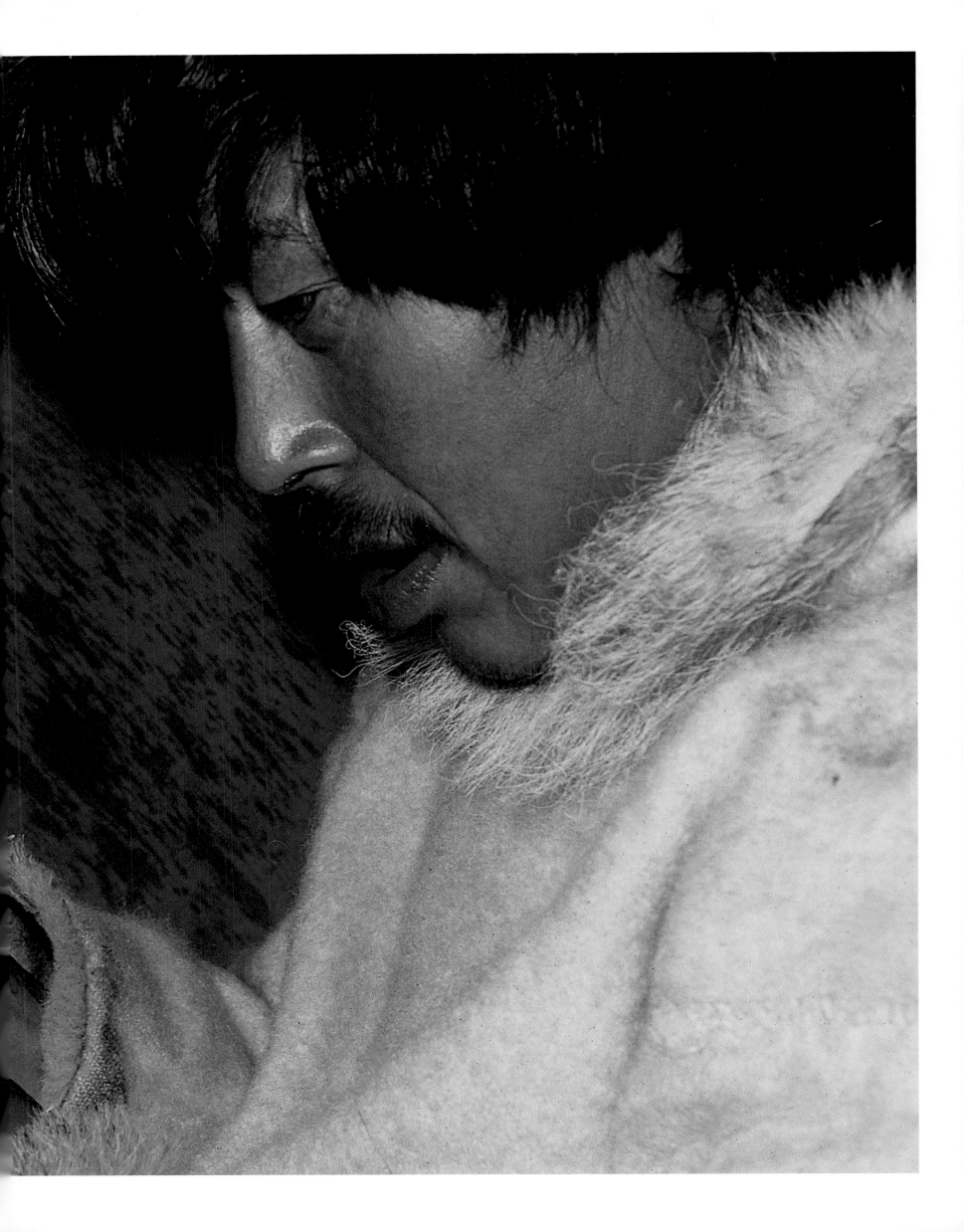

I WAS NOT PREPARED TO FIND [THESE NETSILINGMUIT] SO DIRTY OR PHYSICALLY REPUGNANT.
WHAT MEANING CAN THE CHRISTIAN RELIGION HAVE FOR THESE PEOPLE? I DO THINK IT CAN
ELIMINATE THEIR SUPERSTITIONS, THEIR TABOOS, BUT HOW CAN WE RECONCILE THESE
TEACHINGS WITH THEIR PRACTICES, THEIR CUSTOMS, THEIR TRADING OF WOMEN?

GONTRAN DE PONCINS, *KABLOONA*, 1939

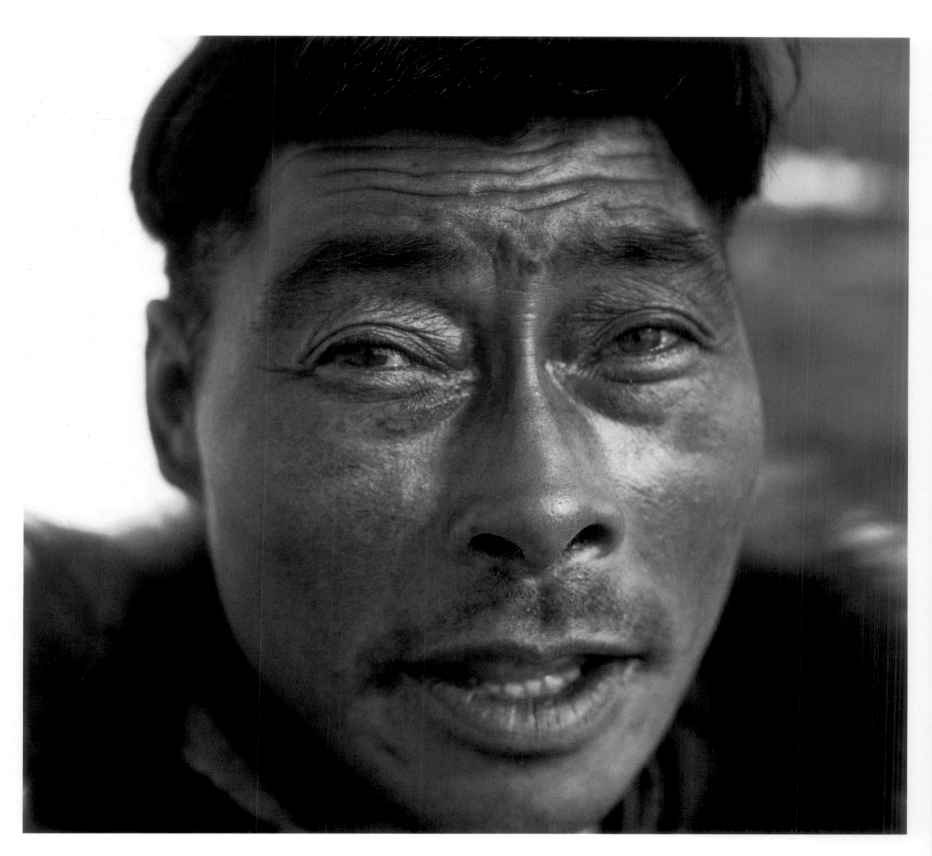

Igpik. Thom Bay, Boothia Peninsula, August 1961. Two snapshots during an interview about
euthanasia. To the left, the Eskimo observes me skeptically, ready to work with me. To the
right, fear and anxiety: the cruel eye doesn't like when I refer to the dead.

I HAVE NEVER ENCOUNTERED A MORE HOSPITABLE PEOPLE. IT'S EASY TO LOOK DOWN ON THE POOR. WE DON'T TRADE OUR WOMEN, BUT HERE, WHERE MANY PEOPLE ARE STERILE AND THE GROUP BARELY SURVIVES, CIRCUMSTANCES ARE DIFFERENT. CUSTOMS CAN ONLY BE UNDERSTOOD FROM A HISTORICAL PERSPECTIVE.

JEAN MALAURIE, 2001

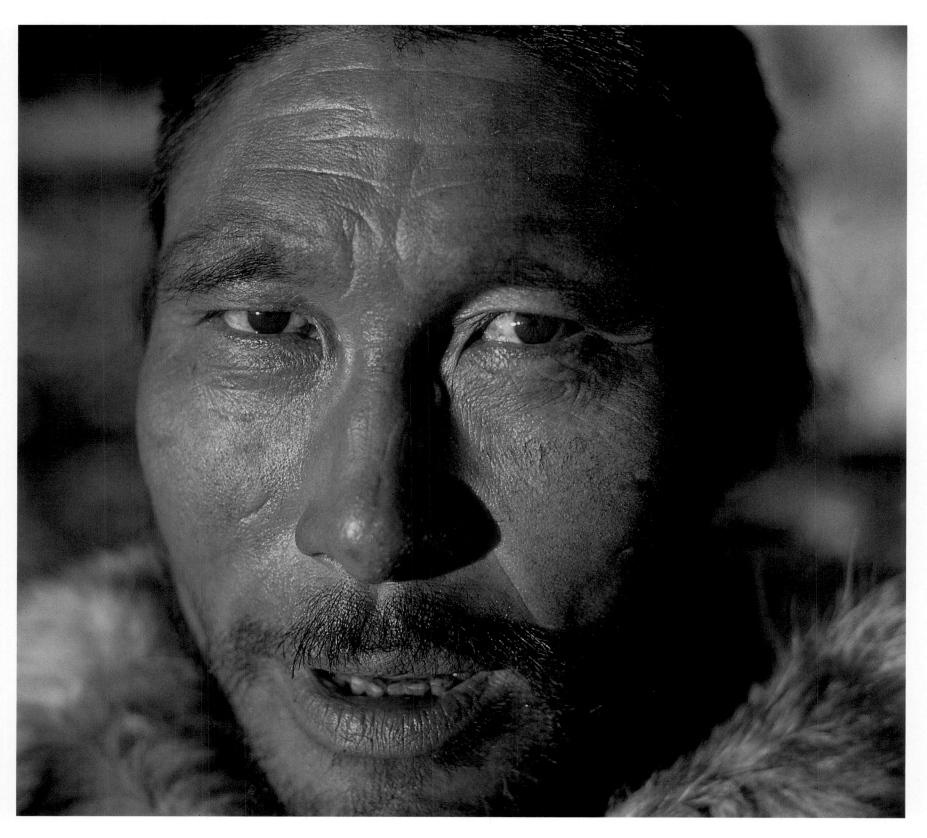

The euthanasia of little girls—horrible where we are or in China—is cruel for these young mothers. Slow progress. 1909: Boas, the anthropologist, counted 66 girls for 138 boys. 1923: out of 359 Netsilik, 150 men and 109 women (K.R.). 1961, according to my census, the deficiency comes to 15% (260 Netsikik, 99 women). Abortion has been banned. The suicide rate: between 1910-1960, out of 250 Netsilik, 50 suicides or attempted suicides. The rate worsened in the year 2000: six times higher than in the rest of Canada. An old belief implies that Inuit paradise is reserved for victims of violent deaths: hunts, wars, brawls, suicides.

Previous pages: Igpik, Thom Bay. August 1961. Majesty of the Arctic. Salmon trout fishing has become essential to these seal people. 2,500 fish per family. 200 fish for the winter under rocks. The supplement is vital for the winter. Ancestral dams: according to tradition, you can only harpoon with a spear. The nets used by the police or missionaries are scorned. Fish do not accept being caught collectively. Fish have their honor. They like to be chosen one by one by the Inuit, to whom they are related. The fish lay on the rocks in the direction of the torrent. Taboo women—women who are menstruating or who have miscarried—have to stay back. They are outside the frame of the photograph.

Upper left: In the cold tundra where the permafrost is inches from the ground, marsh flax (*eriophorum*) flowers in August. A joyful white quivering in the wind. The Inuit use catkin as wicks for their seal and caribou-oil lamps.

Stone, water, air, and sun: this is the equation of life, with its complexities. In this desert of stone, plants have to survive and fight against other plants. Some are friendly, grouped in threes. All search for an ancient order. "Eternal unity in diversity." (Goethe). August 1961.

Bottom left: Boothia Peninsula, August 1961. *Inugsuk* or stone cairns standing "like men" on the tundra. They are traps with a tuft of vegetation at the top, resembling a head of hair. Scaring the herds of caribou, they steer them towards a precipice or a lake. The hunters wait for them here, bows and rifles in hand.

Right: Walking back from Thom Bay (Igpik) to Spence (Talurjuaq): the Netsilik asked Arnadja to accompany me and talk with me. At daybreak, conversation with a wise man about ancient rituals and current problems. Born in 1913. August 1961.

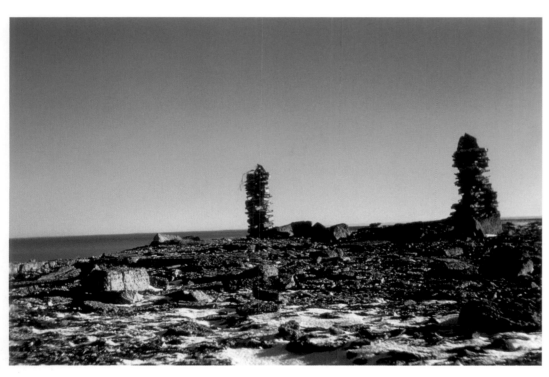

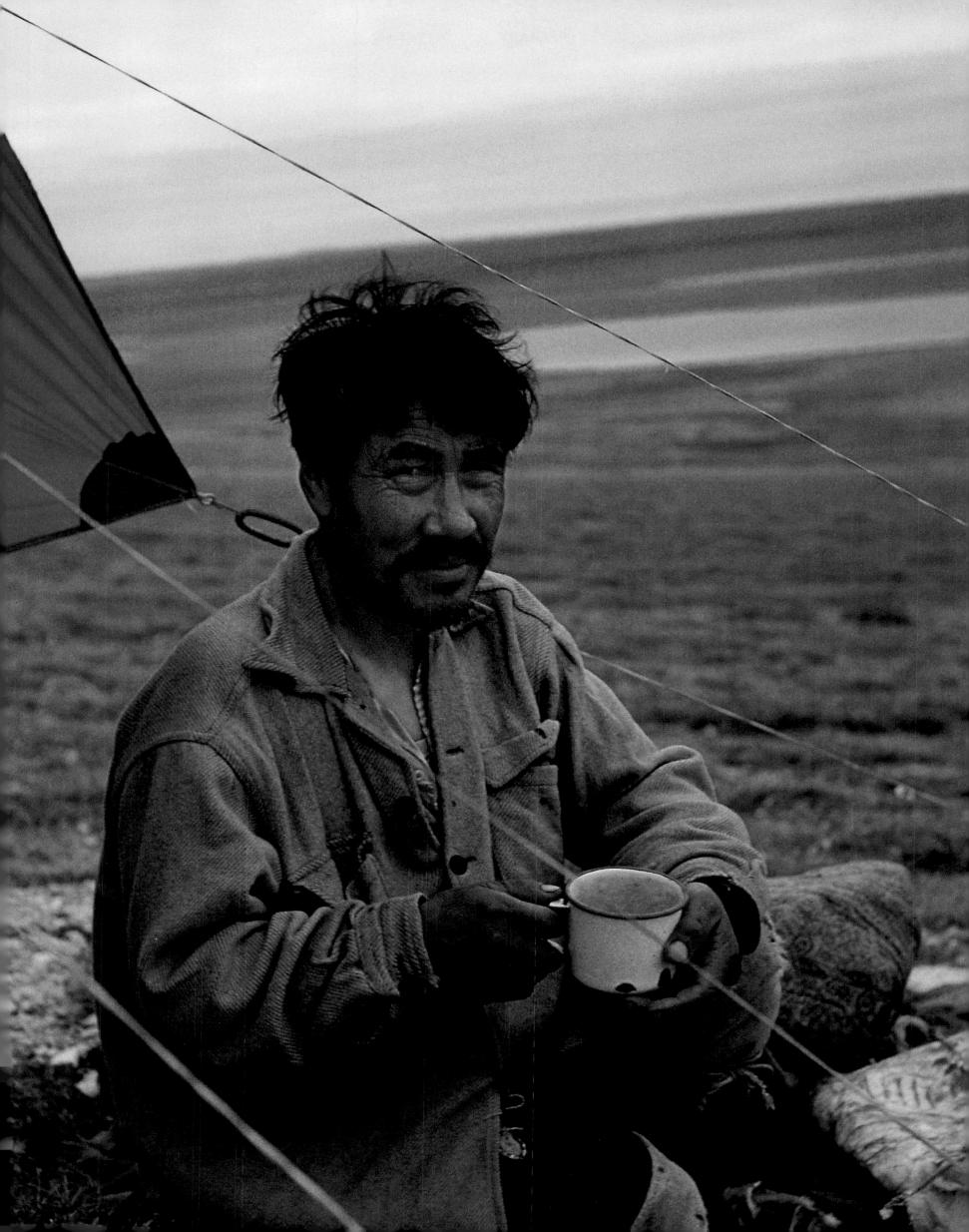

Right: Spence, Boothia Peninsula, August 1961. I told this old hunter how much I admired shamanism. He showed me his appreciation with his eyes. The Inuit are pantheists who see themselves as part of a cosmic order that predates their own history. This shaman is reading the great book of Nature and deciphering its coded meaning.

Below: Clyde, Baffin region, May 1987. Figurines made of reindeer wood, sculpted in front of me. Natural man. Nature makes natural. The shaman can turn into a walrus-man, a bear-man, a bird-man. "The universe is one and its origin can only be eternal unity. It is a vast organism in which the forces of life are in sympathetic harmony." (Paracelsus)

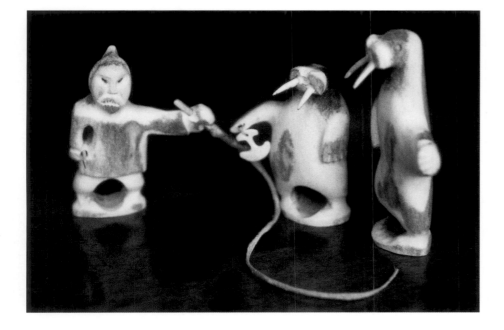

Following pages: Igloolik, September 1960. A seal-hunting camp, used from July to October. When famine looms the Inuit share an ethic of austerity. This is natural: they are like desert nomads. They know how to take care of their needs. In Spence, in October, the Netsilik sat shivering in their tents as it snowed outside. They were laughing proudly. According to the Canadian government, each family needed 100 caribou per year. I saw them live off of only half that. The government also proclaimed that they needed fifty seals; they had ten. The Inuit are filled with a spiritual energy. This helps explain their conservative habits—they believe they have a reserve of energy and adaptation. Their secret? A belief in the future. Societies don't die away. They evolve in sorrow, a result of crises.

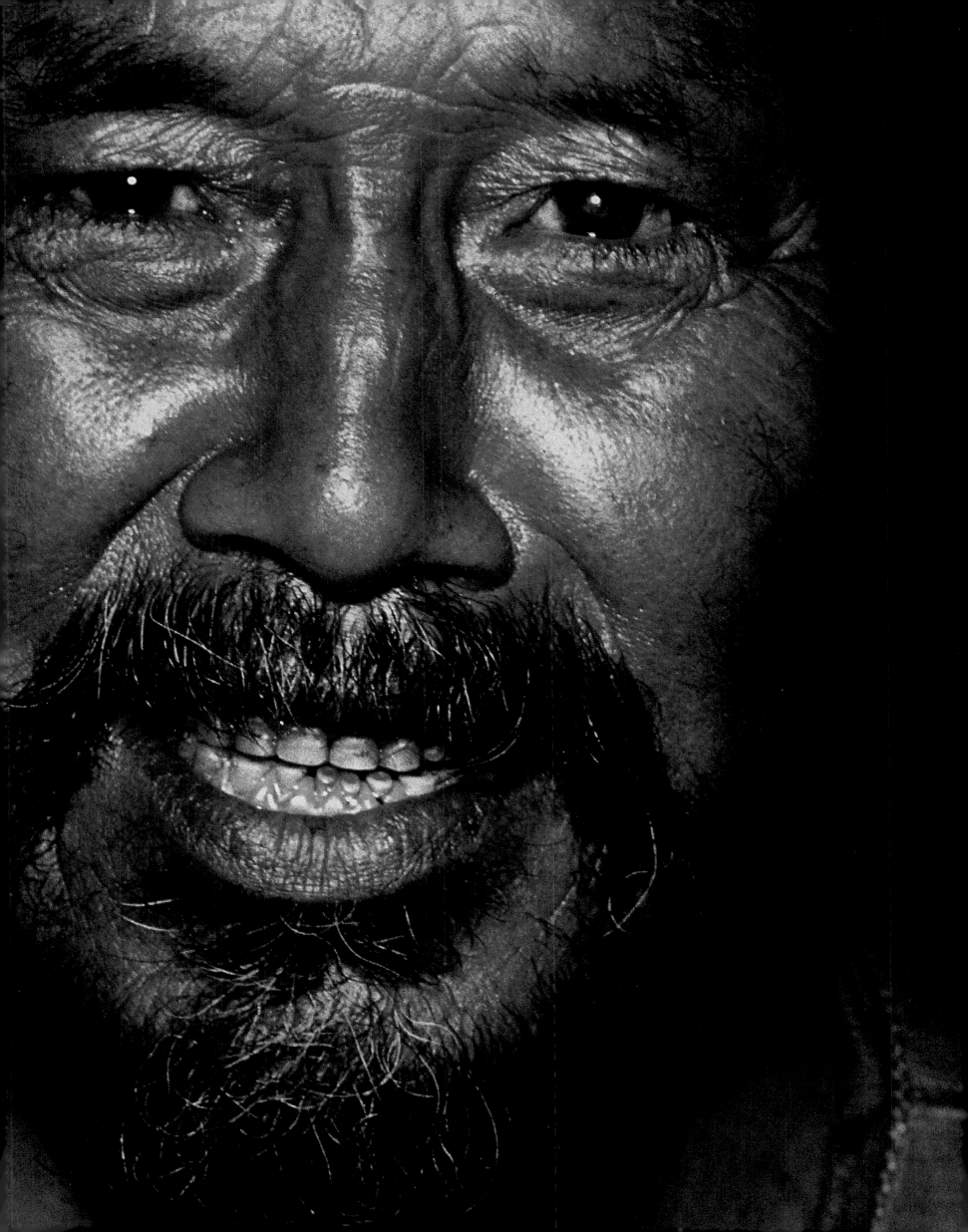

THE NETSILIK, MEN OF THE ARCTIC'S CRUELEST LAND

BOOTHIA PENINSULA, CENTRAL CANADIAN ARCTIC

"There is scarcely any country on earth that presents conditions more severe and inclement for man."
—Knud Rasmussen, *The Netsilik Eskimos: Social Life and Spiritual Culture*, Copenhagen, 1931

MYTH AND IMAGINATION

GENESIS

"In the beginning, it was night. There were no men. Then there was a time of happiness, when an androgynous man—with male genitals, female breasts, a little beard, and a tail—lived in harmony with his relatives, the animals. Then came the flood, after which two shamans, by copulating, gave birth to two daughters."
—Jean Malaurie, *Hummocks*, Volume I, Paris, 1999

GIANTS

"There was in this tribe an ancient tradition as to a race of giants who had once lived in this land before they themselves came here. These were called 'Tungi,' and were always spoken of with the greatest respect. They were said to have been considerably taller than the Eskimo and much stronger. Bearskin was their clothing. Some ruins of ancient stone huts . . . were supposed by the Eskimo to have been Tungi huts."
—Roald Amundsen, *The North West Passage*, London, 1908

PROHIBITIONS

"But while the moon is in this particular quarter, venturing to light a fire is out of the question. Such superstitions as these abound among the Eskimo, and it is useless trying to convince them of their absurdity. . . . During the hunting season . . . no one could induce them to touch a needle except for some case of absolute necessity."
—Roald Amundsen, *The North West Passage*, London, 1908

THE GOOD SAVAGE OR A PRIMITIVE?
A MATTER OF PERSPECTIVE

CAPTAIN JOHN ROSS

"It has been the custom, on one side, to overrate the virtues of savage nations, and, on the other, to exaggerate their vices. These things must be left to the novelist, and to the navigator who desires to emulate him, for the sake of producing an effect; to the false philanthropist and the lover of paradox."
—Sir John Ross, *Appendix to the Narrative of a Second Voyage in Search of a North-West Passage and of a Residence in the Arctic Regions During the Years 1829, 1830, 1831, 1832, 1833*, London, 1835

JAMES CLARK ROSS

"Nor did I ever entertain romantic notions of the perfectibility of savage nations; still less being given to suppose that any human power can ingraft a reasonable and

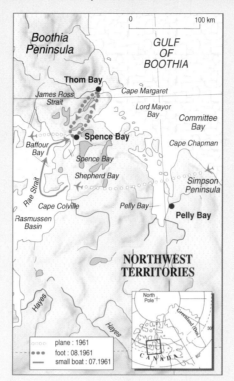

efficient religion on men who have never exerted their reason: who are deficient in every thing on which a rational faith, as well as a sound practice, can be founded." (Major J. C. Ross spent four years among the Netsilik during the expedition headed by his uncle, Captain John Ross. His report, made after three winters with the Netsilik, expresses his classist mindset, which was prevalent at the time . . . and, unfortunately, common during our time, too. He is one of the great British polar heroes.)
—Sir John Ross, *Narrative of a Second Voyage in Search of a North-West Passage and of a Residence in the Arctic Regions During the Years 1829, 1830, 1831, 1832, 1833*, London, 1835

"I have given several instances of their kindness . . . so did they appear to live together in perfect harmony, and to be free of selfishness, even on the subject of that great article, food, which constitutes the whole, it may almost be said, of a savage's enjoyments. I had no reason to suppose that I had prematurely formed this favorable opinion, though it is so much at variance with what has been reported of other tribes of the same people."
—Sir John Ross, *Narrative of a Second Voyage in Search of a North-West Passage and of a Residence in the Arctic Regions During the Years 1829, 1830, 1831, 1832, 1833*, London, 1835

"They were all well dressed. . . . We could now easily see that their appearance was very superior to our own; being at least as well clothed, and far better fed."
—Sir John Ross, *Narrative of a Second Voyage in Search of a North-West Passage and of a Residence in the Arctic Regions During the Years 1829, 1830, 1831, 1832, 1833*, London, 1835

KNUD RASMUSSEN

"Never in my life have I seen such frolicsome and happy people, so gaily starving, so cheerfully freezing in miserable, ragged clothing."
—Knud Rasmussen, *The Netsilik Eskimos: Social Life and Spiritual Culture*, Copenhagen, 1931

"Oh! You strangers only see us happy and free of care. But if you knew the horrors we often have to live through, you would understand too why we are so fond of laughing, why we love food and song and dancing."
—Knud Rasmussen, *The Netsilik Eskimos: Social Life and Spiritual Culture*, Copenhagen, 1931

"The main result of my visit there was, however, the strong and intimate impression I received of the summer joys of the Netsilingmuit. Life round my tent was so vigorous . . ."
—Knud Rasmussen, *The Netsilik Eskimos: Social Life and Spiritual Culture*, Copenhagen, 1931

DAILY LIFE

OBSERVING REGULATIONS

King William Island, on board Amundsen's boat, the *Gjoa*, trapped by ice, 1904. "An Eskimo by the name of Akla came to see us that night with a child. The boy had a bad cold and was coughing and spitting continuously. At first I said nothing, but towards the end, disgusted by this filth, I reminded Akla in no uncertain terms about observing regulations [on board the ship]. Taken aback by my severe tone, the Eskimo bent down quickly, gathered the spit with his hands off the floor and swallowed it all."
—Roald Amundsen, *Le Passage du Nord-Ouest*, Paris, 1909

THE HEART OF THE HUNT

"The Netsiliks, whom I had just left, had a thick layer of indescribable filth and fat on thigh, shin, feet and face, not to speak of ears, throat and neck. Naturally, this was because they were at the height of the spring hunting and were in constant contact with bloody meat and blubber, without ever making an attempt to wash themselves after flensing or after a meal."
—Knud Rasmussen, *The Utkuhikhalingmiut, in Report of the Fifth Thule Expedition, 1921–1924*, Volume VIII, No. 2, Copenhagen, 1931

GEOGRAPHY: BORN OBSERVERS

"It is astonishing how much the Netsilingmuit know about the land they live in, be it natural conditions and fauna or its early history. Though they had no previous knowledge of paper and pencil, they were remarkably quick in outlining the shape of their great country."
—Knud Rasmussen, *The Netsilik Eskimos: Social Life and Spiritual Culture*, Copenhagen, 1931

"One of them, Tullahiu, then took the pencil and drew the line by which they came, afterwards making spots on it, and counting their fingers to show that they had slept only nine times on the journey. Tiagashu then drew a line of coast around which we could sail in the autumn; this being in a westerly direction, and including capes, bays and rivers."
—Sir John Ross, *Narrative of a Second Voyage in Search of a North-West Passage and of a Residence in the Arctic Regions During the Years 1829, 1830, 1831, 1832, 1833*, London, 1835

HOW DO THEY EAT FISH?

SALMON . . .

"They preferred their fish raw. . . . One salmon, and half of another, was more than enough for all of us English, these voracious animals had devoured two each. . . . Each man had eaten fourteen pounds of this raw salmon."

—Sir John Ross, *Narrative of a Second Voyage in Search of a North-West Passage and of a Residence in the Arctic Regions During the Years 1829, 1830, 1831, 1832, 1833*, London, 1835

"The head and backbone being taken off from two fish, they were handed to Ikmallik and Tullahiu . . . who slit the body longitudinally into two equal parts, dividing each of those afterwards into two more. They were rolled up into cylinders of two inches in diameter; when putting one end into the mouth as far as possible, it was cut off with a knife so close as to endanger the end of the nose; the party then handing the remainder to his neighbour."

—Sir John Ross, *Narrative of a Second Voyage in Search of a North-West Passage and of a Residence in the Arctic Regions During the Years 1829, 1830, 1831, 1832, 1833*, London, 1835

. . . AND TROUT

"Thom Bay, Boothia Peninsula, August 1961: the Netsilik spear trout in the river. They immediately consume some of the raw fish, their heads in particular, which they eat with delight. They also cook fish over fires of roots and brush; they are in a hurry and will not wait—it will be half-boiled fish then, a fish soup."

—Jean Malaurie, Notebooks, 1961

THE HUNTING SITUATION IN PELLY BAY

An accounting of the hunting in Pelly Bay, southeast of Spence (1951–52, 1961). "Total caribou: fifty-eight between August 15 and November 2; the maximum killed by each hunter is six, the minimum, one. Yet fifty to sixty caribou are necessary per year to survive. Over the course of 1952, the number of foxes hunted on average per family is ten, though some families take only one or two. Many of these hunters are good trappers but they are too proud to serve the whites and the trading post: the average price paid for a fox is pathetic: $5.50. Annual revenue per family is $60. The price of products sold at the trading post: a 30-30 rifle in 1951–52: $105; a trap: $0.90; a net: $0.21; a knife: $3.10; a tent: $79. The Mounted Police noted in 1952 report: 'A hunter with a 30-30 rifle and who wants to obtain the necessary munitions for a seal hunt will need to trap eight foxes to be able to pay for these munitions; if he wants two fishnets: nine additional foxes.' The Netsilik, economically, are in a bad situation. The Netsilik are a story of poor people, very poor people."

—Jean Malaurie, Notebooks, 1960–63

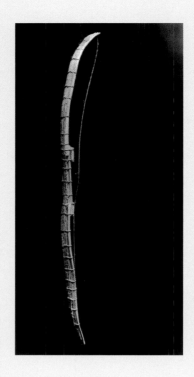

LAWS AND CUSTOMS

THE JUSTICE OF PROXIMITY

"The murderer's punishment consisted of being banished to perpetual solitude, or shunned by every individual of the tribe; insomuch that even his sight was avoided by those who might inadvertently meet him."

—Sir John Ross, *Appendix to the Narrative of a Second Voyage in Search of a North-West Passage and of a Residence in the Arctic Regions During the Years 1829, 1830, 1831, 1832, 1833*, London, 1835

TRADING WIVES

"It is the custom to interchange wives. . . . In this country, the views of the citizens may be physiological, for aught that I know to the contrary, though it remained to discover whether they proved sound in practice. The people thus considered that they should have more children."

—Sir John Ross, *Narrative of a Second Voyage in Search of a North-West Passage and of a Residence in the Arctic Regions During the Years 1829, 1830, 1831, 1832, 1833*, London, 1835

THE *KIPOUKTUT*

Boothia, 1961. "On the trail, Arnadja mentions the *kipouktut* [trading wives]. 'It's natural between men. What is the harm? It reinforces friendship.' Arnadja adamantly tells me that priests and pastors have no business getting involved with Inuit customs. The men and women who are traded are called *Aitpareik*. The children from this exchange can only marry each other. The children born from the trade of women always help each other; they consider each other brothers."

—Jean Malaurie, Notebooks, 1961

MORTALITY AND SUICIDE

Boothia, 1960. "The Inuit's situation is bad, frankly. Endemic famine decimates the Netsilik and caribou hunters. Two dead here, five there. People are indifferent; the elite is silent. The general public has only learned about the horrible famine in Garry Lake (more than fifty dead in 1953). In Back River during the winter of 1959, five percent of the group starved to death. In my research, I want to calculate prenatal and infant mortality rates, which are very high among the Netsilik. Between 1900 and 1939, the Nunavik Inuit population decreased by more than sixty percent. There is a lack of transparency in statistics when there is famine and catastrophe. The Canadian government in Ottawa hesitates to take action; they adopt wait-and-see politics. Official reports are contradictory: 'All goes well: the country has fish. They are hungry but prefer caribou to fish and there is no more caribou. They no longer want to gather around the trading post. They are courageous. . . . But they turn lazy and beg if they settle near the trading posts. What can be done? They are so complicated.' To cite a speech delivered by Prime Minister Louis Saint-Laurent: 'We have governed these vast lands in the Far North with an almost continuous state of absence of mind.'"

—Jean Malaurie, Notebooks, 1961–63, and *Hummocks*, Volume I, Paris, 1999

INFANTICIDE

"The most glaring consequence of the struggle for existence is manifested in the way in which they try to breed the greatest possible number of boys and the fewest possible girls."

—Knud Rasmussen, *The Netsilik Eskimos: Social Life and Spiritual Culture*, Copenhagen, 1931

"Infanticide (of female children) remains a hidden reality among the Netsilik. The result is a dearth of women. A friend of mine, a hunter, went to seek a young girl or a woman within three hundred miles. He could not find one. The decision to kill a female child is made discreetly by the father or mother, for fear of the police. The babies are generally suffocated with a piece of reindeer hide placed over the mouth. The body is thrown far from the igloo or the tent so that it won't be eaten by the dogs. In the past, a widow was condemned to eliminate her young baby if it was a girl. An exception: adoption."

—Jean Malaurie, Notebooks, 1961

SUICIDE

"The Canadian ethnologist, Asen Balikci, with whom I became friendly in Ottawa, carefully studied the Arviligmarmiut of Pelly Bay between 1959 and 1965. He notes that in a population of five hundred Netsilik, fifty suicides or attempted suicides in fifty years were counted. The men, young and old, are more suicidal than the women. Suicide is committed by hanging, rifle or drowning. The Inuit believe that victims of violent deaths benefit from a better world beyond."

—Jean Malaurie, *Hummocks*, Volume I, Paris, 1999. *Also see* Asen Balikci, *The Netsilik Eskimo*, New York, 1970

THE UTKUHIKHALINGMIUT.
HEADING OFF TOWARDS THE ARCTIC SPARTANS.

Below: Gjoa Haven (Uqsuqtuuq), southeast of King William Island, 1963. The shadow of a great past. The Norwegian explorer Roald Amundsen wintered here from September 1, 1903 to August 13, 1905, on board the *Gjoa* (47 ton, 7-man Norwegian cutter), crossing the northwest passage towards which the British strove so heroically for a century. To the north of these shores, they suffered the greatest tragedy of polar exploration: the disappearance of captain John Franklin—his body and provisions—with his two ships and their crews.

Right: Gjoa Haven, April 1963. My Netsilik companion, Koorssout, who was born near Spence. He's forty-nine years old and is dressed entirely in caribou, as am I: boots, pants, *kolitak* jacket with hood and gloves. The dogs eat fish, seal, and bear. He accompanies the interpreter, Tootalik, who is also from Spence. Tootalik was my interpreter in 1961, too.

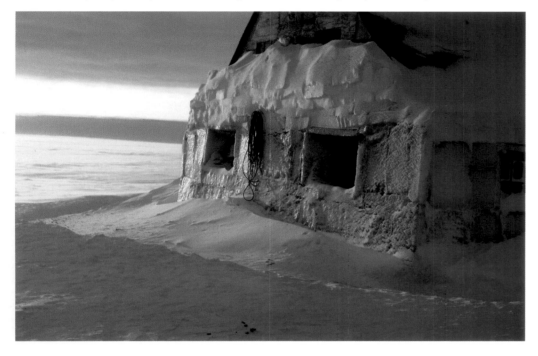

Following pages: Going toward the Utku, April 1963. I head south from Uqsuqtuuq on two sleds, accompanied by an English-speaking Mounted Police officer and a guide and a Netsilik interpreter, both Anglicans. We were on a mission for the Ministry of the Far North; our goal was to evaluate the situation of seven Utku (or Utkuhikhalingmiut) families who had experienced a famine in 1959. We were there to urge them to move closer to a trading post.

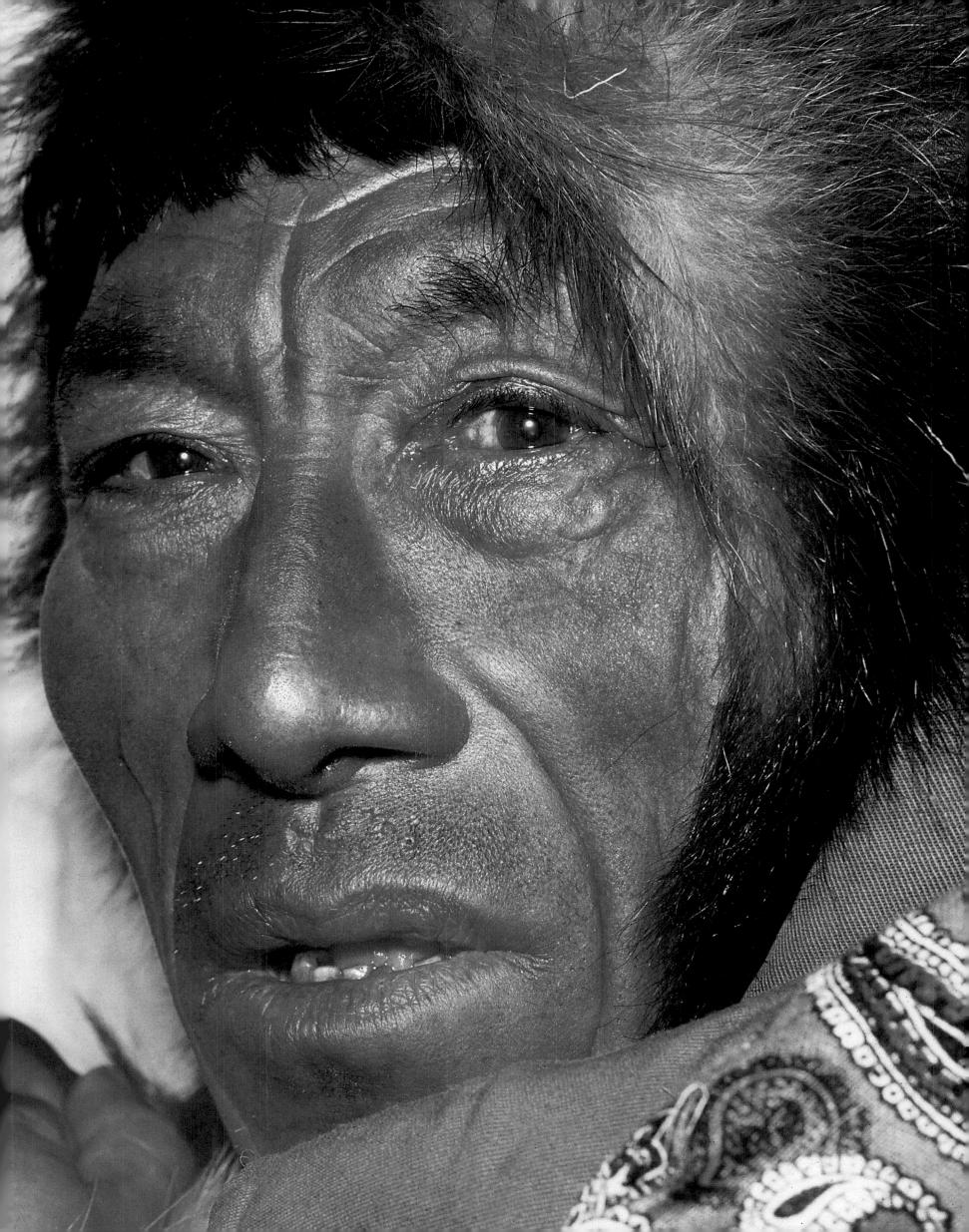

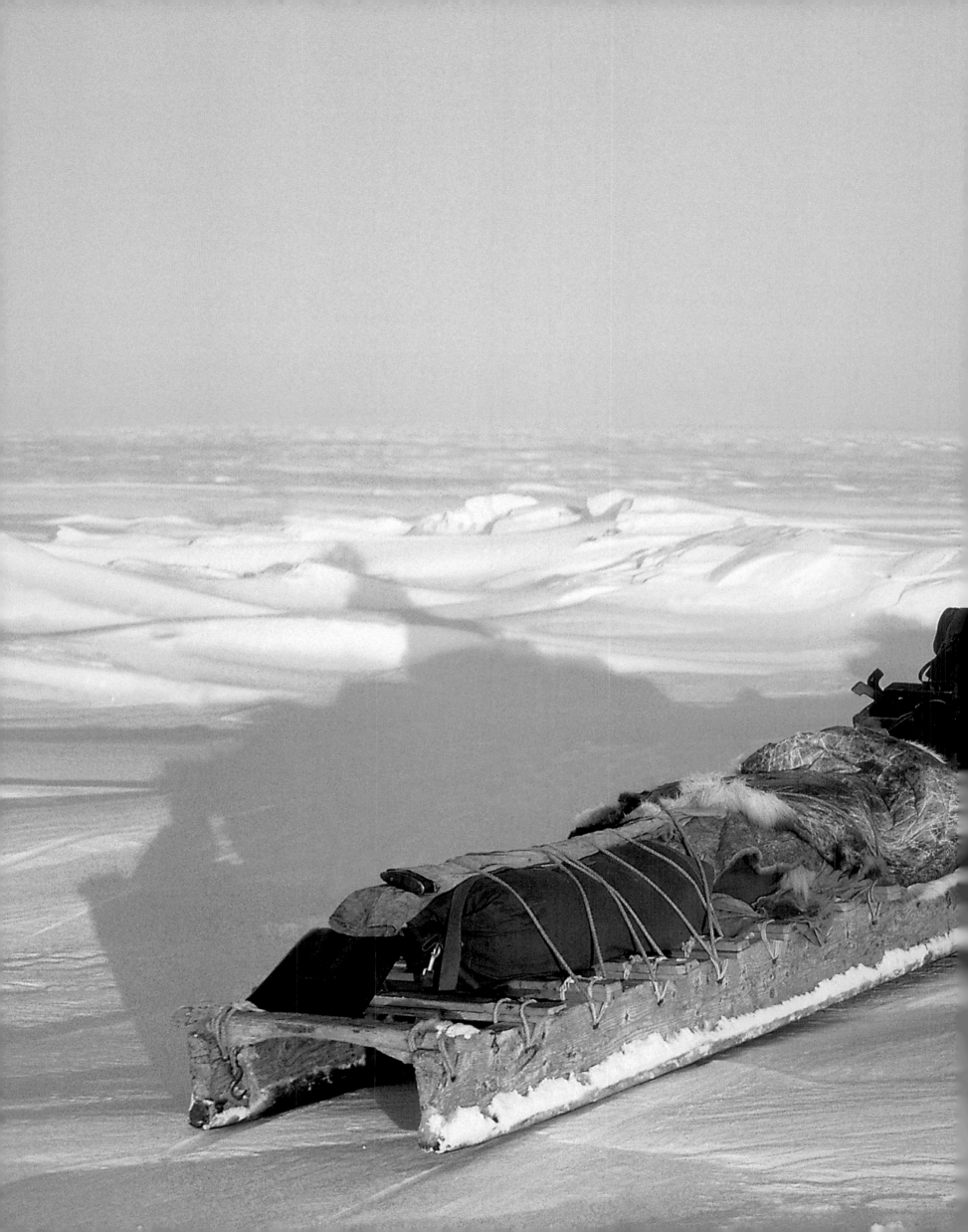

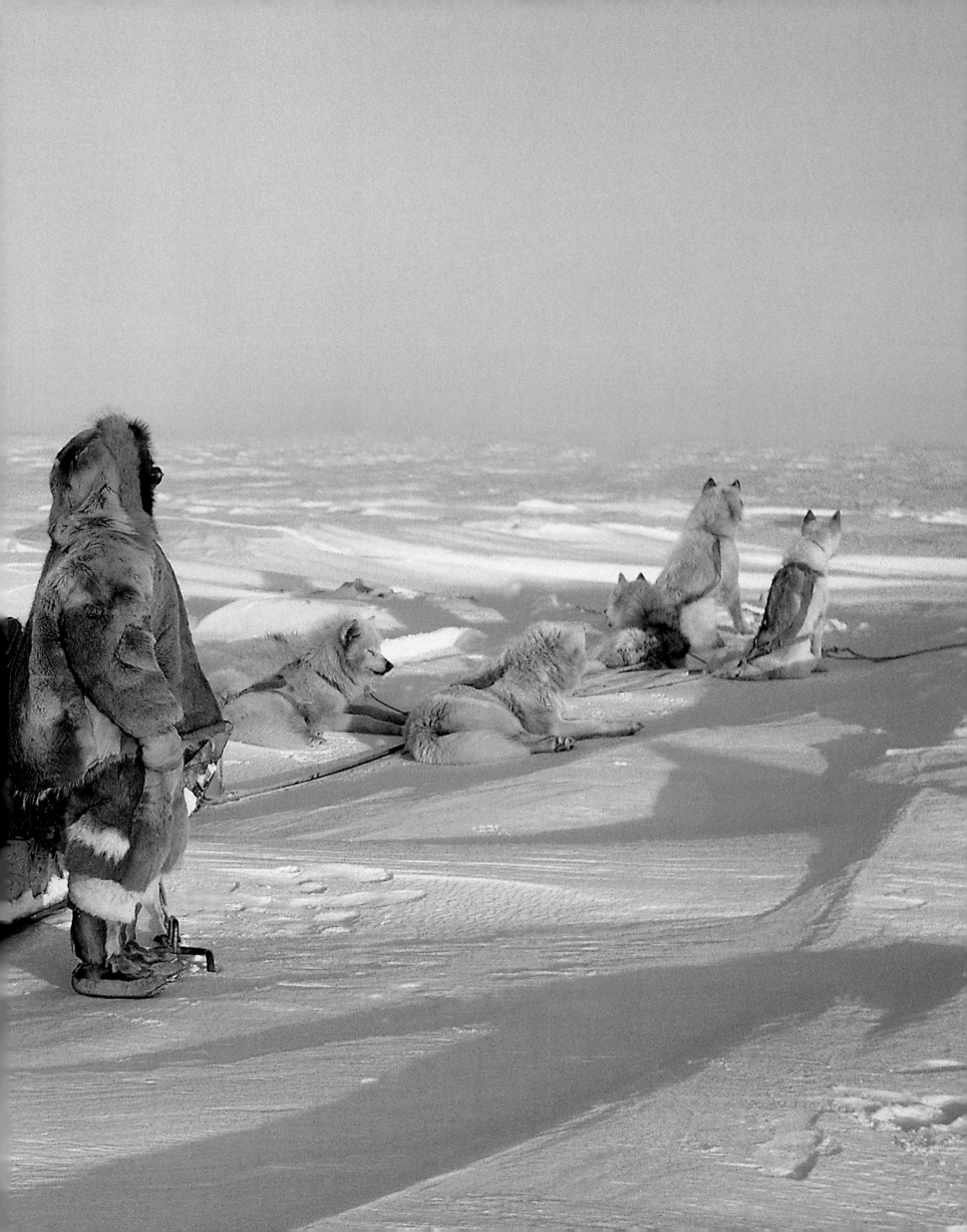

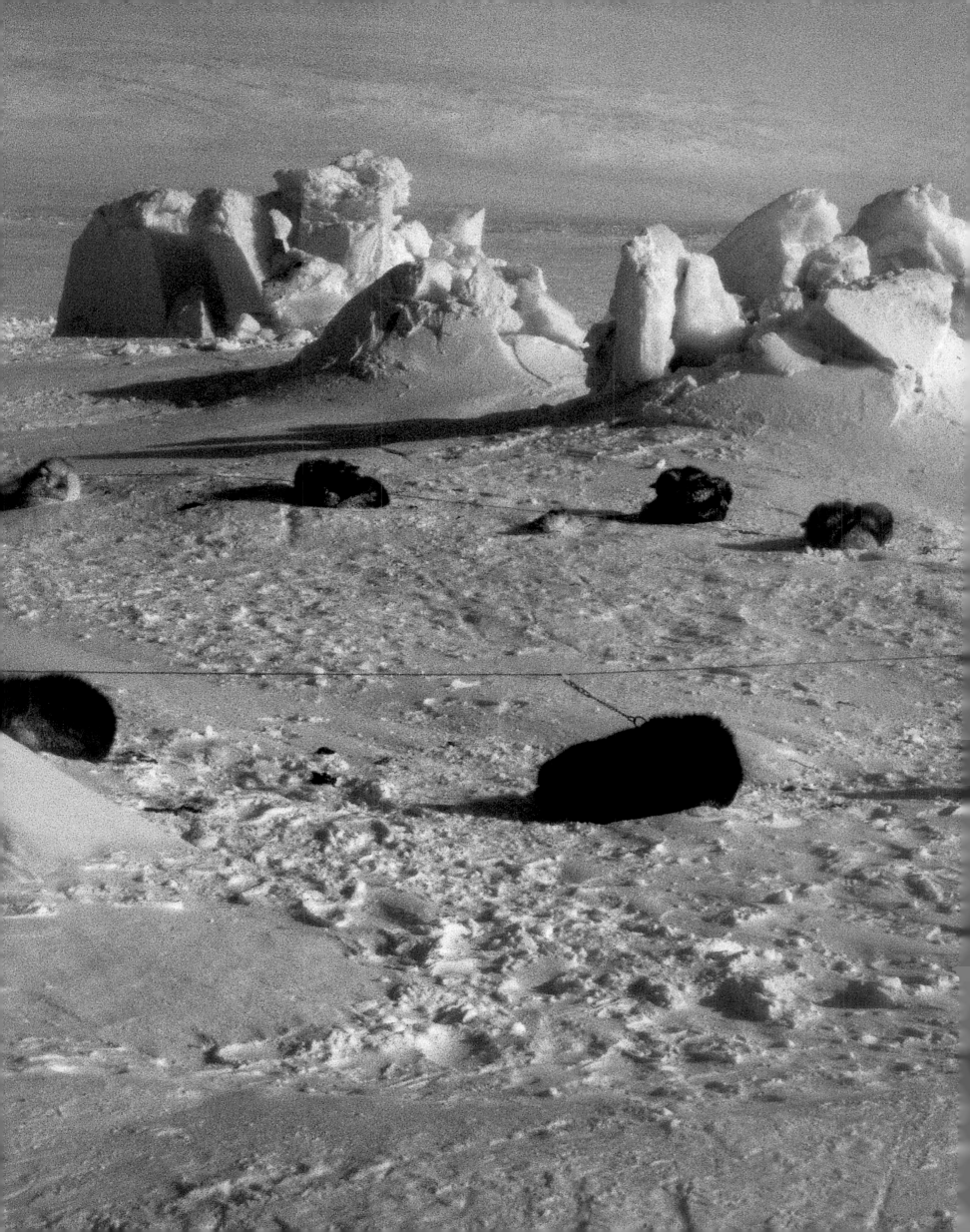

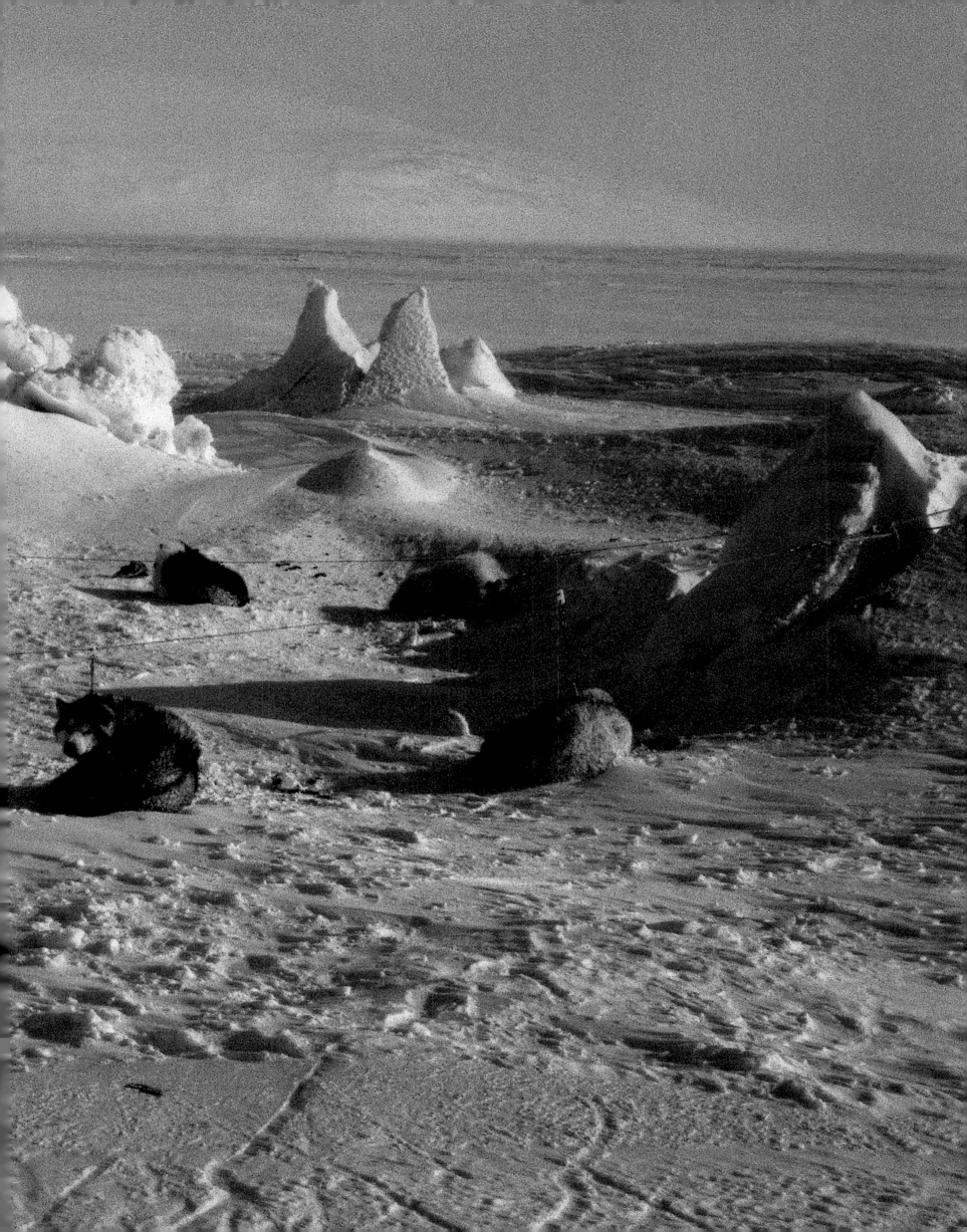

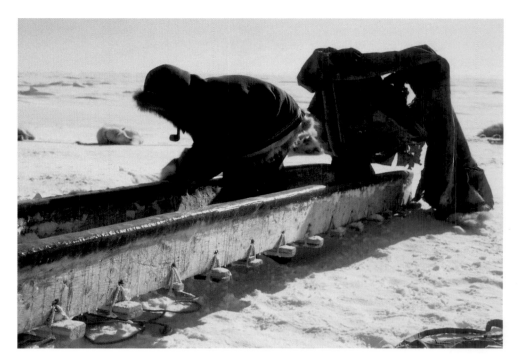

Some of our twenty-six dogs. As Sir Francis McClintock had observed in 1859, there
are no hummocks on the ice floe. The sailors of the Franklin Expedition therefore
had to cross only a single ice floe to reach the Back River.

From my journal, April 1963. "April 20, afternoon. At the Chantrey Fjord (Utkuhikjalik), seventy-five miles long and twelve miles wide. The weather is turning bad. A storm looms. This deserted island (Montreal), discovered on August 3, 1834 —you can see its northern foothills at the right—was the final point reached by the starving members of the Franklin expedition in the spring of 1848 on their way to the Back River and its fish. We trace a large circle in the packed snow for the four-person igloo we're going to build. It's cold, -22°F. Our breath fogs the air. In the morning we're covered in snow; it came through cracks of the igloo walls. We eat frozen and raw caribou and bear, which Koorssout cuts into small slices with his ax. The blizzard is whistling loudly."

Far left: Resting on the trail. A small tower of snow protects the harnesses from our starved, voracious dogs.

Center: Old-style sleds with blades made of peat. The blades are covered with a thin layer of ice that has to be refreshed every two hours. Their sleds are at the same level, technologically, as they were in 1848.

Right: I give instructions to Tootalik, the interpreter, as we reload the sleds. We are with a traveling Utku hunter.

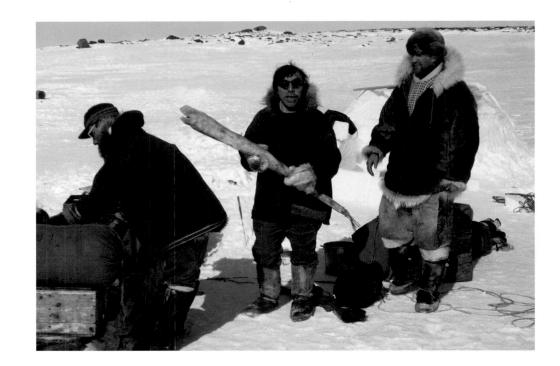

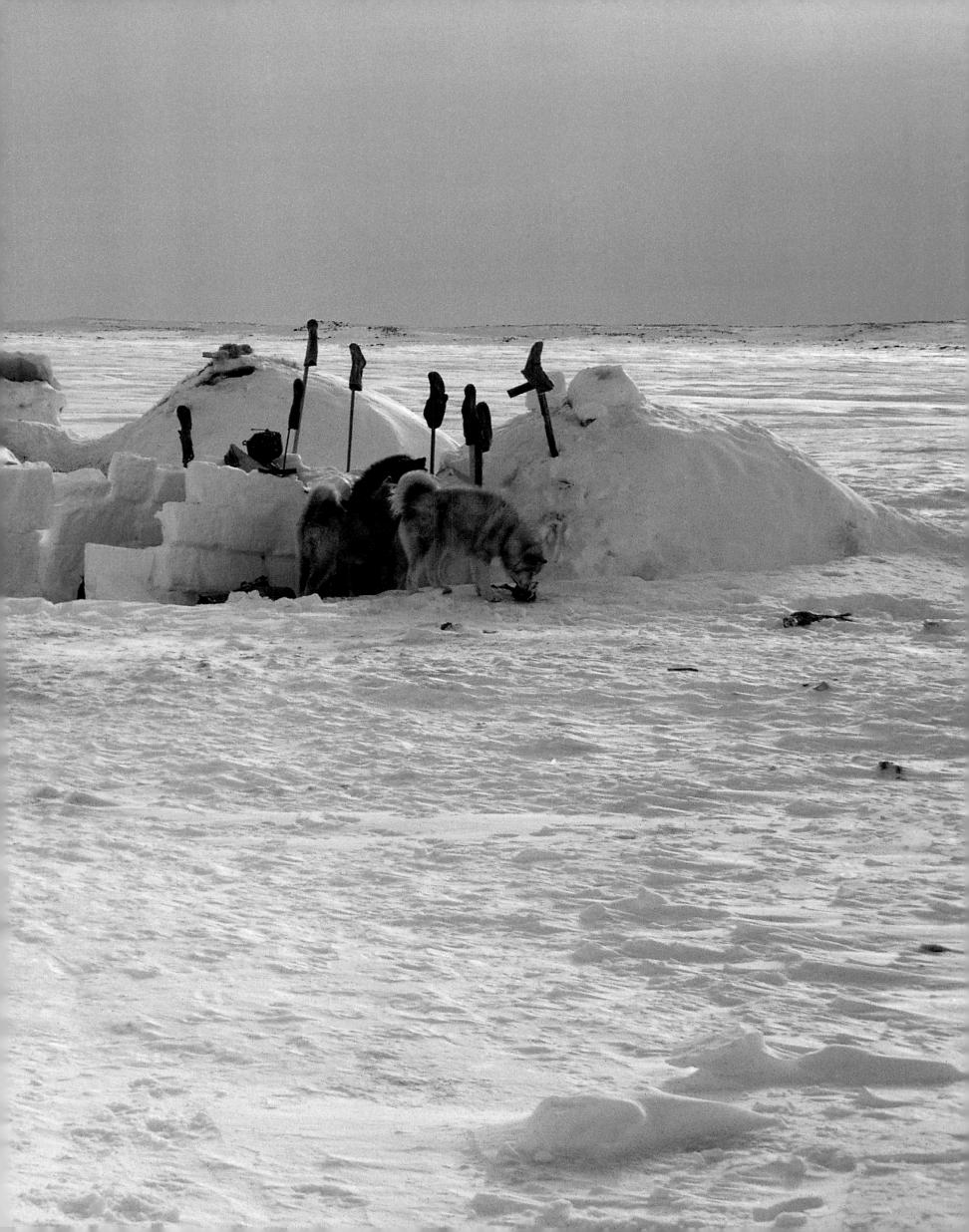

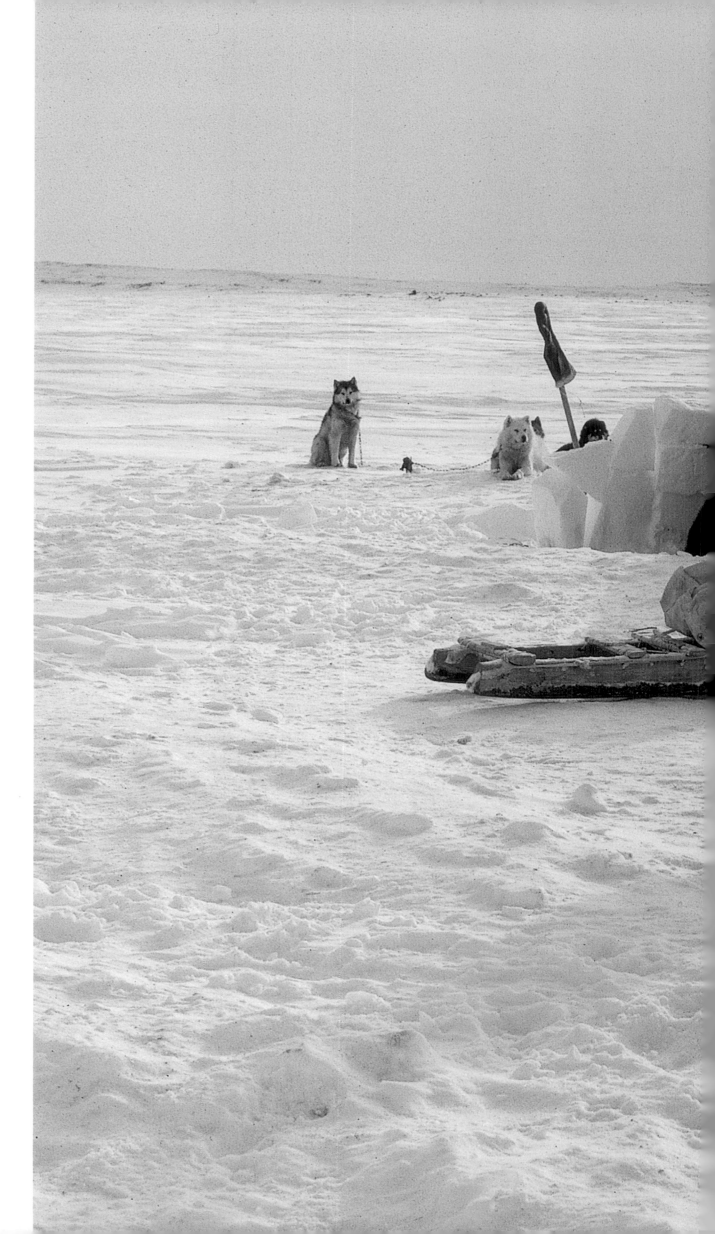

Previous pages: Amujat, Back River, April 1963. "I had wanted to meet the Eskimos for such a long time," noted Lieutenant George Back on July 28, 1833. "I walked right over to them, raised my arms, and cried out *Timâ!* Peace! They threw their lances to the ground, laid their hands on their chests, and also cried out *Timâ!*" The Danish explorer Knud Rasmussen stayed here for six days in June 1923. I am the first scientist in this hard-to-reach place since him. In this spartan land, the Inuit live off of raw fish and caribou, which are, unfortunately, scarce. The mysticism of poverty. The Inuit worry that the Master of Animals no longer likes them. Are they being punished for having abandoned their ancestral spirits for the god of the white man? Having been converted to Christianity, though, they see poverty as the passport to eternal life.

Right: Three snow igloos. Two families stand before me: men in front, women and children behind. Silent, standing erect, we shake hands. The women come closer. We do not shake hands with them. I hesitate between several igloos. I make a lucky choice. This *iglurjuaq* with two alcoves is home to a family with children. It belongs to Inoukshook, who was born in 1911, and his adopted son Akitok, born in 1940. The body heat of the many visitors keeps us warm. Farther away is the igloo of Toolegaak, born in 1891, where his wife and adoptive son are freezing.

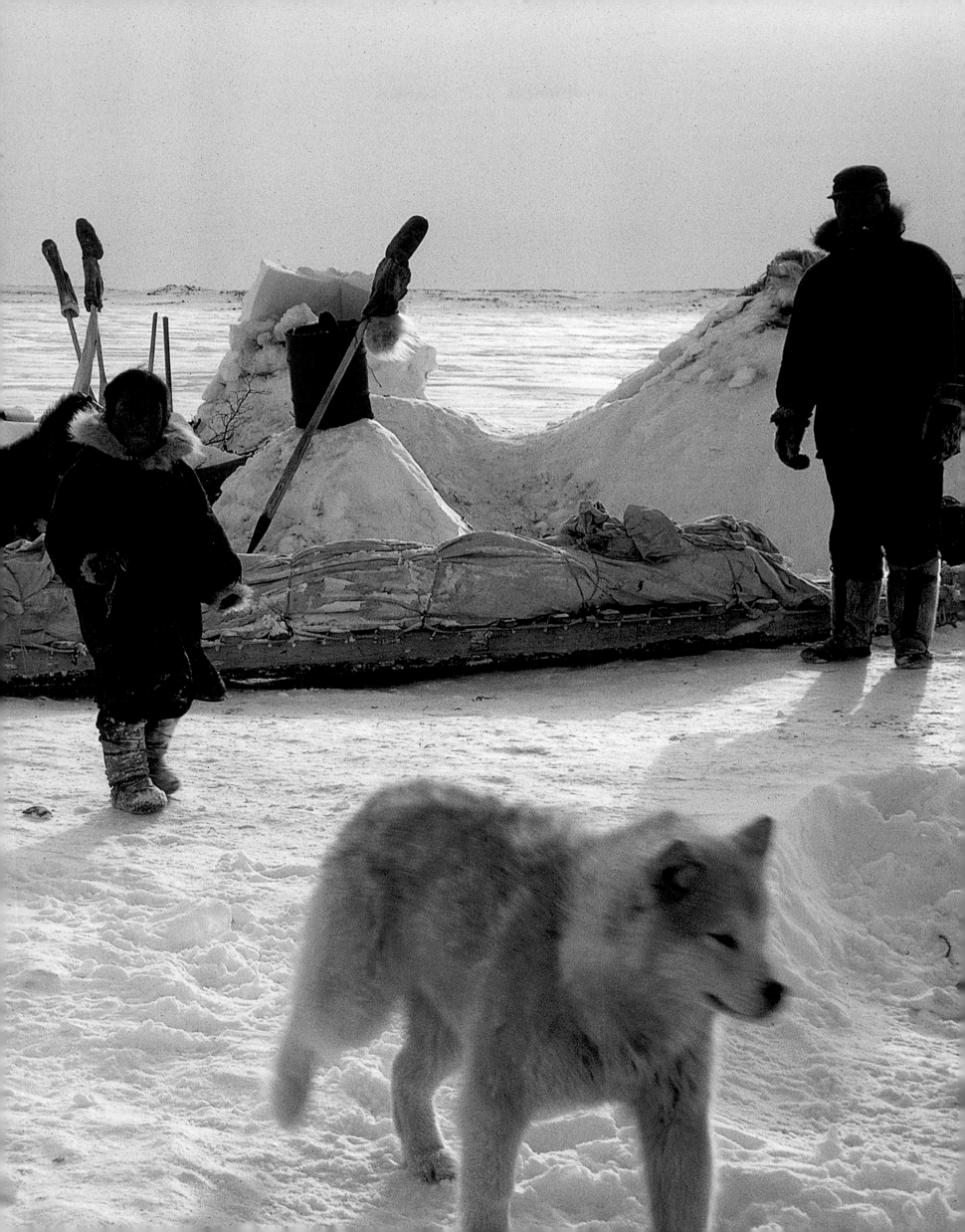

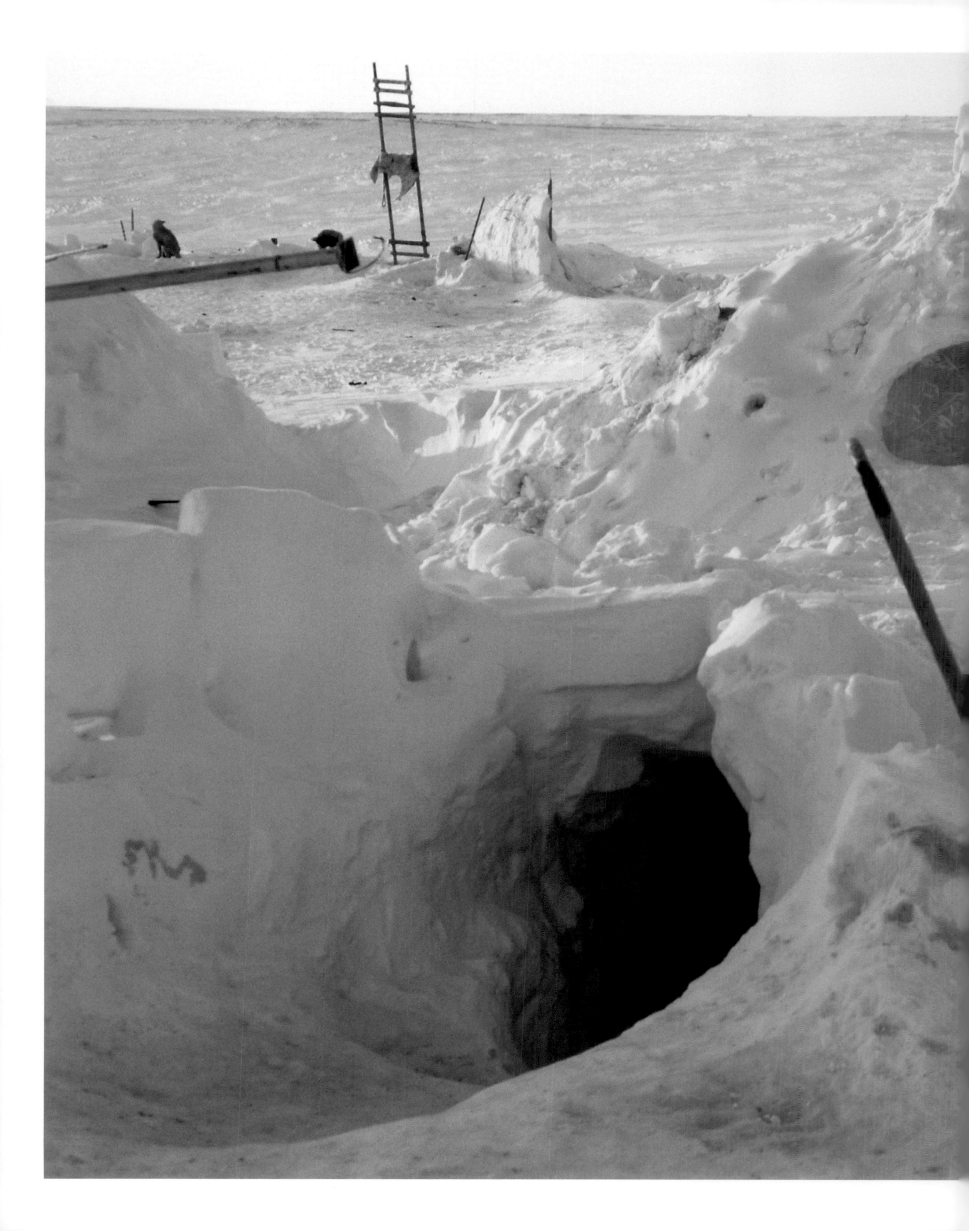

Previous pages: Amujat. April 19, 1963. Inoukshook's snow igloo, built on March 4. Six weeks "old," it will be all the "warmer" if the snow is powdery, and if the inside walls are not yet covered with a layer of ice, blackened by human breath—the "filth of life"—and the smoke from the hall, from when we occasionally build a fire in the *ishavik*.

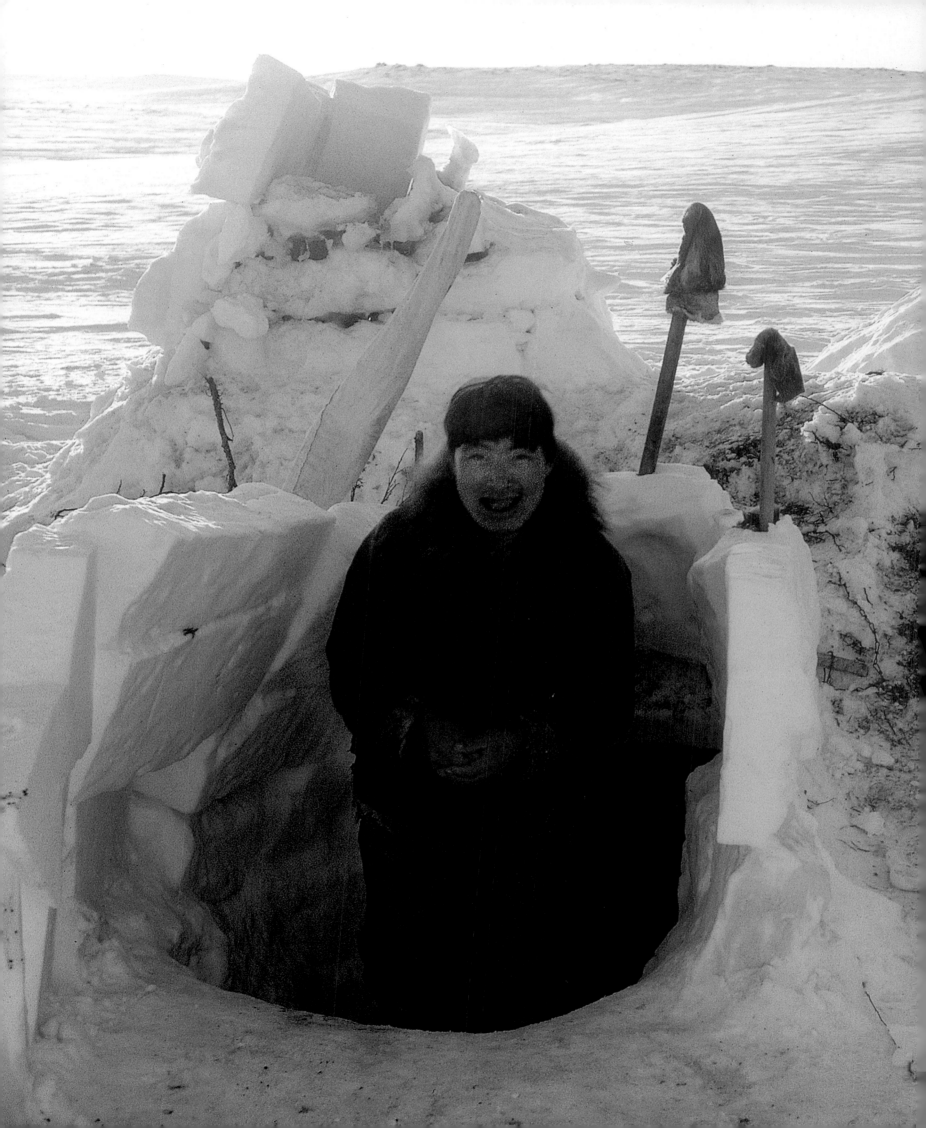

Previous pages: Amujat, April 19, 1963. Inoukshook's snow igloo was built on March 4. Six weeks old, it would be warmer if the snow was powdery, and if the interior walls were not covered with a layer of ice.

Above: A single *igalaak* (ice window), built at eye level. The window sparks flights of imagination; it is filled with the fantastic, sometimes even with monsters.

Left: An igloo entrance opening onto the sky. We descend into the icy snow, making our way like moles under the ground, twisting and turning nine feet down. This is the igloo's mouth—or its umbilical cord.

Following pages: Amujat, Back River, April 1963. Do the poor of societies with oral traditions have a unique place in human history? "The mysterious vocation of poverty . . . established in this world to atone for misery . . . The ancient tradition of poverty, to live one day at a time . . . to eat from the hand of God" (Georges Bernanos). These Eskimos have practically no heating. They are men of the tundra, and as such they refuse to hunt seals from the nearby sea despite a looming famine, a famine like the one that struck four years earlier.

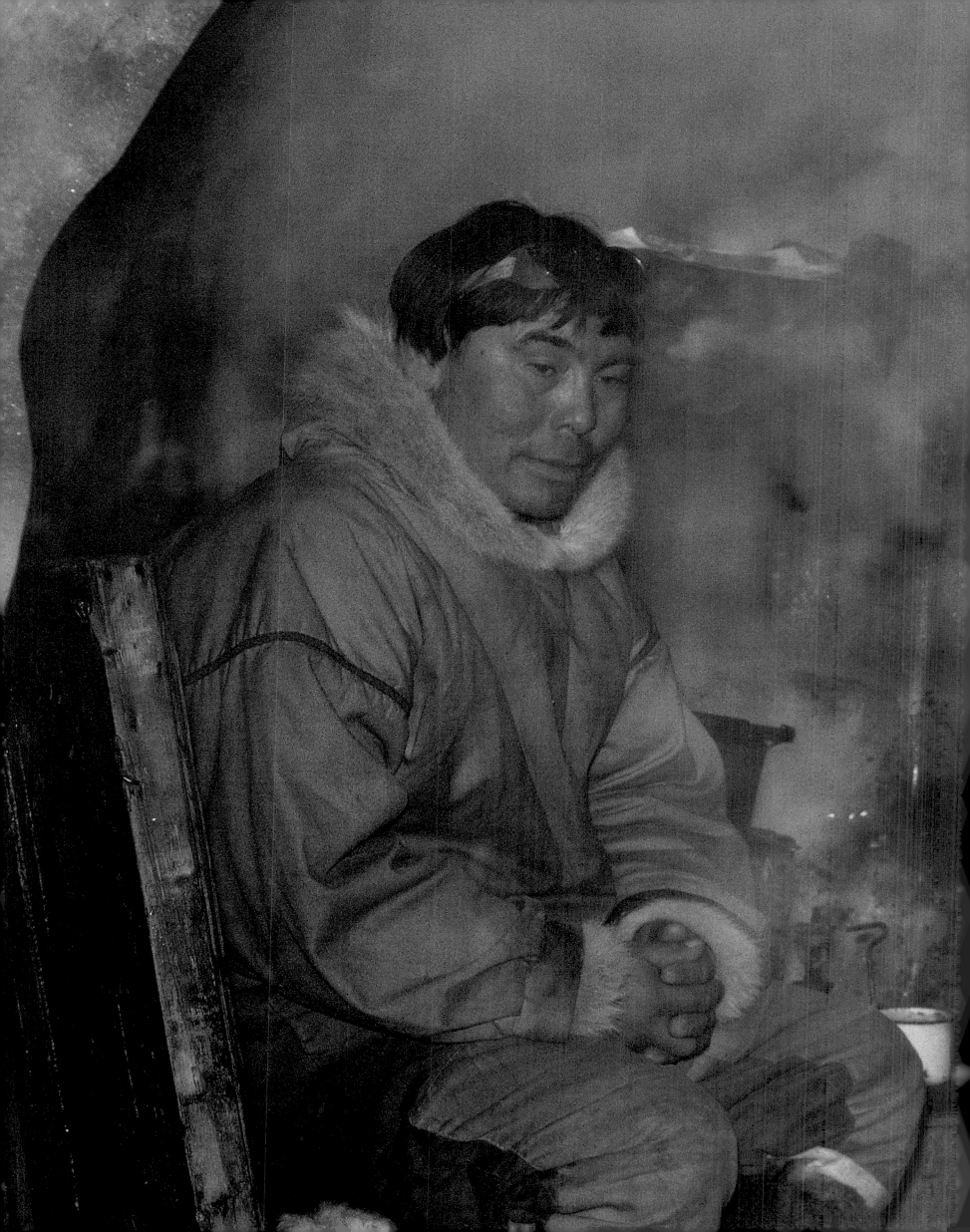

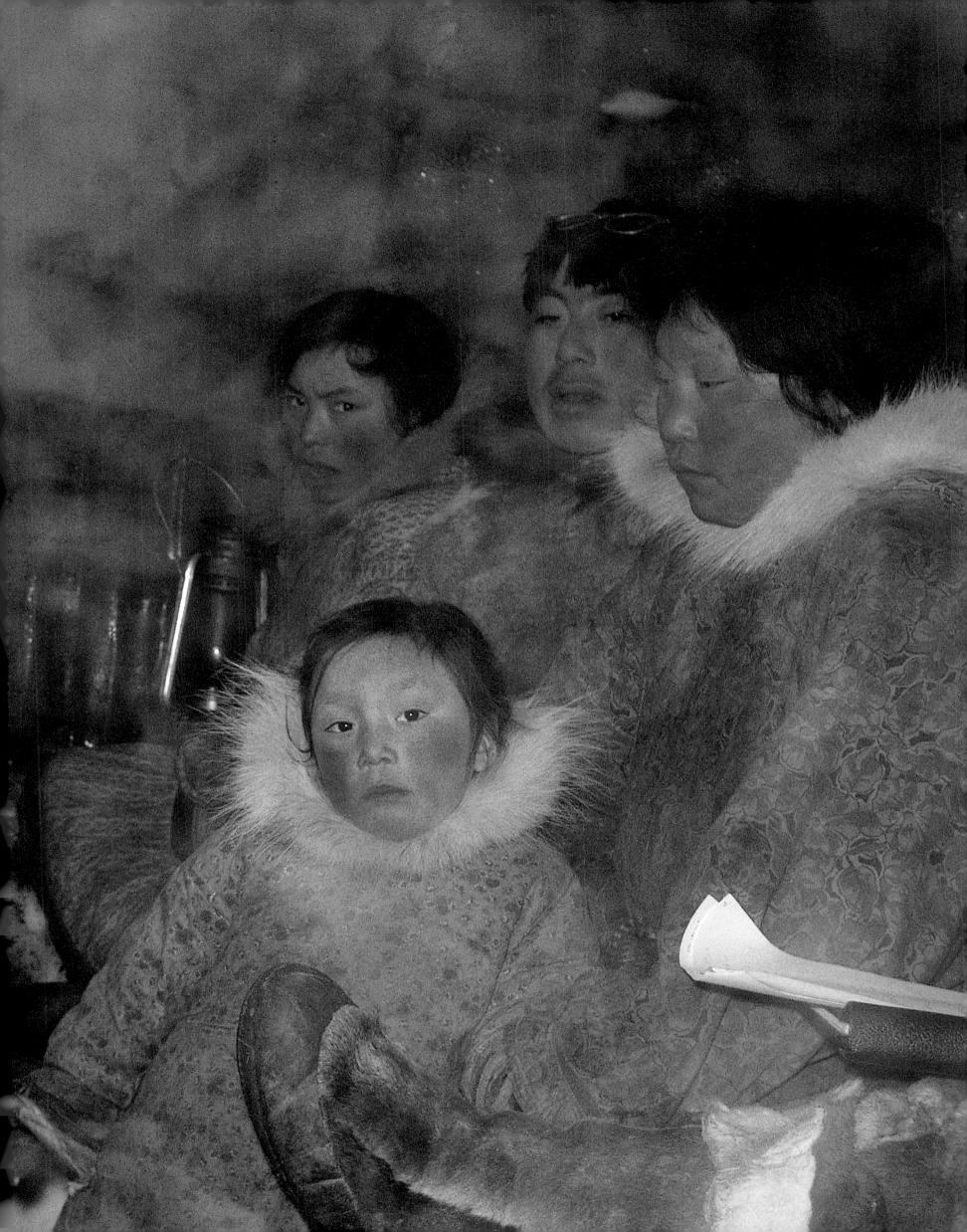

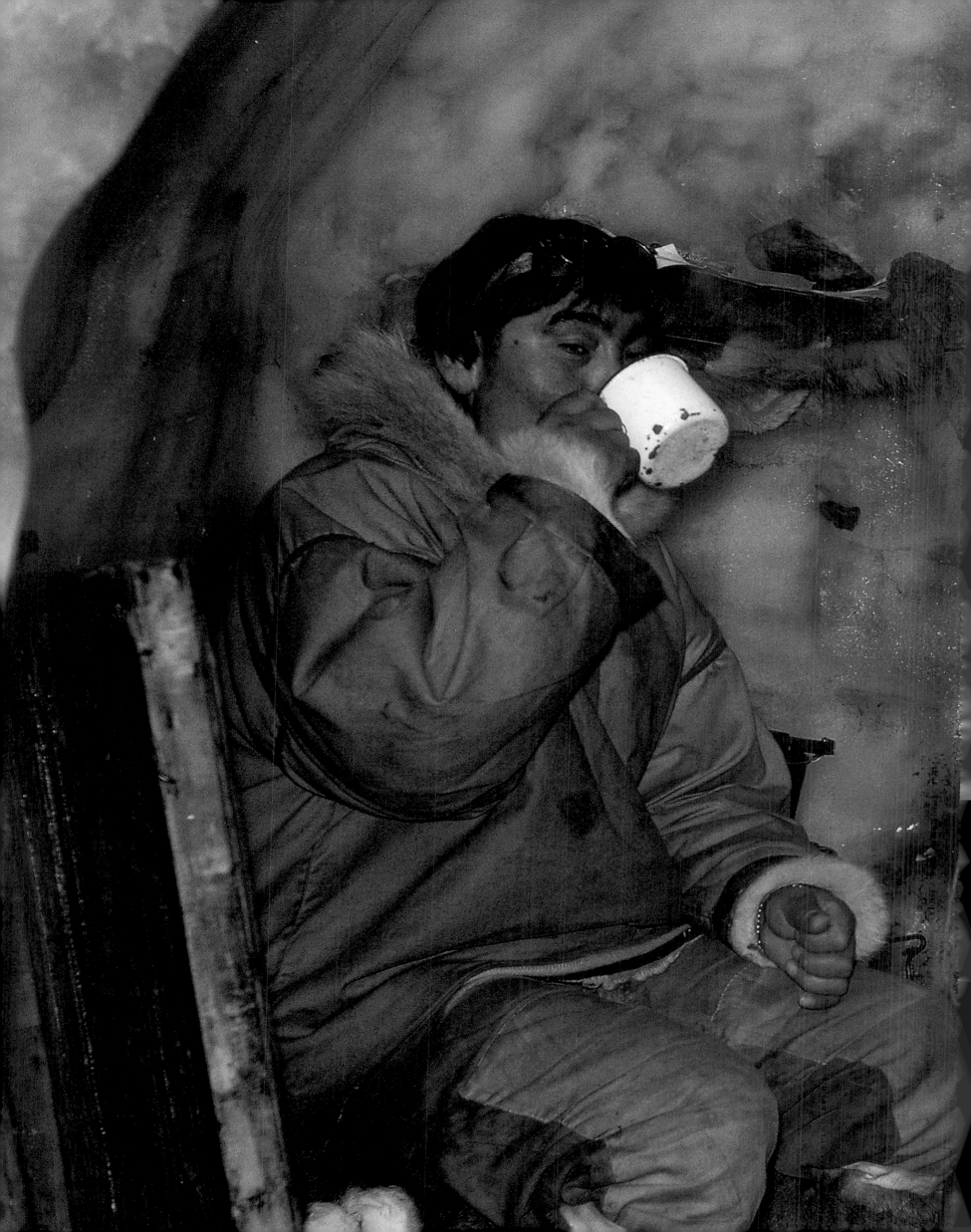

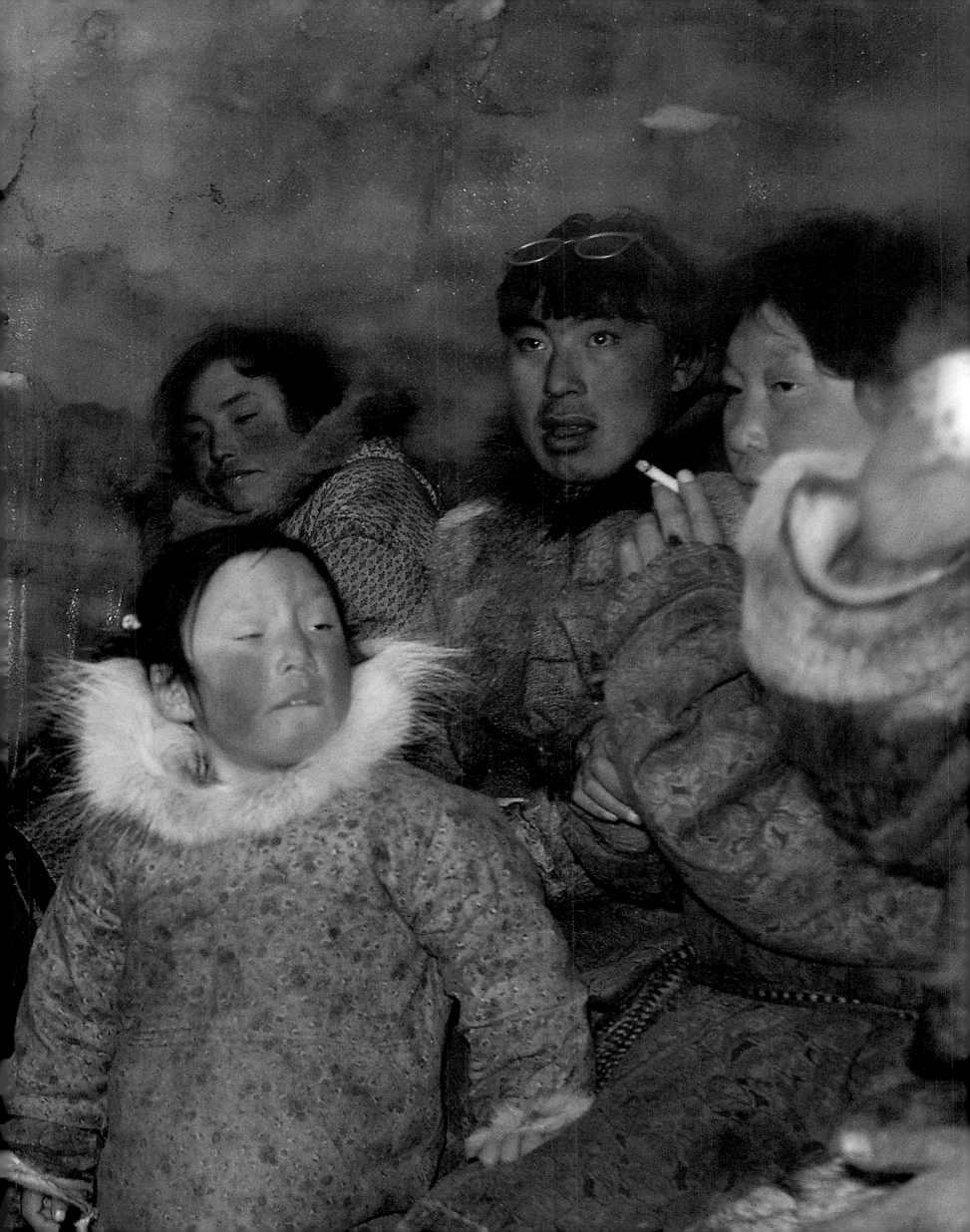

Amujat, Back River, April 1963. Early morning. I had evicted this dog and her pungent puppies when I moved into the alcove of an adjoining igloo. My host has just woken up; he is thinking about the government's relocation proposal I had told the community about the day before. A low wall of ice separates me from the alcove where Akitok sleeps on his stomach under a caribou hide. His wife, whom he had married on March 16, sleeps to his left; her name is Kresouk ("the wood"). Her eyes are soft and sad. I have nicknamed her "little fish." Every morning I delicately place a two-pound bag of tea beneath her head.

"AFFABLE SAVAGES"

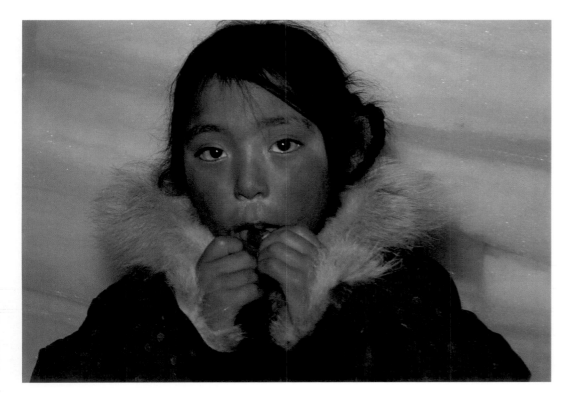

Above: Amujat, Back River. April 1963. My flash bulbs and tape recorder draw a great deal of attention. This little girl is sucking on a still-warm flash bulb.

Right: Amujat, Back River, April 1963. A Netsilik and her child. Like all the Inuit, the Utku and Netsilik are both cooperative and eloquent. They tell me that they often marry Netsilik women from Spence and Igpik, which are traditionally seal-hunting communities. But these Netsilik don't hunt or eat seals—it's an old taboo. The group includes seven families in two camps of igloos—twenty-five people total, ten men and fifteen women. The average age is low; there are seven daughters and three sons, including one adopted son who is less than fifteen years old. There is a senior or great elder, 72, an elder, 57, two elders older than 50, two men older than 40, and two women between 30 and 40. A widowed man has the most children: three, with six- and three-year age differences between them. Neonatal and infant mortality is high; life is so harsh here. Welfare turns children into a source of revenue: a family gets $5 to $8 a year until a child turns sixteen. The same is true for the seniors, who receive $65 after the age of fifty-five, an age very few reach.

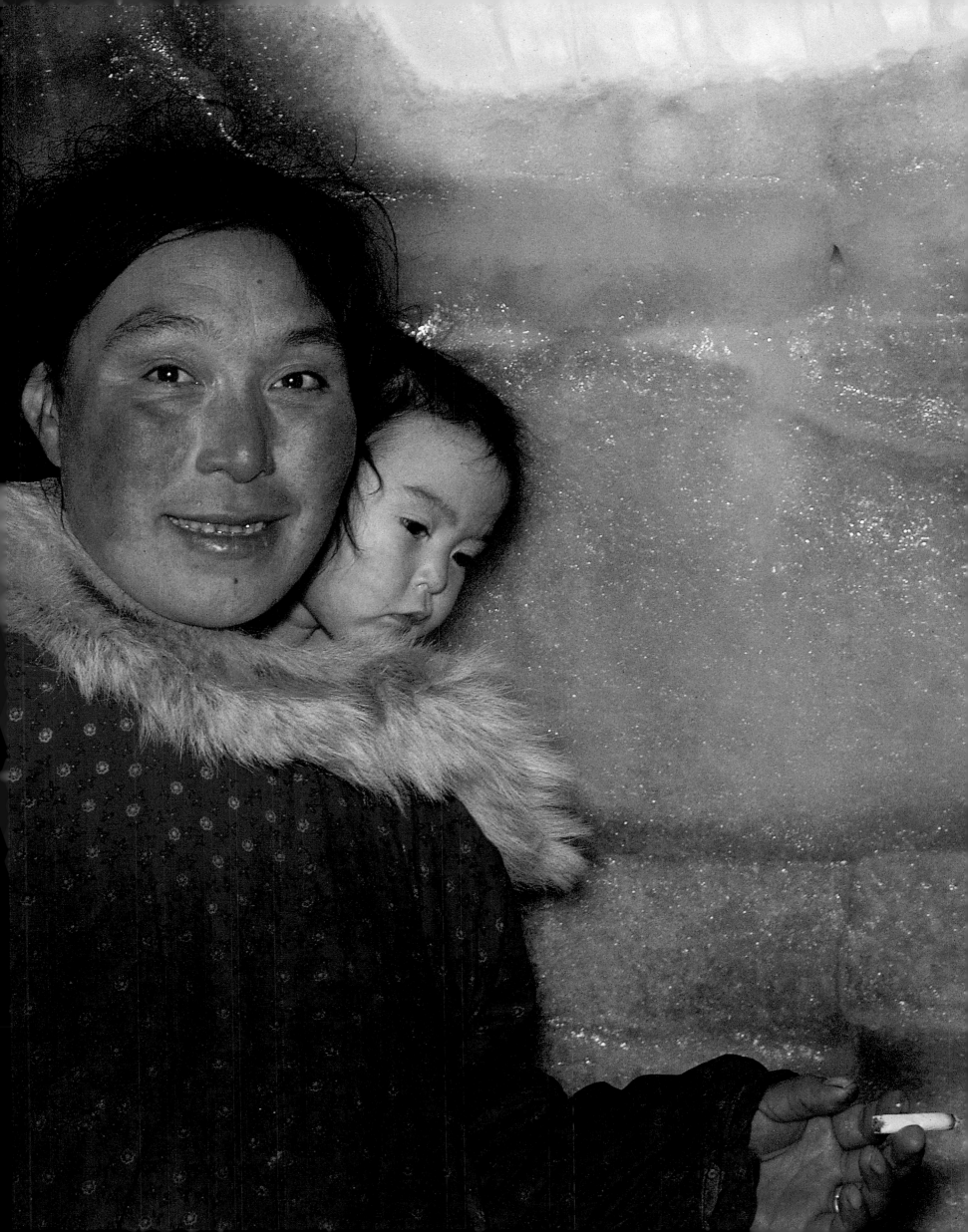

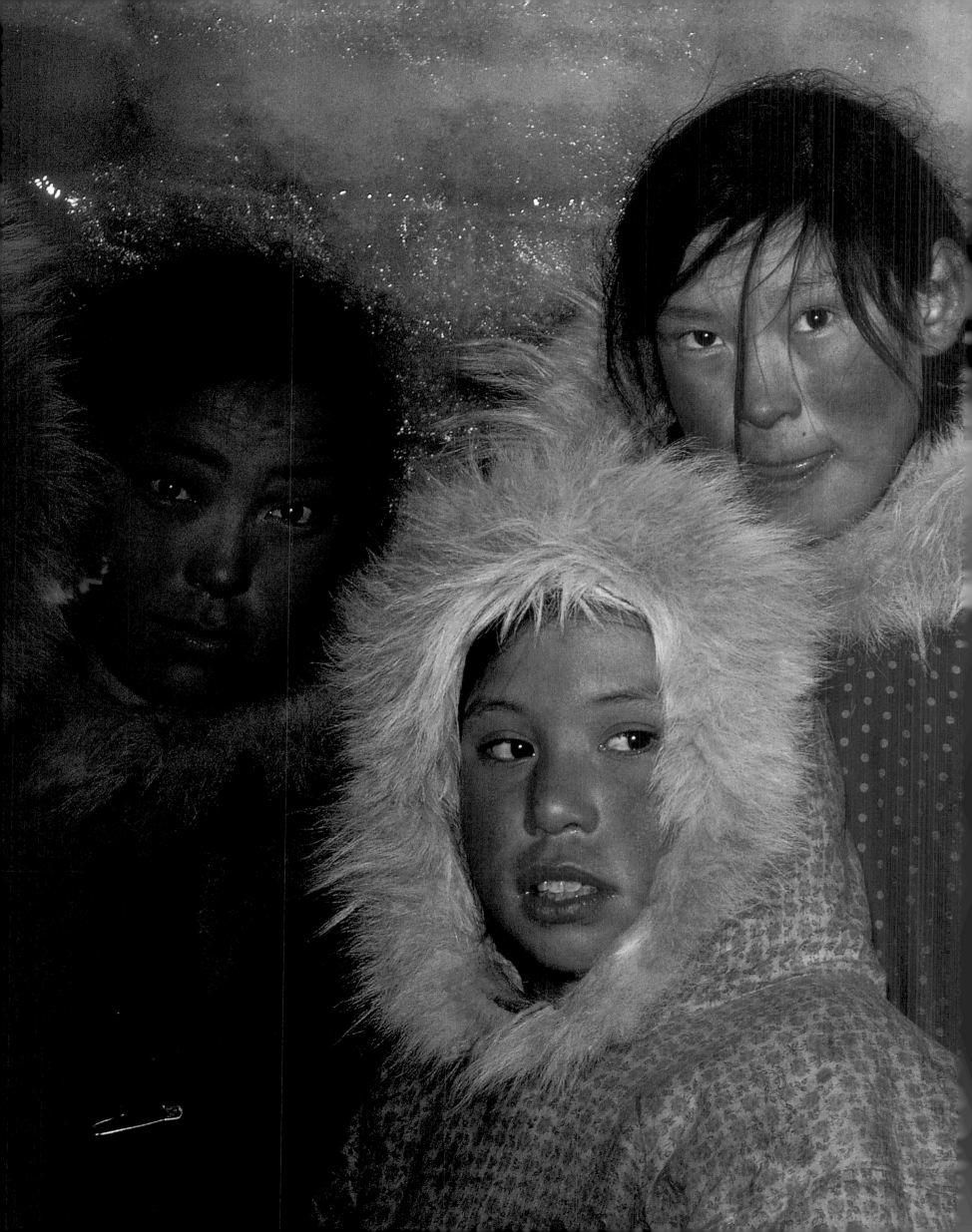

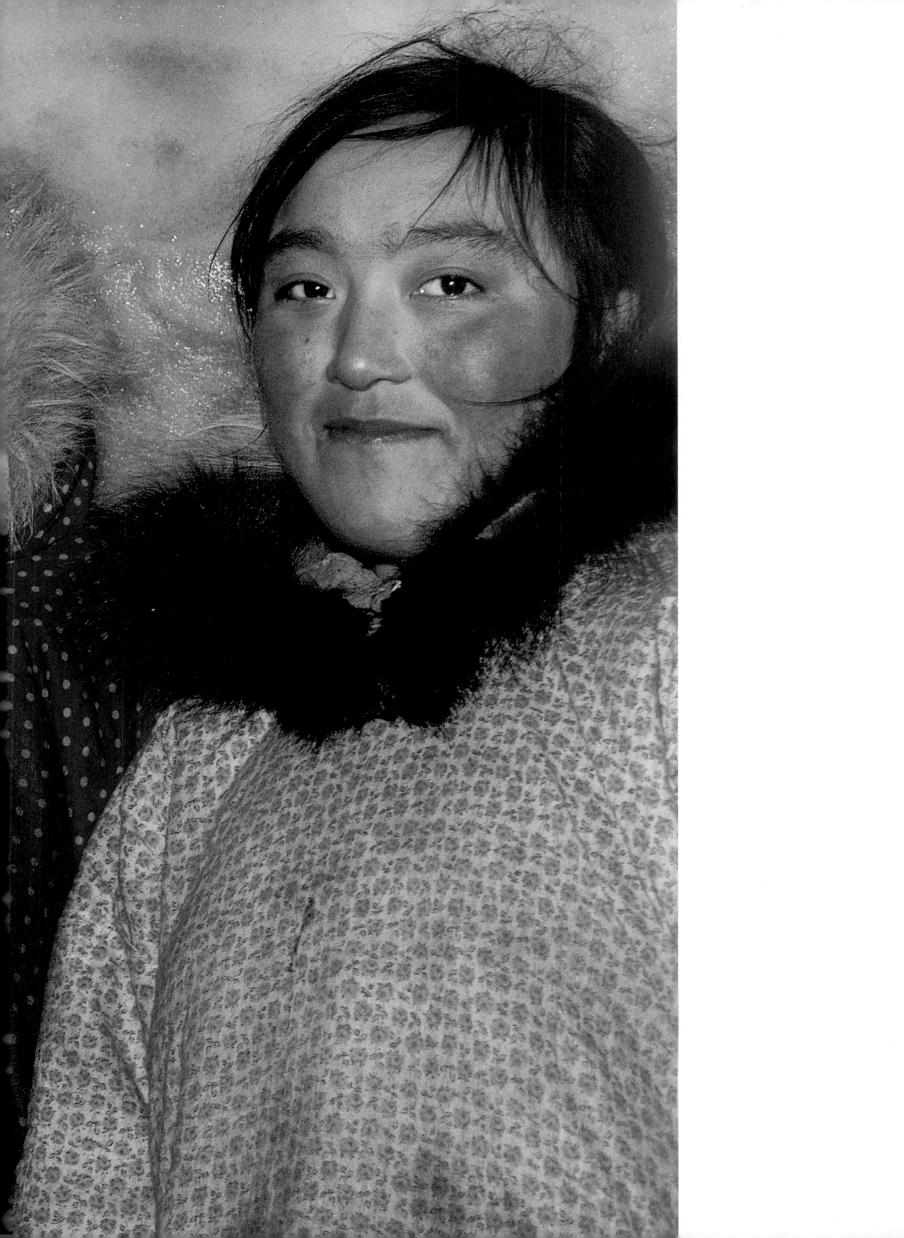

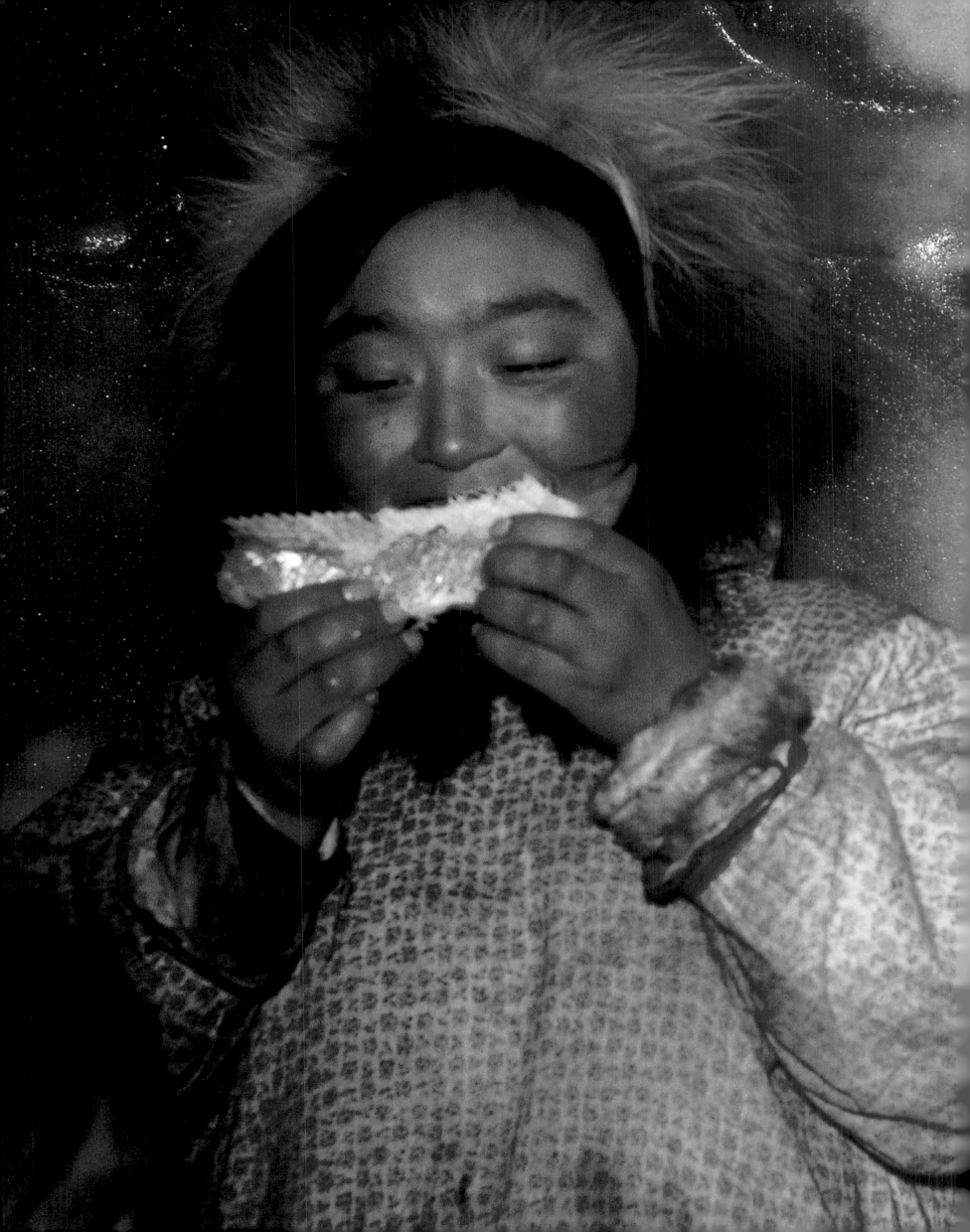

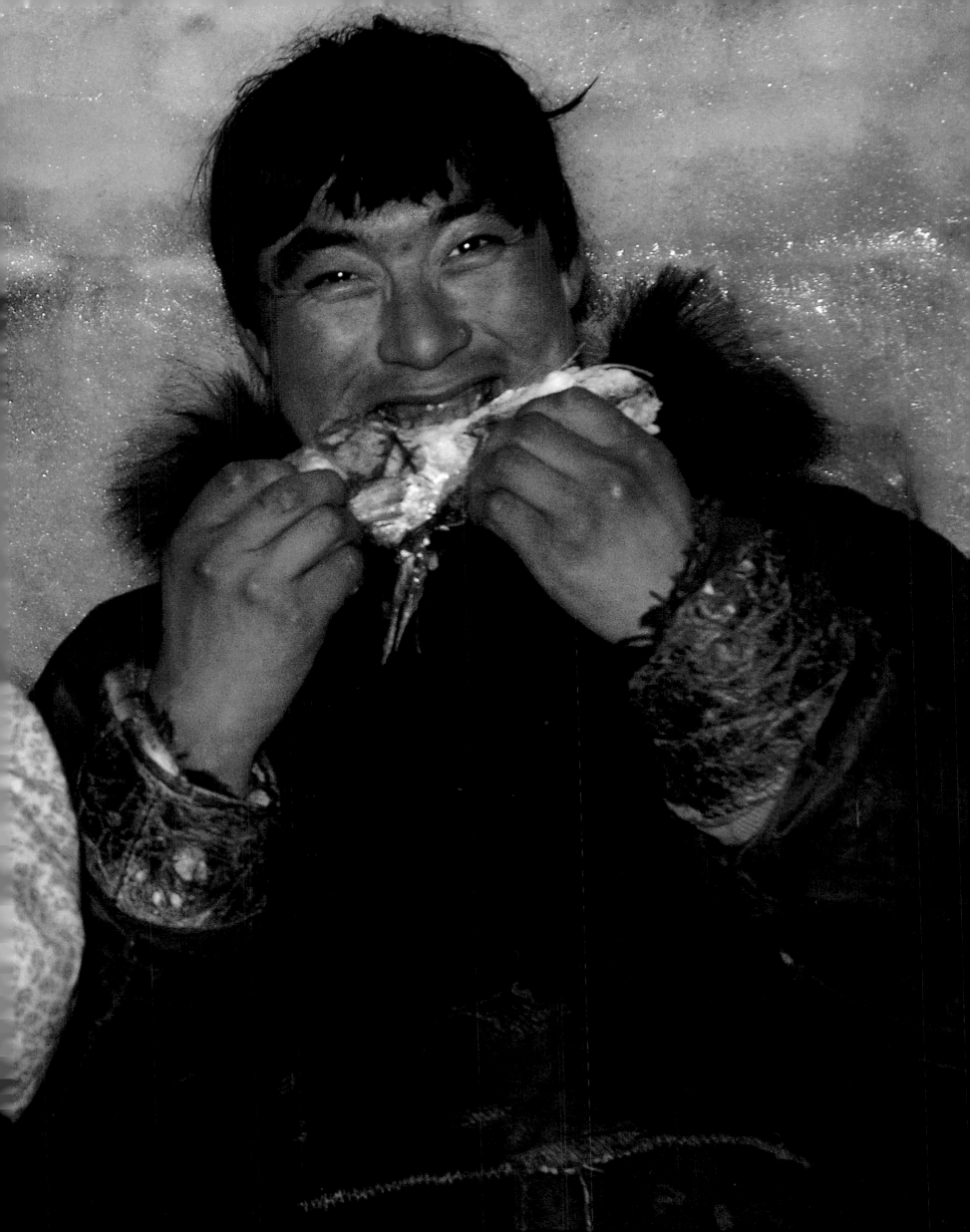

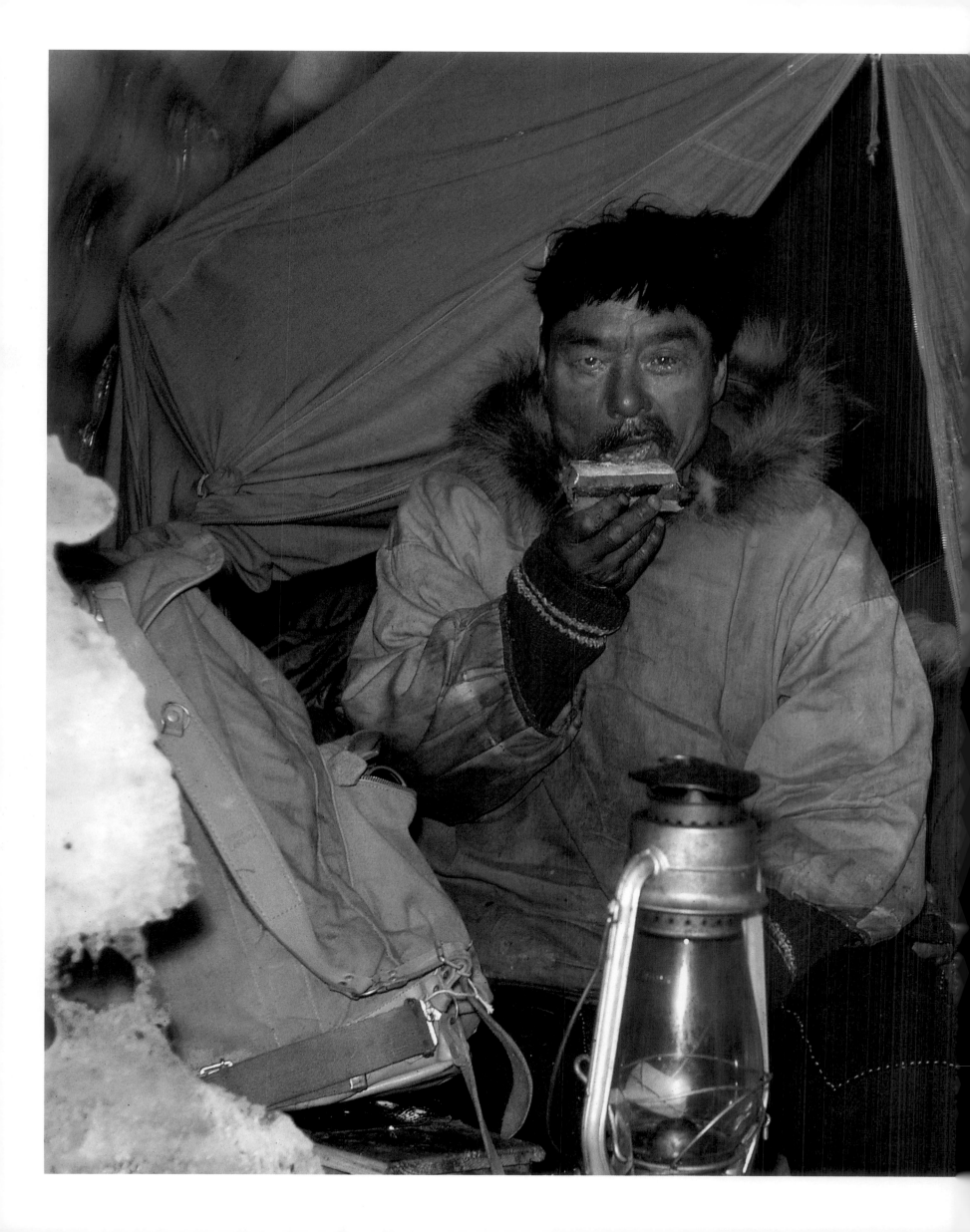

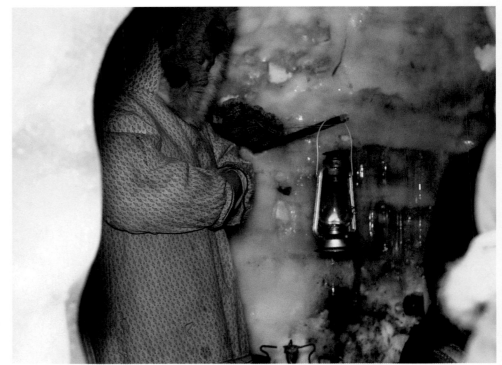

Above: Amujat, Back River, April 1963. This visitor has come to draw in my notebocks. She wears a hood because it's so cold. That's my oil lamp hanging from the snow wall.

Left: My little Q. G. in the igloo's second alcove, where I pitched a tent for writing and taping. At the far left is the ridge of snow that separates me from Akitok and Kresouk. Akitok is visiting me.

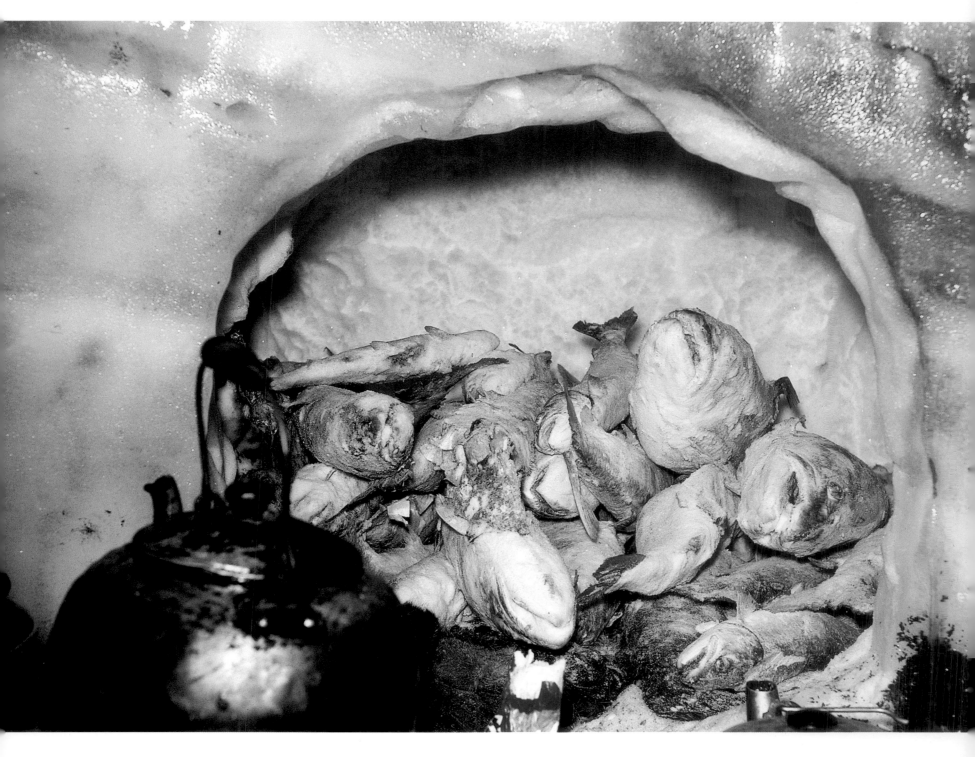

Amujat, Back River. April 1963. There's a reserve of fish in every igloo. On average, each Utku catches 2,500 trout and 1,000 whitefish each year, as well as hunting a caribou or two. During the summer, they eat birds and their eggs as well as blueberries and roots. A family of two adults and two children requires about fifty caribou hides every five years for clothing, bedding, summer tents, etc. Fox hunting with traps is marginal.

From a report by the Mounted Police: "They use bush roots to cook and make tea. . . . They only make fire on a porch apart from the igloo, which is the main living space. It seems that no effort is made to heat their living quarters."

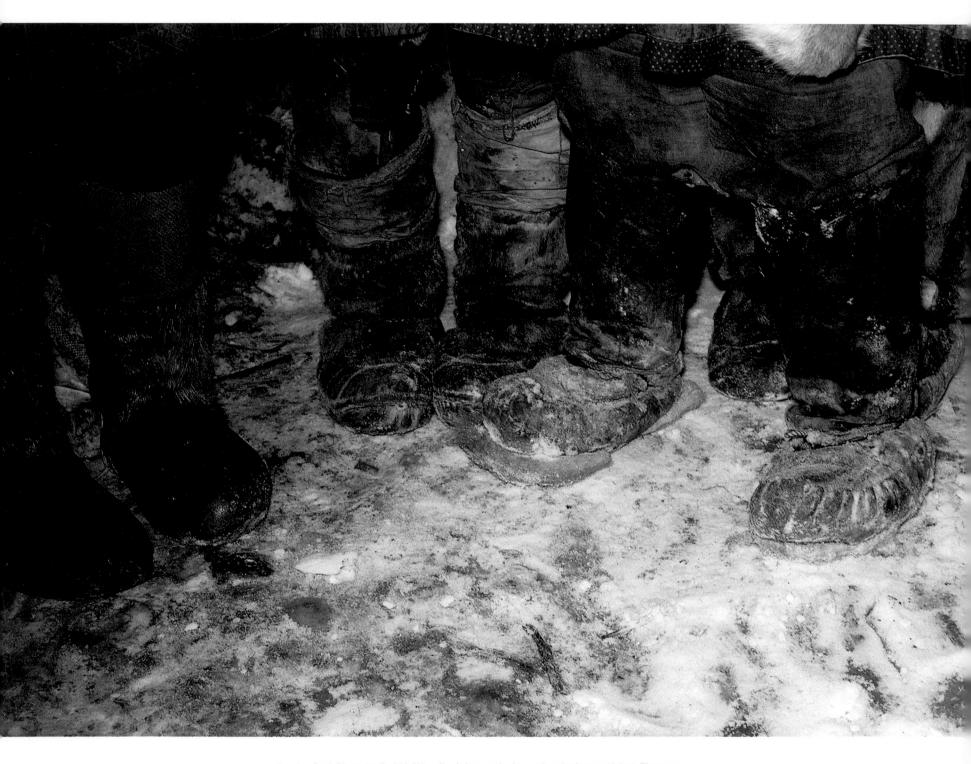

Amujat, Back River, April 1963. We talk, sitting on the ice and packed snow (*igleq*). They are united and extremely proud. Only a few hunt for fox, their only way to earn money. Under no circumstances will they leave their homes, where their dead and the spirits roam. They are unanimous, insistent, practically aggressive. The answer is no, they will not relocate.

In 1922, salmon skin was still used to sole the boots worn in the igloos. Kayaks were used until 1925. The charity offered by Christian missionaries is usually inappropriate: for example, canvas gowns and sweaters that don't dry easily. The Makalufs of Tierra del Fuego died of pneumonia after being "dressed" by the Franciscans, who considered their traditional hide ponchos indecent because they exposed their upper thighs and stomachs. But those traditional ponchos had the great advantage of letting the water stream over their bodies.

Right: Amujat, Back River, April 1963. Silence. This hunter is recalling his experiences with shamanism and his journeys into the cosmos. As he stares into the distance, he retells an old legend. "There were children playing on the ice. Amayorolou, a giant, took them and put them in his bag. He brought them to where he lived, in the hollow of a rock. The entrance to the cave was blocked by leather netting. Once he made sure that they couldn't get out, Amayorolou went out to get some roots to make the fire. The older girl asked a bird outside to open the way for them. The bird freed the children. They all ran out and went home. When Amayorolou returned, the snow bird was still at the entrance of the cave. Amayorolou suspected the bird had freed the children. He was furious. '*It's too late,*' the bird said, '*they're already far away.*' Amayorolou cried, '*Oumiktik! I'm going to kill someone!*' The bird answered, '*One of my toes is hungry, so it's going to eat me.*' And he left."

Below: Amujat, Back River, April 1963. Akitok, sitting on the only snow bench, begins to get dressed. The sleeping platform rests on a root and caribou structure on the snow. The temperature inside is below freezing, especially at the top of the igloo; if it were hotter, the walls of the dome would melt. The ground-level temperature is less than 14°F. Outside, it's -22°F, and drops to -40°F in the wind.

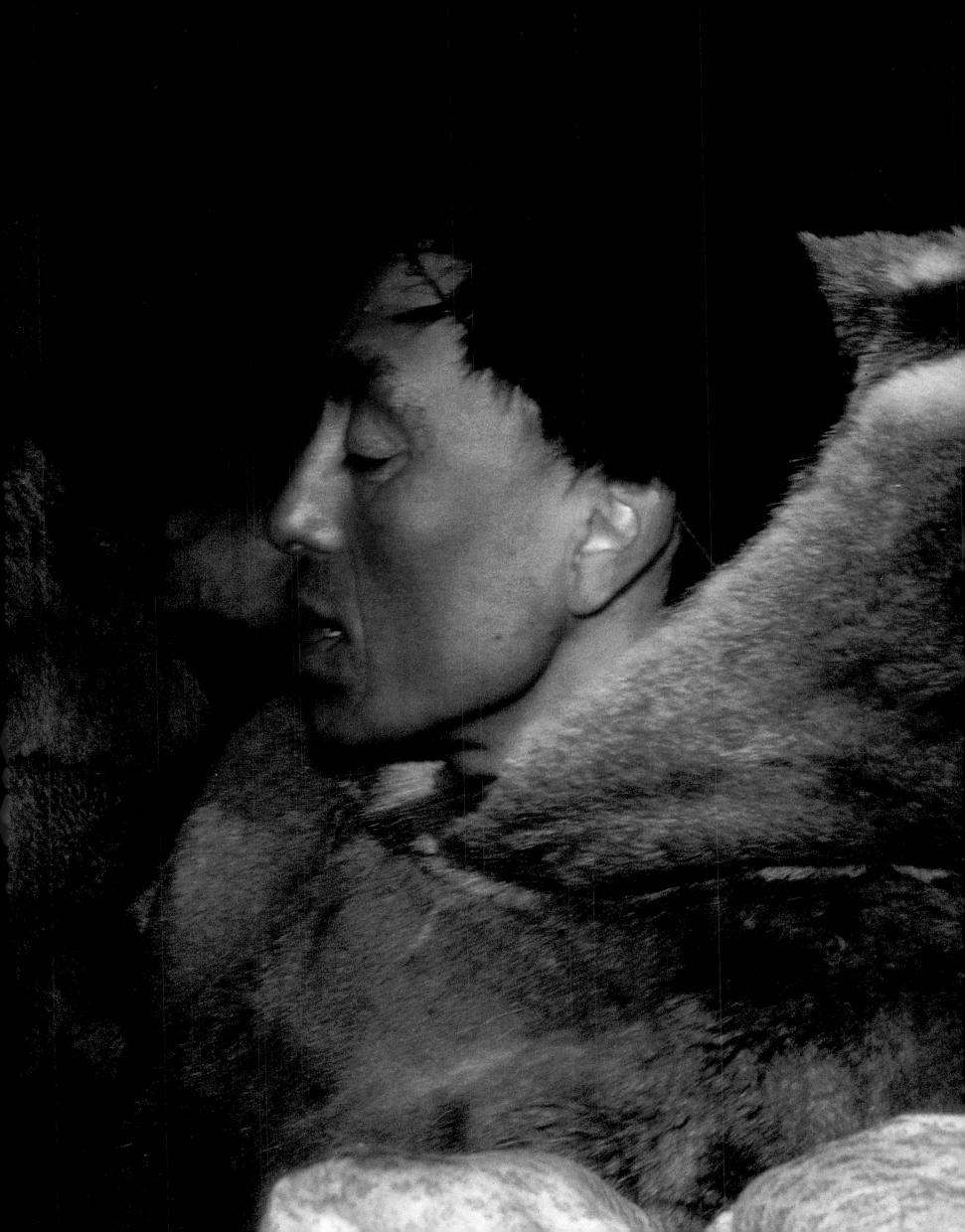

Amujat, Back River, April 1963. Tounee, the oldest Utku, was born in 1906. Another world fills the igloo, the world of the Giants. "*Tautsamani*. A long, long time ago . . ." the Eskimo mimes to me, moving his lips, as one of the spirits talks to him. By whistling, he orders them to keep their distance.

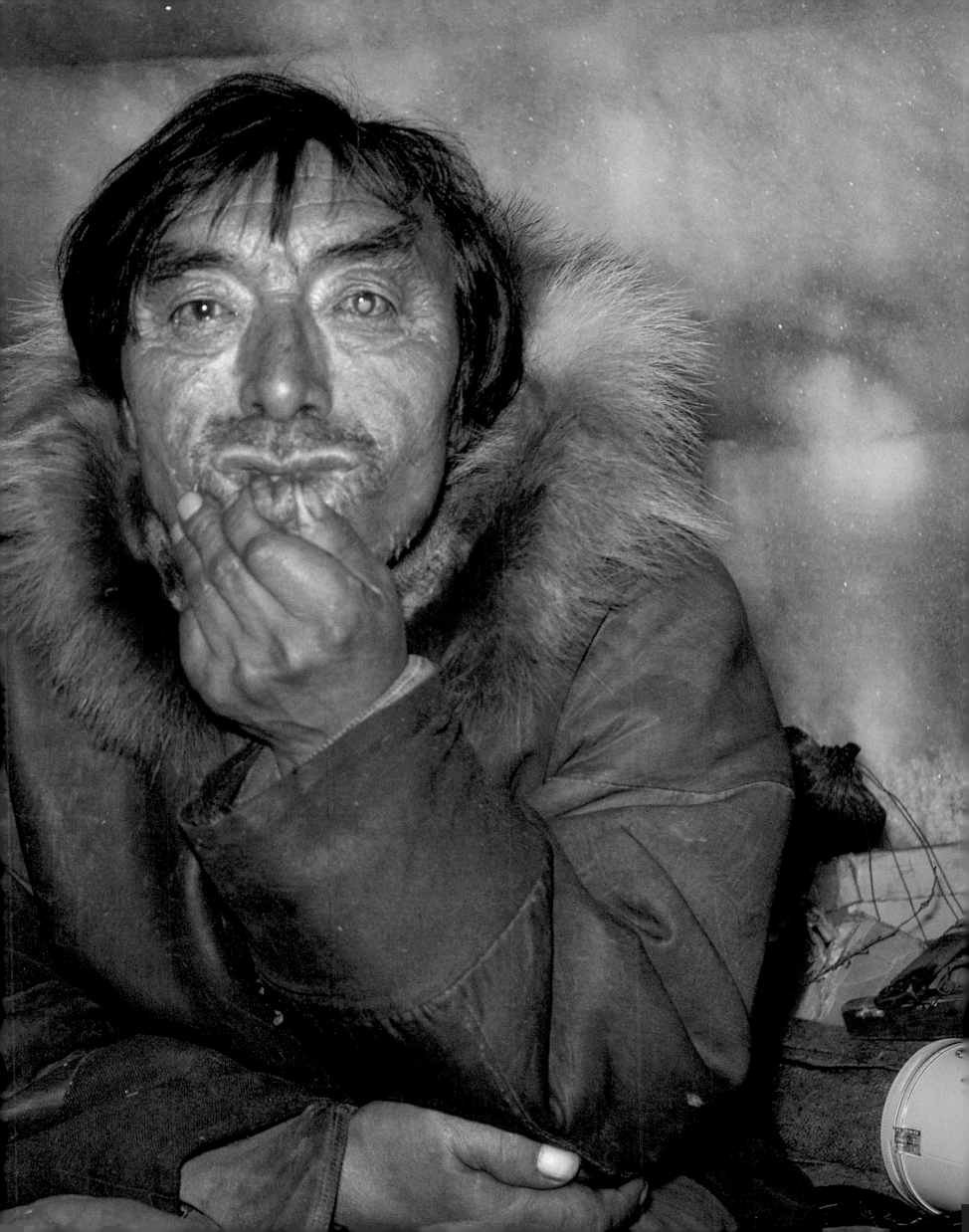

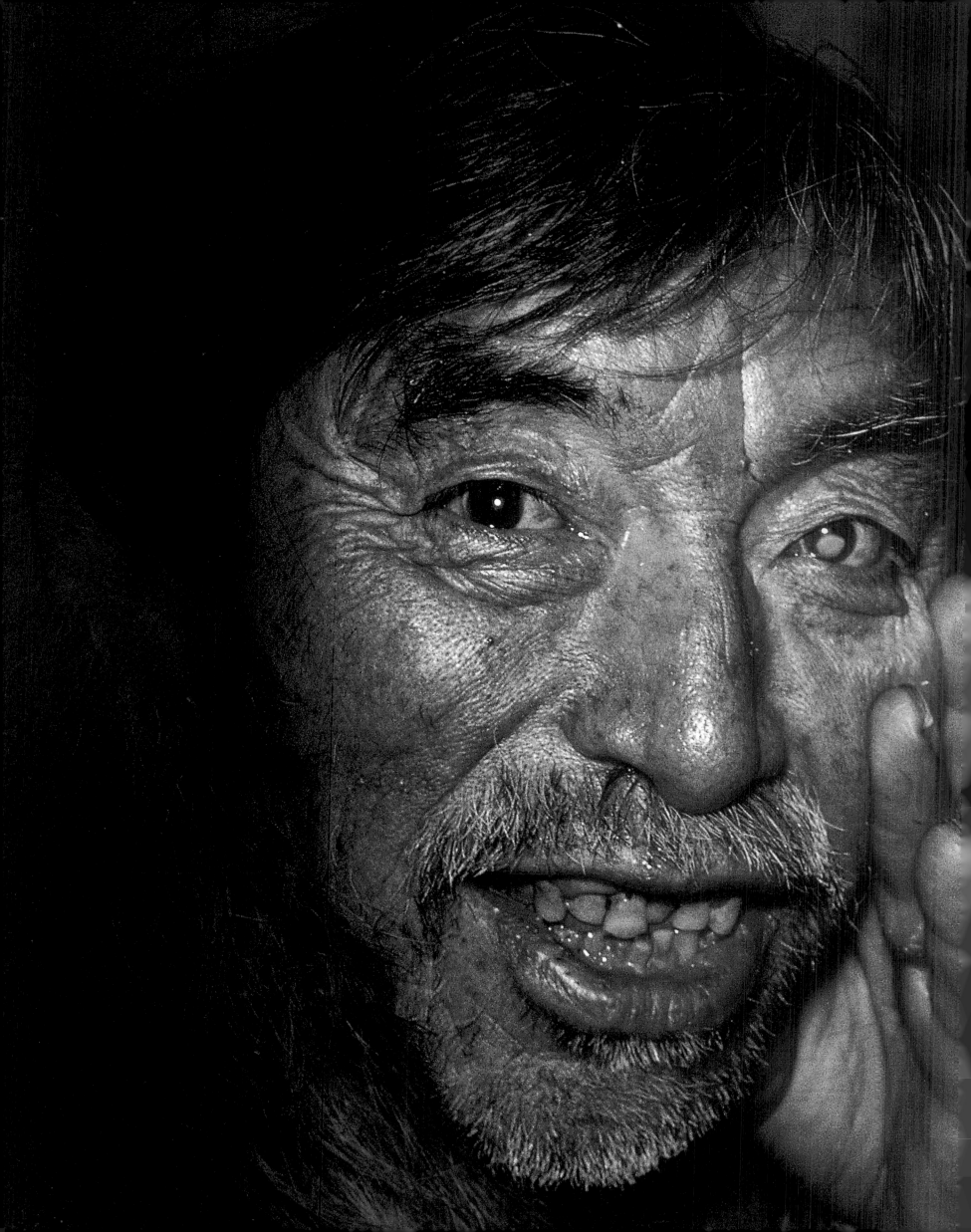

Amujat, Back River, April 1963. Tounee looks at me with kindness. He wants to make sure that I liked his legend. Like all Inuit, he has a knack for drama. Meeting these Utkuhikhalingmiut enlightened me and I became conscious of their huge history. Unfortunately, I only found broken pillars. This community, which was relocated after my 1963 mission, no longer exists. Their fishing site has become a vacation spot for North Americans.

AN ESOTERIC WRITING ON THE SKIN.
THE POWER OF NUMBERS.

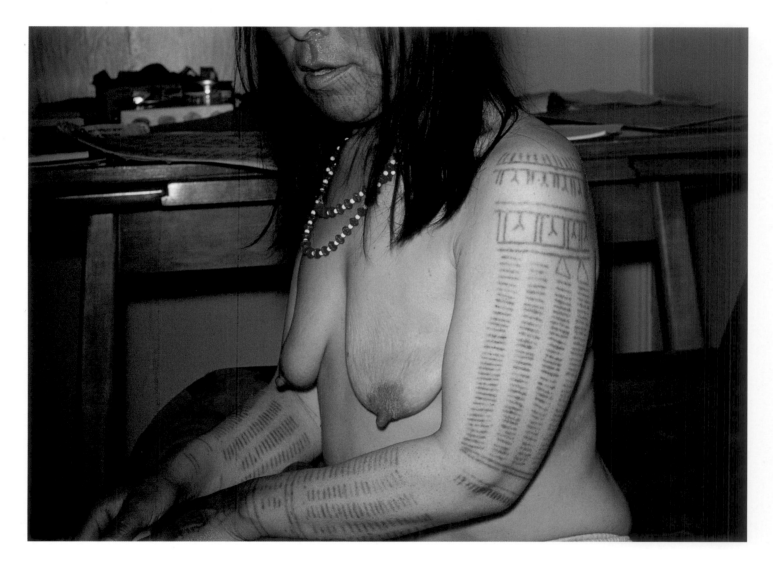

Gjoa Haven, May 5, 1963. *Tumnit,* or tattooing; *erkrirutit,* or tattooing around the mouth. Before a girl reaches puberty she is tattooed by an older woman. Tattoos represent many things, but some symbolize the myth of the sun and the moon, sister and brother—the winter sun emerges bloodstained. As soon as a woman begins to menstruate, an older woman tattoos her chin: a vertical line in the center and two on the side. The tattoos are made with an ivory point attached to a thread covered in soot from the seal oil lamp. The thread leaves a bluish line when it is run over the skin. The marks on her arms come from a complex numerology that might be linked to the sacred numbers of the *I Ching.* Whale tails peek out of the water on top of her shoulders. Women between thirty and thirty-five have no tattoos—a result of missionaries' proscriptions.

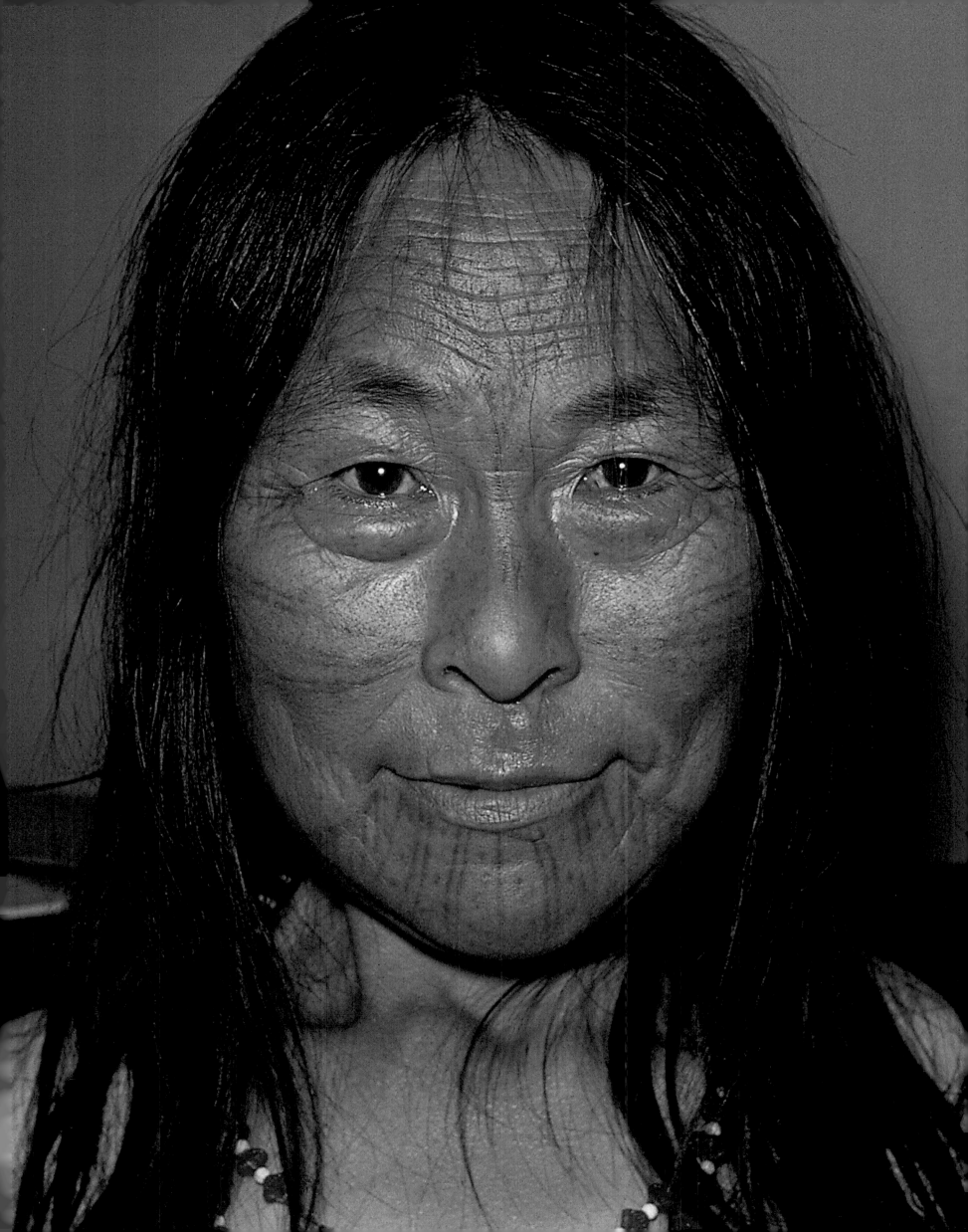

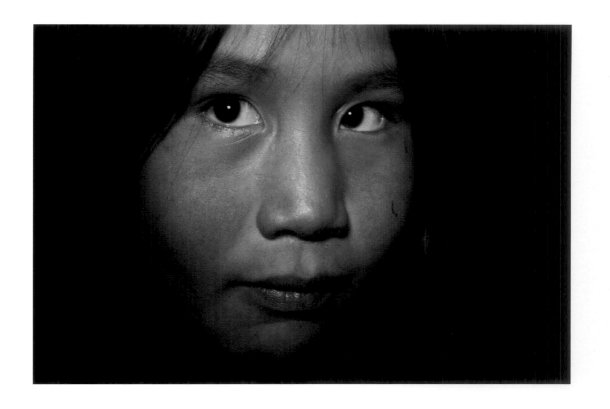

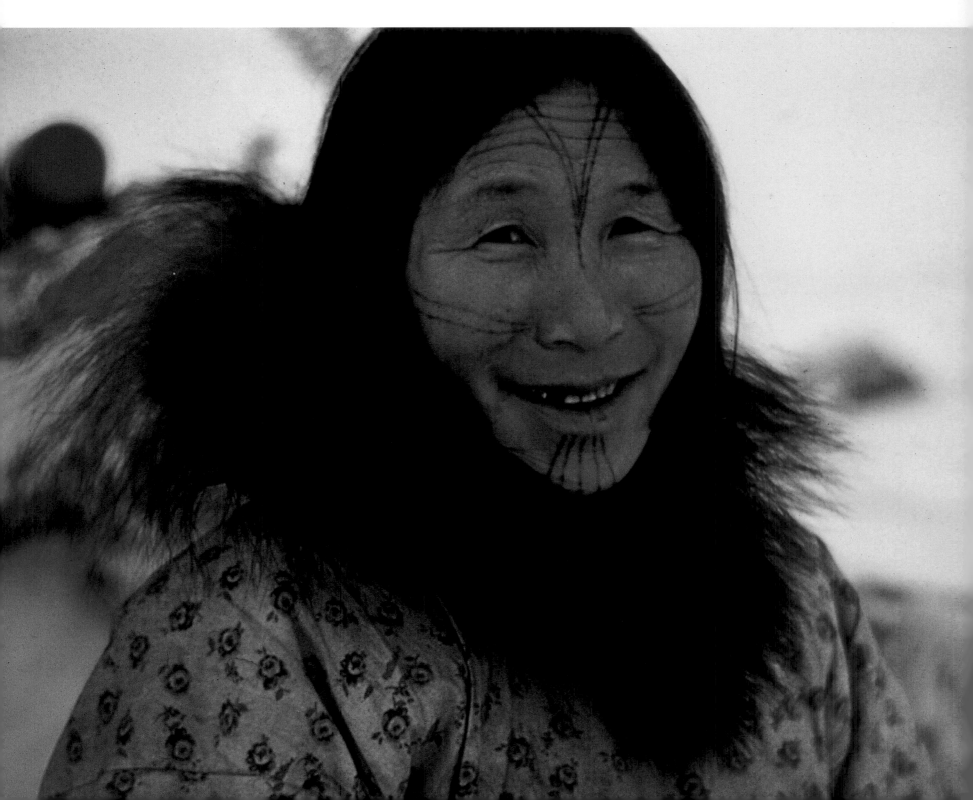

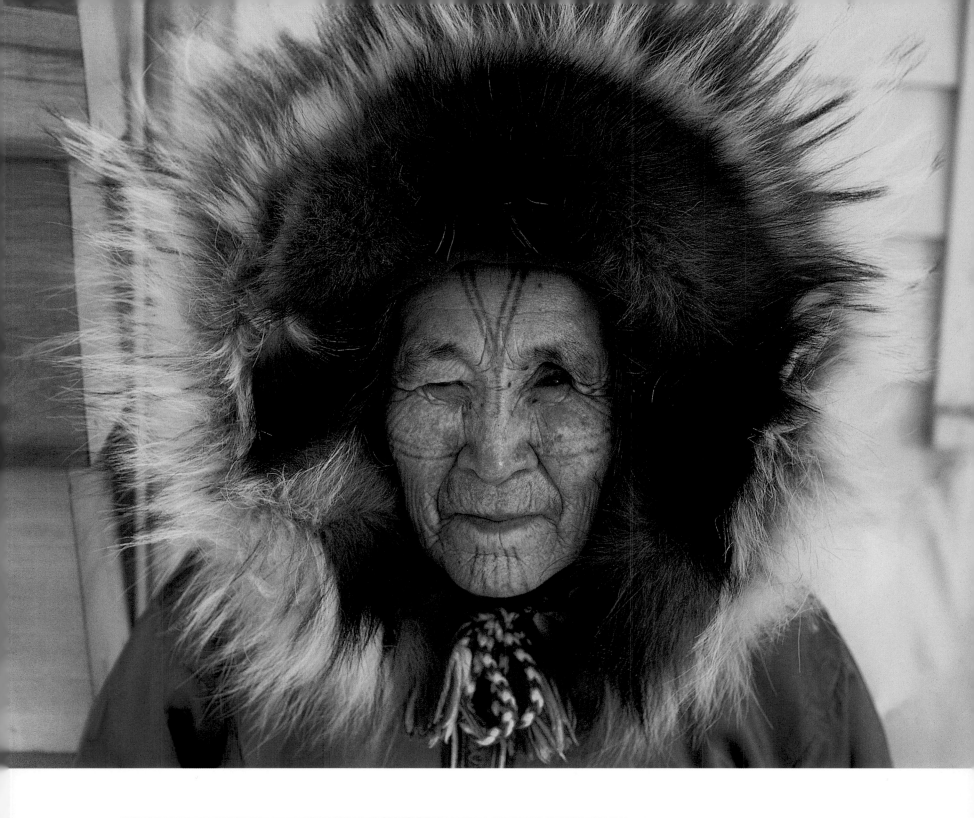

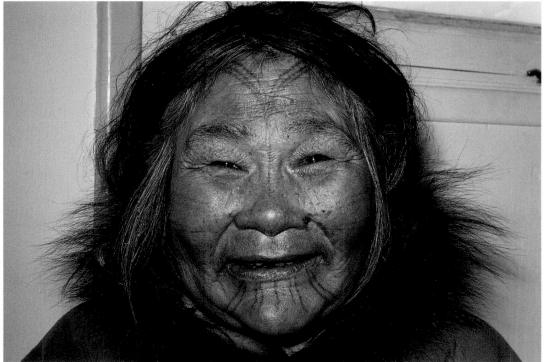

Gjoa Haven, May 1963. I am with the Netsilik and Utku emigrants of Gjoa Haven. The trading post is run by a Catholic Inuit. Two isolated communities exist side by side.

Top left: I met this young Netsilik at the Gjoa Haven school.

Bottom left and top right: Two Netsilik.

Bottom right: Homaok, an Utku born in Oudjoulik in 1895. She was a never-ending source of precise information.

DISCOVERY

JULY 1833

Back River, Chantrey Inlet. "These were the Esquimaux of whom we had so long and ardently wished to get a sight.... The men were of average stature, well knit, and athletic. They were not tattooed, neither did their vanity incommode them with the lip and nose ornaments of those farther west ... [they had] a more luxurious growth of beard, or more flowing mustachioes.... The women were much tattooed about the face and the middle and fourth fingers.... They had only five keiyaks or canoes; such as were indispensable for the procuring of food; viz, knives, spears and arrows.... There might have been thirty-five altogether; and, as far as I could make out, they had never seen "Kabloona" [whites] before."

—George Back, *Narrative of the Arctic Land Expedition to the Mouth of the Great Fish River, and Along the Shores of the Arctic Ocean in the Years 1833, 1834, and 1835,* London, 1836

THE FIRST ETHNOGRAPHIC STUDIES

"All these people live in a state of complete independence of the sea, to which they never go nowadays.... The inhabitants of the delta region round about Back River, and in fact all their kinsmen further inland, were among the least known of all Eskimos.... 'Here in our country,' Ikinilik said to Rasmussen in June 1923, 'there are caribou all the year round.... We admit that our houses are sometimes cold, but as they always are like that we do not become soft.... When the Netsilingmiut have no more blubber, their huts seem to be even colder than ours, for they have accustomed themselves to a heat that we never have.... But we always have water from the lakes.... And thirst is the worst misfortune that can come over a man; it is worse than hunger.'"

—Knud Rasmussen, *The Utkuhikhalingmiut, in Report of the Fifth Thule Expedition, 1921–1924,* Vol. VIII, No. 2, 1931

CARIBOU HUNTERS

Jean Malaurie was the first anthropologist since Knud Rasmussen to visit this isolated group. From April 15 to May 6, 1963, Malaurie undertook a three-week mission in Back River and Gjoa Haven to study their budget, calendar, itinerary, and legends. He calls it the Inuit Sparta; there were seven families, twenty-five people total. Malaurie's visit is detailed in *Hummocks,* Volume I.

THE QUICK PERCEPTIONS OF THE UTKUHIKHALINGMIUT

"Another thing that struck me was, that while the Netsiliks at first had with difficulty understood formulated questions and answered them, these inland dwellers were quick of perception, replied intelligently, and vied with each other in giving me the information I wanted."

—Knud Rasmussen, *The Utkuhikhalingmiut, in Report of the Fifth Thule Expedition, 1921–1924,* Vol. VIII, No. 2, 1931

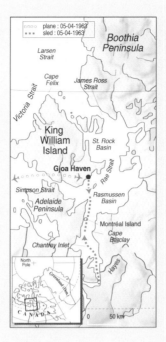

AUSTERITY AND TABOO

TRAPPING FOXES IS CONSIDERED DISGRACEFUL

"April 1963. They don't heat their igloos properly. I confirm the accuracy of a 1956 Mounted Police report about them: 'The abundance of fish allows Eskimo life to continue ... an active Eskimo can take thirty fish per day, even during the winter. The lack of seal fat is a true handicap. They only have the stomach fat from whitefish, which is really not a lot. For cooking and for tea they make a fire in a porch that is separate from their igloo. It seems that they make no effort to heat their dwellings.' Indeed, they don't heat their igloos, and they cook in a special part of the dwelling's corridor. They should need fifty to seventy caribou per year, yet they have at their disposal only ten per family. They refuse to hunt foxes out of pride. Government assistance: $477 for seven months, or $11 per family per month."

—Jean Malaurie, *Hummocks,* Volume I, Paris, 1999

THE MYSTIQUE OF POVERTY

Back River, 1963. Do oral societies, do poor people have a special claim on eternal life? "The mysterious vocation of poverty ... established in this world to atone for misery . .. The age-old tradition of poverty, that lives one day at a time ... to eat from the hand of God, according to the old adage" (Georges Bernanos, *Vie de Jésus,* in *La Vocation Spirituelle de la France*). This is what I feel with regard to these Inuit, who want to retain their ancient socioeconomic traditions while also being Christians.

—Jean Malaurie, Notebooks, 1963, and *Hummocks,* Volume I, Paris, 1999

DAILY LIFE IN A SNOW IGLOO

April 1965. "While I talk, I look at Inoukshook in profile. He listens to me carefully, motionless, his mouth half open, his eye steady and shining. His left thumb gently rubs a caribou hide. They all bow their head and look down. Their faces are black-brown, their heads half-covered by their caribou hoods, their eyes focused on the speaker, following his every movement. Face to face,

mute. Would they eat separately, as the Inuit do in Thom Bay? When I finish talking, two men slice a two-foot trout, frozen and raw, which they took from an inner alcove of the igloo. This space is a pantry, an icebox containing about twenty fish all in a jumble. The wet sound of our tongues, interrupted occasionally by the crack of bones as they are chewed. They spit out the bones in front of them; they aren't kicked aside, they're crushed. The men think while they eat in silence. The dog whose place I took in the other alcove comes and goes, her teats hanging, at the foot of the *iglerk* (here they say *igle'q*). She has a strong smell.

There is no continuous heat. The ground is packed snow. There is no *kutdleq* (a soapstone or stone oil lamp). A cloud of condensation accompanies every word. It's between 14°F and 23°F, depending on the time of day. Do they mean to have no heat? Yes. The rare fire is made outside the alcove or near the entrance of the *torsuk,* in a side annex known as *ishavik* that has an opening in its snow roof, with a dented can shaped like a funnel to let the smoke out. When they have tea they boil water on an oil-burning stove. But oil is rare. They are impoverished as Job."

—Jean Malaurie, *Hummocks,* Volume I, Paris, 1999

FROM SHAMANISM TO CHRISTIANITY, IN A PLACE WITH FEW PEOPLE AND LITTLE CARIBOU AND OTHER GAME

"In looking at them tonight, pensive, their brows furrowed, I think about those prophets in the Bible who rose at night—and these are the lamentations of Jeremiah—to remind the Jews, the Chosen People, that if the Temple had been destroyed, it was because they had sinned against the Eternal, and because they had broken the Covenant. The time of penitence had begun. Who knows if these Inuit from Back River don't feel that these difficult times are punishment for some sin? The caribou have turned away from them, the master of animals is abandoning them. And what if they felt they had sinned and that Nature regretted it? It is extremely difficult for the Inuit to leave their territory; it would mean leaving their dead and the familiar spaces, it would be like cutting the umbilical cord. The white man's rifles kill. Game are no longer invited. The ancient agreement between humans and animals has been broken. My interpretations are tinted by a Western perspective and become fragile. But the human spirit stems from ancient cognitive structures. The animist mind of these proud hunters and fisherman clearly could not be made Christian in just one or two generations."

—Jean Malaurie, *Hummocks,* Volume I, Paris, 1999

FAMINE AND INDIFFERENCE. WHAT A GREAT PHOTOGRAPHER HAS WITNESSED

There was a recurring famine in the central Arctic between 1950 and 1963, in Padlei, in Garry Lake, and in Back River. In his book *The Faces of the Arctic,* which was published to an indifferent reception in the United States in 1952, Richard Harrington describes with both text and poignant black-and-white photographs the rampant famine that resulted from the disappearance of caribou. "They did not yell for social security. They held no

demonstrations. They did not even think of criticizing the white man. They were totally unaware that a mass of government officials in Ottawa looked after the welfare of the Eskimo. . . . I asked what the missionaries were doing about the situation. 'Praying, I guess.' . . . During this time of hunger, the missionaries did not help; the R.C.M.P. had no instructions to help; officials were bent over triplicates of vague statistics." In 1977, this group of twenty-five Utku were relocated despite their resistance. Their fishing site is now used by North American tourists. At the dawn of the twenty-first century, is history still Darwinian?

THE MYSTICAL AND THE POLITICAL

1963. "Everything starts as mystical and ends as political. Everything starts with the mystical, with a mysticism, with its own mysticism, everything ends with politics" (Charles Péguy, *Notre Jeunesse*). The Utku's politics, whether for or against anything, are about settling in the places of their ancestors."

—Jean Malaurie, *Hummock*, Volume I, Paris, 1999

RELIGIOUS CRISIS

THE END OF SHAMANS

"'Here at Utkuhikjalik there are no shamans now,' Ikinilik told Knud Rasmussen in June 1923. 'The shamans of our day do not even serve an apprenticeship. . . . Now that we have firearms it is almost as if we no longer need shamans, or taboo.'"

—Knud Rasmussen, *The Utkuhikhalingmiut*, in *Report of the Fifth Thule Expedition, 1921–1924*, Vol. VIII, No. 2, 1931.

EXISTENTIAL ANGST: FROM SHAMANISM TO CHRISTIANITY

There is existential angst among these people. They are divided between an ancient, underground pantheist shamanism and Protestant Christianity, which has just been taught to them. Why are the caribou no longer at the ancient rendez-vous? "Is it because we Inuit have betrayed shamanism, or because we are bad Christians? What are we to do?"

—Jean Malaurie, *Hummocks*, Volume I, Paris, 1999

ABANDONING THEIR ANCESTRAL LAND IS LIKE A DEPORTATION

1959. There is an absolute refusal to leave this place, despite the famine of 1959. Their answer to such a suggestion is a resounding No. "This is our ancestral land; [government] assistance would be our death," they tell me.

—Jean Malaurie, *Hummocks*, Volume I, Paris, 1999

ECONOMIC ASSESSMENT. APRIL 1963

ONE FAMILY'S ASSETS

Equipment: five dogs (one female, three years old; one two-year-old; three one-year-olds). One trap (captured

one fox in 1963). One sled; he built it himself. The wood came from Gjoa Haven, inherited after his son-in-law drowned. One .22 caliber rifle, which he has owned for sixteen years, purchased by barter. One 30-30 rifle, bought at the HBC trading post in Gjoa. One tent, purchased. One net, gift of the Mounted Police in 1962.

Domestic goods: One plane, two years old. One saw. One oil-burning stove. One sewing machine, purchased in 1960. One accordion. One hurricane lamp, two years old.

Hunting: five seals taken in the spring. No caribou. One fox.

No heat during the winter.

—Jean Malaurie, *Hummocks*, Volume I, Paris, 1999

THEIR PURCHASES AT THE TRADING POST. THEIR BANK STATEMENT

They make the journey to the trading post once or twice a month; it takes two days on a sled, not counting storms, ninety miles each way, to make $5 to $38.

	Credit	Debit
November 10, 1962		$38
December 16	$47.50	$18.35
January 12, 1963	$57.50	$38.70
February 6		$8
February 19	$11.50	$11
March 11	$11.50	$8.80
April 2	$15	$13
April 29	$5	$5

—Jean Malaurie, *Hummocks*, Volume I, Paris, 1999

WHAT DO THEY WANT?

The Utku refuse to become part of the colonial fox hunting regime, and so they have no financial resources. "If we looked at the details, we would see that, for the most part, financial revenue comes from family assistance and exceptional aid (relief) in cases of extreme poverty. Family assistance is $6 per month for children up to the age of ten and $8 for kids age eleven to sixteen. Senior citizens receive a pension of $65 after the age of 55, though very few live to see that age. This pension arrangement was established only a few years ago. The total for family assistance per family per month, from September 1962 to March 1963, was $11." We could not say that this society receives help. *Beati pauperes* . . . "To maintain our lan-

guage, our people. These are our traditions: To go off in the summer to look for caribou, to come back together in winter around the lake, where there is always spring water, and where the river is so filled with fish." "One or two boats. That's all we want. Try to get them for us . . . and three paddles," he adds with a sad smile. He repeats that it would be misunderstanding them—and disrespecting them—to make them settle around the school and trading post. "Here are our dead, this is our land. Here and nowhere else."

—Jean Malaurie, *Hummocks*, Volume I, Paris, 1999

SONGS AND SUPERNATURAL BELIEFS

The Joy of a Singer

A wonderful occupation
Making songs!
But all too often they
Are failures.

A wonderful fate
Getting wishes fulfilled!
But all too often they
Slip past.

A wonderful occupation
Hunting caribou!
But all too rarely we
Excel at it
So that we stand
Like a bright flame
Over the plain.

Piuvkaq

MAN'S SOUL

"'The only thing of value in a man is the soul,' Ikinilik told Rasmussen. 'That is why it is the soul that is given everlasting life, either in the Land of the Sky or in the Underworld. The soul is man's greatest power; it is the soul that makes us human, but how it does so we do not know. Our flesh and blood, our body, is nothing but an envelope about our vital power.'"

—Knud Rasmussen, *The Utkuhikhalingmiut*, in *Report of the Fifth Thule Expedition, 1921–1924*, Vol. VIII, No. 2, 1931

THE MASTER OF THE UNIVERSE

"Nuliajuk is the centre about which all religious beliefs revolve. 'We are afraid of her,' Ikinilik says. But although the deity was called Nuliajuk, the girl of the tale still goes by the name Putulik. . . . Ikinilik is not at all interested in how Putulik became Nuliajuk. He simply shakes his head. . . . 'We know that there is a Nuliajuk who watches over all beasts, all the game of mankind, and that is enough for us. How she turned into such a dangerous and terrible spirit is surely immaterial.'"

—Knud Rasmussen, *The Utkuhikhalingmiut*, in *Report of the Fifth Thule Expedition, 1921–1924*, Vol. VIII, No. 2, 1931

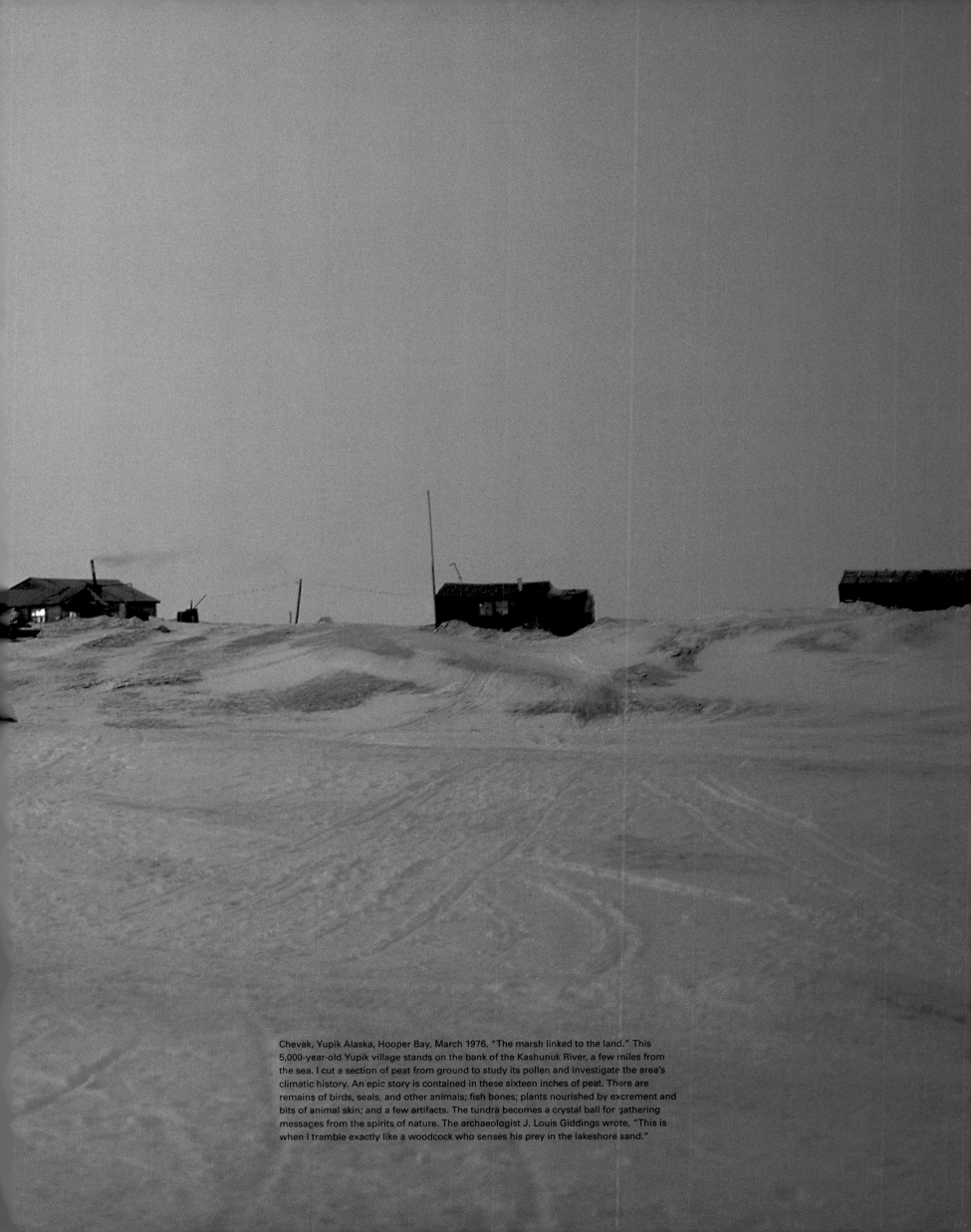

Chevak, Yupik Alaska, Hooper Bay, March 1976. "The marsh linked to the land." This 5,000-year-old Yupik village stands on the bank of the Kashunuk River, a few miles from the sea. I cut a section of peat from ground to study its pollen and investigate the area's climatic history. An epic story is contained in these sixteen inches of peat. There are remains of birds, seals, and other animals; fish bones; plants nourished by excrement and bits of animal skin; and a few artifacts. The tundra becomes a crystal ball for gathering messages from the spirits of nature. The archaeologist J. Louis Giddings wrote, "This is when I tremble exactly like a woodcock who senses his prey in the lakeshore sand."

Shishmaref, Seward Peninsula, October 1974.

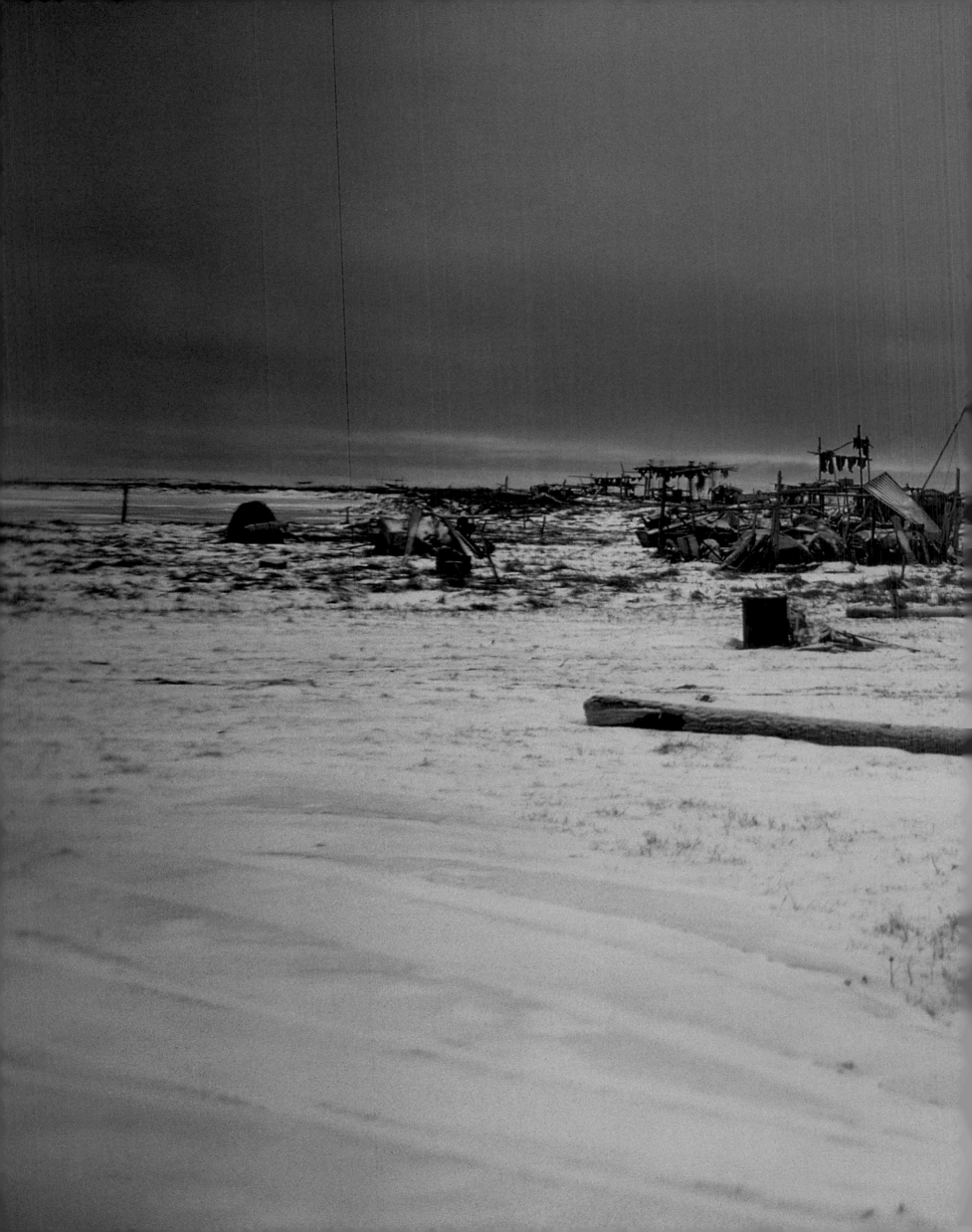

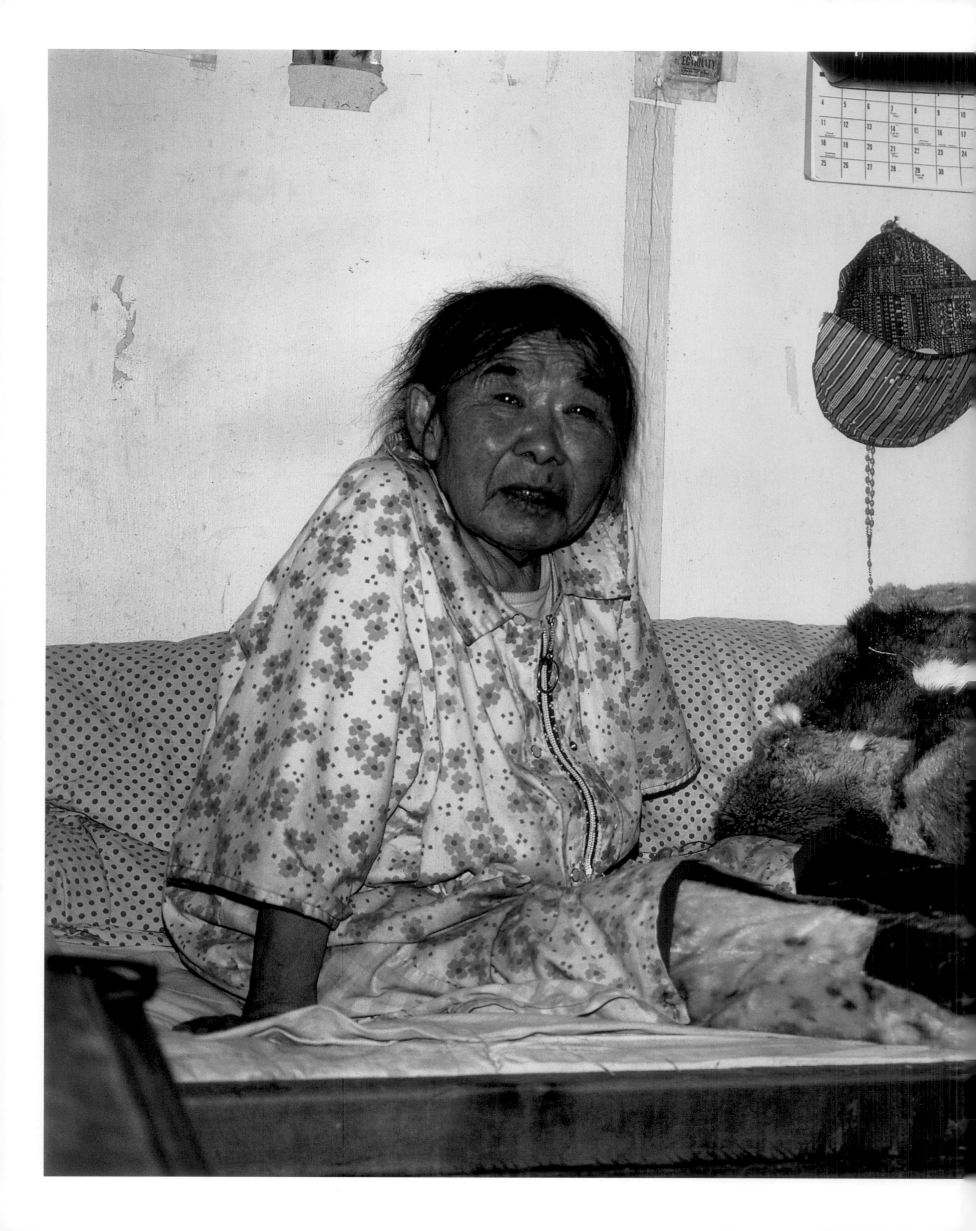

Previous pages: Shishmaref, Seward Peninsula, October 1974. Alaska plunged into crisis in 1965. The Indian and native population refused to recognize that the newly discovered oil belonged to the whites. "We are tired of being second-class Americans."

Chevak, Yupik Alaska, Hooper Bay, May 1976. Just like Alain-René LeSage's character Gil Blas, I wish I could raise rooftops and just slide into Inuit private life. Drugs, incest, battered women, suicide: these are the tragic consequences of their brutal encounter with the West. Between 1934 and 1999, the suicide rate among Indians and Inuit increased fivefold. In 1990, more than 20 percent of the native population was unemployed. In almost a third of Alaska's indigenous villages the unemployment rate among men reached 32 percent. In 1867, 99 percent of the population was native; in 1965, 30 percent; in 1990, 16 percent. Yet this 16 percent represents 30 percent of the prison population. "We are nobody," many young Inuit told me in 1965.

In southern Alaska and on the Aleutian islands, women have taken economic power. The Yupik are waging a cultural and religious revolution. And with the rhythms of their sacred drums, the Yupik are inventing a neo-Shamanism—Christianity made Inuit.

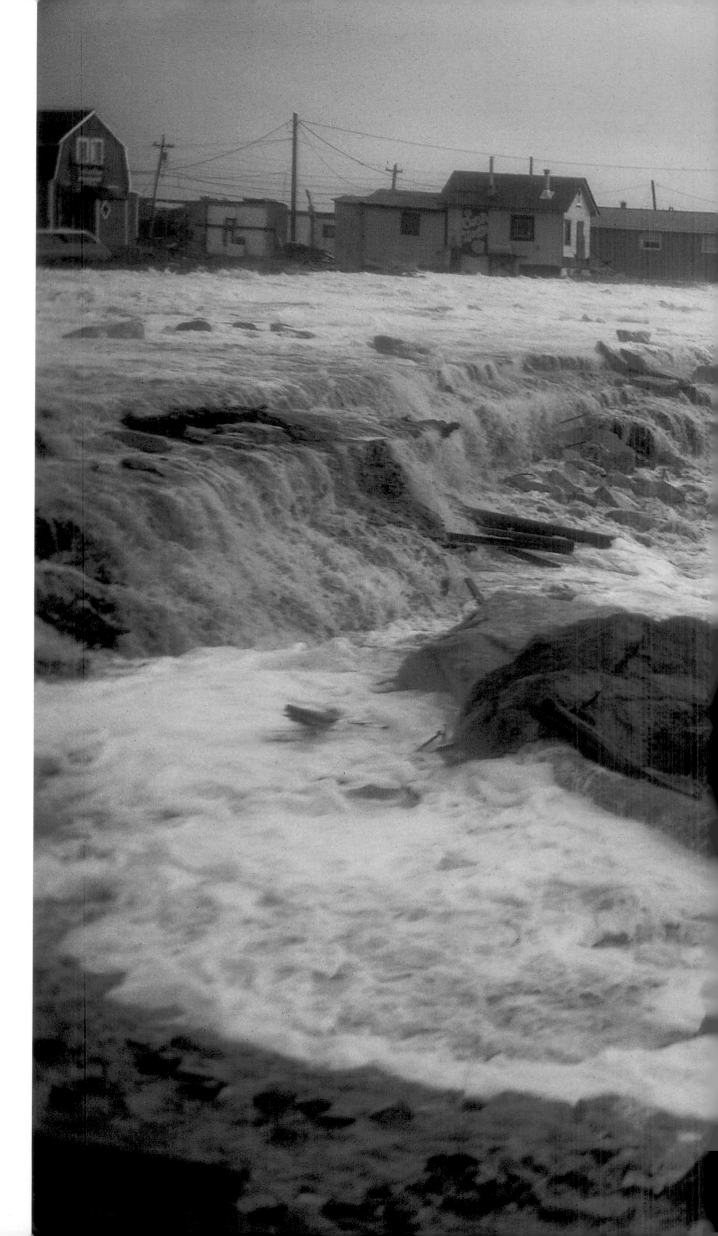

November 11, 1974. The village of Nome on King Island was submerged by a tidal wave right before my eyes. Storms caused by global warming threaten every coastal village. In 1990, Shishmaref had to be evacuated. The Inuit live under extreme conditions. In the 1870s, California whalers destroyed much of the wildlife they depended on. Later, during the Yukon gold rush, miners colonized the land.

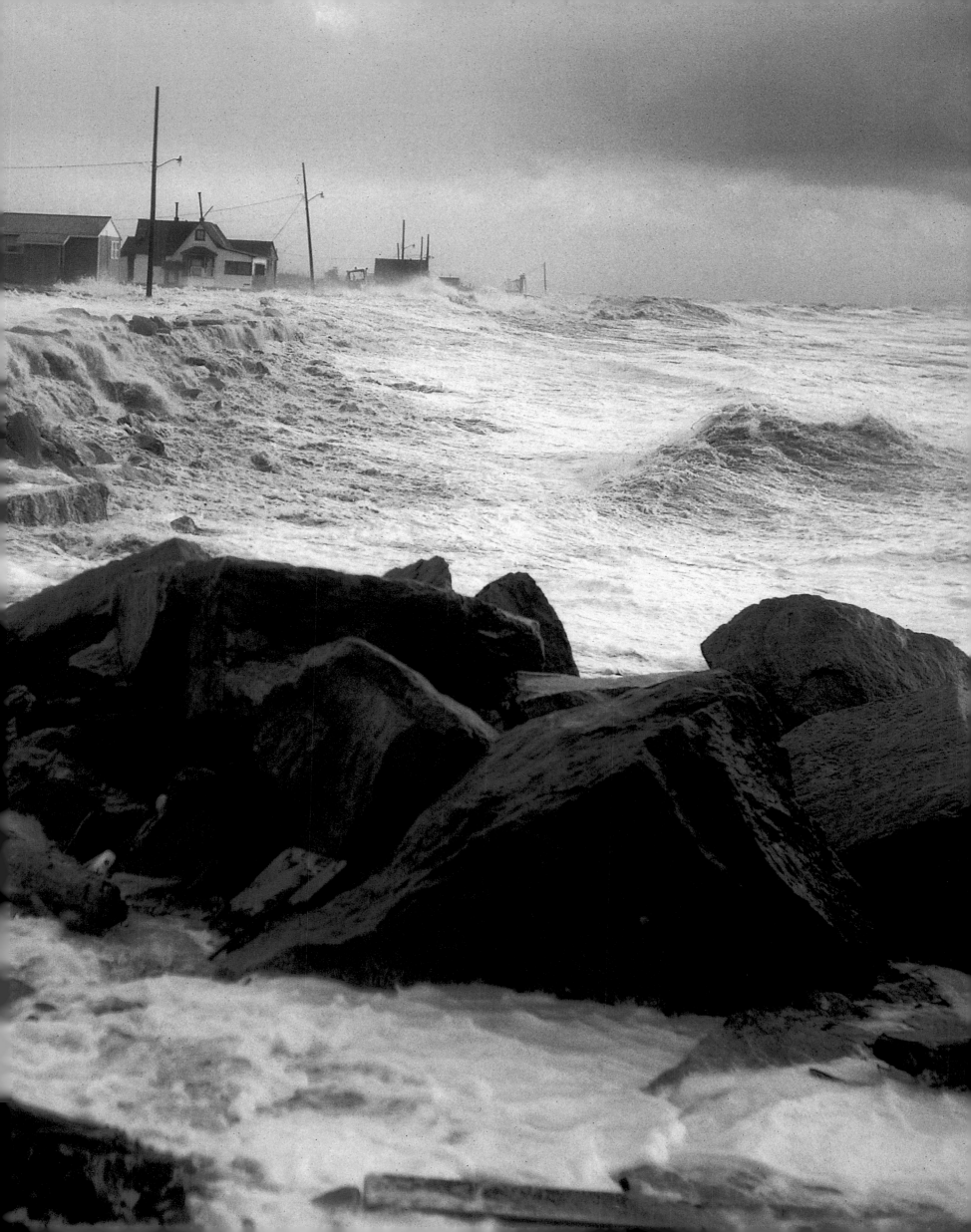

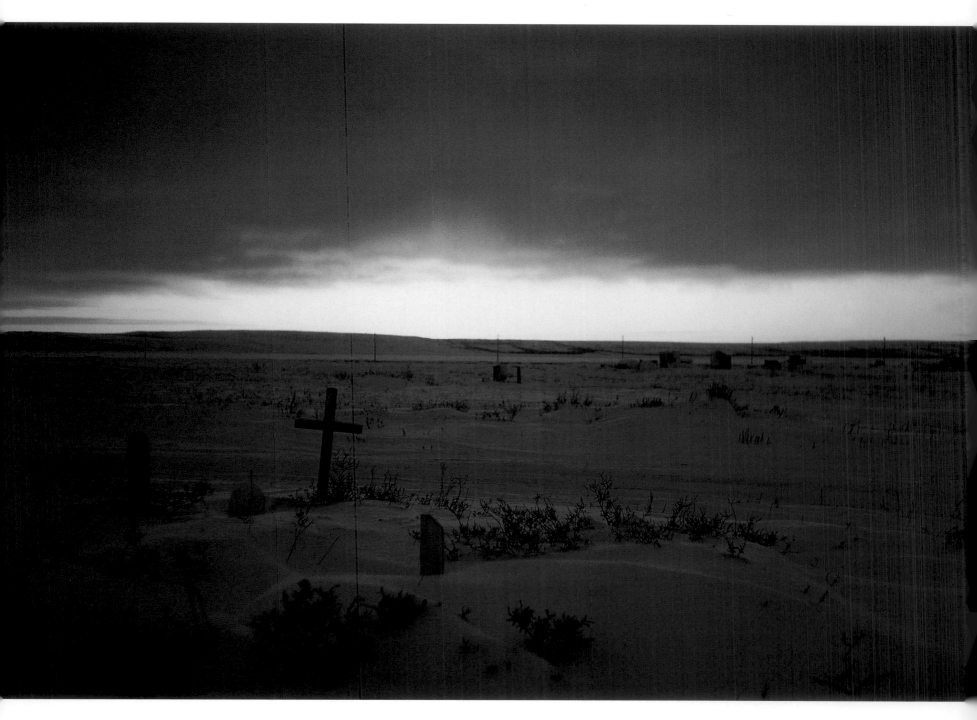

MAJOR CRISIS

The revolt supported by The Tundra Times, the consciousness of the humiliated, the Native Americans. "We are the blacks of the Far North, the failures of civilization. And we are like the 30 million blacks, a third of whom live in poverty." The Eskimo natives and Indians are fighting a relentless battle with the government. They have asked me to join the ranks. And the Pan-Inuit Historical Congress of November 1969, in France, under the aegis of the Centre d'Etudes Arctiques [Center for Arctic Studies], has been lending important support. It has helped bring about the December 18, 1971 agreement, signed by Richard Nixon.

The innocence of the Thule people of Northern Greenland before the construction of the U.S. air base in 1951, has always been on the forefront of my mind. A Pantheist joy is recorded in these photographs. After the clash with the Thule Base, on June 16, 1951, my perspective changed. The effects were felt even in the isolated Iglulik, Netsilik and Back River regions of Canada. Despite their extreme poverty, they held on to their ancestral integrity and a Cornelian dignity that demands respect.

From east to west, like the hands of a watch, I deliberately traced the great Eskimo migration in the opposite direction (Yuit, Yupiit, Inupiat, Inughuit), heading quickly back to the roots. There is no time to wait with deteriorating populations. I took no pleasure in taking pictures on assignment. I will keep them for a subsequent book, one that will condemn the greatest acts of infamy of the time: humiliation, negation of mythical thought, the test of man's imagination.

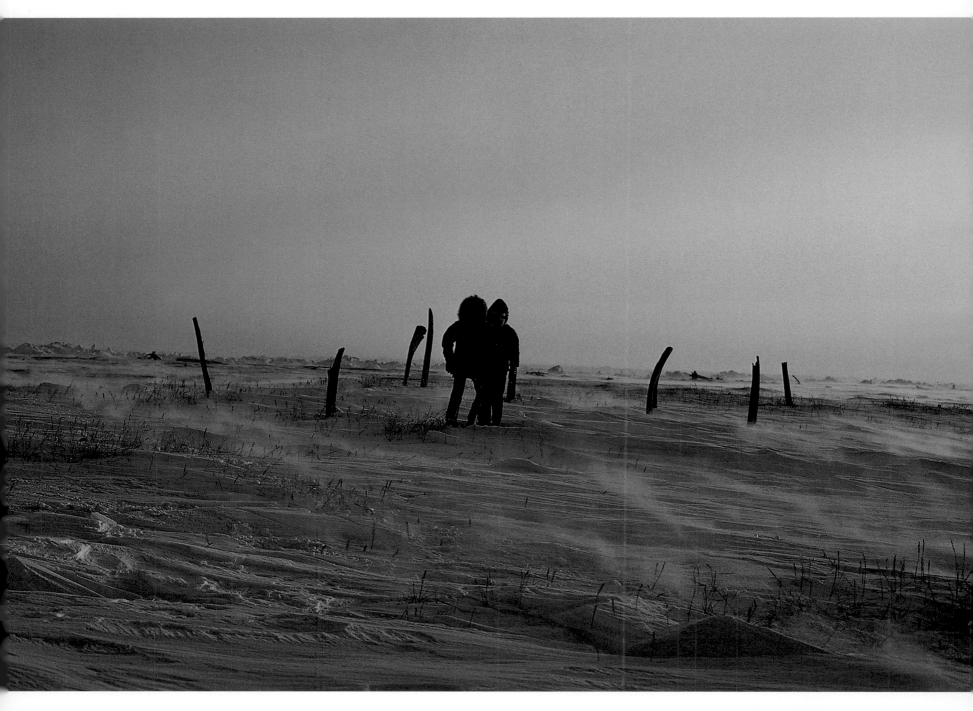

Top, left: The Kotzebue cemetery, November 1974.

Top, right: Point Hope, Tigara, Chukchi Sea, May 1976. Tombs of Umialik, captains of Inuit whalers

Bottom, left: Jean Malaurie with an Inupiat leader from Alaska. (Selawik, September 1984).

Bottom, right: The first International Pan-Inuit Congress in May 1973 on Arctic oil, presided over by Jacques Le Goff and organized by Jean Malaurie. Center for Arctic Studies (EHESS [Ecole des Haut Etudes en Science Social], CNRS [Centre National de la Recherche Scientifique]). Le Havre, 3-5 May, 1973.

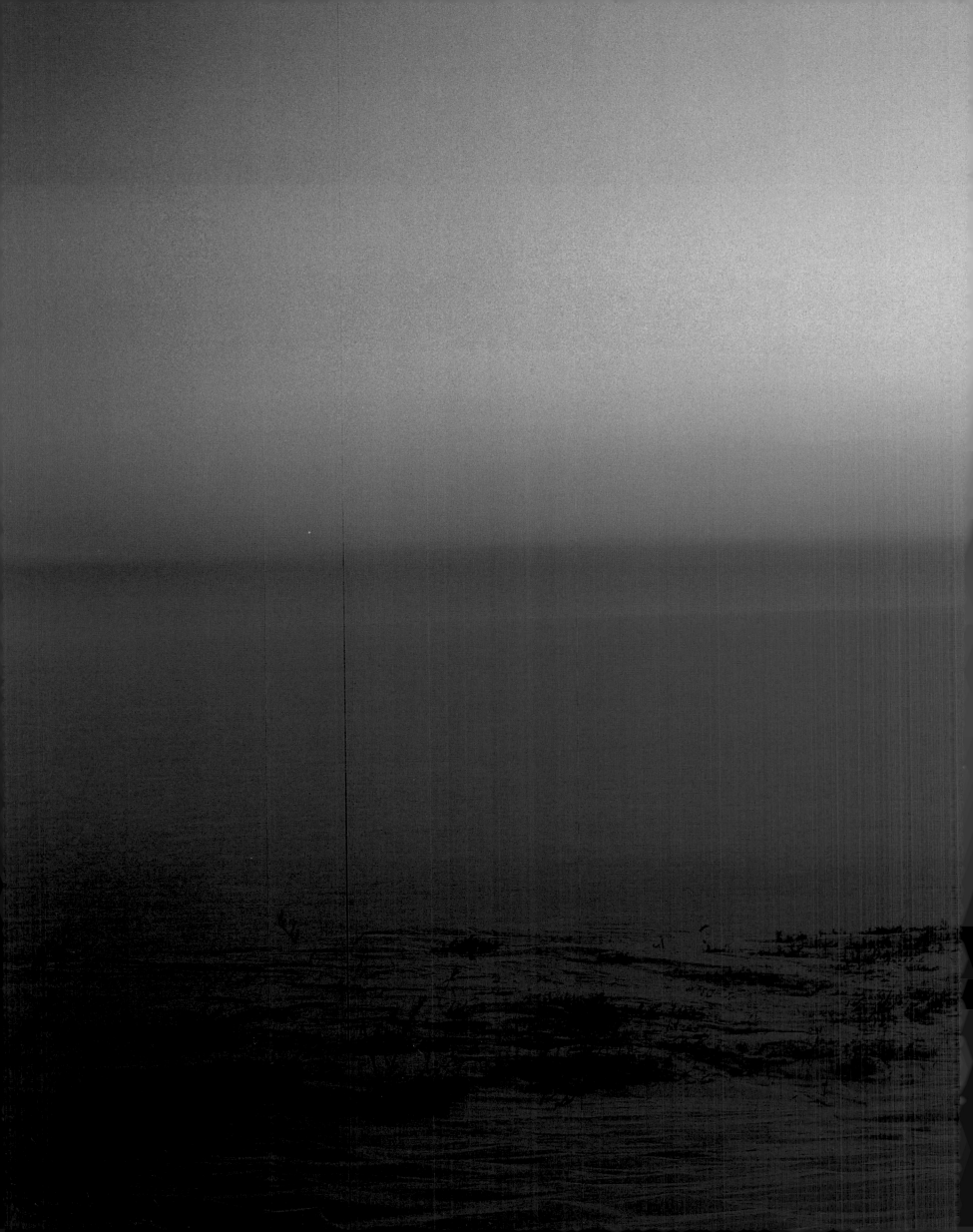

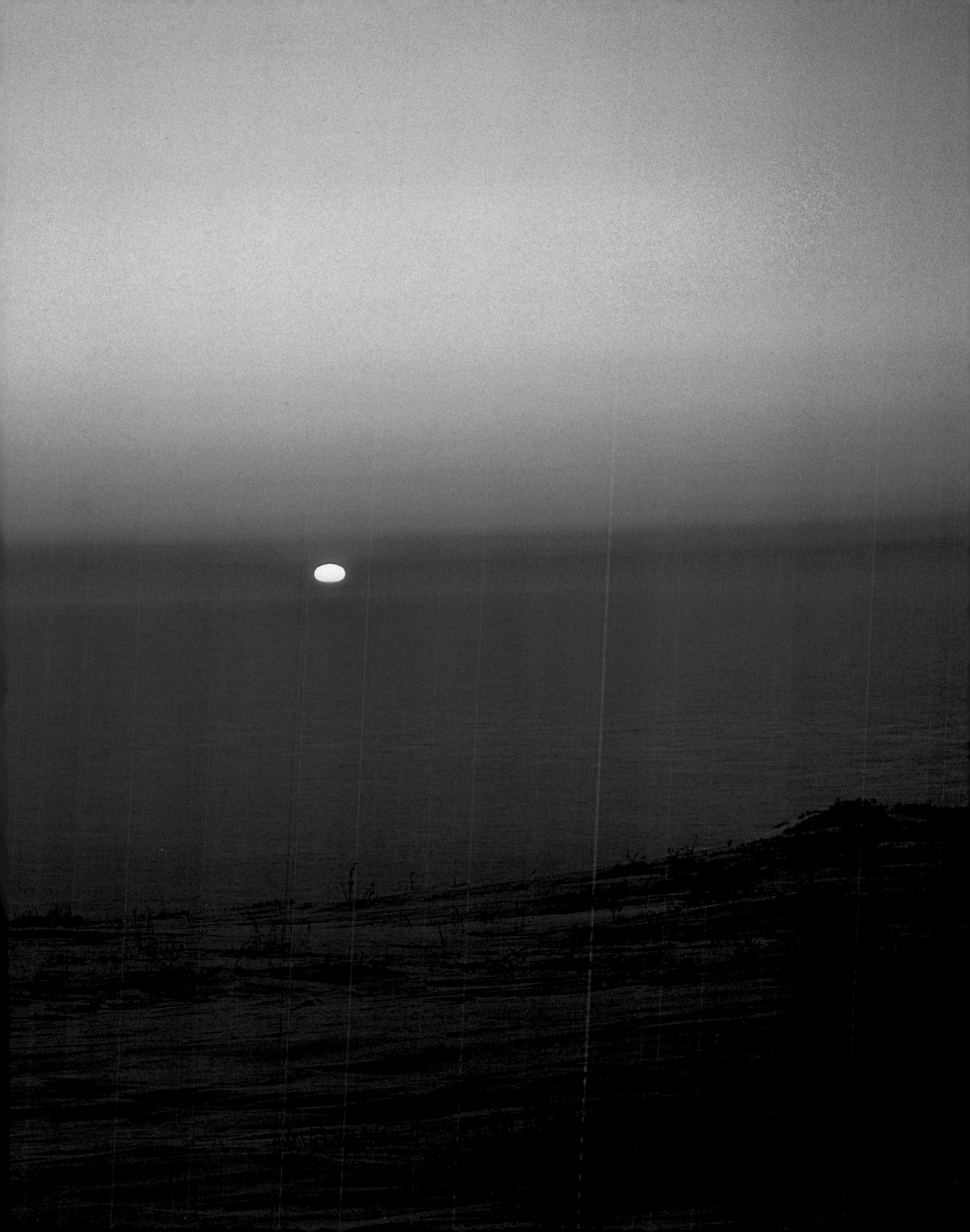

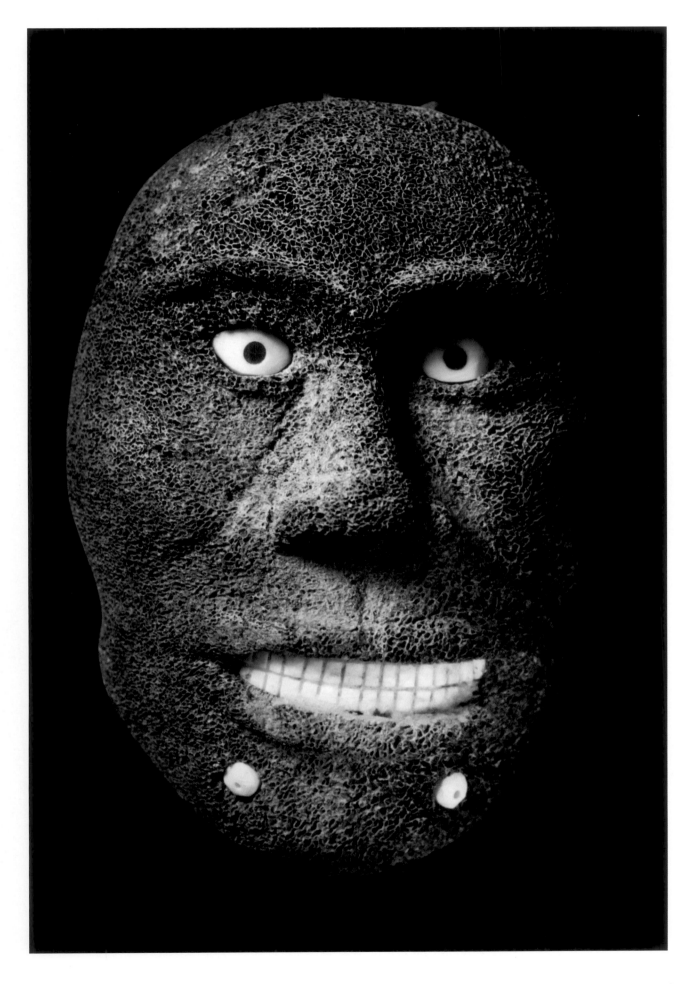

Previous pages: Cape Prince of Wales, October 1974. In August 1965, I left Saint Lawrence Island in the middle of the Bering Sea to return to this isolated and miraculously preserved community of whale hunters. I was finally able to complete my fifty-year voyage spanning all of the Inuit world in 1990. I received permission from the scientific adviser to Mikhail Gorbachev, the president of the Soviet Union, to travel to Chukotka, the cradle of Inuit thought. There I found an extraordinary ancient site, Whalebone Alley.

Left: Shishmaref, October 1974. Foreigners were the enemy. Until 1850, the Yupik Inuit and Inupiat tortured and massacred their enemies, usually under the influence of psychedelic mushrooms. They urinated on the conquered's faces, plucked out their eyeballs, cut off their eyelids, sewed their tongues, emasculated them, and finally tore apart their intestines, the core of their personality. Women who were too rebellious or too old were impaled through the vagina. Sexual trophies and heads were displayed when the victors returned. The Yupik language is precise: war (*pillugaq*), to cut the nose (*qengiit kepgaghlluk*). Only children and young women were enslaved. Escaped slaves were immediately recognizable —their noses were missing. In 1900, a slave from Saint Lawrence Island was worth thirty reindeer.

Right: Museum of Anthropology and Ethnography, Saint Petersburg, February 1959. This warrior is outfitted for a killing ride. He wears a double layer of walrus hide covered with stones glued with fat and walrus blood. His armor is made of walrus ivory; the front piece has straps of walrus, while the breastplate is made of old leather lined with glued sand, to protect against arrows. The shield, *magnitaq*, is whalebone.

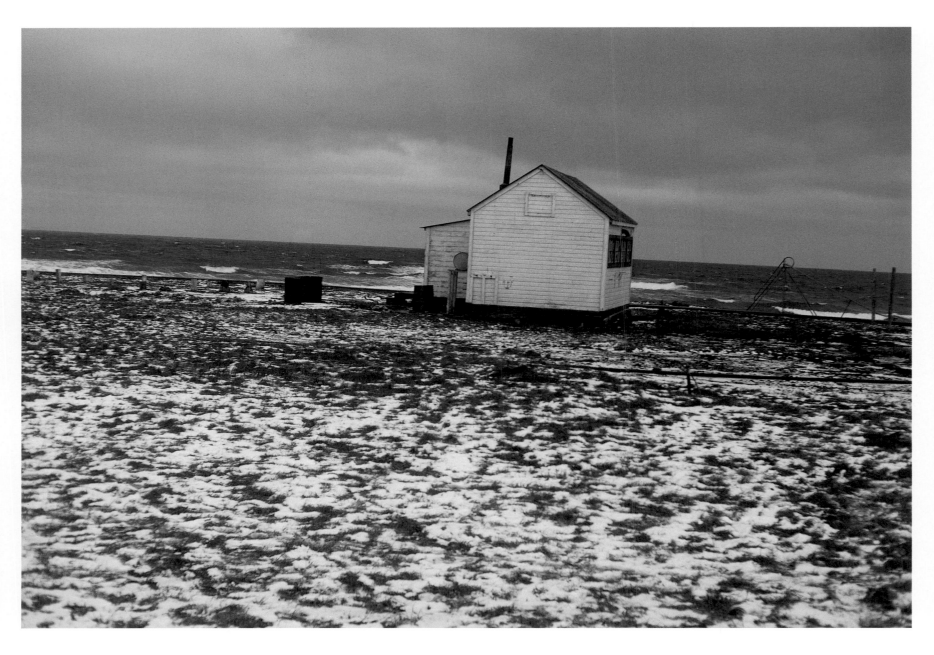

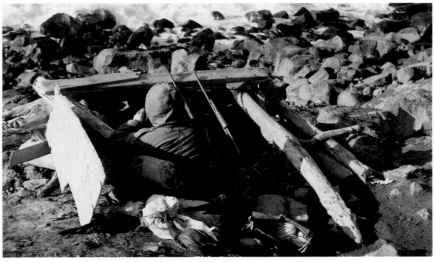

The *angyalik* sleeps very little between April and May. He thinks only about the whale—he talks to it, he compliments it. Dressed in his newest clothing, wearing a bag filled with meat, blueberries, and amulets, the *angyalik* goes to pray under his boat, its keel turned to the sky. The eight-man team heeds ancient restrictions on sex and food for three months.

In May, the whales cross the Bering Sea heading toward the North. They break the ice with their powerful backs, widening cracks in the ice floe, seeking channels of free water.

Above: Savoonga, September 1965. My poet's hut looks out over Chukotka.

Bottom left: Savoonga, September 1965. On the lookout for whales.

Savoonga, August 1965. The hunt begins. The *angyalik*'s bag is taken down from a pole at the entrance to his igloo. Pinch by pinch, the captain sprinkles the meat into the sea, keeping the roots. He raises his paddle to the sky, pronouncing the name of a person who has died or of a spirit. Wood shavings and grass are burned under the boat to keep the spirits away. The flame is the expression of the energy that sets the celestial mechanisms in motion. Thoughts have to be pure. Images of blood, of violence, of the vicious whale, of the sharpened harpoon, all have to be erased from the mind. The whale hears and understands everything. When the hunters are out at sea, their wives must not sew under any circumstances—their husbands would run the risk of getting stabbed by harpoons. To form an alliance with the cosmic forces, the "fiancée" walks around the boat in the direction of the sun's rotation, singing sacred songs for the *Arwooq*. In her hand she carries a small whale made of ivory or wood.

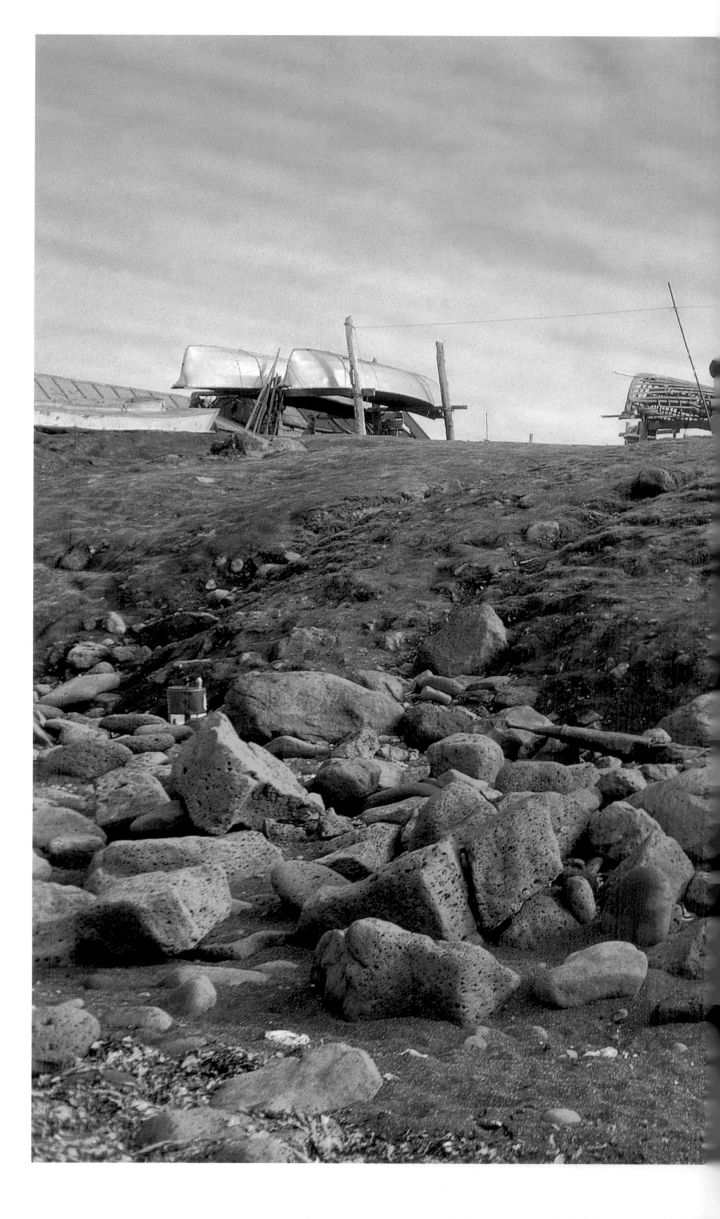

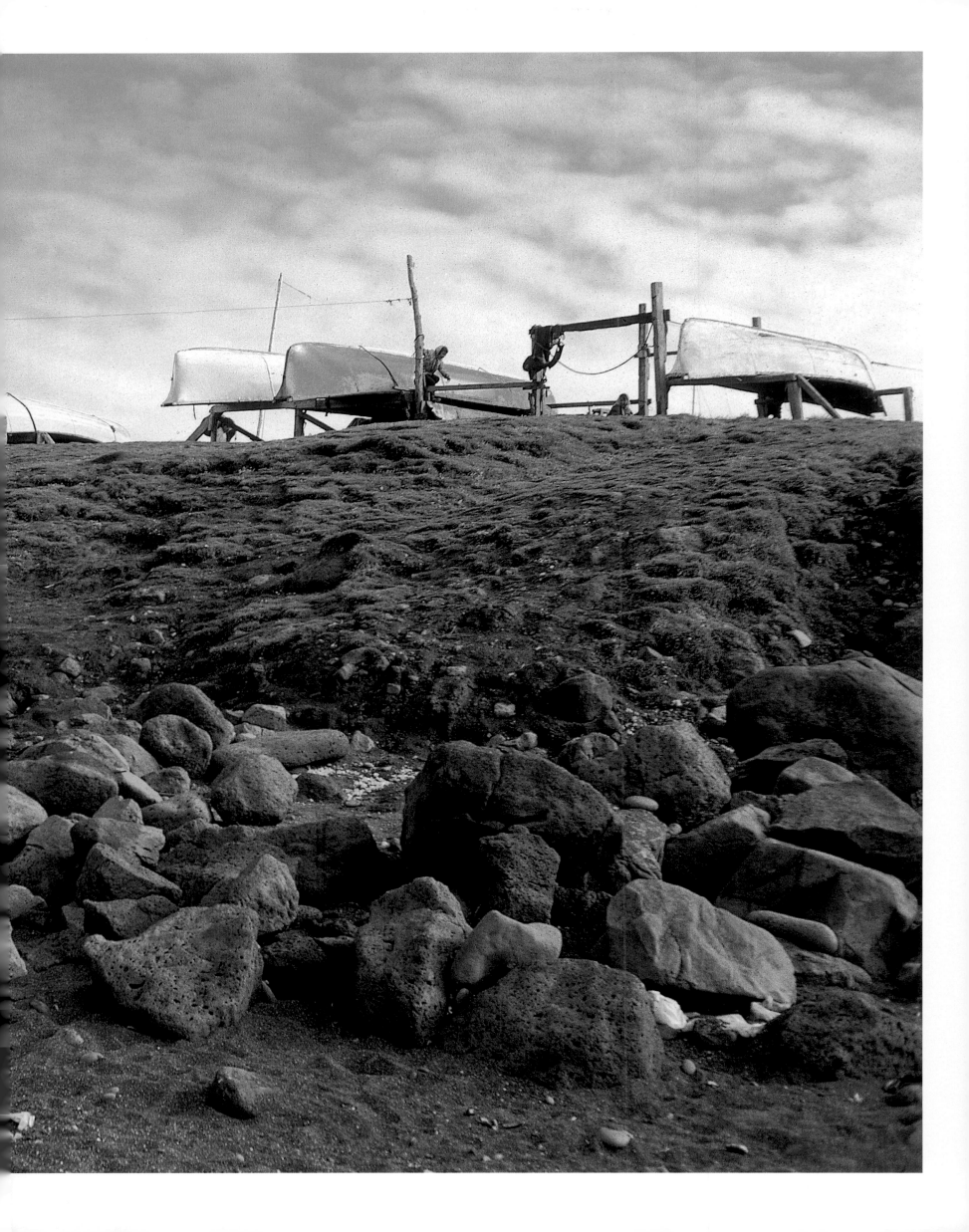

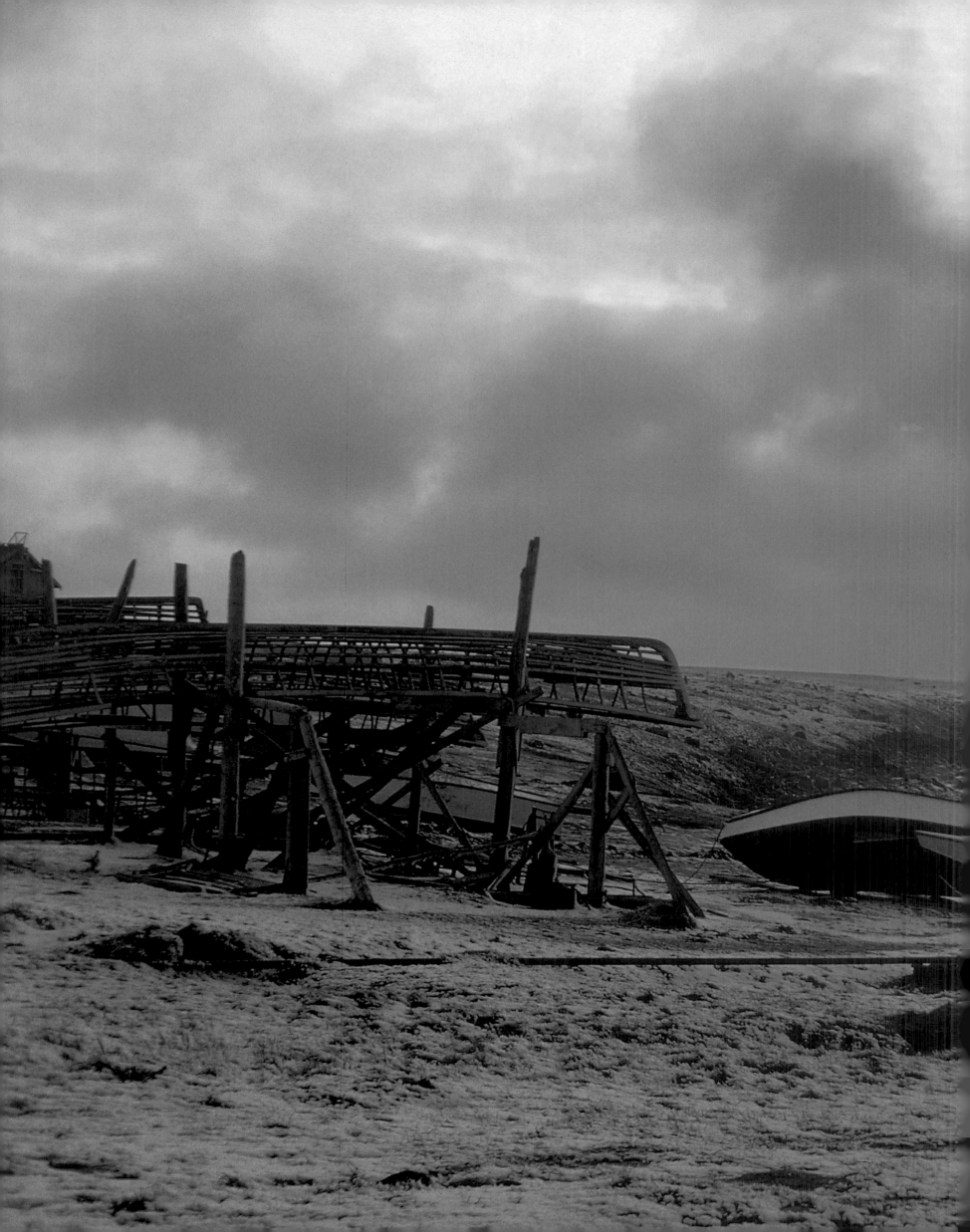

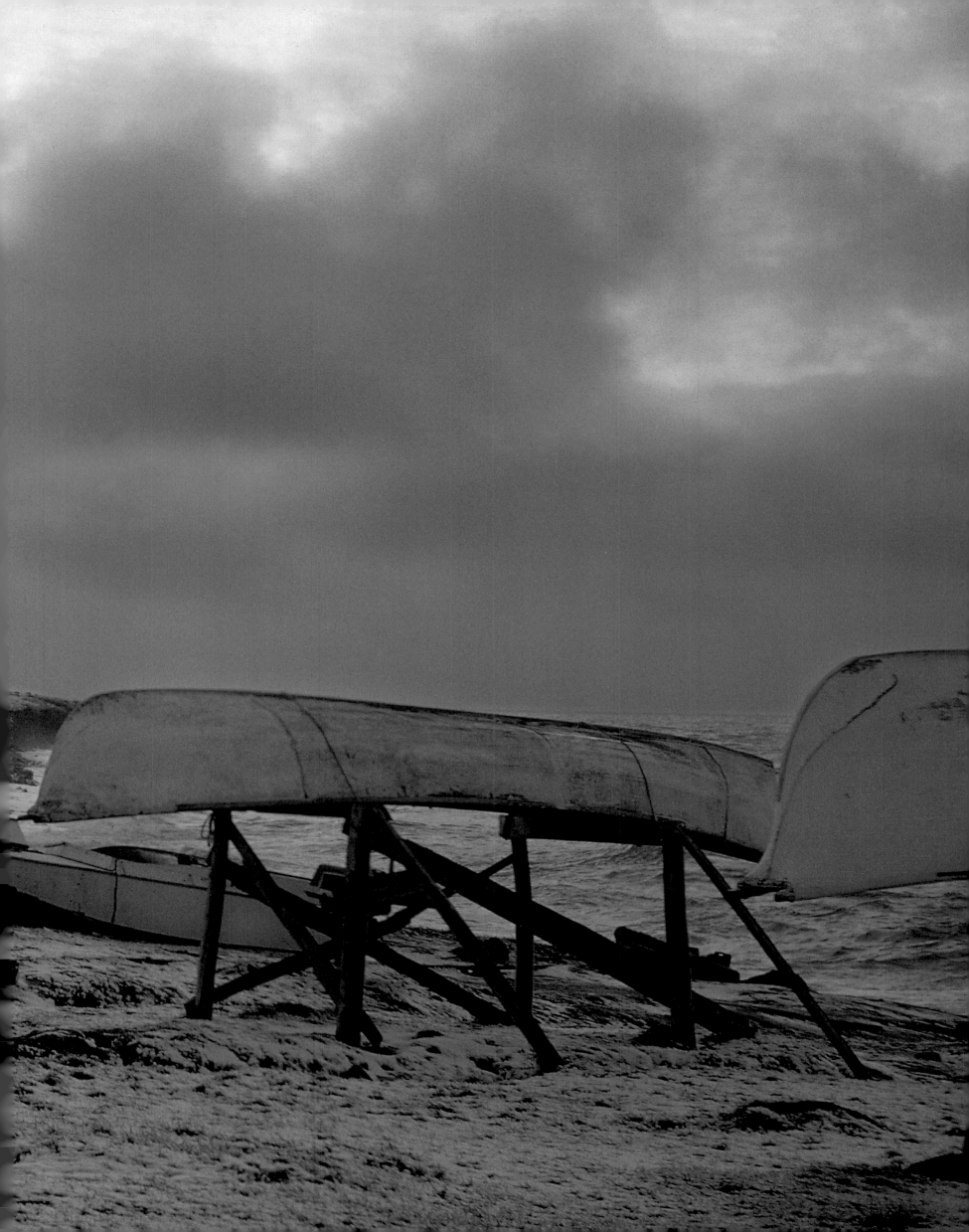

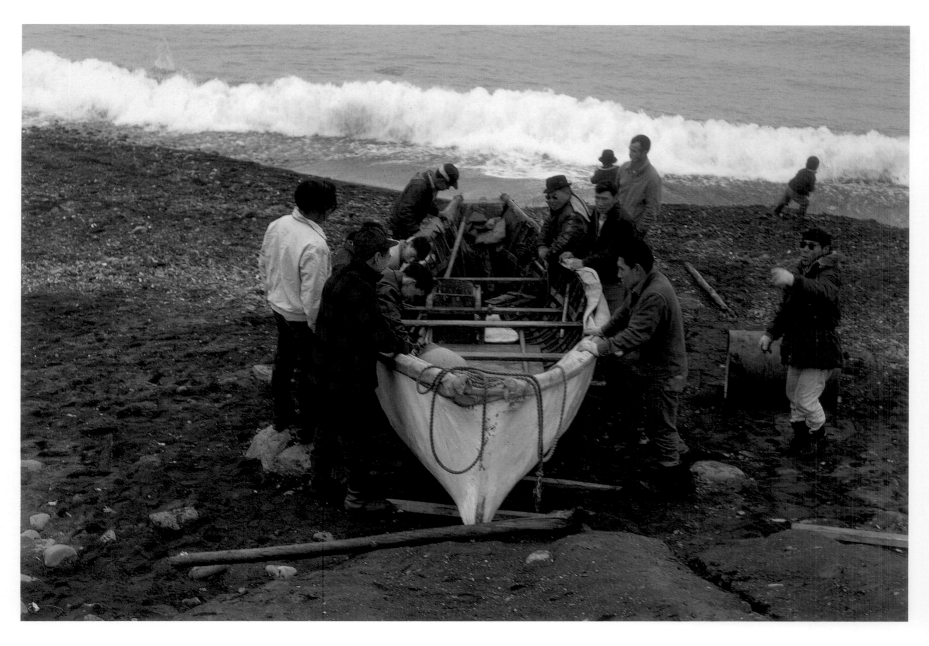

Savoonga, August 1965. Before setting out on the hunt, the harpooner must sleep with the captain's daughter, to immerse himself in her vaginal odor. This will trick the whale into approaching—he will think it leads to the captain's wife. The Inuit, just like the whale, bear, and wolf, have a heightened sense of hearing, as well as smell. The smell of bodily fluids, of sperm and a woman's vagina, has a place in lover's seductions and play.

 The Yuit of Savoonga did not say they were going whale or walrus hunting. They were only going to transmit a message to their dear relatives: "Come join us so we humans can be immersed in your strength and knowledge."

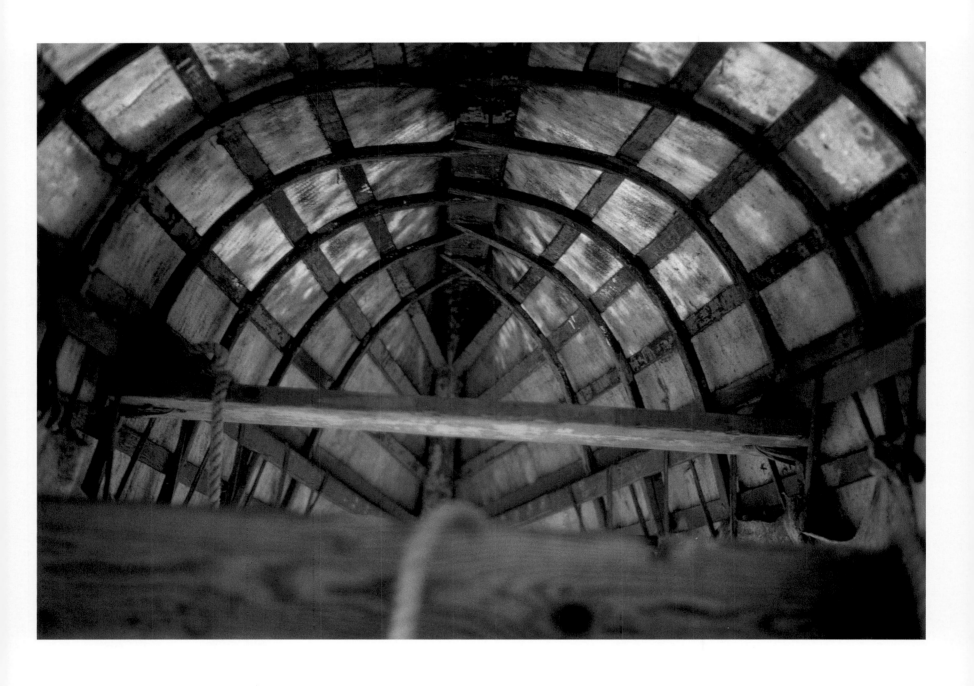

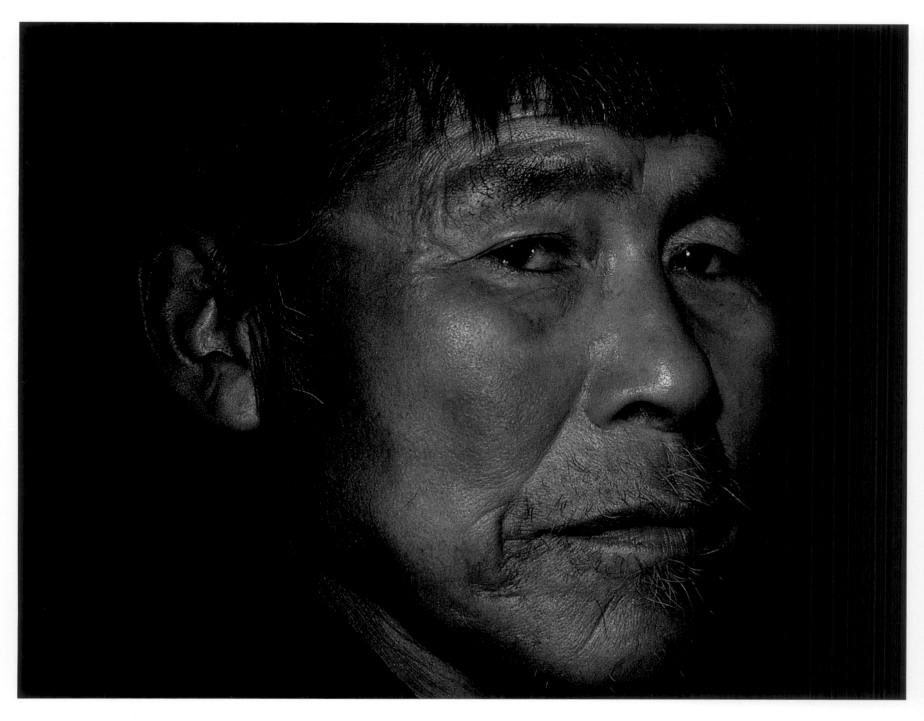

Above: Savoonga, September 1965.

Opposite: Mask, Point Barrow, northern Alaska, 1970.

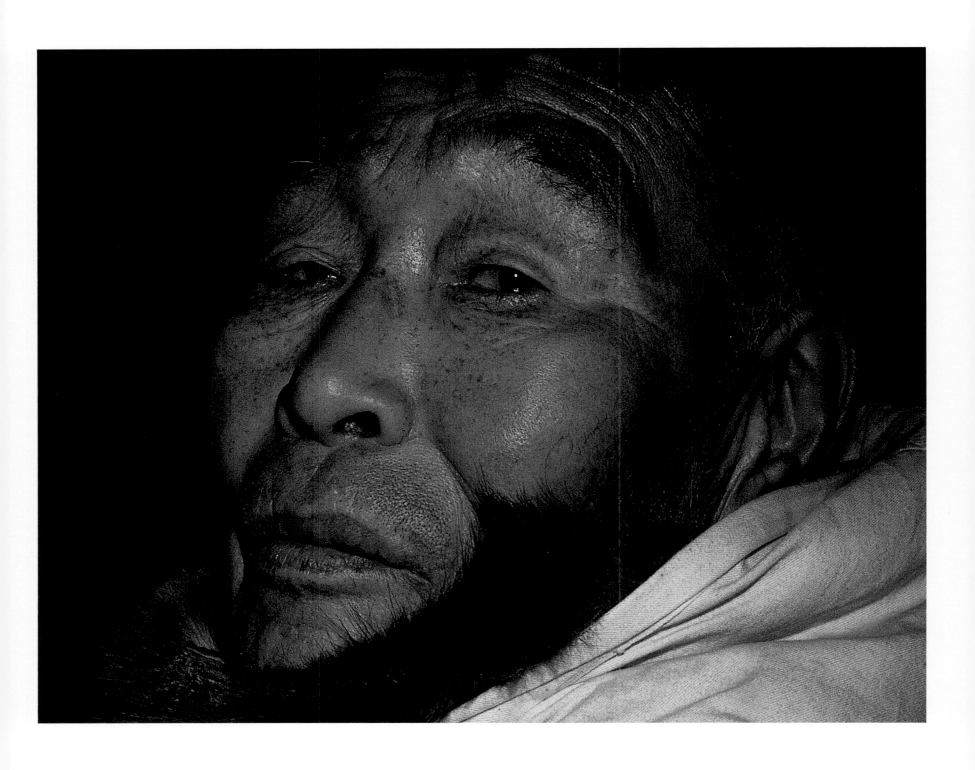

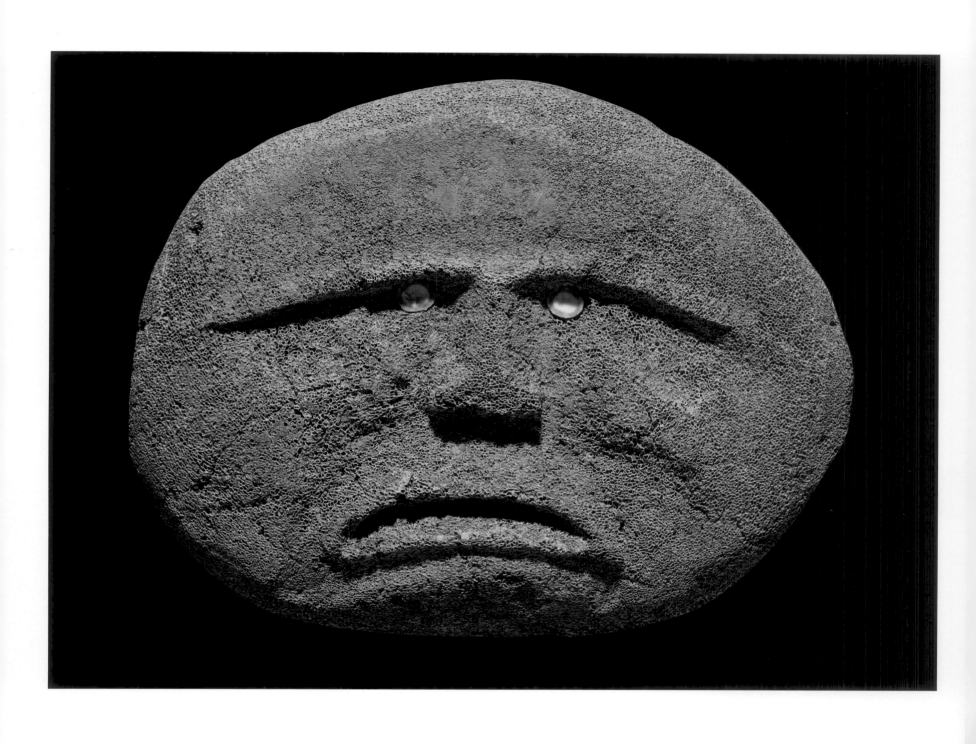

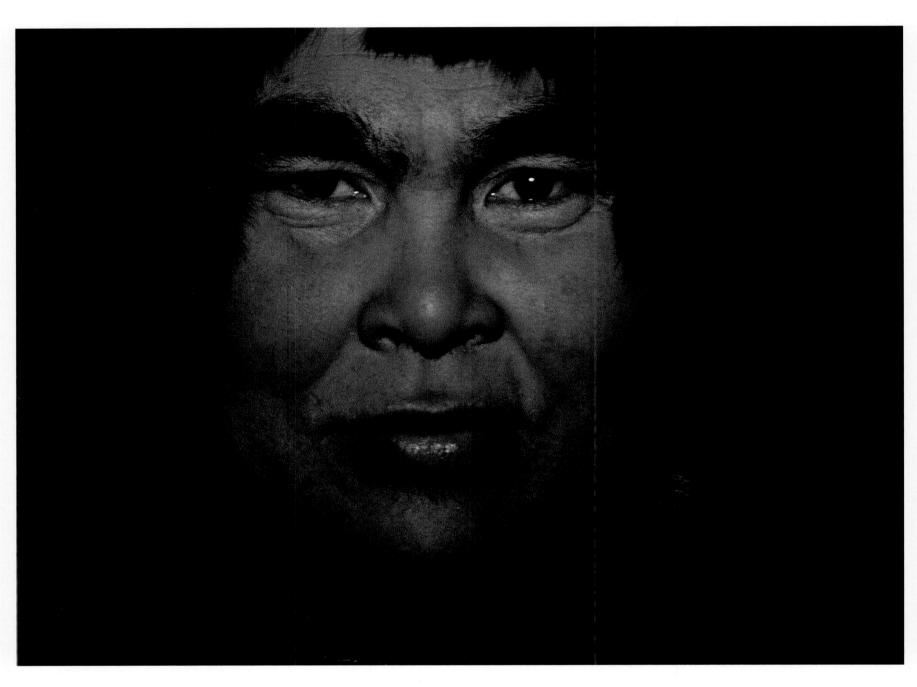

"You saw the young whale, right?" one of them whispered, staring at me with his shining eyes.

Savoonga, September 1965. In a low voice, almost as though we are reading a psalm, let us recite aloud the story of the whale's birth in Naukan, on Cape Dezhnyov in Chukotka, the easternmost tip of Asia.

"Leaving her igloo, the woman began to sing.
She called to her husband, the whale . . .
When she finished her song, she listened.
From afar, she heard the whale's whistle . . .
The whistle could be heard nearby.
Finally, the whale appeared and lay against a steep rock.
The woman fed it, watered it, and then a man came out of its nose and grabbed her . . .
And so this woman became pregnant and brought a whale into this world . . ."

In the Inuit imagination, whales are born each year in an artificial pool in Naukan, the sacred high place of the Bering Strait. I relive the legend in my head, like a dream.

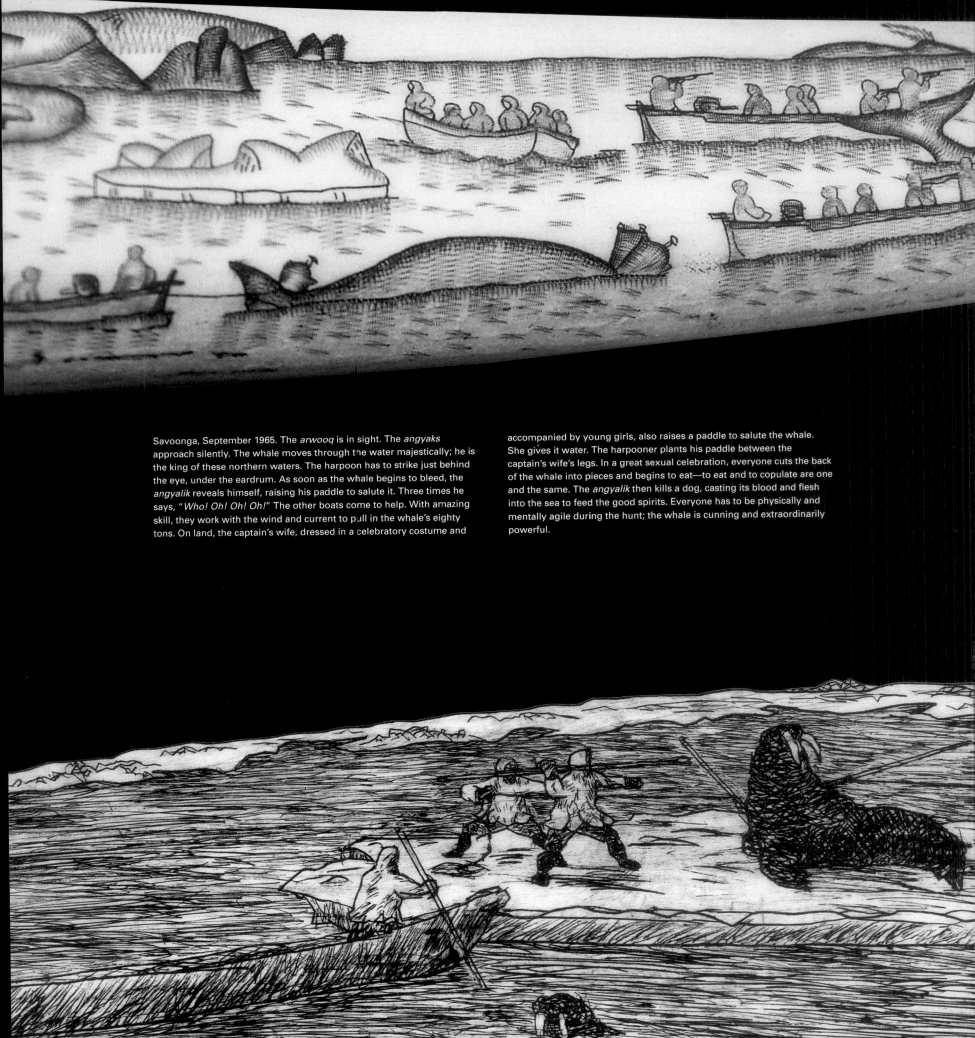

Savoonga, September 1965. The *arwooq* is in sight. The *angyaks* approach silently. The whale moves through the water majestically; he is the king of these northern waters. The harpoon has to strike just behind the eye, under the eardrum. As soon as the whale begins to bleed, the *angyalik* reveals himself, raising his paddle to salute it. Three times he says, "*Who! Oh! Oh! Oh!*" The other boats come to help. With amazing skill, they work with the wind and current to pull in the whale's eighty tons. On land, the captain's wife, dressed in a celebratory costume and accompanied by young girls, also raises a paddle to salute the whale. She gives it water. The harpooner plants his paddle between the captain's wife's legs. In a great sexual celebration, everyone cuts the back of the whale into pieces and begins to eat—to eat and to copulate are one and the same. The *angyalik* then kills a dog, casting its blood and flesh into the sea to feed the good spirits. Everyone has to be physically and mentally agile during the hunt; the whale is cunning and extraordinarily powerful.

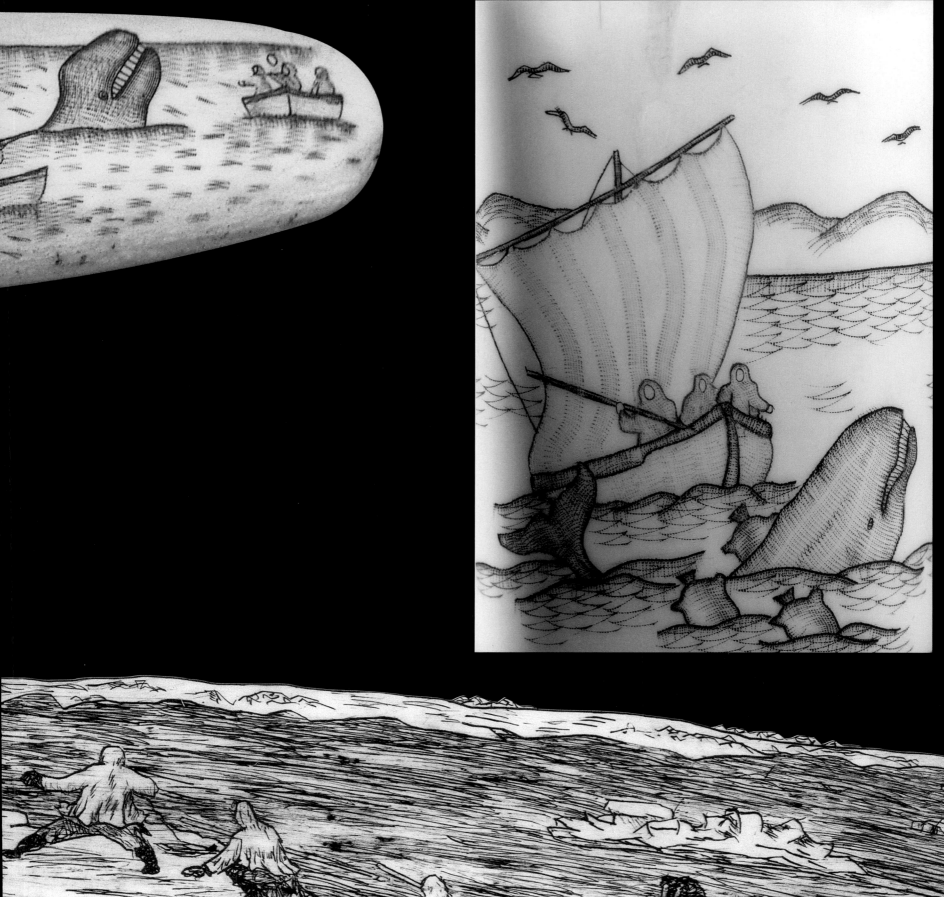
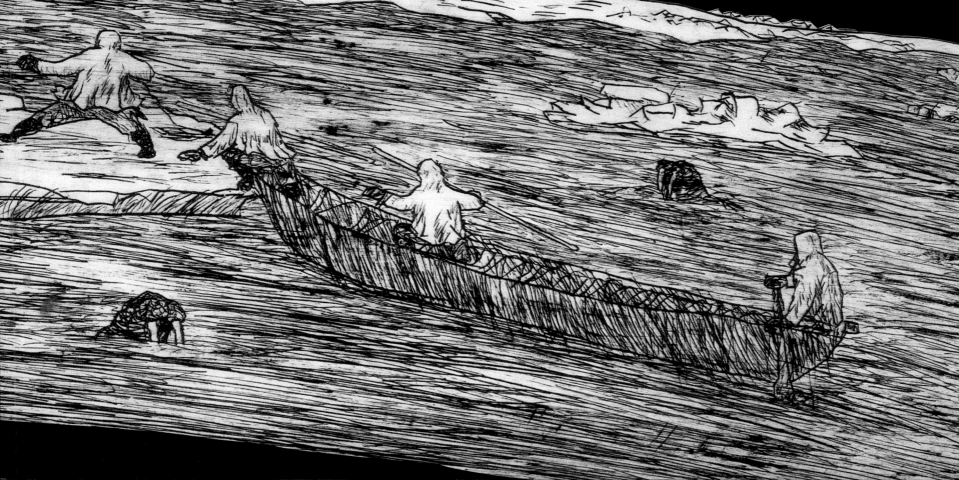

ANCIENT CELEBRATION OF THE WHALE

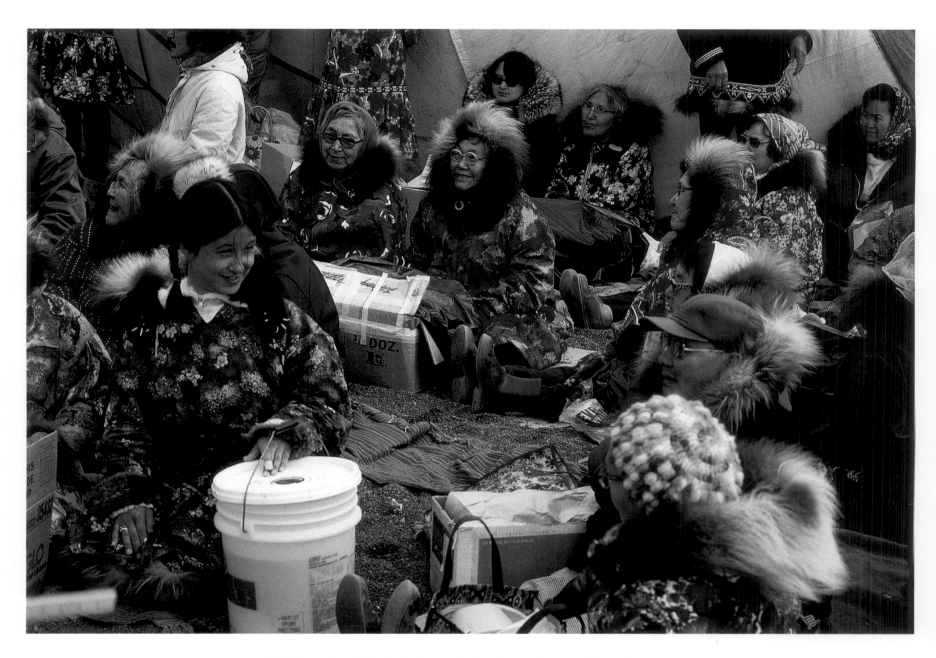

Point Barrow, June 1977, after the first pan-Inuit conference. A quarter of the year is devoted to festivals. Guests from neighboring villages are respectfully welcomed. The main celebrations are the festival of the messengers, the festival of the bladder, and the festival of the dead. Guests are barraged with food and gifts, and the generosity becomes competitive: giving less than someone else can be shameful. Men and women are exchanged in order to break the hold of the couple—The group is all that matters, a unit of men and women, not families. One out of every four children is given up for adoption to an unrelated family. The dances and chants continue until dawn. On the fifth and final day, an elder, with his drum, solemnly calls upon the dead: "Oh! Oh! Oh! Dear brother . . . come back!" Jumping on a walrus-hide trampoline concludes the festival.

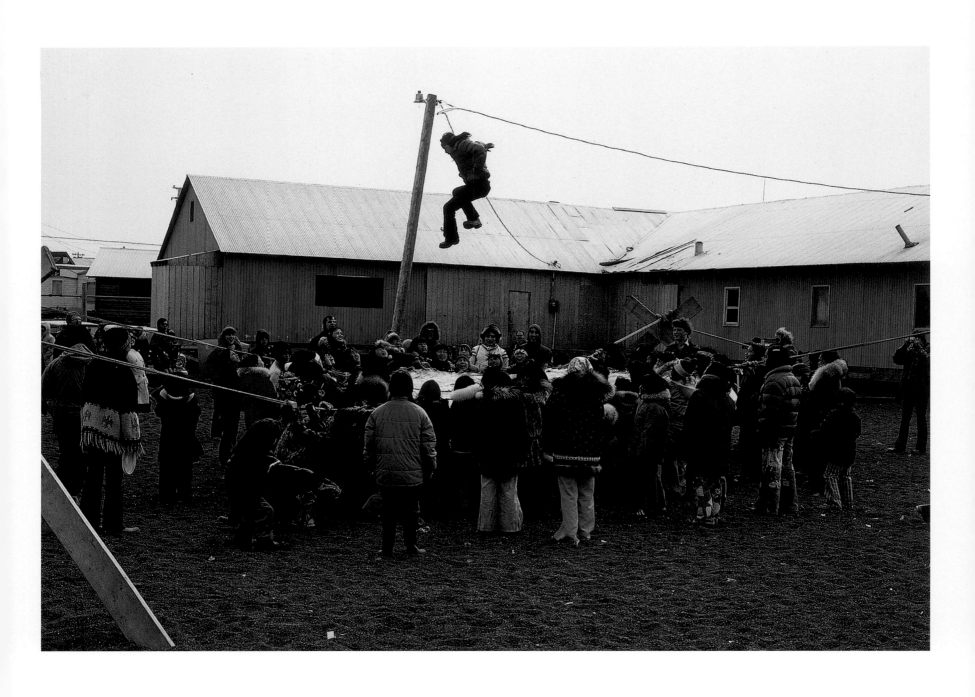

THE ANCESTRAL CALL OF THE SACRED DRUMS

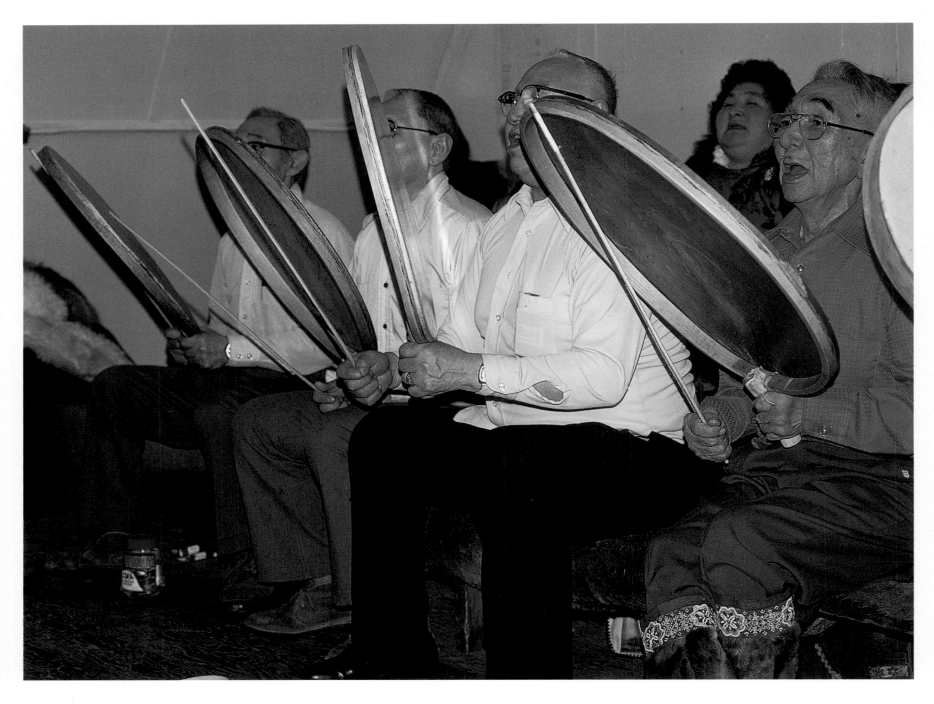

Above: Savoonga, September 1965. The Eskimo is filled with anxiety. Death looms. Wicked, resentful spirits threaten him. Communal life makes a man's natural aggression worse. This is why the community invented their festivals. After the whale hunt, goods are redistributed to attain the communal egalitarianism that is the foundation of the Inuit world.

Left: Point Hope, April 1976. Underground violence is controlled by dancing and chanting. During my stay, every other night there resounded "Aya, Aya, Aya . . .," the legendary refrain heard from Siberia to Greenland over which are told epic or mythical stories. Well into the night, all of Savoonga can be found in the *Q'assigi* or common house.

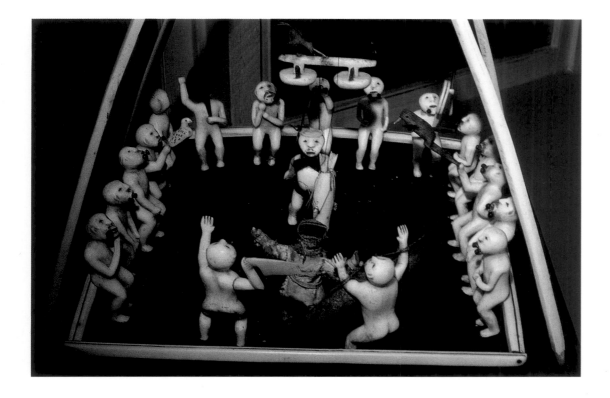

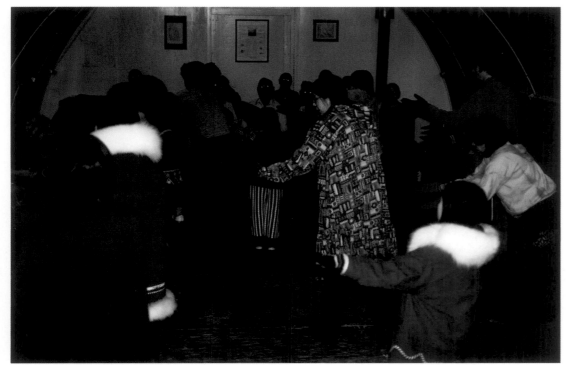

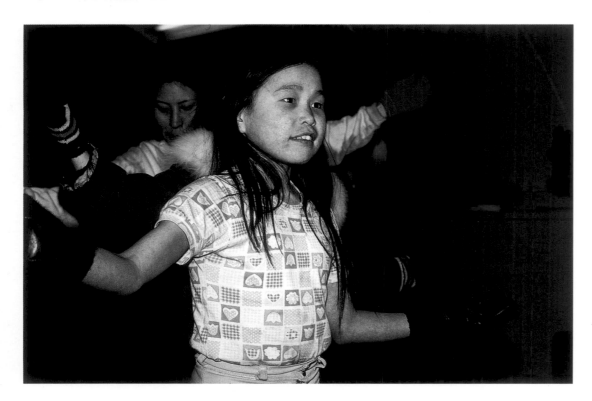

Top and middle: Savoonga, September 1965.

Bottom: Nome, October 1997.

Right: Nome, October 1997.

Following pages: Savoonga, September 1965. Man's inner violence is controlled through graceful hand movements. Gloves are worn to respect the dead. A dance accompanies this incantation to the dead, to animals, to wind, sky, and sea. The torso is twisted, the knee and foot bent. The chants reveal a hidden sorrow, but also a hope for unification with the spirits of Nature and the shadows that slowly envelop you.

The big drums are held at an angle with the left hand. The drummer uses a long, thin drumstick to strike the edge of the *cauyak* twice. Then comes silence, and then two more beats. "1-2-1-2-3/ 1-2-1-2-3." Singing accentuates the rhythm. Wooden masks, painted red, green, and jade blue, are contorted into twisted expressions, with fangs or a hole for a mouth. The masks are a reminder of the importance of staying with the *tuurngaq,* the great spirits. A fox-man with a beak nose bends over; he turns into a bird with a giant's ears. A human torso becomes a whale's tail; little fins grow at its sides. Four teenagers move toward the audience and the audience joins in. The group is carried by a wave of rhythm. Squatting in line, they mime that they are paddling. They're followed by an elder; with a distanced authority he looks out to the sea, his hands over his brow. He places his right hand on his hip, his left in front of him; then he places both hands on his back. He cries out: "*Ayouk! Ayouk!*" imitating the cry of a baby walrus. The very young jump in; they have five white snow-owl feathers in their hair.

It's three in the morning. The drums beat heavily, like a cathedral bell, calling to the dead, as the group disperses into the starry night.

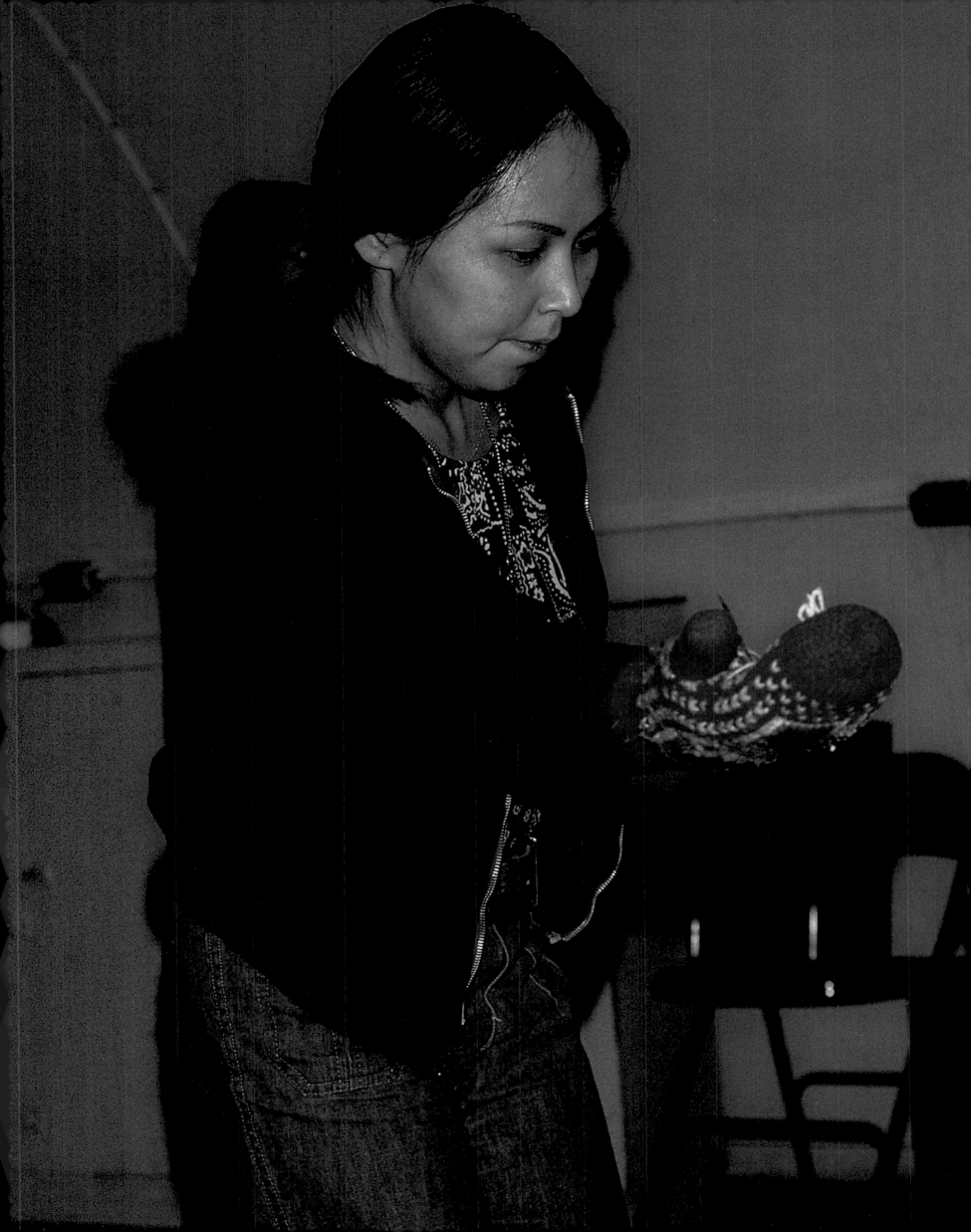

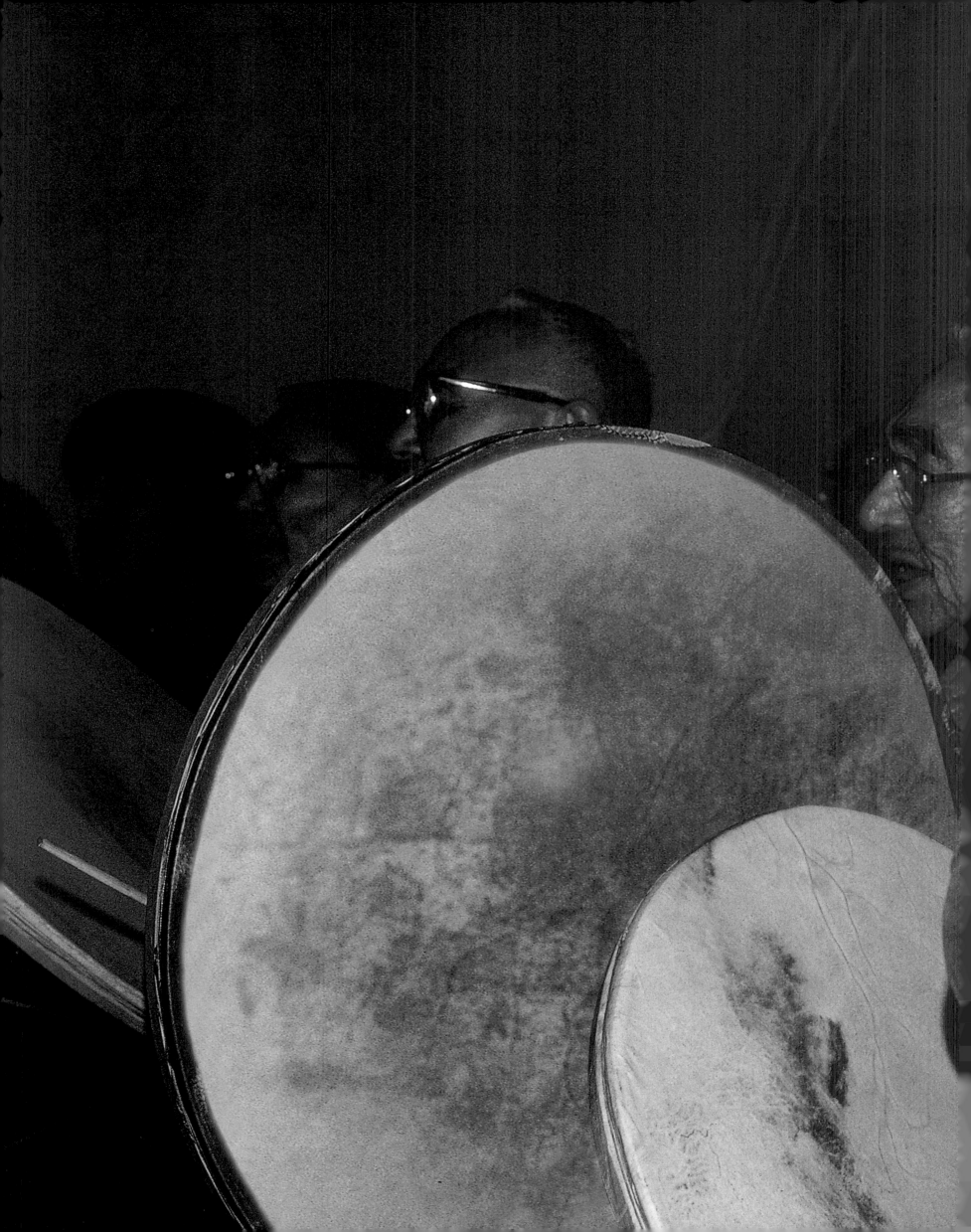

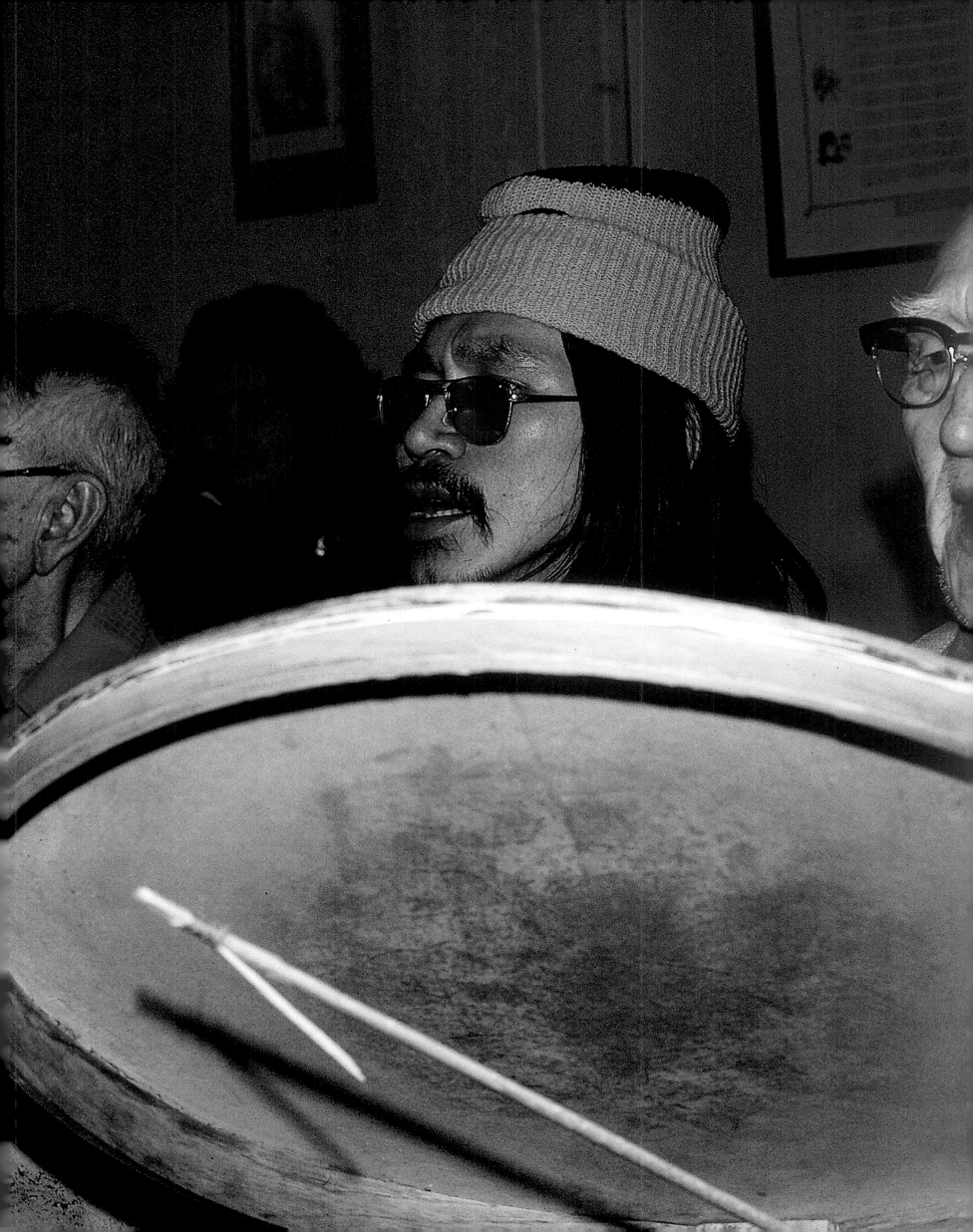

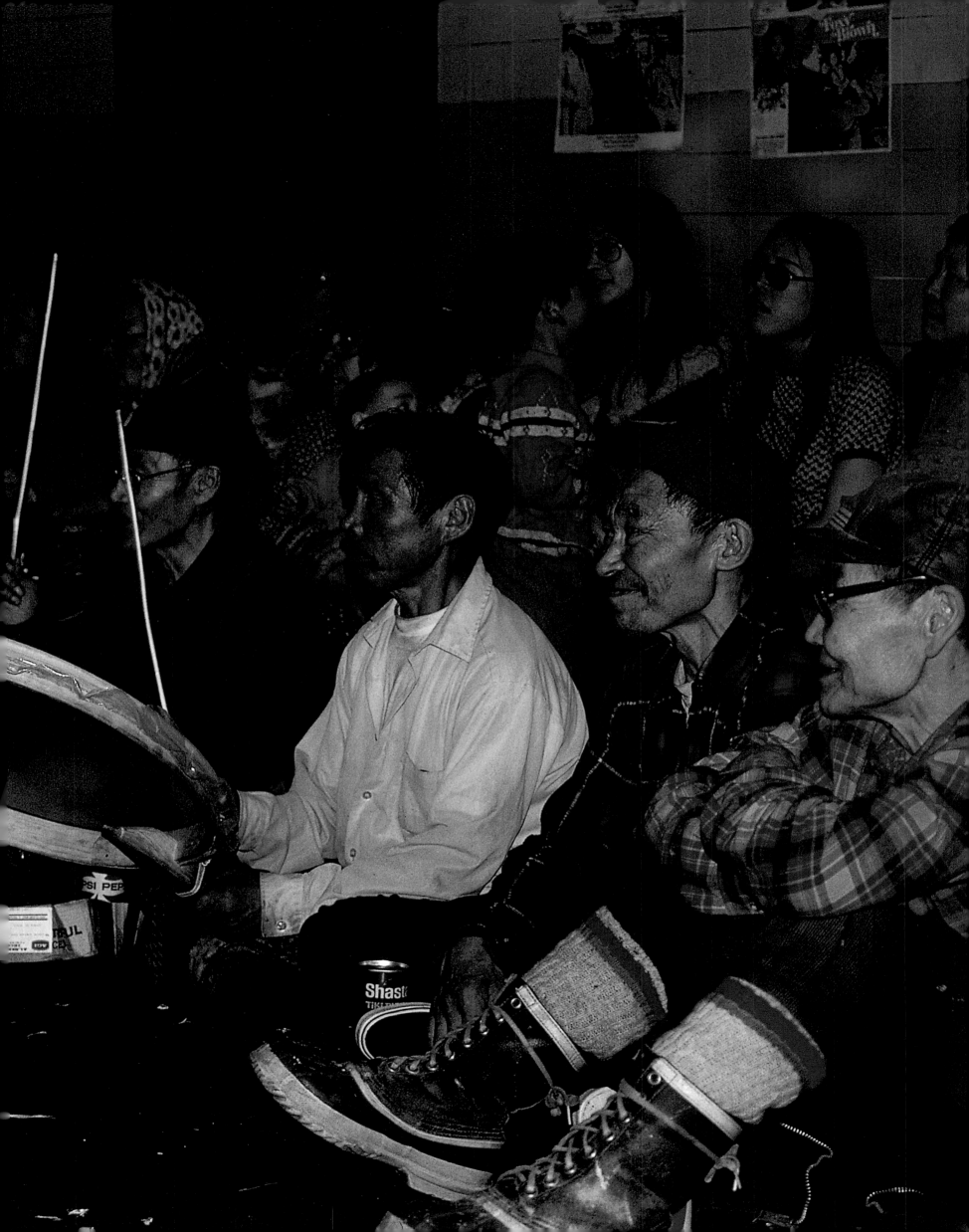

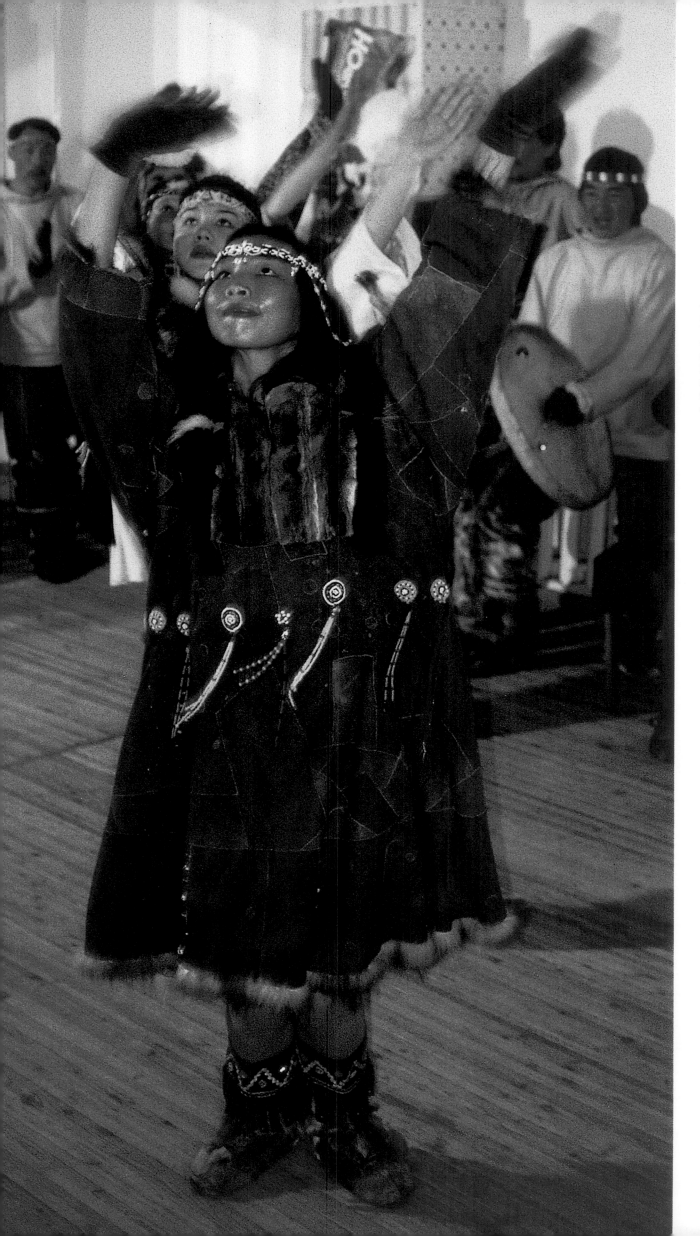

Anadyr, Chukotka, August 1990. This theatrical
performance is a ritual without a sacred aura.
The Inuit's great myths are revised with a Soviet
edge, the USSR's "progressive thinking" meant
to do away with superstitions. The powers that
be only honor folklore; shamanism, which is
outlawed, thrives in secret, in underground
thoughts. This Marxist, atheist country erased
shamanism by making the sacred secular.

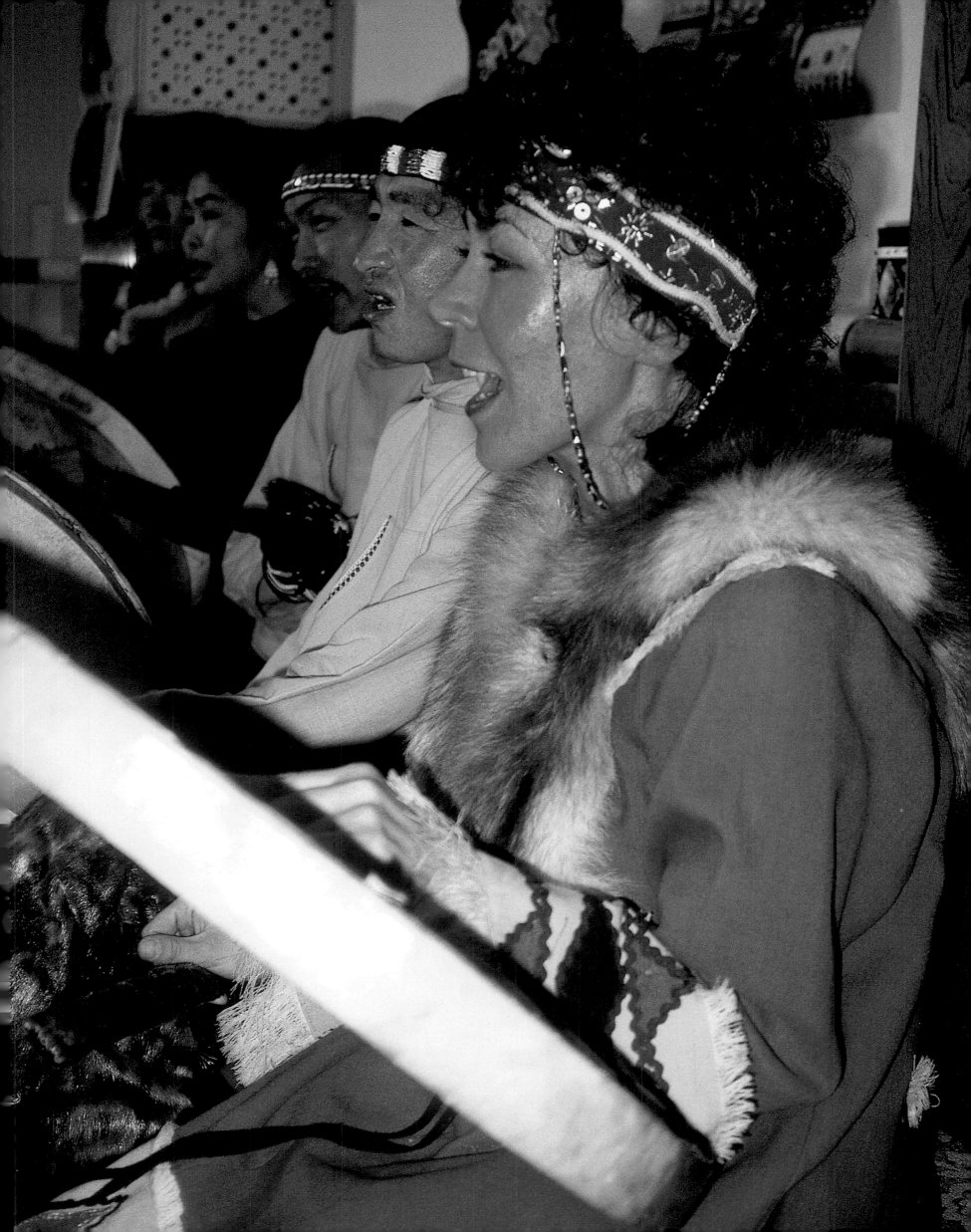

THE YUPIIT AND THE SACRED WHALE

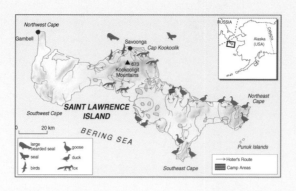

THE WILDEST PEOPLE OF SIBERIA: CHUKCHIS AND YUIT

THE INDOMITABLE

"The inhabitants resemble the country: they are the most savage, harshest, most uncontrollable, least civilized, hardest, and cruelest people in all of Siberia; they have neither letters nor writing, nor any kind of education. Even today, no one has been able to entirely subjugate them."

—Gerhard Friedrich Müller, *Description of All the Nations of the Empire of Russia in Which the Mores, Religion, Customs, Habitation, Clothing and Other Remarkable Particularities are Exposed,* Saint Petersburg, 1776

A FATALISTIC AND SUICIDAL PEOPLE

"They bear setbacks with great displeasure and are very quick to put an end to their suffering through suicide, a circumstance that has placed large obstacles in our attempts to subjugate them."

—Gerhard Friedrich Müller, *Description of All the Nations of the Empire of Russia in Which the Mores, Religion, Customs, Habitation, Clothing and Other Remarkable Particularities are Exposed,* Saint Petersburg, 1776

BERINGIA

"Twenty thousand years ago, there was a large land bridge across the Bering Sea that stretched more than 750 miles north to south. The thaw after the Ice Age submerged Beringia and an archaeology was forever lost. Saint Lawrence Island and the Diomedes Islands are all that remain of this long and great history."

—Jean Malaurie, Notebooks, 1964, and *Hummocks,* Volume II, Paris, 1999

A SOCIETY OF WARRIORS AND SLAVERS

WAR RAIDS

"The raids are short: one to two weeks. They take place most often during the summer and by sea. The *oumiaks* in Inupiat (*angyak* in Yup'ik or *baïdares* in Russian), each containing up to fifteen men, gather on the Siberian coast with their equipment and provisions. A dozen or so *baïdares* participate in an attack."

—Jean Malaurie, *Hummocks,* Volume II, Paris, 1999

FREQUENT INTERTRIBAL WARS

"The frequency of body armour in all the ruins bears out the traditions of the natives that they were constantly at war with the surrounding peoples, both in Asia and Alaska."

—Diamond Jenness, National Museum of Canada, *Annual Report for 1926*

THE USE OF HALLUCINOGENS

"Villages, small fortresses where the warriors regroup, usually stand at the foot of a hill . . . Near Savoonga, such

a "fortress" was surrounded by a wall of whale jaws and skulls. Attacks are prepared for with intense spying. . . . The Yuit and Yupiit do not use poisonous arrows. . . . The end of their [arrow] shafts were immersed in hot water so the tips would be stronger. Small knives are used for hand-to-hand combat; they can be hidden in a boot or a sleeve. Large knives, measuring twenty or twenty-five inches long, are worn over the shoulder, on the left side, and are used like sabers. . . . They fill the enemy's homes with smoke through breathing holes and chimneys in their roofs, then throw boiling water inside. When residents flee through the main door, they are speared with an arrow and then impaled. . . . The use of narcotic mushrooms explains the ferocity of these warriors."

—Jean Malaurie, *Hummocks,* Volume II, Paris, 1999

CAPTAIN JAMES COOK, AUGUST 10, 1778, SAINT LAWRENCE BAY

"Forty or fifty Men each armed with a Spontoon Bow and Arrows drawn up on a rising ground on which the village stood. As we drew near three of them came down towards the shore and were so polite as to take off their Caps and make us a low bow. . . . But nothing we had to offer them would induce them to part with a Spear or Bow, which they held in constant readiness never once quitting them, excepting one time, four or five laid them down while they gave us a Song and a Dance, and then they placed them in such a manner as they could lay hold of them in an instant and for greater security desired us to sit down."

—James Cook, *Journal,* Volume IV, 1811

A SLAVE SOCIETY

"In this egalitarian society that glorifies strength, the men held slaves. Slaves did menial tasks: getting water, gathering driftwood, carrying heavy loads. They lived in the same house as their masters but slept on the north side, a humiliating and cold place, or just to the right of the entrance. They ate separately. Among the Chukchis, slaves wore women's clothing. They were punished for their smallest mistakes. The village terrorized them; if they hadn't, they might have rebelled while the men were away hunting. If a slave tried to escape his nose was cut. As a result, everyone could identify him as a potential runaway. If he tried again, he was put to death. In prehistoric gravesites in Chukotka, according to Russian archaeologist Sergei Arutiunov, there were not only tombs for the hunters, but also for their slaves, who were strangled when their masters died so that they would serve him in the afterlife."

—Jean Malaurie, *Hummocks,* Volume II, Paris, 1999

"We learn from the information gathered that slavery exists among the Chukchis. The richest have entire families: these slaves cannot change their home, they own nothing, and depend entirely on their master who uses them for the harshest work. He feeds them and clothes them instead of paying them. They are, I believe, descendants of old prisoners of war."

—Ferdinand Petrovitch de Wrangel, *The North of Siberia: Journey Among the Small Tribes of Asian Russia and in the Arctic Ocean,* Volume II, Paris, 1843

SHAMANISM: ACTIVE UNTIL THE RUSSIAN REVOLUTION, UNDERGROUND EVER SINCE

DOG SACRIFICE

"We were in sight of the North Cape of the Island [Saint Lawrence], a steep and rocky headland. . . . Three *baïdares* immediately push off from the bank, each one carrying about ten people who, before paddling towards the ship, practice religious rites; for a moment, they sang a slow melody; then, in the middle of their circle, one of them sacrificed a black dog, which he held up in the air, slitting its throat with a knife and throwing it into the sea. They only approached after this solemn act and some boarded the deck." [According to Billings, Müller, and Chamisso, the spirit of the dog plays a major role in the great sacrificial rites of the Yup'ik. The fact that there are no dog bones in the ceremonial hearths might be because the bodies are cast into the sea. These rituals do not exist in the central Canadian Arctic or in Greenland.]

—Adalbert Von Chamisso, *Travels Around the World: 1815-1818,* Paris, 1991

THE HOME FLAME

"*Ut,* the flame, is a more respectable divinity, it purifies, enriches and offers happiness. It's to *Ut* that the yurt and home are dedicated. Newlyweds dedicate their first fire to it. One can spit on man but not on the flame. *Ut* is elated when it is offered oil, fat, or alcohol. If it is in a bad mood, it burns anything that does not please it."

—Fedor Lütke, *Journey Around the World, Made . . . on the Corvette "Seniavine": 1826–1829,* Paris, 1835

TO EASE TENSIONS: SONG AND DANCE

"Song and dance are meant to ease tension in a self-contained world and to better link together man in his mythical environment. . . . During the five celebrations of the whale, the group shares a communal life in an intense cultural exchange."

—Jean Malaurie, Notebooks, 1965, and *Hummocks,* Volume II, Paris 1999

MENTAL STIMULATION: COMMUNAL SONG AND DANCE

"Dances that imitate animals stimulate thought associations and cognitive faculties. Visual and aural stimuli are

transmitted to the cortex. The final auditory impression and the memory of the musical experience is established in the temporal lobe.... The action is accomplished with an intense rhythmic movement and formal play."

—Thomas F. Johnston, *InterNord*, No. 16, Paris, 1982

FIVE SUCCESSIVE NOTES:
A HALF-TONE STAFF

"In Eskimo chants, there is typically a series of five notes. Through a transposition of sharp and flat octaves in half-tone notes, there is a micro-tonal intermediate station that develops their musical expression. Eskimo melodies are always sung in unison, with an octave difference between the men's voices and the women's."

—Thomas F. Johnston, *InterNord*, No. 16, Paris, 1982

NO VOCAL STRATIFICATION:
EGALITARIANISM

"The absence of vocal stratification reflects the absence of sexual and social classes in this communal society."

—Thomas F. Johnston, *InterNord*, No. 16, Paris, 1982

SACRED RITUALS

FIVE CELEBRATIONS IN
THE COMMUNAL HOUSE

"In the *q'assigi*, or communal house, five major holy rituals are observed: the celebration of the bear, the celebration of the messenger, the great celebration of the bladders, the celebration of masks, and the great celebration of the dead. A quarter of the year is devoted to these ceremonies, which relieve tensions and allow men, women, and children to commune with bears, nature, and the cosmos. *Tu'tu-uk*; starting at dawn, they go from house to house. Hunters and teenagers gather in the *q'assigi*; they take off their clothes and stand completely naked.... They blacken their faces with wood that is burnt with oil; they paint their bodies in long bands of alternating stripes. Holding wooden plates in their hands, one behind the other, they move about "groaning," making sounds that seem to come from the center of the Earth.... Ernest Hawkes observed them on the Diomede Islands, "Howling, stamping, and grunting . . ." They hold out their plates like beggars. Holding flaming torches above their heads, they leap, jump, and yell like madmen; they run around the room, encircling the bladders with flame. In the middle of this, they make for the exit, one after another; one supposes that the *inuas* who are in this *q'assigi* understand that soon it will be time to leave, that it is high time to get ready."

—Jean Malaurie, *Hummocks*, Volume II, Paris, 1999

THE WHALE HUNT

"The whale hunt is also a ritual marriage between the wife of the captain leading the hunt and the great whale.... In July 1927, photographer Edward S. Curtis described the departure of a whale-hunting party on

Cape Prince of Wales: "The boat is launched and allowed to drift out. The crew sing, and the woman [chosen to take part in the ceremony], standing on the ice, sings. The boat is then turned about and heads towards her, while the spearer makes as if to harpoon her. She scatters ashes to drive away evil influence, and runs home without looking back. There she remains, fasting, until a whale has been killed or the crew returns."

—Edward S. Curtis, *L'Amérique indienne*, Paris, 1992, in Jean Malaurie, *Hummocks*, Volume II, Paris, 1999

MEETING THE *ARWOOQ*

"During the entire hunt, the captains focuses his attention on the whale. He becomes one with the *Arwooq*. He imagines it as an effigy, he talks to it privately, with the intent of meeting it.... He is filled with dignified thoughts of his noble guest.... When he is about to harpoon the whale, the eight hunters on the edge of the open walrus-hide boat helping him, he turns so the *Arwooq* is in the direction of the sun's rotation, and salutes with this cry: 'Who! Oh! Oh! Oh! Oh! Oh,' which he repeats three times.... In sight of the shore, the harpooner cries again three times: 'Who! Oh! Oh! Oh! Oh! Oh.' Thus alerted, the wife of the *angyalik*, takes a small paddle in her right hand and moves to the front of a group of young girls dressed for the celebration. Upon seeing the whale, the wife, now shared by her husband and the whale, dances, her hands and the paddle in the air. 'It's good you have come to visit us, thank you, thank you!' Then she goes to give the whale water."

—Jean Malaurie, *Hummocks*, Volume II, Paris, 1999

THE FUTURE

THE HISTORIC ACCORD OF DECEMBER
18, 1971, SIGNED BY RICHARD NIXON.

"An act to provide for the settlement of certain land claims of Alaska Natives, and for other purposes. Be it enacted by the Senate and House of Representatives of the United States of America in Congress Assembled, that this Act may be cited as the Alaska Native Claims Settlement Act."

Fred Bigjim, *Letters to Howard*, 1974, in Jean Malaurie, *Hummocks*, Volume II, Paris, 1999

A CALL FOR HELP FROM ESKIMO
LEADERS AND INDIANS TO THE
HOUSE OF REPRESENTATIVES

Although an elite of notable decision makers—politicians, businessmen—were moved by the accord of December 18, 1971, statistics in Inuit villages remain alarming. "Between 1964 and 1989, the suicide rate among indigenous people rose 500 percent. Fifty percent of these suicides were committed by individuals between the ages of fifteen and twenty-four, compared to twenty-five percent among the nonindigenous population.... Crime: indigenous people make up sixteen percent of the population of Alaska but are thirty-two percent of Alaska's prisoners."

—Jean Malaurie, *Hummocks*, Volume II, Paris, 1999

CULTURAL AND ETHICAL AWAKENING

"Since 1990, we have been witnessing a cultural awakening in the southwest of Alaska in Yup'ik regions. This renaissance is marked by a language that is living again, by dance, by song, and by masks. Shamanistic ceremonies are experienced with joy, alternating with Christian ceremonies. Culture, song, and dance are the vehicles of the future for a nation coming into its own.... These communities are assimilating into modern life with vitality. *Agayuliararput*: our path of prayer. A wonderful book by Ann Fienup-Riordan, *The Living Tradition of Yup'ik Masks*, eloquently attests to this. In terms of action, standards must be raised and steps must be taken, despite the haze, towards the trembling light, in the distance, the far distance."

—Jean Malaurie, *Hummocks*, Volume II, Paris, 1999

THE RUSSIANS, AN
APOCALYPTIC PEOPLE

"The Russians, a people who believe in the apocalypse, cannot bring about a humanitarian realm that is a happy medium; they can only bring about fraternity in Christ, or camaraderie in the anti-Christ; if there is no fraternity in Christ, let camaraderie reign in the anti-Christ. The Russians posed this question to the entire world with extraordinary power."

—Nicolas Berdiaiev, *Un nouveau Moyen Âge*, Paris, 1930

THE POLAR ACADEMY
OF SAINT PETERSBURG

"The State Polar Academy of Saint Petersburg, founded by my Russian colleagues in 1991 from an idea of mine, aims, with eight hundred students, the sons and daughters of native shepherds and hunters, to create a dialogue with the elite of the north-Siberian peoples to whom power was restored. This dialogue respects the area's cultural and spiritual heritage and looks to the future."

—Jean Malaurie, Notebooks, 1997

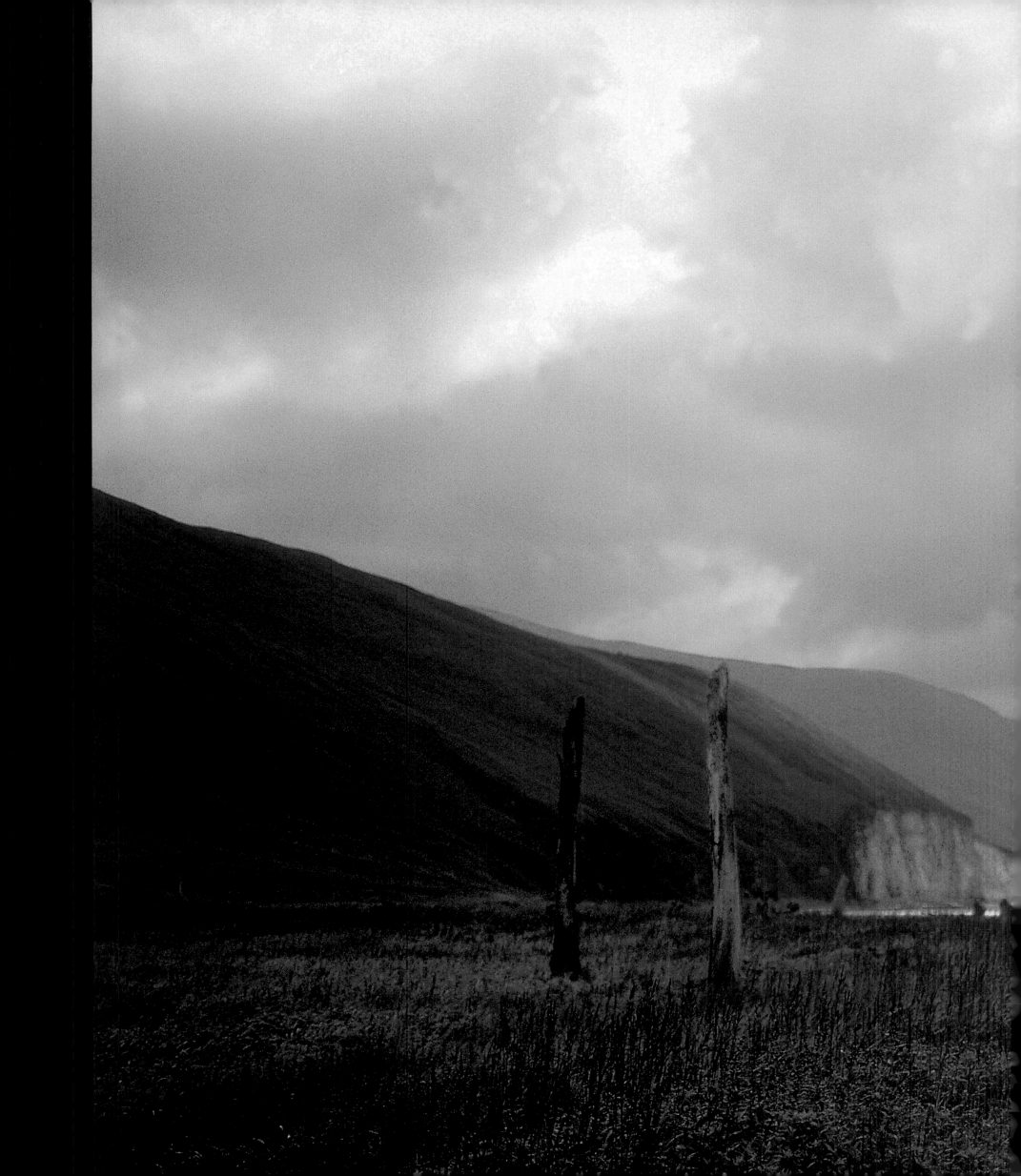

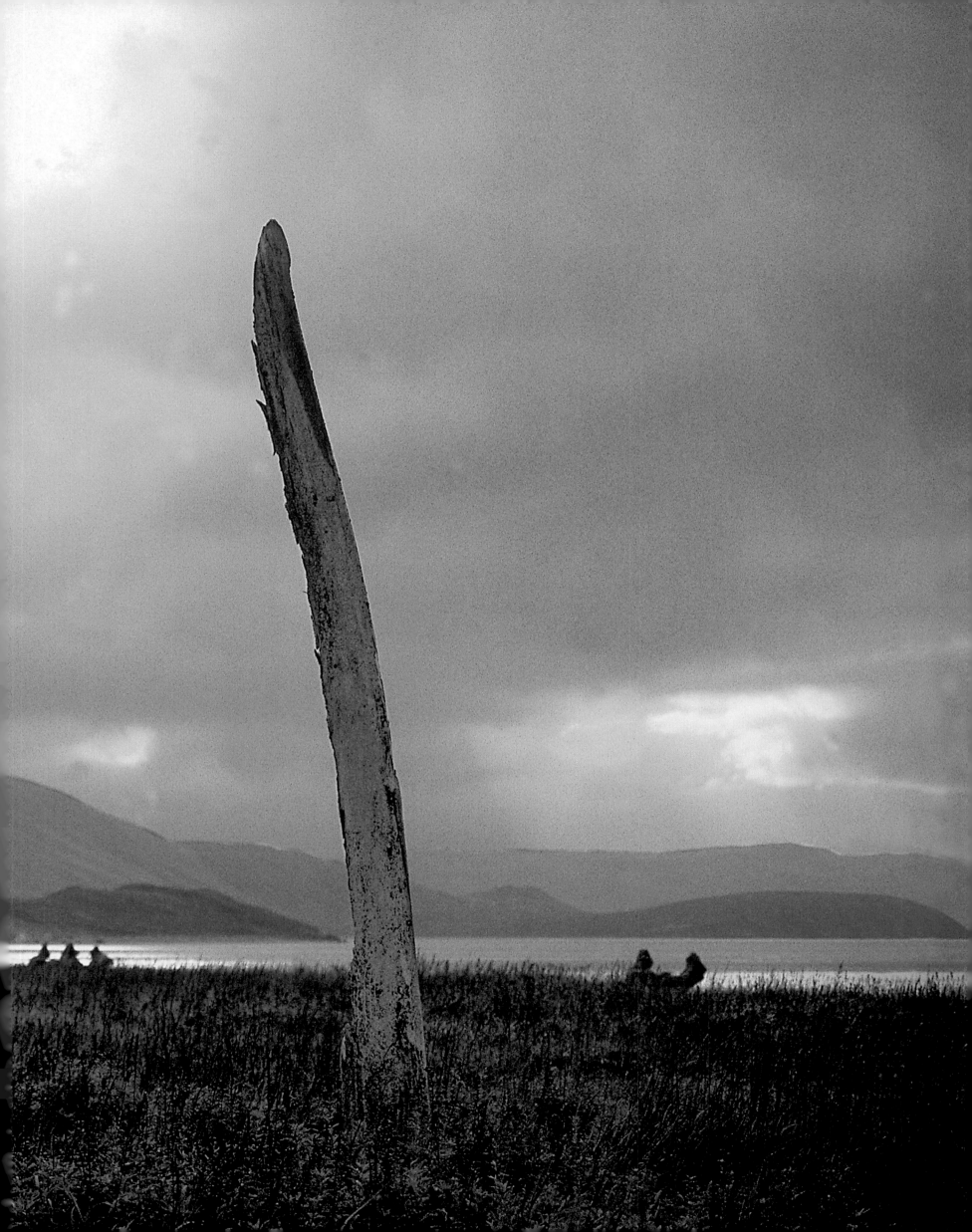

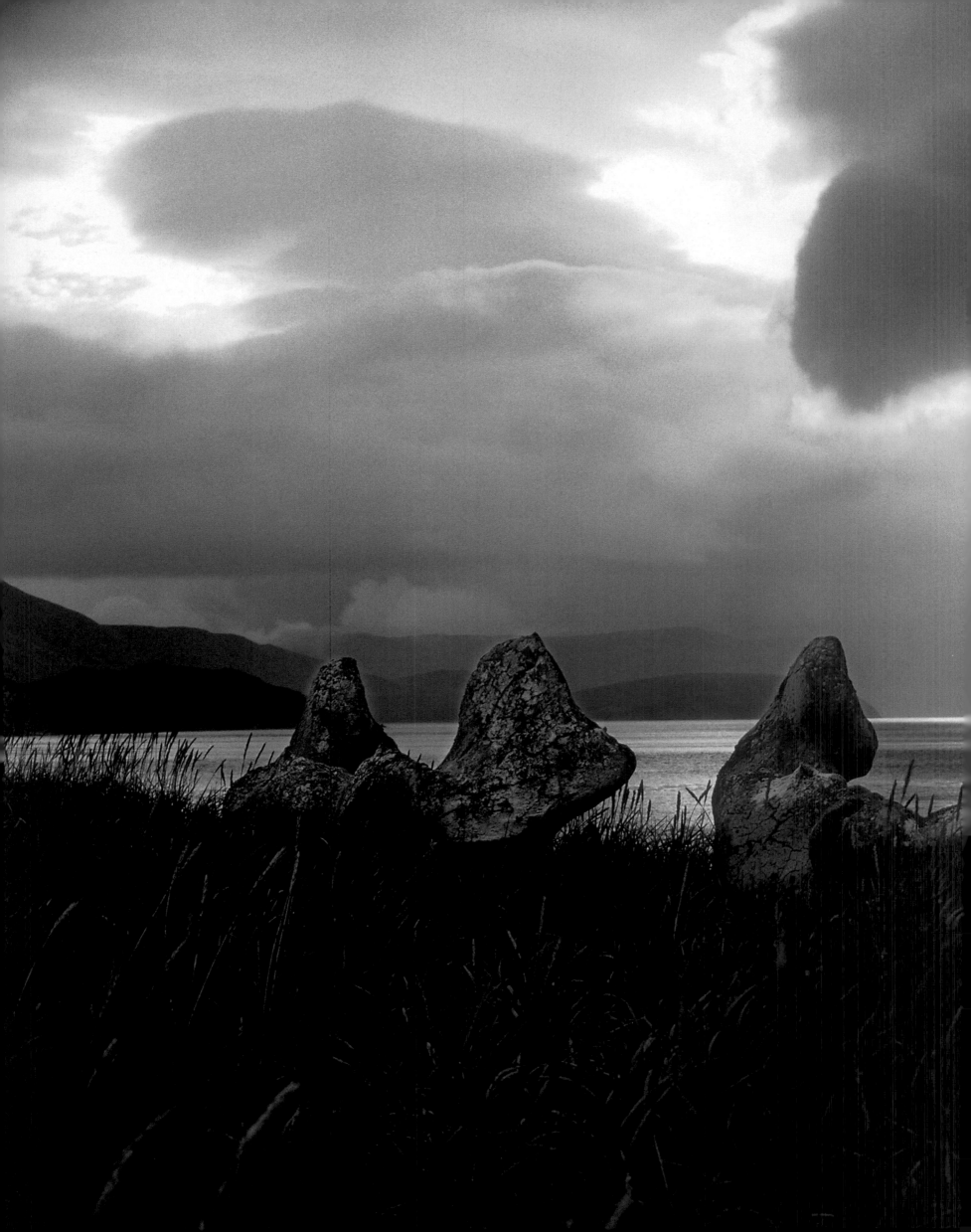

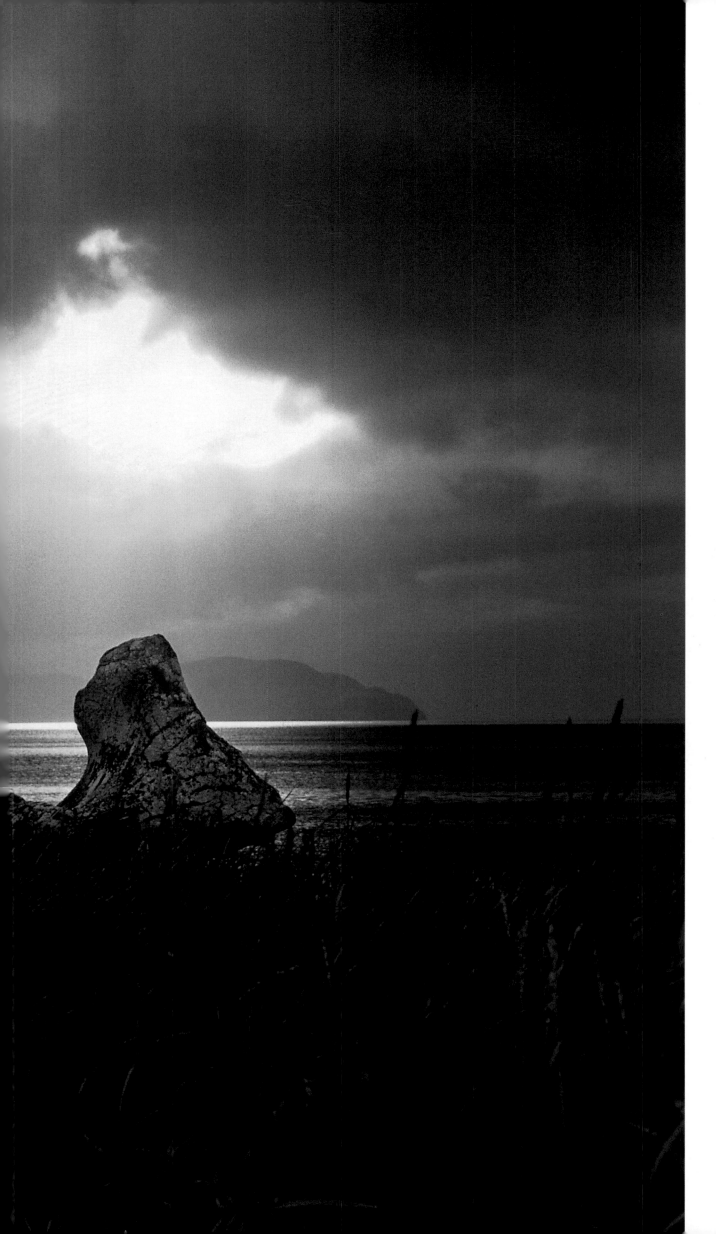

The Ittygran-Arakamchechen Islands, Seniavin Strait, Chukotka, August 1990. This row of forty-seven whale skulls is a source of wonder. Each skull weighs one-and-a-half tons; their occipital bones face up toward the sky. They are arranged according to Asian numerology, perhaps adopting *feng shui* in the tradition of the I Ching. Thirty-four posts, the fifteen-foot-tall lower jaws of the right whale, are lined up with the stars. Lines of the Earth's energy. Ivory arms and objects are engraved with geometric markings—squares, triangles, dashes, and curves. Their logical structure draws on the oldest books of Chinese divination.

These blinding white lances call to the sky: "Oh! Good wise men, you do not know that your religion, your ideology makes you deaf and blind," the great poet André Suarès reminds us.

It took two centuries for Moscow's archaeologists to learn that this northern place, near the Inuit village Chaplino, expressed complex, metaphorical thoughts, that it represented a pantheistic intelligence. Five Russian expeditions and several Soviet missions had come to this island since Catherine II commissioned Captain Joseph Billings in the eighteenth century to explore Russia's northern reaches. But this site was not identified until 1976. It was as though Captain James Cook had not noticed the statues when he landed at Easter Island.

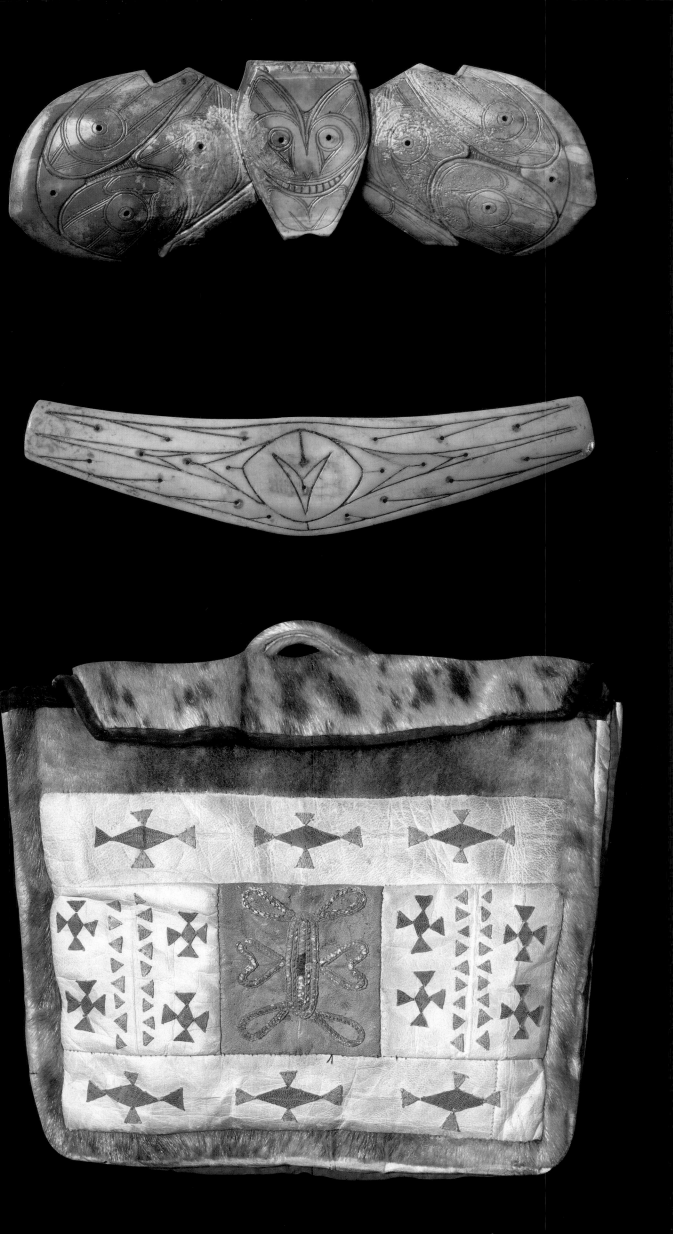

Light/night, cold/hot, humid/dry, male/female, life/death. Three, five, seven, nine. "*Logos, kosmos,* and fire. It's all one," Heraclitus reminds us. If you seek the part of the imagination that invents the world, you have to experience matter with empathy. You have to live in matter like Gaston Bachelard, the master of this phenomenological approach. To believe in that unique transmigration, reincarnation. This is what inspires shamanism, this is the universal Inuit belief, the roots of which are to be found in ancient, prehistoric thought.

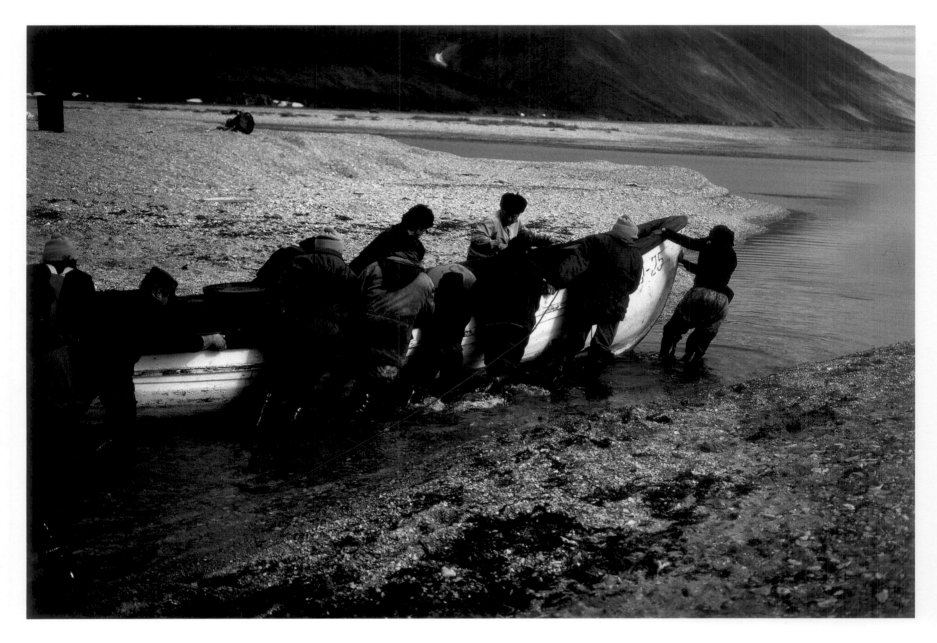

The Russian-French expedition to Whalebone Alley.

Near Yttygran Island, Seniavin Strait, August 1990.

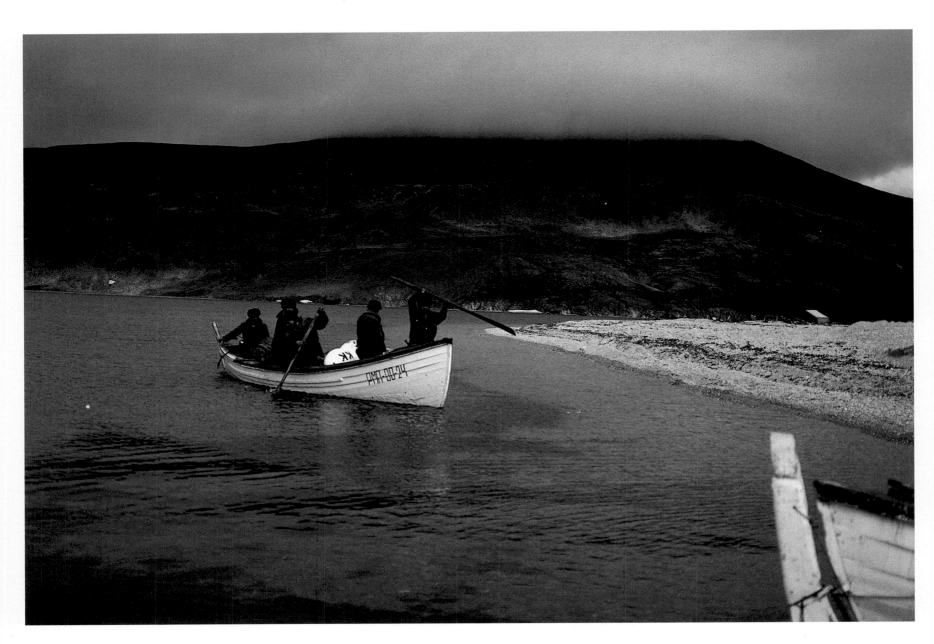

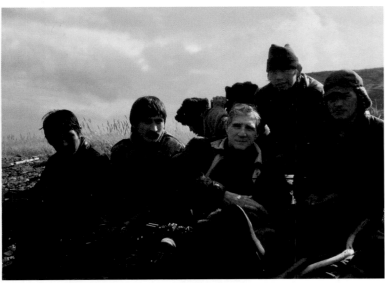

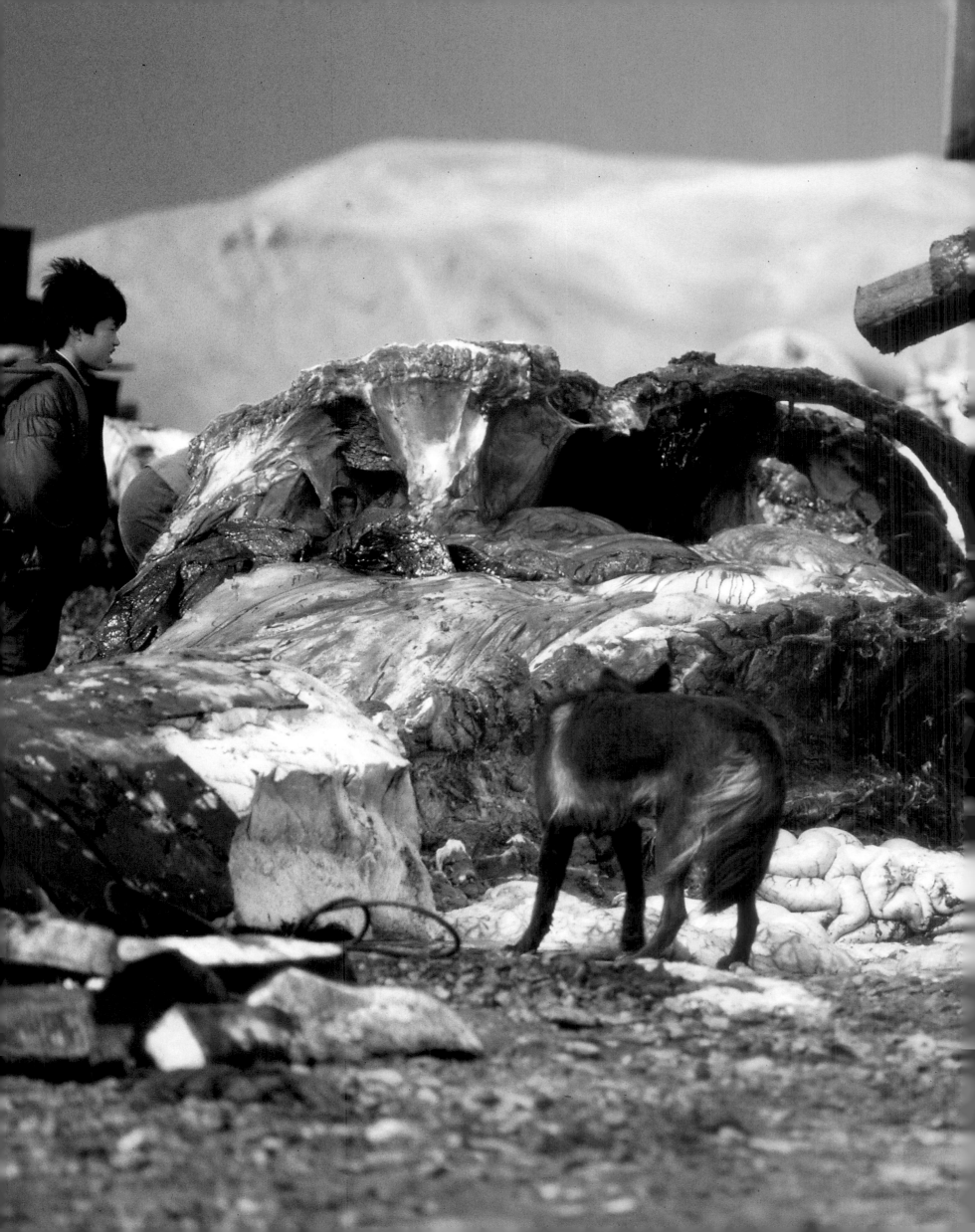

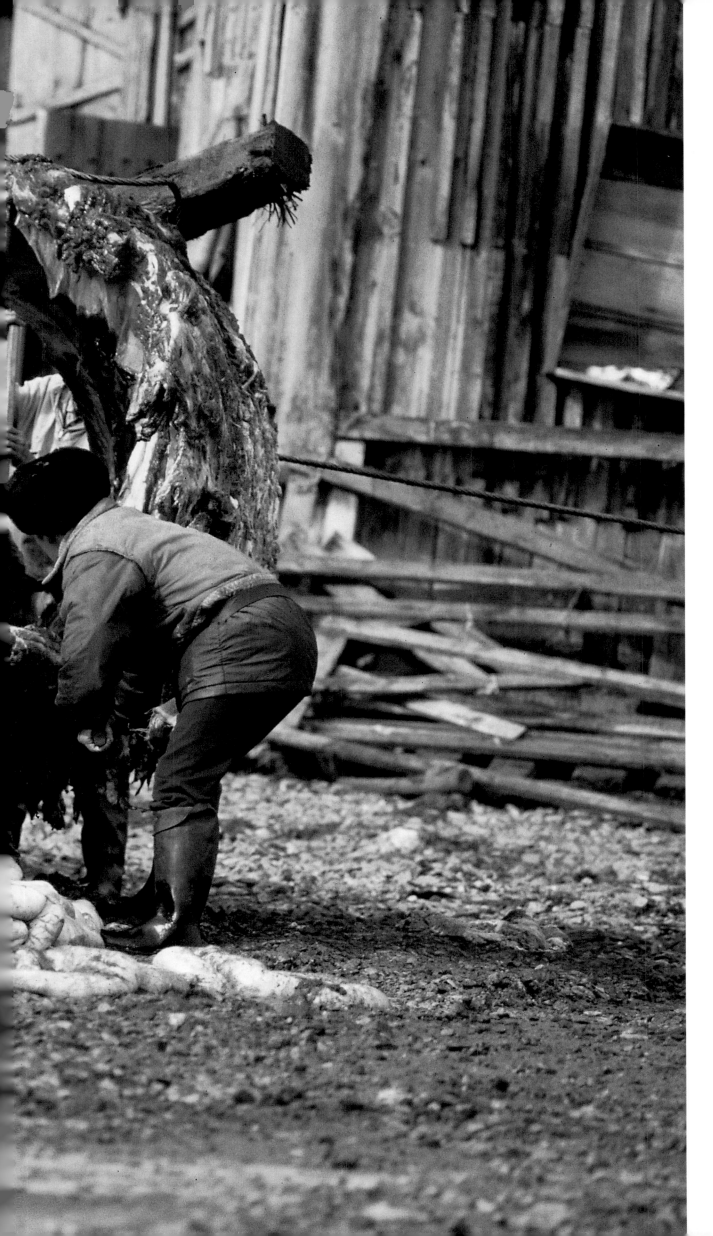

Chaplino, Chukotka, August 1990. Family reserves of meat are cut straight from the whale during the celebration—the group copulation—after the hunt. The hunt takes place in April and May and requires more than a month of propitiatory rituals that involve the whole community. The whale is invited to celebrate with the humans. Whale hunts in the *oumiaklangyak*, the walrus-skin boat, have been taking place in the Bering Strait since 1,000 B.C.

Where did these Asian Eskimos come from? From Siberia; or rather, from places west of eastern and central Siberia, 10,000 to 20,000 years ago. But beyond, where did they come from? From the south, from Altai and northern China, one of the major birthplaces of man. In the 1950s, at the Onion Portage site on the Kobuk River in western Alaska, the archaeologist J. Louis Giddings found some forty layers of artifacts. His studies established that the Pacific north was inhabited some 8,000 or 10,000 years ago, after the late Paleolithic hunters had taken over from Neanderthal man, and before the mammoths. The Bering land bridge—its first arch can be seen in these photographs—is an important site in the world's history. It was used for more than twenty thousand years by Asian emigrants heading toward the empty American continent.

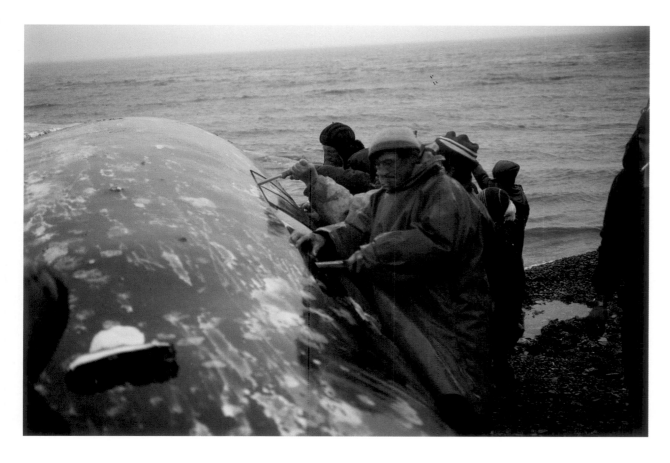

Myths and symbols inspired Man's imagination, allowing him to invent the world as he looked at the stars during the long polar night. Creation myths are strong in the Inuit world. They point to the unifying power of the first Inuit thought, and to its originality. The incestuous union of the moon (the brother) and the sun (the sister); the father-dog and the victim of the great rituals; giants battling with the first Inuit, who were but dwarfs then; the protective raven; the spider, the familiar insect of the tundra and man's sexual confidant; Nerrivik, the sacrificial young girl who has power over the creatures of the sea. To seek this truth, to decipher these images, one must assume a shamanistic frame of mind.

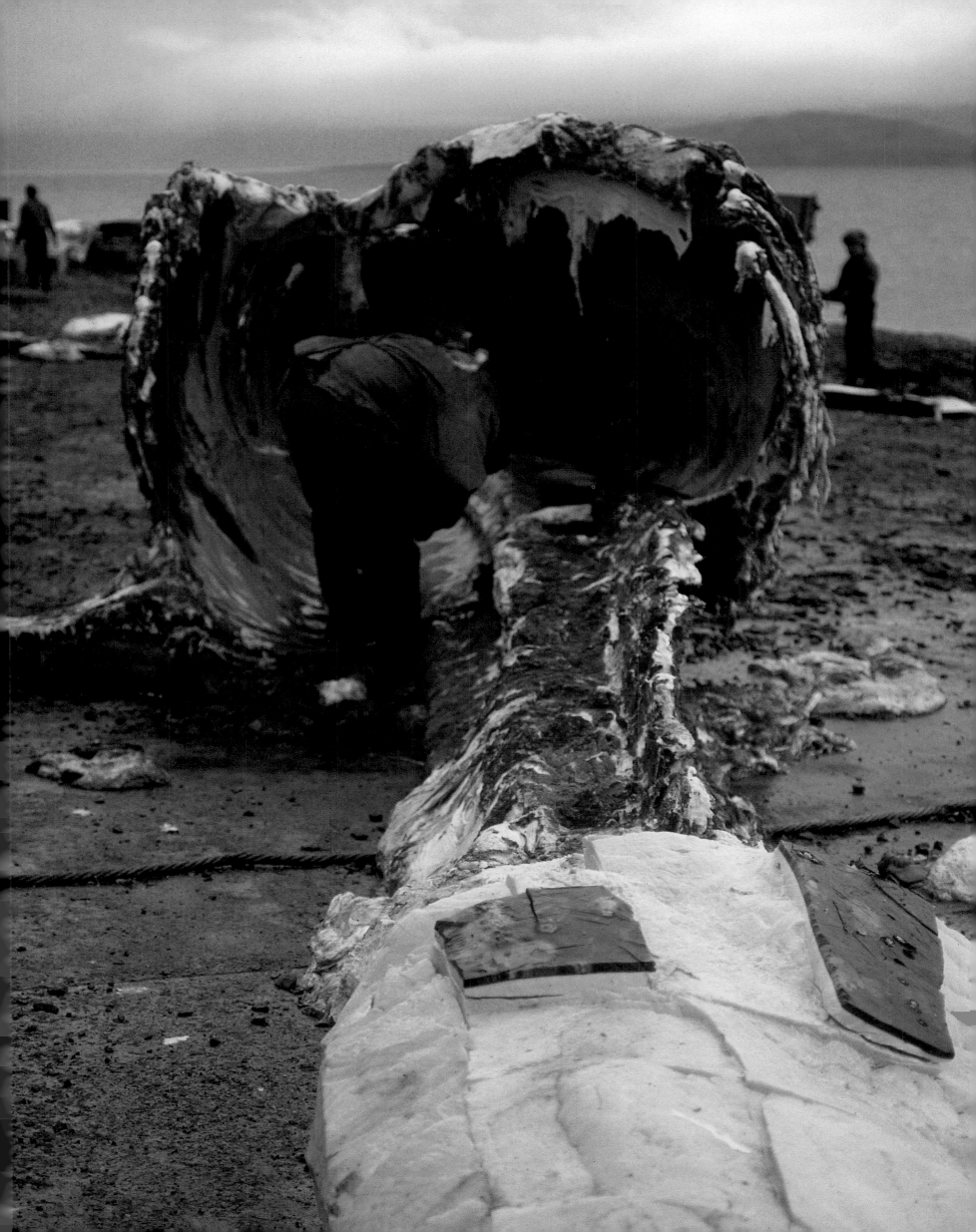

**"WHEN WE FORCE THE MASSES TO LIVE LOW,
WE'RE NOT HELPING THEM TO THINK HIGH."
ANDRÉ MALRAUX, *L'ESPOIR,* 1937**

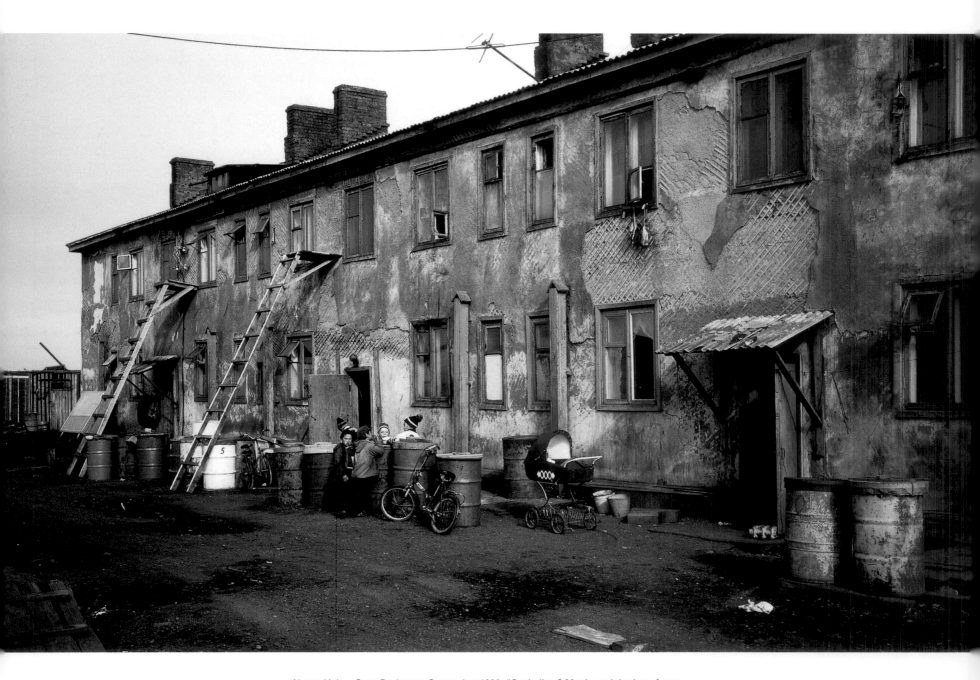

Above: Uelen, Cape Dezhnyov, September 1990. "Capitalism? Man's exploitation of man. And Stalin's dialectic Communism?" a Yuit Eskimo asked a member of the Party. "Well, the opposite, *Tovaritch!*"

Right: Chaplino, August 1990. This Eskimo family had been waiting for more than ten years for decent housing. Modern apartments were reserved for Party officials.

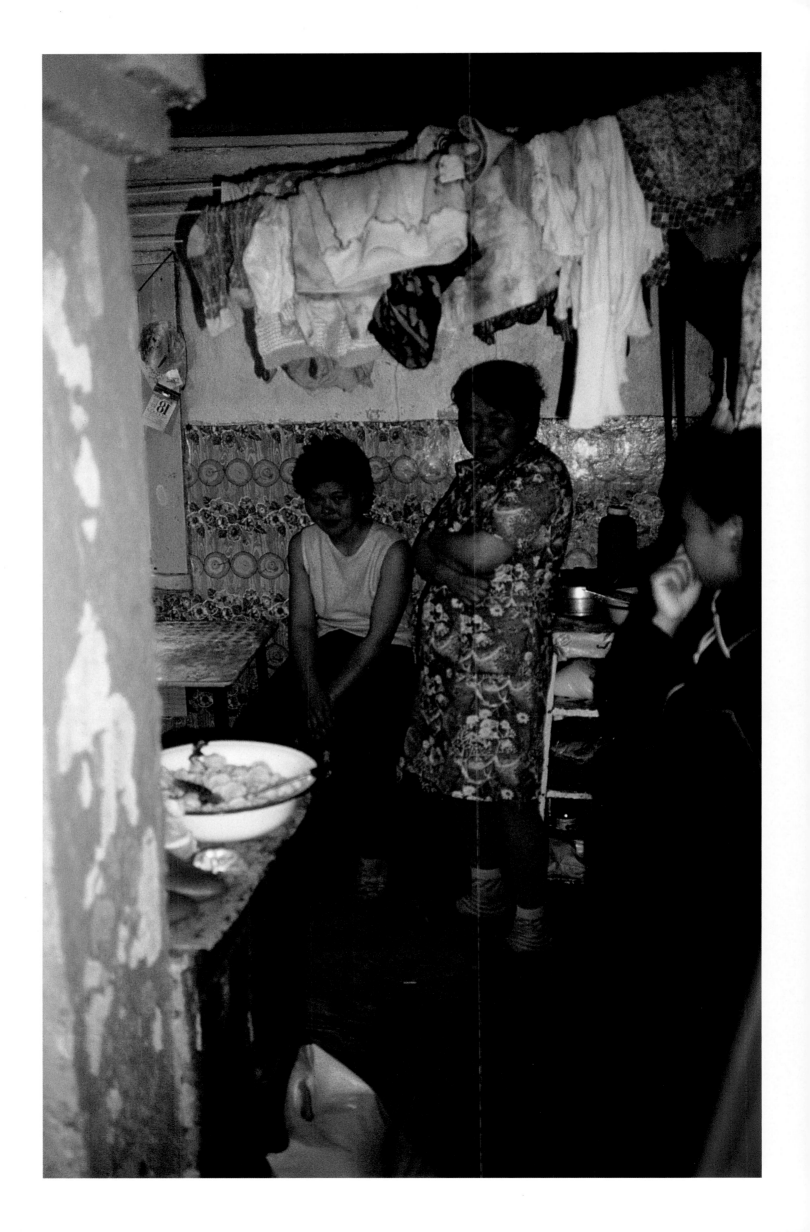

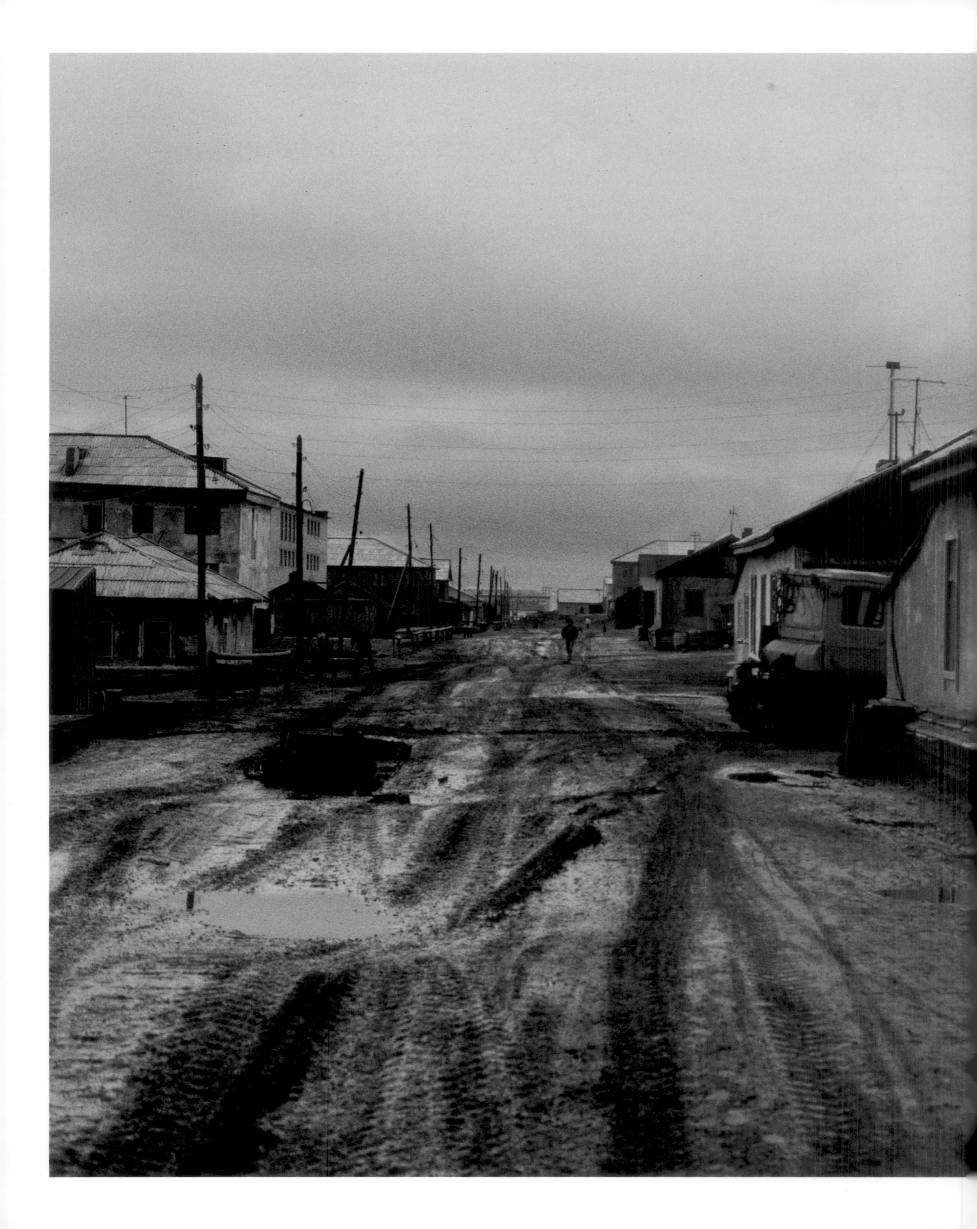

Uelen, Cape Dezhnyov, September 1990.
I worked in Uelen as a volunteer teacher in the
village's elementary school. This is where I
lived; I have one room—the first two windows.
My neighbors are a Chukchi family of six.

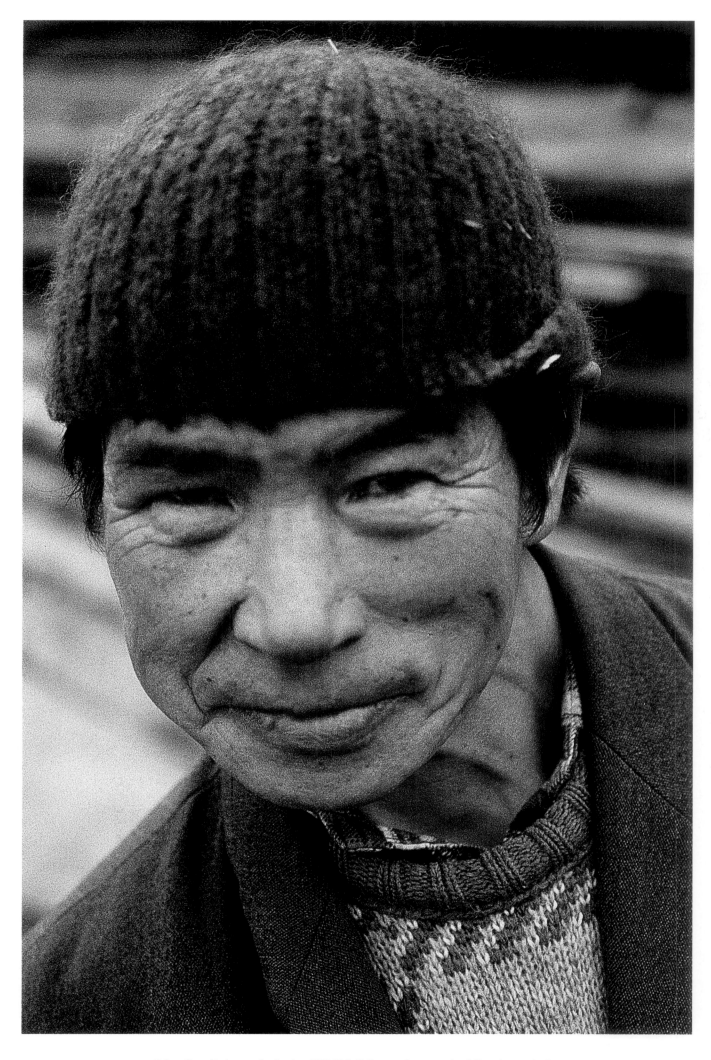

Uelen, Cape Dezhnyov, September 1990. This Yuit man often came to visit me in my single room, sharing his personal thoughts on Eskimo life under the Stalin regime. He was one of the few Yuits to do so.

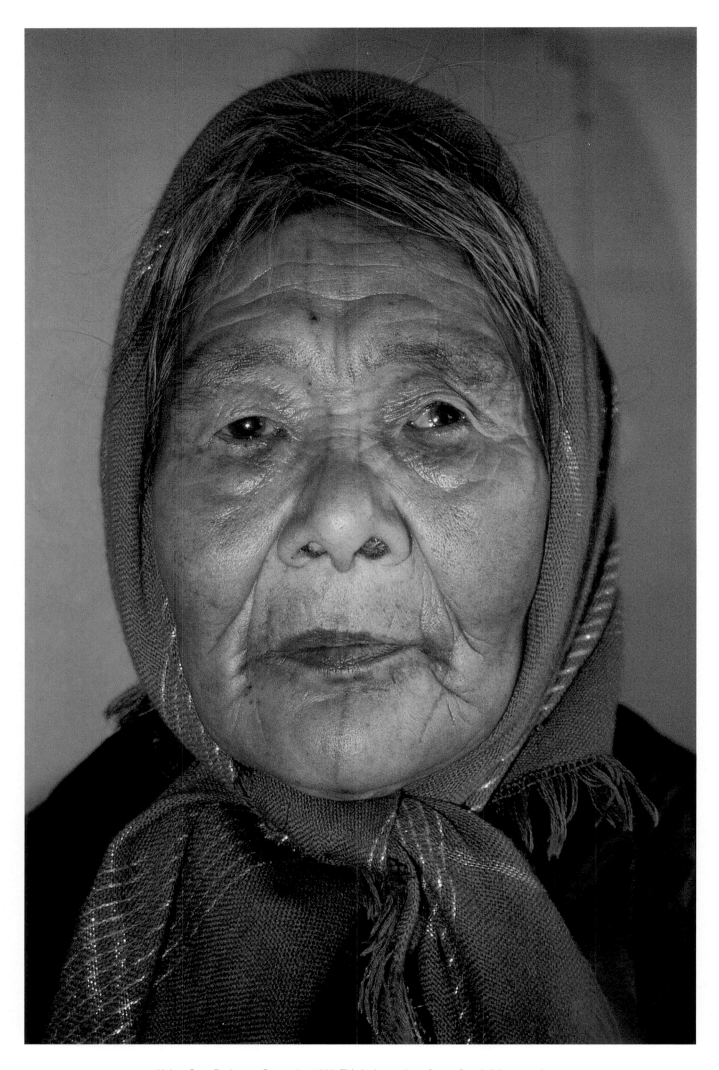

Uelen, Cape Dezhnyov, September 1990. This is the mother of one of my brightest students, a fourteen-year-old Inuit. The mothers of Uelen held a secret political power. They took great interest in my style of teaching and in my focus on heritage. which was such a departure from official Soviet education.

Uelen, Cape Dezhnyov, September 1990. This house was shared by several Eskimo (Yuit) families. Imported charcoal was used to heat the whole house. For cooking, each family had its own charcoal stove.

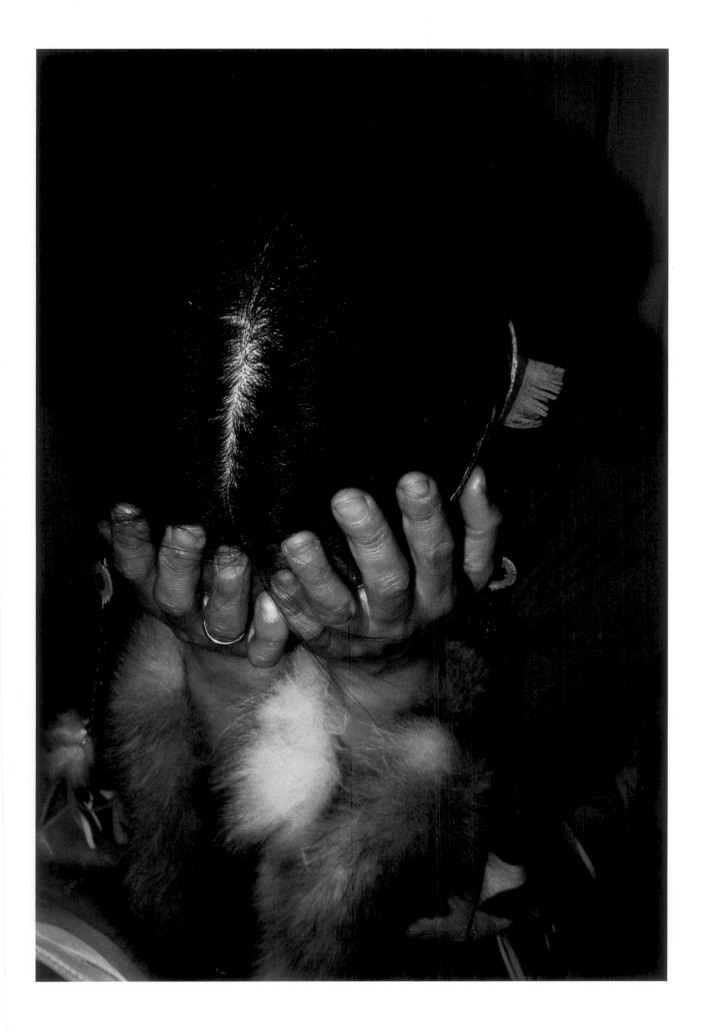

Uelen, Cape Dezhnyov, September 1990. These hard, almost hounded faces reflect the harshness of the Stalinist regime that ruled here for seventy years. It was a dictatorship of Party *apparatchiks*. The shamans—the most enlightened Eskimos—were humiliated by the Soviets, as were their best hunters, all in the name of Communist "justice."

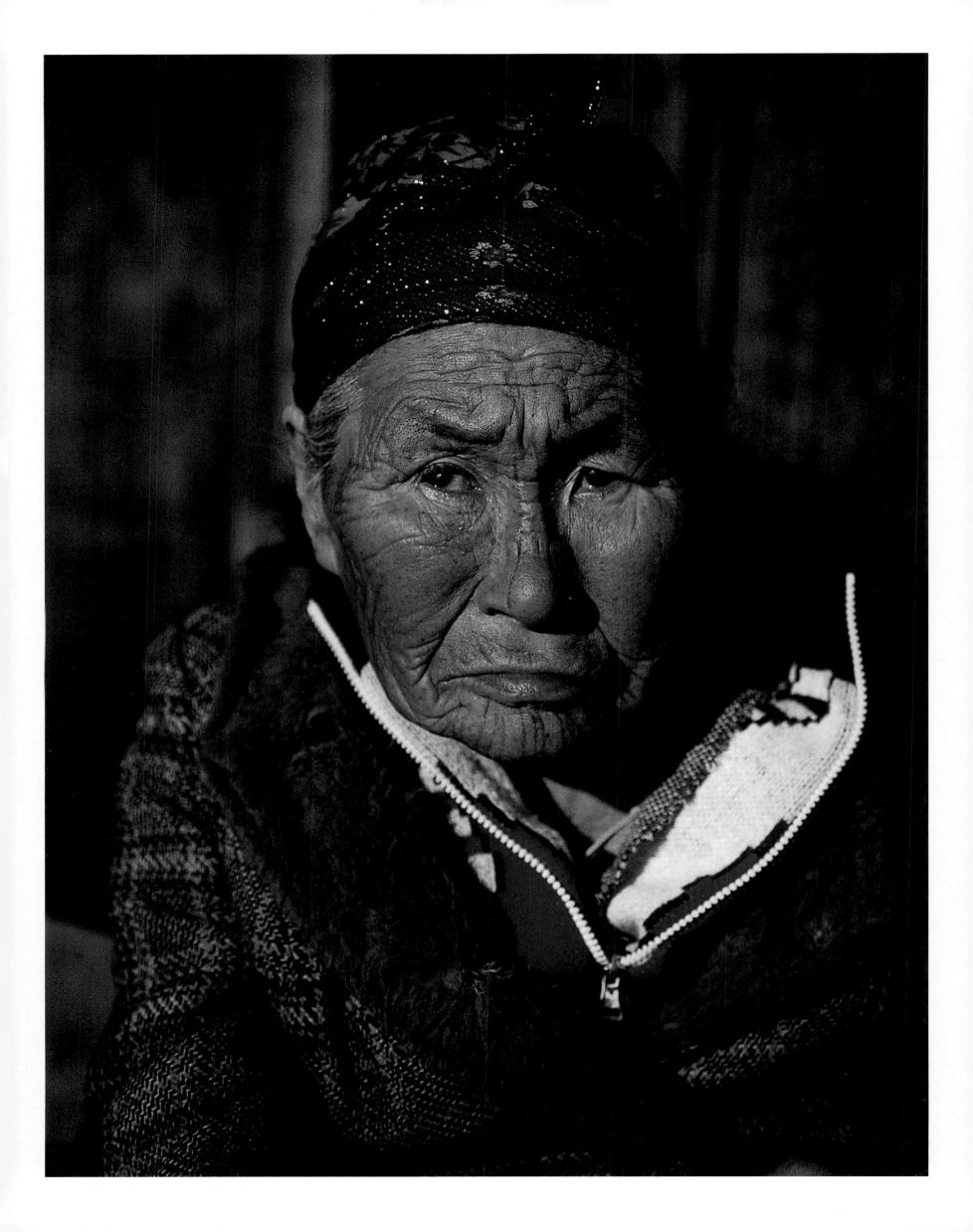

Uelen, Cape Dezhnyov, September 1990. As a volunteer teacher in Uelen, I was responsible for two classes, one of twelve- to fourteen-year-olds, and the other of sixteen- to eighteen-year-olds. I observe the selection by failure. The natives, who all come from an oral tradition, are eliminated from higher classes taught in a Russian vein. The class of sixteen- to eighteen-year-olds was mostly made up of Russian immigrants, the sons and daughters of *apparatchiks*.

In Uelen my expedition companions and I decided to found a school in Saint Petersburg to train native leaders using a specific pedagogy. Established in January 1991 with the support of the Gorbachev administration, it is now a reality. The Polar Academy of Saint Petersburg has 800 native students and sixty Russian teachers. It represents the future of northern Siberia. I am the honorary president.

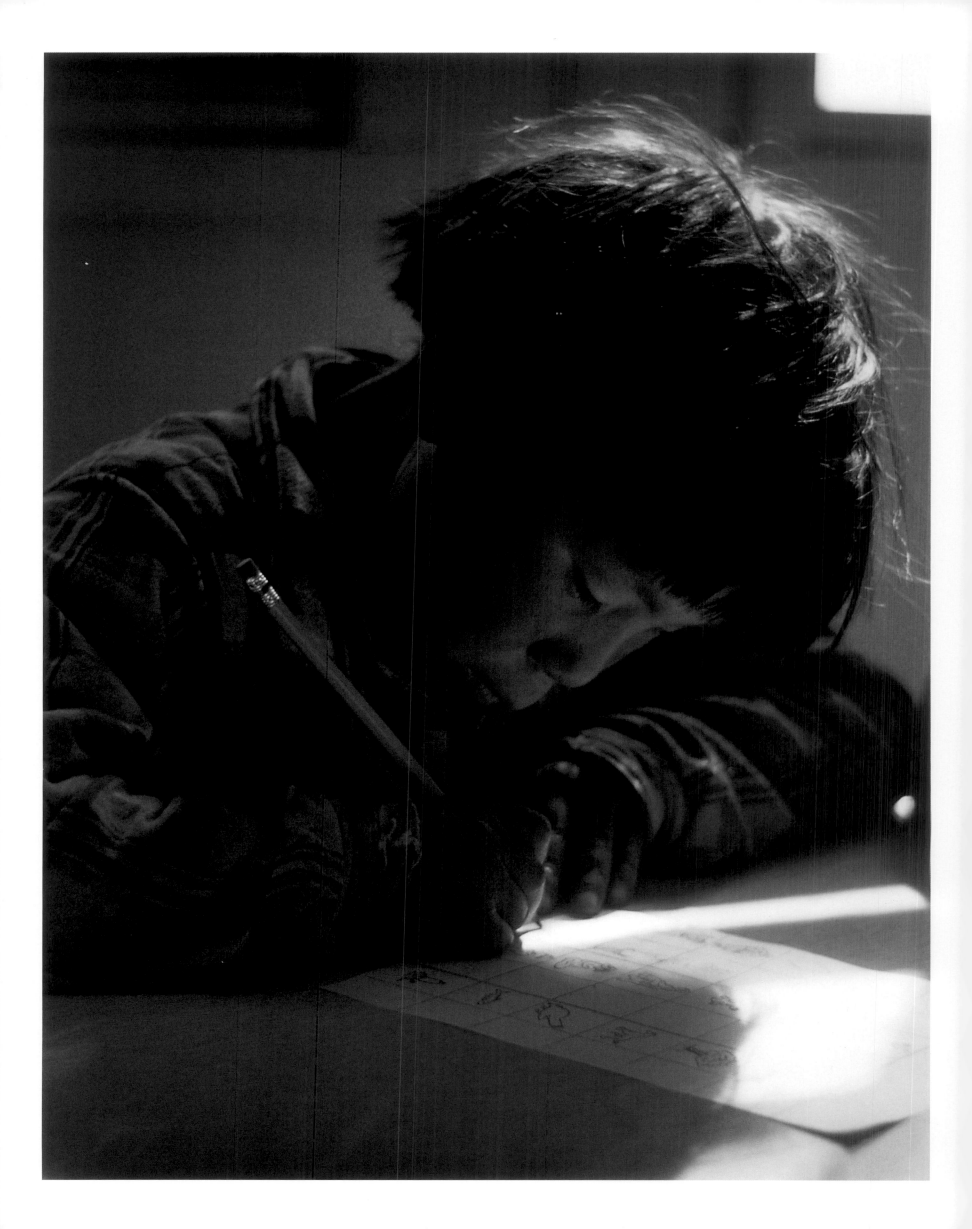

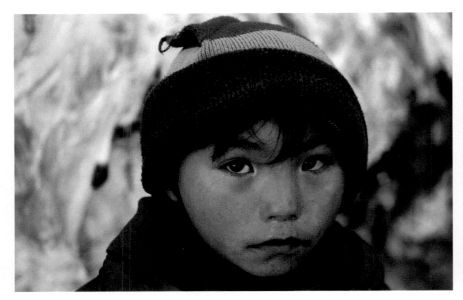

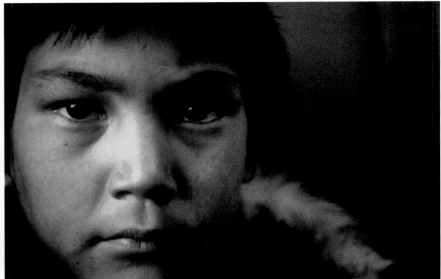

Uelen, Cape Dezhnyov, September 1990. Forty KGB agents lived in this barracks; from the watchtower they kept their eyes on the Bering Strait and on every resident of the village, myself included, day and night. Two members of our Soviet-French expedition were KGB, though I was unable to identify them. I suffered under this regime of public denouncements and slander. Defamation is second nature to totalitarian regimes, whether Stalin's or the Nazis'. It is their signature. The expedition also showed me what good friends I had in my Russian colleagues, a camaraderie that continued all the way to the Academy of Human Sciences in Saint Petersburg, where they asked me to become a tenured professor in 1997.

THE YUIT. THE CRADLE OF THE INUIT, WHALEBONE ALLEY

CHUKOTKA, NORTHERN SIBERIA. THE BERING STRAIT.

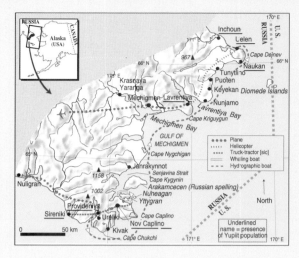

THE UNIVERSAL IMPACT OF THE INUIT MESSAGE

YTTYGRAN ISLAND AND ITS MYTHS

"The attack always comes from behind. Places like Ytty-gran, with its secret myths, are an eloquent example. The people do not lie; you must always turn to them when looking into an ancient culture. They are its strength. 'These powerless and incapable people, *miserabilis personae*, who can't do anything for themselves, can do much for us. They have a mysterious power, a hidden fecundity, they are a spring within the depths of nature. Barbarians, savages, children . . . they have this common misfortune, that their instinct is unknown, that they themselves cannot understand it.' (Jules Michelet, *Le Peuple*)"

—Jean Malaurie, *Hummocks*, Volume II, Paris, 1999

THE ARAKAMCHECHEN COLUMNS

"Whalebone Alley is a chain of eleven columns stretching over 1800 feet along the northern coast of Yttygran Island and along the southern coast of Arakamchechen Island. From each column, you can see the one ahead and behind."

—Jean Malaurie, *Hummocks*, Volume II, Paris, 1999

A ROW OF FORTY-SEVEN SKULLS

"The skulls have a diameter of seven to eight feet. . . . It is likely that these skulls were buried, the nose facing the frozen ground, the eyes turned up toward the sky. They protrude two-and-a-half to four feet. . . . The posts are made from the lower jaws of Greenland whales. Two large, isolated posts mark the ends of this row. . . . Thirteen columns are standing, twenty-one have fallen; some are almost fifteen feet high. . . . To the north, three pairs of columns form a kind of arch."

—S.A. Arutiunov, I.I. Krupnik, and M.A. Chlenov, "L'Allée des Baleines," *Sibériana*, 1983, quoted in Jean Malaurie, *Hummocks*, Volume II, Paris, 1999

A SACRED ARCHITECTURE

"The bone-posts and skulls are ordered according to a sacred architecture that must stem from the Golden Ratio. From this we learn that these hunters know about measurement. There are several key numbers: three, five, nine. For the Eskimos, three is masculine and five is feminine. Three is the family: father, mother, son; the three universes: superior, earthly, and inferior. The three forces of the world: air, water, fire. The three terms of thought: subject, verb, object. Five: the pentagon, the perfect geometric image. Nine: totality, the last number before double digits, and three times three. The sea is the source of life, it is home to the power that rejuvenates animal life in the waters, a woman. And in my mind, the strait is the middle part of this double Whalebone Alley. The space is doubled and points in a direction: it is vertical and is lined up with the cosmos, but it is also horizontal. The rays of the sun at daybreak sweep, from east to west,

across this alley of ritual that extends for more than 1640 feet and is dotted with several structures along a pebble beach that stands twenty inches above the ocean and its crown of black seaweed. We find here lines of the Earth's energy that the elders can recognize and to which they assign complex functions, just as in Cornouaille, in St. Michael's Alley, or in Carnac, in Brittany."

—Jean Malaurie, *Hummocks*, Volume II, Paris, 1999

THE ALTAR OF THE FLAME

"Practically at the geometric center of Whalebone Alley—in relationship to the solitary posts that mark its ends—there is a relatively flat surface forming a semi-circle, an amphitheater measuring fifteen feet around and bounded by enormous rock blocks. . . . When its northwest corner was excavated, one to two-and-a-half feet of ashes were discovered, still containing remains of charred whale and walrus bones. This hearth was surrounded by a large, vertical slab of stone and smaller, erratic blocks measuring fifteen to twenty inches. . . . Another stone circle, five hundred feet up the mountain that rises above the Alley, is reached by a marked path and can be considered an 'observation point.' These kinds of observation points (*agixsylgak* in the Eskimo language) were common in coastal villages."

—S.A. Arutiunov, I.I. Krupnik, M.A. Chlenov, "L'Allée des Baleines," *Sibériana*, 1983, quoted in Jean Malaurie, *Hummocks*, Volume II, Paris, 1999

AN ATTEMPT AT INTERPRETATION

LOGOS, KOSMOS, AND FIRE

"The still-blackened circle of stones, the altar at which the flame—*ikuma*—was revered as one of the expressions of the unspeakable, of vital energy. We know that fire was the force honored in all Eskimo rituals in Asia and Chukotka and I am reminded of Bachelard's psychoanalysis of fire. 'Lived fire . . . a cohesion of images, an internalization of the powers of the cosmos . . . a psychology of intensity—pure intensity, intensity of being . . . for man who dreams, who thinks, images of fire are a school of intensity" (Gaston Bachelard, *Fragments d'une Poétique du Feu*). Fire, alpha, and omega of the cosmos. Flame, charred whale and walrus bone, sea, moon, stars, and planets. . . . What do they feel during the Yttygran ceremonies, those great shamans who are joined by their disciples? Light/night; hot/cold; wet/dry; earth/sea; freshwater/seawater; male/female; life/death. 'Whole and par-

tial conjunctions, convergent/divergent, consonant/dissonant: from all things One and from One, all things' (*Fragments d'Héraclite*) translated into French and annotated by Roger Munier). 'Logos, Kosmos and Fire, all are One.' Pre-Socratic thought immediately comes to mind. Fire, the universal principle. Fire that is 'forever alive' and that will consume the world before there is a new reincarnation that, according to Hereclitian thought, will assure a future without end. This large altar, before which I continue to pray, was undoubtedly a place of sacrifice. But what did they sacrifice, other than these whales and walruses whose ashes remain? Did they sacrifice dogs? Did homosexuality, which was an integral part of shamanistic life in eastern Siberia, play a key role in these ceremonies? It is certain that this stone circle, at the geometric center of Whalebone Alley, is the ultimate expression of propitiatory thought and is the key to this immense and ancient effort."

—Jean Malaurie, *Hummocks*, Volume II, Paris, 1999

THE QUESTIONS

QUESTION ONE

"Why don't the sites on Yttygran and Arakamchechen Islands have parallels on the Alaskan coast? This is the main question one has after visiting the site and after reading Soviet archeologists's 1976 studies of Whalebone Alley."

—Jean Malaurie, *Hummocks*, Volume II, Paris, 1999

QUESTION TWO

"At Cape Kygynin, near Arakamchechen and Yttygran Islands, they hunt gray whales. Yet the Whalebone Alley is built only with Greenland right whales. Why only this species?"

—Jean Malaurie, *Hummocks*, Volume II, Paris, 1999

QUESTION THREE

"Why is the stretch of Whalebone Alley on Arakamchechen Island not edged by a row of Greenland whale bones along the coastal beach, as it is on Yttygran? Could it be that Seniavin Strait, which lies between these two rows of posts, is the real alley of the metaphor?"

—Jean Malaurie, *Hummocks*, Volume II, Paris, 1999

QUESTION FOUR

"The absence of women at the site, which the Soviet archeologists suggest, is hard to explain. Why are rituals so different on the Alaskan shore and the Siberian? In Savoonga, on Saint Lawrence Island, with its Yup'ik tradition, women are glorified. There, by contrast, women are excluded from the benefits of a particular Yup'ik ritual. According to the Soviet archeologists, headed by my colleague Sergei Arutiunov, the architects of Whalebone Alley were a brotherhood of initiated men, who, in late Punuk times—around the fourteenth century A.D.—practiced shamanistic rituals that facilitated the *Arwaaq*'s,

or whale's, visit. In all likelihood, these men were Eskimos. According to Arutiunov, eleven boats came to these shores each year, bringing about one hundred men."

—Jean Malaurie, *Hummocks*, Volume II, Paris, 1999

QUESTION FIVE

"There are no winged objects on Yttygran. Yet in Uelen, not far from Yttygran Island, winged objects can be found in tombs. They measure six by six inches and are made of walrus ivory. In all likelihood, they are butterflies with their wings spread. . . . This symbol, a butterfly with open wings, may have been placed at the bow of Eskimo boats. . . . The butterfly is the 'mythological exterminator' of marine animals among the Chukchis, the enemies of the Eskimos."

—Jean Malaurie, *Hummocks*, Volume II, Paris, 1999

QUESTION SIX

It remains to be seen why Whalebone Alley was not noticed by Russian explorers until 1976 and why it does not seem to be important in Soviet Eskimo consciousness. This is surprising—the psychological tests, Rorscharch tests in particular, that I conducted in Uelen show that despite pressure from the Communist Party and the police, shamanistic thinking thrives among young people and, of course, among the elders.

SACRED NUMEROLOGY AND CHINESE INFLUENCE

"Can we regard as a clue the things discovered in 1976 near Cape Chaplino, which Jean Malaurie commented on in his recent article concerning the sacred geography of places? Fifteen groups of enormous whale skulls are aligned according to a strict two/four alternation. There's another alley of bones behind this one made of thirty-four columns, three of which are in pairs. The two/four relationship is the most certain way to mark a duplication. In terms of one/two relationships, it is not clear whether the two was obtained by the addition of one to another or by duplication. On one side the fifteen, with which a sign of duplication is associated; on the other, thirty-four, which in terms of the Chinese I Ching is thirty-two plus one plus one. However, the I Ching divides its sixty-four hexagrams into two unequal parts: the first consists of thirty, but it is enough to know about fifteen of them to clearly know about the situation of the other fifteen. The second part of thirty-four hexagrams is more ambiguously organized; it suggests that the last hexagrams have a special status. The ordered structures of the first part stem from a more regular binary logic. The order of two-times-fifteen is that of the fundamental world while the order of thirty-four is that of the circumstantial world. The comparison between these two numerologies is the subject of a report, nothing more. Nevertheless, the general organization of the I Ching stems from logical prescriptions that emerge only at the end of rigorous analyses."

—Charles Morazé, "Études Arctiques et Préhistoire," in *Pour Jean Malaurie*, Paris (édit: Sylvie Devezs), 1990

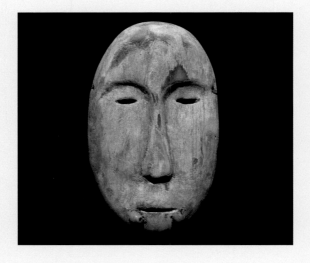

NEOLITHIC CHINA AND THE NORTHWEST COAST INDIANS: A STYLISTIC RELATIONSHIP?

"Eskimo civilization with all its many facets—continental culture with its caribou hunters, maritime culture with its whale and walrus hunters, and coastal culture, known as Thule culture, with its seal hunters—continues to be a complex mystery for the anthropologist and geohistorian. This civilization has roots that date back 10,000 years, a time of migration and contact with the seminomadic peoples of Asia, within Altai and perhaps even China. A very long perspective—the *temps long* of Fernand Braudel, the very long time of paleoanthropology—will take into account an extended period of maturation at this junction in Northern history that is the Bering Sea, showing that the shamanistic thought of the late Paleolithic era is much more elaborate than supposed.

"'Art does not reproduce the visible, it makes visible,' said Paul Klee. Twenty-five hundred years ago, Eskimo societies reached what was undoubtedly their peak, as revealed in their beautiful objects. Whalebone Alley is only the visible part of a great civilization, "Old Bering Sea (OBS) thought." The finely wrought and sculpted ivories of OBS, found in the tombs of Ekven and Uelen and accompanying the dead in their afterlife, represent both anthropomorphous animals and geometric shapes—multiple and expanded circles, triangles, dashes, dots, parallel lines. These two representational modes were aimed at helping hunters attract game. The geometric shapes relate to an interpretation of the cosmos, to an understanding of the sky, to an esoteric science transmitted by an uninterrupted chain of initiates. The American Henry Collins discovered these ivory objects—harpoons, shamanistic paddles, tools for women, ivory butterflies—east of Savoonga in Punuk in 1935.

"'Stylistic relationships suggest that during the very brilliant OBS culture that flourished approximately 500 B.C., artistic creation sprung from Asian thought that was linked to 'a partially Siberian, Shang, and Chou-Oriental art,' proposed S.A. Arutiunov and W.W. Fitzhugh.

"When we examine this complex OBS artistic period, which drew to a close at Cape Punuk around 800 B.C., we wonder if the Eskimos from the Bering Strait area—Chukotka, Saint Lawrence, and the Diomede Islands—

and from the Alaskan coast were a link between the seminomadic Neolithic cultures of central Asia and the Indian cultures of the northwest coast of Canada and Alaska. This may help locate the common foundations of Asian art, which Joseph Campbell marvelously explored in his superb historic "atlas" of world mythology."

—Jean Malaurie, Notebooks, 1990

SHAMANISM AND HOMOSEXUAL INITIATION

"Secret initiation rites were practiced in the autumn outside the *assigi*, far from the village, near a lake or mountain, at a site that was deemed grand enough. The shaman first communicated with the *irigiak*, the shadows living in a wild state, then with the *tornghat*, which he consulted in the moon. Shamanistic education was a very personal system of tutoring. It was the shaman who taught his disciples about the great taboos. He conveyed his sacred chants only in the utmost confidentiality. The power was not only in the words and music, but also in the master's vital energy and inspiration. There was a loving relationship, a Platonic relationship, between the disciple and the guru. The disciple sought to immerse himself in the shaman's saliva at the very moment he was singing. Since the intestine is one of the homes of the spirit, did the master and his disciple turn to a homosexual relationship? This subject is one of the great taboos of anthropological research."

—Jean Malaurie, "Homosexuality and Androgyny Among Chukchis and Yuit in Eastern Siberia and South Alaska: A New Perspective" from Tromsoe University Religious Studies, Institute of Social Science, First International Tromsoe Religious Studies Conference, October 18–20, 1995

TO LOOK AND TO NOT SEE.

THE BACKWARDNESS OF RUSSIAN ETHNOLOGY

History has shown that the Russian aristocracy ignored the genius of its own people, the vigor of the empire, that is, Russian peasant thought. Until Pushkin, Russian was considered a gutter language. What was a *moujik* in 1840? A serf, subject to the will of his master. What if we turn to the West and see how it viewed indigenous peoples? It took Gauguin's intuition, which was magnified by the Surrealists, to see that there were *other* civilizations than Western civilization; as was proposed by Emile Durkheim, Lucien Lévy-Bruhl, and Marcel Mauss, we call them "exotic civilizations." Christopher Columbus did indeed discover America for the conquerors; but they were blind and greedy enough to physically and spiritually massacre entire populations in the name of Christ. Soviet Russia's ethnological backwardness was extended by atheistic Marxism, which denied shamanism and anything else that opposed Leninist thought. As early as 1926, shamans were being executed or sent to the gulag.

—Jean Malaurie, Notebooks, 1965

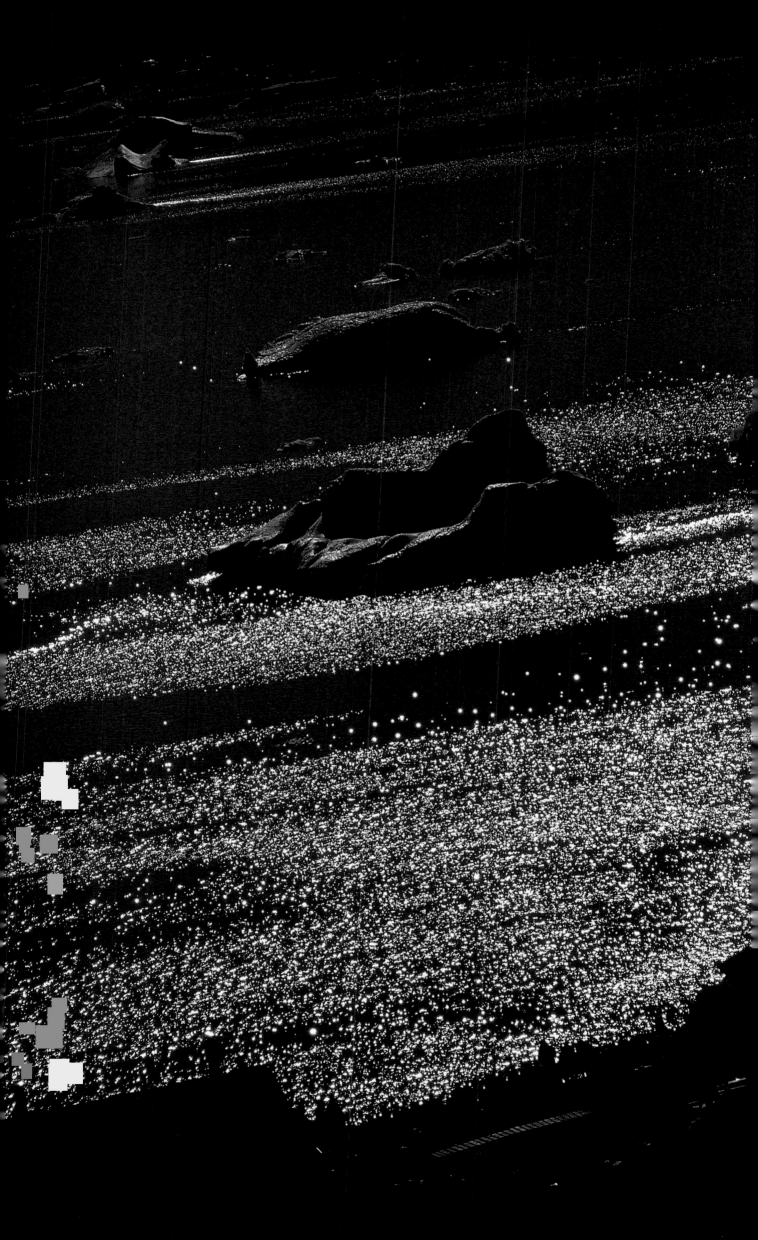

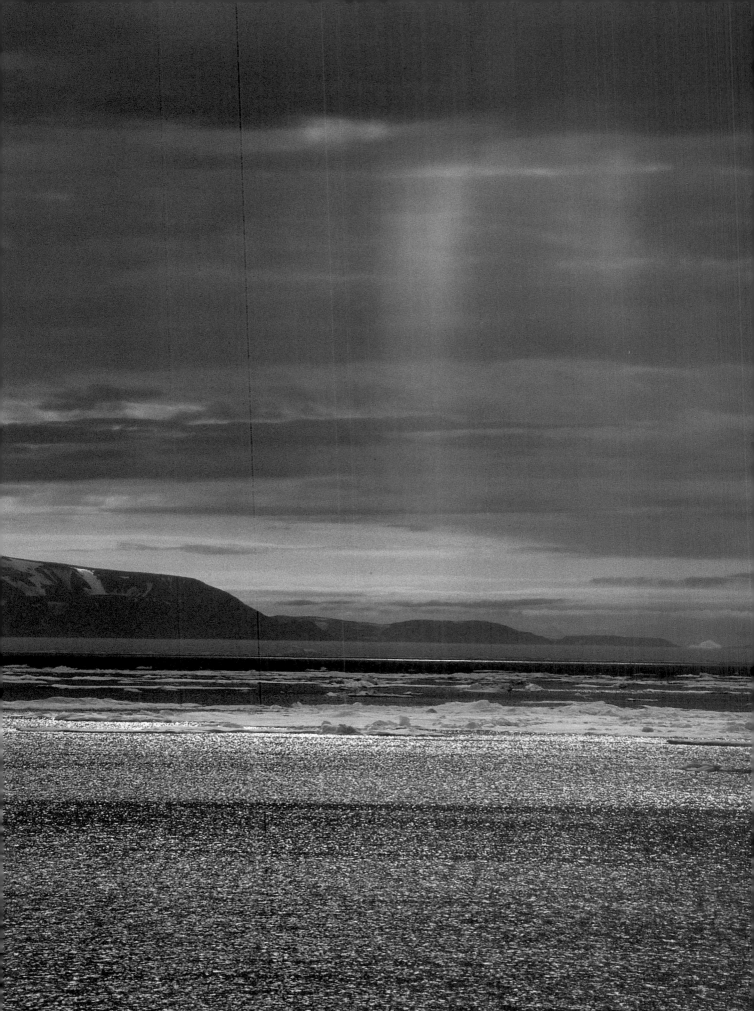

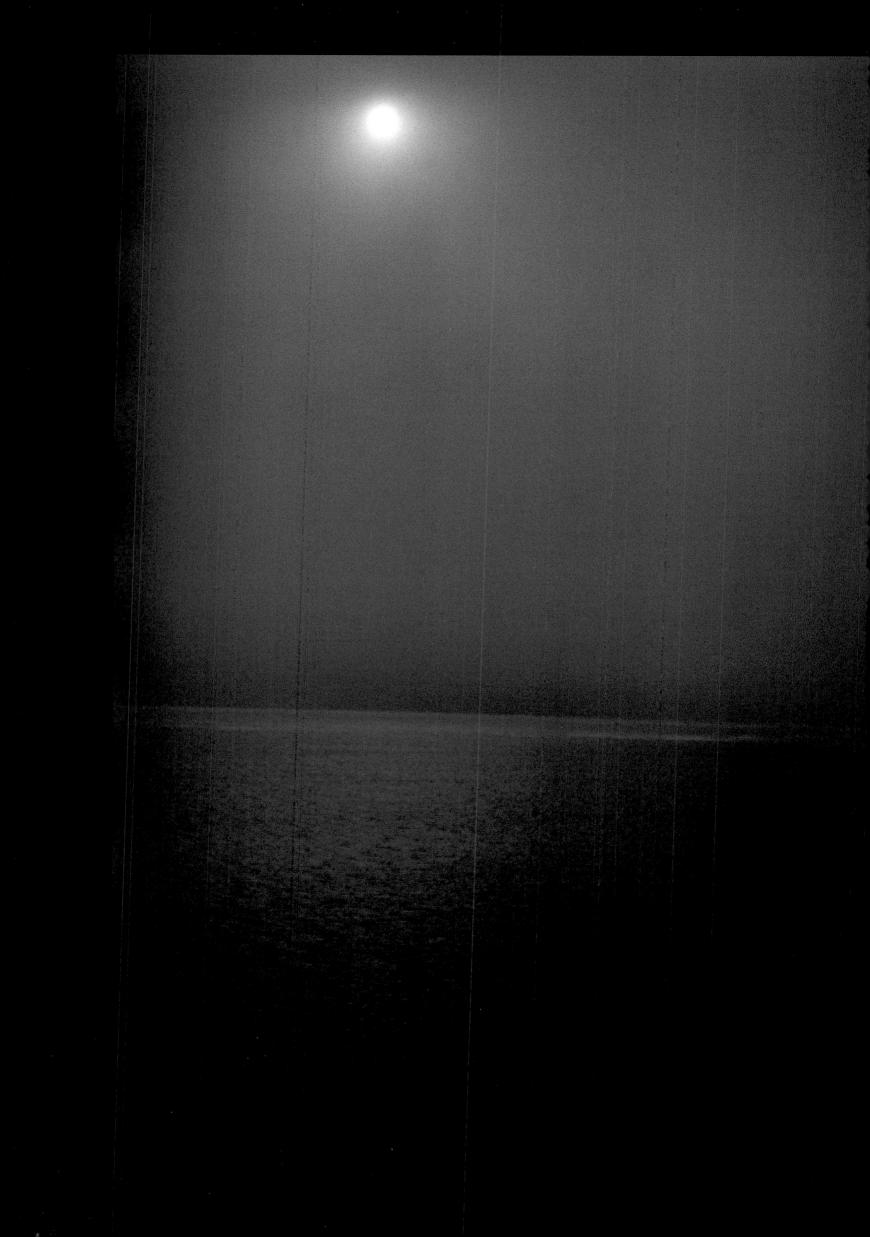

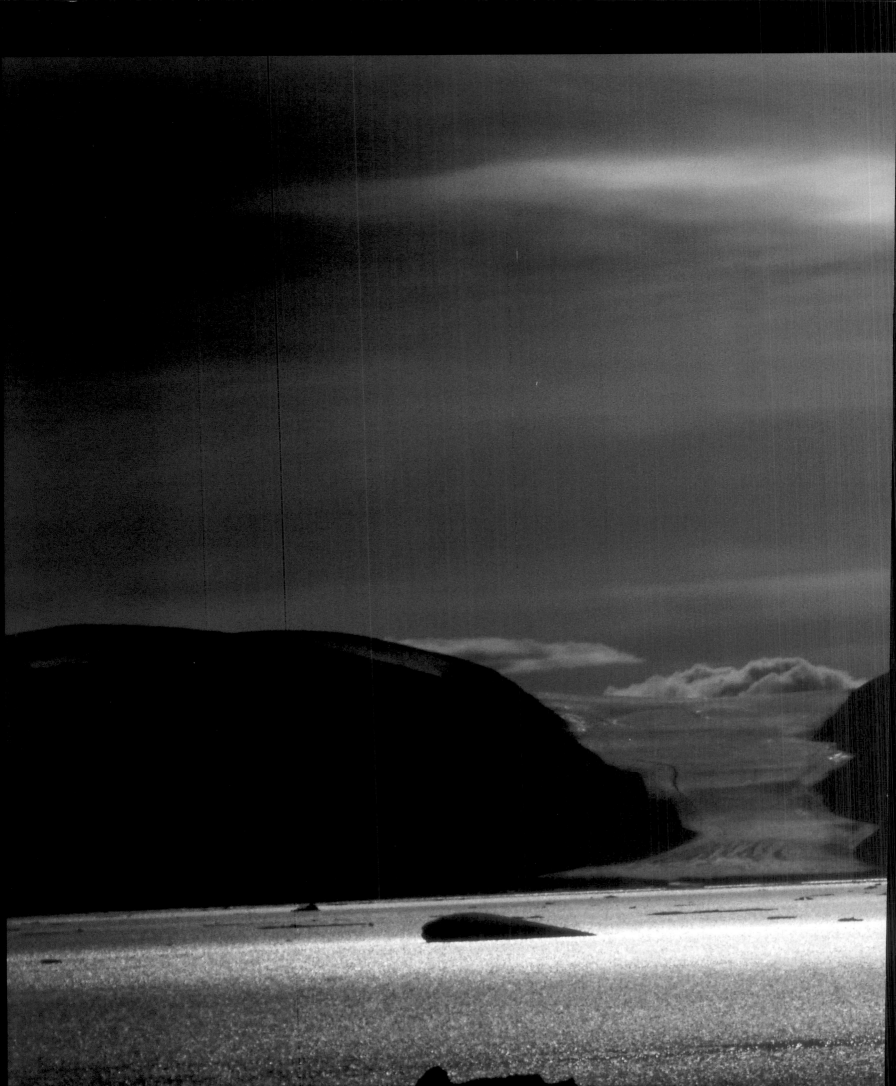

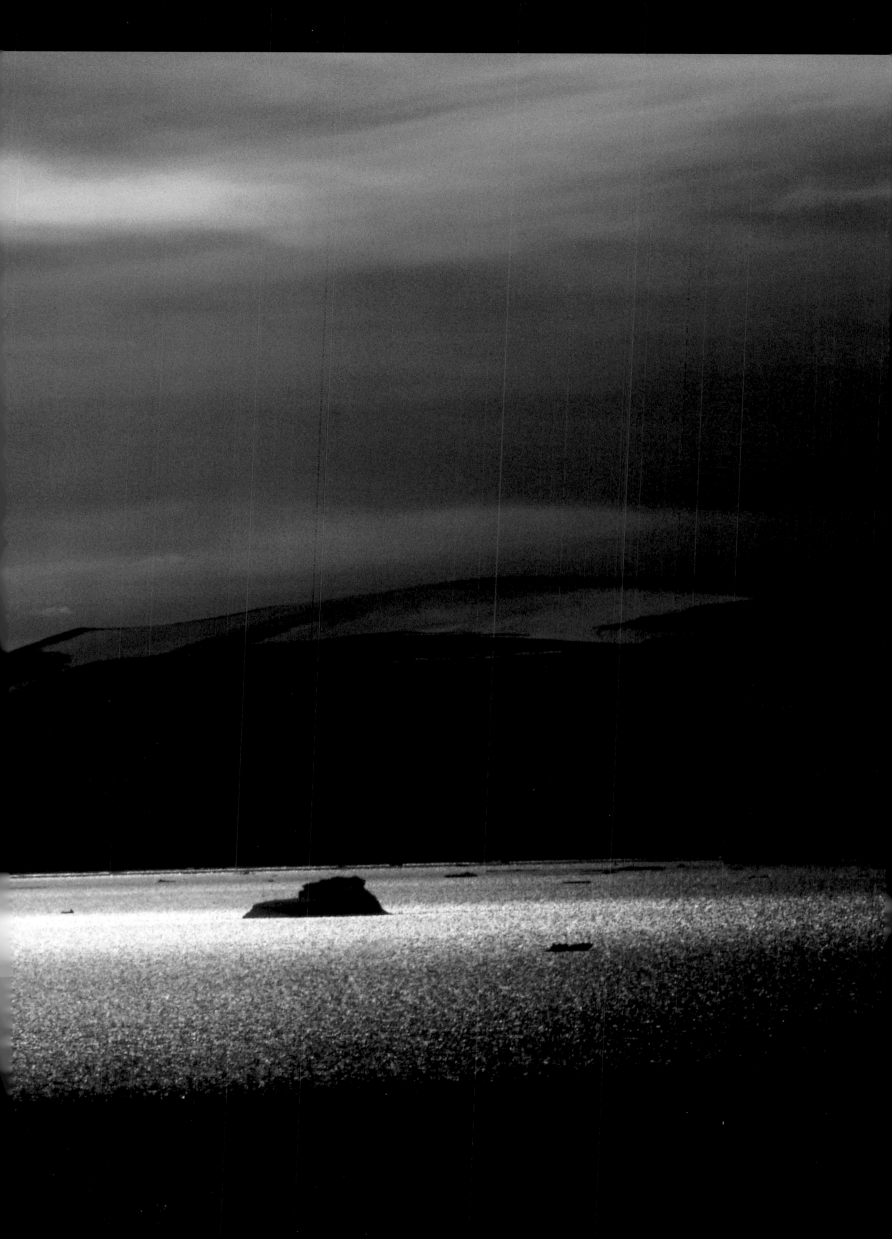

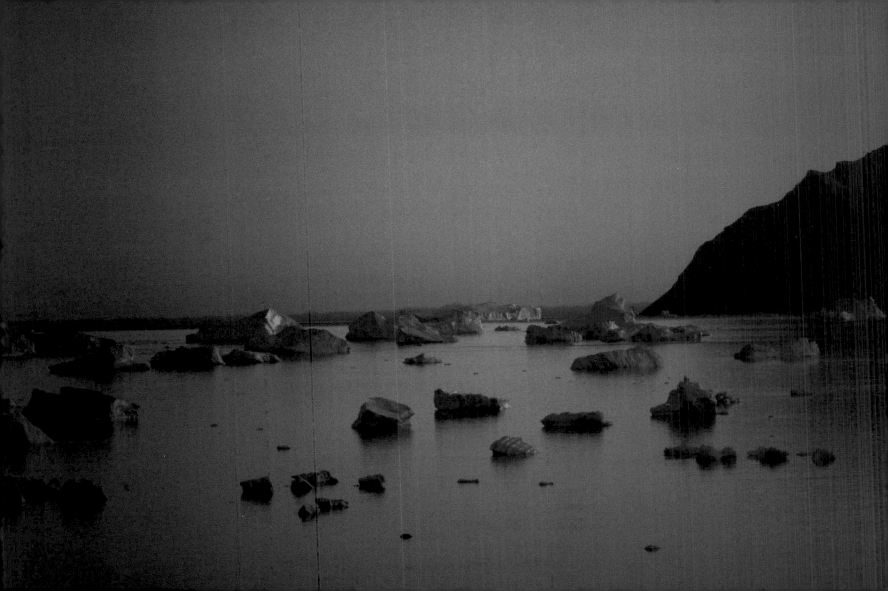

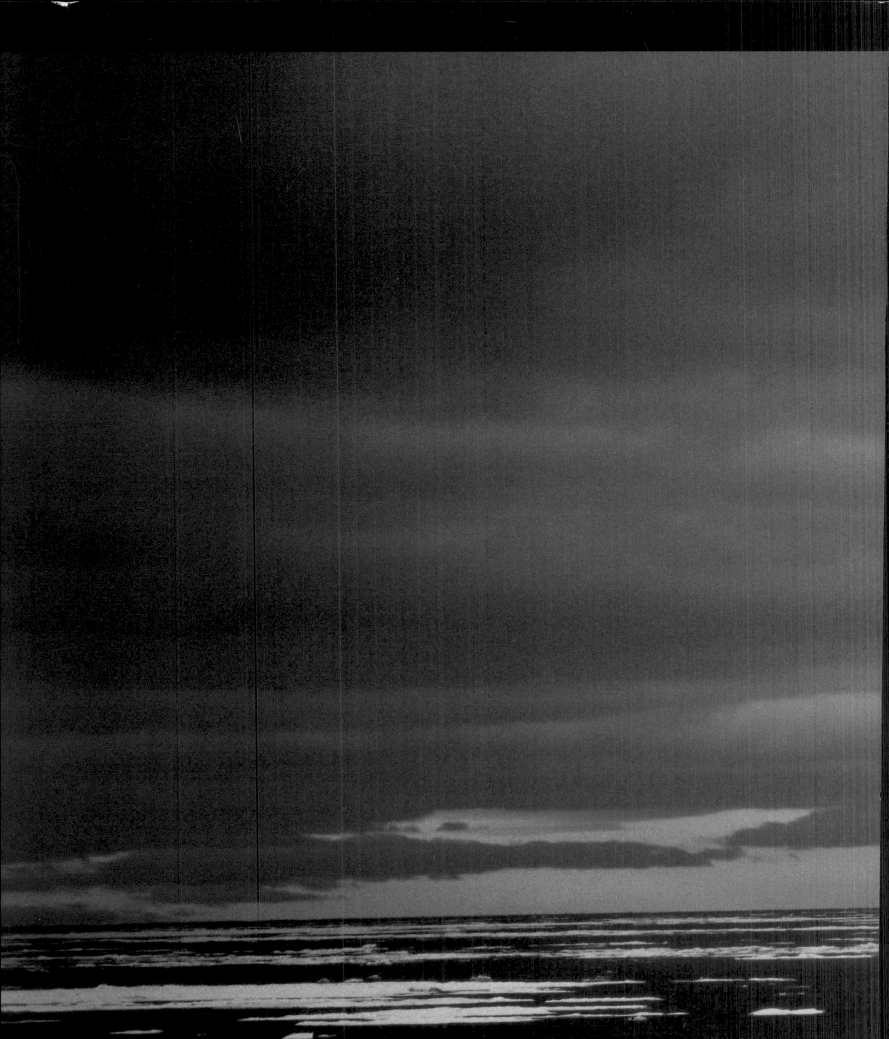

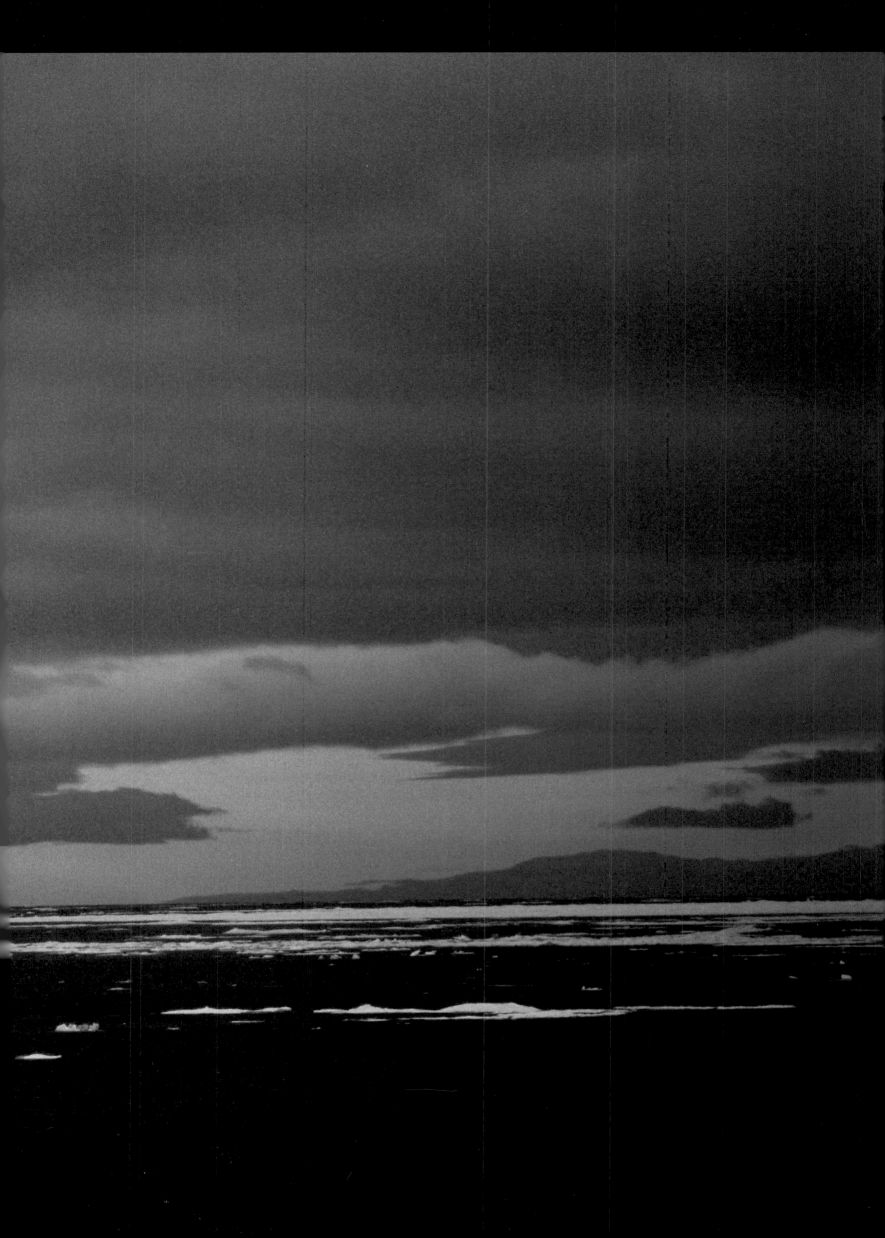

EXPLORERS' BIOGRAPHIES

AMUNDSEN, Roald
(1872–1928)
Head of the *Gjoa* expedition (1903–1906), which left Oslo, June 16, 1903. After two winter layovers in the south of King William Island, reached the first northwest passage from the Atlantic to the Pacific (Nome and then San Francisco, October 19, 1906). During the course of the two winters: exploration of King William Island and Boothia Peninsula; studies of Netsilik Inuit customs. Prestigious explorer; the first to reach the South Pole on December 14, 1911.

ARUTIUNOV, Serge
(1920–)
Ethno-archeologist. One of the discoverers of the Baleines passage in Chukotka (Yttygran, 1976). Worked with Dorain Sergueev until 1975. On of the most eminent ethno-archeologists of Chukotka.

BACK, George
(1796–1878)
Trent, 1818; lieutenant of the Franklin expedition of Northwest Canada; explored the great Mackenzie River up to the Arctic Ocean, 1819–1822. Lieutenant of Captain J. Franklin's expedition, 1825–1827. Commandant and head of the expedition, 1833–1835; explored the Thlew-ee-Choh River (now Back River, formerly *Grand Poisson* River) from the Great Slave Lake to the Arctic Ocean (Chantrey Inlet). Two winter layovers at Fort Reliance (Great Slave Lake); Captain and head of the *Terror* expedition, 1836–1837.

BILLINGS, Joseph
(ca. 1760–1806)
Navigator-explorer. Assistant on the Discovery, 1776–1780. Head of the "Great Northern Expedition," 1785–1794, which operated out of Chukotka under the direction of Catherine II.

BOGORAZ, Vladimir
(1860–1936)
Bolshevik, Russian Jew deported to the north of Yakoutie for 10 years. Self-educated, wrote the authoritative monograph on the Chuktches. After the October Revolution, held the first chair in Siberian ethnography at the University of Leningrad. Founded the Hertzen Institute, Faculty of Peoples of the North (group of aboriginal instructors of northern Siberia).

CHAMISSO, Adalbert von
(1781–1838)
Naturalist of French Huguenot origin. Expedition of the *Ryurik* led by Captain Otto von Kotzebue, 1815–1818. Saint Lawrence Island, Kotzebue. Goal: to find a north Siberian sea route from the Bering Strait to Western Europe.

COOK, Frederick Albert
(1865–1940)
Doctor and ethnologist. R.E. Peary Expedition, 1891–1892; head of the expedition on board the *Zeta*, 1893, and on the *Miranda*, 1894. In 1907–1909, led the expedition to the North Pole, proclaiming to have attained it on April 26, 1908 with two Eskimos, and with 26 dogs pulling two sleds. Always a lively controversy around the personality of Dr. F.A. Cook and his self-proclaimed conquest of the North Pole. First medical study of Polar Eskimos.

COOK, James
(1728–1779)
Celebrated captain and head of the *Resolution* and *Discovery* expeditions, 1776–1780. Searched for a northwest passage from the northern Pacific toward Baffin Island on the one hand, and toward the Northeast Passage starting from the Bering Strait.

FREUCHEN, Peter Elfred
(1896–1957)
Assistant meteorologist of the Danish expedition (1906–1908) on the northeastern coast of Greenland. Administrator of the Arctic Station at Thule, 1910. Assistant to Knud Rasmussen during the first Thule expedition, 1912. Geographer of the fifth Thule expedition of the eastern Canadian Arctic. The first scientist to have married an Eskimo.

GREELY, Adolphus Washington
(1844–1935)
Head of the American expedition of the international First Polar Year (1881–1884), Ellesmere Island.
Brilliant scientific results but it ended in tragedy: 19 young Americans died of hunger.

HARRINGTON, Richard
(1912–)
First photo-reporter in the central Canadian Arctic during a famine period, 1949 and 1950–1951.

HAYES, Isaac Israël
(1832–1881)
Doctor aboard the *Advance*. American expedition in the north of Greenland led by Elisha Kent Kane, 1853–1855. Head of the American expedition in the north of Greenland and in Ellesmere Island on board the *United States*, 1860–1861. Tourist guide on board the *Panther*, northeast coast of Greenland, 1869. In 1853–1855, betrayed head of the expedition, E.K. Kane, during a mutiny.

JENNESS, Diamond
(1886–1969)
Canadian anthropologist of New Zealand orgin. Ethnologist on board *Karluk* of the Canadian Arctic Expedition under the leadership of V. Stefansson, 1913–1916. Jenness's winter layover at the Eskimo community at Cuivre, 1914–1916. 1926: Expedition in Alaska (region of Wales). One of the most important authorities on studies of Eskimos and Canadian Indians.

JOHNSTON, Thomas E.
(1920–1996)
British ethno-musicologist of Eskimos and Alaskan Indians (1913–1996). An important authority on Alaskan ethno-musicology.

LOW, Peter Albert
(1861–1952)
Geologist. *Dianna* (1897), head of the first Canadian Geological Expedition, 1898–1899 (Hudson Bay coast, Cape Wolstenholme), and head of the *Neptune* expedition, 1903–1904. Hudson Bay (west coast) and the archipelago up to Cape Sabine, Ellesmere Island and Cape Herschell, the Mackenzie coast. Goal: To affirm Canadian sovereignty. Winter layover of the ships. Reconnaissance squads with dogsled.

LUTKE, Fedor Petrovich
(1792–1882)
First Russian officer to disembark on what was to become the illustrious islands of Arakamchechen and Ittygran, which he mapped. His report does not mention the Baleines passage which he doesn't seem to have noticed. Aide-de-camp of Czar Nicolas I. Captain of the *Seniavine*, 1826–1829.

MENOVTSCHIKOV, Georgi Alexeievitch
(1910–)
Philologist (USSR Academy of Sciences). Instructor, then philologist and folklorist on Asian Eskimos (1930–1970); Chaplino, Uelen, Sireniki.

MULLER, Gerhardt Freidrich
(1705–1783)
Ethnographer and historian. Expedition of Capt. Vitus Behring — quest for the strait that now bears his name, under the direction of Peter the Great, 1733–1743.

ORLOVA, E.P.
(1910–)
. Geographer (Khabarovsk). Mission to study human geography in Chukotka in 1931 and 1934. "Asian Eskimos have not been spoiled by Soviet ethnographers; nothing has been written about them with the exception of some notes, owing to the riskiness of several fragmentary missions and stays that were too brief."

PARRY, William Edward
(1790–1855)
Lt. Commander of the *Alexander*, 1818, when the expedition was led by Capt. John Ross aboard the *Isabella*. Expedition head and lieutenant commander of the *Hecla*, 1819–1820, during the first Northwest Passage expedition up to Melville Island. Expedition head and commander on the *Fury*, 1821–1823. He discovered the Iglulik Inuits and made the first study of them.

PEARY, Josephine Diebitsch
Wife of R.E. Peary. Participated in his expeditions to northern Greenland, 1891–1892, 1893–1895 (years 1893–1894), 1897, 1898–1892 (1900–1901). Her pluck helped sustain R.E. Peary in his voyage to Pole. She gave birth to a daughter in northern Greenland on September 12, 1893: Marie Ahnighito.

PEARY, Robert Edwin
(1856–1920)
Engineer in the U.S. Navy, head of American expeditions to Greenland, then to Ellesmere Island, then to the geographic Pole 1886, 1891–1892, 1893–1895, 1896, 1897, 1898–1902, 1905–1906, 19081909. Admiral (1910). On April 6, 1909, Robert Edwin Peary reached the North Pole, accompanied by four Eskimos and his black companion Matthew Henson. A controversy brewed, first questioning the claim of Dr. Frederick Albert Cook then, some years later, Peary's. It was Sir Wally Herbert, incontestable British discoverer of the Pole (April 6, 1969) who, it appeared, definitively established that R.E. Peary could not have reached the Pole and that, owing to ice floes and relentless winds, he only came within 92.5km. of the geographic Pole. (*See* Jean Malaurie: *Ultima Thulé. De la découverte à l'invasion*, 2nd revised and augmented edition; Edition du Chêne, Paris, France; 2000; 400 pages, 800 photographs, 40 maps.)

RASMUSSEN, Knud Johann Victor
(1879–1933)
Student. "Den Danske Literaere Gronlands Ekspeditions," 1902–1904 (west coast of Greenland, from Cape Farewell to Uummannaaq, northwest Greenland), head of the Danish expedition of 1905–1908. Along with Peter Freuchen, founder of Thule's Arctic Station; headed seven expeditions from Thule, including the celebrated fifth one in 1922–1925, which was done on dogsleds from Greenland to Alaska. One of the founders of Eskimo Studies.

WRANGEL, Ferdinand Petrovitch, baron de
(1797–1870)
Explorer, navigator. *Kamtchatka*, 1817–1819, head of an expedition on the northern Siberian coast of Kolymka up to the eastern outskirts of Chukotka, 1820–1824.

BIBLIOGRAPHY

MALAURIE, Jean
(1922–)
Geographer, "French Polar Expeditions—Paul-Émile Victor," west-central Greenland, 1948, 1949. Head of the "French Geographic and Ethnographic Mission"; CNRS, northern Greenland, 1950–1951. Geomagnetic North Pole, May 29, 1951. Missions (CNRS-EHESS) 1960, 1961 (Canada: Foxe Basin, Boothia), 1962 (Hudson Bay), 1963 (Canada: Back River), 1965 (Alaska: Saint Lawrence Island) 1967 (North Greenland), 1968 (Canada: Ungava), 1969 (Canada:Ungava; North Greenland), 1970 (Alaska: Bering Strait) 1972 (North Greenland), 1973 (Siberia:Yakoutie) 1974 (Alaska), 1980, 1982 (Greenland), 1987, 1988 (Canada: Baffin), 1991, 1992 (Greenland) 1995 (Alaska). Head scientist of the "First Franco-Soviet Expedition, Chukotka 1990." 1997: Nome-Teller, Alaska.

GREENLAND

COOK, F. A., *My Attainment of the Pole*, New York, 1913.

COOK, F. A., *Return from the Pole*, New York, 1951.

FREUCHEN, P., *Arctic Adventure*, New York, 1935.

GREELY, A. W., *Three Years of Arctic Service*, New York, 1886.

HARPER, Kenn, *Minik, l'Esquimau déraciné*, Plon, coll. "Terre Humaine," Paris, 1980.

HAYES, I. I., *The Open Polar Sea*, New York, 1886.

HENDRIK, Hans, *Memoirs of Hans Hendrik, the Arctic Travelle*, London, 1878.

HOLTVED, E., *Polareskimoer*, Copenhagen, 1942.

MALAURIE, Jean, *Thèmes de recherché géomorphologizue dans le Nord-Ouest du Groenland*, CNRS, Paris, 1968. 497 pp., 79 photos, 161 fig., 2 maps in color.

MALAURIE, Jean, *Les Derniers Rois de Thulé*, 5e éd. Revue et augmentée, Éditions Plon, coll. "Terre Humaine," Paris, 1989, 840 pp., 190, ill., 25 maps.

MALAURIE, Jean, *Hummocks*, tome 1, Nord Groenland—Arctique central *Canadien*, Éditions Plon, coll. "Terre Humaine," Paris, 1999. 560 pp., 79 ill. in-texte, 41 maps.

MALAURIE, Jean, *Ultima Thulé*. De la découverte à l'invasion. Éd. Revue et augmentée. Editions du Chêne, Paris, 2000. 400 pp., 700 illus. 52 maps.

OLLIVIER-HENRY, Jocelyne, *Silanaalagavog*, Editions Diabase, Paris, 1998.

PEARY, Josephine, *My Arctic Journal*, New York. 1893.

PEARY, Robert Edwin, *Northward Over the Great Ice*, 2 vol., New York, 1898.

PEARY, Robert Edwin, *Nearest the Pole*, New York, 1907.

PEARY, Robert Edwin, *The North Pole, It's Discovery in 1909*. New York, 1910.

RASMUSSEN, Knud, *The People of the Polar North: A Record*, London, 1908.

RASMUSSEN, Knud, *Greenland by the Polar Sea*, London, 1921.

CANADA
1. Igloulik

DAMAS, D., *Igluligmiut Kinship and Local Groupings: A Structural Approach*, Ottawa, 1963.

LOW, Albert Peter, Cruise of the Neptune, Ottawa, 1906.

LYON, G. F., *The Private Journal*, London, 1824.

MALAURIE, Jean, *Hummocks, tome I, Nord Groenland—Arctic central canadien*. pp. 228–243, Editions Plon, coll. "Terre Humain," Paris, 1999.

MATHIASSEN, T., *Material Culture of the Igloulik Eskimos* (from Report of the Fifth Thule Expedition), 1921–1924, vol. 7, no. 3, Copenhagen, 1928.

PARRY, William Edward, *Journal of a Second Voyage for the Discovery of a Northwest Passage from the Atlantic to the Pacific*, London, 1824.

RASMUSSEN, Knud, *Iglulik and Caribou Eskimo Texts* (from Roport of the Fifth Thule Expedition, 1921–24, vol. 7, no. 3, Copenhagen, 1928.

2. Netsilik

AMUNDSEN, Roald, *Le Passage du Nord-Ouest*, Paris, 1909.

BALIKCI, A., *The Netsilik Eskimo*, New York, 1970.

MALAURIE, Jean, *Hummocks, tome I, Nord Groenland–Arctique central canadien*. pp. 275–340. Editions Plon, Paris, 1999.

PONCINS, G. de, *Kabloona*, Paris, 1939.

RASMUSSEN, Knud, *The Netsilik Eskimos: Social Life and Spiritual Culture* (report from the Fifth Thule Expedition, 1921–24, vol. 8, nos. 1, 2, Copenhagen, 1931.

ROSS, J., *Appendix to the Narrative of a Second Voyage in Search of the Northwest Passage and of a Residence in the Arctic Regions during the years 1829–33*, London, 1835.

3. Utkuhijhalingmiut

BACK, Sir George, *Narrative of the Arctic Land Expedition to Mouth of the Great Fish River and Along the Shores of the Arctic Ocean in the Years 1833, 1834, 1835*, London, 1836

HARRINGTON, Richard, *The Face of the Arctic*, New York, 1952.

MALAURIE, Jean, *Hummocks, tome I, Nord Groenland–Arctique central canadien*, pp. 364–434 and pp. 473–477, Editions Plon, Paris, 1999.

RASMUSSEN, Knud, *The Utkuhikhalinguit* (report from the Fifth Thule Expedition, 1921–24, vol. 8, no. 2, Copenhagen. 1931.

BERING STRAIT (Alaska: Saint Lawrence Island, Diomede Island, and the Seward Peninsula; Siberia: Tchoukotka)

ARUTIUNOV, S.A., KRUPNIK, I. I., CLENOV, M. A., *Kitovaja alleja, drevne-eskimosskij kul'tovyi pamjatnik na ostrove Ittygran/L'Allée des Baleines, site actuel de l'ancienne culture esquimaude sur l'île Ittygran, Sovetskaja etnografia no. 14, 1979, and in Siberia*, CNRS, Paris, 1909.

BOGORAZ, Vladimir, *The Chukchee*, New York, 1909.

COOK, James, The Journals of Captain James Cook, edited by J.C. Beaglehole, 4 vols., Cambridge, 1955–1974.

INDEX

The vocabulary and orthography belong to the Inuit language

Aarnguq: amulet

Aaviq: walrus

Aggiruk: dance (Alaska, Inupiat language)

Agliqtuq: "He observes the taboos."

Agluq: breathing hole that the seal makes in the ice floe when the water first freezes in the fall

Amaruq: wolf

Angakkuq: shaman

Angyak (Chukotka), *umiak* (Alaska): walrus skin boat

Alerhiq: socks (hare skin turned inside out)

Amaut: skin anorak with hood for babies

Anirhaaq: human spirit

Anuri: wind

Aput: snow

Arwooq: whale

Assiliihuq: "He is taking a picture."

Havik: rifle

Igliq: sleeping platform

Igloo: stone house surrounded with peat

Igluigaq: snow igloo

Iglutuqqaq: traditional house in stone and peat

Imaq: sea

Ingmirut: traditional song

Kakivvak: fish spear

Kamik: seal skin boots, lined, the inside boot—*alerssuit*—is made of hare skin turned inside out

Kapatak: fox skin anorak

Kipoupktut: trade of women

Man'tyg'ak: summer yurt (Chukotka)

Nannuk: bear skin pants

Nanuq: bear

Natsiq: summer anorak made of seal skin

Natsiaq: young seal

Niqi: meat (by extension, all food)

Nuna: land

Polog: inside space made from skin in the igloo (Chukotka)

Pualuk: gloves

Puihi: seal

Qaamutik: sled

Qangmat: igloo made from stone, peat and wood

Q'assigi: communal house or house for men (Siberia)

Qilak: sky

Qilalugaq (*qirniqtaq*): narwhal

Qilaut: drum

Qimmiq: dog

Qivittoq: evil spirit

Qulittaq: reindeer clothing put on through the top. It has a hood, foxtail trim and bear hair chin piece

Qulliq: seal oil lamp (Greenland and Canada)

Saluktut: dancer's leap on walrus skin, held taught by participants (Alaska, Inupiat language)

Sermeq: glacier

Tiriganniaq: fox

Tupik: tent

Tupilak: evil spirit sent by its maker as revenge

Tuquhuq: "He is dead."

Tuto: reindeer

Tuurngaq: good spirit that looks over an individual

Ujarak: stone

Umingmak: musk ox

CREDITS

Pastels by Jean Malaurie: p. 91, endpapers. *Collection of Jean Malaurie*: p. 137: Qaaqutsiaq's personal harpoon in walrus ivory and used to hunt walruses, narwhals, and white whales. Etah, June 1951; p. 191: *Oulou* or traditional knife for women, wood handle. Iglulik, 1960; p. 217: caribou antler handle for ice hole fishing. Utkuhikhalingmiut. Back River, April 1963; p. 276: mask made of whale fossil bone. Shishmaref, 1974; p. 288: mask made from whale fossil bone. Nome, 1974; pp. 290–291: engraved walrus ivory. Uelen, 1990. Walrus ivory with black engraving, walrus hunt. Shishmaref, 1974. Walrus ivory cup with whale hunt engraving. Uelen, 1990; p. 305: mask made of whale fossil bone. Shishmaref, 1974; p. 310: ivory fossil with color engraving. Old Bering Sea. Traditional bag from Chukotka with esoteric decorations. Uelen, 1990; p. 335: wood mask, Point Barrow, 1800–1900; p. 27: poetry by Carlos Drummond de Andrade, © Editions Gallimard, 1990. *Maps*: pp. 4–5, 136, 190, 216, 260, 304, 334, by Patrick Mérienne, color by Izumi Cazalis. *Photographs*: p.72–73, 74–75 © Francis Parel; p. 37 © National Museet, Copenhagen. Endpapers, p. 91, 137, 191, 217, 261, 288, 290 (bottom), 291 (top), 305, 310 (middle, bottom), 335 © Patrick Lorette. p. 310 © Museum of Anthropology of St. Petersburg / Vladimir Terebenin.

THE AUTHOR WISHES TO THANK

Sylvie Devers, my precious colleague who runs the Fonds Polaire Jean Malaurie so competently. Bibliothèque Centrale du Muséum National d'Histoire Naturelle, Paris. My friend the Inuit Senator, Charlie Watt, Ottawa. Mark Malone, Senate, Ottawa, comrade in arms for the defense of the minorities of the Canadian Far North. Bruce Jackson, University of Buffalo, New York. Eva Rude, Copenhagen. Serguëi Arutiunov, eminent Russian archeologist in Chukotka, and friend of thirty years. Azurguet Chaoukenbaeva, Rector of the Polar Academy of the State of Saint Petersburg. Henri Bancaud, who came with me to Chukotka (1990). Cécile Kilburg, my secretary, who, fortunately, assisted me with the preparation of this book. Finally, the editorial team at Editions de La Martinière: Carole Daprey, Céline Moulard and Valérie Roland. I want to especially thank Benoit Nacci, whose talent and friendship go unmatched.

Editor, English-language edition: David Brown
Designers, English-language edition:
Brankica Kovrlija, Tina Thompson

Library of Congress Control Number: 2001093281

ISBN 0–8109–0622–8

Printed and bound in Italy

10 9 8 7 6 5 4 3 2 1

Harry N. Abrams, Inc.
100 Fifth Avenue
New York, N.Y. 10011
www.abramsbooks.com